PENGUIN BOOKS

THE PENGUIN BOOK OF ART WRITING

Martin Gayford studied philosophy at Cambridge and art history at the Courtauld Institute. He is the art critic of the *Spectator*, and contributes regularly to the *Daily Telegraph*, *Modern Painters* and *Harpers & Queen*. He is married, with two children, and lives in Cambridge.

Karen Wright was born in the USA and studied art history at Brandeis and Cambridge. She is the editor and director of *Modern Painters* magazine and director of *21 Publishing*. She is married, with two daughters, and lives in Cambridge.

THE PENGUIN BOOK OF

Art Writing

EDITED BY

Martin Gayford and

Karen Wright

PENGUIN BOOKS

PENGUIN BOOKS

Published by the Penguin Group
Penguin Books Ltd, 27 Wrights Lane, London w8 5tz, England
Penguin Putnam Inc., 375 Hudson Street, New York, New York 10014, USA
Penguin Books Australia Ltd, Ringwood, Victoria, Australia
Penguin Books Canada Ltd, 10 Alcorn Avenue, Toronto, Ontario, Canada m4v 3b2
Penguin Books (NZ) Ltd, Private Bag 102902, NSMC, Auckland, New Zealand

Penguin Books Ltd, Registered Offices: Harmondsworth, Middlesex, England

First published by Viking 1998
Published in Penguin Books 1999
10 9 8 7 6 5 4 3 2 1

Set in Monotype Garamond
Printed in England by Clays Ltd, St Ives plc

To Josephine, Cecily and Tom – MG
To Richard, Louisa and Rebecca – KW

Contents

Preface

In the course of this project, we have incurred many debts of gratitude — first of all, to Clare Alexander for suggesting the whole idea, and second to Andrew Kidd at Viking for shepherding us through endless prevarications and alterations with great patience and charm. Toby Buchan has added enormously to the accuracy and coherence of the final book with his painstaking copy-editing, and Nick Wetton has spent much time and effort in arranging for permission to be granted to use all manner of texts, often recondite ones. Alexandra Bovey, Alex Reinburg and Jonathan Blackwood all did sterling initial research. Josephine Gayford has given invaluable advice on literary and stylistic points at numerous moments of indecision and crisis, and also practical help with scissors and glue.

We would also like to thank the many people who have suggested authors and books for inclusion, especially Frank Auerbach, Julian Barnes, Paul Bonaventura, William Boyd, Craig Brown, A. S. Byatt, Michael Dibdin, Margaret Drabble, Geoff Dyer, Duncan Fallowell, the late Boris Ford, Lucian Freud, John Golding, Michael Holroyd, Robert Hughes, Siri Hustvedt, Howard Jacobson, Jonathan Kellerman, John Kerrigan, R. B. Kitaj, John McEwen, Julian Mitchell, Andrew Motion, Anthony O'Hear, Jed Perl, Bryan Robertson, Nicholas Serota, David Sylvester, Euan Uglow, Leslie Waddington, Richard Wollheim, and Patrick Wright. We both very much regret that for copyright reasons we were unable to include any work by the late Peter Fuller, first editor of *Modern Painters*.

The dates that appear at the end of each piece generally represent as closely as we can determine the date of writing, rather than the date of publication.

Introduction

What are anthologies for? The answer, we believe, is, for reading – if possible right through, from beginning to end. At any rate, taking in a chapter at a time. It is with that end in view that we have compiled this collection.

Walter Benjamin had a similar ambition: to put together a whole, coherent book entirely out of quotations. He never got around to doing so, perhaps because the project is impossible. Certainly we would not claim to have succeeded where Benjamin has failed. For one thing, we intrude into the text with regular editorial comments of our own. For another, not all the passages we have selected connect, logically or even illogically, with the others.

None the less, we have tried to assemble pieces of writing that fit together – from widely separated times and places – in terms of harmony or contrast of meaning, style, length, or tone. We certainly don't agree with them all – we are, after all, art writers ourselves, and one characteristic of the genre is that it is a rare event for two exponents to concur absolutely. In fact, a propensity for disagreeing is virtually a job qualification for a critic; while artists themselves are, if anything, even more opinionated.

What we have tried to do is allow the various pieces of writing to set each other off, like complementary colours, or different depths of tone. In this case, rather than red against green, light or shade, we have myriad points of view, a spectrum of attitudes: short snatches, long meditations, solemn thoughts, snide remarks. The main criterion by which we chose our snippets of writing was that they should be vivid, interesting, and belong in one of the sections of the book. That seemed the best way to deal with a subject – art – to which approaches, and about which opinions, are so diverse, not to say cacophonously discordant.

This is not intended to be a Domesday résumé of all that is wise and deep that has ever been written about art. Such a book would probably be impossible to assemble – or at any rate, would require as many volumes as an encyclopaedia – and even if it were completed would probably be impossible to read. For that reason there are many celebrated

writers on art whose names are not to be found in the index to this book.

Often the reason for leaving them out is that their words defied our efforts to fit them in. In particular, treatises on art history and art theory conceived and written on the grand scale do not respond well to being anthologized. A short excerpt, more frequently than not, turns out merely to be a meaningless fragment, a travesty of the whole. On the other hand, there are quite a few surprising contributors to our selection – an Emperor of Byzantium, Mrs Thatcher – who found their way in because, in a relatively short span, what they had to say was pointed, lively, vivid, entertaining – the qualities we wanted for this book.

That leads us on to another question. What is art writing? One possible answer might be that it is equivalent to art criticism, but that seemed to us too narrow a definition. Art criticism is a type of writing which has existed, at least in a fully developed form, for only a little over two centuries (the earliest clearly distinguishable examples are perhaps the commentaries that Denis Diderot wrote on the Paris Salons of the 1760s). Essentially, art criticism is an informed and provocative discussion of an artist or a current exhibition – a type of reporting that flourished in the newspapers and periodicals of the nineteenth century, and continues to flourish today. It is, however, by no means the whole of art writing.

That is a far wider field, which has been around for very much longer – there are small detachable nuggets of it in some of Plato's works from the fourth century BC. Since that small beginning art writing has increased in volume until, these days, it has become a flood, a Niagara – of histories, theories, anecdotes, epigrams, how-to-do-it manuals, recorded conversations, fictions and poems, to name only the more common manifestations. All of these need to be included in order to get the whole picture; all of them are pointers arranged around the central mystery: what is art?

The informed verdict of a professional observer – that is, art criticism – is one element of this flood of writing. But so too is the response of those amateurs for whom art criticism is not even a part-time profession. Charles Baudelaire, who himself moonlighted prolifically as a critic, made some wise remarks on this subject. 'I sincerely believe,' he wrote in 'The Salon of 1846', 'that the best criticism is the criticism that is entertaining and poetic; not a cold analytical type of criticism, which, claiming to explain everything, is devoid of hatred and love, and deliberately rids itself of any trace of feeling, but, since a fine painting is nature reflected by an

artist, the best critical study, I repeat, will be the one that is that painting reflected by an intelligent and sensitive mind. Thus the best accounts of a picture may well be a sonnet or an elegy.'

That is plainly true. Marvellous writing about art – some of the very best – can be found embedded in literature, in the novels of Proust, Henry James, and Joyce Cary, for example, or the poems of Auden and Keats. Conversely, more conventional art writing can on occasion also be good, even great, literature. It is quite possible to read Ruskin simply as an artist in prose, irrespective of what he has to say about art – and, given that a good deal of what he says about art, as in his notorious attack on Whistler, or in the passage on Canaletto to be found in 'Bad Reviews and Stinging Replies', is so crashingly wrong-headed, that is no bad thing.

Here we come to one of the paradoxes of the subject. Painting, sculpture and so forth are of course arts. But art writing itself can be an art; moreover, the merits of a piece of good prose do not disappear simply because the author happens to be wrong. This is plainly the case with Ruskin, and as a matter of fact with all critics. Robert Hughes, an outstanding contemporary writer on art, has remarked that from time to time every critic misses by a 'country mile'; he admits to having done so over Philip Guston's later work. We have all missed on occasion, and some of us do so incessantly.

That does not necessarily matter, however. As Walter Sickert, a painter who also wrote with wit and dash, observed: 'The bulk of Ruskin's writing is not invalidated by his attack on Whistler. A certain girlish petulance of style that distinguished Ruskin is not altogether a defect. It served to irritate and fix attention, where a more evenly judicial writer might have remained unread. The pretension of a great critic is not like the pretension of the ridiculous modern being called an expert. A great critic does not stand or fall by immunity from error.'

Nor, on the other hand, is getting it right necessarily enough. Guillaume Apollinaire, generally speaking, got it right, if backing the artists valued by posterity is what counts. He supported the Cubists and many others in their early, struggling days. Most of those he tipped for fame did indeed become famous (he could do this because, unlike Ruskin, he associated with artists, the best way to find out what's going on). But his writings suggest that he supported Picasso and Braque without really understanding what they were doing; furthermore, and worse, despite being a distinguished poet, novelist and dramatist (and supposedly the coiner of the term 'surrealism') he wrote rather dully on art. So, although he was right, we have left him out.

As has been said, being dreadfully wrong is not necessarily fatal. Diderot, father of modern art criticism, made an observation on this subject which, Sickert kindly remarks, is full of consolation for the critic: 'I would rather have foolish things said on matters of importance than have them passed over in silence. At least thus they have become subjects of discussion and dispute, and truth is elicited.' There are some views expressed in this collection which are arguably foolish – or worse, in the case of, say, Adolf Hitler's contribution – but they are included for the vividness with which that foolishness is expressed.

In any case, one might well ask, with a subject as elusive as art, what is the truth? One point that clearly emerges is that whatever it is, artists very seldom, if ever, think that any writer has hit on it in the case of their own work. There are a number of reasons for this, one being that every artist views the subject of art from the perspective of his or her own preoccupations. Nor is this an ordinary perspective, but a highly geared one in which the artist's own work bulks huge in the foreground; other work relevant to his or her preoccupations can be discerned in the middle distance, while the rest disappears to infinity. (This state of affairs is one of the best justifications for the existence of critics.)

Again, Walter Sickert tells an anecdote about this solipsistic tendency of artists. 'I have never been able to get out of any painter-pure exactly what he would like art criticism to be. My nearest approach to discovery was from the lips of Whistler himself. I wished to introduce McColl [a leading critic of the period, and supporter of Whistler and Sickert] to him, and thinking to prepare the way, and to tinder, as they say in France, the spirit of the master, I said:

' "You know – author of that article in the *Saturday*, 'Hail, Master!' [a piece, clearly, in fulsome praise of Whistler]."

' "Humph," said Whistler, "That's all very well – 'Hail, Master!' But he writes about OTHER PEOPLE, OTHER PEOPLE, Walter!" '

The other reason why artists tend to retain a degree of reserve about even the most unstinting praise is less egomaniacal. The most gushing adulation is unlikely to express the whole truth, as they see it, about their work. Indeed, even they themselves probably cannot do that. Recently a contemporary British painter, Patrick Heron, who has also written brilliantly about art, confessed as much. 'There's no absolute statement, verbally, which remains exclusively valid. The moment you put it to yourself, or to an audience, at that moment you are aware of a need to modify, and restate. So the talk about the paintings really goes on changing

all the time.' At that point, someone – as a matter of fact, one of the editors of this book – asked whether in that case, the critic's role was a doomed one, the critic destined never quite to get it right. 'Yes,' Heron replied, 'that's true, actually. It can't be got quite right.'

It is easy to see why this should be so. All verbal statements about art are attempts at translation – in this case translation from an intuitive, non-verbal, visual medium into that of words (something which remains true even of those works that contain words or actually consist of words – some Cubist, medieval, and conceptual art, for example; the dictionary meaning of the words isn't really the point, otherwise we would be dealing with literature). Those who – like post-Modernist critics – believe that art is in reality a system of signs akin to writing, or as they would doubtless prefer to put it, écriture – will not go along with this. But there it is – we disagree with *them*. One of the most obvious aspects of art, and one of the main points to emerge from any conversation with artists, is that we are dealing here with an intuitive, and finally mysterious, activity. As Georges Braque noted, the most important part of a work of art is the little bit that can't be explained. That is among the major reasons why art is so interesting.

Art writing, then, is a kind of translation, and we all know what is said about translations: if they are beautiful, they are not faithful, and if they are faithful, they are not beautiful. Here is Walter Sickert again: 'The real subject of a picture or a drawing is the plastic facts that it succeeds in expressing, and all the world of pathos, of poetry, of sentiment that it succeeds in conveying, is conveyed by means of the plastic facts expressed, by the suggestion of the three dimensions of space, the suggestion of weight, the prelude or the refrain of movement, the promise of movement to come, or the echo of movement past. If the subject of a picture could be stated in words there would be no need to paint it. Writers on art, wisely, in their own interests, mostly ride off at once from any real contact, either with a picture or its subject, to irrelevant secondary considerations that can be buttoned on to that subject. The nearer a writer on art is to the heart of that subject, the better he knows that the subject is very poor copy.'

There is a good deal of truth in this. Those who write for newspapers and magazines, or for broadcasting, are aware that their editors may grow uneasy if they go on too much about, say, colour harmony or form. Patrick Heron was once sacked as art critic of the *New Statesman* because, as the arts editor put it, the reader cannot be expected to read, week after week, about 'abstruse questions of space'.

In that case, the editor got it badly wrong. But it is also true – a point that has made our job of selection easier – that much writing about art is stale, weary and unprofitable to read. The clichés that began in antiquity with wearyingly frequent accounts of birds pecking painted grapes, cows lowing at brazen oxen, and so forth, have, like art writing itself, become a mighty torrent.

Most people see what they expect to see. If one reads through the works of eighteenth-century travellers in Italy, one finds that one after another, when they come to the Doge's Palace in Venice, they praise one painting – Veronese's *Rape of Europa* – and what they praise about it is the tender way the nymph's foot is painted. Few even notice the picture these days, let alone that foot; we read different guidebooks, and utter other, but equally derivative ideas.

Just at the moment, the art-writing clichés tend to be the intellectual and stylistic mannerisms of Derrida, Barthes, and Baudrillard, retailed a million times. But over the centuries art jargon has taken myriad forms. The result – whether post-Modernism or seventeenth-century classicism – is much the same: a blanket of heavy prose that settles over the reader's mind like a thick smog, and through which any worthwhile thoughts can be discerned only with much straining.

However, a leading financial journalist once pointed out that there is nothing dull about money, though there is about quite a few people who write about it. The same applies to art. In fact, it is possible to write in a thoroughly interesting fashion about matters of space, colour, light and form (Heron, of course, despite that editor's opinion, did just that). We made it a principle of our selection to search out those who had done so.

One way to make such matter live for the reader – perhaps the best – is for the writer to be autobiographical, to describe his or her own response. That, presumably, is what David Sylvester – the doyen of art writers in the English language – meant when he modestly referred to 'the way I can't help writing about art, which is not unlike St Teresa of Ávila's reports on her intercourse with the deity'. Sylvester's comparison brings out the feeling that one is dealing with the unknowable, and also the excitement, the passion, which are often present in good art writing.

That, by the way, is the best reason for resisting the view – now the orthodox, and perhaps the prevalent one – that opinions in art are simply a matter of taste, if not disguised expressions of snobbery and social climbing. It may be true that tastes vary in different times and places; and that even in the same time and place few of us agree completely. We do

not admire all the same works as would an eighteenth-century connoisseur; our top ten choices would be largely different (though some artists, such as Michelangelo, are perennially in the charts). We do not all harmoniously nod our heads when the winner of the Turner Prize is announced.

None the less, likes and dislikes in art do not *feel* entirely subjective. When we encounter a new style, or artist, or idiom, and we love it, it feels much more as if we have met up with something marvellous, and external, something from which we can learn – as St Teresa felt, rightly or wrongly, when the angel with the burning lance fluttered into her cell. It is just that we all bump into the angel from different directions, on different days, in different moods.

So the reactions of Henry James sauntering through the galleries of the Pitti Palace in a mellow mood – as he describes in the section 'Gallery-going' – were not quite the same as anyone else's or, indeed, his own on another occasion. This multiplicity of diverse approaches to art, an infinite number of perspectives dissolving one into another, has led us to be as catholic as possible in our selection.

Particularly, in addition to the observer's story – whether the observer is a professional critic or not – it seemed important to include the artist's point of view (an alternative title would have been *The Penguin Book of Artists and Art Writing*). It is not just that artists down the years have produced some of the best art writing (as several artists hastened, quite rightly, to point out). It is also that their angle is necessarily quite different from that of the art consumer. A famous jazz pianist was once accosted after his set by a fan who remarked that it had sounded as if he were really enjoying himself. 'To you it may sound happy,' the pianist replied, 'but I'm just thinking about how I'm going to get to the end of the next eight bars.' Evidently, making art can be much like that. Indeed, Damien Hirst – as he explains in this book – considers part of the point of his dot paintings is that they always look happy, however he feels. They are a comment on the theory that artists are expressing their emotions in their work.

Since what it is like to make art is probably even harder to describe than what it feels like to look at it, this is best approached circuitously as well as directly. There is the question of how the art is made, to which a heroic set-piece such as Benvenuto Cellini's account of the casting of his *Perseus* gives one kind of answer, while the practical hints and tips from Manet, Gauguin, Bernini *et al.* give another. It is intriguing to discover that certain problems – notably how one can tell when a painting is

finished – have been discussed since the fourth century BC (at least, if Pliny's anecdotes about the Greek painter Apelles are to be believed).

It goes without saying that we are all embedded in history like flies in amber. None the less, certain themes persist through time. There are echoes as well as contrasts down the centuries, as themes such as nature or drawing are discussed. For that reason, it seemed much more stimulating to arrange this collection thematically rather than chronologically.

Then there is the question of where art comes into being – artists' studios, for those who love art, being among the most fascinating of rooms because they can tell us something about the process of creation. Finally, and most importantly, there is the matter of who makes the art. The characters, the rivalries, the blindnesses and the eccentricities, the daily lives of artists, can all tell us something about the art itself. For example, the figure of the artist as outsider, which goes back further into the past than the word 'bohemian' in its sense of social gypsy – to seventeenth-century Rome at least – tells us more than that some artists have lived from hand to mouth and drunk a lot (though both are undoubtedly true). An existence outside the comforts and constraints of normal life can be a way – although not, of course, the only one – of freeing the imagination.

Our hope is that all these observations, thoughts, comments and reflections from widely separated places and epochs, make up a whole that is greater than the sum of its parts. We also hope that they are entertaining to read, not as an 'added extra', but because – as Baudelaire points out – the more vivid and entertaining a piece of writing is, the more revealing it is likely to be. But as to what this book reveals about art – well, to discover that you'll have to read it.

MARTIN GAYFORD
KAREN WRIGHT
July 1998

In
the
Studio:
The
Artist
at
Work

The Parisian photographer Brassaï was able to snap the aged Pierre Bonnard at work, but only from behind.

'I don't think you'll manage to photograph Bonnard. He's in a bad way,' Matisse had warned me in Vence. 'The filmmakers who did a short about me wanted to film him as well, but he refused. The death of his wife was a terrible shock to him. He's still suffering from it . . .'

I was therefore somewhat apprehensive on that radiant August morning in 1946 when I rang the bell at Pierre Bonnard's door in Le Cannet. What a selective thing fame can be! You can be one of the greatest painters in the world and still be completely unknown to your neighbours. Not one of them was able to point out to me where he lived. 'Bonnard? Never heard of him . . .' Fortunately, the name of his small property was more familiar than his own, and I managed to find Le Bosquet, with its pink walls, perched halfway up the steep hillside. Who would ever have imagined that he would inhabit such a commonplace dwelling?

The door was opened by the painter's grand-nephew, Charles Terrasse, who was curator of the Château de Fontainebleau. The inside of the house did nothing to belie the banality of its outward appearance. Ordinary cheap furniture, white wooden chairs and tables. Thinking of the luxurious and refined taste with which Matisse had selected every object that surrounded him, I was taken aback. However, Bonnard felt no need for Venetian armchairs, Chinese vases; no compulsion to surround himself with a fairyland. His brush could turn the most commonplace objects into poetry, from radiator pipes to his chipped bathtub. He endowed them all with a mysterious, glittering life. He was not bothered by improvised studios, attics, hotel rooms. Indeed, he detested luxurious surroundings, and sumptuous furnishings intimidated him . . . a degree of discomfort almost appeared to suit him.

In the middle of a small, characterless room that was flooded with light from a large window stood a tall, thin, bent man, brush in hand, an old battered hat drawn down over his ears. And I at once thought of Maurice

Denis's *Hommage à Cézanne* [painted in 1900]. Of all the artists who appear in that picture – Vallotton, Roussel, Vuillard, Maillol and others – Bonnard was the only one still alive. In his age-worn features, seemingly withered by the years, in his face, which was like the mask of an old *bonze*, it was hard for me to discern the face – with its moustache and narrow edge of beard – of that young painter who had introduced Toulouse-Lautrec to the world of the poster. It had in fact been Bonnard's poster *France-Champagne*, which appeared in 1891, that had aroused Lautrec's enthusiasm and inspired him to try his hand at accomplishing the same. Through his glasses, with their silver earpieces – which had replaced his earlier steel pince-nez – his golden-brown eyes, eyes of an immense gentleness, stared back at me, and in his broken voice he said, 'I'm happy to meet you, Brassaï. I often admire your pictures in *Verve* and *Le Minotaure*. You're free to photograph whatever you like here, with the exception of my face.'

So Matisse had been right! I could sense the distress this lonely man was feeling. Marthe, the young model he had met in 1893 and who became his wife, had left him for ever four years earlier, after forty-nine years of life together, on the eve of their golden wedding anniversary. With her slender, graceful body, her luxuriant mass of hair, her periwinkle-blue eyes, her high firm breasts, and her long legs, she had been his favourite model all her life. This febrile woman with her delicate health, who spent her time indoors, who was fond of water and the warmth of the bathroom and bedsheets, was the embodiment of all those sensual women in Bonnard's paintings who dream, do their hair, dress, or gaze at themselves in their mirrors, who lie back on their unmade beds, sew by lamplight, and lay or clear the table.

All those nudes in their golden nakedness like mother-of-pearl, with pink thighs, blonde arms, and backs reflecting the play of every shade of rose, mauve, and orange, had Marthe's body. Thanks to Marthe, Bonnard succeeded in re-creating the female that Degas had given him a glimpse of in his last pastels, works that had, I believe, a major influence on Bonnard's own.

When his faithful companion was taken from him, Bonnard had locked the door to Marthe's room, and he was never again to draw or paint a nude. In this house, now deprived for four years of her presence and of their daily intimacy, he drowned his sorrow in work, painting pleasure and happiness in spite of himself, and praising, in spite of everything, the beauty of the universe.

Bonnard had already returned to his work; my presence did not bother

him in the slightest. I looked around for his easel, his palette. There were none. Nailed side by side on to the wall were several unstretched canvases on all of which, to my astonishment, Bonnard was working at the same time. Once he had collected a touch of *laque de garance*, or cadmium yellow, with his nervous, deft fingers, he would then examine each canvas to find the one and only place to put it. In this way, he could nourish several canvases at once until they all came to life. Economy of gesture? The procedure might have seemed a rational one had his 'palette' not obliged him to make a tiresome trip back and forth for each colour – for the paints were laid out far behind him on a low table. However, he had obviously set this onerous task for himself deliberately. By moving away from the canvases after each stroke, he was better able to judge the effect he was obtaining and to seize the colour relationships, as well as to keep an eye out for any empty spaces.

For in Bonnard's eyes, a picture was reduced to a series of touches of colour linked together to form a whole over which the eye could then travel easily, without shock. For a long time I watched him as he enriched his canvases, now with phosphorescent blue, now with a unique shade of mauve or with an almost too vividly intense red. When I mentioned my amazement at this strange manner of working to Charles Terrasse, he told me, 'My uncle loathes stretchers because they set a limit to the canvas. He wants them to have a larger dimension than the picture he is planning. He finds the process is particularly useful when he is working on a landscape, in which the sky, land, water, greenery, always take up a larger space than the painter is able to establish and lay out at the start.'

Forbidden a portrait, I turned my attention to the framework of his life, to what was typically Bonnard in that small suburban villa. I photographed an odd bit of wall on which, above a shelf loaded with brushes and perfume bottles, the painter had pinned up several coloured postcards of works of which he was particularly fond: Vermeer's *Street in Delft*, Monet's *Nymphéas*, Gauguin's *La Vision après le Sermon*, one of Seurat's *Baignades*, and a post-Cubist Picasso. There was only one authentic canvas, a small painting signed by Renoir, with a dedication.

I also photographed his 'palette' alongside his *Self-Portrait* of 1945, a painting that is now in New York. In the dining room, I focused on the wicker baskets and *compotiers* filled with fruits, the motifs that appear in so many of his sumptuous still lifes. Outside the villa, I also took a photograph of the magnificent view of the surrounding countryside: Cannes, the Mediterranean in the distance, the chain of the Esterel.

Charles Terrasse showed me around the garden that Bonnard had managed to enlarge by purchasing the adjacent properties. He took me as far as the little Saigne Canal that borders the property. Oddly enough, that same canal flows in a rapid stream down the hillside in Grasse and crosses Picasso's property, Notre-Dame-de-Vie; then it dashes in its course to water Bonnard's garden before plunging into the sea. Picasso could have sent him a message in a bottle . . . but Bonnard did not figure among his favourite painters . . .

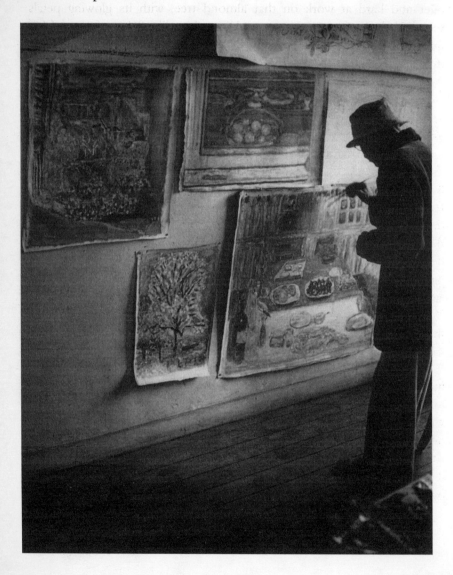

I went back into the studio and was preparing to take my leave of Bonnard when he said to me, 'I asked you not to photograph my face, but if you want to, you can take my picture from the back . . .' Thus, by cheating a bit, I was able to capture him in half profile, his nose close to the canvas, as he laid on a bit of colour with the tip of his brush.

The four canvases that had been affixed to the wall for many months were *La Salle à Manger*, a *Nature Morte*, *Le Paysage du Cannet avec Toit Rouge*, and *L'Amandier en Fleurs*. When I took Bonnard's photograph bending over and hard at work on that almond tree, with its glowing petals seemingly lit up from within in sparkling white, like flakes of snow, I felt quite clearly that it would be his final canvas, his swan song. It now hangs in the Musée National d'Art Moderne in Paris.

(Brassaï, 1982)

A couple of rare glimpses of Turner at work, the first recalled by Hawksworth Fawkes, the son of the painter's patron and friend, Walter Fawkes of Farnley Hall.

'One stormy day at Farnley,' says Mr Fawkes, 'Turner called to me loudly from the doorway, "Hawkey! Hawkey! Come here! come here! Look at this thunderstorm. Isn't it grand? – isn't it wonderful? – isn't it sublime?" All this time he was making notes of its form and colour on the back of a letter. I proposed some better drawing-block, but he said it did very well. He was absorbed – he was entranced. There was the storm rolling and sweeping and shafting out its lightning over the Yorkshire hills. Presently the storm passed, and he finished.

'"There! Hawkey," said he. "In two years you will see this again, and call it *Hannibal Crossing the Alps.*"'

At Farnley is a drawing of a man-of-war, complete, elaborate, and intricate, with a fine frothy, troubled sea in the foreground. This Turner did, under Mr Fawkes's observation, in three hours; tearing up the sea with his eagle-claw of a thumb-nail, and working like a madman; yet the detail is full and delicate, betraying no sign of hurry. There is also a large fir in one of the Farnley drawings, so true, so vigorous, so matchless, that it shows not only that Turner could draw the fir when he chose, but that he might have been one of the finest painters of trees the world ever saw.

(Hawksworth Fawkes, quoted in Walter Thornbury, 1861)

Henry Syer Trimmer, son of Turner's childhood friend the Reverend Henry Scott Trimmer, was not so fortunate as to get a close look at this secretive artist at work.

Henry Howard, RA, was an early friend of my father's; and he and Turner have stayed with us at Heston. I remember, when I was about five years old, going to Penn, in Buckinghamshire, with Howard, Turner, and my father; all of them in search of the picturesque. We went in a postchaise, and, when tired, my father carried me pick-a-back. We came to a halt in a grove or copse where luxuriated wild flowers in profusion. It was a charming day; and, though so many 'years bygone', I can see now vividly before me my father and Howard, both standing legs a-straddle, and Turner at a little distance in a ditch, all hard at work at the æsthetical. After a while Turner emerged from his retreat with a capital watercolour, with which Howard and my father were in raptures. He said he got into the ditch to avoid the sun, but Howard whispered my father that it was to avoid showing his *modus operandi*.

(Henry Syer Trimmer, quoted in Walter Thornbury, 1861)

Monet is visited at Giverny by two art dealers in 1918.

August 19 / At Claude Monet's

In the train taking us to Vernon, Georges Bernheim told me that I was responsible for the trip to Giverny, and that Monet might not receive us. Like Renoir, he doesn't like to be disturbed when he is working. I asked him if he knew Monet well, and he replied: 'Yes, and on a certain occasion I treated him better than he's treated me recently.'

'When was that?'

'You see, Monet had married for the second time – a widow, or perhaps it was a divorcée. She had a son who, on his mother's death, sold me eight of his stepfather's canvases for 8,000 francs.'

'Why so cheap, when he couldn't be ignorant of their value?'

'They weren't signed, and the boy was not on good terms with Monet and could not get the painter to put his signature on them. They were none the less worth 40,000 francs with my testimonial. Monet heard of the transaction and sent me my cousins, the Bernheim brothers, to tell me he would like to buy back the eight pictures and to ask me the price. I wrote to him: "M. Monet, you have only to send me a cheque for 8,000 francs and take the canvases." He sent the cheque, promising me a present.

I waited for it. Two years, three years passed. I decided to go and see him, and I said to him: "M. Monet, I'm not asking you for any presents, but sell me some paintings." He let me have twelve for 120,000 francs, and threw in a thirteenth. I had sold him eight for 8,000 francs. It was a rather expensive present, but then he's a very hard man. So a year ago I went to his house with my colleague Hessel, with whom I had gone half and half on a very bad Monet, and we took it along to him. He remembered the canvas and exclaimed: "What a monstrosity!" "Since it doesn't do you credit," we told him, "give us another in its place." "Not on your life," he cried. "There isn't in all my studio a single painting worth as little as yours." Then we suggested effecting an exchange at a price, and pointed out a landscape and asked him the price. He replied that he wanted 10,000 francs for it, and we accepted. Monet took our painting and split it with one huge kick.'

It was 1.30 when we arrived in Vernon. We got out of the train and climbed on the bicycles we had hired in Paris: transportation isn't easy in wartime. For some miles we followed the Seine valley, which is lovely just there, and so reached the celebrated valley where a number of artists are gathered around the master. I noticed large studio windows opening out of several peasant houses. We finally reached Claude Monet's wall, which is pierced by a large green door and a bit farther on by another very small door, also green. This we opened to enter Monet's oft-described garden. I regret my complete ignorance of the names of flowers, as I should like to name here the varieties I saw. A Maeterlinck would be needed for a garden like this. It resembles no other, first because it consists of only the simplest flowers and then because they grow to unheard-of heights. I believe that none is under three feet high. Certain flowers, some of which are white and others yellow, resembling huge daisies, shoot up to six feet. It's not a meadow, but a virgin forest of flowers whose colours are very pure, neither pink nor bluish, but red or blue.

A servant took our cards and told us that she'd go and see. Bernheim was nervous and whispered: 'Don't be surprised if we aren't received.' I asked him if that was not Monet coming toward us.

'Where? What's he look like?'

'There, under a big pointed straw peasant's hat. With a large white beard.'

'Why, yes, it is he: he's coming.'

We advanced. Bernheim shook his hand, introduced me, and Monet said: 'Ah, gentlemen, I don't receive when I'm working, no, I don't receive.

When I'm working, if I'm interrupted, it just finishes me, I'm lost. You'll understand, I'm sure, that I'm chasing the merest sliver of colour. It's my own fault, I want to grasp the intangible. It's terrible how the light runs out, taking colour with it. Colour, any colour, lasts a second, sometimes three or four minutes at most. What to do, what to paint in three or four minutes? They're gone, you have to stop. Ah, how I suffer, how painting makes me suffer! It tortures me. The pain it causes me!'

Monet had come to the end of his monologue. I thought he would shake me by the hand and return to his work. I wanted him to stay a few minutes longer, and I said to him: 'Excuse me, M. Monet, I'm the guilty one, it's I who wished to come. Georges Bernheim warned me, but I've been looking forward to this for so long! I sell old paintings, but adore the moderns. I adore your work. I get furious with my collectors when they tell me, "It's finished, no one knows how to paint any more, the ancients will never be equalled." What idiots!' Then, looking at his flowers: 'How pretty your garden is. Mary Cassatt has so often spoken to me of it.' 'How is she?' he asked. I told him that she is nearly blind, and I sensed in the painter an old man's indifference. At this point Georges Bernheim said to notice how young M. Monet looked. I asked him his age, and he answered that he was seventy-eight. I complimented him, and indeed it's astonishing; I've never seen a man of that age look so young. He can't be taller than about five foot five, but he is absolutely erect. He looks like a young father on Christmas Day wearing a false white beard to make his children believe in old Father Christmas. His face is softly coloured and unblotched. His small round chestnut eyes, full of vivacity, add emphasis to whatever he says. 'Come into the studio,' he said. It's a large rectangular room. About a hundred paintings are hung on the wall in three or four graduated rows. For the most part they are paintings of little interest, rather flat, without colour: just foundations. But here and there a picture stands out from the others. I see one which seems to me to represent a thick forest with rifts of startling light, a forest of flowers which could be his garden . . .

Bernheim had told me about an immense and mysterious decoration on which the painter was working and which he probably wouldn't show us. I made a frontal attack and won the day: he took us down the paths of his garden to a newly built studio constructed like a humble village church. Inside there is only one huge room with a glass roof, and there we were confronted by a strange artistic spectacle: a dozen canvases placed one after another in a circle on the ground, all about six feet wide by four

feet high: a panorama of water and water lilies, of light and sky. In this infinity, the water and the sky had neither beginning nor end. It was as though we were present at one of the first hours of the birth of the world. It was mysterious, poetic, deliciously unreal. The effect was strange: it was at once pleasurable and disturbing to be surrounded by water on all sides and yet untouched by it. 'I work all day on these canvases,' Monet told us. 'One after another, I have them brought to me. A colour will appear again which I'd seen and daubed on one of these canvases the day before. Quickly the picture is brought over to me, and I do my utmost to fix the vision definitively, but it generally disappears as fast as it arose, giving way to a different colour already tried several days before on another study, which at once is set before me – and so it goes the whole day!'

'I understand, M. Monet, why you don't like being interrupted; so with thanks we're going to leave you.'

'Just come and see my dining room.' The room he showed us is rustically simple but of an oriental subtlety, with just one basic colour: yellow, tone upon tone, a Monet yellow, the colour of his genius the day he mixed it – which is why it can never be repeated.

As we left him, the door almost shut, he called: 'Come back to see me at the beginning of October when the days are drawing in and I take a fortnight's holiday; we'll have a chat then.'

As I was pedalling along the road with Georges Bernheim, he said: 'That was a fine reception.'

(René Gimpel, diary entry for 19 August 1918, 1966)

Sitting for Frank Auerbach, the Australian-born critic Robert Hughes finds himself in a dingy cavern of a studio, a midden encrusted with paint.

Perhaps one should begin where the paintings do, in Frank Auerbach's studio, a brown cave in north-west London where he has worked for more than thirty years.

It is one of a line of three studios in an alley that runs off a street in Camden Town, a rootedly lower-middle-class area between Mornington Crescent and the park of Primrose Hill. They were built around 1900, with high north-facing windows. Auerbach 'inherited' his from Kossoff [the painter Leon Kossoff], in 1954; before Kossoff, it had been used by photographers and, earlier, by the painter Frances Hodgkins. The emblematic artist of Camden Town, up to that time, had of course been

Walter Richard Sickert (1860–1942), who kept a studio a couple of hundred yards away at 6 Mornington Crescent – a narrow three-storey terrace house whose stucco façade is as dingy today as it probably was then. The flavour of Camden Town recalls a fact of Sickert's work which applies to Auerbach's today – its attachment to the common-and-garden, to the compost of life as it is lived.

You enter the alley through a wicket gate, set between a liver-brick Victorian semi-detached villa on the left and on the right a decayed block of 60s maisonettes. A roughly lettered sign says TO THE STUDIOS. Auerbach's door opens on a scene of dinginess and clutter. The studio is actually a generous-sized room, but it seems constricted at first, all peeling surfaces, blistered paint, spalling plaster, mounds and craters of paint, piles of newspapers and books crammed into rickety shelves, a mirror so frosted with dust that movements reflected inside it are barely decipherable. It is a midden-heap. Because Auerbach paints thick and scrapes off all the time, the floor is encrusted with a deposit of dried paint so deep that it slopes upwards several inches, from the wall to the easel. One walks, gingerly, on the remains of innumerable pictures. Where he sets his drawing easel this lava is black from accumulated charcoal dust. 'I changed the lino three times,' Auerbach says. 'The last time quite recently, less than ten years ago. If I didn't, the paint would be up to here.' He gestures at thigh-height. And then, a few days later: 'Leonardo said painting is better than sculpture because painters kept clean. How wrong he was!'

The walls are brown, mottled with damp-borne salts. The high north window has not been cleaned in years. It does admit light: on fine May days a tender Rembrandtian gloom, in February a grim Dickensian one. The only colour is the paint itself – the canvas on the easel, and two palettes. The first of these is a slab, perhaps wood, perhaps stone, turgid with pigment inches thick. The second is an extraordinary object, the fossil of a wooden box upended, so that its midway partition acts as a shelf. Warm colours are mixed on the top of the box, cool ones on the shelf. Years of use have turned it into a block of pigment, its sides encrusted with glistening cakes and stalactites of the same magma that encrusts the floor. One side of the box is partly worn through by the slapping of Auerbach's brushes. The darkness and dirt of the studio are only relieved by the gleam of the paint: a bright epiphany of raw material, cadmium red, cadmium yellow, flake white, pure and buttery in their tins.

Images are pinned on the window wall and above the sink: a photo of Rembrandt's patriarchal head of Jakob Trip and another of Saskia; a

small self-portrait by Auerbach's early friend and dealer Helen Lessore; a reproduction of Lucian Freud's head of Auerbach himself, the forehead bulging from the surface with tremendous, knotted plasticity; a drawing by Dürer of Conrat Verkell's head seen from below, the features gnarled and squeezed like the flesh structure in one of Auerbach's portraits; souvenirs of the work of friends (Bacon, Kossoff, Kitaj) and of dead masters. They are all emblems and have been there for years, browned and cockled, like votives of legs and livers hanging in a Greek shrine. A string runs from above the sink to below the window, carrying a line of yellowed sheets of newspaper, years old. Auerbach hangs his underpants on it to dry. New newspapers will not do, because their ink leaches into the cotton. Paper towels will not do, because (one supposes) they would be too white. Like one of Beckett's paralysed heroes, like Sterne's father in *Tristram Shandy*, who put up with a squeaking door all his life because he could not summon up the decision to apply a few drops of oil to the hinges, Auerbach is inured to his own domestic irritants. They are part of the solemn game of stasis.

The essence of this place is that things do not change in it, except that dust accumulates, waste pigment slowly builds its reef on the floor, the light fluctuates, models (as few as possible, and nearly always the same ones, because Auerbach does not do commissions and not many people can endure the arduous business of posing for him) arrive, sit for three hours, and go; paintings and drawings are finished and are taken away. The studio is the antitype of the Matissean ideal. But it offers the painter a certain stability, a guarantee of changelessness, as Nice did Matisse. 'In order to paint my pictures,' Matisse remarked, 'I need to remain for several days in the same state of mind, and I do not find this in any atmosphere but that of the Côte d'Azur.' So with Auerbach and his studio. It is a troglodyte's den of internalization, the refuge in which the artist becomes unavailable, digging back into the solitary indurated habits without which nothing can be imagined, made or fully seen. There is no television set – 'a barbarous invention' – and, of course, no telephone.

The position of each easel is fixed. The wooden chair in which the sitter poses is also fixed, with a white circle drawn on the floor around each leg. To the left of the chair is a pedestal paraffin heater, unlit, on which the sitter balances a cup of strong coffee and an ashtray. To the right is another heater, mercifully red-hot, with another locating circle of white paint drawn around its base. You know you may not move it, and do not try to. You roast on one side and freeze on the other. The distance

between Auerbach's surface and the sitter's face is always the same. The sitter has only one way to sit: facing the easel, staring back at the stare. Whatever happens to left or right is not part of a room; it is just 'space'. The purple cover on the studio bed has its own role in the light, as the sitter will find when, coming in from the underground station at 7.30 one winter morning, he throws his *Times* on it; after twenty minutes' work Auerbach screws up his face and complains about the nagging white light reflected from the paper. This morning in February 1986 there are other irritations. The outside lavatory has frozen and the ice in the bowl has to be broken with jabs of a broom-handle. Inside the studio, a plastic jug of turps has cracked in the cold and flooded the floor under the sink.

The work of drawing begins. Auerbach has a sheet of paper, or rather two sheets glued together, ready on the easel. The paper is a stout rag, almost as thick as elephant hide, resistant to the incessant rubbing-out that will go on for days and weeks. As he scribbles and saws at the paper, the sticks of willow charcoal snap; they make cracking sounds like a tooth breaking on a bone. When he scrubs the paper with a rag clouds of black dust fly. An hour into the session the sitter blows his nose and finds his snot is black. The studio is like a colliery; the drawing easel is black and exquisitely glossy from years of carbon dust mixed with hand-grease. Auerbach works on the balls of his feet, balanced like a welterweight boxer, darting in and out. Sometimes he and the sitter talk about painting, and poetry. He recites from memory long runs of Yeats, George Barker and Auden. Asked if he ever works to music, he answers with a curious vehemence: 'Oh, no, never! I like silence! I think I must be completely unmusical. I can't remember phrases; that makes me useless in a concert hall. If you're to enjoy music I suppose you have to remember something of what went before in order to grasp what you're hearing at the moment – and I can't. That rubbish of Pater's! It is *absolutely* untrue that art aspires to the condition of music. Painting never wants to be like music. It is best when it is *least* like music: fixed, concrete, immediate and resistant to time.' Then he shuts up and goes into high gear, working with redoubled concentration, cocking his head at the sitter and grimacing. He hisses and puffs. He darts back to consult the reflection of the drawing in a mirror on the wall; the sitter sees Auerbach's peering reflection, the chin and cheeks smudged with black. Sometimes his mouth broadens into a rictus of anxiety, very much like a Japanese armour-mask. He talks to himself. 'Now what feels specially untrue?' 'Yes, yes.' 'That's it.' 'Come on, come *on*!' And a long-drawn-out, morose 'No-o-o.' Now and again he fumbles

out a book from the nearby shelf, opens it to a reproduction – Giacometti's *Woman with Her Throat Cut*, Cézanne's *Self-Portrait with Cap*, 1873–5, from the Hermitage, Vermeer's young turbaned girl – and lays it on the floor where he can see it, 'to have something good to look at', a purpose not kind to the sitter's vanity until one understands that Auerbach is hoping for osmosis. By the end of the day the drawing is some kind of a likeness, though not a flattering one: a blackened Irishman with a squashed nose and a thick, swinging chop of shadow under his right cheekbone. Through the next twelve sittings, spaced over not quite four weeks, this creature will mutate, becoming dense and troll-like one day and dissolving in *furioso* passages of hatching the next; lost in thought in one version, belligerently staring in another, eye contact almost obliterated in a third as the mass of the face is lost in a welter of hooking lines (the hair) and zigzag white scribbles of the eraser (a twisting in the space behind the head). In the end, the likeness is retrieved, but as a ghost, the colour of very tarnished silver.

(Robert Hughes, *Frank Auerbach*, 1990)

According to his model, Pauline – who also complained that the artist scratched her naked body while making measurements with dividers – Degas worked in a dingy midden, too. Her memories were related by Alice Michel in a Parisian newspaper after the artist's death.

Although vast, it was gloomy, because the high north-facing windows which occupied a whole wall were almost obstructed by a linen curtain, falling very low; only a dim daylight filtered in, hardly reaching the end of the studio. This feeble light was interrupted everywhere by cupboards, numerous easels jumbled together, sculpture stands, tables, armchairs, stools, several screens and even a bathtub used for posing models as bathers.

The corners were no less cluttered; a quantity of picture frames was arranged beside empty stretchers, rolls of canvas, rolls of paper. The only space left for Degas to work was very confined, at the front of the studio just under the windows. It was here, between the modelling dais surrounded by a screen, between the sculpture stand and the stove, that the mornings were spent . . . [Dust covered all the furniture.] Old Zoë was only allowed to light the fire, sweep around the stand, the stove and the length of the route to the door, which ran down the middle of the studio. Apart from

that, there was a strict ban on removing the dirt that had accumulated over the years. Degas, who was perhaps afraid of clumsiness, maintained that sweeping only moved dust around, that it would damage the frames and especially the canvases. No matter how much the models begged Zoë to clean at least the bench behind the screen on which they put their clothes, she always reminded them of Monsieur's ruling.

There was nothing, not the slightest ornament or drapery to brighten up this sombre interior. The brown doors and high walls were bare, without a single drawing or painting. Degas put away all his work in folders or cupboards, or piled them up in the little room at the end of the studio.

(Alice Michel, 1919)

The best-selling Austrian author of yesteryear, Stefan Zweig, observes Rodin in the throes of creation.

After dinner we went over into the studio. It was a huge room, which contained replicas of most of his works, but amongst them lay hundreds of precious small studies – a hand, an arm, a horse's mane, a woman's ear, mostly only clay models. Today I can still recall exactly some of these sketches, which were made for his own practice, and could talk about them for an hour. Finally the master led me to a pedestal on which, covered with wet cloths, his latest work, a portrait of a woman, was hidden. With his heavy, furrowed peasant's hand he removed the cloths, and stepped back. 'Admirable' escaped from my lips, and at once I was ashamed of my banality. But with quiet objectivity in which not a trace of pride could have been found, he murmured, looking at his own work, merely agreeing: 'N'est-ce-pas?' Then he hesitated. 'Only there at the shoulder . . . just a moment.' He threw off his coat, put on a white smock, picked up a spatula and with a masterly stroke on the shoulder smoothed the soft material so that it seemed the skin of a living, breathing woman. Again he stepped back. 'And now here,' he muttered. Again the effect was increased by a tiny detail. Then he no longer spoke. He would step forward, then retreat, look at the figure in a mirror, mutter and utter unintelligible sounds, make changes and corrections. His eyes, which at table had been amiably inattentive, now flashed with strange lights, and he seemed to have grown larger and younger. He worked, worked, and worked, with the entire passion and force of his heavy body; whenever

he stepped forward or back the floor creaked. But he heard nothing. He did not notice that behind him stood a young man, silent, with his heart in his throat, overjoyed that he was being permitted to watch this unique master at work. He had forgotten me entirely. I did not exist for him. Only the figure, the work, concerned him, and behind it, invisible, the vision of absolute perfection.

So it went on for a quarter or half an hour, I cannot recall how long. Great moments are always outside of time. Rodin was so engrossed, so rapt in his work that not even a thunderstroke would have roused him. His movements became harder, almost angry. A sort of wildness or drunkenness had come over him; he worked faster and faster. Then his hands became hesitant. They seemed to have realized that there was nothing more for them to do. Once, twice, three times he stepped back without making changes. Then he muttered something softly into his beard, and placed the cloths gently about the figure as one places a shawl round the shoulders of a beloved woman. He took a deep breath and relaxed. His figure seemed to grow heavier again. The fire had died out. And then the incomprehensible occurred, the great lesson: he took off his smock, again put on his housecoat and turned to go. He had forgotten me completely in that hour of extreme concentration. He no longer knew that a young man whom he himself had led into the studio to show him his work had stood behind him with bated breath, as immovable as his statue . . . In that hour I had seen the Eternal secret of all great art, eyes, of every mortal achievement, made manifest; concentration, the collection of all forces, all senses, that *ecstasis*, that being-out-of-the-world of every artist. I had learned something for my entire lifetime.

(Stefan Zweig, 1943)

The traveller and writer Bruce Chatwin offers an insight into the working methods by which the British painter Sir Howard Hodgkin translates his experiences into almost abstract images.

I first made friends with Howard in the early sixties; and happened to come in useful.

I knew a man in France, who knew a woman in Switzerland, who was the widow of a famous German scholar of Islamic art, who owned a great masterpiece of Indian painting. It was a page – perhaps the most beautiful page – of the Hamza-Nama, a colossal manuscript done for the Emperor

Akbar around 1580. Howard lusted after it – the word is not too strong – and with a bit of juggling, he got it, though not before he had hocked off several lesser masterpieces.

At the time, I lived in a flat behind Hyde Park Corner which, he recalls, was the 'most dandyish interior I had ever seen'. I had recently come back from a desert journey in the Sudan and the sitting room had a monochromatic desert-like atmosphere and contained only two works of art – the arse of an archaic Greek marble *kouros*, and an early seventeenth-century Japanese screen. One evening, the Hodgkins and the Welches came to dinner, and I remember Howard shambling around the room, fixing it in his memory with the stare I came to know so well.

The result of that dinner was a painting called *The Japanese Screen* in which the screen itself appears as a rectangle of pointillist dots, the Welches as a pair of gun turrets, while I am the acid green smear on the left, turning away in disgust, away from my guests, away from my possessions, away from the 'dandified' interior, and possibly back to the Sahara.

(Bruce Chatwin, 1982)

The failed painter of the Regency period, chronic debtor, engaging autobiographer and suicide-to-be, Benjamin Robert Haydon, is visited by a grand inspiration (sadly the work itself did not turn out to be so grand).

Whilst looking over prints at the British Museum one day, about this time, I saw a resuscitation of 'Lazarus' in such a state that a space was left vacant where the head of Lazarus ought to be. My imagination filled the vacancy, and I trembled at my terrific conception of the head.

I went home and sketched it, and determined to make it my grandest and my largest work.

I always filled my painting room to its full extent; and had I possessed a room 400 feet long, 200 feet high, and 400 feet wide, I would have ordered a canvas 399 feet long by 199 feet high, and so have been encumbered for want of room, as if it had been my pleasure to be so.

My room was 30 feet long, 20 wide, 15 high. So I ordered a canvas 19 long by 15 high, and dashed in my conception; the 'Christ' being 9 feet high.

This was a size and a subject which I loved to my very marrow. But how should I get through it? 'Go on,' said the inward voice I had heard from my youth; 'work and trust'; and trust and work I did.

For Haydon, moments of exhilaration alternated with – better founded – dejection.

7th. [1815] – Passed a miserable and bitter morning in comparing myself to Raffaele. At my age he had completed a room of the Vatican.
 (Benjamin Robert Haydon, 1786–1846)

In the 1890s, William Rothenstein observes his less healthy but more artistically brilliant contemporary, the tubercular Aubrey Beardsley, at work.

Beardsley was living in Cambridge Terrace, Pimlico, with his mother and his sister Mabel. The walls of his rooms were distempered a violent orange, the doors and skirtings were painted black; a strange taste, I thought; but his taste was all for the bizarre and exotic. Later it became somewhat chastened. I had picked up a Japanese book in Paris, with pictures so outrageous that its possession was an embarrassment. It pleased Beardsley, however, so I gave it him. The next time I went to see him, he had taken out the most indecent prints from the book and hung them around his bedroom. Seeing he lived with his mother and sister, I was rather taken aback. He affected an extreme cynicism, however, which was startling at times; he *spoke* enormities; *mots* were the mode, and provided they were sufficiently witty, anything might be said. Didn't someone say of Aubrey that even his lungs were affected? It was a time when everyone, in the wake of Whistler, wanted to take out a patent for brilliant sayings. Referring to my bad memory, Beardsley remarked 'It doesn't matter what good things one says in front of Billy [i.e. Rothenstein], he's sure to forget them.'

 Beardsley was an impassioned worker, and his hand was unerringly skilful. But for all his craftsmanship there was something hard and insensitive in his line, and narrow and small in his design, which affected me unsympathetically. He, too, remarkable boy as he was, had something harsh, too sharply defined in his nature – like something seen under an arc lamp. His understanding was remarkable; his mind was agate-like, almost too polished, in its sparkling hardness; but there was that in his nature which made him an affectionate and generous friend. Max Beerbohm, in the sympathetic and discerning study he wrote on Beardsley after his death, said no one ever saw Beardsley at work. I could not quite understand this, as Beardsley pressed me, whenever I came to town, to make use of his workroom. Before going to Oxford and while I was

mainly there, I was glad enough to have somewhere to work when in town. Beardsley seemed to get on perfectly well as he sat at one side of a large table, while I sat at the other. He was then beginning his *Salome* drawings.

He would indicate his preparatory design in pencil, defining his complicated patterns with only the vaguest pencil indication underneath, over which he drew with the pen with astonishing certainty. He would talk and work at the same time; for, like all gifted people, he had exceptional powers of concentration.

But one was always aware of the eager, feverish brilliance of the consumptive, in haste to absorb as much of life as he could in the brief space he instinctively knew was his sorrowful portion. Poor Aubrey! he was a tragic figure. It was as though the gods had said, 'Only four years more will be allowed you; but in those four years you shall experience what others take forty years to learn.' Knowledge he seemed to absorb through his pores. Always at his drawing desk, he still found time to read an astonishing variety of books. He knew his Balzac from cover to cover, and explored the courts and alleys of French and English seventeenth- and eighteenth-century literature. Intensely musical, too, he seemed to know the airs of all the operas. No wonder Oscar [Wilde] thought him wonderful, and chose him at once as the one artist to illustrate his *Salome*.

(William Rothenstein, 1931)

The formidable New York critic Hilton Kramer pays a call on the sculptor Louise Nevelson.

Certain experiences in the realm of art remain forever associated in our minds with the places where the art was first fully revealed to us. Subsequent experience may augment our knowledge, alter our perspective, and deepen our understanding, but it can never quite eradicate the impression made upon us by the quality of that initial encounter. If only for that moment, something central to the spirit of the art seemed to belong to the very atmosphere that enclosed it. Thereafter, the art itself seems to us to carry the spirit of that atmosphere with it, no matter what the actual physical circumstance in which it is seen.

Anyone lucky enough to have seen the sculptures of Henry Moore reposing in the grey-green winter light of the cosy meadows surrounding the artist's studios in Herefordshire, for example, is unlikely ever again to

conjure them up in his mind's eye in any other setting. Likewise, to have seen the constructions of David Smith arrayed like magic sentinels in the open fields of the Terminal Iron Works at Bolton Landing, above Lake George, or to have glimpsed the fugitive figures of Alberto Giacometti emerging from the crushed plaster and grisaille light of his cell-like Paris studio was to have experienced something essential to the inner life of the art itself. At such times we are made to realize that, whatever the nature of its material realization, there is a world of mind, feeling, and spirit at the core of every work of art that captures our imagination, and that world is often co-extensive with the place where the art is created.

As a young man in the 1950s, when I was just beginning to write about the visual arts, the visits I made to the studios of Moore, Smith, and Giacometti were among the experiences that meant the most to me, and they remain today among my most precious memories of that rich period. Yet in some respects the most extraordinary of all my encounters with artists and works of art in those days occurred on a sunny spring day when I paid a visit to a tall town house on East 30th Street in Manhattan. This house, which has since been torn down, was then the residence and workshop of Louise Nevelson – a sculptor virtually unknown to the art public, unexhibited in the museums, and scarcely ever written about by the critics.

From the street, the house hardly looked like the sort of place where an artist, especially a sculptor, might be engaged in serious work. For one thing, the neighbourhood – though already a little rundown in anticipation of the wrecker's ball – was distinctly bourgeois. It was certainly far removed from the ambience of 10th Street and the Cedar Bar or, indeed, from any social milieu one associated with the art life of the time. The New York art scene was, it must be remembered, a very different place in those days. Among other things, it was smaller. There were fewer artists, fewer galleries, fewer collectors, fewer critics, and fewer museums that took an interest in the new art of the day. It was also less chic. And word of its activities reached the 'outside' world – the world of money and the media – at a much slower rate of speed. Artists' lofts had not yet come to be featured in the home-decorating pages of our newspapers and magazines. For an artist to live in comfort and luxury seemed almost a contradiction in terms.

But there was also another reason why one did not expect to find a sculptor at work in a town house on East 30th Street. This was the heyday of welded sculpture, and there were many practical considerations that

made a town house in midtown Manhattan an unsuitable environment for the welder's torch. In those days there was much talk – and with ample reason, too – about 'The New Sculpture', and it was more or less assumed that this new sculpture would be welded sculpture. The new sculpture tended to be 'open' in its forms. It was often spoken of as 'drawing in space', and welding was deemed the most appropriate means of achieving its artistic objectives. No one, as far as I know, had laid down any laws to that effect; but it was a commonly held belief among those who were interested in new sculpture. Welded metal was therefore considered avant-garde. The use of wood – like the use of stone and bronze in this respect – was identified with 'tradition', despite the fact that many (indeed most) of the major modern sculptors had employed these materials. And 'tradition', it will be remembered, was not in good odour in the fifties, especially among the sculptors who wished to be associated with the Abstract Expressionist movement in painting.

It was painting, moreover, that dominated the scene – dominated, indeed, our very notions of what art was, and what it might be. It was around this time, as I recall, that André Malraux observed that while painting was the art we had inherited, sculpture was an art the modern world had been obliged to reinvent. And although this project of reinvention had been launched decades earlier and achieved spectacular results, it had not yet met with the kind of acceptance and understanding that much of modern painting had already received. In the fifties, neither Paris nor New York had yet seen the bulk of the sculpture that Picasso had been producing for half a century, and it was not until the mid-fifties that New York saw its first museum retrospective of the work of Julio González. Even to devotees of modern art – still, in those days, a minority among those who took a serious interest in art – much of modern sculpture remained unknown, and was in any case looked upon as ancillary and marginal. It was painting that was assumed to represent the mainstream of creative endeavour. Those interested in new sculpture, especially abstract sculpture, thus constituted a minority within a minority.

I mention all this because it is essential to any understanding of the art of the fifties, to the place that sculpture occupied in the art of that period, and to the role that Louise Nevelson came to play in the evolution of that art. It may also help to explain why it was that my visit to the house on East 30th Street proved to be such an extraordinary experience.

Nothing that one had seen in the galleries or museums or, indeed, in other artists' studios could have prepared one for the experience that

awaited a visitor to this strange house. It was certainly unlike anything one had ever seen or imagined. Its interior seemed to have been stripped of everything – not only furniture, rugs, and the common comforts of daily living, but of many mundane necessities – that might divert attention from the sculptures that crowded every space, occupied every wall, and at once filled and bewildered the eye wherever it turned. Divisions between the rooms seemed to dissolve in an endless sculptural environment. When one ascended the stairs, the walls of the stairwell enclosed the visitor in this same unremitting spectacle. Not even the bathrooms were exempted from its reach. Where, I wondered, did one take a bath in this house? For the bathtubs, too, were filled with sculpture. Somewhere, I suppose, there were beds that the occupants of the house slept on, but I never saw them. There were, I remember, a plain table and some unremarkable chairs in the basement kitchen and a glass coffee table in the 'living room', which was otherwise designed less for living than for the storage and display of the sculpture that was the overwhelming raison d'être of the whole interior.

Once inside this enchanted interior, one quite forgot that one had entered a town house in mid-Manhattan. One had entered a new world. It was a very mysterious world, too, very far removed from the sunshine and traffic of the street. Here one entered a world of shadows, and it required a certain adjustment in one's vision simply to see even a part of what there was to see. The separate sculptural objects were mostly painted a uniform matt black, and they seemed to absorb most of the available light. The light itself seemed to be a permanent and unrelieved twilight – grey, silvery, and shadowy, without colour or sharp contrast. It was austere without being bleak. It was also, as one came afterwards to realize, intensely theatrical. Emerging from that house on this first occasion, I felt very much as I had felt as a child emerging from a Saturday afternoon movie. The feeling of shock and surprise upon discovering that the daylight world was still there, going about its business in the usual way, was similarly acute.

(Hilton Kramer, 'Encountering Nevelson', 1983)

Charles Baudelaire was a privileged visitor to Delacroix's studio. Here he recalls that sanctum from the distractions of the world shortly after the painter's death.

I know a number of people who have the right to say *Odi profanum vulgus*; but which of them can add triumphantly *et arceo* [I hate the common herd . . . and I keep them away]? Handshakes, too freely given, debase the

character. If ever a man had an 'ivory tower', well defended by bars and bolts, it was Eugène Delacroix. Who more than he has loved his 'ivory tower', his privacy, in other words? I believe he would willingly have armed it with cannon, and removed it to the depth of a forest or to the top of an inaccessible rock. Who more than he has loved his home, both sanctuary and den? Others may seek privacy for the sake of debauchery; he sought it for the sake of inspiration, and he indulged in veritable orgies of work. 'The one prudence in life is concentration; the one evil is dissipation,' says the American philosopher we have already quoted [Ralph Waldo Emerson].

M. Delacroix could have been the author of that maxim; in any case he certainly practised it with austerity. He was too much a man of society not to despise society; and the efforts he made to avoid being too visibly himself drove him naturally to enjoy our society most. 'Our' does not imply merely the humble author of these lines; but also some others, young or old, journalists, poets, musicians, amongst whom he could freely relax and let himself go.

In his delightful monograph study on Chopin, Liszt numbers Delacroix amongst the musician-poet's most frequent visitors, and says that he loved to fall into deep reverie at the sound of that delicate and passionate music, which evokes a brightly coloured bird, hovering over the horrors of a bottomless pit.

And so it came about that, owing to our very genuine admiration, we were admitted, though still very young at the time, into that well-guarded studio, where the temperature, despite our inclement climate, was equatorial, and where the first thing that struck the visitor's eye was the air of restrained solemnity, and that austerity peculiar to the old school. Exactly similar were the studios, seen in our childhood, of the former rivals of David, men of touching heroism, long since gone. To penetrate this retreat was to feel at once that it could not be the abode of a frivolous mind excited by a thousand incoherent whims.

No rusty armour, no Malayan kris, no old Gothic ironwork, no trinkets, no old clothes, no bric-à-brac, nothing that reveals in its owner a liking for the latest trifle, or for wandering away in childish dreaming. A wonderful portrait by Jordaens [Jacob, 1593–1678, Flemish painter], which he had unearthed heaven knows where, a few studies, and a number of copies, done by the master himself, were all the decoration to be seen in this vast studio, where reigned a spirit of reflection, bathed in a soft peaceful light.

These copies will probably be seen at the sale of Delacroix's drawings and pictures due to take place, so I am told, next January. He had two very distinct manners in copying. One, the free and broad, was compounded of fidelity and infidelity, and into it he put a great deal of himself. From this manner a bastard and delightful product emerged, throwing the mind into an agreeable state of uncertainty. It is in this paradoxical guise that I first saw a copy of the *Miracles de Saint Benoît* by Rubens. In his other manner, Delacroix becomes his model's most obedient and humble slave, and he achieved an exactness of imitation that those people may well doubt who have not seen these miracles. Such, for example, are the copies made of two heads by Raphael in the Louvre, where the expression, the style and manner are imitated with such perfect naturalness that nothing could be easier than to take the originals for the translations and vice versa.

After a luncheon lighter than an Arab's, and having arranged the colours on his palette with as much care as a flower girl or a cloth vendor, Delacroix would strive once more to recapture the interrupted flow of ideas; but before launching into his stormy work, he would often experience a feeling of languor or of terror, or of exasperation that recalls the pythoness fleeing the presence of the God, or Jean-Jacques Rousseau frittering his time away or tidying up papers and books for a whole hour before putting pen to paper. But once the fascination had gripped the artist, he would stop only when overcome by physical fatigue.

One day as we were discussing a matter of abiding interest to artists and writers, namely the tonic effect of work and the conduct of life, he said to me: 'Years ago, when I was young, I could settle down to work only when I had some pleasure in prospect for the evening. Some music, or dancing, or any other sort of entertainment. But nowadays I am no longer like a schoolboy; I can work without ceasing and without any hope of reward. Moreover,' he added, 'if only you knew how broad-minded and easy to please hard work makes one when it comes to pleasures! The man who has filled his working day to his own satisfaction will be quite happy in the company of the local street porter, playing cards with him!'

This remark made me think of Machiavelli playing at dice with the peasants. One day, a Sunday, I caught sight of Delacroix in the Louvre; with him was his old maid, the one who looked after him so devotedly, and served him for thirty years. He, the man of fashion, the dandy, the scholar, was not at all above showing and explaining the mysteries of Assyrian sculpture to this worthy woman, who, moreover, was listening

to him with unaffected attention. The image of Machiavelli and the memory of my conversation years before at once came into my mind.

The truth is that in his last years, all the things we commonly call pleasure had disappeared from his life. One pleasure only, harsh, demanding, terrible, had replaced them all: work, which by then was no longer merely a passion but could well have been called a craving.

After devoting all the hours of daylight to painting, either in his studio or on the scaffoldings to which his big decorative work called him, Delacroix still found strength in his love of art, and he would have felt his day had been badly filled if the evening hours at his fireside had not been used, by the light of the lamp, to draw, to cover his paper with dreams, with projects, with figures he had chanced to catch a glimpse of in the daily round, sometimes to copy the drawings of other artists with temperaments wholly opposed to his; for he had a passion for notes and sketches, and used to busy himself with them wherever he might be. For quite a long time, he had a habit of drawing at the houses of friends with whom he was spending the evening. That is how M. Villot comes to own quite a number of excellent drawings from this prolific pen.

He once said to a young man I know: 'If you have not got the knack of making a sketch of a man who has thrown himself out of the window whilst he is falling from the fourth storey to the ground, you will never be able to go in for the big stuff.' I perceive in that colossal hyperbole the central preoccupation of his whole life, which, as is well known, was to execute a drawing with enough speed and enough exactness to let no particle evaporate of the action's intensity or of the idea.

As many other people have been able to observe, Delacroix was fond of conversation. But the funny thing is that he was suspicious of conversation, as if it were a kind of debauchery, a sort of dissipation in which he ran the risk of wasting his strength. His first words when you went to see him at his studio were: 'We won't have a talk this morning, if you agree? Or else only a very short one.'

And then he would talk for three hours on end. His conversation was startling, subtle but full of facts, memories and anecdotes: in short, full of nourishment.

(Charles Baudelaire, 'The Life and Works of Eugène Delacroix', 1863)

In a way Marcel Duchamp, founder of conceptual art and chess fanatic, lived in the strangest lodgings of any artist – as a young visitor to his New York apartment discovered in the 1940s.

It was a medium-sized room. There was a table with a chessboard, one chair, and a kind of packing crate on the other side to sit on, and I guess a bed of some kind in the corner. There was a pile of tobacco ashes on the table, where he used to clean his pipe. There were two nails in the wall, with a piece of string hanging down from one. And that was *all*.

 (William Copley, in Calvin Tomkins, 1997)

One of Titian's pupil's gives a historian of Venetian art a description of the master at work.

Titian was truly the most excellent of all painters, since his brushes always gave birth to expressions of life. I was told by Palma Giovane ... who was himself fortunate enough to enjoy the learned instruction of Titian, that he used to sketch in his pictures with a great mass of colours, which served, as one might say, as a bed or base for the compositions which he then had to construct; and I too have seen some of these, formed with bold strokes made with brushes laden with colours, sometimes of a pure red earth, which he used, so to speak, for a middle tone, and at other times of white lead; and with the same brush tinted with red, black and yellow he formed a highlight; and observing these principles he made the promise of an exceptional figure appear in four strokes. The most sophisticated connoisseurs found such sketches entirely satisfactory in themselves, and they were greatly in demand since they showed the way to anyone who wished to find the best route into the Ocean of Painting. Having constructed these precious foundations he used to turn his pictures to the wall and leave them there without looking at them, sometimes for several months. When he wanted to apply his brush again he would examine them with the utmost rigour, as if they were his mortal enemies, to see if he could find any faults; and if he discovered anything that did not fully conform to his intentions he would treat his picture like a good surgeon would his patient, reducing if necessary some swelling or excess of flesh, straightening an arm if the bone structure was not exactly right, and if a foot had been initially misplaced correcting it without thinking of the pain it might cost him, and so on. In this way, working on the

figures and revising them, he brought them to the most perfect symmetry that the beauty of art and nature can reveal; and after he had done this, while the picture was drying he would turn his hand to another and work on it in the same way. Thus he gradually covered those quintessential forms with living flesh, bringing them by many stages to a state in which they lacked only the breath of life. He never painted a figure all at once and used to say that a man who improvises cannot compose learned or well-constructed verses. But the final stage of his last retouching involved his moderating here and there the brightest highlights by rubbing them with his fingers, reducing the contrast with the middle tones and harmonizing one tone with another; at other times, using his finger he would place a dark stroke in a corner to strengthen it, or a smear of bright red, almost like a drop of blood, which would enliven some subtle refinement; and so he would proceed, bringing his living figures to a state of perfection. And as Palma himself informed me, it is true to say that in the last stages he painted more with his fingers than his brushes.

(M. Boschini, 1660)

Winifred Nicholson, a painter and first wife of Ben, recalls a visit to Mondrian's austere Paris studio in the 1930s.

When one thought of visiting Mondrian one had to telephone beforehand – no free and easy knocking at his door – this was not because he might be working – he was always at work; but so that he could put on his patent-leather shoes and his black striped trousers. His studio was in a noisy street of Paris up many flights. There was no lift, no water, nor heating in it. What there was, was clarity and silence. The silence in which one could compose and create. The clarity did not come from windows but from the many canvases of which the studio was full, in all stages of their creation, for he worked at each one, for long periods, considering each charcoal horizontal, each charcoal vertical and moving them an inch or a millimetre one way or another. When at last the positions were settled then there were many coats of white to be applied one after another and only last of all after many months or even years the rectangles of colour. Yellow, blue or red were painted, sometimes only one colour, sometimes a duet of two, sometimes but more rarely a trio of three. For if the studio was full of the silence of human voices, the voices of the pictures were all the more audible – and what they said, clear, fundamental without frills

or fancy – but sometimes did their speech become insistent to their creator, or was he lonely in his hermitage of purest art? Anyhow he had a cheap square little squeaky gramophone painted vivid dutch red – and on it he played the hottest blue jazz – only jazz, never that classical stuff – I don't remember any other objects in the studio except that gramophone, I doubt if there was any room for anything except all those canvases – sometimes we had tisane made of cherry-stone stalks, that was if he had sold a picture in Switzerland and was in funds. He seldom sold a picture, and when he did he lived on the proceeds for long periods. He liked flowers, he told me that in his degenerate days he lived on the pictures that he had painted of them – but in Paris he had never had any. One would not have dared to bring any to him. Too fancy; one took flowers when one visited Brancusi [Constantin, 1876–1957, master Modernist sculptor] – he loved them and kept them for ever, dead and dry as beautiful he said as when they were in bloom. Mondrian bought Cambridge colours not because they were less expensive than others, but because he thought that Oxford and so also Cambridge was the most reliable English commodity. I regret that in this reliability we English let him down. He was just and honest and Dutch and stern, friendly to those who were people of progress, harsh to those who were not, surrealists, Fascists, reactionaries, people who tolerated green, purple, or orange all impure. 'You are the first person who has ever painted Yellow,' I said to him once, 'pure lemon yellow like the sun.' He denied it, but next time I saw him, he took up the remark. 'I have thought about it,' he said, 'and it is so, but it is merely because Cadmium yellow pigment has been invented.'

 (Winifred Nicholson, 1966)

And the poet, writer and art critic Herbert Read adds an interesting note on Mondrian's painting methods:

When Mondrian sought refuge in England in 1938 he naturally came to Hampstead where he already had friends – Ben Nicholson, Barbara Hepworth, and others who had sometimes visited him in Paris. I myself had once penetrated to the immaculate white cell in which he worked there, and it was interesting to observe how quickly he reduplicated his familiar environment in London. He found (or someone found for him) a room on the ground floor of a house in Upper Parkhill Road which was almost exactly opposite the studio in Mall Studios which I then occupied.

I have always respected an artist's privacy, especially during the precious hours of daylight, but Mondrian was lonely and in the evening one or more of the community of artists living in the district at that time would 'drop in' unannounced and he always received us with the gracious dignity that was one of his characteristics. I do not remember any very profound discussions – we were more worried about his material comfort and practical difficulties – but no doubt we did discuss his paintings and art in general. I once noticed, during a period of two or three visits, that he was always engaged in painting the black lines in the same picture, and I asked him whether it was a question of the exact width of the line. He answered No: it was a question of its intensity, which could only be achieved by repeated applications of the paint. There is a tendency to consider Mondrian's paintings as primarily the organization of form or space, but to the artist himself these qualities could not be divorced from colour, and colour to him was a quality of the utmost purity and exactitude. Hence any attempt to re-paint or 'restore' a painting by Mondrian (and it has been done) inevitably destroys the perfection which was the artist's supreme passion.

(Herbert Read, 1966)

David Lewis plays ping-pong with Ben Nicholson at Carbis Bay, near St Ives, in the 1940s, and looks at 'some work' in his studio, which sounds a little like his mentor, Mondrian's. Though invited, Mondrian himself never joined the band of Modernists who gathered at the tip of Cornwall in those years.

I had played a lot of ping-pong at school and thought I was quite good, but I'd never played like that. Instead of a net, Ben had an eight-inch plank laid flat on a pile of books at the same height as the net would be. This simple substitution completely changed the game. 'Reinvented' was the way Ben put it. You could hit the ball over the plank in the usual way, or you could hit the ball on to the plank and off, or you could hit the ball on to the plank and on to the table and off, and the width of the plank meant that you could angle your shots so widely as to be almost lateral, with exponential increases in energy and hilarity.

It was not because I had just emerged from the Edward Hain that I was thrashed by Ben within an inch of my life. In all the subsequent years I won only a handful of games against him. He was expert as a juggler and fast as a cat, darting here and there in his sea-blue trousers and white under-

shirt, his bald head bobbing about so much like a ping-pong ball that he would even leap in the air and play with his head. We laughed until our sides ached; and we had to sit side by side on the floor to get our breath.

The ping-pong table was the only furniture in what must have once been a living room, overlooking the walled garden and the sea. Between games we went upstairs to Ben's whitewashed studio which must have been once a bedroom, also overlooking the majestic sweep of Carbis Bay, to see what he referred to as 'some work'.

Most of the paintings were small, taking their cue perhaps from the size of the room. They were on paper or hardboard, a composition of compressed wood fibres used by carpenters, and were based on textured surfaces which were layers of thin pigment applied with broad brushes, or wiped on with rags soaked in turpentine, and scraped with razor blades to form what Ben referred to as 'a ground'. On to the ground he drew in pencil, and painted interstitial shapes with sharp flat colours. Some of the paintings were 'pure abstracts', circles and rectangles; others were 'still lifes', which reminded me at first of transparent Cubist tables with bottles and goblets made linear, and some included elements of landscape, a glimpse of a hill and a farmhouse or of a harbour. The most astonishing thing was a playfulness that seemed to come from what he said was 'free colour' but which struck me as being anything but free, sharp assonances of green or red or orange, so firmly held in the geometry of the work and so precisely 'right' that although they each might have been exactly the colour of orange lichen or mauve foxglove or green seaweed, they were in that particular painting the most electric and radiant accents of orange or mauve or green or pink I had ever come across. And as if to increase the options in the way that he had increased the options in the game of ping-pong when he incorporated that devilish plank, some of the hardboards were incised, or carved into relief, so that colour and texture were set to work not simply on one plane but on several.

In many later conversations Ben and I returned repeatedly to the 'free' elements of painting and reliefs. If a line or a space could be exact, so too could a colour – in its purity, its dimension, and its 'quality', that is to say its density and its texture, and then of course in its precise relationship to everything else that was going on in that particular painting. Someone once asked him how he got a certain colour, and he said 'if I knew I'd never be able to get it again'.

(David Lewis, 1985)

The first-century Roman author Seneca the Younger provides a unique vignette of a classical painter working in hot encaustic wax.

The painter chooses with great speed between his colours which he has placed in front of him in great quantity and variety of hues, in order to portray faithfully the naturalness of a scene, and he goes backwards and forwards with the eyes and with the hands between the waxes and the picture.

(Seneca, *c*.4 BC–AD 65)

Nature,
Lyric
and
Sublime

*At Wittenham Clumps in Oxfordshire, one day before the First World War, Paul
Nash finds his vocation as a landscape painter.*

Wittenham Clumps was a landmark famous for miles around. An ancient
British camp, it stood up with extraordinary prominence above the river
[Thames] at Shillingford. There were two hills, both dome-like and each
planted with a thick clump of trees whose mass had a curiously symmetrical
sculptured form. At the foot of these hills grew the dense wood of
Wittenham, part of the early forest where the polecat still yelled in the
night hours. Ever since I remember them the Clumps had meant something
to me. I felt their importance long before I knew their history. They
eclipsed the impression of all the early landscapes I knew. This, I am
certain, was due almost entirely to their formal features rather than to any
associative force. For although in my mind they stood apart from other
symbolism – for Sinodun and all the pleasures that implied – it was the
look of them that told most, whether on sight or in memory. They were
the Pyramids of my small world.

I approached them now across the ridge of down linking Wittenham
with the hill which the Welleses had annexed for their habitation. In
between was a small hill capped by a lonely clump, known as Castle Hill.
It had a vague reputation as a folly of some sort. As I came nearer to the
Clumps, the land fell away in a gradual decline and the two great mounds,
crowned with their domes of beeches, began to rise higher and higher
above the sight.

I had come out to get a drawing of the Clumps. I wanted an image of
them which would express what they meant to me. I realized that I might
well make a dozen drawings and still find new aspects to portray. But I
did not wish to worry the subject. There was one aspect which, had I the
wit to perceive it, would convey the strange character of the place, one
image which, in its form, would contain the individual spirit. It was this
I sought and was bent on tracking down.

For some time I roamed over the hills, watching the changing scene.

Yet at no time could I say, honestly, 'This is the view'. At last, feeling tired and hungry, I stretched myself on the turf to eat my lunch. Instantly, I saw that not far from where I lay was the point at which to make my drawing. An unsought, unsuspected aspect of the hills was suddenly disclosed. I sprang up and began slowly walking backwards up the slope until I had reached the perfect elevation. Twenty yards to the right brought me to the position of my attack.

I did not begin at once to draw. My landscape studies since I left the Slade had taught me already one thing. It was better to think or to absorb first, before beginning to interpret. There was also the Sinodun lunch to absorb . . .

My thoughts wandered to the shooters over the hill and to Jack and Ted by the river. At this moment, there was probably little to choose between us. Each had paused in his particular pursuit to consume the good Sinodun lunch. Indeed, we had certain foods in common to eat, the same yellow farm butter and white home-made bread. I had no doubt we shared the Berkshire ham, but the guns would be devouring a steak-and-kidney pie along with it. The Sinodun cooks had the right idea of a man's picnic – no sandwiches fortunately. How good the sweet apples were, and the cook's plum cake! There was our bond – the food cut and packed up, to be eaten out of doors by the shooters in the barn, by the fishers on the river bank, and by me on the hill. I was as good as they. I hunted my quarry, I watched and waited, I had to know where and when to strike. And what was there to choose between a bird, a fish and a sketch, except that my drawing would last longest.

As I began to draw, I warmed to my task. For the first time, perhaps, I was tasting fully the savour of my own pursuit. The life of a landscape painter. What better life could there be – to work in the open air, to go hunting far afield over the wild country, to get my living out of the land as much as my ancestors ever had done.

(Paul Nash, 1949)

In this extract from a longer account, Robert Smithson, the pioneer creator of art out of landscape, describes his sublime and apocalyptic feelings about Spiral Jetty, *the huge construction he built in the Great Salt Lake, Utah, in 1970.*

Driving West on Highway 83 late in the afternoon, we passed through Corinne, then went on to Promontory. Just beyond the Golden Spike

Monument, which commemorates the meeting of the rails of the first transcontinental railroad, we went down a dirt road in a wide valley. As we travelled, the valley spread into an uncanny immensity unlike the other landscapes we had seen. The roads on the map became a net of dashes, while in the far distance the Salt Lake existed as an interrupted silver band. Hills took on the appearance of melting solids, and glowed under amber light. We followed roads that glided away into dead ends. Sandy slopes turned into viscous masses of perception. Slowly, we drew near to the lake, which resembled an impassive faint violet sheet held captive in a stony matrix, upon which the sun poured down its crushing light. An expanse of salt flats bordered the lake, and caught in its sediments were countless bits of wreckage. Old piers were left high and dry. The mere sight of the trapped fragments of junk and waste transported one into a world of modern prehistory. The products of a Devonian industry, the remains of a Silurian technology, all the machines of the Upper Carboniferous Period were lost in those expansive deposits of sand and mud.

Two dilapidated shacks looked over a tired group of oil rigs. A series of seeps of heavy black oil more like asphalt occur just south of Rozel Point. For forty or more years people have tried to get oil out of this natural tar pool. Pumps coated with black stickiness rusted in the corrosive salt air. A hut mounted on pilings could have been the habitation of 'the missing link'. A great pleasure arose from seeing all those incoherent structures. This site gave evidence of a succession of man-made systems mired in abandoned hopes.

About one mile north of the oil seeps I selected my site. Irregular beds of limestone dip gently eastward, massive deposits of black basalt are broken over the peninsula, giving the region a shattered appearance. It is one of few places on the lake where the water comes right up to the mainland. Under shallow pinkish water is a network of mud cracks supporting the jigsaw puzzle that composes the salt flats. As I looked at the site, it reverberated out to the horizons only to suggest an immobile cyclone while flickering light made the entire landscape appear to quake. A dormant earthquake spread into the fluttering stillness, into a spinning sensation without movement. This site was a rotary that enclosed itself in an immense roundness. From that gyrating space emerged the possibility of the *Spiral Jetty*. No ideas, no concepts, no systems, no structures, no abstractions could hold themselves together in the actuality of that evidence. My dialectics of site and non-site whirled into an indeterminate

state, where solid and liquid lost themselves in each other. It was as if the mainland oscillated with waves and pulsations, and the lake remained rock still. The shore of the lake became the edge of the sun, a boiling curve, an explosion rising into a fiery prominence. Matter collapsing into the lake mirrored in the shape of a spiral. No sense wondering about classifications and categories, there were none.

After securing a twenty-year lease on the meandering zone, and finding a contractor in Ogden, I began building the jetty in April, 1970. Bob Phillips, the foreman, sent two dump trucks, a tractor, and a large front loader out to the site. The tail of the spiral began as a diagonal line of stakes that extended into the meandering zone. A string was then extended from a central stake in order to get the coils of the spiral. From the end of the diagonal to the centre of the spiral, three curves coiled to the left. Basalt and earth was scooped up from the beach at the beginning of the jetty by the front loader, then deposited in the trucks, whereupon the trucks backed up to the outline of stakes and dumped the material. On the edge of the water, at the beginning of the tail, the wheels of the trucks sank into a quagmire of sticky gumbo mud. A whole afternoon was spent filling in this spot. Once the trucks passed that problem, there was always the chance that the salt crust resting on the mud flats would break through. The *Spiral Jetty* was staked out in such a way as to avoid the soft muds that broke up through the salt crust, nevertheless there were some mud fissures that could not be avoided. One could only hope that tension would hold the entire jetty together, and it did. A cameraman was sent by the Ace Gallery in Los Angeles to film the process.

The scale of the *Spiral Jetty* tends to fluctuate depending on where the viewer happens to be. Size determines an object, but scale determines art. A crack in the wall if viewed in terms of scale, not size, could be called the Grand Canyon. A room could be made to take on the immensity of the solar system. Scale depends on one's capacity to be conscious of the actualities of perception. When one refuses to release scale from size, one is left with an object or language that *appears* to be certain. For me scale operates by uncertainty. To be in the scale of the *Spiral Jetty* is to be out of it. On eye level, the tail leads one into an undifferentiated state of matter. One's downward gaze pitches from side to side, picking out random depositions of salt crystals on the inner and outer edges, while the entire mass echoes the irregular horizons. And each cubic salt crystal echoes the *Spiral Jetty* in terms of the crystal's molecular lattice. Growth in a crystal advances around a dislocation point, in the manner of a screw.

The *Spiral Jetty* could be considered one layer within the spiralling crystal lattice, magnified trillions of times . . .

Chemically speaking, our blood is analogous in composition to the primordial seas. Following the spiral steps we return to our origins, back to some pulpy protoplasm, a floating eye adrift in an antediluvian ocean. On the slopes of Rozel Point I closed my eyes, and the sun burned crimson through the lids. I opened them and the Great Salt Lake was bleeding scarlet streaks. My sight was saturated by the colour of red algae circulating in the heart of the lake, pumping into ruby currents, no they were veins and arteries sucking up the obscure sediments. My eyes became combustion chambers churning orbs of blood blazing by the light of the sun. All was enveloped in a flaming chromosphere; I thought of Jackson Pollock's *Eyes in the Heat* . . . Swirling within the incandescence of solar energy were sprays of blood. My movie would end in sunstroke. Perception was heaving, the stomach turning. I was on a geologic fault that groaned within me. Between heat lightning and heat exhaustion the spiral curled into vaporization. I had the red heaves, while the sun vomited its corpuscular radiations. Rays of glare hit my eyes with the frequency of a Geiger counter. Surely, the storm clouds massing would turn into a rain of blood.

(Robert Smithson, 1972)

Pietro Aretino, scurrilous Renaissance writer and poet, observes a subject for his friend Titian.

My revered friend, having despite my usual custom eaten dinner alone, or rather in company with the torments provided by the fever which now stops me enjoying the taste of any food at all, I rose from table overcome by despair. And then, resting my arms on the windowsill, and letting my chest and almost my whole body sink on to it, I fell to gazing at the marvellous spectacle presented by the countless number of barges, crammed by no fewer strangers than townspeople, which were delighting not only the onlookers but the Grand Canal itself, the delight of all who navigate her.

And after enjoying the sight of two gondolas, rowed in competition by as many brave oarsmen, I was beguiled by the crowd of people who to see the regatta had flocked to the Rialto bridge, the Riva dei Camerlinghi, the fish market, the ferry at Santa Sofia and the Casa da Mosto.

And after all these various streams of humanity applauded happily and went their way, you would have seen me, like a man sick of himself and not knowing what to do with his thoughts and fancies, turn my eyes up to the sky; and, ever since God created it, never had it been so embellished by such a lovely picture of light and shades. Thus the air was such that those who envy you because they cannot be like you would have longed to show it.

As I am describing it, see first the buildings which appeared to be artificial though made of real stone. And then look at the air itself, which I perceived to be pure and lively in some places, and in others turbid and dull. Also consider my wonder at the clouds made up of condensed moisture; in the principal vista they were partly near the roofs of the buildings, and partly on the horizon, while to the right all was in a confused shading of greyish black. I was awestruck by the variety of colours they displayed: the nearest glowed with the flames of the sun's fire; the furthest were blushing with the brightness of partially burnt vermilion. Oh, how beautiful were the strokes with which Nature's brushes pushed the air back at this point, separating it from the palaces in the way that Titian does when painting his landscapes!

In some places the colours were green-blue, and in others they appeared blue-green, finely mixed by the whims of Nature, who is the teacher of teachers. With light and shades, she gave deep perspective and high relief to what she wished to bring forward and set back, and so I, who know how your brush breathes with her spirit, cried out three or four times: 'Oh, Titian, where are you?'

By heavens, if you had painted what I am telling you, you would have reduced people to the same stupor that so confounded me; and as I contemplated what I have now placed before you, I was filled with regret that the marvel of such a picture did not last longer.

(Pietro Aretino, May 1544)

John Wells, one of the St Ives circle of British Modernists, wonders how to capture the essence of nature: perhaps abstraction is the answer.

. . . so all around the morning air and the sea's blue light, with points of diamond, and the gorse incandescent beyond the trees; countless rocks ragged or round and of every colour; birds resting or flying, and the sense of a multitude of creatures living out their minute lives . . . All this is part

of one's life and I want desperately to express it; not just what I see, but what I feel about it . . . but how can one paint the warmth of the sun, the sound of the sea, the journey of a beetle across a rock, or thoughts of one's own whence and whither? That's one argument for abstraction. One absorbs all these feelings and ideas: if one is lucky they undergo an alchemistic transformation into gold and that is creative work.

(John Wells, 1948)

But abstraction is not the only way. Constable did indeed paint the warmth of the sun (and the wetness of the rain), or so his friend and biographer C. R. Leslie believed.

Constable's art was never more perfect, perhaps never so perfect, as at this period of his life. I remember being greatly struck by a small picture, a view from Hampstead Heath, which I first saw at *Ruysdael House*, as Mr Fisher [Archdeacon John Fisher, Constable's closest friend and correspondent] called his residence in Keppel Street. I have before noticed that what are commonly called warm colours are not necessary to produce the impression of warmth in landscape; and this picture affords, to me, the strongest possible proof of the truth of this. The sky is of the blue of an English summer day, with large, but not threatening, clouds of a silvery whiteness. The distance is of a deep blue, and the near trees and grass of the freshest green; for Constable could never content to parch up the verdure of nature to obtain warmth. These tints are balanced by a very little warm colour on a road and gravel pit in the foreground, a single house in the middle distance, and the scarlet jacket of a labourer. Yet I know no picture in which the midday heat of Midsummer is so admirably expressed; and were not the eye refreshed by the shade thrown over a great part of the foreground by some young trees, that border the road, and the cool blue of water near it, one would wish, in looking at it, for a parasol, as Fuseli wished for an umbrella when standing before one of Constable's showers. I am writing of this picture, which appears to have been wholly painted in the open air, after an acquaintance with it of five-and-twenty years; and, on referring to it again and again, I feel my first impressions, whether right or wrong, entirely confirmed. At later periods of his life, Constable aimed, and successfully, at grander and more evanescent effects of nature; but in copying her simplest aspects, he never surpassed such pictures as this; and which, I cannot but think, will obtain

for him, when his merits are fully acknowledged, the praise of having been the most genuine painter of English landscape that has yet lived.

(C. R. Leslie, *Memoirs of the Life of John Constable, RA*, 1843)

It was the changeable English weather, argues the critic David Sylvester, that provides the key to the drama of Constable's landscapes.

Constable was no realist. The proof of this is that in his big pictures of home it's eternally summer, and around midday. It seems quite probable that the remark in a current publisher's blurb that Constable is 'best known for his sun-dappled landscapes of the English countryside' is not a cynical attempt to cash in on the popularity of Renoir but a slip which occurred because the writer had noticed that the landscapes were summery but not that this didn't mean they were sunny. The way in which Constable made his skies factual was, first, to make them as temperamental as skies are in England, and second, to make them as dominant as they are in Suffolk through consuming so much of the field of vision. His art is a celebration of the experience that, standing on the bank of the Stour by Flatford Mill, you can see sky everywhere around you, and the sky you see is a number of different skies, many of them threatening, and ten minutes later those skies have changed position and several new ones have appeared, and ten minutes after that they have all changed. (And there are skies to be seen there which are never seen in his pictures – for instance, a silver-gilded sky that Tiepolo might have painted.)

Constable's landscapes, then, often present a contrast between a terrestrial nature that is benign and ordered and on a human scale and a celestial nature that is ungovernable and hostile as well as vast. In speaking of Claude he said that the master's 'chief power consisted in uniting splendour with repose, warmth with freshness, and dark with light'; he gave himself the task in most of his major paintings of uniting antitheses which were far more emphatic in their opposition.

I think it was through this epic duality between land and sky that he achieved his avowed aim of endowing landscape painting with the moral significance and weight which were traditionally the prerogative of history painting. Through that duality the paintings become sermons about the antithesis between the earth, where man has some say at least in ordaining its destiny, and the skies, where man has no control at all; they remind us that the god of the sky and of atmospheric phenomena was Zeus himself

and that the skies are the playgrounds of the gods, to be used in killing us for their sport (or they remind us of the Christian equivalent, in which Constable believed, of all that bullying). Furthermore, the skies have the power to rule our feelings, in life (leaving us to turn the tables in art).

Out of doors in Suffolk or in Wiltshire menacing summer skies are a commonplace. On the small flat surface that is a picture the contrast risks producing the effect of playing the *Appassionata* during a recitation of Gray's *Elegy*. Claude resolves his oppositions by endowing everything in the painting with the same marvellous radiance; in the sketches Constable resolves his, more testing, oppositions by endowing everything with the same mysterious opaqueness, the opaqueness of a wall of oil paint. The contradictions are dissolved because the painting is so insistent that images are not made of fields or trees or clouds, but of paint on canvas, a vibrant massing of paint with a life of its own: for instance, where there are trees, a complex of surging upward movement in the paint becomes an equivalent for the process of growth. The sketch for *The Leaping Horse* is the most marvellous of them, as everybody knows. Another which has the same miraculous combination of flickering aliveness and brooding gravity – so that at one moment it can call to mind the density of Courbet, at another the dark energy of Goya – is the sketch for *Salisbury Cathedral from the Meadows*, a work of chequered reputation often said to be badly drawn in places (which it probably is, if one is looking at pictures as if they were dogs at Cruft's).

(David Sylvester, 'Constable's Weather', 1991, in his *About Modern Art*, 1996)

The aesthetic dandy James McNeill Whistler frankly doubts whether nature has much to do with art – at least, unless it is filtered through an artist's sensibility.

Nature contains the elements, in colour and form, of all pictures, as the keyboard contains the notes of all music.

But the artist is born to pick, and choose, and group with science, these elements, that the result may be beautiful – as the musician gathers his notes, and forms his chords, until he bring forth from chaos glorious harmony.

To say to the painter, that Nature is to be taken as she is, is to say to the player, that he may sit on the piano.

That Nature is always right, is an assertion, artistically, as untrue, as it is one whose truth is universally taken for granted. Nature is very rarely

right, to such an extent even, that it might almost be said that Nature is usually wrong: that is to say, the condition of things that shall bring about the perfection of harmony worthy a picture is rare, and not common at all.

This would seem, to even the most intelligent, a doctrine almost blasphemous. So incorporated with our education has the supposed aphorism become, that its belief is held to be part of our moral being, and the words themselves have, in our ear, the ring of religion. Still, seldom does Nature succeed in producing a picture.

The sun blares, the wind blows from the east, the sky is bereft of cloud, and without, all is of iron. The windows of the Crystal Palace are seen from all points of London. The holiday-maker rejoices in the glorious day, and the painter turns aside to shut his eyes.

How little this is understood, and how dutifully the casual in Nature is accepted as sublime, may be gathered from the unlimited admiration daily produced by a very foolish sunset.

The dignity of the snow-capped mountain is lost in distinctness, but the joy of the tourist is to recognize the traveller on the top. The desire to see, for the sake of seeing it, is, with the mass, alone the one to be gratified, hence the delight in detail.

And when the evening mist clothes the riverside with poetry, as with a veil, and the poor buildings lose themselves in the dim sky, and the tall chimneys become campanili, and the warehouses are palaces in the night, and the whole city hangs in the heavens, and fairyland is before us – then the wayfarer hastens home; the working man and the cultured one, the wise man and the one of pleasure, cease to understand, as they have ceased to see, and Nature, who, for once, has sung in tune, sings her exquisite song to the artist alone, her son and her master – her son in that he loves her, her master in that he knows her.

To him her secrets are unfolded, to him her lessons have become gradually clear. He looks at her flower, not with the enlarging lens, that he may gather facts for the botanist, but with the light of the one who sees in her choice selection of brilliant tones and delicate tints, suggestions of future harmonies.

He does not confine himself to purposeless copying, without thought, each blade of grass, as commended by the inconsequent, but, in the long curve of the narrow leaf, corrected by the straight tall stem, he learns how grace is wedded to dignity, how strength enhances sweetness, that elegance shall be the result.

In the citron wing of the pale butterfly, with its dainty spots of orange, he sees before him the stately halls of fair gold, with their slender saffron pillars, and is taught how the delicate drawing high upon the walls shall be traced in tender tones of orpiment, and repeated by the base in notes of graver hue.

In all that is dainty and lovable he finds hints for his own combinations, and *thus* is Nature ever his resource and always at his service, and to him is naught refused.

Through his brain, as through the last alembic, is distilled the refined essence of that thought which began with the Gods, and which they left him to carry out.

Set apart by them to complete their works, he produces that wondrous thing called the masterpiece, which surpasses in perfection all that they have contrived in what is called Nature; and the Gods stand by and marvel, and perceive how far away more beautiful is the Venus of Melos than was their own Eve.

(James McNeill Whistler, 'Mr Whistler's 10 O'Clock Lecture', 1885)

The aged Degas, however, according to André Gide, had strong, even murderous feelings about painters of nature (although, one notes, he painted not a few landscapes himself).

Going through Paris for the review copies of *La Porte étroite*, I stop at the Valérys' to get news of Jeannie Valéry, on whom there was some question of operating. Degas is with her and has been wearing her out for more than an hour, for he is very hard of hearing and she has a weak voice. I find Degas has aged but is just like himself; just a bit more obstinate, more set in his opinion, exaggerating his crustiness, and always scratching the same spot in his brain where the itching becomes more and more localized. He says: 'Ah, those who work from nature! What impudent humbugs! The landscapists! When I meet one of them in the countryside, I want to fire away at him. Bang! Bang!' (He raises his cane, closes an eye, and aims at the drawing-room furniture.) 'There ought to be a police force for that purpose.' Etc., etc.

(André Gide, 4 July 1909)

Manuel II Palaeologus, a medieval Emperor of Byzantium, finds solace from the cares of state in a tapestry representing the flowery landscape of spring.

This is the season of spring; this is announced by the flowers and the clear air which lies above them. For this reason also the leaves of the trees rustle softly, the grass seems to sway back and forth when touched by the air, which caresses it with gentle breeze. Surely this is a lovely sight. The rivers are returning to their beds and their powerful swell is diminishing; everything which has been covered by the flood is re-emerging from the water, offering human hands a chance to harvest that which is useful. To this belongs what this youth here is clutching with his left hand, crouching with his head low down, so that up to his nose he is touching the water, feeling with the fingers of his bare hand in the waves the crevices below very gently and carefully, so that the water may not be stirred by his feet and thereby disturb by its gurgling that which is hidden in these holes [a crayfish]. The partridges are enjoying themselves, for their strength, of which they had been bereft by nature, is coming back; the rays of the sun, pleasant in their mildness, are awakening them to new life. Now they dwell gladly in the fields, taking their young ones to feed, first tasting that which they will offer them, thus preparing their table. The songbirds are sitting in the trees, hardly touching the fruit, for they are spending most of their time singing. Their voices, I believe, will announce that all will be better now that the queen of the seasons is here: the fog gives way to a clear sky; the storm calms; that which is troublesome gives way to pleasure. Everything moves more freely, even the smallest animals: moths, bees, grasshoppers and the many other kinds. Some of these have just emerged from their hives, others have barely been born, encouraged by the mildness of the season, or, if you prefer, at the blending of warmth and humidity; they hum around man and fly ahead of the traveller, and those among them gifted with a voice sing with him who sings. Some play, some fight with each other; others sit on the blossoms.

All of this is beautiful to watch. Yet the boys who play in this garden are attempting to chase these little beasts in a charming and gay mood: this one, bareheaded, is using his cap to catch [butterflies]; since he usually does not catch anything, he causes his companions to laugh aloud. A second one is trying to catch the small creature [a beetle] by throwing himself, hands close to his body, with his entire weight upon it. Why should not this be cause for gay laughter? Do you see yonder slim youth? He has just caught a singing bird and is so filled with joy that he is acting

like a bacchant. As he lifts the lower end of his garment to put his prey there in order to be free to catch another one, he is unaware in his eagerness that he is uncovering what otherwise is covered. Yonder smaller boy is even gayer; he has tied two small animals [ladybirds] with a thin thread and is making them fly, yet again preventing them in their effort. He laughs and is glad and jumps around playing as if he were engaged in some serious business. Thus, the art of weaving smiles at us and offers the onlooker deep pleasure. The real reason for all of this, however, is that spring chases away sadness, or, if you prefer, causes us to be gay.

(Manuel II Palaeologus, Emperor of Byzantium, *c.*1400)

An eighteenth-century Chinese artist argues that to depict landscape the painter must get in tune with the vital forces of nature itself.

All matter is formed of accumulated force. Thus even the undulations of hilltops and every rock and tree are possessed by a life-force inherent in them. They are multifarious, yet orderly, perhaps they exist in small numbers, but they are never dried and dead. Each has its own shape, and together they have a related unity. All things differ in shape and manner, yet all are governed by this life-force and possess the beauty of life. This is what we call *shih*, force of movement. When people, speaking of the six techniques [the venerable principles of Chinese art, laid down in the fifth century AD], place first the 'lifelike tone and atmosphere', they mean exactly this. When we speak of the force of the brush (*pi-shih*), we mean that the life-movement of the brush brings out the body posture of the different objects. Only so can the work be called a painting. When one prepares to put ink on paper, one should feel in one's wrist a power like the universe creating life. It flows out from one generously and freely, without obstruction and without deliberation. One puts a dot here and a dash there and the objects take form; anything is possible for one to pick up and carry along. This is the creative moment when hand and mind and brush and ink co-operate. As Wen Cheng-ming says, seize it, capture it at once before it vanishes, for speed is essential to catch that force of movement. Some may quote Tu Fu's line about taking 'ten days to paint a stream and five days to paint a rock', but the poet really means that art cannot be forced or done under pressure by a fixed delivery date. When the inspiration comes, it cannot be stopped, so insistent is the demand for expression. Wu Tao-tse was asked by imperial order to make a picture

of the Kialing River valley, and he did it in one day, whereas it took others over a month. This is an example of achieving force of movement by speedy execution. The forms of hills and forests come from the life-force (*sheng-ch'i*) of the universe, and the ink marks and tracings of the brush come from the spiritual force of the artist's mind and hand. So where the life-force is, the force of movement is also. The life-force makes the force of movement, and the force of movement carries the life-movement. The force of movement (*shih*) can be seen, but the life-force (*ch'i*) itself cannot. Therefore it is necessary to have force of movement to bring out the life of things. When life-force circulates, the force of movement goes in harmony with it. So this life-force and force of movement come from the same source. Let it pour out and it will flow naturally and in graceful movements. There is no need to work carefully and yet it all fits in beautifully. Is it life-force? Or is it force of movement? Just pour it out. The insight of a moment may be thus committed to eternity, and the artist need not be ashamed of his work. Such pleasures of creation cannot be felt by an artist who slowly builds up his structures.

The moment of inspiration comes by itself, and brushes away all doubts and hesitancies. Like an arrow shooting out from the bowstring, it cannot be stopped; it is unfathomable, like rumbling thunder coming from the earth. One has no idea where it comes from, when it starts, nor whither it goes. It comes just at the exact moment, not a second sooner or later. When this inspiration comes at the moment of painting, a true masterpiece is born. It cannot be repeated by doubled effort, it simply eludes it. For the effort to recapture that moment is born of man (artificial), not of heaven (inspired). Only those possessed of the natural expansive spirit have more of such moments; they can shut out the mental effort and let themselves go soaring in freedom to wherever the spirit may carry them. There is a co-operation of human skill and natural gift, and the work is done easily, without planning and design, not comparable with anything done by planning and design.

(Shen Tsung-ch'ien, *fl.*1781)

Reflecting upon the difficulty of drawing leaves, the great Victorian art critic John Ruskin comes to a view not dissimilar to that of the Chinese artist.

All this difficulty, however, attaches to rendering merely the dark form of the sprays as they come against the sky. Within those sprays, and in the

heart of the tree, there is a complexity of a much more embarrassing kind; for nearly all leaves have some lustre, and all are more or less translucent (letting light through them); therefore, in any given leaf, besides the intricacies of its own proper shadows and foreshortenings, there are three series of circumstances which alter or hide its forms. First, shadows cast on it by other leaves, – often very forcibly. Secondly, light reflected from its lustrous surface, sometimes the blue of the sky, sometimes the white of clouds, or the sun itself flashing like a star. Thirdly, forms and shadows of other leaves, seen as darknesses through the translucent parts of the leaf; a most important element of foliage effect, but wholly neglected by landscape artists in general.

The consequence of all this is, that except now and then by chance, the form of a complete leaf is never seen; but a marvellous and quaint confusion, very definite, indeed, in its evidence of direction of growth, and unity of action, but wholly indefinable and inextricable, part by part, by any amount of patience. You cannot possibly work it out in facsimile, though you took a twelvemonth's time to a tree; and you must therefore try to discover some mode of execution which will more or less imitate, by its own variety and mystery, the variety and mystery of Nature, without absolute delineation of detail.

(John Ruskin, *Elements of Drawing*, 1857)

According to this reported remark, Jackson Pollock did not want simply to paint nature, he wanted to be *nature.*

My concern is with the rhythms of nature . . . the way the ocean moves . . . The ocean's what the expanse of the West was for me . . . I work from the inside out, like nature.

(Jackson Pollock, in B. H. Friedman, 1973)

At the beginning of Moby-Dick, *Ishmael encounters a strange, obscure, possibly landscape painting. Could it be that there were abstract painters at work in New England a century before Mark Rothko and Jackson Pollock?*

Entering that gable-ended Spouter Inn, you found yourself in a wide, low, straggling entry with old-fashioned wainscots, reminding one of the bulwarks of some condemned old craft. On one side hung a very large

oil painting so thoroughly besmoked, and every way defaced, that in the unequal cross-lights by which you viewed it, it was only by diligent study and a series of systematic visits to it, and careful inquiry of the neighbours, that you could any way arrive at an understanding of its purpose. Such unaccountable masses of shades and shadows, that at first you almost thought some ambitious young artist, in the time of the New England hags, had endeavoured to delineate chaos bewitched. But by dint of much and earnest contemplation, and oft repeated ponderings, and especially by throwing open the little window towards the back of the entry, you at last come to the conclusion that such an idea, however wild, might not be altogether unwarranted.

But what most puzzled and confounded you was a long, limber, portentous, black mass of something hovering in the centre of the picture over three blue, dim, perpendicular lines floating in a nameless yeast. A boggy, soggy, squitchy picture truly, enough to drive a nervous man distracted. Yet was there a sort of indefinite, half-attained, unimaginable sublimity about it that fairly froze you to it, till you involuntarily took an oath with yourself to find out what that marvellous painting meant. Ever and anon a bright, but, alas! deceptive idea would dart you through. – It's the Black Sea in a midnight gale. – It's the unnatural combat of the four primal elements. – It's a blasted heath. – It's a Hyperborean winter scene. – It's the breaking-up of the ice-bound stream of Time. But at last all these fancies yielded to that one portentous something in the picture's midst. *That* once found out, and all the rest were plain. But stop; does it not bear a faint resemblance to a gigantic fish? even the great Leviathan himself?

(Herman Melville, 1851)

In a letter to his friend Archdeacon Fisher, Constable emphasizes the importance of the sky in landscape painting.

I am most anxious to get into my London painting room, for I do not consider myself at work unless I am before a six-foot canvas. I have done a good deal of skying, for I am determined to conquer all difficulties, and that among the rest. And now talking of skies, it is amusing to us to see how admirably you fight my battles; you certainly take the best possible ground for getting your friend out of a scrape (the example of the old masters). That landscape painter who does not make his skies a very

material part of his composition, neglects to avail himself of one of his greatest aids. Sir Joshua Reynolds, speaking of the landscapes of Titian, of Salvator [Rosa], and of Claude, says: 'Even their *skies* seem to sympathize with their subjects.' I have often been advised to consider my sky as '*a white sheet thrown behind the objects*'. Certainly, if the sky is obtrusive, as mine are, it is bad; but if it is evaded, as mine are not, it is worse; it must and always shall with me make an effectual part of the composition. It will be difficult to name a class of landscape in which the sky is not the key note, the standard of scale, and the chief organ of sentiment. You may conceive then, what a 'white sheet' would do for me, impressed as I am with these notions, and they cannot be erroneous. The sky is the source of light in nature, and governs everything; even our common observations on the weather of every day are altogether suggested by it. The difficulty of skies in painting is very great, both as to composition and execution; because, with all their brilliancy, they ought not to come forward, or, indeed, be hardly thought of any more than extreme distances are; but this does not apply to phenomena or accidental effects of sky, because they always attract particularly. I may say all this to you, though *you* do not want to be told that I know very well what I am about, and that my skies have not been neglected, though they have often failed in execution, no doubt, from an over-anxiety about them, which will alone destroy that easy appearance which nature always has in all her movements.

(John Constable, 23 October 1821, in C. R. Leslie, *Memoirs of the Life of John Constable, RA*, 1843)

Lucy Snowe, the heroine of Charlotte Brontë's novel Villette, *is disapproving of the lack of true nature in art.*

It seemed to me that an original and good picture was just as scarce as an original and good book; nor did I, in the end, tremble to say to myself, standing before certain *chef d'œuvres* bearing great names, 'These are not a whit like nature. Nature's daylight never had that colour; never was made so turbid, either by storm or cloud, as it is laid out there, under a sky of indigo: and that indigo is not ether; and those dark weeds plastered upon it are not trees.' Several very well executed and complacent-looking fat women struck me as by no means the goddesses they appeared to consider themselves. Many scores of marvellously finished little Flemish pictures, and also of sketches, excellent for fashion-books, displaying varied

costumes in the handsomest materials, gave evidence of laudable industry whimsically applied. And yet there were fragments of truth here and there which satisfied the conscience, and gleams of light that cheered the vision. Nature's power here broke through in a mountain snowstorm; and there her glory in a sunny southern day. An expression in this portrait proved clear insight into character; a face in that historical painting, by its vivid filial likeness, startlingly reminded you that genius gave it birth. These exceptions I loved: they grew dear as friends.

(Charlotte Brontë, 1853)

According to the nineteenth-century essayist William Hazlitt, Poussin managed to paint nature not only as it is, but as it has been, and is capable of being.

Orion, the subject of this landscape, was the classical Nimrod; and is called by Homer, 'a hunter of shadows, himself a shade'. He was the son of Neptune; and having lost an eye in some affray between the Gods and men, was told that if he would go to meet the rising sun he would recover his sight. He is represented setting out on his journey, with men on his shoulders to guide him, a bow in his hand, and Diana in the clouds greeting him. He stalks along, a giant upon earth, and reels and falters in his gait, as if just awaked out of sleep, or uncertain of his way; you see his blindness, though his back is turned. Mists rise around him, and veil the sides of the green forests; earth is dank and fresh with dews, the 'grey dawn and the Pleiades before him dance', and in the distance are seen the blue hills and sullen ocean. Nothing was ever more finely conceived or done. It breathes the spirit of the morning; its moisture, its repose, its obscurity, waiting the miracle of light to kindle it into smiles; the whole is, like the principal figure in it, 'a forerunner of the dawn'. The same atmosphere tinges and imbues every object, the same dull light 'shadowy sets off' the face of nature: one feeling of vastness, of strangeness, and of primeval forms pervades the painter's canvas, and we are thrown back upon the first integrity of things. This great and learned man might be said to see nature through the glass of time; he alone has a right to be considered as the painter of classical antiquity. Sir Joshua has done him justice in this respect. He could give to the scenery of his heroic fables that unimpaired look of original nature, full, solid, large, luxuriant, teeming with life and power; or deck it with all the pomp of art, with temples and towers, and mythologic groves. His pictures 'denote a foregone

conclusion'. He applies Nature to his purposes, works out her images according to the standard of his thoughts, embodies high fictions; and the first conception being given, all the rest seems to grow out of and be assimilated to it, by the unfailing process of a studious imagination. Like his own Orion, he overlooks the surrounding scene, appears to 'take up the isles as a very little thing, and to lay the earth in a balance.' With a laborious and mighty grasp, he puts nature into the mould of the ideal and antique; and was among painters (more than any one else) what Milton was among poets. There is in both something of the same pedantry, the same stiffness, the same elevation, the same grandeur, the same mixture of art and nature, the same richness of borrowed materials, the same unity of character. Neither the poet nor the painter lowered the subjects they treated, but filled up the outline in the fancy, and added strength and reality to it; and thus not only satisfied, but surpassed the expectations of the spectator and the reader. This is held for the triumph and the perfection of works of art. To give us nature, such as we see it, is well and deserving of praise; to give us nature, such as we have never seen, but have often wished to see it, is better, and deserving of higher praise. He who can show the world in its first naked glory, with the hues of fancy spread over it, or in its high and palmy state, with the gravity of history stamped on the proud monuments of vanished empire, – who, by his 'so potent art,' can recall time past, transport us to distant places, and join the regions of imagination (a new conquest) to those of reality, – who shows us not only what Nature is, but what she has been, and is capable of, – he who does this, and does it with simplicity, with truth, and grandeur, is lord of Nature and her powers; and his mind is universal, and his art the master art!

There is nothing in this 'more than natural', if criticism could be persuaded to think so. The historic painter does not neglect or contravene Nature, but follows her more closely up into her fantastic heights or hidden recesses. He demonstrates what she would be in conceivable circumstances and under implied conditions. He 'gives to airy nothing a local habitation', not 'a name'. At his touch, words start up into images, thoughts become things. He clothes a dream, a phantom, with form and colour, and the wholesome attributes of reality. *His* art is a second nature; not a different one. There are those, indeed, who think that not to copy nature is the rule for attaining perfection. Because they cannot paint the objects which they have seen, they fancy themselves qualified to paint the ideas which they have not seen. But it is possible to fail in this latter and more difficult style of imitation, as well as in the former humbler one.

The detection, it is true, is not so easy, because the objects are not so nigh at hand to compare, and therefore there is more room both for false pretension and for self-deceit. They take an epic motto or subject, and conclude that the spirit is implied as a thing of course. They paint inferior portraits, maudlin, lifeless faces, without ordinary expression, or one look, feature, or particle of nature in them, and think that this is to rise to the truth of history. They vulgarize and degrade whatever is interesting or sacred to the mind, and suppose that they thus add to the dignity of their profession. They represent a face that seems as if no thought or feeling of any kind had ever passed through it, and would have you believe that this is the very sublime of expression, such as it would appear in heroes, or demi-gods of old, when rapture or agony was raised to its height. They show you a landscape that looks as if the sun never shone upon it, and tell you that it is not modern – that so earth looked when Titan first kissed it with his rays. This is not the true *ideal*. It is not to fill the moulds of the imagination, but to deface and injure them; it is not to come up to, but to fall short of the poorest conception in the public mind. Such pictures should not be hung in the same room with that of Orion.

(William Hazlitt, 'On a Landscape of Nicolas Poussin', 1821–2)

Leonardo da Vinci gives instructions on how to depict a universal deluge.

Let the dark gloomy air be seen beaten by the rush of opposing winds wreathed in perpetual rain mingled with hail, and bearing hither and thither a vast network of the torn branches of trees mixed together with an infinite number of leaves. All around let there be seen ancient trees uprooted and torn in pieces by the fury of the winds. You should show how fragments of mountains, which have been already stripped bare by the rushing torrents, fall headlong into these very torrents and choke up the valleys until the pent-up rivers rise in flood and cover the wide plains and their inhabitants. Again there might be seen huddled together on the tops of many of the mountains many different sorts of animals, terrified and subdued at last to a state of tameness, in company with men and women who had fled there with their children. And the fields which were covered with water had their waves covered over in great part with tables, bedsteads, boats, and various other kinds of rafts improvised through necessity and fear of death, upon which were men and women with their children, massed together and uttering various cries and lamentations,

dismayed by the fury of the winds which were causing the waters to roll over and over in mighty hurricane, bearing with them the bodies of the drowned; and there was no object that floated on the water but was covered with various different animals who had made truce and stood huddled together in terror, among them being wolves, foxes, snakes, and creatures of every kind, fugitives from death. And all the waves that beat against their sides were striking them with repeated blows from the various bodies of the drowned, and the blows were killing those in whom life remained.

Some groups of men you might have seen with arms in their hands defending the tiny footholds that remained to them from the lions and wolves and beasts of prey which sought safety there. Ah, what dreadful tumults one heard resounding through the gloomy air, smitten by the fury of the thunder and the lightning it flashed forth, which sped through it, bearing ruin, striking down whatever withstood its course! Ah, how many might you have seen stopping their ears with their hands in order to shut out the loud uproar caused through the darkened air by the fury of the winds mingled together with the rain, the thunder of the heavens and the raging of the thunderbolts! Others were not content to shut their eyes, but placing their hands over them, one above the other, would cover them more tightly in order not to see the pitiless slaughter made of the human race by the wrath of God.

Ah, me, how many lamentations! How many in their terror flung themselves down from the rocks! You might have seen huge branches of the giant oaks laden with men borne along through the air by the fury of the impetuous winds. How many boats were capsized and lying, some whole, others broken in pieces, on the top of men struggling to escape, with acts and gestures of despair which foretold an awful death. Others with frenzied acts were taking their own lives, in despair of ever being able to endure such anguish; some of these were flinging themselves down from the lofty rocks, others strangled themselves with their own hands; some seized hold of their own children, and with mighty violence slew them at one blow; some turned their arms against themselves to wound and slay; others falling upon their knees were commending themselves to God.

Alas, how many mothers were bewailing their drowned sons, holding them upon their knees, lifting up open arms to heaven, and, with divers cries and shrieks, declaiming against the anger of the gods! Others, with hands clenched and fingers locked together, gnawed and devoured them

with bites that ran blood, crouching down so that their breasts touched their knees in their intense and intolerable agony.

Herds of animals, such as horses, oxen, goats, sheep, were to be seen already hemmed in by the waters and left isolated upon the high peaks of the mountains, all huddling together, and those in the middle climbing to the top and treading on the others, and waging fierce battles with each other, and many of them dying for want of food.

And the birds had already begun to settle upon men and other animals, no longer finding any land left unsubmerged which was not covered with living creatures. Already had hunger, the minister of death, taken away their life from the greater number of the animals, when the dead bodies already becoming lighter began to rise from out the bottom of the deep waters and emerged to the surface among the contending waves; and there lay beating one against another, and as balls puffed up with wind rebound back from the spot where they strike, these fell back and lay upon the other dead bodies. And above these horrors the atmosphere was seen covered with murky clouds that were rent by the jagged course of the raging thunderbolts of heaven which flashed light hither and thither amid the obscurity of the darkness.

(Leonardo da Vinci, 1452–1519)

A work of art is a corner of the Creation seen through a temperament.

(Émile Zola, *c.*1866)

I am much more interested in achieving unison with nature than in copying it.

(Georges Braque, in *Notebooks 1917–1947*)

Artists

and

Models

A classical precedent for the relationship between artist and model.

As for the loathsome Propoetides, they dared to deny the divinity of Venus. The story goes that as a result of this, they were visited by the wrath of the goddess, and were the first women to lose their good names by prostituting themselves in public. Then, as all sense of shame left them, the blood hardened in their cheeks, and it required only a slight alteration to transform them into stony flints.

When Pygmalion saw these women, living such wicked lives, he was revolted by the many faults which nature has implanted in the female sex, and long lived a bachelor existence, without any wife to share his home. But meanwhile, with marvellous artistry, he skilfully carved a snowy ivory statue. He made it lovelier than any woman born, and fell in love with his own creation. The statue had all the appearance of a real girl, so that it seemed to be alive, to want to move, did not modesty forbid. So cleverly did his art conceal its art. Pygmalion gazed in wonder, and in his heart there rose a passionate love for this image of a human form. Often he ran his hands over the work, feeling it to see whether it was flesh or ivory, and would not yet admit that ivory was all it was. He kissed the statue, and imagined that it kissed him back, spoke to it and embraced it, and thought he felt his fingers sink into the limbs he touched, so that he was afraid lest a bruise appear where he had pressed the flesh. Sometimes he addressed it in flattering speeches, sometimes brought the kind of presents that girls enjoy: shells and polished pebbles, little birds and flowers of a thousand hues, lilies and painted balls, and drops of amber which fall from the trees that were once Phaethon's sisters. He dressed the limbs of his statue in woman's robes, and put rings on its fingers, long necklaces round its neck. Pearls hung from its ears, and chains were looped upon its breast. All this finery became the image well, but it was no less lovely unadorned. Pygmalion then placed the statue on a couch that was covered with cloths of Tyrian purple, laid its head to rest on soft down pillows, as if it could appreciate them, and called it his bedfellow.

The festival of Venus, which is celebrated with the greatest pomp all through Cyprus, was now in progress, and heifers, their crooked horns gilded for the occasion, had fallen at the altar as the axe struck their snowy necks. Smoke was rising from the incense, when Pygmalion, having made his offering, stood by the altar and timidly prayed, saying: 'If you gods can give all things, may I have as my wife, I pray –' he did not dare to say: 'the ivory maiden', but finished: 'one like the ivory maid.' However, golden Venus, present at her festival in person, understood what his prayers meant, and as a sign that the gods were kindly disposed, the flames burned up three times, shooting a tongue of fire into the air. When Pygmalion returned home, he made straight for the statue of the girl he loved, leaned over the couch, and kissed her. She seemed warm: he laid his lips on hers again, and touched her breast with his hands – at his touch the ivory lost its hardness, and grew soft: his fingers made an imprint on the yielding surface, just as wax of Hymettus melts in the sun and, worked by men's fingers, is fashioned into many different shapes, and made fit for use by being used. The lover stood, amazed, afraid of being mistaken, his joy tempered with doubt, and again and again stroked the object of his prayers. It was indeed a human body! The veins throbbed as he pressed them with his thumb. Then Pygmalion of Paphos was eloquent in his thanks to Venus. At long last, he pressed his lips upon living lips, and the girl felt the kisses he gave her, and blushed. Timidly raising her eyes, she saw her lover and the light of day together. The goddess Venus was present at the marriage she had arranged and, when the moon's horns had nine times been rounded into a full circle, Pygmalion's bride bore a child, Paphos, from whom the island takes its name.

(Ovid, *c.*AD 2–8)

For Rodin, the difference between female flesh and clay was an indistinct one. In retrospect, the dancer Isadora Duncan was sorry that in her case she made him stop at a little superficial modelling.

Since viewing his work at the Exhibition, the sense of Rodin's genius had haunted me. One day I found my way to his studio in the Rue de l'Université. My pilgrimage to Rodin resembled that of Psyche seeking the God Pan in his grotto, only I was not asking the way to Eros, but to Apollo.

Rodin was short, square, powerful, with close-cropped head and plentiful beard. He showed his works with the simplicity of the very great.

Sometimes he murmured the names of his statues, but one felt that names meant little to him. He ran his hands over them and caressed them. I remember thinking that beneath his hands the marble seemed to flow like molten lead. Finally he took a small quantity of clay and pressed it between his palms. He breathed hard as he did so. The heat streamed from him like a radiant furnace. In a few moments he had formed a woman's breast, that palpitated beneath his fingers.

He took me by the hand, took a cab, and came to my studio. There I quickly changed into my tunic and danced for him an idyll of Theocritus which André Beaunier had translated for me thus:

> 'Pan aimait la nymphe Écho,
> Écho aimait Satyr,' etc.

Then I stopped to explain to him my theories for a new dance, but soon I realized that he was not listening. He gazed at me with lowered lids, his eyes blazing, and then, with the same expression that he had before his works, he came toward me. He ran his hands over my neck, breast, stroked my arms and ran his hands over my hips, my bare legs and feet. He began to knead my whole body as if it were clay, while from him emanated heat that scorched and melted me. My whole desire was to yield to him my entire being and, indeed, I would have done so if it had not been that my upbringing caused me to become frightened, and I withdrew, threw my dress over my tunic, and sent him away bewildered.

(Isadora Duncan, 1927)

According to Vasari, the reason why the Mona Lisa is smiling is that Leonardo took the trouble to keep her amused.

For Francesco del Giocondo Leonardo undertook to execute the portrait of his wife, Mona Lisa. He worked on this painting for four years, and then left it still unfinished; and today it is in the possession of King Francis of France, at Fontainebleau. If one wanted to see how faithfully art can imitate nature, one could readily perceive it from this head; for here Leonardo subtly reproduced every living detail. The eyes had their natural lustre and moistness, and around them were the lashes and all those rosy and pearly tints that demand the greatest delicacy of execution. The eyebrows were completely natural, growing thickly in one place and lightly

in another and following the pores of the skin. The nose was finely painted, with rosy and delicate nostrils as in life. The mouth, joined to the flesh tints of the face by the red of the lips, appeared to be living flesh rather than paint. On looking closely at the pit of her throat one could swear that the pulses were beating. Altogether this picture was painted in a manner to make the most confident artist – no matter who – despair and lose heart. Leonardo also made use of this device: while he was painting Mona Lisa, who was a very beautiful woman, he employed singers and musicians or jesters to keep her full of merriment and so chase away the melancholy that painters usually give to portraits. As a result, in this painting of Leonardo's there was a smile so pleasing that it seemed divine rather than human; and those who saw it were amazed to find that it was as alive as the original.

(Giorgio Vasari, 1568)

For one of its subjects – the daughter of one of the painter's friends – the art of Édouard Vuillard evokes her lost childhood.

Being a pampered child, freely admitted to the company of my elders, I used from an early age to be on first-name terms with most of my father's friends. But there was one whom affection mingled with respect led me to treat differently. Using, for him alone, the English form of polite address, I called him reverently and for ever: 'Monsieur Vuillard'.

Through wartime and peacetime, schooldays and holidays, as far back as I can remember, he was there: from the time I first learnt to walk at L'Étang-la-Ville, with Annette and Jacques Roussel, his niece and nephew, until that May morning in 1940 when we parted in the avenue du Bois. He was finishing the portrait of Madame Wertheimer, who lived in the same house as General Gamelin. Reassuring rumours ran through our offices: the army was standing firm, no need to worry. Yet a strange, intense stillness hung over the splendour of the chestnut trees. Jos Hessel, taciturn as ever, had brought us back from our last weekend at Les Clayes. I held out my hand, then my cheek, as usual: 'Au revoir, Monsieur Vuillard.' How could I have guessed that it was 'goodbye', that he was at the close of his life, that we were all nearing the end of something that had been so easy for so long, and that a few weeks later, as the exodus scattered us, I should learn through a couple of frigid lines that his fragile heart, rejecting the catastrophe, had ceased to beat, that despair had killed him?

Never again were we to spend happy summer days with him at Les Clayes. Nothing is left today of the burnt-down house but two dead turrets; but there still remain, more living than any relic, the pictures he painted in his ground-floor room: a pot of pink geraniums before a mirror that reflects the trees of the Île-de-France; his studio-bedroom with its narrow bed and all his battery of pots of glue.

In her casual morning dress, Madame Hessel – his lifelong friend, whose youthful jet-black hair had become the white halo of the portrait he painted in the rue de Naples – Lucie Hessel, her secateurs in her gloved hand, arranged huge bouquets. Leaning forward, his eyes ready to pounce, he would in a flash set down in his sketchbook the exact look of her as she held the branches. How many sketches I have seen him make! Peering gimlet-eyed over his spectacles, he often pinned down our attitudes at play or caught us unawares, with cup raised, at breakfast in the garden.

Looking backwards over his work, I retrace the stages of my life from 1940 to my early childhood. From the glades of Vaucresson to Cabourg (where Vuillard was then painting Madame Gosset's portrait – I can still see the daffodil-yellow cushion). From the boulevard Malesherbes to Loctudy, where with Annette and Jacques Roussel I raced along the windswept Breton shore. Last summer, revisiting Loctudy as one revisits a graveyard, I found the house overshadowed by tall trees and the verandah grown dark, whereas its summer-morning brightness lives forever in his great luminous panels. In the same way, not long ago, I suddenly met my mother on the wall of a picture gallery; there she sat, embroidering, in her yellow peignoir, with a white shawl over her shoulders . . .

What happened to the fantastic silk stockings – violet, absinthe-green, tango, lemon-coloured – that Mother kept in a casket? He had given them to her for Christmas. Gone, too, is my charming Japanese tea-set on its pretty bamboo tray; Monsieur Vuillard's presents were like no one else's. Nor were his outbursts of anger: for this model of kindness and tolerance, always intensely sensitive, flared up at times. Should one, with thoughtless irony, decry something about which, in secret, he felt deeply; should one dare to suggest that Puvis de Chavannes . . . he would fly into a passion. Losing all self-control, he would utter terrible words. I think the saints must be like that, too.

Here we are, then, my sister and I, spade in hand, a dog at our feet, small creatures from that world of his that belongs to another age, when fine summers seemed eternal. Thanks to him, many years from now,

if Heaven preserves this painting which I love, the little girl that I have long ceased to be will go on living. She wears a woollen bodice under her thin taffeta frock. Her tiny hands clutch the hard wooden arms of her chair. My father sits on the old-fashioned sofa, whose long cushion gleams with unfaded brightness; he is reading aloud *Le Compagnon de voyage*, a story which I scarcely understand but which I feel is sad. Shall I, too, travel alone some day along the road? Or will the door that leads into the past swing open, and will my mother come in, young and gay? And then Monsieur Vuillard – with his round-toed boots, his soft collar, his slender bow-tie, the clean smell of his honey-coloured beard – will bend over to kiss me before, once again, he starts to clean his paintbrushes.

(Annette Vaillant, 1961)

The Duke of Ferrara's Ambassador to Venice indicates the possible cause of a health problem from which Titian had been suffering.

I have been to see Titian, who has no fever at all: he looks well, if somewhat exhausted; and I suspect that the girls whom he often paints in different poses arouse his desires, which he then satisfies more than his limited strength permits; but he denies it . . .

(Jacopo Tebaldi to Alfonso d'Este, Duke of Ferrara, 1521)

According to the nineteenth-century French painter and writer Eugène Fromentin, Rubens was always painting the same woman, of whom he met two incarnations. Here Fromentin discusses the Descent From the Cross *in Antwerp Cathedral.*

The sinning woman is admirably done. Without a doubt it is by far the best piece in the picture – the most delicate, most personal, one of the best that Rubens ever painted in his long career, so rich in creations of women. This delightful figure has its story: how could it be otherwise, when its very perfection has become storied? It is most likely that this pretty girl with black eyes and steadfast gaze, with clean-cut profile, is a portrait, the portrait of Isabella Brant, whom he had married two years before, and who also sat to him, probably in a state of pregnancy, for the Virgin in the wing of the triptych of *The Visitation*. And yet her ample proportions, her pale yellow hair, her fullness of flesh, make

one think of all that would one day comprise the radiant and so distinctive charms of the beautiful Helen Fourment, whom he married twenty years later.

From the first to the last years of Rubens's life a certain ineffaceable form seems to have taken possession of his heart, an unchangeable ideal haunted his amorous and constant imagination. He takes delight in it, he completes it, he achieves it. He pursued it, after a manner, in both his marriages, just as he never ceased to repeat it in his works. There was always something of both Isabella and Helen in every woman he modelled upon one of them. In the first he seems to put a preconceived trait of the second; in the second he inserts a vague but indelible memory of the first. At the time of which we are speaking he possesses the first, and is inspired by her – the second is not yet born, and yet he forecasts her. Already the future is merged in the present, the real in the ideal conception. From the moment the image appears it has its double form. Not only is it delightful, exquisite, but not a trait is wanting. Does it not seem as if Rubens knew, when he thus created and fixed this ideal from the first day, that it would never be forgotten, neither by himself nor by anyone else?

(Eugène Fromentin, 1876)

Manet expresses, from the painter's point of view, his exasperation with sitters – and especially with the Irish writer George Moore.

Whenever I start something, I'm always afraid the model will let me down . . . They come, they pose, then away they go, telling themselves that he can finish it off on his own. Well no, one can't finish anything on one's own, particularly since one only finishes on the day one starts, and that means starting often and having plenty of days available. On the other hand, some of them come back without being asked, wanting me to do some retouching, which I always refuse to do. Look at that portrait of the poet Moore. As far as I was concerned, it was all finished in a single sitting, but he didn't see it that way. He came back and annoyed me by asking for a change here, something different there. I won't change a thing in his portrait. Is it my fault if Moore looks like squashed egg yolk and if his face is all lopsided? Anyway, the same applies to everybody's face and this passion for symmetry is the plague of our time. There's no symmetry in nature. One eye is never exactly the same as the other, there's always

a difference. We all have a more or less crooked nose and an irregular mouth.

(Édouard Manet, 1878)

Despite being a monk, the fifteenth-century Italian painter Fra Filippo Lippi – known for the sweet piety of his work – behaves disgracefully with his model.

It is said that Fra Filippo was so lustful that he would give anything to enjoy a woman he wanted if he thought he could have his way; and if he couldn't buy what he wanted, then he would cool his passion by painting her portrait and reasoning with himself. His lust was so violent that when it took hold of him he could never concentrate on his work. And because of this, one time or other when he was doing something for Cosimo de' Medici in Cosimo's house, Cosimo had him locked in so that he wouldn't wander away and waste time. After he had been confined for a few days, Fra Filippo's amorous or rather his animal desires drove him one night to seize a pair of scissors, make a rope from his bedsheets and escape through a window to pursue his own pleasures for days on end. When Cosimo discovered that he was gone, he searched for him and eventually got him back to work. And after that he always allowed him to come and go as he liked, having regretted the way he had shut him up before and realizing how dangerous it was for such a madman to be confined. Cosimo determined for the future to keep a hold on him by affection and kindness and, being served all the more readily, he used to say that artists of genius were to be treated with respect, not used as hacks . . .

In Prato near Florence, where he had some relations, Fra Filippo stayed for many months doing a great deal of work in various parts of the district in company with Fra Diamante of the Carmelite convent at Prato, who had been his companion when they were novices together. Subsequently, he was asked by the nuns to paint the altarpiece for the high altar of Santa Margherita, and it was when he was working at this that he one day caught sight of the daughter of Francesco Buti of Florence, who was living there as a novice or ward. Fra Filippo made advances to the girl, who was called Lucrezia and who was very beautiful and graceful, and he succeeded in persuading the nuns to let him use her as a model for the figure of Our Lady in his painting. This opportunity left him even more infatuated, and by various ways and means he managed to steal her from the nuns, taking her away on the very day that she was going to see the exposition of the

Girdle of Our Lady, one of the great relics of Prato. This episode disgraced the nuns, and Francesco, the girl's father, never smiled again. He did all he could to get her back, but either from fear or some other reason she would never leave Fra Filippo; and by him she had a son, Filippo, who became, like his father, a famous and accomplished painter.

(Giorgio Vasari, 1568)

In Paris Cavaliere Gianlorenzo Bernini, maestro of the Roman Baroque sculpture, on being shown the work of a young draughtsman, makes a disgraceful suggestion concerning art education.

After the boy showed him some of his academy drawings, the Cavalier said, 'It spoils young men to make them draw so soon from life when they are not yet capable of choosing the beautiful and leaving the ugly, the more so since the models available in France are not very good.' He said that the King [Louis XIV] should send for some models and that they should be chosen from the Levantine slaves. He said that the Greeks had the best-formed bodies and that they could be bought. Turning to me, he told me he had forgotten to put that in his recommendations for the Academy, and that it should be added to them.

(Paul de Fréart, Sieur de Chantelou, 10 October 1665)

One of Lucian Freud's male models describes the experience of sitting, and how he first came to do so.

I was very nervous about my naked body, when the idea of sitting for Lucian first came up, not only because I'm an unusually big heifer carting around sixteen or seventeen stones, but because of some of my body modifications.

At the point at which Lucian contacted me, I had just completed a series of shows in which I danced virtually naked, working some novel and surprising effects. Because I'm chubby, I can pleat the flesh across my chest and hold it in place with heavy grade gaffer tape. Then by wearing a specially constructed, under-padded, uplift bra, I create the impression of a heaving bosom with a six-inch cleavage. Rather than dance with my penis flopping about, I do a tuck-and-glue job: inverting the penis inward, and pushing the balls up into the pelvic cavity, I take a strip of gaffer tape

and secure everything into place. I then glue on a pubic wig, using theatrical spirit gum. The effect? – big breasts and a luxurious bush, *and* I'm still able to do splits and high kicks without anything falling out.

Of course I have to shave my pubes right off to facilitate taping and glueing, and the strips of gaffer tape bound tightly round my tits almost invariably begin to cut into me, finally breaking the skin, leaving quite spectacular marks, as if I'd been whipped across my upper-carriage with a riding crop. I shave my legs as well, and my arms, my chest, my pits, and to get a good fit on the skin-tight beaded mask I was wearing, I'd shaved my face and all my hair off. I also have pierced nipples and piercings in both my cheeks (facial), in which I sometimes wear punk-style safety pins, and sleepers the rest of the time to prevent them growing closed.

So, when I thought of this catalogue of ghoulish features, I began to feel a little self-conscious and embarrassed – distant from regular nudes.

Our first meeting took place over lunch at Harry's Bar. I dressed in colours from Lucian's palette – grey-brown trousers and jumper, and a man's short mouse-coloured wig. I was hoping he'd ask me to sit for a picture, and I wanted to please him. I was nervous and Lucian is always nervous. Lunch was tense and enjoyable. We talked about a show I'd done that week in Amsterdam which climaxed in my squirting an enema at the audience. I described my costume and dance. Lucian finally brought up the idea of painting me. I told him I loved the idea. He hadn't spooked my wig, so I asked him if he wanted me to wear it in the picture, or not. I hoped I might go on to declare some of my other physical irregularities. He said, 'Oh, we can decide later,' and closed the subject.

I had slightly incorrectly assumed it would be a naked portrait, because the male models he had worked from before who were gay were always painted naked. Lucian, however, had thought I'd be reluctant to 'pose' without my regular crutch of make-up and costume. I showed up at the studio a couple of days later at the crack of dawn. I immediately began to peel (strip). Lucian wasn't quite expecting me to, but he just got on with it, took up some charcoal and began to sketch.

I have been sitting for Lucian now for three and a half years. I have been the subject of four etchings, two small head paintings, a groin painting, a double naked portrait, and three big nudes in oil. I usually sit in the mornings, from as soon as it's light, to mid-afternoon, averaging seven hours a day. We have a break every forty-five minutes or thereabouts, when I can stretch and play with Lucian's gorgeous whippet.

Lucian likes to work wearing casual cotton separates, especially Agnes B and Muji, boots by Timberland. If we go out to lunch he'll perhaps change into a grey suit, one of many from Huntsman, his Savile Row tailor, and an impeccable cotton shirt by Charvet, Paris.

Over this time I have carefully maintained my body, keeping it in the same state it was in when first we met. And my physical features which so worried me in the beginning? – they are now in paintings which are housed in the greatest collections and museums in the world!

(Leigh Bowery, 1993)

Picasso, one of the supreme exponents of the theme of artist and model – the subject of innumerable works in his later years – did not work from an actual model. But none the less, according to his friend Hélène Parmelin, the subject was his second wife, Jacqueline.

And Picasso begins tenderly to show us his last-born among the pictures of *The Painter and His Model*. His tenderness is for the painter. He laughs at his little palette. And the care he takes of his painter's beard. And that inimitable seriousness. Even though she is there, luscious, delicious, appetizing, within his reach, the wretched creature can do nothing better than to make a little stroke on his little canvas with his little brush.

Poor fellow!

And the painter becomes one of us. Is there anyone who doesn't pity his misfortunes? Anyone who doesn't share his pain? And we laugh at him. Over and above everything else. As always. But it doesn't matter, he goes on. '*He thinks he's going to make out, poor chap!*' says Picasso. And the living painters gaze at the painters on the canvas, sighing with compassion.

The model never poses.

She is Jacqueline as in life.

She never posed for the *Dames de Mougins* nor *The Painter and His Model*, nor the *Dames de Vauvenargues* nor the *Dames de la Californie*. But every eye has her eye within it, and every woman has her being.

That is Picasso's way of existence: to be alone in the studio to paint the essential elements of his life.

But this way he has with Jacqueline has become more pronounced. For so many years Jacqueline has always been there, living the same life, creating the same climate, diffusing through this house a special atmosphere, half painting and half love, all painting, all love. The tragedy of painting is

hers, and all the canvases have her face. He has put her everywhere, in every colour.

She hangs on every wall. And dozens of her heads cut off at the neck look at you from all sides with their eyes of paint above a cheek of iron.

Picasso's model, who never poses, lives in the midst of the ten thousand canvases he has made of her. She is his imaginary truth, well known, vividly alive, deeply probed, willing, deserving, beloved and loving.

And I venture to say all this because it very often happens that the canvas is reversed. And – miracle! – Picasso in his studio paints a painter painting his model. The naked model poses for the painter on a couch ready spread for her, as tranquil as though the infinite variety of her body could raise problems for no one. Sure of herself. Of her beauty. As obvious as truth itself.

Sitting behind Picasso, warmly clothed in an armchair, Jacqueline watches Picasso at his easel painting a painter at his easel painting a posing model who is Jacqueline in one of the ten thousand ways the painter has of 'saying' her.

That is how the pictures were painted.

(Hélène Parmelin, 1966)

In an interview with David Sylvester, Francis Bacon confesses that he would rather not have the model present, preferring photographs instead.

DS: Up to now we've been talking about your working from photographs which were in existence and which you chose. And among them there have been old snapshots which you've used when doing a painting of someone you knew. But in recent years, when you've planned to do a painting of somebody, I believe you've tended to have a set of photographs taken especially.

FB: I have. Even in the case of friends who will come and pose, I've had photographs taken for portraits because I very much prefer working from the photographs than from them. It's true to say I couldn't attempt to do a portrait from photographs of somebody I didn't know. But, if I both know them and have photographs of them, I find it easier to work than actually having their presence in the room. I think that, if I have the presence of the image there, I am not able to drift so freely as I am able to through the photographic image. This may be just my own neurotic sense but I find it less inhibiting to work from them through memory

and their photographs than actually having them seated there before me.

DS: You prefer to be alone?

FB: Totally alone. With their memory.

DS: Is that because the memory is more interesting or because the presence is disturbing?

FB: What I want to do is to distort the thing far beyond the appearance, but in the distortion to bring it back to a recording of the appearance.

DS: Are you saying that painting is almost a way of bringing somebody back, that the process of painting is almost like the process of recalling?

FB: I am saying it. And I think that the methods by which this is done are so artificial that the model before you, in my case, inhibits the artificiality by which this thing can be brought back.

DS: And what if someone you've already painted many times from memory and photographs sits for you?

FB: They inhibit me. They inhibit me because, if I like them, I don't want to practise before them the injury that I do to them in my work. I would rather practise the injury in private by which I think I can record the fact of them more clearly.

DS: In what sense do you conceive it as an injury?

FB: Because people believe – simple people at least – that the distortions of them are an injury to them – no matter how much they feel for or how much they like you.

DS: Don't you think their instinct is probably right?

FB: Possibly, possibly. I absolutely understand this. But tell me, who today has been able to record anything that comes across to us as a fact without causing deep injury to the image?

(David Sylvester, *Interviews with Francis Bacon*, 1987)

Henrietta Moraes, one of Bacon's models and Soho friends, describes some pitfalls of his method of painting at one remove from specially taken photographs.

One afternoon I was having a drink in the French Pub [a Soho watering-hole, like other establishments mentioned in the text] with Francis Bacon and [John] Deakin and others. Francis said, 'I'm thinking of painting some of my friends and I'd like to do you but I can really only work from photographs, so, if it's OK, Deakin will come round to your house and take them. I'll tell him what I want. You are beautiful, darling, and you always will be, you mustn't worry about that.'

Deakin arrived at Apollo [9 Apollo Place, a house left to the writer by the painter John Minton] a few days later. We had some drinks and a little bit later retired to my bedroom.

Deakin said, 'He wants them naked and you lying on the bed and he's told me the exact positions you must get into.' Feeling a little shy of stripping in front of someone who definitely did not desire me and for all I knew might never have seen a female body in its entirety, might even be disgusted by it, I sat on the edge of the bed with my arms and legs crossed.

'For God's sake, sweetie, that's not exactly inspiring. I mean, he's not into the Pietà phase.'

'Well what shall I do, then?' I squeaked.

'Throw yourself back on to the bed and abandon yourself. Open up your arms and legs wide. Come on.' He started snapping wide-angle shots between my legs.

'Deakin, I know you've got it wrong. Francis can't possibly want hundreds of shots of these most private parts in close-up. I just don't believe that is what he is interested in painting. It can't be so.' In the end, he overrode me. After all Bacon had told *him*, not me, what he was after and so forth. I had a couple more drinks and gave in.

'Oh, all right, then, go ahead. It's only images, after all.' Snap, snap, snap, and on and on he went.

'That's it,' he said finally.

'Yeah, I should think that you'd have just about covered every angle,' and eventually, 'Shall we go and have a drink?'

I was having a drink with Francis Bacon and Deakin in the Colony Room. Francis said, 'Look here, Henrietta, this blithering nitwit has reversed every single shot of you that I wanted.'

'Ho,' I said. 'You amaze and astonish me.'

'Well, look here, Henrietta –' Francis shot his cuffs, displaying enormously strong-looking wrists – 'would you mind letting him do the whole thing all over again, but the other way up this time?'

I gazed at him. When I was eighteen, I had spent almost all my mornings, afternoons and evenings with him, dined alone with him at Wheeler's, oysters and Chablis, gone with him to the Gargoyle, listened to the wit and wisdom which flowed almost continuously from his lips. Sometimes I was aghast at the scathing sarcasm which bubbled out of him, but it had never been directed at me. At every meeting I had learned something new

from him, been captivated, spellbound. Wherever he appeared, the air brightened, groups of people were animated, electricity hummed and buzzed and bottles of champagne appeared. I had learned so much of the ways of the world from him and, though at that time I had not properly understood half of his teaching, it had nevertheless, willy-nilly, been assimilated.

'No, of course I don't mind. Any time.'

So Deakin and I had a reverse performance and this time it came out right. 'One day I'll give you a picture,' Francis said.

'Goody.' I thanked him, not understanding just how much it meant.

One afternoon, about a week later, I wandered into a Soho drinking club, a bit off my beat, but in I went. The room was full of sailors, all of them crowding round a familiar figure – Deakin. His hands were full of the original photographs he'd taken of me and he was selling them off for ten bob a time.

'Deakin,' I yelled at him, 'I don't care, really, but don't you think you should buy me a large drink?'

John Deakin was never at a loss. His leathery face grinning, he bought me several.

(Henrietta Moraes, 1994)

A twentieth-century British painter-critic imagines his still-life talking back. Like many a human model, however, it is not satisfied with his efforts.

PAINTER: Well I hope you are pleased. You are drawn well and tolerably modelled, coloured just a little more brilliantly than you deserve, well placed, against a . . .

APPLE: It is you who are to be satisfied.

PAINTER: I have a right to be. I have painted you adequately, without fuss, even with distinction. And my picture is in tone to a nicety, which is more than might be said of you. As I look from you to my picture and back again I can see nothing wrong.

APPLE: But are you pleased?

PAINTER: Perhaps not entirely, if you must know.

APPLE: I knew it. Today you have done only ten minutes' painting in the whole morning.

PAINTER: I have a great many calls on me.

APPLE: I believe you are in despair about me.

PAINTER: On the contrary . . .

APPLE: Let us hope you are at any rate.

PAINTER: Well! That I who have done you the most exquisite justice . . .

APPLE: Justice, that is what you have done. An act of unexceptional justice. An act inoffensive and well precedented, without sympathy, without poetry. An act of justice!

PAINTER: Then where have I erred?

APPLE: In taking up my time.

PAINTER: Your time!

APPLE: Try and remember what I am. I am alive, not a studio property, or a figment of thought, or a peg to hang tone values on. I am an apple.

PAINTER: Yes?

APPLE: And an apple is an organism of some dignity, greater perhaps than a painter's, and with a longer history.

PAINTER: I am afraid there is no question of painting your history.

APPLE: I reminded you of it in passing.

PAINTER: And your dignity, you thought I needed reminding of that? I respect your dignity.

APPLE: But even your respect, your bare respect is not immoderate.

PAINTER: What more is due to you?

APPLE: I am a fruit, a feast, a reproductive organ.

PAINTER: Shall I sell you or eat you, if you prefer it, or sow your pips?

APPLE: I would prefer not to forgo my functions merely in order to be judiciously measured until I wrinkle and rot.

PAINTER: Come, come. I am very fond of you, you know. If your fate disturbs you . . .

APPLE: Does my ripeness, my round lustre, mean nothing to you? A summer has done its best to make me an attractive prize, make my shape an irresistible invitation. And yet you resist me.

PAINTER: I am quite distressed.

APPLE: Look at your picture and at me. I offered you a taste of the ravishment to which the ages have not been indifferent. I gave you a clue to a receding perspective of life which men have found good, of work done and appetites satisfied. But you have seen only a cultivated commonplace, an artistic impression. Really the Greek painter who deceived the birds did better.

PAINTER: I am sorry, you must believe me . . .

APPLE: Imagine! I waited here confident in the knowledge of my luminous perfection. But where your eyes should have raped me they did me justice.

(Lawrence Gowing, *Painter and Apple*, 1983)

Sitting for Walter Sickert involved even less effort than sitting for Francis Bacon, and sounds rather more fun, as Vanessa Bell's son discovered in the 1920s.

He said at once that he wanted to paint me as I was; that is to say, in evening dress. I was wearing a black tie and a boiled shirt for the first time (whose black tie and whose boiled shirt I cannot recall). Thus, after some further negotiation, I found myself early one cold foggy Sunday morning in January on the underground railway, dressed as though for a dance. I felt exceedingly uncomfortable and concealed my awkwardly assembled finery beneath a very shabby overcoat. I had been told that the master would meet me at Highbury Station but felt that it was very unlikely that he would, and the prospect of waiting for him and probably missing him in that rather desolate spot and in that unsuitable disguise did not attract me.

But there he was dressed, as I recollect, in a brilliant green tail coat, sponge-bag tartan trousers of a reddish hue and startlingly patterned carpet slippers. The sight of him cheered me immensely. We must have made a pretty remarkable looking pair as we left the entrance to the station and I dare say it was our aspect no less than his violent exclamation which visibly shook a melancholy, cornet-playing band of salvationists on the station – 'God damn Christianity' was what he shouted at them. He must have been in a naughty mood that morning, for when the door was opened for us by a sluttish-looking maid he turned to me and said, 'Beautiful as a Pinturicchio but an awful bitch really.' The girl was much less put out than the salvationists had been, but she gave us a dirty look.

Sickert's studio was large, dusty and chaotic – very much, in fact, the kind of thing with which I was familiar; but it differed from the establishments which I knew mainly because of its many books. In recollection, it seems to me that volumes of all shapes and sizes had accumulated to such an extent that the visitor had to make his way between precipitous cliffs of literature which threatened at any moment to fall and leave the painter imprisoned within an impenetrable wilderness of printed matter. Probably I exaggerate; I do remember Sickert, looking for some

volume, thinking against all probability to find it and saying as he lifted it, 'No, German, I can tell by the weight' – with which words he let it fall back into the general detritus of books, its pages open to show that it contained erotica. In the midst of this chaos there still remained a clearing at the centre of which rose a model's throne. To this I ascended and with no attempt at setting me in a pose, Sickert took pen and ink and began at once to draw.

That it was an honour to be Sickert's model I had no doubt. Nevertheless, I had sufficient experience of this form of service to look forward to the next few hours without enthusiasm. I was standing; I had no book, my legs would ache abominably after a time; it would be a long business and thoroughly uncomfortable.

I soon discovered my mistake. He kept me about ten minutes, certainly not more than a quarter of an hour, in which time he executed a small full-length drawing, a study of my face and a detail of a hand and arm. After many years this drawing has returned to me; it was for some years at my mother's studio at 8, Fitzroy Street. It was one of the very few things to survive an incendiary bomb. I don't think that it is very like, except in the pose and generally rather shabby aspect of the model. Sickert has been kind enough to provide me with eyebrows, things which, to all intents and purposes, I do not have. But he was quite prepared to use it as a basis for a full-length, life-sized portrait, nor did he seem to think that it would be necessary for me to return for further sittings.

(Quentin Bell, 1989)

Sitting for Cézanne at the turn of the century, on the other hand, appears to have been hard work, unless the model fell asleep (as this one, a leading art dealer, did).

'Don't go to sleep!' Renoir had said. I repeated the warning to myself when I went to sit to Cézanne. In his studio I was required to seat myself on a stool placed on a ramshackle platform supported by four pegs.

Seeing my distrust of the solidity of all this contraption, 'I arranged all this myself,' said Cézanne with an engaging smile. 'Nothing will happen if you keep your balance. And after all, sitting means sitting still.'

But hardly was I settled on my pedestal when sleep overtook me. My head sank on to my shoulder. The equilibrium was shattered: platform, chair and myself were all on the floor.

Cézanne rushed forward:

'You wretch! You have upset the pose! You should sit like an apple. Whoever saw an apple fidgeting?'

Motionless as that fruit may be, Cézanne was sometimes obliged to leave a study of apples unfinished. They had rotted. He came to like paper flowers better. But he ended by giving them up too, for though they did not rot, 'they fade, the bitches.' In despair, he fell back on the pictures in the illustrated *Magasin Pittoresque*. What did it matter? Painting, for him, did not consist in copying objects, but in 'realizing sensations'.

But for Cézanne to feel sure that the day's work in the studio was going to be a success, a great many conditions were necessary – the colour of the weather a light grey, and no annoyance such as coming upon the news, in his paper *La Croix*, of a victory of the English over the Boers, or a dog barking, or the noise of a lift near by, which he declared came from a 'sledgehammer factory'. About a hundred sittings had to be endured before Cézanne could even announce to me, with satisfaction, 'I haven't done so badly with the front of your shirt.'

(Ambroise Vollard, 1936)

Vincent Van Gogh expresses a doubt as to whether his model is up to the task of sitting for him.

I don't know if I can convey the postman *as I feel him*. This man is a revolutionary like old Tanguy. He is probably considered a good republican, because he heartily detests the republic which we now enjoy, and because all in all he is somewhat doubtful and a little disillusioned with the republican idea itself. But one day I saw him singing the Marseillaise, and I thought I was watching '89, not next year, but the one 99 years ago. It was a Delacroix, a Daumier, straight out of old Holland. Unfortunately he cannot pose, and a painting demands an intelligent model.

(Vincent Van Gogh to Théo Van Gogh, mid-August 1888)

Denis Diderot – philosopher, critic and live-wire of the Enlightenment – confronts his own portrait at the Paris Salon of 1767.

Myself. I am fond of Michel [the painter Michel van Loo, 1707–71, nephew of the more famous Carle van Loo, and painter of Diderot's portrait], but I am fonder still of truth. A fairly good likeness. To those

who do not recognize him he can say, like the farmer in the comic opera, 'That's because he's never seen me without my wig.' Very lively. It has his kindness, along with his vivacity. But too young, his head too small. Pretty like a woman, leering, smiling, dainty, pursing his mouth to make himself look captivating. None of the skilful use of colour in the *Cardinal Choiseul*. And then clothing so luxurious as to ruin the poor man of letters should the tax collector levy payment against his dressing gown. The writing table, books, and accessories as fine as possible, when brilliant colour and harmony were both aimed at. Sparkling from close up, vigorous from a distance, especially the flesh. And beautiful well-modelled hands, though the left one is badly drawn. He faces us. His head is uncovered. His grey forelock, with his air of affectation, makes him seem like an old flirt still out to charm; his posture, more like a government official than a philosopher. The falsity of the first moment of his posing left its mark on the remainder. Madame Van Loo came to chatter with him while he was being painted, giving him that air and spoiling everything. If she had played her harpsichord, if she had played or sung 'Non ha ragione, ingrato', 'Un core abbandonato', or some other piece in the same vein, the sensitive philosopher would have taken on another character completely, and the portrait would have differed accordingly. Or better still, he should have been left alone, abandoned to his reveries. Then his mouth would have been partially open, his glance would have been distracted, focused on the distance, the workings of his thoroughly preoccupied head would have been legible on his face, and Michel would have produced a beautiful thing. My pretty philosopher, you will always serve me as precious testimony to the friendship of an artist, an excellent artist, and a more excellent man. But what will my grandchildren say, when they compare my sad works to this smiling, affected, effeminate old flirt? My children, I warn you that this is not me. In the course of a single day I assumed a hundred different expressions, in accordance with the things that affected me. I was serene, sad, pensive, tender, violent, passionate, enthusiastic. But I was never such as you see me here. I had a large forehead, penetrating eyes, rather large features, a head quite similar in character to that of an ancient orator, an easygoing nature that sometimes approached stupidity, the rustic simplicity of ancient times. Without the exaggeration of my features introduced into the engraving after Greuze's drawing [Jean-Baptiste Greuze, 1725–1805, painter], it would be a better likeness. I have a facial mask that fools artists, either because too many of its features blend together or because the impressions of my soul succeed one another

very quickly and register themselves on my face, such that the painter's eye does not perceive me to be the same from one moment to the next and his task becomes far more difficult than he'd expected. I've never been well captured save by a poor devil named Garant [presumably Jean-Baptiste Garand, a minor painter], who managed to trap me, just as an idiot sometimes comes up with a witty remark. Whoever sees my portrait by Garant, sees me. 'Ecco il vero Polichinello.'

(Denis Diderot, *The Salon of 1767*)

Alberto Giacometti painted David Sylvester – again and again and again. The model explains why.

The need for repetition was insatiable and comprehensive. It applied to the method as well as to the theme: his habitual way of realizing a work was by incessantly building, effacing and building again. It applied to the sitter as well as to the pose: of the several tens of thousands of hours spent, during the last thirty years of his life, in working from a model, all but a minute percentage were shared between nine sitters – and that, he sometimes hinted, was eight more than he would have used if he had had the choice.

Most of the painting and drawing during those thirty years was done from life, and in the final ten years very few paintings indeed were done from memory. There was a period – 1935 to 1939 – when little sculpture was done from memory and another – from 1939 to 1953 – when little was done from life, but after that there was a roughly equal amount from memory and from life. Since the one dealt with all that was there in all its complexity, the other with what stayed in the mind, the results were bound to be different: 'the truth lies between the two – the relative truth of perception, anyway . . . none of them is really right, which is why one has to go on trying.' He hoped to close the gap between them. 'Ultimately, my idea would be to work in exactly the same way whether from memory or from life – that the two should overlap completely.' As it was, they did help each other: he said one day in the summer of 1960 that the progress made the day before with a portrait he was painting from the model had helped him make decisive progress that night with a figurine he was working on from memory.

The portrait was the one that I was sitting for. The sittings would begin between three and four o'clock and go on till about seven-thirty, when

the light went, and then he would work by electric light (a single tungsten bulb) with Isaku Yanaihara, of whom he was doing both a painting and a bust in clay of near life-size. (The several previous portraits of Yanaihara had been done while he was working in Paris; this time he had come from Japan expressly to sit. Giacometti was having to work overtime because he had absent-mindedly brought these two models to Paris simultaneously and did not want to disappoint them. He was, of course, paying our expenses, and more than once he told me with great relish that Yanaihara's air fare was making him the most expensive model in the history of art.) He would usually stop working towards midnight and would then go out and eat at a brasserie and drink in a bar or a cabaret. He generally invited me to join him and sometimes Caroline [the artist's mistress]; when I said that he must be bored with seeing me day and night, he answered that those who work together dine together. (Yanaihara was not with us because he was seeing Annette [the artist's wife].) Coming home at about four or five o'clock in the morning, he would work from memory for an hour or two or longer on the figurine.

There were twenty of those three- to four-hour sittings for my portrait; there would probably have been several more if I had not had to leave Paris. At the first sitting he started two paintings – a large canvas for a three-quarter-length in medium close-up, and a small canvas for a head-and-shoulders in close-up which was abandoned after the second day. He painted sitting down, putting thin paint on rapidly, mostly with sable brushes. His glance moved very quickly, almost continuously, between canvas and model; he rarely hesitated before making a mark. He never got up to stand back and take a look at the picture. He waited till the next break for a more distant view – and then, as this particular picture was large by his standards and there was little room to move in the studio, he would sometimes take it outside. There would generally be three breaks in a session, two of them to allow me to stretch my legs, the other long enough for coffee at a nearby bar.

For about two-thirds of the time he would be working in a relaxed way, talking freely and listening fairly attentively. His talk itself was more relaxed and less argumentative than usual. Normally his conversation tended to become vehemently analytical, often rather like a game of chess in which, after taking a piece, he would reset the board in an earlier position and try out an alternative series of moves. Here he mostly gossiped, and when he told stories about himself they were less consistently self-mocking than usual. There would be about three spells in a sitting

when he made it clear that he wanted silence. Then he would soon start muttering to himself, often exploding into a curse or a lamentation: he didn't know how to paint; he lacked daring; why was I wasting my time sitting to him; it was hard even to put the brush to canvas. I never heard him go on in this way when he was working from memory, and he was often doing this on a sculpture when I was in the studio, simply because a visit was no reason to interrupt work. Furthermore, that sort of wailing and cursing has been reported by observers of both Cézanne and Matisse when they were painting from the motif or the model: it is working in the presence of the subject that tends to generate despair. When the portrait was going more or less well for a while the incantatory recurrent phrases would stop and from then he would hold on to his tension. He generally seemed to make most progress during the final half-hour, perhaps because the failing light was helpful, perhaps because time was running out.

At the end of the twenty sittings there were still patches of canvas left bare as in an alla prima painting [technique of painting a picture in one session], and the shirt and trousers had hardly been touched since the first day. The work had gone into the head. This was painted out and painted in again at every sitting. It was Giacometti's habit to efface by careful overpainting. He seldom scraped paint off. He never – while I sat for him, and no doubt this too was habitual – freely obliterated an area. The demolition was gradual and deliberate; it appeared, indeed, to take more time than the ostensible reconstruction, was, of course, already the beginning of the reconstruction (hence, perhaps, the eschewal of scraping-off). Losing and finding were a continuous process.

Sometimes, at the end of the day, the head was softly modelled, atmospheric, sometimes hard and stark. One small area, the middle of the forehead, remained relatively unchanged, as if this central vertical plane were serving as a *point d'appui*. At one stage, after a few days, the head was rather bright in colour, predominantly terracotta; within a day or two it was grey and dark; later some colour came back, then went again. The underlying aims seemed to be, from what he said recurrently, to get the nose to appear to project from the face as it did in Byzantine art and to give the head the presence of a portrait of Gudea: he several times spoke, alluding to my ancestry, of the ancient relationship between the Jews and the Chaldeans.

The painting developed as Giacometti's talk habitually developed: one line of argument was pushed to an extreme, and then an opposing line

was taken up and pushed to an extreme; any assertion had to be balanced against its antithesis; reality was not either/or but both/and. The more he pinned down something he had seen, the more aware he would be the next day of just those things in the model which contradicted what was on the canvas – as if by being on the canvas this was now subtracted from his sensation of the model. Each day's work seemed an attempt to reconcile the contradictions between what had been got so far and what emerged as he went on looking.

The daily loss of what was there at the start was plainly of no account to him regardless of how pleased he had been with it the night before: the value of the work done so far was in what had been learned in doing it. He seemed decidedly gratified with the result at the close of certain days towards the end; more, perhaps, than with the final state – and, indeed, comparison of photographs (taken by Herbert Matter) of the successive states suggests that the penultimate state at least was distinctly better than the last; the same seems to apply to another portrait with recorded states, that of James Lord. But because I was able to go on sitting, he saw no reason not to go on painting. A remorselessly dialectical approach precluded the idea of reaching a conclusion. As he said to Lord: 'That's the terrible thing: the more one works on a picture, the more impossible it becomes to finish it.' Circumstance might decide how long he went on with one and when he stopped. Otherwise he would often go on until there were too many layers of paint for it to be technically possible to put more on. This would be the point at which he did sometimes scrape off.

(David Sylvester, *Looking at Giacometti*, 1994)

The

Human

Clay:

Humanity

in

Art

Oskar Kokoschka outlines the philosophy behind his portraits, and is shocked by the policies of the National Portrait Gallery in London.

When I paint a portrait, I am not concerned with the externals of a person – the signs of his clerical or secular eminence, or his social origins. It is the business of history to transmit documents on such matters to posterity. What used to shock people in my portraits was that I tried to intuit from the face, from its play of expressions, and from gestures, the truth about a particular person, and to recreate in my own pictorial language the distillation of a living being that would survive in memory. I usually start my paintings without having done any preliminary drawing: and I find that neither routine nor technique is of any help. I depend very much on being able to capture a mental impression, the impression that remains behind when the image itself has passed. In a face I look for the flash of the eye, the tiny shift of expression which betrays an inner movement. In a landscape I seek for the trickle of water that suddenly breaks the silence, or a grazing animal that makes me conscious of the distance or height of a range of mountains, or a lonely wayfarer whose shadow lengthens as evening falls. It would be too high-flown to call these things decisive experiences: they are simply what make me a *seeing* observer of nature. So too I could never have accepted as a sitter everyone who wanted to be painted: the sitter must have something worth noticing about him. I can't paint bemedalled gentlemen, or dressmaker's dummies festooned with pearls. A bare canvas has always filled me with a *horror vacui* until, initially in a half-indecipherable form, I am able to bring out from its prepared surface the vision of my inner eye.

I try to keep my sitters moving and talking, to make them forget they are being painted. This has nothing to do with extracting intimate secrets or confessions, but rather with establishing, in motion, an essential image of the kind that remains in memory or recurs in dreams. I could not do this if my sitter had to keep still, as he might for a photographer, or to

hold a stiff pose until we were both sick of it. A person is not a still-life – not even a dead person.

I once drew the likeness of a dead girl in her coffin, at the request of her parents. I had known her briefly at the private school where I taught drawing. She was carried off by the murderous influenza epidemic at the end of the First World War. The scent of lilies and hyacinths in the room where the body was laid out could not entirely mask a faint smell of corruption, and I dropped my charcoal in fright when I suddenly saw moisture dripping from the dead girl's nose.

Simple records of fact bear no fruit; like the winter sun, they do not warm the heart. For example, the portrait of Reinhold, a picture especially important to me, contains one detail that has been hitherto overlooked. In my haste, I painted only four fingers on the hand he lays across his chest. Did I forget to paint the fifth? In any case, I don't miss it. To me it was more important to cast light on my sitter's psyche than to enumerate details like five fingers, two ears, one nose.

I was astonished to read in a paper some time ago that the then director of the National Portrait Gallery in London has attempted to redefine the portrait on the grounds that photography, film and voice recording express more of the personality than the traditional painted or sculptured portrait. That you can deduce useful information from details – whether a gentleman's trousers are well pressed, or whether the shoes of life's victims are down at heel – only argues for not piling up quantities of trash in museums. Goya painted a woman's body once naked and once in a diaphanous costume. This is interesting as a fact, but tells us nothing about the art of portraiture. However, when Queen María Luisa de Borbón-Parma had herself painted by Goya several times in the garb of a *pétroleuse* of the French Revolution, the result is a revelation of her character and of Goya's genius.

A violent stimulus produces a trauma in an organism. So too a work of art – if it really is a work of art – can create a genuine experience, a visual shock, in the consciousness of a receptive observer. Since I am not a pessimist, I venture to suppose that one or other of my readers will give more credence to me than to the director of the National Portrait Gallery. I see creative art as a source, a spring, like Nature itself. I defend it as the constantly active, living material of thought. Had the politicians and generals not spared a few of the testimonies of art, what, today, would we make of history with its long record of millions slaughtered for the sake of abstract ideas?

(Oskar Kokoschka, 1974)

The eighteenth-century English novelist Henry Fielding defends his friend William Hogarth against the charge of being a merely comic artist.

Now, what *caricatura* is in painting, burlesque is in writing, and in the same manner the comic writer and painter correlate to each other. And here I shall observe that, as in the former the painter seems to have the advantage; so it is in the latter infinitely on the side of the writer; for the Monstrous is much easier to paint than describe, and the Ridiculous to describe than paint.

And though perhaps this latter species doth not in either science so strongly affect and agitate the muscles as the other, yet it will be owned, I believe, that a more rational and useful pleasure arises to us from it. He who should call the ingenious Hogarth a burlesque painter would, in my opinion, do him very little honour; for sure it is much easier, much less the subject of admiration, to paint a man with a nose, or any other feature, of a preposterous size, or to expose him in some absurd or monstrous attitude, than to express the affections of men on canvas. It hath been thought a vast commendation of a painter to say his figures seem to breathe, but surely it is a much greater and nobler applause that they appear to think.

(Henry Fielding, 1742)

A contemporary painter – Lucian Freud – reflects on the relationship between artist, model, and work.

Painters who use life itself as their subject matter, working with the object in front of them, or constantly in mind, do so in order to translate life into art almost literally, as it were. The subject must be kept under closest observation: if this is done, day and night, the subject – he, she, or it – will eventually reveal the *all* without which selection itself is not possible; they will reveal it, through some and every facet of their lives or lack of life, through movements and attitudes, through every variation from one moment to another. It is this very knowledge of life which can give art complete independence from life, an independence that is necessary because the picture in order to move us must never merely *remind* us of life, but must acquire a life of its own, precisely in order to *reflect* life. I say that one needs a complete knowledge of life in order to make the picture independent from life, because, when a painter has a distant adoration of nature, an awe of it, which stops him from examining it, he

can only copy nature superficially, because he does not dare to change it.

A painter must think of everything he sees as being there entirely for his own use and pleasure. The artist who tries to serve nature is only an executive artist. And, since the model he so faithfully copies is not going to be hung up next to the picture, since the picture is going to be there on its own, it is of no interest whether it is an accurate copy of the model. Whether it will convince or not, depends entirely on what it is in itself, what is *there* to be seen. The model should only serve the very private function for the painter of providing the starting point for his excitement. The picture is *all* he feels about it, *all* he thinks worth preserving of it, *all* he invests it with. If all the qualities which a painter took from the model for his picture were really taken, no person could be painted twice.

The aura given out by a person or object is as much a part of them as their flesh. The effect that they make in space is as bound up with them as might be their colour or smell. The effect in space of two different human individuals can be as different as the effect of a candle and an electric light bulb. Therefore the painter must be as concerned with the air surrounding his subject as with that subject itself. It is through observation and perception of atmosphere that he can register the feeling that he wishes his painting to give out.

A moment of complete happiness never occurs in the creation of a work of art. The promise of it is felt in the act of creation but disappears towards the completion of the work. For it is then that the painter realizes that it is only a picture he is painting. Until then he had almost dared to hope that the picture might spring to life. Were it not for this, the perfect painting might be painted, on the completion of which the painter could retire. It is this great insufficiency that drives him on. Thus the process of creation becomes necessary to the painter perhaps more than is the picture. The process in fact is habit-forming.

(Lucian Freud, 1954)

The sixty or so self-portraits of Rembrandt amount to a profound visual autobiography, in the view of Kenneth (later Lord) Clark. His starting point is the late self-portrait at Kenwood House, London.

Even if that head had emerged unsupported from the darkness, as with Rembrandt it often does, this would be a great picture. All artists have an obsessive central experience round which their work takes shape.

Rembrandt's was the face. It was to him like the sun to Van Gogh, the waves to Turner or the sky to Constable, the 'standard of scale, the organ of sentiment', the microcosm of a comprehensible universe. As a youth of twenty-two, when his subject pictures are still loutish and derivative, his paintings and etchings of his parents are subtle and masterly; and from the first he paints himself.

A quantity of pictures, drawings and etchings done in the 1620s show us the tough young student of Leyden University at no pains to disguise his plebeian nose and truculent mouth. Why did he begin this astonishing series, to which there is no parallel in the seventeenth century, or, indeed, in the whole of art? At this date we cannot say a desire for self-knowledge, for the young man in the early self-portraits is clearly not the introspective type. Nor can it have been due solely to shortage of models, although it is true that for the eager self-educator no other model is quite as convenient. No doubt there was an overflow of vital egotism, but this is true of many young artists; and perhaps the effective reason for the early self-portraits should be deduced from the first critical reference to Rembrandt by the Dutch connoisseur Constantyn Huygens, who says that his peculiar excellence lay in vivacity of expression (*affectuum vivacitate*). The young Rembrandt – he was twenty-five at the time – set himself to give visible form to human feelings; and at first this meant simply making faces. He portrayed himself because he could make the faces he wanted, and could study the familiar structure of his own head distorted by laughter, anger or amazement.

But what was he making faces at? A man must laugh or scowl at something. The answer is that Rembrandt was making faces at polite society. His early biographers all lament that (in their words) 'he frequented the lower orders' and 'would not make friends with the right people'. The most revealing of all his early self-portraits is an etching of 1630, in which he portrays himself as his favourite subject, a tousled and unshaven beggar, snarling at the prosperous world which was soon to engulf him. In a sense 'engulf' is the wrong word. From 1632 to 1642 Rembrandt rolled and spouted in success like a dolphin. Bored by the black cloth and stiff white linen of his rich and prudent sitters, he lived in fancy dress. He covered his smiling, gap-toothed Saskia with satin and brocade, he disguised himself in fur and armour. But it was no good. He could not disguise his nose. There it was, the broad, bulbous truth, waiting to reassert itself as soon as this time of exuberant make-believe was over. It came to an end gradually, about the year 1650, and that is the date on a picture in

Washington . . . where for the first time one feels that the motive for his self-portraits has changed. He still wears the gold braid of fancy dress, but in the sad countenance all attempt at disguise has been dropped. The jolly toper has gone for ever and so has the grimacing rebel. He no longer needs to make a face: time and the spectacle of human life have made one for him.

Unconsciously he has come to see that if he is to penetrate more deeply into human character he must begin – as Tolstoy, Dostoevsky, Proust and Stendhal began – by examining himself. It is a process that involves the most subtle interplay of detachment and engagement. To counteract the self-preserving vanity which makes so many self-portraits ridiculous, the painter must, at a certain point, forget himself in problems of pictorial means. By 1650 Rembrandt humbly recognized the pouches on his ageing face as records of weakness and disappointment; but as his brush approached the canvas he forgot everything except how to render their exact colour and tone. Then, as he stood back to contemplate the result, he could see how far from heroic this pictorial obsession had made him. At this point most of us would be tempted to let the two processes overlap; to modify, very slightly, that purplish red on the left eyelid. But the thought never entered his mind. He saw no reason for making himself out to be better or handsomer than his neighbours, who, after all, might have been Our Lord's disciples.

This patient self-scrutiny took him a very long time. Baldinucci, in one of the earliest lives of Rembrandt, tells us that one reason why the number of his sitters declined was the quantity of sittings he demanded, and this is confirmed by the technique of his later portraits. The surface is covered with scumbling, scratching, glazing – every known device in the cookery of painting – and with minute touches of the brush or palette knife, each put on after the preceding layer was dry. We need no longer ask why he was forced to paint himself; the wonder is that he found anyone else to sit for him, let alone to sit twice, like that patient old beauty, Margaretha Tripp, whose public and private likeness may now be compared in the London National Gallery.

All Rembrandt's self-portraits convince us that they are absolutely truthful, yet they differ from one another to a surprising extent. In the course of a year his face seems to hollow itself and then fill out again, the wrinkles cover it and then recede and finally return as deeper gashes. Even supposing that the portraits in Aix-en-Provence and the de Bruyn Collection were painted during an illness, this variation proves that the most

faithful portrait is the expression of the painter's mood. The Kenwood self-portrait is one of the most relaxed of Rembrandt's later works. He looks less worried than usual and a little fatter; and this relaxation is evident also in the technique which, compared with the relentless autopsy of the Ellesmere portrait, is almost easygoing. On the forehead there is a melodious ease of transition from shadow to light, but to the left the concentration becomes more intense, the paint is worked into a thicker paste, and he scores the deepest wrinkle by scratching the surface with the sharpened handle of his brush. This sharp point also scrabbles round the left eye, like a gigantic etching needle, and is used to indicate his moustache with a scrawl like a carefree signature. Every touch is both a precise equivalent of the thing seen and a seismographic record of Rembrandt's character.

More than any of the series, the Kenwood portrait grows outward from the nose, from a splatter of red paint so shameless that it can make one laugh without lessening one's feeling of awe at the magical transformation of experience into art. By that red nose I am rebuked. I suddenly recognize the shallowness of my morality, the narrowness of my sympathies and the trivial nature of my occupations. The humility of Rembrandt's colossal genius warns the art historian to shut up.

(Kenneth Clark, 1960)

A contemporary art historian, on the other hand, sees Rembrandt not so much as a profound self-portraitist, but as an inventor of the profound self.

The effect of singularity and of individuality given off by Rembrandt's works is a product of this master's domination of the world he brought into the studio. Retirement to rule, and the delight mixed with the horror in the discovery that the self alone is what one rules, is a familiar scenario from Prospero on his island to Monet in his garden. To these examples I would add Rembrandt in his studio. The nineteenth century credited Rembrandt with being uniquely in touch with something true about the individual human state. I would put it differently. It is something stranger and more unsettling. Rembrandt was not the discoverer, but one of the inventors of that individual state. And so his late works became a touchstone for what Western culture, from his day until our own, has taken as the irreducible uniqueness of the individual.

(Svetlana Alpers, 1988)

Rodin gave hands as much communicative force as another might give an entire body, argues the Austrian poet Rainer Maria Rilke, who was the sculptor's secretary from 1905 to 1906.

Rodin has made hands, independent, small hands which, without forming part of a body, are yet alive. Hands rising upright, angry and irritated, hands whose five bristling fingers seem to bark like the five throats of a Cerberus. Hands in motion, sleeping hands and hands in the act of awakening; criminal hands weighted by heredity, hands that are tired and have lost all desire, lying like some sick beast crouched in a corner, knowing none can help them. But hands are a complicated organism, a delta in which much life from distant sources flows together and is poured into the great stream of action. Hands have a history of their own, they have, indeed, their own civilization, their special beauty; we concede to them the right to have their own development, their own wishes, feelings, moods and favourite occupations.

But, thanks to his self-imposed training, Rodin knows that the body consists of so many stages for the display of life, of such life as in any and every part can be individual and great, and he has the power to bestow on any part of the vast, vibrating surface of the body the independence and completeness of a whole. And, as the human body is for Rodin a whole only so long as all its limbs and powers respond to one common movement (internal or external), so, on the other hand, do parts of different bodies, brought together by inner necessity, become for him a single organism. A hand laid on the shoulder or limb of another body is no longer part of the body to which it properly belongs: something new has been formed from it and the object it touches or holds, something which was not there before, which is nameless and belongs to no one; and it is this thing with clearly defined limits which now becomes the subject of our attention. This fact is the fundamental explanation of Rodin's manner of grouping figures; it is the source of that extraordinary dependence of the figures on one another, the utter impossibility of dissociating the forms, their refusal to be considered apart. His point of departure is not the figures which embrace one another, he has no models, which he arranges and groups. He begins with surfaces where contact is strongest, as if at points of climax; he starts where something new appears and employs all his understanding of his material in the service of the mysterious phenomena which accompany the birth of what is new. He works as if by the light of flashes occurring at

such points and sees only such parts of the entire bodies as are thus illuminated.

(Rainer Maria Rilke, 1903, in Denys Sutton, 1966)

Robert Louis Stevenson contemplates some personalities of Regency Edinburgh, as portrayed by Sir Henry Raeburn.

Through the initiative of a prominent citizen, Edinburgh has been in possession, for some autumn weeks, of a gallery of paintings of singular merit and interest. They were exposed in the apartments of the Scottish Academy; and filled those who are accustomed to visit the annual spring exhibition with astonishment and a sense of incongruity. Instead of the too common purple sunsets, and pea-green fields, and distances executed in putty and hog's lard, he beheld, looking down upon him from the walls of room after room, a whole army of wise, grave, humourous, capable, or beautiful countenances, painted simply and strongly by a man of genuine instinct. It was a complete act of the Human Drawing-Room Comedy. Lords and ladies, soldiers and doctors, hanging judges and heretical divines, a whole generation of good society was resuscitated; and the Scotsman of today walked about among the Scotsmen of two generations ago. The moment was well chosen, neither too late nor too early. The people who sat for these pictures are not yet ancestors, they are still relations. They are not yet altogether a part of the dusty past, but occupy a middle distance within cry of our affections. The little child who looks wonderingly on his grandfather's watch in the picture is now the veteran Sheriff *emeritus* of Perth. And I hear a story of a lady who returned the other day to Edinburgh, after an absence of sixty years: 'I could see none of my old friends,' she said, 'until I went into the Raeburn Gallery, and found them all there.'

It would be difficult to say whether the collection was more interesting on the score of unity or diversity. Where the portraits were all of the same period, almost all of the same race and all from the same brush, there could not fail to be many points of similarity. And yet the similarity of the handling seems to throw into more vigorous relief those personal distinctions which Raeburn was so quick to seize. He was a born painter of portraits. He looked people shrewdly between the eyes, surprised their manners in their face, and had possessed himself of what was essential in their character before they had been many minutes in his studio. What

he was so swift to perceive, he conveyed to the canvas almost in the moment of conception. He had never any difficulty, he said, about either hands or faces. About draperies or light or composition, he might see room for hesitation or afterthought. But a face or a hand was something plain and legible. There were no two ways about it, any more than about the person's name. And so each of his portraits is not only (in Doctor Johnson's phrase, aptly quoted on the catalogue) 'a piece of history', but a piece of biography into the bargain. It is devoutly to be wished that all biography were equally amusing, and carried its own credentials equally upon its face. These portraits are racier than many anecdotes, and more complete than many a volume of sententious memoirs. You can see whether you get a stronger and clearer idea of Robertson the historian from Raeburn's palette or Dugald Stewart's woolly and evasive periods. And then the portraits are both signed and countersigned. For you have, first, the authority of the artist, whom you recognize as no mean critic of the looks and manners of men; and next you have the tacit acquiescence of the subject, who sits looking out upon you with inimitable innocence, and apparently under the impression that he is in a room by himself. For Raeburn could plunge at once through all the constraint and embarrassment of the sitter, and present the face, clear, open, and intelligent as at the most disengaged moments. This is best seen in portraits where the sitter is represented in some appropriate action: Neil Gow with his fiddle, Doctor Spens shooting an arrow, or Lord Bannatyne hearing a cause. Above all, from this point of view, the portrait of Lieutenant-Colonel Lyon is notable. A strange enough young man, pink, fat about the lower part of his face, with a lean forehead, a narrow nose and a fine nostril, sits with a drawing-board upon his knees. He has just paused to render himself account of some difficulty, to disentangle some complication of line or compare neighbouring values. And there, without any perceptible wrinkling, you have rendered for you exactly the fixed look in the eyes, and the unconscious compression of the mouth, that befit and signify an effort of the kind. The whole pose, the whole expression, is absolutely direct and simple. You are ready to take your oath to it that Colonel Lyon had no idea he was sitting for his picture, and thought of nothing in the world besides his own occupation of the moment.

(Robert Louis Stevenson, 1881)

The novelist and art critic John Berger considers the nude an essentially sexist subject.

To be naked is to be oneself.

To be nude is to be seen naked by others and yet not recognized for oneself. A naked body has to be seen as an object in order to become a nude. (The sight of it as an object stimulates the use of it as an object.) Nakedness reveals itself. Nudity is placed on display.

To be naked is to be without disguise.

To be on display is to have the surface of one's own skin, the hairs of one's own body, turned into a disguise which, in that situation, can never be discarded. The nude is condemned to never being naked. Nudity is a form of dress.

In the average European oil painting of the nude the principal protagonist is never painted. He is the spectator in front of the picture and he is presumed to be a man. Everything is addressed to him. Everything must appear to be the result of his being there. It is for him that the figures have assumed their nudity. But he, by definition, is a stranger – with his clothes still on.

Consider the *Allegory of Time and Love* by Bronzino. The complicated symbolism which lies behind this painting need not concern us now because it does not affect its sexual appeal – at the first degree. Before it is anything else, this is a painting of sexual provocation.

The painting was sent as a present from the Grand Duke of Florence to the King of France. The boy kneeling on the cushion and kissing the woman is Cupid. She is Venus. But the way her body is arranged has nothing to do with their kissing. Her body is arranged in the way it is, to display it to the man looking at the picture. This picture is made to appeal to *his* sexuality. It has nothing to do with her sexuality. (Here and in the European tradition generally, the convention of not painting the hair on a woman's body helps towards the same end. Hair is associated with sexual power, with passion. The woman's sexual passion needs to be minimized so that the spectator may feel that he has the monopoly of such passion.) Women are there to feed an appetite, not to have any of their own.

(John Berger, *Ways of Seeing*, 1972)

A papal legate writes to Cardinal Alessandro Farnese about Titian's Danaë.
Mythology does not seem to be on his mind.

. . . The nude which Your Reverence saw in Pesaro in the apartment of
the Duke of Urbino looks like a nun beside this one.

 (Giovanni della Casa, 1544)

*Ten years later, Titian himself writes to the King of Spain, apparently most concerned
that the monarch should get a good view of the goddess's bottom.*

Because the figure of Danaë, which I have already sent to Your Majesty,
is seen entirely from the front, I have chosen in this other *poesia* [his *Venus
and Adonis*] to vary the appearance and show the opposite side, so that
the room in which they are to hang will seem more agreeable. Shortly I
hope to send you the *poesia* of *Perseus and Andromeda*, which will have a
viewpoint different from these two; and likewise *Medea and Jason*.

 (Titian, September 1554)

Sickert takes a mellow view of the nude.

Compositions consisting solely of nudes are usually (I have not forgotten
certain exceptional flights of genius, such as the Rubens, in Munich, of
the *Descent into Hell*) not only repellent, but slightly absurd. Even the
picture or two (I think there are two) of the master Ingres, which is a
conglomeration of nudes, has something absurd and repellent, a suggestion
of a dish of macaroni, something wriggling and distasteful. I think all great
and sane art tends to present the aspect of life in the sort of proportions
in which we are generally made aware of it. I state the law clumsily, but
it is a great principle. Perhaps the chief source of pleasure in the aspect
of a nude is that it is in the nature of a gleam – a gleam of light and
warmth and life. And to appear thus, it should be set in surroundings of
drapery or other contrasting surfaces.

 (Walter Sickert, 21 July 1910)

The novelist Julian Barnes takes issue with a politically correct antipathy towards Degas's portrayals of women.

Great artists attract base prejudices; base but instructive. Jean-François Raffaelli, 1880–1924, painter of the Parisian suburbs, claimed in 1894 that Degas was an artist 'seeking to render ignoble the secret forms of Woman'; he was someone who 'must dislike women'; and in evidence Raffaelli reported the words of one of Degas's models: 'He's a strange gentleman – he spent the whole four hours of the sitting combing my hair.' Edmond de Goncourt (who had his own sarcastic doubts about Degas, as about everybody else) noted down these charges in his journal and added, as a clincher, a story told him by the writer Léon Hennique, who at one time had shared with Degas a pair of sisters as mistresses. Hennique's 'sister-in-law' had apparently complained of Degas's 'lack of amorous means'.

Could anything be plainer? Can't get it up; hates women; behaves oddly with models; rubbishes women in his art. Case closed, defendant guilty. Nor should we laugh knowingly at such century-old crassness and envy (Raffaelli was at the time announcing his intention to address the subject of Woman, which perhaps makes his motivation easier to read). Here is a critic of our time, Tobia Bezzola:

> It is not known whether Degas had sexual relationships with women; at any rate there is no evidence that he did . . . [His] series of monotypes depicting brothel scenes is the most extreme example of the mixture of voyeurism and abhorrence with which he reacted to female sexuality.

Or, if you prefer an even more catch-all version, listen to our Tom Paulin on *The Late Show*. Paulin went to the Degas exhibition at the National Gallery with the foreknowledge that the artist was anti-Semitic and anti-Dreyfusard.

> I wondered how this would affect the paintings. You can't see it in the paintings, and I thought, Well, I should be admiring their beauty, but then I realized from reading this study of Eliot [by Anthony Julius] that misogyny and anti-Semitism are closely connected, so that what we have in this exhibition are women in contorted poses . . . They're like performing animals, they're like animals in the zoo. There's some deep, deep hatred of women, and I thought what does this remind me of, and I thought something like a concentration camp doctor has created these figures . . . I'm inside the

head of someone who's a deeply, deeply hateful person . . . I think it's coded – basically what he's thinking about is women on the loo, and I think that is his eroticism. He's an old tit-and-bum man – a woman wiping herself – I kept thinking what would children think of this? – woman wiping herself, it goes on and on.

This is a masterly application of the biographical fallacy; 'admiring beauty' is obviously a suspect business best got out of by discovering that beauty's creator was someone you wouldn't employ as a childminder . . .

Time. Degas spent four hours combing a model's hair. What a strange gentleman, when the norm might have been: get your kit off, hop on that pedestal, and how about a quick drink afterwards. The 'strange gentleman' was always looking. There is a story of Degas coming out of a party one evening and turning to his companion with the complaint that you never saw sloping shoulders in society any more. It's the tiny aside of a great artist. Goncourt reports the remark, confirms its justice, and seeks its explanation in habits of physical breeding over several generations; but it is Degas – the artist, rather than the novelist, social observer and art critic – who has *seen* it. Degas's tone, it's worth noticing, is one of complaint. The story remains unannotated by Goncourt, but the complaint is presumably an artistic one; a realization that the great and fundamental shape which was the subject of so many of his paintings was changing, if not exactly before his eyes, then within his lifetime – and would continue to change thereafter.

Four hours (and this was only one four hours among many): this show is full of moments in which hair is 'seen'. Intimate, informal hair – hair with its hair down. Degas knows how a woman holds her hair to comb it, how she supports it when another is combing it, how she alleviates scalp strain with a flattened palm at the tuggingest moments of the business. But (truth to life melting into truth to art) hair is also so malleable and metamorphic that it seems eager to take on abstract form. In many of the after-the-bath pictures, it echoes and plays against the twists and cascades of the towel, sometimes appearing to trade places. There is even a kind of jokey visual misleading, as in [one painting] where the maid's water jug – posing as bunched-up hair – occupies the space of the head, while the head itself is ducked down forwards.

The modern female body represented in a state of intimacy by an observing male. A century on, we have become more self-conscious spectators; queasiness and correct thinking have entered the equation for some. The artist also helped things along with his much-quoted statement

that: 'Women can never forgive me; they hate me, they feel I am disarming them. I show them without their coquetry.' Perhaps extremely coquettish women hated him for his art; perhaps the models he shouted at (but whom he also treated with 'enormous patience') felt they had earned their corn. On the other hand, as Richard Kendall acutely demonstrates, it was often women who were the first purchasers of these scenes of private grooming. It is a strange coincidence that two of the finest exhibitions of the last twelve months have both had female self-absorption as a central theme: the other being the Vermeer.

This isn't an easy area: we all import our prejudices. At the National Gallery press view I ran into a museum director who said he thought the pictures were all about 'the decay of the flesh'; whereas it seemed to me that Degas was portraying flesh at its most robust. His ballet dancers are no longer sylphs and nymphets; but even their states of exhausted resting (that hands-on-waist, backstrainy, can't-wait-for-it-to-end pose) are predicated upon a vital physical life. Is this just my prejudice? As it's my prejudice to differentiate between the life, in which Degas may or may not have been misogynistic, and the art, in which it seems to me that Degas plainly loved women. That remark needs immediate qualification, of course (when he painted he wasn't 'loving women', he was painting a picture, and the picture was doubtless what filled his mind), but otherwise let it stand. Do you constantly and obsessively fret at the representation of something you dislike or despise? 'For each man draws the thing he loaths'? On the whole, not. Would Degas's 'lack of amorous means' (if true – and there is recent evidence of condom-buying to dispute it) have made him a misogynist? Not necessarily: it might even make him the more attending an observer.

The artist as 'voyeur'? But that is exactly what the artist should be: one who sees (and voyeur can also carry the sense of hallucinatory visionary). The painter who tortured his models by forcing them into uncomfortable poses? Except that he also used photography, and memory; besides, if the body could get there, it had clearly got there before in its history. The brothel-depictor who thus let slip his 'abhorrence' of female sexuality? Yet these monotypes seem to me to reflect all the jollity, boredom, absorption, professionalism and 'work' of those engaged in this assembly-line trade, the tone no more abhorring than it is in Lautrec's brothel work. Perhaps Lautrec's reputation as a merry figure marginalized by dwarfism – and thus on a moral level with the marginalized prostitutes – works for him, whereas Degas's reputation works against him here. The graphic

output remains the same either way. But if you can look at, say, Degas's *La fête de la patronne* and see only abhorrence of female sexuality, then I suspect you are in deep critical trouble.

(Julian Barnes, 'The Artist as Voyeur', 1996)

A feminist critic finds, among other things, that Gustave Courbet's painting of the nymph of the spring, La Source, *is a mythologization of brainless female fecundity.*

Embedded in Gustave Courbet's *The Source* (1868) . . . is the deep-rooted notion that woman is nature. Both the subject – a naked woman at a spring – and the theme – woman as origin of life – are conventional, but Courbet's conflation of woman and nature is unusually deft. A fleshy woman sits by a stream. One hand holds on to a branch, seems almost moulded to it, as if she herself were part of the tree; and her contours, from the buttocks up, are eaten by shadows, so that nature absorbs her flesh, is actually one with it. Her lower left leg and right foot are submerged, so that she and the water are also one; more so, because Courbet creates an equivalent sensuousness between her dimpled thighs and the rippling water. Woman and nature literally mirror one another for the material of the female body is the material world.

Not only does this equation cast woman as body, as opposed to man as mind, which, of course, is analogous to culture; but also, because Courbet is a master at making paint read as the texture of whatever it describes, landscape and woman reverberate with one another's physicality. Water feels like flesh, dense, smooth, heavy; and flesh feels like water – surely it would 'give' with pressure. Courbet elaborates this bonding in various ways: the spring gushes from the dark vegetation much as the nude emerges from it; the water pours over her left hand, and light dapples skin and liquid; lush greenery reads as a metaphor for the lushness of the body.

All in all, woman symbolizes fecundity and lack of consciousness. But who is this nude? She is the single, anonymous woman who represents all women, not as a social group, but as Woman – Female of the Species in one aspect of the Eternal Feminine: Earth Mother/Mother Earth. This myth of Woman is not necessarily repugnant. However, it is only a fragment of reality, an ideology through which we should not expect to see what any individual woman genuinely is.

Courbet painted *Woman with White Stockings* (1861) for Khalil Bey, a wealthy one-time Ottoman ambassador in St Petersburg, who settled in

Paris. In the painting a seated young woman pulls a stocking over a bare foot balanced on an already stockinged, raised knee. The view, from below, angles up, making her genitals a focal point. Patronage indicates where aesthetic, economic, and political power lies, bluntly, who can 'own' people and things. The artist owns the image as a creation, but the buyer owns the art as an object of aesthetic and/or monetary value and the image as an object of desire.

Most likely, Khalil Bey did not want the painting primarily because, as Jack Lindsay writes, 'This is a masterpiece in its organization of form, making of the nude a compact unity without parallel.' According to Lindsay, Khalil Bey 'kept it locked in a sort of tabernacle or cabinet'. An image of power resonates: Khalil Bey as purchaser of two 'sacred' objects: the painting and the woman, who he 'has' (to himself). She, of course, is woman, whose being is locked up in *her* tabernacle, the genitals. Lindsay disengages her from any selfness, for she is only 'a brilliantly original piece of patterning, with the body a single solid mass, yet with the limbs clearly articulated in a rhythmic structure balanced on the slit of the genitals.' That slit! It is the pivotal point: not only of a composition, but also of the myth that Woman is a cunt and no more.

(Joanna Frueh, 1988)

Henry Moore extols the humanity of the medieval Italian sculptor Giovanni Pisano, who might be described as the Giotto of sculpture.

I want to say something about stone and marble carving as a technical thing. For instance, if you carve a piece of marble freshly quarried, it is much softer than it will be a year or two later. When it is new, it is called 'green' (like a green tree with the sap in it), and a stone used quickly out of a quarry is twice as easy to cut and to carve as stone which has been quarried a few years. I think that having his quarry near Pisa would mean that the marble would be used very soon after being quarried. Then, again, I think Giovanni had better-tempered tools than his predecessors. This would have given him more speed and freedom than his father [Nicola Pisano]. He would not have taken half as long to block out a big mass, and then to articulate it into his smaller masses. This could be one of the explanations for his freedom in the use of stone compared to other sculptors before him. Of course there's a difference in the hardness of various stones, but even this relates to its time of quarrying. This applies

even to very hard stones like granite. The granite in Cornwall is worked into kerbstones and cobblestones immediately it is quarried, and while it is 'green'. Giovanni's marble from San Giuliano wasn't all that hard, which is why his exterior sculptures are so weathered. I don't think we lose anything essential by that weathering. I even think the weathering reveals the big, simple design of his forms more clearly. It probably reduces what we see to what it had been a stage before it was finished, simplifying it back again without the detail.

Nicola Pisano used the drill as part of his studio technique because with the drill you can free the stone so that you are not punching against absolute resistance but against something that will free itself; you open it up like a Gruyère cheese before you cut it away. The drill technique was a very special mark of the Pisano school, but Giovanni used it as an expressive instrument as well as a practical one. He used it to give colour and texture to a surface so that if he wanted to make a beard have darkness, he would so drill it that it would take on a colour and a texture seen from a distance. This is one of the things that amazes me about him, this expressive use of the drill, not simply to make the job easier, but to accentuate its form. If you look at really primitive stone sculpture, such as early archaic Greek or Pre-Columbian work, you will find the drill used, but most of it is what we call 'rubbed sculpture', that's to say that after roughing out the forms with a punch, which breaks and stuns the stone, the craftsman got to work with abrasives, and rubbed the surface down until he got as far as he could beyond the stunning marks, and as smooth as he wanted his surface to be. By these means he got very simplified forms which are thought to be typically 'stone', but people think this because the sculptors did not have tools which could go beyond these simplicities; once you get a drilling technique as expert as Giovanni's you can go deeper into the stone and give it more expression, more colour, texture, light and shade.

But it's wrong to think that form and expression are separate things. For instance, if I put my hand on someone's shoulder, I can put it in a way that seems to be gripping or just gently touching. I may be touching it with affection and gentleness or I may be making some kind of empty gesture. All this is in the intention of the sculptor; it's part of his expression but it's part of form; you cannot separate the two. If you made a sculpture of Adam and Eve and Adam had his hand on Eve's shoulder, you could do it in a way that would show that he loved her or that he was ashamed of her; it's all done by a sensitivity to form, perhaps a greater sensitivity

than is needed in dealing *only* with simple geometric abstract shapes – and it's in this way that Giovanni Pisano was a fully developed sculptor. His form, his abstraction, his sculptural qualities were integrated. The human and the abstract formal elements were inseparable and that is what I think really great sculpture should be.

The way Giovanni used and understood marble gave the stone life, the power to live from inside. Michelangelo said once 'the figure is in the stone; you have only to let it out,' so that stone sculpture is not man-made but man-revealed. Giovanni let the inside of the stone come out; he freed something from the inside.

Giovanni Pisano's humanism has a quality which is for me the same as Rembrandt's humanism or Masaccio's humanism or the humanism of the late Michelangelo drawings. He was a man who showed in his sculpture the whole situation of the human being. It is, for me, this quality which makes Masaccio and Piero della Francesca and Rembrandt great. If I were asked to choose ten great artists, the greatest in European art, I would put Giovanni Pisano among them. It would be because of his understanding of life and of people. I feel terribly strongly that he was a great man because he understood human beings and if you asked me how I would judge great artists it would be on this basis. It would not be because they were clever in drawing or in carving or in painting or as designers; something of these qualities they must naturally have, but their real greatness, to me, lies in their humanity.

(Henry Moore, 1969)

The Cavalier poet Edmund Waller suggests that Van Dyck's portraits are so beautiful as to inspire love in the observer. Even Van Dyck, however, needed many sittings to portray Waller's 'Sacharissa' – Dorothy Sidney, Countess of Sunderland.

> Rare Artisan, whose pencil moves
> Not our delights alone, but loves!
> From thy shop of beauty we
> Slaves return, that entered free.
> The heedless lover does not know
> Whose eyes they are that wound him so;
> But, confounded with thy art,
> Inquires her name that has his heart.
> Another, who did long refrain,

Feels his old wound bleed fresh again
With dear remembrance of that face,
Where now he reads new hopes of grace:
Nor scorn nor cruelty does find,
But gladly suffers a false wind
To blow the ashes of despair
From the reviving brand of care.
Fool! that forgets her stubborn look
This softness from thy finger took.
Strange! that thy hand should not inspire
The beauty only, but the fire;
Not the form alone, and grace,
But act and power of a face.
Mayst thou yet thyself as well,
As all the world besides, excel!
So you the unfeigned truth rehearse
(That I may make it live in verse)
Why thou couldst not at one assay
That face to aftertimes convey,
Which this admires. Was it thy wit
To make her oft before thee sit?
Confess, and we'll forgive thee this;
For who would not repeat that bliss?
And frequent sight of such a dame
Buy with the hazard of his fame?
Yet who can tax thy blameless skill,
Though thy good hand had failed still,
When nature's self so often errs?
She for this many thousand years
Seems to have practised with much care,
To frame the race of women fair;
Yet never could a perfect birth
Produce before to grace the earth,
Which waxed old ere it could see
Her that amazed thy art and thee.
　　But now 'tis done, O let me know
Where those immortal colours grow,
That could this deathless piece compose!
In lilies? or the fading rose?
No; for this theft thou hast climbed higher
Than did Prometheus for his fire.

(Edmund Waller, 1645)

Henry James enjoys a portrait of a lady, in this case Sargent's Portrait of Miss
Burckhardt, *now in the Metropolitan Museum of Art, New York.*

The young lady, dressed in black satin, stands upright, with her right hand
bent back, resting on her waist, while the other, with the arm somewhat
extended, offers to view a single white flower. The dress, stretched at the
hips over a sort of hoop, and ornamented in front, where it opens on a
velvet petticoat with large satin bows, has an old-fashioned air, as if it had
been worn by some demure princess who might have sat for Velázquez.
The hair, of which the arrangement is odd and charming, is disposed in
two or three large curls fastened at one side over the temple with a comb.
Behind the figure is the vague faded sheen, exquisite in tone, of a silk
curtain, light, undefined, and losing itself at the bottom. The face is young,
candid and peculiar. Out of these few elements the artist has constructed
a picture which it is impossible to forget, of which the most striking
characteristic is its simplicity, and yet which overflows with perfection.
Painted with extraordinary breadth and freedom, so that surface and
texture are interpreted by the lightest hand, it glows with life, character
and distinction, and strikes us as the most complete – with one exception
perhaps – of the author's productions. I know not why this representation
of a young girl in black, engaged in the casual gesture of holding up a
flower, should make so ineffaceable an impression and tempt one to
become almost lyrical in its praise; but I remember that, encountering the
picture unexpectedly in New York a year or two after it had been exhibited
in Paris, it seemed to me to have acquired an extraordinary general value,
to stand for more artistic truth than it would be easy to formulate. The
language of painting, the tongue in which, exclusively, Mr Sargent expresses
himself, is a medium into which a considerable part of the public, for the
simple and excellent reason that they don't understand it, will doubtless
always be reluctant and unable to follow him.

(Henry James, 'John S. Sargent', 1893)

And one of his characters is moved by another lady in a Bronzino:

She found herself, for the first moment, looking at the mysterious portrait
through tears. Perhaps it was her tears that made it just then so strange
and fair – as wonderful as he had said; the face of a young woman, all
magnificently drawn, down to the hands, and magnificently dressed; a

face almost livid in hue, yet handsome in sadness and crowned with a mass of hair rolled back and high, that must, before fading with time, have had a family resemblance to her own. The lady in question, at all events, with her slightly Michelangelesque squareness, her eyes of other days, her full lips, her long neck, her recorded jewels, her brocaded and wasted reds, was a very great personage – only unaccompanied by a joy. And she was dead, dead, dead.

(Henry James, *The Wings of the Dove*, 1902)

In 1618, the Mughal Emperor Jahangir orders a record to be made of a dying courtier.

On this day news came of the death of 'Inayat Khan. He was one of my intimate attendants. As he was addicted to opium, and when he had the chance, to drinking as well, by degrees he became maddened with wine. As he was weakly built, he took more than he could digest, and was attacked by the disease of diarrhoea and in this weak state he two or three times fainted. By my order Hakim Rukna applied remedies, but whatever methods were resorted to gave no profit. At the same time a strange hunger came over him, and although the doctor exerted himself in order that he should not eat more than once in twenty-four hours, he could not restrain himself. He also would throw himself like a madman on water and fire until he fell into a bad state of body. At last, he became dropsical, and exceedingly low and weak. Some days before this, he had petitioned that he might go to Agra. I ordered him to come into my presence and obtain leave. They put him into a palanquin and brought him. He appeared so low and weak that I was astonished. 'He was skin drawn over bones' . . . or rather his bones, too, had dissolved. Though painters have striven much in drawing an emaciated face, yet I have never seen anything like this, or even approaching to it. Good God, can a son of man come to such a shape and fashion?

As it was a very extraordinary case, I directed painters to take his portrait.

(Jahangir, 1618)

The

Artist

Interrogated:

Interviews

and

Other

Inquisitions

Whistler is cross-questioned rather sharply about the work he had put into his painting
Nocturne in Black and Gold: The Falling Rocket, *but gives much better than*
he gets. This exchange occurred during a libel action he had brought against John
Ruskin, who had written the damning review with which the passage begins.

Prologue

'For Mr Whistler's own sake, no less than for the protection of the
purchaser, Sir Coutts Lindsay ought not to have admitted works into the
gallery in which the ill-educated conceit of the artist so nearly approached
the aspect of wilful imposture. I have seen, and heard, much of cockney
impudence before now; but never expected to hear a coxcomb ask two
hundred guineas for flinging a pot of paint in the public's face.'

John Ruskin

The Action

In the Court of Exchequer Division on Monday, before Baron Huddleston
and a special jury, the case of Whistler *v.* Ruskin came on for hearing. In
this action the plaintiff claimed £1,000 damages.

Mr Serjeant Parry and Mr Petheram appeared for the plaintiff; and the
Attorney-General and Mr Bowen represented the defendant.

Mr SERJEANT PARRY, in opening the case on behalf of the plaintiff,
said that Mr Whistler had followed the profession of an artist for many
years, both in this and other countries. Mr Ruskin, as would be probably
known to the gentlemen of the jury, held perhaps the highest position in
Europe and America as an art critic, and some of his works were, he
might say, destined to immortality. He was, in fact, a gentleman of the
highest reputation. In the July [1877] number of *Fors Clavigera* there
appeared passages in which Mr Ruskin criticized what he called 'the
modern school', and then followed the paragraph of which Mr Whistler

now complained [quoted above] ... That passage, no doubt, had been read by thousands, and so it had gone forth to the world that Mr Whistler was an ill-educated man, an impostor, a cockney pretender, and an impudent coxcomb.

Mr WHISTLER, cross-examined by the ATTORNEY-GENERAL, said: 'I have sent pictures to the Academy which have not been received. I believe that is the experience of all artists ... The nocturne in black and gold is a night piece, and represents the fireworks at Cremorne [pleasure gardens in west London].'

'Not a view of Cremorne?'

'If it were called a view of Cremorne, it would certainly bring about nothing but disappointment on the part of the beholders. (*Laughter*) It is an artistic arrangement. It was marked two hundred guineas.'

'Is not that what we, who are not artists, would call a stiffish price?'

'I think it very likely that that may be so.'

'But artists always give good value for their money, don't they?'

'I am glad to hear that so well established. (*A laugh*) I do not know Mr Ruskin, or that he holds the view that a picture should only be exhibited when it is finished, when nothing can be done to improve it, but that is a correct view; the arrangement in black and gold was a finished picture, I did not intend to do anything more to it.'

'Now, Mr Whistler. Can you tell me how long it took you to knock off that nocturne?'

'I beg your pardon?' (*Laughter*)

'Oh! I am afraid that I am using a term that applies rather perhaps to my own work. I should have said, "How long did you take to paint that picture?"'

'Oh, no! permit me, I am too greatly flattered to think that you apply, to work of mine, any term that you are in the habit of using with reference to your own. Let us say then how long did I take to – "knock off," I think that is it – to knock off that nocturne; well, as well as I remember, about a day.'

'Only a day?'

'Well, I won't be quite positive; I may have still put a few more touches to it the next day if the painting were not dry. I had better say then, that I was two days at work on it.'

'Oh, two days! The labour of two days, then, is that for which you ask two hundred guineas!'

'No – I ask it for the knowledge of a lifetime.' (*Applause*)

'You have been told that your pictures exhibit some eccentricities?'

'Yes; often.' (*Laughter*)

'You send them to the galleries to incite the admiration of the public?'

'That would be such vast absurdity on my part, that I don't think I could.' (*Laughter*)

'You know that many critics entirely disagree with your views as to these pictures?'

'It would be beyond me to agree with the critics.'

'You don't approve of criticism then?'

'I should not disapprove in any way of technical criticism by a man whose whole life is passed in the practice of the science which he criticizes; but for the opinion of a man whose life is not so passed I would have as little regard as you would, if he expressed an opinion on law.'

'You expect to be criticized?'

'Yes; certainly. And I do not expect to be affected by it, until it becomes a case of this kind. It is not only when criticism is inimical that I object to it, but also when it is incompetent. I hold that none but an artist can be a competent critic.'

'You put your pictures upon the garden wall, Mr Whistler, or hang them on the clothes line, don't you – to mellow?'

'I do not understand.'

'Do you not put your paintings out into the garden?'

'Oh! I understand now. I thought, at first, that you were perhaps again using a term that you are accustomed to yourself. Yes; I certainly do put the canvases into the garden that they may dry in the open air while I am painting, but I should be sorry to see them "mellowed".'

'Why do you call Mr Irving [Henry Irving, the leading tragic actor of his day] "an arrangement in black"?' (*Laughter*)

Mr BARON HUDDLESTON: 'It is the picture, and not Mr Irving, that is the arrangement.'

A discussion ensued as to the inspection of the pictures, and incidentally Baron Huddleston remarked that a critic must be competent to form an opinion, and bold enough to express that opinion in strong terms if necessary.

The ATTORNEY-GENERAL complained that no answer was given to a written application by the defendant's solicitors for leave to inspect the pictures which the plaintiff had been called upon to produce at the trial. The WITNESS [i.e. Whistler] replied that Mr Arthur Severn had been to his studio to inspect the paintings, on behalf of the defendant, for the

purpose of passing his final judgment upon them and settling that question for ever.

Cross-examination continued: 'What was the subject of the nocturne in blue and silver belonging to Mr Grahame?'

'A moonlight effect on the river near old Battersea Bridge.'

'What has become of the nocturne in black and gold?'

'I believe it is before you.' (*Laughter*)

The picture called the nocturne in blue and silver was now produced in Court.

'That is Mr Grahame's picture. It represents Battersea Bridge by moonlight.'

BARON HUDDLESTON: 'Which part of the picture is the bridge?' (*Laughter*)

His Lordship earnestly rebuked those who laughed. And witness explained to his Lordship the composition of the picture.

'Do you say that this is a correct representation of Battersea Bridge?'

'I did not intend it to be a "correct" portrait of the bridge. It is only a moonlight scene, and the pier in the centre of the picture may not be like the piers at Battersea Bridge as you know them in broad daylight. As to what the picture represents, that depends upon who looks at it. To some persons it may represent all that is intended; to others it may represent nothing.'

'The prevailing colour is blue?'

'Perhaps.'

'Are those figures on the top of the bridge intended for people?'

'They are just what you like.'

'Is that a barge beneath?'

'Yes. I am very much encouraged at your perceiving that. My whole scheme was only to bring about a certain harmony of colour.'

'What is that gold-coloured mark on the right of the picture like a cascade?'

'The "cascade of gold" is a firework.'

A second nocturne in blue and silver was then produced.

WITNESS: 'That represents another moonlight scene on the Thames looking up Battersea Reach. I completed the mass of the picture in one day.'

The Court then adjourned. During the interval the jury visited the Probate Court to view the pictures which had been collected in the Westminster Palace Hotel.

After the Court had reassembled the 'Nocturne in Black and Gold' was again produced, and Mr WHISTLER was further cross-examined by the ATTORNEY-GENERAL: 'The picture represents a distant view of Cremorne with a falling rocket and other fireworks. It occupied two days, and is a finished picture. The black monogram on the frame was placed in its position with reference to the proper decorative balance of the whole.

'You have made the study of Art your study of a lifetime. Now, do you think that anybody looking at that picture might fairly come to the conclusion that it had no peculiar beauty?'

'I have strong evidence that Mr Ruskin did come to that conclusion.'

'Do you think it fair that Mr Ruskin should come to that conclusion?'

'What might be fair to Mr Ruskin I cannot answer.'

'Then you mean, Mr Whistler, that the initiated in technical matters might have no difficulty in understanding your work. But do you think now that you could make *me* see the beauty of that picture?'

The witness then paused, and examining attentively the Attorney-General's face and looking at the picture alternately, said, after apparently giving the subject much thought, while the Court waited in silence for his answer:

'No! Do you know I fear it would be as hopeless as for the musician to pour his notes into the ear of a deaf man. (*Laughter*)

'I offer the picture, which I have conscientiously painted, as being worth two hundred guineas. I have known unbiased people express the opinion that it represents fireworks in a night scene. I would not complain of any person who might simply take a different view.'

The Court then adjourned.

Verdict for plaintiff. Damages one farthing.

(James McNeill Whistler, 'Whistler *v.* Ruskin', 1878)

When Damien Hirst exhibited a white lamb in a tank of formaldehyde at the Serpentine Gallery in 1994, another artist, visiting the exhibition, poured ink all over it. They were both examined and cross-examined at the trial of the perpetrator, Mark Bridger.

Mark Bridger:

DEFENCE

'I noticed that the glass and lid on the sheep exhibit was loose, then I had the idea of changing it and calling it *The Black Sheep*, I was in a *carpe diem* frame of mind. Having had the inspiration, I was of the bold intention to act. To me it was a true reflection of the artist's intention. I did understand that the sculpture intended to focus on mortality. To me, *carpe diem* means tomorrow might not be available.'

'How did you think the artist would react?'

'I thought he would think that this initial event was meant as an interesting addendum to his work, a continuation of his art if you like. His reaction took me slightly by surprise. I felt it was inconsistent with my view of him.'

'Did it occur to you, you would be damaging his art?'

'Well, it depends whether you define that as damage. In real terms I added ink. In conceptual art the sheep had already made its statement. I added something which emphasized it.'

PROSECUTION

'Could you describe your current employment status?'

'I'm thirty-five years old. I run a gallery. At present I'm doing temporary teaching of English. I describe myself as an artist, but that would be a poor definition of an artist. I've had a few exhibitions, I believe.'

'What are your feelings towards Mr Hirst?'

'I verge on liking him. His works, of the sheep and so on, are interesting.'

'Did you object to this exhibit?'

'You could say I did, you could say I didn't. I thought I could make a positive contribution by objecting providing that it wasn't destructive. Brian Sewell [the art critic] was there being interviewed behind the gallery. He was forming very destructive objections, saying that the art was rubbish

and shouldn't be allowed. I wasn't of that opinion. I was making an objection of action, but not for the same reasons.'

'Would it be fair to say that your motive was to draw attention to yourself?'

'Well, that's not correct. Of course, I was realistically aware that there would be some focus of attention on me but that was not my intention. Hirst has said that the worst thing is if somebody walks in and walks out and sees nothing.'

'You placed a label on the work with your name on it. Was this with a view to furthering your own career?'

'Well, publicity is not what it's all about. I thought it would endorse his standing and increase his profile far more than it would for me. I accept responsibilities for my action and was in breach of convention, but I see Hirst as an unconventional artist. I thought he would appreciate the breach of convention. That's what happens with his art. It's part of the reason that it's there. To provide some meaning for somebody.'

Damien Hirst:

PROSECUTION

'Why are you an artist?'

'Why are you a lawyer?'

'Answer the question.'

'I don't know why I'm an artist. I've always been an artist.'

'What sort of artist?'

'I do paintings, installations and sculptures.'

'Tell us about the sheep.'

'It was bought from an abattoir.'

'In what condition?'

'It was dead.

 'I was worried that the damage could have been more lasting. The ink completely obscured the sheep.

 'Of course. I didn't want to take the sculpture out of the exhibition. People worked late into the night, we hired a pump to pump out the formaldehyde, then we had to remove the lamb, wash it, clean the tank out and then put the lamb back in.'

DEFENCE

'Mr Hirst, can you tell us, was this work intended to shock?'

'I wanted people to think about themselves, about their lives, about their own mortality. That is a question about art, not about this case.'

'Your art is referred to as conceptual art. What does that mean?'

'It means, it means . . . It refers to a group of sixties people who said art consisted outside the piece and in the mind of the viewer. I do not believe my work is conceptual.'

'Subsequent to Mr Bridger's action, you were interviewed in a magazine, *Dazed and Confused*, where you said, referring to the work after the ink had been poured in: "I don't really like it but I thought I might leave it like that. But I don't think you can do that because you are just inviting people to come in and do what they like to any of the work, and it just gets out of hand."'

'What I meant was, as an artist you make the best of the situation.'

'What are your feelings about publicity?'

'It can cause problems. It can be good or bad. I live in Berlin and try to avoid publicity.'

'Doesn't the publicity attached to some works increase their value?'

'I wouldn't think so.'

(Court report, 1994, in Damien Hirst, 1997)

Andy Warhol is quizzed about a thing or two by a girl called Damian.

Damian walked over to the window and looked out. 'I guess you have to take a lot of risks to be famous in any field,' she said, and then, turning around to look at me, she added: 'For instance, to be an artist.'

She was being so serious, but it was just like a bad movie. I love bad movies. I was starting to remember why I always liked Damian.

I gestured toward the gift-wrapped salami that was sticking out of my Pan Am flight bag and said, 'Any time you slice a salami, you take a risk.'

'No, but I mean for an artist –'

'An artist!!' I interrupted. 'What do you mean, an "artist"? An artist can slice a salami, too! Why do people think artists are special? It's just another job.'

Damian wouldn't let me disillusion her. Some people have deep-rooted long-standing art fantasies. I remembered a freezing winter night a couple of years ago when I was dropping her off at two-thirty in the morning after a very social party and she made me take her to Times Square to find a record store that was open so she could buy *Blonde on Blonde* [Bob Dylan album, 1966] and get back in touch with 'real people'. Some people have deep-rooted long-standing art fantasies and they really stick with them.

'But to become a famous artist you had to do something that was "different". And if it was "different", then it means you took a risk, because the critics could have said that it was bad instead of good.'

'In the first place,' I said, 'they usually did say it was bad. And in the second place, if you say that artists take "risks", it's insulting to the men who landed on D-Day, to stuntmen, to babysitters, to Evel Knievel, to stepdaughters, to coal miners, and to hitchhikers, because they're the ones who really know what "risks" are.' She didn't even hear me, she was still thinking about what glamorous 'risks' artists take.

'They always say new art is bad for a while, and that's the risk – that's the pain you have to have for fame.'

I asked her how she could say 'new art'. 'How do you know if it's new or not? New art's never new when it's done.'

'Oh yes it is. It has a new look that your eyes can't adjust to at first.'

I waited for the cars to roar around the hairpin curve again below my window. The building was shaking slightly. I wondered what was taking B so long.

'No,' I said. 'It's not new art. You don't know it's new. You don't know *what* it is. It doesn't become new until about ten years later, because then it looks new.'

'So what's new right now?' she asked. I couldn't think of anything so I said I didn't want to commit myself.

'Is what's new now what happened ten years ago?'

That was pretty smart. I said, 'MMmmmmaybe.'

'That's what that lesbian was saying at lunch. She said that even the very intelligent French people who are interested in everything cultural don't know the names of famous American modern artists. They're just now learning about Jasper Johns and Rauschenberg. But what I want to know is, when people were saying how bad your movies and art were, did it bother you? Did it hurt to open the newspapers and read how bad your work was?'

'No.'

'It didn't bother you when a critic said you couldn't paint?'

'I never read the paper,' I said.

(Andy Warhol, 1975)

The American critic Leo Steinberg tries to get a straight answer out of Jasper Johns, and in a way, he does.

When you ask Johns why he did this or that in a painting, he answers so as to clear himself of responsibility. A given decision was made for him by the way things are, or was suggested by an accident he never invited.

Regarding the four casts of faces he placed in four oblong boxes over one of the targets [a celebrated series of paintings by Johns, depicting the flat, concentric pattern of a target]:

Q: Why did you cut them off just under the eyes?

A: They wouldn't have fitted into the boxes if I'd left them whole.

He was asked why his bronze sculpture of an electric bulb was broken up into bulb, socket, and cord:

A: Because, when the parts came back from the foundry, the bulb wouldn't screw into the socket.

Q: Could you have had it done over?

A: I could have.

Q: Then you liked it in fragments and you chose to leave it that way?

A: Of course.

The distinction I try to make between necessity and subjective preference seems unintelligible to Johns. I asked him about the type of numbers and letters he uses – coarse, standardized, unartistic – the type you associate with packing cases and grocery signs.

Q: You nearly always use this same type. Any particular reason?

A: That's how the stencils come.

Q: But if you preferred another typeface, would you think it improper to cut your own stencils?

A: Of course not.

Q: Then you really do like these best?

A: Yes.

This answer is so self-evident that I wonder why I asked the question at all; ah yes – because Johns would not see the obvious distinction between free choice and external necessity. Let me try again:

Q: Do you use these letter types because you like them or because that's how the stencils come?

A: But that's what I like about them, that they come that way.

(Leo Steinberg, 1972)

A rock star, David Bowie, chats with Balthus – Count Balthasar Klossowski de Rola – a veteran star of Parisian art.

DB: . . . Your commitment to the way you work has not changed in nearly all your time painting.

B: Well, it might have changed in a certain way, but I can't change myself, because I was always tapping on the same nail. I think what I have kept in a certain way, is my vision as a child. That sort of surprise in front of things. I think that the modern painter . . . the modern painter is like a . . . is like a person who is dying of hunger before an enormous meal, and he doesn't see the meal. He's sort of tantalized. It's curious, no? Because Tantalus wanted to eat it because he was hungry. But they don't seem to be hungry at all. They are just hungry for themselves. They are looking into themselves. I remember we had a discussion with Alberto [Giacometti] and Bataille. Bataille said a painter is destroying what he paints, and Alberto and I said but we are only underneath of what we see so we can't destroy. We are trying to reach what we see. I remember when I was sent to Rome, I came back to Paris and discussed the thing with Miró and Giacometti. Because, the *pensionnaires* [resident students] are supposed to produce a given subject. And he, Giacometti, said: 'But why don't they make a glass of water, for instance. Why don't they put a glass of water on a table and I'm sure that they will discover many many views of seeing the glass of water'. And then I report that to the people of the Institute and they said: 'Oh that's much too difficult'.

DB: So, would it be true to say that for you it's something else you're trying to capture, that it could be a person or a mountain – the subject could be arbitrary?

B: True. The subject has no importance. The subject for me is always a pretext to make a painting.

DB: So would you feel that you're trying to document your own presence and your relationship to perceived reality?

B: Well, I shouldn't put it like that. That sounds so intellectual to me.

But when I paint something after nature, I'm always recognizing something in myself.

DB: Do you still surprise yourself while you're working?

B: I am still surprised, and whatever I'm looking to – that's the trouble with the painter who is obsessed by painting – there's no . . . there's always a tension and always a sort of no repose, looking at a chair, looking at a cup of tea, or any object at all.

DB: What did you think of Alberto Giacometti's work?

B: I have the greatest admiration, because he really invented something that had not been done before, a sort of distance that he creates in his sculpture. Have you seen a great exhibition of Giacometti?

DB: I've seen quite a number of Giacometti's works, but I haven't seen a lot of them en masse.

B: I have made a great exhibition after his death, in Rome. And there was one in New York, I think, or in Paris – I don't remember now – and it was so wonderful. So impressive. About things which have never been told in sculpture. A sort of distance between the person who looks at it and the sculpture itself, and magnificent portraits he did just before dying. And he was one of the greatest draughtsmen. Wonderful, wonderful drawings.

DB: His sculptures had such a starved elegance. Quite the opposite of Picasso's sculptures – playful, childlike.

B: They were completely different. Picasso was a skater. Artistic skater.

(David Bowie, 1994)

Jackson Pollock is grilled in 1950 by William Wright for the Sag Harbor radio station. Though snappy enough, the result was not broadcast.

WW: Mr Pollock, in your opinion, what is the meaning of modern art?

JP: Modern art to me is nothing more than the expression of contemporary aims of the age that we're living in.

WW: Did the classical artists have any means of expressing their age?

JP: Yes, they did it very well. All cultures have had means and techniques of expressing their immediate aims – the Chinese, the Renaissance, all cultures. The thing that interests me is that today painters do not have to go to a subject matter outside of themselves. Most modern painters work from a different source. They work from within.

WW: Would you say that the modern artist has more or less isolated

the quality which made the classical works of art valuable, that he's isolated it and uses it in a purer form?

J P: Ah – the good ones have, yes.

w w: Mr Pollock, there's been a good deal of controversy and a great many comments have been made regarding your method of painting. Is there something you'd like to tell us about that?

J P: My opinion is that new needs need new techniques. And the modern artists have found new ways and new means of making their statements. It seems to me that the modern painter cannot express this age, the airplane, the atom bomb, the radio, in the old forms of the Renaissance or of any other past culture. Each age finds its own technique.

w w: Which would also mean that the layman and the critic would have to develop their ability to interpret the new techniques.

J P: Yes – that always somehow follows. I mean, the strangeness will wear off and I think we will discover the deeper meanings in modern art.

w w: I suppose every time you are approached by a layman they ask you how they should look at a Pollock painting, or any other modern painting – what they look for – how do they learn to appreciate modern art?

J P: I think they should not look for, but look passively – and try to receive what the painting has to offer and not bring a subject matter or preconceived idea of what they are to be looking for.

w w: Would it be true to say that the artist is painting from the unconscious, and the – canvas must act as the unconscious of the person who views it?

J P: The unconscious is a very important side of modern art and I think the unconscious drives do mean a lot in looking at paintings.

w w: Then deliberately looking for any known meaning or object in an abstract painting would distract you immediately from ever appreciating it as you should?

J P: I think it should be enjoyed just as music is enjoyed – after a while you may like it or you may not. But – it doesn't seem to be too serious. I like some flowers and others, other flowers I don't like. I think at least it gives – I think at least give it a chance.

w w: Well, I think you have to give anything that sort of chance. A person isn't born to like good music, they have to listen to it and gradually develop an understanding of it or liking for it. If modern painting works the same way – a person would have to subject himself to it over a period of time in order to be able to appreciate it.

J P: I think that might help, certainly.

ww: Mr Pollock, the classical artists had a world to express and they did so by representing the objects in that world. Why doesn't the modern artist do the same thing.

jp: H'm – the modern artist is living in a mechanical age and we have a mechanical means of representing objects in nature such as the camera and photograph. The modern artist, it seems to me, is working and expressing an inner world – in other words – expressing the energy, the motion, and other inner forces.

ww: Would it be possible to say that the classical artist expressed his world by representing the objects, whereas the modern artist expresses his world by representing the effects the objects have upon him?

jp: Yes, the modern artist is working with space and time, and expressing his feelings rather than illustrating.

ww: Well, Mr Pollock, can you tell us how modern art came into being?

jp: It didn't drop out of the blue; it's a part of a long tradition dating back with Cézanne, up through the Cubists, the post-Cubists, to the painting being done today.

ww: Then, it's definitely a product of evolution?

jp: Yes.

ww: Shall we go back to this method question that so many people today think is important? Can you tell us how you developed your method of painting, and why you paint as you do?

jp: Well, method is, it seems to me, a natural growth out of a need, and from a need the modern artist has found new ways of expressing the world about him. I happen to find ways that are different from the usual techniques of painting, which seems a little strange at the moment, but I don't think there's anything very different about it. I paint on the floor and this isn't unusual – the Orientals did that.

ww: How do you go about getting the paint on the canvas? I understand you don't use brushes or anything of that sort, do you?

jp: Most of the paint I use is a liquid, flowing kind of paint. The brushes I use are used more as sticks rather than brushes – the brush doesn't touch the surface of the canvas, it's just above.

ww: Would it be possible for you to explain the advantage of using a stick with paint – liquid paint rather than a brush on canvas?

jp: Well, I'm able to be more free and to have greater freedom and move about the canvas, with greater ease.

ww: Well, isn't it more difficult to control than a brush? I mean, isn't there more a possibility of getting too much paint or splattering or any

number of things? Using a brush, you put the paint right where you want it and you know exactly what it's going to look like.

JP: No, I don't think so. I don't – ah – with experience – it seems to be possible to control the flow of the paint, to a great extent, and I don't use – I don't use the accident – 'cause I deny the accident.

WW: I believe it was Freud who said there's no such thing as an accident. Is that what you mean?

JP: I suppose that's generally what I mean.

WW: Then, you don't actually have a preconceived image of a canvas in your mind?

JP: Well, not exactly – no – because it hasn't been created, you see. Something new – it's quite different from working, say, from a still life where you set up objects and work directly from them. I do have a general notion of what I'm about and what the results will be.

WW: That does away, entirely, with all preliminary sketches?

JP: Yes, I approach painting in the same sense as one approaches drawing; that is, it's direct. I don't work from drawings, I don't make sketches and drawings and colour sketches into a final painting. Painting, I think today – the more immediate, the more direct – the greater the possibilities of making a direct – of making a statement.

WW: Well, actually every one of your paintings, your finished canvases, is an absolute original.

JP: Well – yes – they're all direct painting. There is only one.

WW: Well, now, Mr Pollock, would you care to comment on modern painting as a whole? What is your feeling about your contemporaries?

JP: Well, painting today certainly seems very vibrant, very alive, very exciting. Five or six of my contemporaries around New York are doing very vital work, and the direction that painting seems to be taking here – is – away from the easel – into some sort, some kind of wall – wall painting.

WW: I believe some of your canvases are of very unusual dimensions, isn't that true?

JP: Well, yes, they're an impractical size – nine by eighteen feet. But I enjoy working big and – whenever I have a chance, I do it whether it's practical or not.

WW: Can you explain why you enjoy working on a large canvas more than on a small one?

JP: Well, not really. I'm just more at ease in a big area than I am on something two by two; I feel more at home in a big area.

w w: You say 'in a big area'. Are you actually on the canvas while you're painting?

j p: Very little. I do step into the canvas occasionally – that is, working from the four sides I don't have to get into the canvas too much.

(Jackson Pollock and William Wright, 1950)

The Venetian painter Paolo Caliari, better known as 'Veronese', is questioned – quite gently – by the Holy Tribunal of the Inquisition in Venice about the propriety of his painting, The Feast in the House of Simon.

Venice, July 18, 1573. The minutes of the session of the Inquisition Tribunal of Saturday, the 18th of July, 1573. Today, Saturday, the 18th of the month of July, 1573, having been asked by the Holy Office to appear before the Holy Tribunal, Paolo Caliari of Verona, domiciled in the Parish Saint Samuel, being questioned about his name and surname, answered as above.

Questioned about his profession:

ANSWER: I paint and compose figures.

QUESTION: Do you know the reason why you have been summoned?

A: No, sir.

Q: Can you imagine it?

A: I can well imagine.

Q: Say what you think the reason is.

A: According to what the Reverend Father, the Prior of the Convent of SS Giovanni e Paolo, whose name I do not know, told me, he had been here and Your Lordships had ordered him to have painted [in the picture] a Magdalen in place of a dog. I answered him by saying I would gladly do everything necessary for my honour and for that of my painting, but that I did not understand how a figure of Magdalen would be suitable there for many reasons which I will give at any time, provided I am given an opportunity.

Q: What picture is this of which you have spoken?

A: This is a picture of the Last Supper that Jesus Christ took with His Apostles in the house of Simon.

Q: Where is this picture?

A: In the Refectory of the Convent of SS Giovanni e Paolo.

Q: Is it on the wall, on a panel, or on canvas?

A: On canvas.

Q: What is its height?

A: It is about seventeen feet.

Q: How wide?

A: About thirty-nine feet.

Q: At this Supper of Our Lord have you painted other figures?

A: Yes, milords.

Q: Tell us how many people and describe the gestures of each.

A: There is the owner of the inn, Simon; besides this figure I have made a steward, who, I imagined, had come there for his own pleasure to see how the things were going at the table. There are many figures there which I cannot recall, as I painted the picture some time ago.

Q: Have you painted other Suppers besides this one?

A: Yes, milords.

Q: How many of them have you painted and where are they?

A: I painted one in Verona for the reverend monks at San Nazzaro which is in their refectory. Another I painted in the refectory of the reverend fathers of San Giorgio here in Venice.

Q: This is not a Supper. We are asking about a picture representing the Supper of the Lord.

A: I have painted one in the refectory of the Servi of Venice, another in the refectory of San Sebastiano in Venice. I painted one in Padua for the fathers of Santa Maddalena and I do not recall having painted any others.

Q: In this Supper which you made for SS Giovanni e Paolo, what is the significance of the man whose nose is bleeding?

A: I intended to represent a servant whose nose was bleeding because of some accident.

Q: What is the significance of those armed men dressed as Germans, each with a halberd in his hand?

A: This requires that I say twenty words!

Q: Say them.

A: We painters take the same licence the poets and the jesters take and I have represented these two halberdiers, one drinking and the other eating near by on the stairs. They are placed here so that they might be of service because it seemed to me fitting, according to what I have been told, that the master of the house, who was great and rich, should have such servants.

Q: And that man dressed as a buffoon with a parrot on his wrist, for what purpose did you paint him on that canvas?

A: For ornament, as is customary.

Q: Who are at the table of Our Lord?

A: The Twelve Apostles.

Q: What is St Peter, the first one, doing?

A: Carving the lamb in order to pass it to the other end of the table.

Q: What is the Apostle next to him doing?

A: He is holding a dish in order to receive what St Peter will give him.

Q: Tell us what the one next to this one is doing.

A: He has a toothpick and cleans his teeth.

Q: Who do you really believe was present at that Supper?

A: I believe one would find Christ with His Apostles. But if in a picture there is some space to spare I enrich it with figures according to the stories.

Q: Did any one commission you to paint Germans, buffoons, and similar things in that picture?

A: No, milords, but I received the commission to decorate the picture as I saw fit. It is large and, it seemed to me, it could hold many figures.

Q: Are not the decorations which you painters are accustomed to add to paintings or pictures supposed to be suitable and proper to the subject and the principal figures or are they for pleasure – simply what comes to your imagination without any discretion or judiciousness?

A: I paint pictures as I see fit and as well as my talent permits.

Q: Does it seem fitting at the Last Supper of the Lord to paint buffoons, drunkards, Germans, dwarfs and similar vulgarities?

A: No, milords.

Q: Do you not know that in Germany and in other places infected with heresy [that is, the Reformation] it is customary with various pictures full of scurrilousness and similar inventions to mock, vituperate, and scorn the things of the Holy Catholic Church in order to teach bad doctrines to foolish and ignorant people?

A: Yes that is wrong; but I return to what I have said, that I am obliged to follow what my superiors have done.

Q: What have your superiors done? Have they perhaps done similar things?

A: Michelangelo in Rome in the Pontifical Chapel painted Our Lord, Jesus Christ, His Mother, St John, St Peter, and the Heavenly Host. These are all represented in the nude – even the Virgin Mary – and in different poses with little reverence.

Q: Do you not know that in painting the Last Judgment in which no

garments or similar things are presumed, it was not necessary to paint garments, and that in those figures there is nothing that is not spiritual? There are neither buffoons, dogs, weapons, or similar buffoonery. And does it seem because of this or some other example that you did right to have painted this picture in the way you did and do you want to maintain that it is good and decent?

A: Illustrious Lords, I do not want to defend it, but I thought I was doing right. I did not consider so many things and I did not intend to confuse anyone, the more so as those figures of buffoons are outside of the place in a picture where Our Lord is represented.

After these things had been said, the judges announced that the above named Paolo would be obliged to improve and change his painting within a period of three months from the day of this admonition and that according to the opinion and decision of the Holy Tribunal all the corrections should be made at the expense of the painter and that if he did not correct the picture he would be liable to the penalties imposed by the Holy Tribunal. Thus they decreed in the best manner possible.

In the event, Veronese simply changed the title of his painting from The Feast in the House of Simon *or, according to some scholars,* The Last Supper, *to* The Feast in the House of Levi. *It can now be seen in the Accademia in Venice.*

(Trial of Veronese before the Holy Tribunal, 18 July 1573, in Elizabeth G. Holt, 1958)

On

the

Couch:

Art

and

Psycholology

William Blake insists that all good artists are mad.

> All pictures that's painted with sense and with thought
> Are painted by madmen as sure as a groat;
> For the greater the fool in the pencil more blest,
> And when they are drunk they always paint best.

(William Blake, MS notebook, *c.*1808–11)

The paintings of Willem de Kooning, an eminent philosopher argues, re-create the sensations of an infant in arms.

The sensations that de Kooning cultivates are, in more ways than one, the most fundamental in our repertoire. They are those sensations which gave us our first access to the external world, and they also, as they repeat themselves, bind us for ever to the elementary forms of pleasure into which they initiated us. Both in the grounding of human knowledge and in the formation of human desire, they prove basic. De Kooning, then, crams his pictures with infantile experiences of sucking, touching, biting, excreting, retaining, smearing, sniffing, swallowing, gurgling, stroking, wetting. These experiences, it will be noticed, extend across the sense modalities, sometimes fusing them, sometimes subdividing them: in almost all cases they combine sensations of sense with sensations of activity. And these pictures of de Kooning's, particularly the later ones, which are to my mind the greatest, contain a further reminder. They remind us that, in their earliest occurrence, these experiences invariably posed a threat. Heavily charged with excitation, they threatened to overwhelm the fragile barriers of the mind that contained them, and to swamp the immature, precarious self.

If I am right in my perception of these pictures, it follows that, for all the primitiveness of the material they carry, there is within them a duality of content. There are two different things to which they try to do justice.

There are the experiences, and there is also the experiencer. The self is set over and against the sensations that it contains. Each of these two elements finds its own way into the picture. For the sensations themselves de Kooning relies upon the lusciousness of the paint, and he conveys their archaic character by the fat and gaudy substance into which he works it up. And he selects as the vehicle of the self the box-like look of the support, for which he characteristically chooses a near-square format, and he then establishes a correspondence between the near-square look and the simplicity and the fragility of the rudimentary self. De Kooning's pictures assimilate themselves to enormous shallow saucers in which a great deal of primitive glory is held in delicate suspense: it slops around, but it is kept back by the rim.

(Richard Wollheim, 1987)

Was Géricault, when he painted the insane, painting his fellow inmates?

The ardour with which Géricault had undertaken and executed the [*Raft of the*] *Medusa*, and the indifference with which it was received, had predictable results. He left Paris, threatened by his most serious nervous depression to date. It is at this point that Clément's admirable narrative falters and can be amplified by more recent research. Clément gives no account of the time that elapsed between the exhibition of *Medusa* and the arrival in London in the spring of 1820, yet a self-portrait in Rouen, showing Géricault with hair *en brosse* and a disquieting expression, impels us to concentrate on his vicissitudes in those crucial months. Within the relatively recent past a French scholar, Denise Aimé-Azam, has discovered valuable letters that passed between Géricault's friends, including his former schoolmaster Castel, describing his instability, his excitement, his desire to paint, and his disabling fear that boatmen on the river near Castel's house in Fontainebleau had been sent to take him away. It is Mme Aimé-Azam's excellent theory (which cannot, however, be substantiated) that Géricault's friends were obliged to have recourse to a young man specializing in obsessional neuroses, the excellent Dr Georget, that Georget removed Géricault to his clinic in the rue de Buffon, and that Géricault there painted the miraculous heads of the insane, who were in fact his fellow sufferers. Great mystery surrounds this episode, and has created the equivalent of the San Andreas fault in the chronology of Géricault's works.

The traditional and more cheerful explanation for these canvases is that

after a successful trip to England Géricault returned to Paris in good order and painted for his friend Georget ten portraits (only five are extant) to illustrate a forthcoming treatise on alienation. There are several reasons for not accepting this view, the most practical being that drawings or engravings, or, even better, lithographs would seem to be a more appropriate medium for this kind of illustration. Moreover, on his return to Paris, Géricault was suffering from many ailments, notably a disease of the spine, and in fact painted relatively little; even his drawings weaken noticeably.

But perhaps the most convincing argument lies in the execution of the portraits of the insane: painted with extreme rapidity, without retouches, and in a state of unflinching empathy, they correspond with the state of excitability and delusion for which Mme Aimé-Azam's letters provide slender but convincing evidence. It would have been difficult to use these portraits in a didactic work, for they show no attributable symptoms; they are merely faces of people sunk in terror, suspicion or bewilderment. The titles by which they are known are not contemporary. There is no attempt to interpret the minds of these people, or to illustrate their condition in a public way. Accessories, like the child molester's hat (*Fou voleur d'enfants*), worn in fact like a child's schoolcap, are in no sense explanatory to the lay spectator. The kleptomaniac (*Monomanie du vol*) has a face of great beauty, with eyes sunk in innocence and doubt. The woman characterized as *Monomanie de l'envie* is not bending her mind in any recognizable direction. In view of this evidence – or lack of evidence – it is reasonable to assume that the portraits were painted at the lowest point of the descending curve triggered off by the public failure of the *Medusa*.

The journey to England in 1820 was undertaken partly for therapeutic reasons and partly for commercial ones. An impresario named Bullock put *The Raft of the Medusa* on public exhibition in the Egyptian Hall in Piccadilly, where it drew crowds and received a favourable notice in *The Times*. His confidence thus restored, Géricault began to concentrate on new subjects, and also on making money, chiefly through the medium of lithographs, his best work at this time. He painted and drew anodyne subjects, ladies riding in the park, ostlers, the Derby, but also a public hanging, and members of the urban poor. He set out to learn what he could from painters such as Wilkie and Landseer, and he began to find fault with the French school. A rather unexpected desire to make a fortune began to be noticeable, and on his return to France he started to invest unwisely, and to sink money into an enterprise for making artificial jewellery, possibly in the sinister little building known as 'The Lime Kiln'.

He had already tried to kill himself in London, and a melancholy now distorts his work. Projects were sketched but abandoned as too demanding; magnanimous advice and help were offered to Delacroix; and the very few pictures that he finished exude sadness in their turbid paint and their irrational darkness. Louise Vernet, who was to become a beauty and to marry the painter Delaroche, is portrayed as a cynical child clasping a cat. Her waved hair has a grossness that suggests that the paint was difficult to move. Similar distortions of scale are present in the Louvre picture known as *Le Vendéen*, also an approximate title. The sitter is probably a dressed-up model and any disharmony conveyed by the painter himself. The grotesque black hat extinguishes the sitter's face like a candle-snuffer. He wears a dark blue coat and a light brown waistcoat, striped a pinker brown with the brush. His glistening white shirt is arbitrarily arranged to expose a rhomboid of dark blushing flesh.

Géricault's death is equally sinister. Returning from the jewellery factory one morning, he fell from his horse on to a pile of stones. An abscess developed which he opened with his knife; the infection accelerated and he was soon bedridden. On 16 May 1823 he managed a visit to Delacroix's studio, looking very ill, as Delacroix noted. He died at the beginning of January 1824, the year of the great Romantic Salon, in which Constable showed *The Hay Wain* and Delacroix *Scenes of the Massacre at Chios*. He was thirty-three years old.

(Anita Brookner, *Soundings*, 1997)

The French writer and dramatist Antonin Artaud insists, a trifle insanely, that Van Gogh was not insane, but inspired (and Artaud should know, since he himself was inspired and spent many years in mental institutions).

To come back to the painting of the crows [*Crows Over the Wheat Fields*, generally regarded as one of Van Gogh's very last works].

Who has ever seen, as in this canvas, land equal to the sea?

Van Gogh, of all painters, is the one who strips us down the furthest, and right down to the thread, just as one would delouse oneself of an obsession.

Of making objects look different, finally of risking the sin of the alter ego, and the earth cannot take on the colour of a liquid sea, and yet, with his hoe Van Gogh tosses his earth like a liquid sea.

And he infused his canvas with the colour of the dregs of wine, and it

is the earth that smells of wine, still splashing among the waves of wheat, rearing a sombre cockscomb against the low clouds gathering in the sky on all sides.

But, as I have already said, the funereal part of the story is the opulence with which the crows are treated.

That colour of musk, of rich nard, of truffles from a great banquet.

In the purplish waves of the sky, two or three heads of old men made of smoke venture an apocalyptic grimace, but Van Gogh's crows are there inciting them to be more decent, I mean inciting them to less spirituality,

that is what Van Gogh meant in this canvas with its underslung sky, painted at almost the exact moment that he was delivering himself of life, for on the other hand this work has the strange almost pompous aspect of birth, marriage, departure.

I hear the wings of the crows beating cymbals loudly above a world whose flood Van Gogh can apparently no longer contain.

Then, death.

The olive trees of Saint-Rémy.

The solitary cypress.

The bedroom.

The promenades.

The Arles Café.

The bridge where one feels like plunging one's finger in the water, in a gesture of violent regression to a state of childhood forced upon one by Van Gogh's amazing grip.

The water is blue,

not a water-blue,

but a liquid-paint blue.

The suicided madman has been there and given the water of paint back to nature,

but who will give it back to him?

Van Gogh, a madman?

let him who once knew how to look at a human face take a look at the self-portrait of Van Gogh, I am thinking of the one with the soft hat.

Painted by an extra-lucid Van Gogh, that face of a red-headed butcher, inspecting and watching us, scrutinizing us with a glowering eye.

I do not know of a single psychiatrist who would know how to scrutinize a man's face with such overpowering strength, dissecting its irrefutable psychology as if with a knife.

Van Gogh's eye belongs to a great genius, but from the way I see him

dissecting me, surging forth from the depths of the canvas, it is no longer the genius of a painter that I feel living within him at this moment, but the genius of a certain philosopher never encountered by me in this life.

No, Socrates did not have this eye; perhaps the only one before Van Gogh was the unhappy Nietzsche who had the same power to undress the soul, to pluck the body from the soul, to lay the body of man bare, beyond the subterfuges of the mind.

Van Gogh's gaze is hanging, screwed, glazed behind his naked eyelids, his thin wrinkleless eyebrows.

It is a look that penetrates, pierces, in a face roughly hewn like a well-squared tree.

But Van Gogh chose the moment when the pupil of the eye is going to spill into emptiness,

where this glance, aimed at us like the bomb of a meteor, takes on the atonal colour of the void and inertia that fills it.

This is how Van Gogh located his illness, better than any psychiatrist in the world.

I pierce, I resume, I inspect, I cling to, I unseal, my dead life conceals nothing, and, after all, nothingness has never harmed anyone. What forces me to withdraw within myself is that disheartening absence that passes and overwhelms me at times, but I perceive it clearly, very clearly, I even know what nothingness is, and could even say what is inside it.

And Van Gogh was right, one can live for the infinite, and only be satisfied with infinite things, there is enough of the infinite on the earth and in the spheres to satisfy a thousand great geniuses, and if Van Gogh was unable to satisfy the desire to fill his life with it, it is simply that society forbade it.

Flatly and consciously forbade it.

One day Van Gogh's executioners arrived, as they did for Gérard de Nerval, Baudelaire, Edgar Allan Poe and Lautréamont.

Those who one day said to him:

And now, enough, Van Gogh, to your grave, we've had our fill of your genius, and as for the infinite, the infinite belongs to us.

For it is not because of his search for the infinite that Van Gogh died, obliged to choke with misery and asphyxiation,

he died from seeing the infinite refused him by the rabble of all those who thought to withhold it from him during his own life;

and Van Gogh could have found enough infinite to live on for his whole life span had not the bestial mind of the masses wanted to appropriate

it to feed their own debaucheries, which have never had anything to do with painting or poetry.

Besides, one does not commit suicide alone.

No one was ever born alone.

Nor has anyone died alone.

But, in the case of suicide, a whole army of evil beings is needed to force the body to perform the unnatural act of depriving itself of its own life.

And I believe that there is always someone else, at the extreme moment of death, to strip us of our own life.

And thus, Van Gogh condemned himself because he had finished with living, and we gather this from his letters to his brother; because of the birth of his brother's son,

he felt that he himself would be one mouth too many to feed.

But above all Van Gogh wanted to join that infinite for which, said he, one embarks as on a train to a star,

and one embarks the day one has finally decided to finish with life.

Now in Van Gogh's death, as it actually occurred, I do not believe that is what happened.

Van Gogh was dispatched from this earth by his brother, first by announcing the birth of his nephew, and he was sent away by Dr Gachet who, instead of recommending rest and solitude, sent him off to paint from nature, a day when he was well aware that it would have been better for Van Gogh to go to bed.

For lucidity and sensibility such as the martyred Van Gogh possessed cannot be so obviously thwarted.

There are souls who, on certain days, would kill themselves over a simple contradiction, and it isn't necessary to be insane for that, a registered and catalogued lunatic; on the contrary, it is enough to be in good health and to have reason on one's side.

I, in a similar situation, could no longer bear to hear, without committing a crime: 'Monsieur Artaud, you're raving,' as so often has happened to me.

And Van Gogh heard just that.

And that is what caused the knot of blood that killed him to twist in his throat.

(Antonin Artaud, 1947)

Leonardo da Vinci – a case of passive homosexuality, fixated on his mother, stepmother and grandmother? Dr Freud investigates.

As far as I know Leonardo only once interspersed in his scientific descriptions a communication from his childhood. In a passage where he speaks about the flight of the vulture, he suddenly interrupts himself in order to follow up a memory from very early years which came to his mind.

'It seems that it had been destined before that I should occupy myself so thoroughly with the vulture, for it comes to my mind as a very early memory, when I was still in the cradle, a vulture came down to me, he opened my mouth with his tail and struck me a few times with his tail against my lips.'

We have here an infantile memory and to be sure of the strangest sort. It is strange on account of its content and [on] account of the time of life in which it was fixed. That a person could retain a memory of the nursing period is perhaps not impossible, but it can in no way be taken as certain. But what this memory of Leonardo states, namely, that a vulture opened the child's mouth with its tail, sounds so improbable, so fabulous, that another conception which puts an end to the two difficulties with one stroke appeals much more to our judgement. The scene of the vulture is not a memory of Leonardo, but a fantasy which he formed later, and transferred into his childhood . . .

When we examine Leonardo's vulture fantasy with the eyes of a psycho-analyst, then it does not seem strange very long; we recall that we have often found similar structures in dreams, so that we may venture to translate this fantasy from its strange language into words that are universally understood. The translation then follows an erotic direction. Tail, 'coda', is one of the most familiar symbols, as well as a substitutive designation of the male member which is no less true in Italian than in other languages. The situation contained in the fantasy, that a vulture opened the mouth of the child and forcefully belaboured it with its tail, corresponds to the idea of fellatio, a sexual act in which the member is placed into the mouth of the other person. Strangely enough this fantasy is altogether of a passive character; it resembles certain dreams and fantasies of women and of passive homosexuals who play the feminine part in sexual relations . . .

The vulture fantasy of Leonardo still absorbs our interest. In words which only too plainly recall a sexual act ('and has many times struck against my lips with his tail'), Leonardo emphasizes the intensity of the

erotic relations between the mother and the child. A second memory content of the fantasy can readily be conjectured from the association of the activity of the mother (of the vulture) with the accentuation of the mouth zone. We can translate it as follows: My mother has pressed on my mouth innumerable passionate kisses. The fantasy is composed of the memories of being nursed and of being kissed by the mother.

A kindly nature has bestowed upon the artist the capacity to express in artistic productions his most secret psychic feelings hidden even to himself, which powerfully affect outsiders who are strangers to the artist without their being able to state whence this emotivity comes. Should there be no evidence in Leonardo's work of that which his memory retained as the strongest impression of his childhood? One would have to expect it. However, when one considers what profound transformations an impression of an artist has to experience before it can add its contribution to the work of art, one is obliged to moderate considerably his expectation of demonstrating something definite. This is especially true in the case of Leonardo.

He who thinks of Leonardo's paintings will be reminded by the remarkably fascinating and puzzling smile which he enchanted on the lips of all his feminine figures. It is a fixed smile on elongated, sinuous lips which is considered characteristic of him and is preferentially designated as 'Leonardesque'. In the singular and beautiful visage of the Florentine Monna Lisa del Giocondo it has produced the greatest effect on the spectators and even perplexed them. This smile was in need of an interpretation, and received many of the most varied kind but none of them was considered satisfactory ...

It was quite possible that Leonardo was fascinated by the smile of Monna Lisa, because it had awakened something in him which had slumbered in his soul for a long time, in all probability an old memory. This memory was of sufficient importance to stick to him once it had been aroused; he was forced continually to provide it with new expression. The assurance of Pater [the nineteenth-century English critic and essayist, Walter Pater] that we can see an image like that of Monna Lisa defining itself from Leonardo's childhood on the fabric of his dreams, seems worthy of belief and deserves to be taken literally.

Vasari mentions as Leonardo's first artistic endeavours 'heads of women who laugh'. The passage, which is beyond suspicion, as it is not meant to prove anything, reads more precisely as follows: 'He formed in his youth some laughing feminine heads out of lime, which have been reproduced

in plaster, and some heads of children, which were as beautiful as if modelled by the hands of a master . . .'

Thus we discover that his practice of art began with the representation of two kinds of objects, which would perforce remind us of the two kinds of sexual objects which we have inferred from the analysis of his vulture fantasy. If the beautiful children's heads were reproductions of his own childish person, then the laughing women were nothing else but reproductions of Caterina, his mother, and we are beginning to have an inkling of the possibility that his mother possessed that mysterious smile which he lost, and which fascinated him so much when he found it again in the Florentine lady.

The painting of Leonardo which in point of time stands nearest to the *Monna Lisa* is the so-called *Saint Anne* of the Louvre, representing Saint Anne, Mary and the Christ child. It shows the Leonardesque smile most beautifully portrayed in the two feminine heads. It is impossible to find out how much earlier or later than the portrait of Monna Lisa Leonardo began to paint this picture. As both works extended over years, we may well assume that they occupied the master simultaneously. But it would best harmonize with our expectation if precisely the absorption in the features of Monna Lisa would have instigated Leonardo to form the composition of *Saint Anne* from his fantasy. For if the smile of Gioconda had conjured up in him the memory of his mother, we would naturally understand that he was first urged to produce a glorification of motherhood, and to give back to her the smile he found in that prominent lady. We may thus allow our interest to glide over from the portrait of Monna Lisa to this other hardly less beautiful picture, now also in the Louvre.

Saint Anne with the daughter and grandchild is a subject seldom treated in the Italian art of painting; at all events Leonardo's representation differs widely from all that is otherwise known . . .

On becoming somewhat engrossed in this picture it suddenly dawns upon the spectator that only Leonardo could have painted this picture, as only he could have formed the vulture fantasy. This picture contains the synthesis of the history of Leonardo's childhood, the details of which are explainable by the most intimate impressions of his life. In his father's home he found not only the kind stepmother, Donna Albiera, but also the grandmother, his father's mother, Monna Lucia, who we will assume was not less tender to him than grandmothers are wont to be. This circumstance must have furnished him with the facts for the representation of a childhood guarded by a mother and grandmother. Another striking

feature of the picture assumes still greater significance. Saint Anne, the mother of Mary and the grandmother of the boy, who must have been a matron, is formed here perhaps somewhat more mature and more serious than Saint Mary, but still as a young woman of unfaded beauty. As a matter of fact Leonardo gave the boy two mothers, the one who stretched out her arms after him and another who is seen in the background; both are represented with the blissful smile of maternal happiness. This peculiarity of the picture has not failed to excite the wonder of the authors. Muther, for instance, believes that Leonardo could not bring himself to paint old age, folds and wrinkles, and therefore formed also Anne as a woman of radiant beauty. Whether one can be satisfied with this explanation is a question. Other writers have taken occasion to deny generally the sameness of age of mother and daughter. However, Muther's tentative explanation is sufficient proof for the fact that the impression of Saint Anne's youthful appearance was furnished by the picture and is not an imagination produced by a tendency.

Leonardo's childhood was precisely as remarkable as this picture. He has had two mothers, the first his true mother, Caterina, from whom he was torn away between the age of three and five years, and a young tender stepmother, Donna Albiera, his father's wife. By connecting this fact of his childhood with the one mentioned above and condensing them into a uniform fusion, the composition of Saint Anne, Mary and the Child, formed itself in him. The maternal form further away from the boy designated as grandmother, corresponds in appearance and in spatial relation to the boy, with the real first mother, Caterina. With the blissful smile of Saint Anne the artist actually disavowed and concealed the envy which the unfortunate mother felt when she was forced to give up her son to her more aristocratic rival, as once before her lover.

Our feeling that the smile of Monna Lisa del Giocondo awakened in the man the memory of the mother of his first years of childhood would thus be confirmed from another work of Leonardo. Following the production of *Monna Lisa*, Italian artists depicted in Madonnas and prominent ladies the humble dipping of the head and the peculiar blissful smile of the poor peasant girl Caterina, who brought to the world the noble son who was destined to paint, investigate, and suffer.

When Leonardo succeeded in reproducing in the face of Monna Lisa the double sense comprised in this smile, namely, the promise of unlimited tenderness, and sinister threat (in the words of Pater), he remained true even in this to the content of his earliest reminiscence. For the love of

the mother became his destiny, it determined his fate and the privations which were in store for him. The impetuosity of the caressing to which the vulture fantasy points was only too natural. The poor forsaken mother had to give vent through mother's love to all her memories of love enjoyed as well as to all her yearnings for more affection; she was forced to it, not only in order to compensate herself for not having a husband, but also the child for not having a father who wanted to love it. In the manner of all ungratified mothers she thus took her little son in place of her husband, and robbed him of a part of his virility by the too early maturing of his eroticism. The love of the mother for the suckling whom she nourishes and cares for is something far deeper-reaching than her later affection for the growing child. It is of the nature of a fully gratified love affair, which fulfils not only all the psychic wishes but also all physical needs, and when it represents one of the forms of happiness attainable by man it is due, in no little measure, to the possibility of gratifying without reproach also wish feelings which were long repressed and designated as perverse. Even in the happiest recent marriage the father feels that his child, especially the little boy, has become his rival, and this gives origin to an antagonism against the favourite one which is deeply rooted in the unconscious.

When in the prime of his life Leonardo re-encountered that blissful and ecstatic smile as it had once encircled his mother's mouth in caressing, he had long been under the ban of an inhibition, forbidding him ever again to desire such tenderness from women's lips. But as he had become a painter he endeavoured to reproduce this smile with his brush and furnish all his pictures with it, whether he executed them himself or whether they were done by his pupils under his direction, as in *Leda, John,* and *Bacchus.* The latter two are variations of the same type. Muther says: 'From the locus eater of the Bible Leonardo made a Bacchus, an Apollo, who with a mysterious smile on his lips, and with his soft thighs crossed, looks on us with infatuated eyes.' These pictures breathe a mysticism into the secret of which one dares not penetrate; at most one can make the effort to construct the connection to Leonardo's earlier productions. The figures are again androgynous but no longer in the sense of the vulture fantasy, they are pretty boys of feminine tenderness with feminine forms; they do not cast down their eyes but gaze mysteriously triumphant, as if they knew of a great happy issue concerning which one must remain quiet; the familiar fascinating smile leads us to infer that it is a love secret. It is possible that in these forms Leonardo disavowed and artistically conquered the unhappiness of his love life, in that he represented the wish fulfilment

of the boy infatuated with his mother in such blissful union of the male and female nature.

(Sigmund Freud, 1910)

In his old age, suggests John Richardson, Picasso both measured himself against the masters of the past, and sought inspiration in their works.

Just as the sexuality of Picasso's late work (especially when it was exploited by unscrupulous publishers out to titillate a prurient public) discouraged its serious acceptance, so did the artist's flagrant borrowing from the old and not-so-old masters – Velázquez, Rembrandt, Delacroix, Van Gogh, Manet, Ingres among them. Another symptom of failing powers and an impoverished imagination, we were told. In fact it was nothing of the sort.

Why did Picasso lock horns with one great painter after another? Was it a trial of strength like arm wrestling? Was it out of admiration or mockery, irony or homage, Oedipal rivalry or Spanish chauvinism? Each case was different, but there is always an element of identification, an element of cannibalism involved – two elements that, as Freud pointed out, are part of the same process. Indeed Freud described the process of identification as 'psychic cannibalism': you identified with someone; you cannibalized them: you assumed their powers. How accurately this describes what the predatory old genius was up to in his last years.

Picasso also cannibalized his friends. He would switch on the magnetism and let his ego feed on whatever emotional response – critical understanding or silly starstruck *Schwärmerei* – could be extracted from his companions. A day spent with the great man would thus induce spiritual exhaustion. Picasso cannibalized great artists in much the same way. He engaged them in mortal, or immortal, combat, and devoured them one after another. With their powers added to his, this very small, very frail, very old man felt himself more powerful than any other artist in history, so powerful indeed that he embarked on a one-man apotheosis of post-Renaissance painting. The irony is that although Picasso was the most famous artist in the world, and a regular exhibitor, hardly anyone understood, let alone appreciated what he was doing.

Of all the artists with whom Picasso identified, Van Gogh is the least often cited but probably the one who meant most to him in later years. He talked of him as his patron saint, talked of him with intense admiration

and compassion, never with any of his habitual irony or mockery. Van Gogh, like Cézanne earlier in Picasso's life, was sacrosanct – 'the greatest of them all', he said. Parmelin has described how Picasso badgered the director of the museum in Arles to get him a photostat of a press cutting, the only documentary record of Van Gogh chopping off his ear and giving it to Rachel, the prostitute. He, who seldom framed anything, was going to frame it, he said. Parmelin also touches on another incident that I witnessed. Apropos a certain dealer who coerced his artists, or their widows, into exchanging a painting for a Rolls-Royce, Picasso said rather bleakly, 'Can you imagine Van Gogh in a Rolls-Royce?' It became a standing joke: 'Can you imagine Velázquez in a Rolls?' The answer I seem to remember was, yes. But Van Gogh never – not even a Deux-Chevaux.

At first glance Van Gogh does not manifest himself very overtly in Picasso's work, certainly not as overtly as Manet or Velázquez. But that is largely because his influence is not a superficial stylistic question of borrowed compositions or anecdotal trappings, but a matter of deep spiritual identification. True, some of the landscapes or seascapes of 1967 recall the tornado turbulence, if not the ominousness, of Van Gogh's terminal *Cornfields*. However, it is the paintings of a red-bearded, straw-hatted artist at his easel (1963–64), with their generic resemblance to Van Gogh's self-portraits (one of which Picasso used to project, floor to ceiling, on the studio wall) that reveal the extent of the old Spaniard's debt to the doomed Dutchman.

Why, one wonders, should a great artist want to paint self-portraits in the guise of another great artist? Had Picasso lost some sense of his own identity? The answer is surely that in losing your identity to someone else you gain a measure of control over them. These proxy self-portraits suggest that Picasso was out to assume something of Van Gogh's identity and by osmosis something of the Protestant *Angst*, which is what makes northern Europeans sometimes so attractive, sometimes so unattractive, to southern ones.

In his self-pitying Blue Period days Picasso had thought of Van Gogh as a kindred spirit – the quintessential *peintre maudit*. At the end of his life Picasso's attitude to the Dutchman was less sentimental. What he wanted was to enlist Van Gogh's dark spirits on his side, to make his art as instinctive and 'convulsive' as possible – something that African art had helped him achieve in 1907, something that the Surrealists had helped him do in the twenties. I suspect that Picasso also wanted to galvanize his paint surface – not always the most thrilling aspect of the epoch before

Jacqueline's [the period of his relationship with Jacqueline Roque, his second wife, which lasted from 1954 until his death] – with some of the Dutchman's Dionysian fervour. It worked. The surface of the late paintings has a freedom, a plasticity, that was never there before: they are more spontaneous, more expressive and more instinctive, than virtually all his previous work. The imminence of his own end may also have constituted a link with Van Gogh. The more one studies these late paintings, the more one realizes that they are, like Van Gogh's terminal landscapes, a supreme affirmation of life in the teeth of death.

If Van Gogh became an explosive spirit lurking in the depths of Picasso's psyche, how should we see Rembrandt, the other great Dutchman whose presence presides over the late work? More, I think, as an all-powerful God-the-father figure whom Picasso had to internalize before he died . . .

The artist has supplied us with a clue in the form of his famous Oedipal boast – first published by Jaime Sabartés (Picasso's secretary) and unquestioningly accepted by every subsequent biographer except Daix – that, when he was thirteen, his father 'gave me his paints and his brushes and never went back to painting'. That Don José equipped his prodigy of a son with the tools of his trade goes without saying: as for the rest of the claim, it is the more interesting for being false – wishful thinking on the artist's part. For there is incontrovertible evidence that, far from abdicating in favour of his son, Don José continued to paint: for instance, he always portrayed the pigeon of the year for Barcelona's Colombofila, of which he was president. Given Picasso's fantasy – a fantasy he came to believe – about this symbolic paternal gift, it is surely possible that he entertained a similar fantasy about a far more formidable antecedent, Rembrandt, and that he was out to appropriate the Dutchman's 'brushes'. Just as Picasso used to joke that he had repaid his debt to his pigeon-fancying father 'millions of times over' in kind – that is to say, in pigeons or doves – were not his late works a way of paying Rembrandt back in musketeers? For Picasso's ubiquitous musketeers have an undoubtedly Rembrandtian provenance. The artist used a slide machine to project *The Night Watch* in all its vastness on his studio wall – thus enabling the musketeers to step straight out of seventeenth-century Amsterdam into the time-warp of Picasso's *teatrum mundi*.

'Every artist takes himself for Rembrandt,' Picasso once told Françoise Gilot [his mistress from 1946–53], and this is truer of nobody than of himself. He repeatedly inscribed books, especially ones to his friends the

Rosengarts, with a sketch of a self-portrait of Rembrandt over his signature as if to advertise the degree of this identification. And long before Rembrandtian references became a regular feature of his work, Picasso used to say that the Dutchman was *his* kind of painter, that he infinitely preferred the Dutch to the Italian masters, whom he regarded as too *pompier*, too 'artistic' (a pejorative word in his vocabulary). The Dutch knew how to rub people's noses in real life. It was also my impression that Picasso identified with Rembrandt because they had both suffered a similar fate in old age. From being enormously popular *chefs d'école* both had turned reclusive; both were accused of not finishing their work; both lost out to new gods.

And then, as Cohen suggests, Picasso identified with Rembrandt 'as an ageing artist. Rembrandt's pictorial identification of his own ageing process as seen in his self-portraits was surely not lost on the ageing Picasso.' True, but let us go a step further and see Picasso's identification with Rembrandt in the light of art-historical concepts of a great late period. Picasso knew all about the almost religious awe which certain art historians feel for the late works of certain artists. And he must have suspected that his own late work was seen by critics as a decline and fall rather than an apotheosis. This was the view that John Berger advanced in his *Success and Failure of Picasso* (1965): compared to 'Bellini, Michelangelo, Titian, Tintoretto, Poussin, Rembrandt, Goya, Turner, Degas, Cézanne, Monet, Matisse, Braque', whose work 'gained in profundity and originality as [they] grew older', Picasso 'became a national monument and produced trivia'. His late work (Berger claimed) 'represents a retreat ... into an idealized and sentimental pantheism ... Picasso is a startling exception to the rule about old painters.' These words were the more wounding coming from a supposedly sympathetic Marxist pen.

In the circumstances what more natural than that Picasso should identify with a master whose late work was rejected by his former followers, then vindicated by posterity, and ultimately revered for being centuries ahead of its time? And what more natural than that Picasso, who saw himself as the greatest artist of his time, should lay claim, as if by right, to the mantle of one of the greatest artists of all time?

(John Richardson, 'L'Époque Jacqueline', 1988)

Why have there been so few major women painters? Germaine Greer argues that it is because their psyches have been crushed.

Ever since the 1850s observers have been claiming that all the obstacles in the way of women artists have melted away. Every woman who seized a price or a scholarship or sold a work to a national collection or sat upon a hanging jury stoutly believed that hundreds of women would follow her into the breach in the defences of the male establishment. The history of art however remained virtually unaffected. Anna Lea Merritt's *Love Locked Out* which was bought for the Tate by the Chantrey Fund, and opened the way for the acquisition of more women's work, is a laughing stock. Rosa Bonheur, whose example justified all the struggles of nineteenth-century women artists, is no longer regarded as a great master or even as a good painter. In her recent book, *Nineteenth-Century Painters and Painting*, Geraldine Norman has to stretch a point to include six women, one of whom is Vigée-Le Brun, in more than seven hundred entries. Besides Bonheur, Cassatt and Morisot, she includes the Danish Anna Ancher (1859–1935) and the Norwegian Harriet Backer (1845–1932).

The reason why Mrs Norman has not included more women is not that she is a lunatic anti-feminist but that she actually considers that their contribution does not merit inclusion even in a book which attempts to give a true picture of the main preoccupations of nineteenth-century artists rather than concentrating on the breakaway groups which advanced furthest and fastest. In her view the rest of the hundreds of women working as painters in the nineteenth century are minor members of schools founded and demonstrated by male artists, and have simply been sifted out in arriving at the seven hundred-odd artists whose achievement is in her view significant. Ancher and Backer were both significant figures in provincial schools. Of the two hundred-odd English female artists listed in Christopher Wood's *Dictionary of Victorian Painters*, itself selective, for the number might easily be doubled, not one has merited inclusion in a work on a wider scale.

The narrower and more provincial the view taken by any exhibition or study, the more women appear in it, as we draw closer and closer to the school situation in which the women studying art outnumber the men. Even in the jubilee exhibition at the Royal Academy of 'British Painting from 1953–1978', out of three hundred and ninety-two paintings hung, only forty-six were by women.

There is no point in denying the situation or in pretending that it is

purely the result of a male chauvinist interpretation of the facts. It would be possible, perhaps, without doing violence to Geraldine Norman's intellectual position, to quadruple the number of women she includes, but twenty-four is not much better as a showing out of seven hundred than six. It must be borne in mind however that concepts of relative importance are often mistaken. The case is often oversimplified: it is not always the woman who follows the man's influence. She is often the innovator, but it is the man who recognizes the innovation for what it is, commandeers it and establishes it as his own. The assessment of importance is not based upon the assessment of talent, which is imponderable.

In the last analysis the external obstacles are less insidious and destructive than the internal ones. Poverty and disappointment do not afflict the work itself as effectively as do internalized psychological barriers. All women are tortured by contradictory pressures, but none more so than the female artist. The art she is attracted to is the artistic expression of men: given the present orientation of art history she is not likely to have seen much women's work and less likely to have responded to it. She certainly would not, unless she grew up in a very strange environment, be able to say that she responded primarily to women's work. If she does she is probably not referring to painting, but to textiles or some other 'minor' art in which women have not been inspired, led, influenced, taught and appreciated by men.

A woman knows that she is to be womanly and she also knows that for a drawing or a painting to be womanish is contemptible. The choices are before her: to deny her sex, and become an honorary man, which is an immensely costly proceeding in terms of psychic energy, or to accept her sex and with it second place, as the artist's consort, in fact or in fantasy. To live alone without emotional support is difficult and wearing and few artists have been able to survive it. To find emotional support in another woman is only possible for some women, most of whom have been continually distressed and oppressed by social pressures. The lesbian is more tortured than any other woman by the suspicion that she is a sort of mock-male: she more than another will be teased by the alien tradition of representing women as sex objects, as the 'other'.

For all artists the problem is one of finding one's own authenticity, of speaking in a language or imagery that is essentially one's own, but if one's self-image is dictated by one's relation to others and all one's activities are other-directed, it is simply not possible to find one's own voice. Time and again, women painters' work, however competent, fails to survive

fashion. As the superficial predilection for a certain kind of treatment ebbs away, the paintings are seen to be hollow, posturing, empty and absurd. In their anxiety to feel the right feelings and give evidence of having lovable natures, many nineteenth-century women painters falsified their own perceptions and overstated emotional experiences which they did not actually understand.

Feminism cannot supply the answer for an artist, for her truth cannot be political. She cannot abandon the rhetoric of one group for the rhetoric of another, or substitute acceptability to one group for acceptability to another. It is for feminist critics to puzzle their brains about whether there is a female imagery or not, to examine in depth the relations between male and female artists, to decide whether the characteristics of masculine art are characteristics of all good art and the like. The painter cannot expend her precious energy in polemic, and in fact very few women artists of importance do.

The point is, after all, not to question irritably whether women artists are any good in order to reject them if we find that they are not as good as another group, but to interest ourselves in women artists, for their dilemma is our own. Every painting by anyone is evidence of a struggle, and not all such struggles are conclusively won. There are more warring elements in women's work than in men's and when we learn to read them we find that the evidence of battle is interesting and moving, like the trampled grass of Lady Butler's *Quatre Bras* [Lady Butler was a successful painter of military scenes]. Many women artists in our own day are journeying inward, away from inherited statement to an inner truth, as Gwen John did, to the point where all posture and surface appeal is bleached away. Others take the surrealist road, hoping in dream imagery to find the same kind of truth. Others strive for truly gratifying forms, to which they may respond more deeply than in words, beyond consciousness. Others turn to photo-realism in the search for a way out of hypocrisy. To the deadening pull towards passivity is added the pressure of politics which would drag the artist in another direction until her soul lies dismembered.

Most of us, despite our schools' insistence that anyone can draw, are not artists: it is to our advantage to become the women artists' audience, not in a foolishly partisan way so that anything a woman does is good in our eyes, but to offer the kind of constructive criticism and financial, intellectual and emotional support that men have given their artists in the past. The first prerequisite is knowledge, not only of women's work but

of the men's work to which it relates, and not in vague generalizations but precise examples. The young Californian women who came to the 'Women Painters: 1550–1950' exhibition in Los Angeles were often disappointed to see how closely the women's work related to that of the men, whom they knew more about, and many of them lost interest right there. That should have been the starting point, for understanding how women artists sometimes led men, were plundered and overtaken, is an important part of recovering our history. At a recent exhibition at the Victoria and Albert Museum a small Cubist gouache by Alexandra Exter, dated 1914–15, was accompanied by an unusually generous note, pointing out how much more advanced her work was than what Braque and Picasso were doing at the same time. Unfortunately on the postcards that were being sold showing this work her name was rendered *Alexander* Exter.

There is then no female Leonardo, no female Titian, no female Poussin, but the reason does not lie in the fact that women have wombs, that they can have babies, that their brains are smaller, that they lack vigour, that they are not sensual. The reason is simply that you cannot make great artists out of egos that have been damaged, with wills that are defective, with libidos that have been driven out of reach and energy diverted into neurotic channels. Western art is in large measure neurotic, for the concept of personality which it demonstrates is in many ways antisocial, even psychotic, but the neurosis of the artist is of a very different kind from the carefully cultured self-destructiveness of women. In our time we have seen both art and women changing in ways that, if we do not lose them, will bring both closer together.

(Germaine Greer, 1979)

La

Vie

de

Bohème

William Blake on the nature of painters:

Painters are noted for being dissipated and wild.
　(William Blake, annotations to Reynolds's *Discourses, c.* 1808)

Vasari on the necessity of misanthropy for an artist like Michelangelo.

No one should think it strange that Michelangelo loved solitude, for he was deeply in love with his art, which claims a man with all his thoughts for itself alone. Anyone who wants to devote himself to the study of art must shun the society of others. In fact, a man who gives his time to the problems of art is never alone and never lacks food for thought, and those who attribute an artist's love of solitude to outlandishness and eccentricity are mistaken, seeing that anyone who wants to do good work must rid himself of all cares and burdens: the artist must have time and opportunity for reflection and solitude and concentration.
　(Giorgio Vasari, 1568)

Giovanni Baglioni, an early biographer, describes the miserable and murderous life of Michelangelo Merisi, better known from his place of birth as Caravaggio.

Michelangelo Merisi was a satirical and proud man; at times he would speak badly of the painters of the past, and also of the present, no matter how distinguished they were, because he thought that he alone had surpassed all the other artists in his profession. Moreover, some people thought that he had destroyed the art of painting; also, many young artists followed his example and painted heads from life, without studying the rudiments of design and the profundity of art, but were satisfied only with the colours; therefore these painters were not able to put two figures

together, nor could they illustrate a history [narrative painting] because they did not comprehend the value of so noble an art.

Because of his excessively fearless nature Michelangelo was quite a quarrelsome individual, and sometimes he looked for a chance to break his neck or jeopardize the life of another. Often he was found in the company of men who, like himself, were also belligerent. And finally he confronted Ranuccio Tomassoni, a very polite young man, over some disagreement about a tennis match. They argued and ended up fighting. Ranuccio fell to the ground after Michelangelo had wounded him in the thigh and then killed him. Everyone who was involved in this affair fled Rome and Michelangelo too went to Palestrina, where he painted a Mary Magdalen. From there he moved to Naples, where he also produced many paintings.

Then he went to Malta, where he was invited to pay his respects to the Grand Master and to make his portrait. Whereupon this Prince, as a sign of gratitude, presented him with the Mantle of St John and made him a Cavaliere di Grazia. Here, following some sort of disagreement with the Cavaliere di Giustizia, Michelangelo was put into prison. But he managed to escape at night by means of a rope ladder and fled to the island of Sicily. In Palermo he painted some works. But since his enemies were chasing him, he decided to return to Naples. There they finally caught up with him, wounding him on his face with such severe slashes that he was almost unrecognizable. Despairing of revenge for this vindictive act and with all the agony he had experienced, he packed his few belongings and boarded a little boat in order to go to Rome, where Cardinal Gonzaga was negotiating with Pope Paul V for his pardon. On the beach where he arrived, he was mistakenly captured and held for two days in prison and when he was released, his boat was no longer to be found. This made him furious, and in desperation he started out along the beach under the fierce heat of the July sun, trying to catch sight of the vessel that had his belongings. Finally, he came to a place where he was put to bed with a raging fever; and so, without the aid of God or man, in a few days he died, as miserably as he had lived.

If Michelangelo Merisi had not died so soon, the art world would have profited greatly from his beautiful style, which consisted of painting from nature; although in his pictures he did not have much judgement in selecting the good and avoiding the bad, he nevertheless was able to earn great credit for himself, and he was paid more for his portraits than others obtained for their history pictures, such is the value of recognition by the

people, who judge not with their eyes but look with their ears. His portrait was placed in the Academy.

(Giovanni Baglioni, 1642)

Violence, rape, torture and betrayal made up the harsh initiation into adult life of the seventeenth-century painter Artemisia Gentileschi. Perhaps it is not surprising that, as Germaine Greer suggests, Artemisia's greatest subject became the sex war in art.

Great genius is the exception that makes the rule. It is always and everywhere gratuitous; the wonder is not that genius does not appear on earth more often but that it ever appears on earth at all. Like most other women painters, Artemisia Gentileschi was the daughter of a painter, but she was not his collaborator. At one time she wished to be the wife of a painter, but she was saved from this fate against her own will. The retired life of women was an impossibility for her and so she lived aggressive, independent and exposed, forcing herself into the postures of self-promotion, facing down gossip, and working, working with a seriousness that few other women ever permitted themselves to feel.

When Anna Jameson saw the masterpiece of Artemisia Gentileschi in the Palazzo Pitti in 1822, she was thoroughly appalled. This 'dreadful picture' she called it, 'a proof of her genius and of its atrocious misdirection'. The painting depicts an atrocity, the murder of a naked man in his bed by two young women. They could be two female cut-throats, a prostitute and her maid slaughtering her client whose upturned face has not had time to register the change from lust to fear. The strong diagonals of the composition all lead to the focal point, the sword blade hacking at the man's neck from which gouts of blood spray out, mimicking the lines of the strong arms that hold him down, even as far as the rose-white bosom of the murderess.

The excuse for such portrayal is, of course, the apocryphal story of Judith and Holofernes, which might equally well justify the portrayal of Jewish beauty (as it did for Rembrandt) or of a mistress's careless cruelty (as it did in the luscious version of Cristofano Allori). Artemisia Gentileschi's choice of depicting the act of decapitation itself had been made before, by Elsheimer and of course by her father's erstwhile friend, Caravaggio [presumably a reference to his painting of Judith beheading Holofernes, now in the Galleria Nazionale, Rome].

Artemisia's treatment of the same subject clearly refers to Caravaggio's

painting, but in no spirit of emulation; rather she has decided to outdo her predecessor. The composition is swung around and tightened into a terrible knot of violence. The tension away from the act which divides Caravaggio's canvas is abandoned, for all the interest centres upon the ferocious energy and application of dark, angry Judith, who plies her sword like a peasant woman slaughtering a calf, in a claustrophobic oval of light filled with restless seesaw movement. There is no concession to decorative effect in the composition: the warm transparency of Artemisia's palette and her delicate chasing of linear effects, the rippling of the tufted hem of the bed-covering, the tinkle of blood against Judith's jewelled forearm, the sprouting of Holofernes's hair through her rosy fingers, are all expressions of callousness. The spectator is rendered incapable of pity or outrage before this icon of violence and hatred, while he is delighted by such cunning. The painting was, in its own time, both notorious and inconspicuously exposed.

The facts of Artemisia's life are gradually emerging from the fog of inattention which has obscured them for three hundred years. Her birth is recorded in the baptismal register of San Lorenzo in Lucina in Rome, as having taken place on 8 July 1593. We may be sure that this is the Artemisia who grew up to be the great painter of the war between the sexes, and not some elder sister who died in infancy, because of her father Orazio Gentileschi's claim in a letter of 1612, that he had been training his daughter to follow his profession for three years. None of his three sons was to become a painter.

This birthdate, earlier than was thought before the entry was discovered, reinforces Artemisia's claim to be the painter of the *Susannah and the Elders* in the collection at Schloss Weissenstein in Pommersfelden which is inscribed 'ARTE GENTILESCHI 1610'. The palette is her father's [Orazio Gentileschi, 1563–1639, a notable painter who worked, among others, for Charles I of England], but the design and the figure of Susannah are Artemisia's. Only she could paint female figures which had a skeleton as well as flesh and skin texture. Susannah's pelvis is not the invention of voluptuous fantasy, but something observed and understood. Her body is not displayed in Susannah's conventional posture of self-caressing, to excite the observer: she sits heavily, crumpled against the cruel stone of the coping, turning her face away from implication in the tangled drama of the two men conspiring to destroy her. Her useless hands do not so much defend her, as draw her into ruinous complicity with her enemies. The daring of the composition, with its tight lozenge of busy movement

crushing the naked vulnerability of the innocent female body, is clearly derived from the Gentileschi *père*'s boldly asymmetric approach but the shallowness of the spatial arrangement is more typical of Artemisia.

Artemisia entered public life in 1612, when her father brought an action against his friend and collaborator, Agostino Tassi, for raping his daughter and taking away paintings from his house, including a 'rather large *Judith*'. The records of the trial are preserved in not quite legible condition in Rome but as they consist only of the depositions at the trial and not the deliberations of the justices and their final verdict, it is not easy to discover what was deemed then to be the truth of the matter.

Apparently, Tassi went to great lengths to see Artemisia, who was kept, as most Roman women of marriageable age were kept, in seclusion. He contrived to get a sight of her, and then to visit her with the connivance of her chaperone, one Tutia, of whose son Artemisia was painting a portrait. He visited her on a second occasion and, despite her spirited resistance during which she drew blood from her assailant, he overpowered her and raped her.

In his complaint, Orazio said that the offence was repeated *piú e piú volte*, which has occasioned some sneering at him and his unfortunate daughter. What Orazio was anxious to establish was that Tassi deflowered his daughter under promise of marriage, that she understood herself to be betrothed when in fact she was dishonoured – in Orazio's term *assassinata*. Her father's letter to the Grand Duchess of Tuscany, beseeching her to counteract the effects of Lorenzo's intercession on Tassi's behalf, made it clear that at the time of the defloration neither he nor Artemisia knew that Tassi already had a wife. The *nozze di riparazione* were then, as now in Southern Italy, the acceptable sequel to the ravishment of a virgin, a survival of the ancient custom of marriage by capture. The man and woman involved in such violent wooing might continue in intimacy until a marriage ensued. The fact that Tassi took paintings from the house indicates that he was allowing himself the privileges of a prospective member of the family and one entitled to dowry.

It is not easy to disentangle the chronology of these events. Artemisia may have been only fifteen when Tassi raped her, as Gentileschi suggested in his deposition, and the offence may have been committed before Tassi was arraigned on an accusation from his sister Olimpia that he was committing incest with his wife's sister. However, Orazio explained to the Grand Duchess that he himself had helped Tassi to beat that rap, so by then he must have known that Tassi had a wife. He could only have

supposed that Tassi would marry Artemisia if he believed the rumour, which was also repeated in court, that Tassi had arranged for his wife's murder. By the time he wrote to the Grand Duchess, he seemed to have considered that Tassi's wife was living, for he called her, her sister (Tassi's mistress) and Tassi's three sisters, prostitutes. He claimed also that Tassi had a brother who was hanged and another brother banished for procuring sodomites.

The unavoidable conclusion is that the society of artists among which Tassi and Gentileschi moved was lawless and unsavoury. Once she was deflowered by Tassi, Artemisia was exposed to the intrigues of this group, for Tassi took her on picnics in the Campagna in company with his sister-in-law and her notoriously obliging husband. The only way he could escape the *nozze di riparazione* was to make a whore of her, and his drinking companions were only too willing to oblige. One in particular, Tassi's hanger-on, a repellent individual called Cosimo Quorli, tried to arrange a gang rape.

Orazio Gentileschi was an old hand at litigation. He must have known that patronage was more relevant than guilt or innocence and yet he wilfully exposed his daughter to torture and the risk of disgrace. It would have to be proved that she was a virgin before and that she had not become a whore since Tassi had deflowered her. She was subjected to the thumbscrew in front of Tassi, to whom she cried out, 'This is the ring and these the promises you gave me.' She did not alter her story but Tassi and his friends, some of whom were subjected to torture, were equally resolute in insisting that she was a whore. After five months of sleazy revelations the trial ended and Tassi was released from gaol.

During the trial, Artemisia had had one champion, who protested against the frivolous and cynical way that Tassi and his cronies had ruined her life. He was a Florentine, Giambattista Stiattesi, a very intimate friend of Tassi's, to judge from some erotic poems produced in evidence as having passed between them. A month after the trial ended, Artemisia was married in the church of Santo Spirito in Saxia to one Pietro Antonio di Vincenzo Stiattesi. Of her married life we know very little.

The abortive trial had left Artemisia nothing but her talent. It also removed the traditional obstacles to the development of that talent. She could no longer hope to live a life of matronly seclusion: she was notorious and she had no chance but to take advantage of the fact. She was probably in love with her rapist, for Tassi's charm is evident in the loyalty that he excited in all kinds of people. He was a dashing figure, handsome and

black-bearded, often to be seen on horseback and sporting a golden chain in defiance of the sumptuary laws. Artemisia did not choose to dwell upon her disappointment. She refused to deal in pathos and the softer emotions, and, as a result, alienated all those critics and historians of art who nurture the usual presuppositions about women. She developed an ideal of heroic womanhood. She lived it, and she portrayed it. It was not as crassly misunderstood in her own lifetime as it has been ever since.

(Germaine Greer, 1979)

Gerald Wilde, a brilliant and erratic Soho artist of the 1940s, is recalled by a fellow victim of Sohoitis (the inability to leave that square mile of London, with a corresponding inability to do much work at all).

Entering the pub one October evening in 1943 I was immediately confronted with Tambimuttu [James Meary Tambimuttu, editor of *Poetry London* and a notable figure in bohemian and literary circles at this time] who, thrusting towards me someone else's hat upturned, exclaimed: 'Ah Julian, just in time to contribute to the cause. I am getting up a fund for Gerald Wilde the Mad Artist, he's starving and with no money, you know?'

I'd never until then heard of Gerald Wilde the Mad Artist, but I put something in the hat and was then introduced to the Mad Artist himself: sitting at a table guarded by Tambi's supporters, with only a glass of mineral water before him and seeming not noticeably insane: just pale, dispirited and sad.

He sat motionless, without speaking, until Tambi had been all round the pub collecting; then stretched out wordlessly a hand, trembling no doubt with hunger, towards the hat which jingled by now with coins and silver. Tambi slapped the hand reprovingly, as one who corrects a too presumptuous or greedy child, and Gerald Wilde relapsed remonstrating in a rapid inaudible mutter, this incipient mutiny being quelled at once by a glance from Tambi's celebrated eyes.

'Gerald's on the wagon, you know?' he told me. 'It's not good for him to drink and he has work to do. Gerald!' he like a lion tamer shouted and Wilde shrank back cowed: 'Gerald go back to the flat and paint. Steven you go too, lock him in, bring back the key. I will return later Gerald with some food.' He pointed with a prehensile finger fiercely to the door and Wilde obediently rose and shuffled out, the tails of a grey overcoat too long for him trailing far below his calves.

Steven followed and Tambi watched the pub door close behind them, his pose gradually relaxing as might that of a tamer whose lion has gone successfully through the flaming hoop.

'Lock him in?' I said incredulously.

'Yes, you must be severe with Gerald, a firm hand you know,' Tambi told me. 'If you give him money he buys drink with it, then he's drunk and does not work,' buying a round himself with money taken from the hat. 'But I am keeping him a prisoner now, locked in my flat, he can't get out to drink so he is painting much.'

'Hasn't he a studio of his own?'

'No no, he has no place not even to sleep, so I am putting him up, he has brushes, paint and canvas there, all he needs to work.'

'Is he really any good?'

'Good? He is a genius, Kenneth Clark says so, you know who is Kenneth Clark? Well a White Hope he says, you know? But soon we will hold a Gerald Wilde exhibition, then you'll see,' and soon, too, the hat was empty and Tambi once more reverted to his regal state of not having money on his person.

It was closing time by then and Steven had returned with the flat key, reporting that Gerald Wilde was safely locked in after two attempts to escape into pubs on the way and obtain credit therein.

Tambi said: 'Let us go to the Coffee An' [a Soho eating spot] and there eat steak.' Steven's eyes lit up and at the Coffee An' Tambi insisted that all of us scrape a portion off our plates into a paper bag which he pulled from his overcoat pocket, scattering several MS poems from contributors in the process; then he toured the cellar as he had earlier the pub, proffering the bag instead of the hat and demanding: 'A donation of food, please, for Gerald Wilde the Mad Artist who is starving you know?'

The idea of a Mad Artist, and starving what's more, appealed strongly to the tourists who in those days flocked to the Coffee An', and the bag was speedily filled to bursting: the response indeed being so big that Tambi was emboldened to go round for a silver collection with yet another hat, the contents of which paid the bill for steaks eaten by himself and his supporters (I don't know if either of the owners ever got their hats back).

But outside the Coffee An' Tambi lost his temper suddenly and flung the bag of food at the head of one of the supporters who'd been slow off the mark in executing some command: however, enough steak and chips was recovered from the pavement to assuage the appetite of Wilde, by

now presumably paint-stained and ravenous locked in Tambi's flat.

Tambi was ceaseless in his vigilance at this time, reporting to us regularly the progress of his protégé and the increasing number of paintings that had got done; and a show was being arranged – when, alas, all came to naught.

One Friday Tambi went away for the weekend, leaving Gerald locked in as usual. Unfortunately it proved to be a long weekend . . . anyhow on the following Tuesday he returned to find the flat door open and askew upon its hinges, a chair lying shattered on the floor near by, and all his books gone from the shelves. Nor, needless to say, was Gerald Wilde inside: also all his paintings and painting gear had gone.

What had happened was this. Gerald, feeling hungry after four days without food (Tambi on his own admission having forgotten to lay any provisions in) got tired of painting: the creative impulse needed a refuel so first he collected Tambi's books in a kitbag which some PL [*Poetry London*] contributor from the Forces had left behind in the flat, then he gathered together canvases and painting gear, then smashed in the lock having telephoned for a taxi, and descended to the waiting cab, which he directed to Subra's bookshop.

When Subra had bought the books, Gerald got back into the cab and was next seen eating and drinking in cafés and pubs belonging to a different area.

Subra had to give back all the books (as happened with someone's Gauguin souvenirs sold by Manolo the Spanish sculptor on a similar occasion described by Alice B. Toklas, which is doubtless where Wilde got the idea), but both he and Tambi forgave Gerald freely ('You know how it is,' they said, 'when you're with no money') and Tambi even went on trying to help him whenever possible with commissions for book jackets etcetera (I think, though I wouldn't be certain, that Gerald was responsible for the cover design of *Chums*, the omnibus *Poetry London*).

But the prospective show had to be abandoned, for Gerald had either sold the paintings in order to prolong the bender that he'd embarked on or simply given them away to strangers in the pub because he was sick of carting them around. He himself could not remember, and that particular relationship with Tambi came to an end: Tambi couldn't in any case continue to lock him in because the door was never repaired: and the shattered chair, left lying on the floor of the flat like the relic of a crime reconstructed in a museum, was seen there by many visitors and caused

Gerald to acquire a quite undeserved reputation for violence, adding to the legend of his madness already blazoned forth by Tambi.

It may be for these reasons that his overcoats were always so long: perhaps they were given to him by very big men met round the pubs; it's inconceivable to imagine Gerald actually buying an overcoat of his own and, owing to the stories that were current, only outsize men would have had the courage to invite him home where they had overcoats to spare. Since I've known him he has had three overcoats, one grey tweed, one black (with a large rent just below the collar) and one dark brown, which is the one I last saw him wearing though he wore the black one with the rent for a very long time. All three overcoats had cuffs coming down over the knuckles though his arms were long. I have also seen him wearing a pink shirt and he never appeared without a bootlace tie, usually black and turned partly inside out.

He was not tall, had sloping shoulders and a long neck, his spade-shaped face was also long and his head flat at the back. There used to be a portrait of him by Wayland Dobson in the window of Subra's bookshop, showing Gerald with a scarlet face and one eye about to burst from its socket, to symbolize the feeling of something frustrated, shut in, but about to break out which is present in his own work: arrangements of bold colour patterns in the depths of which some form, not necessarily human, can be dimly discerned attempting to emerge. Dobson's portrait therefore was a better likeness than one more representational would have been, though in fact Gerald's skin was extremely pallid and he showed signs when I first knew him of once having had ginger hair.

His hair now was brownish, carefully brushed back but often growing long on the nape though with a tonsure on top, his lips, eyelashes and eyebrows were almost colourless and his eyes also pale, large and salient, one of them indeed protruding outwards and not quite in alignment. He spoke when sober in a subdued gentle voice, not easy to hear unless one knew him well, and when drunk in a loud slurred inarticulate shout.

Gerald was not a drunkard nor anything approaching it, but alcohol, especially spirits, affected him with extraordinary speed and after a glass or two of Scotch he would begin to whirl his arms with a curious clockwork motion as if drink wound up some mechanism inside him. His speech became incoherent and his movements jerky but rapid like those of a lizard. He never lost the use of his legs. Later would come the stage of staggering and clutching painfully at people's arms while shouting

imaginary grievances into their faces, if he could reach up far enough or they were sitting down.

He developed a persecution complex, not apparent when he wasn't drinking, part of which centred round policemen who, he was convinced, were out to insult if not actually to molest him. In fact they behaved good-humouredly when he got into their hands and in Oxford, where he speedily got to know the whole of the force, would indeed lead him back to where he was staying after a cup of tea at the station, instead of shutting him in a cell or beating him up as he dared them to.

After he got to the shouting and staggering stage few landlords would have him in, and I have seen him many times burst through one door of a double-entrance pub and promptly be ejected, then immediately reappear in the second doorway, same result: a performance he could keep up, scuttling from door to door, for hours, not getting a drink in consequence and ending the evening almost sober.

This happened only when he sold a picture and had, as he would put it, the wherewithal. At other times he was a quiet charming companion with beautiful manners, fond of reading and the cinema: I remember him telling me once of seeing at some film society an unexpurgated version of Pabst's *The Love of Jeanne Ney* which showed, during the orgiastic sequence, a close-up of a Tsarist officer's prick. Gerald was very disappointed since, this being such an unusual sight on the screen, he had not recognized what it was until told by the man sitting next him, by which time the prick had been flashed off.

He was capable of working for long hours with immense concentration whenever he had somewhere to paint in and sometimes talked of holding an exhibition, not as any painter might but as if consciously indulging a fantasy or recounting a daydream. For he knew that, when enough work was done, he would again sell the canvases for nugatory sums when drunk or simply give them to any bystander who showed appreciation, which he once said gave him a feeling of being liberated.

The sense of imprisonment conveyed by his painting was certainly very strong and perhaps of psychological origin since Gerald found the greatest difficulty in understanding the sources of his confusion and was not a ready talker. Perhaps it was the vision of his own interior chaos that was struggling to break through the cryptic coloured patterns that enclosed it, as he had broken out of Tambi's flat.

(Julian Maclaren-Ross, 1965)

A bohemian in seventeenth-century Amsterdam.

This painter, different in his mental make-up from other people as regards self-control, was also most extravagant in his style of painting and evolved for himself a manner which may be called entirely his own, that is, without contour or limitation by means of inner and outer lines, but entirely consisting of violent and repeated strokes, with great strength of darks after his own fashion, but without any profound darks. And that which is almost impossible to understand is this: how ever he, painting by means of these strokes, worked so slowly, and completed his things with a tardiness and toil never equalled by anybody. He could have painted a great quantity of portraits, owing to the great prestige which in those parts had been gained by his colouring, to which his drawing did not, however, come up; but after it had become commonly known that whoever wanted to be portrayed by him had to sit to him for some two or three months, there were few who came forward. The cause of this slowness was that, immediately after the first work had dried, he took it up again, repainting it with great and small strokes, so that at times the pigment in a given place was raised more than half the thickness of a finger. Hence it may be said of him that he always toiled without rest, painted much and completed very few pictures. Nevertheless, he always managed to retain such an esteem that a drawing by him, in which little or nothing could be seen, was sold by auction for 30 scudi, as is told by Bernardo Keillh of Denmark, the much-praised painter now working in Rome. This extravagance of manner was entirely on a par in Rembrandt with his mode of living, since he was a most temperamental man and despised everyone. The ugly and plebeian face by which he was ill-favoured, was accompanied by untidy and dirty clothes, since it was his custom, when working, to wipe his brushes on himself, and to do other things of a similar nature. When he worked he would not have granted an audience to the first monarch in the world, who would have had to return and return again until he had found him no longer engaged upon that work. He often went to public sales by auction; and here he acquired clothes that were old-fashioned and disused as long as they struck him as bizarre and picturesque, and those, even though at times they were downright dirty, he hung on the walls of his studio among the beautiful curiosities which he also took pleasure in possessing, such as every kind of old and modern arms – arrows, halberds, daggers, sabres, knives and so on – and innumerable quantities of exquisite drawings, engravings and medals,

and every other thing which he thought a painter might ever need. He deserves great praise for a certain goodness of his, extravagant though it be, namely, that, for the sake of the great esteem in which he held his art, whenever things to do with it were offered for sale by auction, and notably paintings and drawings by great men of those parts, he bid so high at the outset that no one else came forward to bid; and he said that he did this in order to emphasize the prestige of his profession.

(Filippo Baldinucci, *c*.1681)

The Italian painter Amedeo Modigliani, tubercular, alcoholic and drug-addicted, was as bohemian and doomed as it is possible to be. Here he is remembered by four of his friends and contemporaries.

[The painter Maurice Vlaminck:]
'I can see Modigliani now, with his imperious gaze, sitting at a table at the Rotonde, the nervous fingers of his intelligent hand tracing the features of one of his friends without pause and in a single unbroken line. When he had finished the sketch he would present it as a reward to the subject . . .

'With a grand gesture, as if he were some millionaire distributing largesse, he would hold out the drawing, which he would sometimes sign, as though he were paying with a large banknote for the glass of whisky he had just been treated to . . .

'I knew Modigliani well. I knew him when he was hungry. I have seen him drunk. I have seen him when he had money in his pocket. But in no instance did I ever find him lacking in nobility or generosity. I never knew him to be guilty of the least baseness, although I have seen him irascible and irritated at having to admit the power of money, which he scorned but which could so hamper him and hurt his pride . . .

[The Japanese-born painter Foujita Tsugouharou, invariably known as 'Foujita':]
'I met Modigliani for the first time towards the end of 1913. By a coincidence he, Soutine and I lived for a while in the same place: 14 Cité Falguière, which is in that section of the Rue de Vaugirard just beyond the Boulevard Montparnasse. It had a wide entrance on the Rue Falguière and you went through a court to a small door at the back which led to our studios. You had to cross a sort of bridge, like the approach to a

medieval fortress, though the building itself was anything but fortress-like. Soutine and Modigliani had studios on the ground floor, opposite each other. Mine was on the first floor, and it looked out on a wall on either side.

'At that period Modigliani was spending most of his time on sculpture; he did no painting and made only pencil drawings. He always dressed in corduroy, and he wore checked shirts and a red belt, like a workman. His thick hair was usually tousled. He drank a great deal of Pernod and often did not have enough money to pay for it. When people invited him to have a drink at their table, he would do sketches of them and then give them the drawings by way of thanks. He had a habit of scowling and grimacing a good deal, and he was always saying "Sans blague!" ("No kidding!") He seemed to like me very much. We were both fond of poetry, and every time he came to see me he recited a poem by Tagore that he had found in a magazine. After we became neighbours he would come and talk to me in my studio about the art of the Far East. He was most interested in the art of China and Japan, but not at all in Negro art, which so many people were talking about at that time.' . . .

[The writer André Salmon:]

As Chaim Soutine was also a neighbour of Modigliani's in the Cité Falguière, it was not long before they became great friends. As a result, Modigliani became involved in an incident connected with an ox carcass which the Russian painter used as a model for one of his most startling canvases. Soutine's idea of doing a painting of such a subject undoubtedly derived from a neurosis for which poverty and undernourishment were partly responsible, but the more he thought about it, the more determined he became to undertake it. He must have subjected himself to endless sacrifices and privations, and it seems incredible that he finally managed to scrape together enough money to pay the butcher for the carcass. As he worked very slowly, it was inevitable that the meat, which was hanging from the rafters of his studio, should begin to decay long before the picture was finished. The situation became impossible for him, not to mention everyone else within smelling distance, for the odour spread not only throughout the entire Cité Falguière but also the quarter round about. It was imperative to get rid as soon as possible of the foul object and the hordes of flies it attracted. But how? The huge carcass could not be thrown into the dustbin like a dead cat. The only solution was to get it out of the house at night and dispose of it elsewhere, and the story

goes that it was Modigliani who helped to carry it – heaven knows where . . .

With Soutine, Modigliani had been fast friends almost from the day they met. He admired the Russian's vigorous talent, and he enjoyed talking with him in the dreary surroundings of the Cité Falguière. He painted a striking, if disconcerting portrait of Soutine in 1918, showing his subject as a strong and resolute man, but with a bewildered expression on his face. Soutine had in fact large, beautiful eyes, but they were half closed most of the time in a sort of inexplicable somnolence. His nose was prominent and fleshy and had flattened nostrils; his mouth was weak, and his lips thick. The picture was a good enough likeness but it was an improvement on the original, for it must be admitted that in real life Soutine was far from physically prepossessing. He was for many years a living monument to filth. His face was hardly ever washed, especially during the great days of the Cité Falguière; as for his person, the odour it gave off might easily have been compared to that of his rotting ox carcass.

Chaim Soutine was a man of extremes. He was unperturbed by his lack of cleanliness; on the contrary, he seemed rather to enjoy it. He was naturally slovenly, and it was the lack of amenities in the Cité Falguière, which his neighbours suffered in silence, that explained his distaste for bodily hygiene. His studio was in such a constant state of disorder that the most energetic charwoman imaginable could have done little with it. Yet in the midst of his squalor he never ceased to dream of comfort and luxury, while avoiding even an occasional bath or the cleaning of his ears and nails.

Modigliani was just the opposite. He was so particular about his person that it would have amazed everyone if he had failed to appear clean-shaven in public. He washed and groomed himself regularly even in the coldest weather, whether hot water was available or not. Yet he was as unconcerned about Soutine's stinking body and lair as their owner was. His friend had enormous talent and he possessed the ability of demonstrating it, so to speak, even in his conversation – something not given to all talented artists. In Modigliani's eyes that made up for all the rest, and he derived the greatest satisfaction from the long talks he and Soutine had together . . .

[The sculptor Ossip Zadkine:]
'We never argued with each other; we never talked about sculpture; and often, after some remark of mine, he would break out into a clear, ringing

laugh. He worked at his sculpture during the day in a shed next to his studio, and at night he sketched in the cafés. The forms of the heads he planned to do in stone were first worked out in his sketches, which he outlined heavily in black or blue. You had the feeling of watching a master-draughtsman who *thought in stone*.

'I would watch his progress, and little by little I would see the oval of the head lengthen and become reduced to sharp angles. The nose took on the shape of a fine blade, bent back at the tip. The lips would practically disappear. The olive-like eyes seemed to protrude more and more, as though they were about to burst from the stone.

'I remember how sorry I felt for him as I studied one of his caryatids which was just emerging from the stone block, for the modelling and volumes were blurred and seemed lost in uncertainty and hesitation. It was as though the initial upsurge of the idea that he was trying to express had escaped him, and in his hesitation he had coarsened the volumes instead of making them purer and finer. Some new problem seemed to have taken hold of Modigliani's tormented mind. It was during this period that I became more and more convinced that his talent as a sculptor was waning, and that he was aware of it . . .

'The handsome young man to whom Zarate had first introduced me was very much changed by this time. His face was ravaged by the quantities of cheap wine he had drunk and all the hashish he had absorbed. His well-shaped chin often went unshaven now, but his thick hair still hung in curls over his fine forehead, which as yet showed no sign of wrinkles.'

(André Salmon, 1961)

In an interview with the art historian Germain Bazin, Vuillard recalls his friend Toulouse-Lautrec.

It was in 1892 or 1893 that Vuillard met Lautrec. 'Bonnard and I had a little studio in the rue Pigalle. The *Revue Blanche* brought us all together – painters, critics, singers, writers – the whole Montmartre group.'

I asked if Degas was often in their company. 'No, Degas was very much a man on his own and very difficult to see. But Lautrec idolized him. When they first met, Degas looked at his canvases and said "Well, Monsieur, I can see that you're one of us." No tribute could have pleased him more. I remember how Lautrec gave a characteristic proof of his regard for Degas. It was in 1898 or 1899. Lautrec wanted to thank our

friend Thadée Natanson for having us to stay at Villeneuve-sur-Yonne and he decided to give one of the gigantic dinners which were his speciality. He knew all the best dishes from all the best restaurants in Paris. Nothing was spared to give the luncheon a truly royal character. Lautrec had even brought some bottles of wine from his mother's cellar. At the end of the meal we were all in a highly excited state and we began to wonder what could possibly round off such a feast. Lautrec got up in the spur of the moment and led us off, without a word as to where we were going. We followed him with some apprehension all the way to the Dihaus' in the rue Frochot. Lautrec hauled himself up three flights of stairs to their apartment. Barely stopping to greet the Dihaus he led us up to Degas's painting *Dihau Playing in the Orchestra at the Opéra* and said "There you are – that's the dessert!" He could imagine no more wonderful treat to round off the meal than the sight of a Degas. So I can tell you that when I hear people disparage Degas by way of praising Lautrec I can imagine just how furious Lautrec would be.

'Degas and Lautrec rarely saw one another. Once or twice at the Dihaus', perhaps. They didn't move in the same circles – "the dance" meant the Opéra for Degas and the Moulin Rouge for Lautrec. And as you know Lautrec kept very odd company . . .

'Yes, that prude Joyant said it was to be able to study the female nude quite freely and naturally instead of using professional models.

'It was much more complicated than that. Lautrec loathed hypocrisy, and quite possibly he did go, quite openly, in search of first-hand experience. But the real reasons for his behaviour were moral ones . . . Lautrec was too proud to submit to his lot, as a physical freak, an aristocrat cut off from his kind by his grotesque appearance. He found an affinity between his own condition and the moral penury of the prostitute. He may have seemed cynical, but if he seemed so it was from an underlying despair. Though the most fastidious of men, he couldn't stay sober. Every night he was out with his boon companions – Maxime Dethomas and Romain Coolus were their chief representatives – going from bar to bar till at last they had to carry him home. I can only interpret his drunkenness as a deliberate act of suicide.

'I was always moved by the way in which Lautrec changed his tone when art was discussed. He who was so cynical and so foul-mouthed on all other occasions became completely serious. It was a matter of faith with him.

'He dreaded being alone. His friendship was tyrannical and brooked

no obstruction. Few men were more genuinely liked, by the way. Poor Lautrec! I went to see him one day in the rue Frochot, just after he had been put in a home in Neuilly. He hadn't long to live. He was a dying man, a wreck. His doctor had told him to "take exercise", so he had bought a gymnasium-horse – he, Lautrec, who couldn't even get his feet on the pedals! A cruel irony – and yet it symbolized his whole life.'

(Germain Bazin, 1931, in John Russell, 1971)

Picasso's mistress of the early Cubist years recalls the climax of Monmartrean bohemianism of the day – the great banquet in honour of Henri 'Douanier' Rousseau. But first, she describes her meeting with the Douanier.

One fine day we made the acquaintance of 'Douanier' Rousseau. Apollinaire had been invited round by him one evening and he suggested that we accompany him on the next occasion.

The *douanier* lived in a sort of studio, near to the Rue Vercingétorix. He was a nice, slightly stooping man, who pottered rather than walked, with grey hair still thick despite his sixty-five years and with the appearance of a small-time tradesman. His startled face shone with kindness, though he could easily get quite purple in the face if he was annoyed or put out. He generally agreed with everything that was said to him, but one had the feeling that he was holding himself back and hadn't the courage to say what he was thinking.

When we arrived at about nine, two or three couples, dressed in their best clothes, were sitting bolt-upright on chairs packed into rows as if they were in some lecture hall. They were the bakers, grocers and butchers of the neighbourhood. At the back of the room was a platform.

The guests began to arrive one by one. To avoid a bottleneck Rousseau insisted that they sat down as soon as they came in. He sat on a chair near the door, like a programme seller in a theatre. When everybody had arrived the evening began.

There were lots of painters, writers and actors there: Picasso, Duhamel, Blanche Albane, Max Jacob, Apollinaire, Delaunay and a few Germans were crushed amongst the local tradesmen and Rousseau's personal friends. Suddenly Rousseau leapt onto the platform and played a little tune on the violin to get things going. Immediately after this other people appeared and sang ridiculous songs accompanied by theatrical gestures, or recited

interminable monologues. Rousseau was absolutely delighted with it all and as we left he said: 'There's a successful evening for you!' . . .

Not long after that evening Picasso decided to organize, at his own expense and in his studio, a banquet in honour of Henri Rousseau. The project was received enthusiastically by the gang, who were overjoyed at the prospect of pulling the *douanier*'s leg.

They planned to invite thirty people, and all those who wanted to come after dinner would be allowed to.

Unforeseen incidents were to add to the effect of this party. The decorations were ready, branches concealed columns and beams and covered the ceiling. At the end of the room, opposite the big high window, was the seat intended for Rousseau: a sort of throne, made from a chair built up on a packing case and set against a background of flags and lanterns. Behind this was a large banner bearing the words: 'Honour to Rousseau.'

The table was a long board set on trestles. The chairs, plates and cutlery had been borrowed from our local restaurant, Azon's. Thick glasses, small, heavy plates and tin knives and forks: but nobody bothered about such things.

Everything was ready, the guests crowded into the studio, which was soon far too small to hold them all; but at eight o'clock the dinner, which had been ordered from a caterer's, was still not there. It didn't arrive until the next day, at noon!

We went off to rustle up something from the cake shops and restaurants round about, while the guests, who had gone back to the bar, drank more apéritifs to the encouraging sounds of the pianola.

It was at that point that poor Marie Laurencin ('Coco' to her friends), who was just making her début in this artists' world, became the object of determined attentions from some of the guests who had decided to make her drunk.

It was not difficult. The first thing she did when she came back into the studio was fall onto the jam tarts which had been left on a sofa, and, with her hands and dress smothered in jam, start kissing everybody. She got more and more excited, and then found herself quarrelling with Apollinaire, until finally she was rather brutally packed off to mother.

At last we all sat down.

Rousseau, who thought the food had arrived, installed himself gravely

and tearfully on the dais that had been erected for him. He drank more than he was used to and finally fell into a peaceful sleep.

There were speeches and songs composed especially for the occasion; then a few words from Rousseau, who was so moved that he spluttered with pleasure. Indeed, so happy was he that he accepted with the greatest stoicism the regular dripping of wax tears on to his brow from a huge lantern above him. The wax droppings accumulated to form a small pyramid like a clown's cap on his head, which stayed there until the lantern eventually caught fire. It didn't take much to persuade Rousseau that this was his apotheosis. Then Rousseau, who had brought his violin, started to play a little tune.

What a colourful evening that was! Two or three American couples, who had got there by accident, had to make the most excruciating efforts to keep a straight face. The men in their dark suits and the women in pale evening-dresses seemed a bit out of their element amongst us.

The wives and mistresses of the painters were wearing simple little dresses of undeniable originality. Madame Agero looked like a schoolgirl in a black smock. Her husband hadn't a care in the world, and though he probably imagined he was taking it all in he seemed to be oblivious of everything. There were the Pichots, the Fornerods, André Salmon and Cremnitz, who at the end of the evening did an imitation of *delirium tremens*, chewing soap and making it froth out of his mouth, which horrified the Americans. Jacques Vaillant, Max Jacob, Apollinaire and Leo and Gertrude Stein were there, and many, many others.

After dinner, most of Montmartre trooped into the studio, and those of them who simply couldn't stay consoled themselves with snaffling the petits fours and anything else within easy reach. I actually saw one man stuffing his pockets, although my eyes were glued to him. Rousseau had sung his favourite song: 'Aïe, aïe, aïe, que j'ai mal aux dents . . .' but he couldn't finish it and dozed off, snoring gently. Occasionally he woke up with a jerk and pretended to take an interest in what was going on around him, but he couldn't keep it up for long, and his head would flop back onto his shoulder. He was charmingly weak and naïve, and touchingly vain. He remembered that dinner with emotion for a long time afterwards, and the good man took it in good faith as homage paid to his genius. He even sent a sweet letter to Picasso, thanking him.

It was some time after that that Rousseau, twice a widower, became engaged to be married for the third time. His self-respect was greatly wounded by his future father-in-law, who thought him too old for his

daughter. She was, in fact, fifty-nine. Rousseau must have been a little over sixty-six. As for the father-in-law, he was eighty-three. Rousseau was desolated by the fact that his fiancée would not act against her father's wishes. He was quite cast down by this:

'One can still be in love at my age without being ridiculous. It's not the same sort of love as you young people go in for, but must one resign oneself to living alone, just because one's old? It's dreadful going back to lonely lodgings. It's at my age that one most needs one's heart warmed up again and the knowledge that one won't have to die all alone and that perhaps another old heart will help one's passing to the other side. It's not right to laugh at old people who get married again; you need the company of someone you love when you're waiting to die.'

He said all this in a soft, tearful voice. He hadn't the time, as it turned out, to put all this into practice: he died alone, in hospital, a few months later.

One more story to illustrate his naïveté: I was talking to him one day about the canvas which Picasso had bought from Père Soulier – the woman at the window, which I described earlier. As I'd always thought that that window looked out on to a mountain landscape in Switzerland, I said to Rousseau, 'I suppose you were in Switzerland when that picture was painted?'

He looked reproachfully at me as if I were laughing at him.

'Oh, come on,' he said. 'Don't you recognize the fortifications of Paris? I did that when I was working in the customs and I was living near the —— gate.' I've forgotten which gate it was.

(Fernande Olivier, 1933)

A night in the Cedar Tavern, the New York haunt of the Abstract Expressionists, among them Jackson Pollock and Franz Kline.

JUNE, 1956. AT THE BAR.
Franz pointed to the men's room. 'See the door there?'

I nodded. He said,

'Notice it isn't very straight on its hinges.'

I saw the door wasn't set in straight. Franz said,

'One night, Jackson ripped it off its hinges.'

Jackson was a husky man, maybe six two with long arms and huge powerful hands. His head was square, with a large clear forehead and a

small dome; his heavily lined eyes sharply displayed his emotions – his whole face was expressive, as was his body. His bearlike size and strength made him fluidly hard to keep up with, or track of, as he changed in a matter of seconds hoping to be followed, or met. It was his game and pleasure. He'd dance in laughter, cringe in withdrawal and return rapidly angrily bright-eyed.

I was sitting at the bar having a beer, and I heard John, the bartender, murmur.

'Oh. No.'

In the small square window of the red front door, I saw a part of Jackson's face; one brightly anxious eye was peering in. John walked down the duckboards towards the end of the bar near the door, and stopped, put his left fist on his hip, and extended his right index finger at the small window. He shook his head. The eye looked hurt. John was tight-lipped. I was laughing.

The eye disappeared.

John muttered out of the corner of his mouth and he is a man who can mutter out of the corner of his mouth,

'He'll be back.'

We watched the square window.

Jackson's eye popped in.

'NO!' John yelled. 'YOU'RE 86 [presumably banned from the bar] JACKSON!'

The eye was sad and puzzled. Me 86?

The eye got angry. Jackson's face slid across the window; then his whole face was framed by it; mask of an angry smile.

'NO!' John shouted, shaking his head. 'Beat it!'

Jackson's eyes became bright, and he smiled affectionately. John shook his head.

'Whaddya gonna do? I can't say no to the son of a bitch.'

He sighed. 'All right!' he cried, and pointed to the window, wagging his finger, 'But you've got to be GOOD!'

The door opened and Jackson loped in and they faced each other over the corner of the bar. Jackson had a happy friendly smile. John jabbed a finger in his face.

'Remember – one trick and you're finished.' John leaned forward. 'Do you get that? No cussin', no messin' with the girls –'

Jackson said, darkly,

'Scotch.'

With the drink in his hand Jackson left John angrily wiping the bar; and as I was the only one at the bar that Jackson vaguely recognized, he made his way toward me, looking intently at me. You never knew. When he got to the empty stool beside me he put his hand on it and a little stooping gave me his flickering friendly Rumpelstiltskin smile,

'Okay if I sit here?'

I stammered sure Jackson sure, and in my apprehension rather compulsively arranged the pack of matches exactly in the centre on top of a new pack of cigarettes. Jackson watched me, and glanced down at my neat arrangement, and then at me, then at the cigarettes; then at me. He gravely shook his head. Wrong. He crushed my smokes and matches in his left hand.

He gazed back where people sat at tables, eating supper. Many of them were watching him. It was the right beginning for another eight-cylinder Monday night. They had come from the Bronx, from Queens, from New Jersey and from the Upper East Side to eat at the Cedar and wait until Jackson finished his fifty minutes with his analyst, and came down to the bar to play. Jackson walked by each table glaring down at them. They trembled. Pity the poor fellow that brought his date in for supper, for Jackson was happy to see her. He immediately sat beside the fellow, glared nastily at him and then gave his full crude nonsensical attention to the girl while the fellow said – something – timidly – 'Say, now just a minute –' Jackson turned to him, and looking at the poor guy with a naughty smile, swept the cream pitcher, salt, pepper, parmesan cheese, silverware, bread, butter, napkins, placemats, and drinks on the floor, while waiters screamed, John shouted, Jackson leaned toward the guy with an expression as if to say, how do you like that?

We all got a little of it. But Franz was the real one who gave it back, and then some. One time Franz and Nancy were sitting at the bar, talking, and unaware Jackson was behind them, staring at Franz. Jackson grabbed Franz by the hair and threw him backwards off the barstool onto the floor. Franz got up, straightened himself, glanced at Jackson, and said,

'Okay Jackson, cut it out.'

Jackson had backed away, slightly stooped, head thrust forward, eyes bright. He was so happy he glittered. After Franz had sat down Jackson did it again.

'Jackson!' Nancy cried.

But when Franz got up the third time, he wheeled, grabbed Jackson,

slammed him up against the wall and let Jackson have it in the gut with a hard left-right combination. Jackson was much taller, and so surprised, and happy – he laughed in his pain and bent over, as Franz told me, whispered, 'Not so hard.' . . .

One night in the bar Jackson whipped off Franz's hat, crushed it, and tossed it up, out of reach on the shelf which overhung the bar. Franz was angry and laughing; Jackson was happy. One night shortly thereafter, Jackson appeared at the bar with a brand-new bowler hat on, and when he reached Franz, he glared at him, took off the bowler, crushed it and tossed it up on the shelf . . .

(Fielding Dawson, 1967)

Drunk, dead-ended as a painter, Jackson Pollock met a sad end. At the end of 1956, aged forty-four, he died in a car crash.

How long can a man face an empty canvas? How long can he look at himself in one? How long before he needs a drink? How long before he flees the studio?

Jackson had often said to his wife, 'Painting is no problem; the problem is what to do when you're not painting.' He used to say that in the early days when the barn was simply too cold to paint in or the light inadequate. Now, even with a good stove or even in the summer (which had always been the season in which he worked best), he could have said it – he could have said it any time and all the time.

The painter Conrad Marca-Relli, a neighbour and close friend of Pollock's during the final years, has described Jackson's going to the studio in the morning and lighting the stove, even long after he had stopped painting. Marca-Relli asked him why he did this, why he wasted the time, and the cost of fuel. Jackson replied, 'I light the stove so the studio will be warm in case this is the day I can start to paint again.'

(B. H. Friedman, 1973)

The English painter Roger Hilton describes his life and art in his final years. He died in 1975, the year after this letter was published, aged sixty-four.

Because I have peripheral neuritis I have largely lost the use of my legs, the arms and midriff are going. I have a skin condition which is driving

me mad. All this is caused by alcohol. The usual vicious circle. You have to move to cover up the pain that this creates.

I say this to show how, being bed-ridden, I fell back on gouaches. I use paper and poster paints. Throughout my life I have maintained that you do not need complicated and expensive apparatus to produce a work of art. You could go in the back yard and scrape up some mud and put it on some board the builders had left behind: art, by and large, is in the mind. I have been left-handed from birth, but because I lean on my left hand, I have been forced to paint with my right. I am tobogganing down a downhill slope. Since Dec' 1972 I have produced 3 to 5 gouaches a day, now valued at a considerable sum. I will leave out the whole question of art politics. No Kissinger me.

I have principles, connected with this new medium. 1. Never rub out or attempt to erase; work round it, if you have made a mistake. Make of your mistakes a strength rather than a weakness. 2. Wait for it. i.e. If you don't get a clear message, do nothing. 3. If you have a full brush & you have made a mark do not think you have to use the paint on your brush, wash it out. 4. As in life it is not so much what you put in as what you leave out that counts. See picture brought to Tate by B. Cohen [Bernard Cohen, English painter] where he has left everything out. This I don't believe in. White on white. Malevich & so on.

5. Paint as if you were painting a wall . . . 6. No colour stands alone. They are all influenced by each other. This is where the dicey part comes in. I mean the balancing act. Spilt milk & Mexican corn & a bit of egg & you've got to make something of it. 7. Most pictures can be pulled round. If you run into headwinds, tear it up. 8. Don't drink & smoke so much & lay off the nudes. Nice, but too easy a gambit.

What can I tell that is not already known about me? 14 years with one wife & 14 with this one. One comes through the orange peel, the shrimps and mackerel, the children, the nappies, the motor cars to a new calm of colour (poster) on paper. Aided by whisky and cigarettes. The artist's range is omnivorous . . .

It is true, as my wife points out, that I no longer have any balls, but I get from painting a sort of soulagement. A harmony akin to music, though I am against too much music for painters. One thinks of Pierre Soulages. Great chap. No children. I went there with Scott & again with Terry Frost [William Scott and Terry Frost, English painters associated, like Hilton, with St Ives] . . .

I believe couleurs can be made to speak, particularly poster colours.

The whole problem, apart from having to do everything from my bed, is adjusting to a strange medium. You have to be pretty witty with poster paints, if they are not to become inert (vide [Graham] Sutherland's efforts at portraiture). But I mustn't divagate . . . I look at my couleurs I believe they are living things . . .

As I say, painting is a personal thing, like a shit or a fuck. There is no rationale. You have to cope with women and children as best you can. God bless them. After all, they are the manure. Vide good old Pissarro. Et le père Corot et Daumier. It's all shit anyway except, like my wife says 'that's the only thing you can do'. Recess now and get ready for the royal wedding [of Princess Anne to Captain Mark Phillips, which dates this letter to November 1973] . . . Faith and truth is everything. Brancusi was a simple man. A peasant. Most critics distort the truth because they are impotent. Baudelaire, a great poet, was also a great critic. So was Hume or Hulme. They wrote some good things, but not for bread and butter. I hate & despise all the Goslings & Russells who are the sort of thing Christ turned out of the temple. Pharisees & Scribes.

Breaking up or breaking down. Going back or going on. It is all one process. You dredge up bits from the past. Past lives, past women, past children. Above all, past paintings. The trappings is nothing. It is your internal life which counts. The outside things, the ephemeral, are something to be fended off. Like dogs cats chickens and fowls. Take a chap like Henri Laurens [1885 – 1954, French Modernist sculptor]. Put into the back seats. Yet he shines like a beacon. The tendrils of the art vine are infinite. At the bottom of it all is the poor artist, who tries to keep some probity. Malgré tout. Because he has the usual things to cope with he is not just in an ivory tower. Electrical appliances, cats drinking his paint water & so on.

(Roger Hilton, 1973)

Revolution

Now!

The ageing Picasso remains determined to make his art new, every day.

Picasso said: 'We must kill modern art.'

It was not the first time that sentence had prowled around Notre-Dame-de-Vie. But never had it taken on so imperious and uncompromising an air as it did on that winter evening in 1965.

'It means, too,' said Picasso, 'that we must kill ourselves if we want to go on accomplishing anything.'

That's the hardest thing to do, to kill oneself. The painter gets caught on his own bristles. Try as he may, habit goes on guiding his hand.

But the moment comes when, unless he is to get lost, he must turn back on himself like a dog chasing its tail. The dog always catches the same dog. 'Still, it doesn't always catch it by the same end,' as Picasso says . . .

Thus we must 'kill modern art'.

There was a time when Picasso never tired of uttering that sentence and in his own way putting it into effect, and at that moment he finished *The Painter and His Model.*

That is, actually, a completely inaccurate way of putting it . . . The work contains its own truth, but chiefly it conceals within itself a springboard from which, turning our back on it, we can fly to the discovery of a new truth, the very reverse of the first. It is after all quite normal that in painting as in everything else we should come to deny what once seemed the foundation of all truth, so true that we thought it could never be doubted again.

'And in the end,' said Picasso, 'when the work is there, the painter has already gone' . . .

Picasso, then, declares that we must kill modern art 'since, once again, modern is just what it no longer is' . . .

'If you know exactly what you are going to do,' says Picasso, 'what's the good of doing it? There's no interest in something you know already. It's much better to do something else.'

(Hélène Parmelin, 1966)

An early seventeenth-century Chinese artist, Yüan Hung-tao, concurs with Picasso's attitude.

Once I went with Po-hsiu [his elder brother] to see Tung Ch'i-ch'ang.

'There are modern outstanding artists,' said Po-hsiu, 'like Wen Cheng-ming, T'ang Yin, and Shen Chou. Do you think they have the spirit of the ancients?'

Tung Ch'i-ch'ang replied, 'The distinguished modern artists never paint one stroke that is not like the ancients. But to be absolutely like the ancients is to be not like them at all. It is not even painting.'

I started when I heard this, and said to myself, 'That is from someone who understands.'

(Yüan Hung-tao, *fl.* 1607)

In the storerooms of Grand Central Palace, New York, the painter George Bellows and the collector Walter Arensberg consider an unexpected entry for the 1917 'Independents' exhibition: a porcelain urinal signed 'R. Mutt' and entitled Fountain. *(In fact it was submitted by Marcel Duchamp, the avant-garde iconoclast, and was one of his 'readymades' – a work of art not made by the artist, but found.)*

'We cannot exhibit it,' Bellows said hotly, taking out a handkerchief and wiping his forehead.

'We cannot refuse it, the entrance fee has been paid,' gently answered Walter.

'It is indecent!' roared Bellows.

'That depends upon the point of view,' added Walter, suppressing a grin.

'Someone must have sent it in as a joke. It is signed R. Mutt; sounds fishy to me,' grumbled Bellows with disgust. Walter approached the object in question and touched its glossy surface. Then with the dignity of a don addressing men at Harvard, he expounded: 'A lovely form has been revealed, freed from its functional purpose, therefore a man has clearly made an aesthetic contribution.'

. . . Bellows stepped away, then returned in rage as if he were going to pull it down. 'We can't show it, that's all there is to it.'

Walter lightly touched his arm. 'This is what the whole exhibit is about; an opportunity to allow the artist to send in anything he chooses, for the artist to decide what is art, not someone else.'

Bellows shook his arm away, protesting. 'You mean to say, if a man

sent in horse manure glued to a canvas that we would have to accept it!'

'I'm afraid we would,' said Walter, with a touch of undertaker's sadness.

(Beatrice Wood, 1985)

In the end, Arensberg did not prevail. Here the editors of the Blind Man, *an avant-garde art magazine so select in its appeal that it only ran to one issue, protest at the exclusion from the 'Independents' exhibition of R. Mutt's* Fountain *(among them is none other than M. Duchamp).*

The Richard Mutt Case

They say any artist paying six dollars may exhibit.

Mr Richard Mutt sent in a fountain. Without discussion this article disappeared and never was exhibited.

What were the grounds for refusing Mr Mutt's fountain: –

1. Some contended it was immoral, vulgar.

2. Others, it was plagiarism, a plain piece of plumbing.

Now Mr Mutt's fountain is not immoral, that is absurd, no more than a bathtub is immoral. It is a fixture that you see every day in plumbers' show windows.

Whether Mr Mutt with his own hands made the fountain or not has no importance. He CHOSE it. He took an ordinary article of life, placed it so that its useful significance disappeared under the new title and point of view – created a new thought for that object.

As for plumbing, that is absurd. The only works of art America has given are her plumbing and her bridges.

(*Blind Man*, 1917)

A footnote to the above by an eminent rock musician.

The attempts to keep art special become increasingly bizarre. This was a theme of a talk I gave at the Museum of Modern Art in New York as part of the 'HIGH ART/LOW ART' exhibition.

Looking round the show during the day, I noticed that Duchamp's *Fountain* – a men's urinal basin which he signed and exhibited in [1917] as the first 'readymade' – was part of the show. I had previously seen the same piece in London and at the Biennale of Sao Paolo.

I asked someone what they thought the likely insurance premium would be for transporting this thing to New York and looking after it. A figure of $30,000 was mentioned. I don't know if this is reliable, but it is certainly credible. What interested me was why, given the attitude with which Duchamp claimed he'd made the work – in his words, 'complete aesthetic indifference' – it was necessary to cart precisely this urinal and no other round the globe. It struck me as a complete confusion of understanding: Duchamp had explicitly been saying, 'I can call any old urinal – or anything else for that matter – a piece of art', and yet curators acted as though only this particular urinal was A Work Of Art. If that wasn't the case, then why not exhibit any urinal – obtained at much lower cost from the plumber's on the corner?

Well, these important considerations aside, I've always wanted to urinate on that piece of art, to leave my small mark on art history. I thought this might be my last chance – for each time it was shown it was more heavily defended. At MoMA it was being shown behind glass, in a large display case. There was, however, a narrow slit between the two front sheets of glass. It was about three-sixteenths of an inch wide.

I went to the plumber's on the corner and obtained a couple of feet of clear plastic tubing of that thickness, along with a similar length of galvanized wire. Back in my hotel room, I inserted the wire down the tubing to stiffen it. Then I urinated into the sink and, using the tube as a pipette, managed to fill it with urine. I then inserted the whole apparatus down my trouser-leg and returned to the museum, keeping my thumb over the top end so as to ensure that the urine stayed in the tube.

At the museum, I positioned myself before the display case, concentrating intensely on its contents. There was a guard standing behind me and about twelve feet away. I opened my fly and slipped out the tube, feeding it carefully through the slot in the glass. It was a perfect fit, and slid in quite easily until its end was poised above the famous john. I released my thumb, and a small but distinct trickle of my urine splashed on to the work of art.

That evening I used this incident, illustrated with several diagrams showing from all angles exactly how it had been achieved, as the basis of my talk. Since 'decommodification' was one of the buzzwords of the day, I described my action as 're-commode-ification'.

(Brian Eno, 1996)

George Grosz, a key member of the Berlin chapter of that most iconoclastic of all avant-garde movements, the Dadaists, looks back nostalgically on those happy days when he was young, and anti-art.

We held Dadaist meetings, charged a few marks admission and did nothing but tell people the truth, that is, abuse them. We never minced our words, and would say things like: 'You, you old heap of shit in the front – yes, you, the one with the umbrella, you silly ass!' or: 'What's so funny, fathead?' If anyone answered back, and someone always did, we would bawl: 'Shut your trap or you'll get a kick up your arse!' And so it went on . . .

The news spread quickly and soon our meetings and our Sunday morning matinées were sold out, crammed with people wanting to be scandalized or just after fun. Things came to such a pass that we had to have the police in attendance all the time because of the fights that kept breaking out. Eventually we even had to apply for special police permits. We ridiculed everything, for nothing was sacred, and we spat on everything, because that was what Dada was about. Dada was neither mysticism nor communism nor anarchism, all of which had some sort of programme or other. We were complete, pure nihilists, and our symbol was the vacuum, the void.

Between insults we performed 'art', but the performances were as a rule interrupted. Thus, hardly would Walter Mehring begin to rattle away at his typewriter while reciting some piece or other of his own composition, when Heartfield or Hausmann would come out from behind the stage and yell: 'Stop! You're not trying to bamboozle that feeble-minded lot down there, are you?' Often the whole sequence was planned in advance, but more often still it was improvised – as some of us were always drunk we were constantly having rows and simply continued the arguments on stage, *in coram publico*.

There had never been anything like Dada before. It was the art (or the philosophy) of the dustbin. A leader of the 'school' was a certain Schwitters from Hanover, who walked about collecting anything he could find on rubbish dumps, in refuse bins and God knows where else: rusty nails, old rags, toothbrushes without bristles, cigar boxes, old bicycle spokes, broken umbrellas. All the useless things people had thrown away were piled up on old planks, stuck on to canvas or tied on with wire or string, and then exhibited as so-called 'Merz collages' and even sold. Many critics, who wanted to be 'in' at all costs, praised this send-up of the public and were completely taken in by it. Only ordinary people, who knew nothing about

art, reacted normally, calling Dada art garbage, rubbish and muck – which was exactly what it was.

One of the masterpieces of the school was a giant statue called *Germany's Greatness and Decline in Three Stages*, which was actually the result of piling together a heap of various bits of rubbish and mixing them up at random. This 'monument' was the work of one Baader, who bore the title of 'Dada-in-Chief'. He had been mystically wedded to the Earth, suffered slightly from religious obsession and had delusions of grandeur – in other words he was quite mad. But during that strange period, he was not so very different from the rest of the Dada group, perhaps not even from me. (Certainly not in the opinion of the nice army medical officer who thought my drawings so crazy that he ordered me to take the so-called idiot's test and was surprised to find that I answered all his idiotic questions correctly . . .) Baader was also the author of the *Dadacon*, the greatest book of all time, greater even than the Bible. It consisted of thousands of newspaper pages stuck together like photomontage, and the intention was to induce giddiness in the reader as he leafed through the book – or, as Baader explained, 'you can only hope to get the hang of the *Dadacon* if your head is spinning.'

This, then, was our Dada-in-Chief, but we others also had titles and functions. I, for instance, was the 'Propagandada', a title that appeared on my visiting card under my proper name and over the words in small type: 'What will I be thinking tomorrow?' It was my task to invent slogans to further the cause of Dada. For instance: 'Dada is dada,' or 'Dada conquers all,' or 'Dada, Dada über alles!' We printed these slogans on small slips of paper, and shop windows, café tables, doorways and the like all over Berlin were soon plastered with them. People became really alarmed. The afternoon paper, the *B.Z. am Mittag*, for instance, carried a long leader on the Dadaist peril. Our stickers were everywhere – upstairs, downstairs, right, left and centre. Whenever the waiter at Kempinski's [a famous Berlin restaurant], then our local café, cleared the table, he would take away our silly slogans as well, all over the empty plates, bottles and Havana cigar boxes. Often even the fluttering tails of his coat would read: 'Dada, kick my arse, that's what I like!'

There was more to Dada, of course, than just fun and games. What really mattered was to work in the dark, so to speak. We had no idea what we were doing, but it felt to us as if we were stirring a filthy puddle with a long stick – for no good reason. 'Dada is senseless' was one of our slogans and it was that which infuriated the outside world. A new movement has

to make some sort of sense, they thought. But we said: 'No, all we do is stir shit' – as if that was sense enough.

A leading member of the German Dada movement was my brother-in-law Schmalhausen. He entered Dada history as the so-called Dada-Oz; he also bore the title of Dada-Diplomat, and as such was attached to me, the Propagandada. He was a perfectionist by nature; he was always extremely elegantly turned out and struck a worldly note at our meetings with his sharply creased trousers, bowler, walking stick and yellow gloves.

Another convert was my good old friend Rudolf Schlichter. He was one of the best-read artists I knew and his general knowledge was almost encyclopaedic. At the time, he was still a long way from his religious heart-searching of today and was full of contradictions. He felt that his was the art of the outsider, but to me it was simply part of a German romantic tradition that went back to the Middle Ages. However in 1919, at the first international Dada exhibition in Berlin, he did not exhibit his paintings or drawings but amazed all visitors to the Burchardt Gallery with a super-realistic sculpture: a life-size and lifelike figure of a general, suspended invisibly from the high ceiling and floating above the heads of the frightened and incensed crowd. It would have done credit to Castan's Panopticon.

All these strange constructions, collages and montages had a truly shocking effect on the public and on public opinion. Established modern artists were particularly outraged, feeling that nothing was being treated seriously or with proper respect any more, and that we even mocked at the avant-garde. The whole exhibition soon became, not surprisingly, a matter for the courts, and Dr Burchardt was forced to close it down and to pay a fine.

(George Grosz, 1982)

The Romanian-born poet Tristan Tzara refuses to explain what Dada is – although he was supposed to be the one who discovered the word in the first place (at random, of course).

I know that you have come here today to hear explanations. Well, don't expect to hear any explanations about Dada. You explain to me why you exist. You haven't the faintest idea. You will say: I exist to make my children happy. But in your hearts you know that isn't so. You will say: I exist to guard my country against barbarian invasions. That's a fine reason.

You will say: I exist because God wills. That's a fairy-tale for children. You will never be able to tell me why you exist but you will always be ready to maintain a serious attitude about life. You will never understand that life is a pun, for you will never be alone enough to reject hatred, judgements, all these things that require such an effort, in favour of a calm and level state of mind that makes everything equal and without importance.

Dada is not at all modern. It is more in the nature of a return to an almost Buddhist religion of indifference. Dada covers things with an artificial gentleness, a snow of butterflies released from the head of a prestidigitator. Dada is immobility and does not comprehend the passions. You will call this a paradox, since Dada is manifested only in violent acts. Yes, the reactions of individuals contaminated by *destruction* are rather violent, but when these reactions are exhausted, annihilated by the Satanic insistence of a continuous and progressive 'What for?' what remains, what dominates is *indifference*. But with the same note of conviction I might maintain the contrary.

(Tristan Tzara, 1924)

In the 1940s, George Melly, a jazz singer to be, encounters an elderly Dadaist poet and abstract painter still putting on a good show. At the time Melly was working in a gallery run by the Belgian Surrealist E. L. T. Mesens.

The most memorable event in the three years I spent at the gallery was the afternoon Kurt Schwitters recited the 'Ursonate'.

Mesens had often spoken, and always with great admiration and affection, of Schwitters, the maverick Dadaist from Hanover who had fled Germany and Norway just ahead of the Nazis, arriving eventually in England. As an enemy alien he was immediately interned in the Isle of Man. On his release, after a short period in London, he had somehow landed up in the Lake District where he earned a meagre living painting realistic, rather muddy portraits – a compromise which allowed him to continue with his 'real work', the construction of poetic collages created from the world's detritus: tickets, torn paper, fragments of wood, press headlines, advertisements, words selected and truncated at random. He called his particular Dada tendency *Merz*. There is no such word; it is part of the word *commerz*, which he had incorporated into an early collage. In Hanover, *Merz* took over his entire house. In what he called *Merzbild*, he

constructed a huge architectural collage which writhed through every room, sometimes going out of one window and coming in another. He also called his poetry *Merz*; some of it a kind of caricature of sentimental German romantic poetry, some absurdist like the recitation of a sneezing fit, but much of it involving entirely made-up sounds and culminating in his great 'Ursonate' ('Primitive Sonata'), forty minutes of divine gibberish carefully orchestrated.

He had already recited this at the gallery one afternoon in public while I was still in Liverpool pretending to learn shorthand and typing. Few had attended and a BBC Third Programme producer, whom ELT had invited hoping that he might record it for the archives, had left halfway through. This new visit however was in the hope of selling Édouard [Mesens] some of his recent collages, for few people in the Lake District wanted their portraits painted and in consequence Schwitters and his charming young companion Wantee Thomas were very poor.

Wantee, without whom Schwitters might have found himself unable to cope, was so called because she would so often poke her head round the door when he was working to ask him, 'Do you *want tea*?'

It was a cold wet Saturday morning when Schwitters with his cheap attaché case and Wantee in her thin coat arrived in Brook Street. Although it was Saturday the gallery was open as it was during a short period when Mesens decided to truncate my weekend 'for the benefit of students'. Eventually, as no students chose to take advantage of this offer, he withdrew it, allowing me to stay in bed in fuggy Chelsea, but on this occasion, knowing that Schwitters was coming, I would have showed up anyway; Édouard's tales had made me very curious to meet him.

One anecdote above all delighted me. One day, in the streets of Hanover during the 1920s, Schwitters was accosted by a man, clearly from elsewhere and burdened with a bad stammer: 'C-C-C-C-Could you t-t-t, t-t-t-tell m-m-me, where I c-c-c, where I can b-b-b-b-b-buy some c-c-c, some c-c-c-copper n-n-n-n-n-n-nails?' Schwitters gave him a long and compli-cated route which would lead the man eventually to a large hardware shop.

As soon as he was out of sight, Schwitters ducked down a short alley which led directly to the ironmongers in question. He entered and asked the proprietor if he had in stock any 'c-c-c-c, any c-c, any c-c-copper nails'. Answered in the affirmative, he demanded to see one, but declared it too small for his purpose. He was shown another – still too small – and another – not big enough, and eventually, somewhat irritated, the man

brought out a huge nail, used perhaps in ship-building, and told Schwitters that it was the largest manufactured. Schwitters then told him to shove it up his arse, and ran out of the shop.

Ten minutes later the genuine stutterer, following Schwitters's directions, found the shop and entered. Schwitters, concealed across the street, observed with satisfaction the man, terrified and totally bemused, running out of the ironmongers and legging it down the street pursued by the enraged shopkeeper brandishing a mallet.

Now in the gallery, Schwitters opened his suitcase and displayed his exquisite little *Merz* collages. Édouard bought them all at five pounds each. Later they were put on sale at twelve pounds framed; a minimal profit, but again no one bought except for me and on this occasion my sister. It had been an act of pure altruism on Édouard's part.

At midday I locked up the gallery and joined Kurt, Wantee and Édouard in the Democ ... We returned, all of us rather drunk, at three and Schwitters proposed quite spontaneously that he recite the 'Ursonate'. He stood in a corner of the main gallery – I cannot remember the pictures on the walls – and began to intone:

> 'Fumms bö wö taä zaä Uu,
>> pögiff
>>> Kwii Eee
>>>> Oooooooooooooooooooooooooooooooooo,'

He finished forty minutes later:

> 'Rinnzekete bee bee. Rinnzekete bee be.'

His white hair stuck out wildly. His eyes were bright blue and staring beyond us. His mackintosh was open. He was over six foot tall anyway but seemed to have grown taller.

What did we feel?

According to Hans Richter [in a study of Dadaism], Schwitters first read 'Ursonate' in about 1924 to an audience of retired generals and rich ladies, until that time unexposed to Modernism. After a few minutes hysterical laughter broke out, but he continued unfazed at a louder volume until silence reigned once more. There were no more interventions and then, when it was over '... the same generals, the same rich ladies who had previously laughed until they cried now came to Schwitters again

with tears in their eyes, almost stuttering with admiration and gratitude. Something had been opened up within them, something they had never expected; a great joy.'

While neither retired general nor rich lady, the recital I heard had a similar effect on me. Later on, Schwitters's son, a Norwegian businessman, recorded the 'Ursonate' and, having heard it frequently as a child, offered an accurate if dry and academic reconstruction. There is certainly no 'great joy'.

Recently I was invited to Manchester University where there was a big celebration of Dada including, among other pleasures, a reconstruction of an evening at the Cabaret Voltaire. Elsewhere a plump, bearded German, not young but certainly too young to have heard Schwitters, gave a reading of the 'Ursonate'. He caught the spirit brilliantly and shutting my eyes I could imagine myself back in the London Gallery forty years earlier.

Incidentally, it was in Manchester that in the middle fifties, although already seven years in his grave, Schwitters saved if not my life at any rate my face, the features of which a band of yobs were threatening to rearrange with broken bottles in a dark cul-de-sac. This was to pay out Mick Mulligan, my band leader, who had restrained and ejected one of their number after finding him systematically kicking another young man on the floor of the gents.

At the end of the session I had gone out of the pub where we had been playing to take a little air, and they'd been waiting. They had not yet broken the bottles, but had begun to beat them rhythmically against the brick walls which enclosed us.

Suddenly I thought of Schwitters.

'Rakete Rinnzekete,' I shouted. 'Rakete Rinnzekete. Rakete Rinnzekete. Kwii Eee. Fumms bö wö taä zaä Uu. Ziiuu rinnzkrrmüü . . .'

They turned and fled.

(George Melly, 1997)

Art need not last to be good, argues Richard Dorment, reviewing an exhibition at the Tate Gallery. The ephemeral events and objects created by the Fluxus movement of the 1960s left virtually no visible residue, but they were good art none the less.

Founded by a left-wing, Lithuanian-born American named George Maciunas, and heavily influenced by the Zen-inspired composer John Cage, Fluxus had only one member anybody has ever heard of: Yoko

Ono. And there is a reason for this. Fluxus was an underground anti-art movement, a rearguard action fought against the museum and gallery system, the art object and the cult of the personality of the artist. You might call Fluxus the flip side of Pop. It valued poor materials, ephemerality, mass production and anonymity. Maciunas called it 'art amusement . . . a game or a gag'. According to another member, 'Fluxus is inside you, is part of how you are. It is part of how you live.'

That traces of it survive at all seems to me a miracle, but more miraculous still is its continuing influence. In advertising, rock 'n' roll, video and visual art Fluxus is enjoying a comeback in the 1990s. This is because its aestheticizing attitude towards life, its idealistic belief that young artists can change society by turning people's attention to the quality of everyday living, is compelling still.

The several hundred artists who made up Fluxus wanted to transform society through social change. If that sounds pretentious, in reality Fluxus was light and witty, more Monty Python than Bertolt Brecht. It drew heavily on non-Western visual traditions, refusing to distinguish between high and popular art, designating as 'art' formal gestures, ritualized actions and the conscious aesthetic appreciation of the mundane.

Members of Fluxus were musicians, artists, designers, dancers and poets – but what each individual did or played or made or wrote was of relatively little consequence, since all were working together. It was fun to know someone associated with Fluxus, since communications with them, often by post, were apt to contain bits of collage, poetry or instructions to perform a series of absurd ritualistic acts. Here is a particularly silly one called 'Subway Event':

> Have a quarter and a token and enter a station
> Use token for turnstile
> Leave by nearest exit
> Buy one token at booth
> Say yam instead of thank you.

But if I've made Fluxus sound dumb and pointless, it wasn't. Fluxus was also highly political. William Morris was an important figure for British Fluxus because he argued for the role of art as a weapon for social change. Morris spoke with contempt of the middle classes who used art to camouflage what he saw as the visual and moral wasteland created by the Industrial Revolution. He wrote of his contempt for those who 'look

upon the world merely as if it were an impressionist picture, or [are] pleasantly satisfied with some ruinous piece of picturesque which is but the envelope for dullness and famine'.

Like Dada, Fluxus flourished in part as a protest against an art world that could go on buying and selling aesthetic objects at a time when there was a war in progress. Among the few memorable surviving artefacts in this show are Fluxus posters (now almost as quaint as First World War recruiting posters) protesting against the war in Vietnam ('US surpasses all Genocide Records!'). Remember when John and Yoko took to their bed to demonstrate against the war? Fluxus.

Or when Yoko made a film descriptively entitled *Bottoms*? Some of Fluxus's events were genuinely subversive, others amounted to little more than art-school facetiousness. As a teenager I first became aware of the avant-garde when I saw a picture of the cellist Charlotte Mormon playing bare-breasted on the same stage as the Fluxus artist Nam June Paik. But what had once seemed so outrageous to a boy from the suburbs soon began turning up everywhere. When the Who began smashing guitars on stage, or the former art student Brian Ferry formed his own rock 'n' roll band, they were acting out ideas that had first surfaced in Fluxus.

And the influence of Fluxus on the mainstream of the visual arts has been enormous. In this show I was intrigued to see photos of the work of the French artist Ben Vautier. For an exhibition at Mayfair's Gallery One in 1962, he lived in the gallery window for two weeks, labelling everyone who walked through the door a work of art, and offering himself for sale as a 'living sculpture' for £250. Like so much else in this exhibition, all that is left of Vautier's action is a dim photo redolent of youthful high spirits. But it must have touched two young art students named Gilbert and George, who would soon designate their entire lives 'living sculpture' and who, though not (as far as I know) a part of Fluxus, brought many of its ideas to a much wider British public.

The show will appeal to people who were there at the time and who want to remember, and to young artists who are curious to know what happened. But visual interest has almost nothing to do with it. Objects made by Fluxus should have been stamped with a 'sell-by' date: the most radical thing about the movement was its proposal to replace museum art with ephemeral experience. Part of the bargain these artists struck with life is that what they did in their youth would not survive.

I must add a coda to this. After a decade when Fluxus's emphasis on immateriality made the movement seem totally irrelevant, it is appealing

again to a new generation of young people repelled by the commercial excesses of the 1980s. I found my daughter's seventeenth birthday present at a Fluxus-inspired art gallery in Limehouse devoted to artists' books. It's called WORKFORTHEEYETODO (152 Narrow Street, E14) and almost everything there was cheap and fun and light in spirit.

Me, I'm too old, too mortgaged and too jaded really to respond as I'd like to this art. But it is reassuring to realize that another generation is touched by some of its energy and idealism.

(Richard Dorment, April 1994)

In a lecture, the Belgian painter René Magritte claims that Surrealism offers the true revolution.

Ladies, Gentlemen, Comrades,

The old question: 'Who are we?' is given a disappointing answer in the world in which we have to live.

We are, indeed, no more than the subjects of this so-called civilized world, in which intelligence, depravity, heroism and stupidity jog along happily together, and are extremely topical.

We are the subjects of this absurd and incoherent world in which arms are manufactured for the prevention of war, science is devoted to destroying, killing, building, and prolonging the lives of the dying, and where the most insane activity is self-contradictory.

We live in a world where people marry for money, and where great hotels are built and left to decay on the seafront.

This world still hangs together; but are the signs of its future ruin not already visible in the night sky?

The repetition of these obvious truths will seem naive and pointless to those people who are not bothered by them and benefit serenely from the existing state of affairs. Those who live on and by this chaos are keen to make it last. But their so-called realistic method of touching up the old edifice is compatible only with certain devices which are themselves new forms of chaos, new contradictions.

The realists, unwittingly then, are hastening the collapse of this doomed world.

Other men, among whom I proudly take my place, despite the accusation of utopianism levelled against them, wish consciously for the proletarian

revolution which will transform the world; and we work with this aim, each according to the means at his disposal.

However, as we wait for the destruction of this mediocre reality, we must defend ourselves against it.

Nature provides us with the dream-state, which affords our bodies and our minds the freedom they so vitally need.

Nature has also shown generosity in creating for the weak and the impatient, the refuge of madness which protects them from the stifling atmosphere of a world fashioned by centuries of idolatrous worship of money and the gods.

The great defensive force is love which takes lovers into an enchanted domain made exactly to their measure and admirably protected by solitude. Lastly, Surrealism provides humanity with a method and a mental approach favourable to the investigation of areas which have been deliberately ignored or despised, and yet of direct concern to humanity. Surrealism claims for our waking life a freedom similar to that which we have in dreams. This freedom is a latent possession of the mind, and in practice new technicians need only to concentrate on eliminating some complex or other – the complex of the ridiculous perhaps – and on determining the slight changes in habit that would be necessary for our ability to see only what we choose to see to change into the ability to discover immediately the objects of our desires. Everyday experience, cluttered up though it is by religious, secular or military morality, permits of these possibilities up to a point.

In any case, the Surrealists know how to be free. 'Freedom, the colour of man,' as André Breton proclaims.

In 1910, Chirico played around with beauty, imagining and realizing whatever he wished: he painted *Melancholy of a Fine Summer Afternoon* in a landscape of tall factory chimneys and walls stretching to infinity.

He painted *The Love Song* in which surgeons' gloves and the face of an antique statue are brought together.

This triumphant poetry supplanted the stereotyped effect of traditional painting. It represented a complete break with the mental habits peculiar to artists who are prisoners of talent, virtuosity and all the little aesthetic idiosyncrasies.

It was a new vision through which the spectator might recognize his own isolation and hear the silence of the world.

In illustrating Paul Éluard's 'Répétitions', Max Ernst splendidly demonstrated, by the overwhelming effect of collages made up of old magazine

engravings, that everything that gave traditional painting its prestige could easily be dispensed with.

Scissors, paste, images and genius in effect superseded brushes, paints, models, style, sensibility and that famous sincerity demanded of artists. The works of Chirico and Max Ernst, certain pictures by Derain such as *Man with Newspaper* in which a real newspaper is put into the hands of a painted figure, Picasso's discoveries, the anti-artistic activity of Marcel Duchamp, who suggested that it would be quite natural to use a Rembrandt as an ironing board, marked the beginning of what is now called 'Surrealist Painting'.

(René Magritte, 1938)

The Russian painter Kasimir Malevich invented his own abstract, avant-garde movement, Suprematism. Here the supreme Suprematist delivers his credo.

Only with the disappearance of a habit of mind which sees in pictures little corners of nature, madonnas and shameless *Venuses, shall we witness a work of pure, living art.*

I have transformed myself *in the zero of form* and dragged myself out of the *rubbish-filled pool of Academic art.*

I have destroyed the ring of the horizon and escaped from the circle of things, from the horizon-ring which confines the artist and the forms of nature.

This accursed ring, which opens up newer and newer prospects, leads the artist away from the *target of destruction.*

And only a cowardly consciousness and meagre creative powers in an artist are deceived by this fraud and base *their art on the forms of nature*, afraid of losing the foundation on which the savage and the academy have based their art.

To reproduce beloved objects and little corners of nature is just like a thief being enraptured by his legs in irons.

Only dull and impotent artists screen their work with *sincerity.*
In art there is a need for *truth*, not *sincerity.*

Things have disappeared like smoke; to gain the new artistic culture, art approaches creation as an end in itself and domination over the forms of nature.

(Kasimir Malevich, 1916)

Filippo Marinetti, Italian poet, publicist, and spokesman of the Futurists, foresees a rather brash new world, in which there will be no room for boring old-fashioned art.

We had stayed up all night, my friends and I, under hanging mosque lamps with domes of filigreed brass, domes starred like our spirits, shining like them with the prisoned radiance of electric hearts. For hours we had trampled our atavistic ennui into rich oriental rugs, arguing up to the last confines of logic and blackening many reams of paper with our frenzied scribbling.

An immense pride was buoying us up, because we felt ourselves alone at that hour, alone, awake, and on our feet, like proud beacons or forward sentries against an army of hostile stars glaring down at us from their celestial encampments. Alone with stokers feeding the hellish fires of great ships, alone with the black spectres who grope in the red-hot bellies of locomotives launched down their crazy courses, alone with drunkards reeling like wounded birds along the city walls.

Suddenly we jumped, hearing the mighty noise of the huge double-decker trams that rumbled by outside, ablaze with coloured lights, like villages on holiday suddenly struck and uprooted by the flooding Po and dragged over falls and through gorges to the sea.

Then the silence deepened. But, as we listened to the old canal muttering its feeble prayers and the creaking bones of sickly palaces above their damp green beards, under the windows we suddenly heard the famished roar of automobiles.

'Let's go!' I said. 'Friends, away! Let's go! Mythology and the Mystic Ideal are defeated at last. We're about to see the Centaur's birth and, soon after, the first flight of Angels! . . . We must shake the gates of life, test the bolts and hinges. Let's go! Look there, on the earth, the very first dawn! There's nothing to match the splendour of the sun's red sword, slashing for the first time through our millennial gloom!'

We went up to the three snorting beasts, to lay amorous hands on their torrid breasts. I stretched out on my car like a corpse on its bier, but revived at once under the steering wheel, a guillotine blade that threatened my stomach.

The raging broom of madness swept us out of ourselves and drove us through streets as rough and deep as the beds of torrents. Here and there, sick lamplight through window glass taught us to distrust the deceitful mathematics of our perishing eyes.

I cried, 'The scent, the scent alone is enough for our beasts.'

And like young lions we ran after Death, its dark pelt blotched with pale crosses as it escaped down the vast violet living and throbbing sky.

But we had no ideal Mistress raising her divine form to the clouds, nor any cruel Queen to whom to offer our bodies, twisted like Byzantine rings! There was nothing to make us wish for death, unless the wish to be free at last from the weight of our courage!

And on we raced, hurling watchdogs against doorsteps, curling them under our burning tyres like collars under a flatiron. Death, domesticated, met me at every turn, gracefully holding out a paw, or once in a while hunkering down, making velvety caressing eyes at me from every puddle.

'Let's break out of the horrible shell of wisdom and throw ourselves like pride-ripened fruit into the wide, contorted mouth of the wind! Let's give ourselves utterly to the Unknown, not in desperation but only to replenish the deep wells of the Absurd!'

The words were scarcely out of my mouth when I spun my car around with the frenzy of a dog trying to bite its tail, and there, suddenly, were two cyclists coming towards me, shaking their fists, wobbling like two equally convincing but nevertheless contradictory arguments. Their stupid dilemma was blocking my way – Damn! Ouch! . . . I stopped short and to my disgust rolled over into a ditch with my wheels in the air . . .

O maternal ditch, almost full of muddy water! Fair factory drain! I gulped down your nourishing sludge; and I remembered the blessed black breast of my Sudanese nurse . . . When I came up – torn, filthy, and stinking – from under the capsized car, I felt the white-hot iron of joy deliciously pass through my heart!

A crowd of fishermen with handlines and gouty naturalists were already swarming around the prodigy. With patient, loving care those people rigged a tall derrick and iron grapnels to fish out my car, like a big beached shark. Up it came from the ditch, slowly, leaving in the bottom, like scales, its heavy framework of good sense and its soft upholstery of comfort.

They thought it was dead, my beautiful shark, but a caress from me was enough to revive it; and there it was, alive again, running on its powerful fins!

And so, faces smeared with good factory muck – plastered with metallic

waste, with senseless sweat, with celestial soot – we, bruised, our arms in slings, but unafraid, declared our high intentions to all the *living* of the earth:

Manifesto of Futurism

1 We intend to sing the love of danger, the habit of energy and fearlessness.
2 Courage, audacity, and revolt will be essential elements of our poetry.
3 Up to now literature has exalted a pensive immobility, ecstasy, and sleep. We intend to exalt aggressive action, a feverish insomnia, the racer's stride, the mortal leap, the punch and the slap.
4 We affirm that the world's magnificence has been enriched by a new beauty: the beauty of speed. A racing car whose hood is adorned with great pipes, like serpents of explosive breath – a roaring car that seems to ride on grapeshot is more beautiful than the *Victory of Samothrace.*
5 We want to hymn the man at the wheel, who hurls the lance of his spirit across the Earth, along the circle of its orbit.
6 The poet must spend himself with ardour, splendour, and generosity, to swell the enthusiastic fervour of the primordial elements.
7 Except in struggle, there is no more beauty. No work without an aggressive character can be a masterpiece. Poetry must be conceived as a violent attack on unknown forces, to reduce and prostrate them before man.
8 We stand on the last promontory of the centuries! ... Why should we look back, when what we want is to break down the mysterious doors of the Impossible? Time and Space died yesterday. We already live in the absolute, because we have created eternal, omnipresent speed.
9 We will glorify war – the world's only hygiene – militarism, patriotism, the destructive gesture of freedom-bringers, beautiful ideas worth dying for, and scorn for woman.
10 We will destroy the museums, libraries, academies of every kind, will fight moralism, feminism, every opportunistic or utilitarian cowardice.
11 We will sing of great crowds excited by work, by pleasure, and by riot; we will sing of the multicoloured, polyphonic tides of revolution in the modern capitals; we will sing of the vibrant nightly fervour of arsenals and shipyards blazing with violent electric moons; greedy railway stations that devour smoke-plumed serpents; factories hung

on clouds by the crooked lines of their smoke; bridges that stride the rivers like giant gymnasts, flashing in the sun with a glitter of knives; adventurous steamers that sniff the horizon; deep-chested locomotives whose wheels paw the tracks like the hooves of enormous steel horses bridled by tubing; and the sleek flight of planes whose propellers chatter in the wind like banners and seem to cheer like an enthusiastic crowd.

It is from Italy that we launch through the world this violently upsetting incendiary manifesto of ours. With it, today, we establish *Futurism*, because we want to free this land from its smelly gangrene of professors, archaeologists, *ciceroni* [scholars who act as guides] and antiquarians. For too long has Italy been a dealer in second-hand clothes. We mean to free her from the numberless museums that cover her like so many graveyards.

Museums: cemeteries! . . . Identical, surely, in the sinister promiscuity of so many bodies unknown to one another. Museums: public dormitories where one lies for ever beside hated or unknown beings. Museums: absurd abattoirs of painters and sculptors ferociously slaughtering each other with colour-blows and line-blows, the length of the fought-over walls!

That one should make an annual pilgrimage, just as one goes to the graveyard on All Souls' Day – that I grant. That once a year one should leave a floral tribute beneath the *Gioconda*, I grant you that . . . But I don't admit that our sorrows, our fragile courage, our morbid restlessness should be given a daily conducted tour through the museums. Why poison ourselves? Why rot?

And what is there to see in an old picture except the laborious contortions of an artist throwing himself against the barriers that thwart his desire to express his dream completely? . . . Admiring an old picture is the same as pouring our sensibility into a funerary urn instead of hurling it far off, in violent spasms of action and creation.

Do you, then, wish to waste all your best powers in this eternal and futile worship of the past, from which you emerge fatally exhausted, shrunken, beaten down?

In truth I tell you that daily visits to museums, libraries, and academies (cemeteries of empty exertion, Calvaries of crucified dreams, registries of aborted beginnings!) are, for artists, as damaging as the prolonged supervision by parents of certain young people drunk with their talent and their ambitious wills. When the future is barred to them, the admirable

past may be a solace for the ills of the moribund, the sickly, the prisoner ... But we want no part of it, the past, we the young and strong *Futurists*! So let them come, the gay incendiaries with charred fingers! Here they are! Here they are! ... Come on! set fire to the library shelves! Turn aside the canals to flood the museums! ... Oh, the joy of seeing the glorious old canvases bobbing adrift on those waters, discoloured and shredded! ... Take up your pickaxes, your axes and hammers and wreck, wreck the venerable cities, pitilessly!

 (Filippo Tommaso Marinetti, 20 February 1909)

Jean Auguste Dominique Ingres, on the other hand, felt little need to keep pace with the onward march of history.

Let me hear no more of that absurd maxim: 'We need the new, we need to follow our century, everything changes, everything is changed.' Sophistry – all of that! Does nature change, do the light and air change, have the passions of the human heart changed since the time of Homer? 'We must follow our century': but suppose my century is wrong. Because my neighbour does evil, am I therefore obliged to do it also?

 (Jean Auguste Dominique Ingres, 1780–1867)

Drumbeats and blasting at the Café Royal in 1914, as Percy Wyndham Lewis, leader of the British avant-garde Vorticists, squares up to Marinetti of the Italian Futurists.

Lewis was still entangled in a momentous tussle and feud whose dimensions stretched across the Channel and right down to Italy, whence, to the banging of big drums, arrived F. T. Marinetti – the apostle of Futurism.

They were not metaphorical but very real, these drums. The young [painter] C. R. W. Nevinson was given one to thump when Marinetti was lecturing at the Doré Gallery in Bond Street, the object being to enhance the dynamic qualities of the lecture. Driving in a taxi to the Café Royal after such an exhibition, the perspiring Marinetti remarked to Wyndham Lewis: 'You need to have tremendously powerful lungs for this sort of thing!' – and he banged his chest to prove it.

His poetry being composed of onomatopoeic noises, Marinetti insisted on 'musical' accompaniment. A single drum would serve in a lecture hall, but when Sir Oswald Stoll presented him on the stage of the Coliseum,

he headed an orchestra of ten hurdy-gurdies. The hearty booing of the audience indicated with sufficient 'dynamism' the degree of their appreciation of Futurist poetry.

The root of the trouble was that nobody had the faintest idea what it was all about. In vain did Marinetti lash himself into Futurist frenzies at his lectures; in vain did he frighten a covey of poor little tarts at a neighbouring table in the Café Royal with his *molto agitato, con fuoco* way of conducting an ideological argument, to the extent that they threatened him with the police! There were plenty of the usual hangers-on in the Café who pretended to understand and to appreciate him – the fabulously wealthy Marinetti was very liberal with drinks – but, with the exception of the two young men who were the instigators of his crusade in London, Nevinson and Lewis, nobody really understood or, for that matter, cared about, the ravings and rantings of this prodigious zealot.

At this point the usual break occurred. Lewis turned his back on Futurism and, like a brooding sheik, withdrew into his mountains. He even shunned the Café, where he was missed by his enemies just as much as by his friends. Marinetti hardly noticed his disappearance. He busied himself with things of greater importance – the future of Futurism was at stake!

Finally the great day arrived: the Futurist Manifesto was duly signed by F. T. Marinetti and C. R. W. Nevinson. In the Café Royal, it was read out twice. The first reading was received with polite detachment by two tablefuls of nail-gnawing intellectuals and a trio of pimps who happened to occupy the place next to them, and with complete indifference by the rest of the room, even though Marinetti – already conspicuous with his diamond rings and garlands of gold chains – had mounted one of the tables to attract attention. The second reading drew a larger and more appreciative audience, since the reader was an eminent artist who had slightly rewritten the Futurist Manifesto to his own taste and replaced certain words in it with obscenities that made even the bookies blush.

Suddenly, Wyndham Lewis, galloping in from his mountain lair and followed by his tribesmen, sprang upon the world his counter-manifesto. He entirely and absolutely dissociated himself from the Futurists. He, who considered that *avantgardisme* in this country was primarily his 'pigeon', was not going to allow this foreign importation to usurp the leadership. And he launched his own brand of native Futurism in opposition to the Italian. This was to be known as the *Vortex* and *Vorticism* – 'The English Parallel Movement to Cubism and Expressionism. Imagism in Poetry.

Deathblow to Impressionism and Futurism and all the Refuse of Naif Science', etc., etc. All these mighty capital letters were crowned by the slogan – and it is significant that they had one – 'Long Live the Vortex!'

In order to inculcate the backward inhabitants of Britain with this advanced philosophy, the American-born saviour, with the red-bearded Philadelphian Ezra Pound by his side, issued a puce-covered publication by the title of *Blast*. It was really a contest of sound and fury. Marinetti had banged a drum and his chest and had boasted of the power of his lungs. All right, we'll retaliate with dynamite, and we'll see who can make the bigger noise! Marinetti had money to burn (Wyndham Lewis suspected that his father was running a chain of brothels in Egypt) and no methods were too strong to counter his propaganda.

(Guy Deghy and Keith Waterhouse, 1955)

Wyndham Lewis's counterblast to Futurism, and blast against England, as it appeared in the first issue of the Vorticist magazine, which Lewis edited.

1

BLAST First (from politeness) ENGLAND

CURSE ITS CLIMATE FOR ITS SINS AND INFECTIONS

DISMAL SYMBOL, SET round our bodies,
of effeminate lout within.
VICTORIAN VAMPIRE, the LONDON cloud sucks
the TOWN'S heart.

A 1000 MILE LONG, 2 KILOMETER Deep

BODY OF WATER even, is pushed against us
from the Floridas, TO MAKE US MILD.

OFFICIOUS MOUNTAINS keep back DRASTIC WINDS

SO MUCH VAST MACHINERY TO PRODUCE

THE CURATE of "Eltham"
BRITANNIC ÆSTHETE
WILD NATURE CRANK
DOMESTICATED
POLICEMAN
LONDON COLISEUM
SOCIALIST-PLAYWRIGHT
DALY'S MUSICAL COMEDY
GAIETY CHORUS GIRL
TONKS

(Percy Wyndham Lewis, 20 June 1914)

Some feminists of the 1980s put the case against art created by dead — and living — white males.

THE ADVANTAGES OF BEING A WOMAN ARTIST:

Working without the pressure of success.

Not having to be in shows with men.

Having an escape from the art world in your 4 free-lance jobs.

Knowing your career might pick up after you're eighty.

Being reassured that whatever kind of art you make it will be labeled feminine.

Not being stuck in a tenured teaching position.

Seeing your ideas live on in the work of others.

Having the opportunity to choose between career and motherhood.

Not having to choke on those big cigars or paint in Italian suits.

Having more time to work after your mate dumps you for someone younger.

Being included in revised versions of art history.

Not having to undergo the embarrassment of being called a genius.

Getting your picture in the art magazines wearing a gorilla suit.

Please send $ and comments to: **GUERRILLA GIRLS** CONSCIENCE OF THE ART WORLD
Box 1056 Cooper Sta NY, NY 10276

WHEN RACISM & SEXISM ARE NO LONGER FASHIONABLE, WHAT WILL YOUR ART COLLECTION BE WORTH?

The art market won't bestow mega-buck prices on the work of a few white males forever. For the 17.7 million you just spent on a single Jasper Johns painting, you could have bought at least one work by all of these women and artists of color:

Bernice Abbott	Elaine de Kooning	Dorothea Lange	Sarah Peale
Anni Albers	Lavinia Fontana	Marie Laurencin	Ljubova Popova
Sofonisba Anguisolla	Meta Warwick Fuller	Edmonia Lewis	Olga Rosanova
Diane Arbus	Artemisia Gentileschi	Judith Leyster	Nellie Mae Rowe
Vanessa Bell	Marguérite Gérard	Barbara Longhi	Rachel Ruysch
Isabel Bishop	Natalia Goncharova	Dora Maar	Kay Sage
Rosa Bonheur	Kate Greenaway	Lee Miller	Augusta Savage
Elizabeth Bougereau	Barbara Hepworth	Lisette Model	Vavara Stepanova
Margaret Bourke-White	Eva Hesse	Paula Modersohn-Becker	Florine Stettheimer
Romaine Brooks	Hannah Hoch	Tina Modotti	Sophie Taeuber-Arp
Julia Margaret Cameron	Anna Huntingdon	Berthe Morisot	Alma Thomas
Emily Carr	May Howard Jackson	Grandma Moses	Marietta Robusti Tintoretto
Rosalba Carriera	Frida Kahlo	Gabriele Münter	Suzanne Valadon
Mary Cassatt	Angelica Kauffmann	Alice Neel	Remedios Varo
Constance Marie Charpentier	Hilma af Klimt	Louise Nevelson	Elizabeth Vigée Le Brun
Imogen Cunningham	Kathe Kollwitz	Georgia O'Keeffe	Laura Wheeling Waring
Sonia Delaunay	Lee Krasner	Meret Oppenheim	

Information courtesy of Christie's, Sotheby's, Mayer's International Auction Records and Leonard's Annual Price Index of Auctions

Please send $ and comments to: **GUERRILLA GIRLS** CONSCIENCE OF THE ART WORLD
Box 1056 Cooper Sta. NY, NY 10276

(Guerrilla Girls posters, *c.*1987)

Yves Klein describes the opening in Paris of his exhibition 'The Void', which consisted of a completely empty, white-painted gallery.

9:30 p.m. The whole place is packed, the corridor is full, the gallery as well. Outside, the crowd that gathers begins to have difficulty getting inside.

9:45 p.m. It is frenzied. The crowd is so dense that one cannot move anywhere. I stay in the gallery itself. Every three minutes, I shout in a loud voice, repeating to the people who are more and more cramming into the gallery (the security service is no longer able to contain them or regulate the entrances and exits): 'Mesdames, Messieurs, please have the extreme kindness not to stay too long in the gallery so that other visitors who are waiting outside can enter in their turn.'

9:45 p.m. Restany arrives in a car driven by Brüning from Düsseldorf to Paris. At the very same time, Kricke and his wife also come.

9:50 p.m. In the gallery, I suddenly notice a young man drawing on one of the walls. I rush to stop him and politely but very firmly ask him to leave. While accompanying him to the small exterior door where two guards are posted (the crowd in the gallery is silent and waits to see what is going to happen), I shout to the guards who are outside: 'Seize this man and throw him out with violence.' He is literally expelled and disappears in the clutches of my guards.

10:00 p.m. The police arrive in full force (three full vans) by the rue de la Seine; firemen also arrive in full force with their giant ladder, by the rue Bonaparte, but they cannot enter further than the Galerie Claude Bernard through the crowd in the rue des Beaux-Arts . . .

10:10 p.m. 2,500 to 3,000 people are in the street; the police in the rue de la Seine and the firemen in the rue Bonaparte try to push the crowd toward the quays of the Seine. When a patrol comes to the entrance to ask for an explanation (some people, furious at having paid 1,500 francs admission in order to see nothing at all in the interior with their eyes, went to complain), my bodyguards declare to them laconically and firmly: 'We have our own security service here; we have no need for you.' The patrol cannot legally enter and withdraws.

10:20 p.m. A representative of the Order of Saint Sebastian arrives in full dress (bicorn and cape with red Maltese cross). Many painters are in the

room at the same time. Camille Bryen exclaims: 'In short, it is an exhibition of painters here!'

On the whole, the crowd enters the gallery angry and leaves completely satisfied. What the Great Press will be compelled to record officially in writing is that 40 per cent of the visitors are positive, catching the pictorial sensible state and seized by the intense climate that reigns terrible within the apparent void of the exhibition room.

10:30 p.m. The Republican Guards leave in disgust; for an hour, students from the Beaux-Arts [Academy] have been tapping them on the shoulder in a familiar way, and asking them where they have rented their costumes and if they are movie extras!

10:50 p.m. Blue cocktail is all gone, a run to La Coupole to search for some more. Arrival of two pretty Japanese girls in extraordinary kimonos.

11:00 p.m. The crowd that has been dispersed by the police and firemen comes back in small exasperated groups. Inside, it is still swarming as much as ever.

Half-past midnight. We close and leave for La Coupole. At La Coupole, a big table in the back for forty people.

One o'clock in the morning. Trembling with fatigue, I deliver my revolutionary speech.

(Yves Klein, 1958)

Our art doesn't reflect life at all. You can't take one of these pictures out of this house and go and find the subject somewhere. We are reforming life, showing our tomorrows, we are not showing how life is.

(Gilbert & George, 1997)

Art is meant to upset people, science reassures them.

(Georges Braque, from *Notebooks 1917–1947*)

Artistic Encounters: Greek Meets Greek

Albrecht Dürer does not have a good word to say for the painters of Renaissance Venice, which he visited from 1505 to 1507, with one notable exception.

How I wish you were here at Venice, there are so many good fellows among the Italians who seek my company more and more every day – which is very gratifying to me – men of sense, and scholarly, good lute-players, and pipers, connoisseurs in painting, men of much noble sentiment and honest virtue, and they show me much honour and friendship. On the other hand, there are also amongst them the most faithless, lying, thievish rascals; such as I scarcely believed could exist on earth; and yet if one did not know them, one would think that they were the nicest men on earth. I cannot help laughing to myself when they talk to me: they know that their villainy is well known, but that does not bother them. I have many good friends among the Italians who warn me not to eat and drink with their painters, for many of them are my enemies and copy my work in the churches and wherever they can find it; afterwards they criticize it and claim that it is not done in the antique style and say it is no good, but Giambellin [Giovanni Bellini, then in his seventies] has praised me highly to many gentlemen. He would willingly have something of mine, and came himself to me and asked me to do something for him, and said that he would pay well for it, and everyone tells me what an upright man he is, so that I am really friendly with him. He is very old and yet he is the best painter of all.

(Albrecht Dürer, 7 February 1506)

In front of Cosimo de' Medici, Duke of Florence and Grand Duke of Tuscany, Benvenuto Cellini tells Baccio Bandinelli, an inferior sculptor, a thing or two about his work. In reply, Bandinelli is moved to remark on Cellini's sexual habits.

One feast day or other I went along to the palace, after dinner, and arriving at the Clock Hall I noticed that the door of the wardrobe was open. I

approached nearer and then the Duke called out, greeting me pleasantly:

'You're welcome! Look at that little chest that the lord Stefano of Palestrina has sent me as a present: open it and let's see what it is.'

I opened it at once and said to the Duke: 'My lord, it's a statue in Greek marble, and it's a splendid piece of work: I don't remember ever having seen such a beautiful antique statue of a little boy, so beautifully fashioned. Let me make an offer to your Most Illustrious Excellency to restore it – the head and the arms and the feet. I'll add an eagle so that we can christen it Ganymede. And although it's not for me to patch up statues – the sort of work done by botchers, who still make a bad job of it – the craftsmanship of this great artist calls me to serve him.'

The Duke was tremendously delighted that the statue was so beautiful, and he asked me a multitude of questions, saying:

'Tell me, my dear Benvenuto, exactly what is the achievement of this artist that makes you marvel so much?'

So then, as far as I could, I did my best to make the Duke appreciate such beauty, and the fine intelligence and rare style that it contained. I held forth on these things for a long time, all the more willingly as I knew how much his Excellency enjoyed my doing so.

While I was entertaining the Duke in this agreeable way a page happened to leave the wardrobe and, as he went out, Bandinello [*sic*] came in. When he saw him the Duke's face clouded over and he said with an unfriendly expression: 'What are you after?'

Bandinello, instead of replying at once, stared at the little chest where the statue was revealed and with his usual malignant laugh, shaking his head, he said, turning towards the Duke:

'My lord, here you have one of those things I have so often mentioned to you. You see, those ancients knew nothing about anatomy, and as a result their works are full of errors.'

I remained silent, taking no notice of anything he was saying; in fact I had turned my back on him. As soon as the beast had finished his disagreeable babbling, the Duke said:

'But Benvenuto, this completely contradicts what you have just been proving with so many beautiful arguments. Let's hear you defend the statue a little.'

In reply to this noble little speech of the Duke's, so pleasantly made, I said:

'My lord, your Most Illustrious Excellency must understand that Baccio Bandinello is thoroughly evil, and always has been. So no matter what he

looks at, as soon as his disagreeable eyes catch sight of it, even though it's of superlative quality it is at once turned to absolute evil. But for myself, being only drawn to what is good, I see things in a more wholesome way. So what I told your Illustrious Excellency about this extremely beautiful statue is the unblemished truth; and what Bandinello said about it reflects only the badness of his own nature.'

The Duke stood there, listening with great enjoyment, and while I was talking Bandinello kept twisting and turning and making the most unimaginably ugly faces – and his face was ugly enough already. Suddenly the Duke moved off, making his way through some ground-floor rooms, and Bandinello followed him. The chamberlains took me by the cloak and led me after them. So we followed the Duke till his Most Illustrious Excellency reached an apartment where he sat down with Bandinello and me on either side of him. I stood there without saying anything, and the men standing round – several of his Excellency's servants – all stared hard at Bandinello, sniggering a little among themselves over what I had said in the room above. Then Bandinello began to gabble.

'My lord,' he said, 'when I uncovered my *Hercules and Cacus* I am sure that more than a hundred wretched sonnets were written about me, containing the worst abuse one could possibly imagine this rabble capable of.'

Replying to this, I said: 'My lord, when our Michelangelo Buonarroti revealed his Sacristy, where there are so many fine statues to be seen, our splendid, talented Florentine artists, the friends of truth and excellence, wrote more than a hundred sonnets, every man competing to give the highest praise. As Bandinello's work deserved all the abuse that he says was thrown at it, so Buonarroti's deserved all the good that was said of it.'

Bandinello grew so angry that he nearly burst: he turned to me and said: 'And what faults can you point out?'

'I shall tell you if you've the patience to listen.'

'Go on then.'

The Duke and all the others who were there waited attentively, and I began.

First I said: 'I must say that it hurts me to point out the defects in your work: but I shall not do that, I shall tell you what the artists of Florence say about it.'

One moment the wretched fellow was muttering something unpleasant, the next shifting his feet and gesticulating; he made me so furious that I

began in a much more insulting way than I would have done had he behaved otherwise.

'The expert school of Florence says that if Hercules's hair were shaven off there wouldn't be enough of his pate to hold in his brain; and that one can't be sure whether his face is that of a man or a cross between a lion and an ox; that it's not looking the right way; and that it's badly joined to the neck, so clumsily and unskilfully that nothing worse has ever been seen; and that his ugly shoulders are like the two pommels of an ass's pack-saddle; that his breasts and the rest of his muscles aren't based on a man's but are copied from a great sack full of melons, set upright against a wall. The loins look as if they are copied from a sack of long marrows. As for the legs, it's impossible to understand how they're attached to the sorry-looking trunk; it's impossible to see on which leg he's standing, or on which he's balancing, and he certainly doesn't seem to be resting his weight on both, as is the case with some of the work done by those artists who know something. What can be seen is that he's leaning forward more than a third of a cubit; and this by itself is the worst and the most intolerable error that useless, vulgar craftsmen can make. As for the arms, it's said that they both stick out awkwardly, that they're so inelegant that it seems you've never set eyes on a live nude; that the right leg of Hercules is joined to that of Cacus in the middle in such a way that if one of the two were removed both of them – not merely one – would be without a calf. And they say that one of the feet of the Hercules is buried, and the other looks as if someone has lit a fire under it.'

The fellow couldn't stay quiet patiently and let me carry on describing the great defects of the *Cacus*. First, because I was telling the truth, and second, because I was revealing it clearly to the Duke and the others standing around. They were expressing their amazement and showed that they realized I was justified up to the hilt.

Suddenly the fellow cried out: 'Oh, you wicked slanderer, what about my design?'

I replied that anyone who was good at designing would never make a bad statue, therefore I judged that his design was the same quality as his work. And then, seeing how the Duke and the others were looking, and outraged at their attitude and expressions, he let his insolence get the better of him, turned his foul, ugly face towards me and burst out: 'Oh, keep quiet, you dirty sodomite!'

At that word the Duke frowned angrily, and the others tightened their

lips and stared hard at him. In the face of this wicked insult I choked with
fury, but instantly found the right answer and said:

'You madman, you're going too far. But I wish to God I did know how
to indulge in such a noble practice: after all, we read that Jove enjoyed it
with Ganymede in paradise, and here on earth it is the practice of the
greatest emperors and the greatest kings of the world. I'm an insignificant,
humble man, I haven't the means or the knowledge to meddle in such a
marvellous matter.'

At this no one could restrain himself: the Duke and the others raised
a great shout of laughter which shook the whole place. But for all that I
took the incident jokingly, I can tell you, my kind readers, my heart was
bursting at the thought that this man, the most filthy scoundrel ever born,
was bold enough – in the presence of such a great prince – to hurl at me
an insult of that kind. But, you know, it was the Duke, not me, whom he
insulted. For if I had not been in such noble company I'd have struck
him dead.

(Benvenuto Cellini, 1558–62)

Jackson Pollock clashes in friendly enmity with Willem de Kooning over a book on
Abstract Expressionism, and the latter looks back on their relationship.

Pollock sat clutching the book as if he wanted to crush it. He disagreed
nosily with passages that were read from it, swore a great deal, and finally
threw the book at de Kooning's feet.

'Why'd you do that?' de Kooning asked. 'It's a good book.'

'It's a rotten book,' Pollock replied. 'He treats you better than me.'

Hess, who was not there that night but remembers Pollock popping in
during another night in the series, believes that Pollock's gesture was
playful, his words bantering 'as between two guys on the same team going
after a home-run record'. That may be part of the truth. But if, on one
level, Pollock and de Kooning were playing on the same team, on another,
they were playing for themselves. De Kooning himself has stated, 'A
couple of times [Pollock] told me, "You know more, but I feel more." I
was jealous of him – his talent. But he was a remarkable person. He'd do
things that were so terrific.'

(B. H. Friedman, 1973)

Manet is visited in his studio by the eminent Victorian painter, Sir Frederic (later Lord) Leighton. They did not get on.

Sir Frederic Leighton, the President of the Royal Academy of Art in London ... was here yesterday with Henri Hecht who had introduced me to him a few days earlier. I was busy painting Madame Guillemet. Léon had gone out, and the famous painter was in my way. He wandered about the studio and stopped in front of the *Skating Rink*, saying: 'It's very good but, Monsieur Manet, don't you think that the outlines are not well enough defined and that the figures dance a bit too much?' I replied 'They're not dancing, they're skating; but you're right, they do move and when people are moving, I can't freeze them on the canvas. As a matter of fact, sir, I have been told that the outlines of *Olympia* are too well defined, so that makes up for it.' He realized he was annoying me and went away ...

(Édouard Manet, 1878)

Manet and Cézanne fall out, but Renoir and Degas remain friendly – at least for a while.

The Café de la Nouvelle Athènes, in Montmartre, was a meeting place for Degas, Cézanne, Renoir, Manet, Desboutin, and art critics such as Duranty [one of the first to champion Impressionism]. The latter had constituted himself champion of the 'New Painting', though his praise was not without reservations. He complained of Cézanne, for instance, that he painted with a bricklayer's trowel. In his opinion, Cézanne's reason for putting so much paint on his canvas must be that he thought a kilogram of green would look greener than a gram.

Nor did Manet, for his part, set much store by the painter from Aix. To Manet, the refined and elegant Parisian, the artist in Cézanne was but the counterpart of the 'foul-mouthed' man. But to tell the truth, the vulgarity of speech that he was reproached with was actually a pose adopted by Cézanne for Manet's benefit, irritated as he was by his standoffish airs. Once, for instance, when the painter of *Le Bon Bock* asked his colleague if he was preparing anything for the Salon, he drew upon himself the retort:

'Yes, some nice dung!'

It has sometimes been said that 'Degas and Renoir, with their dissimilar

natures, were not made to understand one another.' As a matter of fact, although Degas disliked the fluffy texture of some of Renoir's paintings – 'He paints with balls of wool,' he would say when confronted with them – at other times, on the contrary, I have heard him exclaim, as he passed his hand amorously over one of his pictures: 'Lord, what a lovely texture!'

On the other hand, there was no greater admirer of Degas than Renoir, although secretly he deplored Degas's desertion of the art of the pastellist, in which he was so entirely himself, for that of the painter in oils.

Notwithstanding their esteem for one another as artists, Renoir and Degas did, however, manage to quarrel. It happened in this way.

The painter Caillebotte, being about to die, wished to indemnify Renoir for purchases he had made from him at prices he was now ashamed of. In his will, therefore, he bequeathed to Renoir any one of the pictures in his collection, at the artist's choice.

Renoir was just beginning to 'sell', though his prices were not yet very high. Having heard that an admirer was prepared to pay 50,000 francs for the *Moulin de la Galette*, Renoir, very naturally, would have liked to select this picture. But Caillebotte's executor pointed out that as the collection was to go to the Luxembourg, it would be a pity if he were to beggar it of one of his most characteristic works. The same objection was made with regard to the *Swing*, on which his choice fell next, and finally, as the bequest included several pictures by Degas, Caillebotte's brother suggested to Renoir that he should take one of the *Leçons de Danse*; and Renoir agreed.

But Renoir soon tired of seeing the musician for ever bending over his violin, while the dancer, one leg in the air, awaited the chord that should give the signal for her pirouette. One day, when Durand-Ruel said to him: 'I have a customer for a really finished Degas,' Renoir did not wait to be told twice, but taking down the picture, handed it to him on the spot.

When Degas heard of it he was beside himself with fury, and sent Renoir back a magnificent painting that the latter had once allowed him to carry off from his studio – a woman in a blue dress cut low in front, almost life-size. This work belongs to the same period as the famous picture *La Dame au Sourire*. I was with Renoir when the painting was thus brutally returned to him. In his anger, seizing a palette knife, he began slashing at the canvas. Having reduced the dress to shreds, he was aiming the knife at the face:

'But, Monsieur Renoir!' I cried.

He interrupted his gesture:

'Well, what's the matter?'

'Monsieur Renoir, you were saying in this very room only the other day that a picture is like a child one has begotten. And now you are going to destroy that face!'

'You're a nuisance with your wise tales!'

But his hand dropped, and he said suddenly:

'That head gave me such a lot of trouble to paint! Ma foi! I shall keep it.'

He cut out the upper part of the picture. That fragment, I believe, is now in Russia.

Renoir threw the hacked strips furiously into the fire. Then taking a slip of paper, he wrote on it the single word 'Enfin!' put the paper in an envelope addressed to Degas, and gave the letter to his servant to post. Happening to meet Degas some time after, I had the whole story from him; and after a silence:

'What on earth can he have meant by that "Enfin!"?'

'Probably that at last he had quarrelled with you.'

'Well, I never!' exclaimed Degas. Obviously he could not get over his astonishment.

(Ambroise Vollard, 1936)

In London one day Michael Ayrton bumps into Francis Bacon, who accuses him of saying that he, Bacon, could not draw.

I encountered Francis Bacon in a bar. There he accused me, with the greatest good nature, of having asserted that he could not draw. I had done so, rashly, and I admitted it, furthermore I rashly maintained it. 'Is drawing what you do?' he asked. A characteristic pause followed. 'I wouldn't want to do that.' In the circumstances, it seemed to me, I had nothing to do but acknowledge the palpable hit and buy the next round.

(Michael Ayrton, 1971)

Delacroix was not very impressed, it seems, by Turner.

Young Armstrong told me about Turner, who bequeathed a hundred thousand pounds sterling to found a retreat for poor or infirm artists. He lived an avaricious life, with one old servant. I remember having received him at my studio just once, when I was living on the Quai Voltaire.

He made only a middling impression on me: he had the look of an English farmer, black coat of a rather coarse type, thick shoes – and a cold, hard face.

(Eugène Delacroix, 24 March 1855)

Constable was rather more impressed when he met Turner in 1813, although he would have seen Delacroix's point.

I was a good deal entertained with Turner. I always expected to find him what I did – he is uncouth, but has a wonderful range of mind.

(John Constable to Maria Bicknell, 30 June 1813)

Turner, however, scored a point over Constable when they were both finishing their pictures on varnishing day at the Royal Academy in 1832.

Turner was very amusing on the varnishing, or rather the painting days, at the Academy. Singular as were his habits, for nobody knew where or how he lived, his nature was social, and at our lunch on those anniversaries, he was the life of the table. The Academy has relinquished, very justly, a privilege for its own members which it could not extend to all exhibitors. But I believe, had the varnishing days been abolished while Turner lived, it would almost have broken his heart. When such a measure was hinted to him, he said, 'Then you will do away with the only social meetings we have, the only occasions on which we all come together in an easy unrestrained manner. When we have no varnishing days we shall not know one another.'

In 1832, when Constable exhibited his *Opening of Waterloo Bridge*, it was placed in the school of painting – one of the small rooms at Somerset House. A sea piece, by Turner, was next to it – a grey picture, beautiful and true, but with no positive colour in any part of it. Constable's *Waterloo* seemed as if painted with liquid gold and silver, and Turner came several times into the room while he was heightening with vermilion and lake the decorations and flags of the city barges. Turner stood behind him, looking from the *Waterloo* to his own picture, and at last brought his palette from the great room where he was touching another picture, and putting a round daub of red lead, somewhat bigger than a shilling, on his grey sea, went away without saying a word. The intensity of the red lead, made

more vivid by the coolness of his picture, caused even the vermilion and lake of Constable to look weak. I came into the room just as Turner left it. 'He has been here,' said Constable, 'and fired a gun.' On the opposite wall was a picture, by Jones, of Shadrach, Meshach, and Abednego in the furnace. 'A coal,' said Cooper, 'has bounced across the room from Jones's picture, and set fire to Turner's sea.' The great man did not come again into the room for a day and a half; and then, in the last moments that were allowed for painting, he glazed the scarlet seal he had put on his picture, and shaped it into a buoy.

(C. R. Leslie, *Autobiographical Recollections*, 1860)

Turner also got the best of the Scottish landscape painter David Roberts, as the Victorian artist William Frith records, again on one of the varnishing days on which Royal Academicians traditionally finished off their paintings before the annual exhibition.

Both he and Roberts stood upon boxes, and worked silently at their respective pictures. I found myself close to them, painting some figures into a landscape by Creswick. I watched my neighbours from time to time, and if I could discover no great change in the aspect of *Edinburgh*, there was no doubt whatever that *Masaniello* was rapidly undergoing a treatment which was very damaging to its neighbour without a compensating improvement to itself. The grey sky had become an intense blue that even Italy could scarcely be credited with it. Roberts moved uneasily on his box-stool. Then, with a sidelong look at Turner's picture, he said in the broadest Scotch:

'You are making that varra blue.'

Turner said nothing; but added more and more ultramarine. This was too much.

'I'll just tell ye what it is, Turner, you're just playing the deevil with my picture, with that sky – ye never saw such a sky as that!'

Turner moved his muffler to one side, looked down at Roberts, and said:

'You attend to your business, and leave me to attend to mine.'

And to this hour *Masaniello* remains – now in the cellars of the National Gallery – with the bluest sky ever seen in a picture, and never seen out of one.

(W. P. Frith, 1887)

At the Royal Academy in 1829, however, Constable takes the sculptor Francis Chantrey's interference with his masterpiece, Hadleigh Castle, *in a gentlemanly spirit.*

I witnessed an amusing scene before this picture at the Academy on one of the varnishing days. Chantrey told Constable its foreground was too cold, and taking his palette from him, he passed a strong glazing of asphaltum all over that part of the picture, and while this was going on, Constable who stood behind him in some degree of alarm, said to me 'there goes all my dew.' He held in great respect Chantrey's judgement in most matters, but this did not prevent his carefully taking from the picture all that the great sculptor had done for it.

 (C. R. Leslie, *Memoirs of the Life of John Constable, RA*, 1843)

The nineteen-year-old Samuel Palmer meets the aged William Blake, whom he finds hard at work in bed.

We found him lame in bed, of a scalded foot (or leg). There, not inactive, though sixty-seven years old, but hard-working on a bed covered with books sat he up like one of the Antique patriarchs, or a dying Michael Angelo. Thus and there was he making in the leaves of a great book (folio) the sublimest designs from his (not superior) Dante. He said he began them with fear and trembling. I said 'O! I have enough of fear and trembling.' 'Then,' said he, 'you'll do.' . . . And there . . . did I show him some of my first essays in design; and the sweet encouragement he gave me (for Christ blessed little children) did not tend basely to presumption and idleness, but made me work harder and better that afternoon and night. And, after visiting him, the scene recurs to me afterwards in a kind of vision; and in this most false, corrupt, and genteelly stupid town my spirit sees his dwelling (the chariot of the sun), as it were an island in the midst of the sea – such a place is it for primitive grandeur, whether in the persons of Mr and Mrs Blake, or in the things hanging on the walls . . .

 (Samuel Palmer, 1824)

William Rothenstein compares Whistler and Degas as men – the latter was the more formidable – and Degas describes his early encounters with Ingres.

Although I was always somewhat excited when visiting Whistler, his curiosity to know what I had been doing, whom I had been seeing, his friendly chaff, would put me at ease. With Degas, I was never quite comfortable. To begin with, nervous people are apt, when speaking in a foreign tongue, to say rather what comes into their heads, than to say what they mean. Moreover, Degas's character was more austere and uncompromising than Whistler's. Compared with Degas Whistler seemed almost worldly in many respects. Indeed, Degas was the only man of whom Whistler was a little afraid. 'Whistler, you behave as though you have no talent,' Degas had said once to him; and again when Whistler, chin high, monocle in his eye, frock-coated, top-hatted, and carrying a tall cane, walked triumphantly into a restaurant where Degas was sitting: 'Whistler, you have forgotten your muff.' Again, about Whistler's flat-brimmed hat, which Whistler fancied, Degas said: 'Oui, il vous va très bien; mais ce n'est pas ça qui nous rendra l'Alsace et la Lorraine!'

Degas was famous, and feared, for his terrible *mots*. He was unsparing in his comments on men who failed in fidelity to the artistic conscience. Flattery, usefulness and subservience provided in some cases the key to intimacy with Whistler; with Degas integrity of character was a *sine qua non* of friendship. One thing he had in common with Whistler – a temperamental respect for the aristocratic tradition, the 'West Point' code of honour, a French West Point, which included anti-Republican and anti-Semitic tendencies, which later made him a strong partisan of the Militarists and anti-Dreyfusards . . .

He was by nature drawn to subtleties of character and to intricate forms and movements. He had the Parisian curiosity for life in its most objective forms. At one with the Impressionists in rejecting the artificial subject matter of the Salon painters, he looked to everyday life for his subjects; but he differed from Manet and his other contemporaries, in the rhythmical poise of his figures and the perfecting of detail. He found, in the life of the stage and the intricate steps of the ballet, with its background of fantasy, an inexhaustible subject-matter, which allowed for the colour and movement of romantic art, yet provided the clear form dear to the classical spirit. He delighted in the strange plumage of the *filles d'opéra*, as they moved into the circle of the limelight or stood, their skirts standing out above their pink legs, chattering together in the wings. The starling-like

flock of young girls, obedient to the baton of the *maître de danse*, Degas rendered with astonishing delicacy of observation. He never forgot that he was once a pupil of Ingres. Indeed, he described at length, on one of my first visits, his early relations with Ingres; how fearfully he approached him, showing his drawings and asking whether he might, in all modesty, look forward to being, some day, an artist; Ingres replying that it was too grave a thing, too serious a responsibility to be thought of; better devote himself to some other pursuit. And how going again, and yet again, pleading that he had reconsidered, from every point of view, his idea of equipping himself to become a painter, that he realized his temerity, but could not bring himself to abandon all his hopes, Ingres finally relented, saying, 'C'est très grave, ce que vous pensez faire, très grave; mais si enfin vous tenez quand même à être un artiste, un bon artiste, eh bien, monsieur, faites des lignes, rien que des lignes.' One of Ingres's sayings which came back to Degas was 'Celui qui ne vit que dans la contemplation de lui-même est un misérable.' Degas had lately been at Montauban, Ingres's birthplace, where the greater number of his studies are preserved. Degas was full of his visit, and of the surpassing beauty of the drawings.

(William Rothenstein, 1931)

Francis Bacon fears that he is boring Giacometti, but makes a good recovery.

One evening in 1962, when Isabel [Rawsthorne] had arranged a dinner at a London restaurant, Francis arrived late, nervous, and drunk. He and Alberto launched into a discussion of painting. It started well but then, as Bacon became progressively drunker, developed into one of those maundering monologues about life, death, and the gravity of it all to which Francis was prone when plastered. Alberto, who never drank to excess, listened patiently to all this and eventually responded with a shrug of his shoulders, murmuring, 'Who knows?' Taken aback, Francis without a word began to raise the edge of the table higher and higher until all the plates, glasses, and silverware crashed to the floor. Alberto was delighted by that kind of answer to the riddle of the universe and shouted with glee.

(James Lord, 1986)

Sickert, a passionate admirer of Degas, gets the better of Roger Fry, an influential critic and feeble painter.

Sickert and Fry had known each other all their lives; Fry had lived for a time with old Mrs Sickert and her sons. The relationship between them was a curious one. Sickert had been a steady support when Fry was passing through a tragic phase; they always rallied to each other in moments of crisis but they could hardly be described as intimates. If they had been constantly together they would not have hit it off. Sickert could not refrain from teasing Fry, as he teased all his friends, and this Fry enjoyed, being very well able to hold his own; but the common interest, painting, which should have forged a link between them, did nothing of the sort; it merely drove them apart. Sickert mistrusted Fry's views on painting and he could be ruthless when his idols were attacked, as on the famous occasion when Fry, all unwittingly, probed him in a tender spot, his affection for Degas.

Fry: 'It took Degas forty years to get rid of his cleverness.'

Sickert: 'And it will take you eighty years to get it.'

This well-known retort may seem unduly harsh; I have resurrected it to remind the reader how quickly Sickert resented any criticism of his friends. And Degas was more than a friend; he was the revered master, the father figure; as Sickert himself put it, 'the lighthouse of my existence.' A blander example of his wit occurred when he and Fry were looking at an exhibition of the Allied Artists.

Fry: 'There's something to be said for this picture.'

Sickert: 'Say it, Roger, say it!'

Reacting violently against his Puritan background, Fry worshipped France and all her works; he seemed to feel for England a sort of nervous distaste and he deplored the cooking, the climate, the hearties and the whole establishment of his native land. But Sickert was attached to England as well as France. And there was a deeper cause of estrangement than this. Sickert valued Fry for his intellect, his scholarship, his industry; he attended Fry's lectures and sat applauding vigorously in the front row of the audience; but he was not interested in Fry's painting. Sooner or later, in their conversations together, they struck, inevitably, the final, inescapable rock.

Nor did he particularly wish to discuss art with Fry. But Fry came to the Frith [studio originally occupied by the Victorian painter William Powell Frith, later by Sickert] to do just that. Unmindful of the gods who had showered so many blessings on him, he did not want praise for the

qualities that Sickert was the first to recognize; he longed only to be accepted as a painter. One word of praise for his pictures meant more to him than oceans of appreciation for all his other gifts and that word Sickert withheld, not from churlishness but from conviction. It is indeed possible that he underrated Fry's talent, that everyone did and that posterity will be fairer to him than Fitzroy Street; but painters thought of Fry almost exclusively as writer and lecturer. Sickert led the conversation away from painting when they were together but Fry, gently determined, pinned him down to it again and again. Sometimes, Sickert took refuge in silence. Only once, years afterwards, did I hear him refer to Fry's work. He was inspecting one of his canvases, shaking his head sadly and murmuring, half aloud, half to himself, '*poor* Roger!'

(Marjorie Lilley, 1971)

Michelangelo is polite when examining work in Titian's studio, but has observations to make after the visit.

One day Michelangelo and Vasari went along to visit Titian in the Belvedere, where they saw a picture he had finished of a nude woman, representing Danaë, who had in her lap Jove transformed into a rain of gold; and naturally, as one would do with the artist present, they praised it warmly. After they had left they started to discuss Titian's method and Buonarroti commended it highly, saying that his colouring and his style pleased him very much but that it was a shame that in Venice they did not learn to draw well from the beginning and that those painters did not pursue their studies with more method. For the truth was, he went on, that if Titian had been assisted by art and design as much as he was by nature, and especially in reproducing living subjects, then no one could achieve more or work better, for he had a fine spirit and a lively and entrancing style. To be sure, what Michelangelo said was nothing but the truth; for if an artist has not drawn a great deal and studied carefully selected ancient and modern works he cannot by himself work well from memory or enhance what he copies from life, and so give his work the grace and perfection of art which are beyond the reach of nature, some of whose aspects tend to be less than beautiful.

(Giorgio Vasari, 1568)

It is unwise to ask another artist, or indeed a critic, for an opinion of your work.
Graham Sutherland makes this mistake with Francis Bacon, Daniel Farson having
arranged what proved to be a doomed reunion.

They had been the best of friends in the early days when both men were
poor, starting their great ascent. They shared a studio and enjoyed an
intimacy which was sensual rather than sexual, though Robert Medley
believes there was 'a strong streak of homosexuality' in Sutherland though
Kathy never allowed it out. Graham, the Catholic convert, may have
disliked Francis's hedonistic atheism, but was too kind to disapprove and
he was selfless with his encouragement when Francis was unknown. The
falling-out of friends is always to be regretted; it was time they met again.

 They did so in the old Jules Bar in Jermyn Street, because Kathy and
Graham Sutherland insisted on meeting outside Soho which they regarded
as alien, if not enemy, territory. At first the three of them were restrained,
formally polite; then they leaped on each other like dogs recognizing their
master as he returns home after a long absence. The champagne and the
laughter flowed as I listened with pleasure. After an hour, Francis suggested
that we move on to dinner at Wheeler's, an outcome the Sutherlands
anticipated and had been determined to avoid. Graham looked nervously
at Kathy, his expression indicating 'Well, why not?', like a schoolboy
hoping for a 'treat'. I sensed her reluctance, but she agreed.

 When we arrived at the familiar stamping ground she retired to the
ladies' cloakroom while we sat down at a ground-floor table, lulled by the
success of the reunion. I noticed Francis's mood change as if a cloud had
obscured the sun, though this was imperceptible to Graham, who leaned
forward with a confidential smile: 'Francis, you may have heard that I've
been doing some portraits recently. I think they're rather good. Have you
seen any of them?'

 I cringed.

 'Yes,' said Francis lightly, with a lethal certainty. 'Very nice . . . if you
like the covers of *Time* magazine.'

 (Daniel Farson, *The Gilded Gutter Life of Francis Bacon*, 1993)

Every

Picture

Tells

a

Story

Julian Barnes considers how the scandalous story of the wreck of a French government ship, the Medusa, *was turned by Géricault into great art.*

How do you turn catastrophe into art?

Nowadays the process is automatic. A nuclear plant explodes? We'll have a play on the London stage within a year. A president is assassinated? You can have the book or the film or the filmed book or the booked film. War? Send in the novelists. A series of gruesome murders? Listen for the tramp of the poets. We have to understand it, of course, this catastrophe; to understand it, we have to imagine it, so we need the imaginative arts. But we also need to justify it and forgive it, this catastrophe, however minimally. Why did it happen, this mad act of Nature, this crazed human moment? Well, at least it produced art. Perhaps, in the end, that's what catastrophe is *for*.

He shaved his head before he started the picture, we all know that. Shaved his head so he wouldn't be able to see anyone, locked himself in his studio and came out when he'd finished his masterpiece. Is that what happened?

The expedition set off on 17th June 1816.

The *Medusa* struck the reef in the afternoon of 2nd July 1816.

The survivors were rescued from the raft on 17th July 1816.

Savigny and Corréard [two survivors] published their account of the voyage in November 1817.

The canvas was bought on 24th February 1818.

The canvas was transferred to a larger studio and restretched on 28th June 1818.

The painting was finished in July 1819.

On 28th August 1819, three days before the opening of the Salon, Louis XVIII examined the painting and addressed to the artist what the *Moniteur Universel* called 'one of those felicitous remarks which at the same time judge the work and encourage the artist.' The King said, 'Monsieur Géricault, your shipwreck is certainly no disaster.'

It begins with truth to life. The artist read Savigny and Corréard's account; he met them, interrogated them. He compiled a dossier of the case. He sought out the carpenter from the *Medusa*, who had survived, and got him to build a scale model of his original machine. On it he positioned wax models to represent the survivors. Around him in his studio he placed his own paintings of severed heads and dissected limbs, to infiltrate the air with mortality. Recognizable portraits of Savigny, Corréard and the carpenter are included in the final picture. (How did they feel about posing for this reprise of their sufferings?)

He was perfectly calm when painting, reported Antoine Alphonse Montfort, the pupil of Horace Vernet; there was little perceptible motion of the body or the arms, and only a slight flushing of the face to indicate his concentration. He worked directly on to the white canvas with only a rough outline to guide him. He painted for as long as there was light with a remorselessness which was also rooted in technical necessity: the heavy, fast-drying oils he used meant that each section, once begun, had to be completed that day. He had, as we know, had his head shaved of its reddish-blond curls, as a Do Not Disturb sign. But he was not solitary: models, pupils and friends continued coming to the house, which he shared with his young assistant Louis-Alexis Jamar. Among the models he used was the young Delacroix, who posed for the dead figure lying face down with his left arm extended.

Let us start with what he did not paint. He did not paint:

1) The *Medusa* striking the reef;
2) The moment when the tow-ropes were cast off and the raft abandoned;
3) The mutinies in the night;
4) The necessary cannibalism;
5) The self-protective mass murder;
6) The arrival of the butterfly;
7) The survivors up to their waists, or calves, or ankles in water;
8) The actual moment of rescue.

In other words his first concern was not to be 1) political; 2) symbolic; 3) theatrical; 4) shocking; 5) thrilling; 6) sentimental; 7) documentational; or 8) unambiguous . . .

What did he paint, then? Well, what does it look as if he painted? Let us re-imagine our eye into ignorance. We scrutinize *Scene of Shipwreck* [the title

under which *The Raft of the Medusa* was originally exhibited] with no knowledge of French naval history. We see survivors on a raft hailing a tiny ship on the horizon (the distant vessel, we can't help noticing, is no bigger than that butterfly would have been). Our initial presumption is that this is the moment of sighting which leads to a rescue. This feeling comes partly from a tireless preference for happy endings, but also from posing ourselves, at some level of consciousness, the following question: how would we know about these people on the raft if they had *not* been rescued?

What backs up this presumption? The ship is on the horizon; the sun is also on the horizon (though unseen), lightening it with yellow. Sunrise, we deduce, and the ship arriving with the sun, bringing a new day, hope and rescue; the black clouds overhead (very black) will soon disappear. However, what if it were sunset? Dawn and dusk are easily confused. What if it were sunset, with the ship about to vanish like the sun, and the castaways facing hopeless night as black as that cloud overhead? Puzzled, we might look at the raft's sail to see if the machine was being blown towards or away from its rescuer, and to judge if that baleful cloud is about to be dispelled; but we get little help – the wind is blowing not up and down the picture but from right to left, and the frame cuts us off from further knowledge of the weather to our right. Then, still undecided, a third possibility occurs: it could be sunrise, yet even so the rescuing vessel is not coming towards the shipwrecked. This would be the plainest rebuff of all from fate: the sun is rising, *but not for you*.

The ignorant eye yields, with a certain testy reluctance, to the informed eye. Let's check *Scene of Shipwreck* against Savigny and Corréard's narrative. It's clear at once that Géricault hasn't painted the hailing that led to the final rescue: that happened differently, with the brig suddenly close upon the raft and everyone rejoicing. No, this is the first sighting, when the *Argus* appeared on the horizon for a tantalizing half-hour. Comparing paint with print, we notice at once that Géricault has not represented the survivor up the mast holding straightened-out barrel-hoops with handkerchiefs attached to them. He has opted instead for a man being held up on top of a barrel and waving a large cloth. We pause over this change, then acknowledge its advantage: reality offered him a monkey-up-a-stick image; art suggested a solider focus and an extra vertical.

But let us not inform ourselves too quickly. Return the question to the tetchy ignorant eye. Forget the weather; what can be deduced from the personnel on the raft itself? Why not start with a head-count. There are

twenty figures on board. Two are actively waving, one actively pointing, two vigorously supplicating, plus one offering muscular support to the hailing figure on the barrel: six in favour of hope and rescue. Then there are five figures (two prone, three supine) who look either dead or dying, plus an old greybeard with his back to the sighted *Argus* in a posture of mourning: six against. In between (we measure space as well as mood) there are eight more figures: one half-supplicating, half-supporting; three watching the hailer with non-committal expressions; one watching the hailer agonizingly; two in profile examining, respectively, waves past and waves to come; plus one obscure figure in the darkest, most damaged part of the canvas, with head in hands (and clawing at his scalp?). Six, six and eight: no overall majority.

(Twenty? queries the informed eye. But Savigny and Corréard said there were only fifteen survivors. So all those five figures who might only be unconscious are definitely dead? Yes. But then what about the culling which took place, when the last fifteen healthy survivors pitched their thirteen wounded comrades into the sea? Géricault has dragged some of them back from the deep to help out with his composition. And should the dead lose their vote in the referendum over hope versus despair? Technically, yes; but not in assessing the mood of the picture.)

So the structure is balanced, six for, six against, eight don't knows. Our two eyes, ignorant and informed, squintily roam. Increasingly, they are drawn back from the obvious focus of attention, the hailer on the barrel, towards the mourning figure front left, the only person looking out at us. He is supporting on his lap a younger fellow who is – we have done our sums – certainly dead. The old man's back is turned against every living person on the raft: his pose is one of resignation, sorrow, despair; he is further marked out by his grey hair and the red cloth worn as a neck protector. He might have strayed in from a different genre – some Poussin elder who had got lost, perhaps. (Nonsense, snaps the informed eye. Poussin? Guérin and Gros, if you must know. And the dead 'son'? A medley of Guérin, Girodet and Prud'hon.) What is this 'father' doing? a) lamenting the dead man (his son? his chum?) on his lap; b) realizing they will never be rescued; c) reflecting that even if they are rescued it doesn't matter a damn because of the death he holds in his arms? (By the way, says the informed eye, there really are handicaps to being ignorant. You'd never, for instance, guess that the father and son are an attenuated cannibalistic motif, would you? As a group they first appear in Géricault's only surviving sketch of the cannibalism scene; and any educated contem-

porary spectator would be assuredly reminded of Dante's description of Count Ugolino sorrowing in his Pisan tower among his dying children – whom he ate. Is that clear now?)

Whatever we decide that the old man is thinking, his presence becomes as powerful a force in the painting as that of the hailer. This counterbalance suggests the following deduction: that the picture represents the mid-point of that first sighting of the *Argus*. The vessel has been in view for a quarter of an hour and has another fifteen minutes to offer. Some believe it is still coming towards them; some are uncertain and waiting to see what happens; some – including the wisest head on board – know that it is heading away from them, and that they will not be saved. This figure incites us to read *Scene of Shipwreck* as an image of hope being mocked.

Those who saw Géricault's painting on the walls of the 1819 Salon knew, almost without exception, that they were looking at the survivors of the *Medusa*'s raft, knew that the ship on the horizon did pick them up (if not at the first attempt), and knew that what had happened on the expedition to Senegal was a major political scandal. But the painting which survives is the one that outlives its own story. Religion decays, the icon remains; a narrative is forgotten, yet its representation still magnetizes (the ignorant eye triumphs – how galling for the informed eye). Nowadays, as we examine *Scene of Shipwreck*, it is hard to feel much indignation against Hugues Duroy de Chaumareys, captain of the expedition, or against the minister who appointed him captain, or the naval officer who refused to skipper the raft, or the sailors who loosed the tow-ropes, or the soldiery who mutinied. (Indeed, history democratizes our sympathies. Had not the soldiers been brutalized by their wartime experiences? Was not the captain a victim of his own pampered upbringing? Would we bet on ourselves to behave heroically in similar circumstances?) Time dissolves the story into form, colour, emotion. Modern and ignorant, we reimagine the story: do we vote for the optimistic yellowing sky, or for the grieving greybeard? Or do we end up believing both versions? The eye can flick from one mood, and one interpretation, to the other: is this what was intended? . . .

What has happened? The painting has slipped history's anchor. This is no longer *Scene of Shipwreck*, let alone *The Raft of the Medusa*. We don't just imagine the ferocious miseries on that fatal machine; we don't just become the sufferers. They become us. And the picture's secret lies in the pattern of its energy. Look at it one more time: at the violent waterspout building up through those muscular backs as they reach for the speck of the

rescuing vessel. All that straining – to what end? There is no formal response to the painting's main surge, just as there is no response to most human feelings. Not merely hope, but any burdensome yearning: ambition, hatred, love (especially love) – how rarely do our emotions meet the object they seem to deserve? How hopelessly we signal; how dark the sky; how big the waves. We are all lost at sea, washed between hope and despair, hailing something that may never come to rescue us. Catastrophe has become art; but this is no reducing process. It is freeing, enlarging, explaining. Catastrophe has become art: that is, after all, what it is for ...

And there we have it – the moment of supreme agony on the raft, taken up, transformed, justified by art, turned into a sprung and weighted image, then varnished, framed, glazed, hung in a famous art gallery to illuminate our human condition, fixed, final, always there. Is that what we have? Well, no. People die; rafts rot; and works of art are not exempt. The emotional structure of Géricault's work, the oscillation between hope and despair, is reinforced by the pigment: the raft contains areas of bright illumination violently contrasted with patches of the deepest darkness. To make the shadow as black as possible, Géricault used quantities of bitumen to give him the shimmeringly gloomy black he sought. Bitumen, however, is chemically unstable, and from the moment Louis XVIII examined the work a slow, irreparable decay of the paint surface was inevitable. 'No sooner do we come into this world,' said Flaubert, 'than bits of us start to fall off.' The masterpiece, once completed, does not stop: it continues in motion, downhill. Our leading expert on Géricault confirms that the painting is 'now in part a ruin'. And no doubt if they examine the frame they will discover woodworm living there.

(Julian Barnes, *A History of the World in 10½ Chapters*, 1989)

John Ruskin talks us through the Scuola di San Rocco in Venice, commenting on Tintoretto's phenomenal narrative paintings.

Moses Striking the Rock. We now come to the series of pictures upon which the painter concentrated the strength he had reserved for the upper room [of the Scuola; Tintoretto also painted a series of canvases for the lower hall]; and in some sort wisely, for, though it is not pleasant to examine pictures on a ceiling, they are at least distinctly visible without straining the eyes against the light. They are carefully conceived, and thoroughly well painted in proportion to their distance from the eye. This carefulness

of thought is apparent at a glance: the *Moses Striking the Rock* embraces the whole of the seventeenth chapter of Exodus, and even something more, for it is not from that chapter, but from parallel passages that we gather the facts of the impatience of Moses and the wrath of God at the waters of Meribah; both which facts are shown by the leaping of the stream out of the rock half-a-dozen ways at once, forming a great arch over the head of Moses, and by the partial veiling of the countenance of the Supreme Being. This latter is the most painful part of the whole picture, at least as it is seen from below; and I believe that in some repairs of the roof this head must have been destroyed and repainted. It is one of Tintoret's usual fine thoughts that the lower part of the figure is veiled, not merely by clouds, but in a kind of watery sphere, showing the Deity coming to the Israelites at that particular moment as the Lord of the Rivers and of the Fountain of the Waters. The whole figure, as well as that of Moses, and the greater number of those in the foreground, is at once dark and warm, black and red being the prevailing colours, while the distance is bright gold touched with blue, and seems to open into the picture like a break of blue sky after rain. How exquisite is this expression, by mere colour, of the main force of the fact represented! that is to say, joy and refreshment after sorrow and scorching heat. But, when we examine of what this distance consists, we shall find still more cause for admiration. The blue in it is not the blue of sky, it is obtained by blue stripes upon white tents glowing in the sunshine; and in front of these tents is seen that great battle with Amalek of which the account is given in the remainder of the chapter, and for which the Israelites received strength in the streams which ran out of the rock in Horeb. Considered merely as a picture, the opposition of cool light to warm shadow is one of the most remarkable pieces of colour in the Scuola, and the great mass of foliage which waves over the rocks on the left appears to have been elaborated with his highest power and his most sublime invention. But this noble passage is much injured, and now hardly visible.

Plague of Serpents. The figures in the distance are remarkably important in this picture, Moses himself being among them; in fact, the whole scene is filled chiefly with middle-sized figures, in order to increase the impression of space. It is interesting to observe the difference in the treatment of this subject by the three great painters, Michael Angelo, Rubens, and Tintoret. The first two, equal to the latter in energy, had less love of liberty: they were fond of binding their compositions into knots, Tintoret of scattering his far and wide: they all alike preserve the unity of composition, but the

unity in the first two is obtained by binding, and that of the last by springing from one source; and, together with this feeling, comes his love of space, which makes him less regard the rounding and form of objects themselves than their relations of light and shade and distance. Therefore Rubens and Michael Angelo made the fiery serpents huge boa-constrictors, and knotted the sufferers together with them. Tintoret does not like to be so bound; so he makes the serpents little flying and fluttering monsters, like lampreys with wings; and the Children of Israel, instead of being thrown into convulsed and writhing groups, are scattered, fainting, in the fields, far away in the distance. As usual, Tintoret's conception, while thoroughly characteristic of himself, is also truer to the words of Scripture. We are told that 'the Lord sent fiery serpents among the people, and they *bit* the people'; we are not told that they crushed the people to death. And, while thus the truest, it is also the most terrific conception. M. Angelo's would be terrific if one could believe in it; but our instinct tells us that boa-constrictors do not come in armies; and we look upon the picture with as little emotion as upon the handle of a vase, or any other form worked out of serpents, where there is no probability of serpents actually occurring. But there is a probability in Tintoret's conception. We feel that it is not impossible that there should come up a swarm of these small winged reptiles; and their horror is not diminished by their smallness: not that they have any of the grotesque terribleness of German invention; they might have been made infinitely uglier with small pains, but it is their *veritableness* which makes them awful. They have triangular heads with sharp beaks or muzzles; and short, rather thick bodies, with bony processes down the back like those of sturgeons; and small wings spotted with orange and black; and round glaring eyes, not very large, but very ghastly, with an intense delight in biting expressed in them. (It is observable that the Venetian painter has got his main idea of them from the sea-horses and small reptiles of the Lagoons.) These monsters are fluttering and writhing about everywhere, fixing on whatever they come near with their sharp venomous heads; and they are coiling about on the ground, and all the shadows and thickets are full of them, so that there is no escape anywhere: and in order to give the idea of greater extent to the plague, Tintoret has not been content with one horizon; I have before mentioned the excessive strangeness of this composition, in having a cavern open in the right of the foreground, through which is seen another sky and another horizon. At the top of the picture, the Divine Being is seen borne by angels, apparently passing over the congregation in wrath, involved in

masses of dark clouds; while, behind, an angel of mercy is descending towards Moses, surrounded by a globe of white light. This globe is hardly seen from below; it is not a common glory, but a transparent sphere, like a bubble, which not only envelopes the angel, but crosses the figure of Moses, throwing the upper part of it into a subdued pale colour, as if it were crossed by a sunbeam. Tintoret is the only painter who plays these tricks with transparent light, the only man who seems to have perceived the effects of sunbeams, mists, and clouds in the far away atmosphere, and to have used what he saw on towers, clouds, or mountains, to enhance the sublimity of his figures. The whole upper part of this picture is magnificent, less with respect to individual figures, than for the drift of its clouds, and originality and complication of its light and shade; it is something like Raffaelle's *Vision of Ezekiel*, but far finer. It is difficult to understand how any painter, who could represent floating clouds so nobly as he has done here, could ever paint the odd, round, pillowy masses which so often occur in his more carelessly designed sacred subjects. The lower figures are not so interesting, and the whole is painted with a view to effect from below, and gains little by close examination.

Fall of Manna. In none of these three large compositions has the painter made the slightest effort at expression in the human countenance; everything is done by gesture, and the faces of the people who are drinking from the rock, dying from the serpent-bites and eating the manna, are all alike as calm as if nothing was happening; in addition to this, as they are painted for distant effect, the heads are unsatisfactory and coarse when seen near, and perhaps in this last picture the most so, and yet the story is exquisitely told. We have seen in the Church of San Giorgio Maggiore another example of his treatment of it, where, however, the gathering of manna is a subordinate employment, but here it is principal. Now, observe, we are told of the manna, that it was found in the morning; that then there lay round about the camp a small round thing like the hoar frost, and that 'when the sun waxed hot it melted.' Tintoret has endeavoured, therefore, first of all, to give the idea of coolness; the congregation are reposing in a soft green meadow, surrounded by blue hills, and there are rich trees above them, to the branches of one of which is attached a great grey drapery to catch the manna as it comes down. In any other picture such a mass of drapery would assuredly have had some vivid colour, but here it is grey; the fields are cool frosty green, the mountains cold blue, and, to complete the expression and meaning of all this, there is a most important point to be noted in the form of the Deity, seen above, through

an opening in the clouds. There are at least ten or twelve other pictures in which the form of the Supreme Being occurs, to be found in the Scuola di San Rocco alone; and in every one of these instances it is richly coloured, the garments being generally red and blue, but in this picture of the manna the figure is *snow white*. Thus the painter endeavours to show the Deity as the Giver of Bread, just as in the *Striking of the Rock* we saw that he represented Him as the Lord of the Rivers, the Fountains, and the Waters. There is one other very sweet incident at the bottom of the picture; four or five sheep, instead of pasturing, turn their heads aside to catch the manna as it comes down, or seem to be licking it off each other's fleeces. The tree above, to which the drapery is tied, is the most delicate and delightful piece of leafage in all the Scuola; it has a large sharp leaf, something like that of a willow, but five times the size . . .

Massacre of the Innocents. The following account of this picture, given in [Ruskin's] *Modern Painters*, may be useful to the traveller, and is therefore here repeated. 'I have before alluded to the painfulness of Raffaelle's treatment of the *Massacre of the Innocents*. Fuseli affirms of it, that, "in dramatic gradation he disclosed all the mother through every image of pity and of terror." If this be so, I think the philosophical spirit has prevailed over the imaginative. The imagination never errs; it sees all that is, and all the relations and bearings of it; but it would not have confused the mortal frenzy of maternal terror with various development of maternal character. Fear, rage, and agony, at their utmost pitch, sweep away all character: humanity itself would be lost in maternity, the woman would become the mere personification of animal fury or fear. For this reason all the ordinary representations of this subject are, I think, false and cold: the artist has not heard the shrieks, nor mingled with the fugitives; he has sat down in his study to convulse features methodically, and philosophize over insanity. Not so Tintoret. Knowing, or feeling, that the expression of the human face was, in such circumstances, not to be rendered, and that the effort could only end in an ugly falsehood, he denied himself all aid from the features, he feels that if he is to place himself or us in the midst of that maddened multitude, there can be no time allowed for watching expression. Still less does he depend on details of murder or ghastliness of death; there is no blood, no stabbing or cutting, but there is an awful substitute for these in the chiaroscuro. The scene is the outer vestibule of a palace, the slippery marble floor is fearfully barred across by sanguine shadows, so that our eyes seem to become bloodshot and

strained with strange horror and deadly vision; a lake of life before them, like the burning scene of the doomed Moabite on the water that came by the way of Edom: a huge flight of stairs, without parapet, descends on the left; down this rush a crowd of women mixed with the murderers; the child in the arms of one has been seized by the limbs; *she hurls herself over the edge, and falls head downmost, dragging the child out of the grasp by her weight*; – she will be dashed dead in a second: – close to us is the great struggle; a heap of the mothers, entangled in one mortal writhe with each other and the swords; one of the murderers dashed down and crushed beneath them, the sword of another caught by the blade and dragged at by a woman's naked hand; the youngest and fairest of the women, her child just torn away from a death grasp, and clasped to her breast with the grip of a steel vice, falls backwards, helplessly over the heap, right on the sword points; all knit together and hurled down in one hopeless, frenzied, furious abandonment of body and soul in the effort to save. Far back, at the bottom of the stairs, there is something in the shadow like a heap of clothes. It is a woman, sitting quiet, – quite quiet, – still as any stone; she looks down steadfastly on her dead child, laid along on the floor before her, and her hand is pressed softly upon her brow.'

I have nothing to add to the above description of this picture, except that I believe there may have been some change in the colour of the shadow that crosses the pavement. The chequers of the pavements are, in the light, golden white and pale grey; in the shadow, red and dark grey, the white in the sunshine becoming red in the shadow. I formerly supposed that this was meant to give greater horror to the scene, and it is very like Tintoret if it be so; but there is a strangeness and discordance in it which makes me suspect the colours may have changed.

(John Ruskin, *The Stones of Venice*, 1851–3)

In his '10 O'Clock Lecture', Whistler derides the notion that a painting can be reduced to mere storytelling.

For some time past, the unattached writer has become the middleman in this matter of Art, and his influence, while it has widened the gulf between the people and the painter, has brought about the most complete misunderstanding as to the aim of the picture.

For him a picture is more or less a hieroglyph or symbol of story. Apart from a few technical terms, for the display of which he finds an occasion,

the work is considered absolutely from a literary point of view; indeed, from what other can he consider it? And in his essays he deals with it as with a novel – a history – or an anecdote. He fails entirely and most naturally to see its excellences, or demerits – artistic – and so degrades Art, by supposing it a method of bringing about a literary climax.

(James McNeill Whistler, 'Mr Whistler's 10 O'Clock Lecture', 1885)

In Evelyn Waugh's unfinished novel Work Suspended, *a very late-Victorian painter enjoys an unexpected return to vogue.*

My father dressed as he thought a painter should, in a distinct and recognizable garb which made him a familiar and, in later years, a venerable figure as he took his exercise in the streets round his house. There was no element of ostentation in his poncho capes, check suits, sombrero hats and stock ties. It was rather that he thought it fitting for a man to proclaim unequivocally his station in life, and despised those of his colleagues who seemed to be passing themselves off as guardsmen and stockbrokers. In general he liked his fellow Academicians, though I never heard him express anything but contempt for their work. He regarded the Academy as a club; he enjoyed the dinners and frequently attended the schools, where he was able to state his views on art in Johnsonian terms. He never doubted that the function of painting was representational. He criticized his colleagues for such faults as innocent anatomy, 'triviality' and 'insincerity'. For this he was loosely spoken of as a conservative, but that he never was where his art was concerned. He abominated the standards of his youth. He must have been an intransigently old-fashioned young man, for he was brought up in the heyday of Whistlerian decorative painting, and his first exhibited work was of a balloon ascent in Manchester – a large canvas crowded with human drama, in the manner of Frith. His practice was chiefly in portraits – many of them posthumous – for presentation to colleges and guildhalls. He seldom succeeded with women, whom he endowed with a statuesque absurdity which was half deliberate, but given the robes of a Doctor of Music or a Knight of Malta he would do something fit to hang with the best panelling in the country; given some whiskers he was a master. 'As a young man I specialized in hair,' he would say, rather as a doctor might say he specialized in noses and throats. 'I paint it incomparably. Nowadays nobody has any to paint,' and it was this aptitude of his which led him to the long, increasingly unsaleable

series of historical and scriptural groups, and the scenes of domestic melodrama by which he is known – subjects which had already become slightly ludicrous when he was in his cradle, but which he continued to produce year after year while experimental painters came and went until, right at the end of his life, he suddenly, without realizing it, found himself in the fashion. The first sign of this was in 1935, when his *Agag before Samuel* was bought at a provincial exhibition for 750 guineas. It was a large canvas at which he had been at work intermittently since 1908. Even he spoke of it, with conscious understatement, as 'something of a white elephant'. White elephants indeed were almost the sole species of four-footed animal that was not somewhere worked into this elaborate composition. When asked why he had introduced such a variety of fauna, he replied, 'I'm sick of Samuel. I've lived with him for twenty years. Every time it comes back from an exhibition I paint out an Israelite and put in an animal. If I live long enough I'll have a Noah's ark in its background.'

The purchaser of this work was Sir Lionel Sterne.

'Honest Sir Lionel,' said my father, as he saw the great canvas packed off to Kensington Palace Gardens, 'I should dearly have liked to shake his hairy paw. I can see him well – a fine, meaty fellow with a great gold watch-chain across his belly, who's been decently employed boiling soap or smelting copper all his life, with no time to read Clive Bell [Modernist art critic]. In every age it has been men like him who kept painting alive.'

I tried to explain that Lionel Sterne was the youthful and elegant millionaire who for ten years had been a leader of aesthetic fashion. 'Nonsense!' said my father. 'Fellows like that collect disjointed Negresses by Gauguin. Only Philistines like my work and, by God, I like only Philistines.'

There was also another, rather less reputable side to my father's business. He received a regular yearly retaining fee from Goodchild & Godley, the Duke Street dealers, for what was called 'restoration'. This sum was a very important part of his income; without it the comfortable little dinners, the trips abroad, the cabs to and fro, between St John's Wood and the Athenaeum, the faithful, predatory Jellabies, the orchid in his buttonhole – all the substantial comforts and refinements which endeared the world and provided him with his air of gentlemanly ease – would have been impossible to him. The truth was that, while excelling at Lely, my father could paint, very passably, in the manner of almost any of the masters of English portraiture, and the private and public collections of the New World were richly representative of his versatility. Very few of his friends knew this traffic; to those who did, he defended it with complete candour.

'Goodchild & Godley buy these pictures for what they are – my own work. They pay me no more than my dexterity merits. What they do with them afterwards is their own business. It would ill become me to go officiously about the markets identifying my own handicraft and upsetting a number of perfectly contented people. It is a great deal better for them to look at beautiful pictures and enjoy them under a misconception about the date, than to make themselves dizzy by goggling at genuine Picassos.'

It was largely on account of his work for Goodchild & Godley that his studio was strictly reserved as a workshop. It was a separate building approached through the garden, and it was excluded from general use. Once a year, when he went abroad, it was 'done out'; once a year, on the Sunday before sending-in day at the Royal Academy, it was open to his friends.

He took a peculiar relish in the gloom of these annual tea parties, and was at the same pains to make them dismal as he was to enliven his other entertainments. There was a species of dry bright-yellow caraway cake which was known to my childhood as 'Academy cake', and appeared then and only then, from a grocer in Praed Street; there was an enormous Worcester tea service – a wedding present – which was known as 'Academy cups'; there were 'Academy sandwiches' – tiny, triangular and quite taste-less. All these things were part of my earliest memories. I do not know at what date these parties changed from a rather tedious convention to what they certainly were to my father at the end of his life, a huge, grim and solitary jest. If I was in England I was required to attend and to bring a friend or two. It was difficult, until the last two years when, as I have said, my father became the object of fashionable interest, to collect guests. 'When I was a young man,' my father said, sardonically surveying the company, 'there were twenty or more of these parties in St John's Wood alone. People of culture drove round from three in the afternoon to six, from Campden Hill to Hampstead. Today I believe our little gathering is the sole survivor of that deleterious tradition.'

On these occasions his year's work – Goodchild & Godley's items excepted – would be ranged round the studio on mahogany easels; the most important work had a wall to itself against a background of scarlet rep. I had been present at the last of the parties the year before. Lionel Sterne was there with Lady Metroland and a dozen fashionable connoisseurs. My father was at first rather suspicious of his new clients and suspected an impertinent intrusion into his own private joke, a calling of his bluff of seedcake and cress sandwiches; but their commissions reassured him.

People did not carry a joke to such extravagant lengths. Mrs Algernon Stitch paid 500 guineas for his picture of the year – a tableau of contemporary life conceived and painted with elaborate mastery. My father attached great importance to suitable titles for his work, and after toying with *The People's Idol, Feet of Clay, Not on the First Night, Their Night of Triumph, Success and Failure, Not Invited, Also Present,* he finally called this picture rather enigmatically *The Neglected Cue*. It represented the dressing room of a leading actress at the close of a triumphant first night. She sat at the dressing table, her back turned on the company, and her face visible in the mirror, momentarily relaxed in fatigue. Her protector with proprietary swagger was filling the glasses for a circle of admirers. In the background the dresser was in colloquy at the half-open door with an elderly couple of provincial appearance; it is evident from their costume that they have seen the piece from the cheaper seats, and a commissionaire stands behind them uncertain whether he did right in admitting them. He did not do right; they are her old parents arriving most inopportunely. There was no questioning Mrs Stitch's rapturous enjoyment of her acquisition.

(Evelyn Waugh, 1943)

A Romantic writer defends William Hogarth from the charge that he was merely a humorous artist, and claims him for the literary profession.

One of the earliest and noblest enjoyments I had when a boy, was in the contemplation of those capital prints by Hogarth, the *Harlot's* and *Rake's Progresses*, which, along with some others, hung upon the walls of a great hall in an old-fashioned house in ——shire, and seemed the solitary tenants (with myself) of that antiquated and life-deserted apartment.

Recollection of the manner in which those prints used to affect me has often made me wonder, when I have heard Hogarth described as a mere comic painter, as one of those whose chief ambition was to *raise a laugh*. To deny that there are throughout the prints which I have mentioned circumstances introduced of a laughable tendency, would be to run counter to the common notions of mankind; but to suppose that in their *ruling character* they appeal chiefly to the risible faculty, and not first and foremost to the very heart of man, its best and most serious feelings, would be to mistake no less grossly their aim and purpose. A set of severer Satires, (for they are not so much Comedies, which they have been likened to, as they are strong and masculine Satires,) less mingled with any thing of

mere fun, were never written upon paper, or graven upon copper. They resemble Juvenal, or the satiric touches in *Timon of Athens*.

I was pleased with the reply of a gentleman, who being asked which book he esteemed most in his library, answered, – 'Shakspeare': being asked which he esteemed next best, replied, 'Hogarth'. His graphic representations are indeed books: they have the teeming, fruitful, suggestive meaning of *words*. Other pictures we look at, – his prints we read.

(Charles Lamb, 1811)

Members of the Bloomsbury Group consider whether Sickert was more of a novelist, or a painter, as reported by the group's leading light.

To me Sickert always seems more of a novelist than a biographer ... He likes to set his characters in motion, to watch them in action. As I remember it, his show was full of pictures that might be stories, as indeed their names suggest – *Rose et Marie*; *Christine Buys a House*; *A Difficult Moment*. The figures are motionless, of course, but each has been seized in a moment of crisis; it is difficult to look at them and not to invent a plot, to hear what they are saying. You remember the picture of the old publican, with his glass on the table before him and a cigar gone cold at his lips, looking out of his shrewd little pig's eyes at the intolerable wastes of desolation in front of him? A fat woman lounges, her arm on a cheap yellow chest of drawers, behind him. It is all over with them, one feels. The accumulated weariness of innumerable days has discharged its burden on them. They are buried under an avalanche of rubbish. In the street beneath, the trams are squeaking, children are shrieking. Even now somebody is tapping his glass impatiently on the bar counter. She will have to bestir herself; to pull her heavy, indolent body together and go and serve him. The grimness of that situation lies in the fact that there is no crisis; dull minutes are mounting, old matches are accumulating and dirty glasses and dead cigars; still on they must go, up they must get.

And yet it is beautiful, said the other; satisfactory; complete in some way. Perhaps it is the flash of the stuffed birds in the glass case, or the relation of the chest of drawers to the woman's body; anyhow, there is a quality in that picture which makes me feel that though the publican is done for, and his disillusion complete, still in the other world, of which he is mysteriously a part without knowing it, beauty and order prevail; all is right there – or does that convey nothing to you? Perhaps that is one

of the things that is better said with a flick of the fingers, said the other. But let us go on living in the world of words a little longer. Do you remember the picture of the girl sitting on the edge of her bed half naked? Perhaps it is called *Nuit d'Amour*. Anyhow, the night is over. The bed, a cheap iron bed, is tousled and tumbled; she has to face the day, to get her breakfast, to see about the rent. As she sits there with her nightgown slipping from her shoulders, just for a moment the truth of her life comes over her; she sees in a flash the little garden in Wales and the dripping tunnel in the Adelphi where she began, where she will end, her days. So be it, she says, and yawns and shrugs and stretches a hand for her stockings and chemise. Fate has willed it so. Now a novelist who told that story would plunge – how obviously – into the depths of sentimentality. How is he to convey in words the mixture of innocence and sordidity, pity and squalor? Sickert merely takes his brush and paints a tender green light on the faded wallpaper. Light is beautiful falling through green leaves. He has no need of explanation; green is enough. Then again there is the story of Marie and Rose – a grim, a complex, a moving and at the same time a heartening and rousing story. Marie on the chair has been sobbing out some piteous plaint of vows betrayed and hearts broken to the woman in the crimson petticoat. 'Don't be a damned fool, my dear,' says Rose, standing before her with her arms akimbo. 'I know all about it,' she says, standing there in the intimacy of undress, experienced, seasoned, a woman of the world. And Marie looks up at her with all her illusions tearfully exposed and receives the full impact of the other's knowledge, which, however, perhaps because of the glow of the crimson petticoat, does not altogether wither her. There is too much salt and savour in it. She takes heart again. Down she trips past the one-eyed char with a pail, out into the street, a wiser woman than she went in. 'So that's what life is,' she says, brushing the tear from her eye and hailing the omnibus. There are any number of stories and three-volume novels in Sickert's exhibition.

But to what school of novelists does he belong? He is a realist, of course, nearer to Dickens than to Meredith. He has something in common with Balzac, Gissing and the earlier Arnold Bennett. The life of the lower middle class interests him most – of innkeepers, shopkeepers, music-hall actors and actresses. He seems to care little for the life of the aristocracy whether of birth or of intellect. The reason may be that people who inherit beautiful things sit much more loosely to their possessions than those who have brought them off barrows in the street with money earned by their own hands. There is a gusto in the spending of the poor; they are

very close to what they possess. Hence the intimacy that seems to exist in Sickert's pictures between his people and their rooms. The bed, the chest of drawers, the one picture and the vase on the mantelpiece are all expressive of the owner. Merely by process of use and fitness the cheap furniture has rubbed its varnish off; the grain shows through; it has the expressive quality that expensive furniture always lacks; one must call it beautiful, though outside the room in which it plays its part it would be hideous in the extreme. Diamonds and Sheraton tables never submit to use like that. But whatever Sickert paints has to submit; it has to lose its separateness; it has to compose part of his scene. He chooses, therefore, the casual clothes of daily life that have taken the shape of the body; the felt hat with one feather that a girl has bought with sixpence off a barrow in Berwick Market. He likes bodies that work, hands that work, faces that have been lined and suppled and seamed by work, because, in working, people take unconscious gestures, and their faces have the expressiveness of unconsciousness – a look that the very rich, the very beautiful and the very sophisticated seldom possess. And of course Sickert composes his picture down to the very castors on the chairs and the fire-irons in the grate just as carefully as Turgenev, of whom he sometimes reminds me, composes his scene.

(Virginia Woolf, 1934)

For his part, Sickert puts in a word for pictures that tell a story.

It is natural to all ages to like the narrative picture, and I fancy, if we spoke the truth, and our memories were clear enough, we liked at first the narrative picture in the proportion that it can be said to be lurid. My uninfluenced interest certainly went out, first of all, to Martin's *Belshazzar's Feast*, and then to Cruikshank's *Bottle*, in the South Kensington Museum. It is only when the mist and the driving rain of intellectual snobbishness, coinciding more or less with the period of puberty, and the consequent 'urge' to compete in agreeing with ladies a little older than ourselves, reach us, that we become ashamed of our true loves, and fidget from novelty to novelty after the will-o'-the-wisp of authority – authority of which I will now endeavour to define the present terminus. I say the present terminus, because, alas! experience has taught us that no terminus even is permanent in its location.

In AD 1922, the terminus, so far as careful and anxious enquiry can

gather, is (lo!) here; the great paintings of the world are got out of the way by the convenient anathema of 'illustration'; Mantegna, Michelangelo, Veronese, Canaletto, Ford Madox Brown, Hogarth, Leech, Keene, *e tutti quanti*, falling, certainly, under the heading of 'illustration', must, I am afraid, go. Rubens, and a few other worms of that ilk, I note on an invitation I have recently received from the Medici Society, can still be mentioned in decent company, but only, if you please, as 'the ancestors of Cézanne'!

(Walter Sickert, 1922)

Leonardo da Vinci makes notes on how to represent an animated group, with his own Last Supper *in mind.*

When you wish to represent a man speaking among a group of persons consider the matter of which he has to treat and adapt his action to the subject. That is, if the subject be persuasive let his action be in keeping, if the matter is to set forth an argument, let the speaker with the fingers of the right hand hold one finger of the left hand keeping the two smaller ones closed; and his face alert and turned towards the people, with mouth slightly open to look as though he spoke; and if he is seated let him appear as though about to rise, with his head forward. If you represent him standing, make him leaning slightly forward with head and shoulders towards the people. These you should represent silent and attentive and all watching the face of the orator with gestures of admiration; and make some old men in astonishment at what they hear, with the corners of their mouths pulled down drawing back the cheeks in many furrows with their eyebrows raised where they meet, making many wrinkles on their foreheads; some sitting with their fingers clasped over their weary knees; and some bent old man, with one knee crossed over the other and one hand resting upon it and holding his other elbow and the hand supporting the bearded chin.

Notes on the Last Supper

One who was drinking and has left the glass in its position and turned his head towards the speaker.

Another twisting the fingers of his hands, turns with stern brows to his companion. Another with his hands spread shows the palms, and

shrugs his shoulders up to his ears, making a mouth of astonishment. Another speaks into his neighbour's ear and he, as he listens, turns towards him to lend an ear while holding a knife in one hand, and in the other the loaf half cut through. Another as he turns with a knife in his hand upsets a glass on the table. Another lays his hands on the table and is looking. Another blows his mouthful. Another leans forward to see the speaker shading his eyes with his hands. Another draws back behind the one who leans forward, and sees the speaker between the wall and the man who is leaning.

The painter ought always to consider, when he has a wall on which he has to represent a story, the height at which he will locate his figures, and when he draws from nature for this composition, he ought to take a position with his eye as much below the object that he is drawing, as the object, when inserted into the composition, will be above the eye of the observer. Otherwise the work will be reprehensible.

(Leonardo da Vinci, 1452–1519)

Duchamp's masterpiece – The Bride Stripped Bare by Her Bachelors, Even, *also known as* The Large Glass *– is based on a narrative that no one can understand, as his biographer explains. Naturally, this has not prevented battalions of critics from trying to explain it. Duchamp himself set the ball rolling with the notes he published in* The Green Box *in 1934.*

The notes from *The Green Box* (italicized here) are essential to any understanding of *The Large Glass*. They constitute the verbal dimension of a work that is as much verbal as visual, by an artist who disdained words as a form of communication but who was fascinated by their other life, in poetry. It should be borne in mind, however, that nobody fully understands *The Large Glass*. The work stands in relation to painting as *Finnegans Wake* does to literature, isolated and inimitable; it has been called everything from a masterpiece to a hoax, and to this day there are no standards by which it can be judged. Duchamp invented a new physics to explain its 'laws', and a new mathematics to fix the units of its measurement. Some of the notes are simply impossible to fathom. A good many of the ideas in them were never even carried out on the *Glass*, for that matter, either because the technical problems were too great or because, as Duchamp sometimes said, after eight years of work on the

project he simply got bored and lost interest. He stopped working on the *Glass* in 1923, leaving it, in his own words, 'definitively unfinished'.

Its full title is *La Mariée mise à nu par ses célibataires, même*, or *The Bride Stripped Bare by Her Bachelors, Even*. Note the 'Even'. This sly adverb, thrown in to discourage literal readings, has also been subjected to endless analysis. One explanation is that it should be read as a pun on '*m'aime*', meaning 'loves me' – that is to say, the bride being stripped by these anonymous bachelors really loves Marcel Duchamp. The tribe can't resist looking for clues to the man in such discoveries, but Duchamp always maintained that his odd little adverb had no meaning whatsoever, that it was just 'fun and poetry in my own way', that 'the word *même* came to me without even looking for it.' It was simply a humorous aside, something like the 'already' in 'enough, already'.

Less attention has been paid to the word 'her' in the title. There are nine bachelors, and the inference is that they belong to the bride – a male harem, servile and inferior in every respect to their peremptory mistress. *The bride has a life centre – the bachelors do not. They live on coal or other raw material drawn not from them but from their not them.* Although she *must appear as an apotheosis of virginity, i.e. ignorant desire, blank desire (with a touch of malice)*, this bride clearly knows the facts of life. *Instead of being merely an asensual icicle*, she *warmly rejects (not chastely) the bachelors' brusque offer*. In fact, she does not reject it at all, but rather uses their lust to further *her own intense desire for the orgasm*. One note describes *The Bride Stripped Bare by Her Bachelors, Even* as an *agricultural machine*, an *instrument for farming*; this seems to suggest fertility, perhaps even birth, but as usual the terms are ambiguous. Other notes establish the bride as a thoroughgoing narcissist, intent on her own pleasure and nothing else.

The notes in *The Green Box* have a cryptic, absurd, self-mocking bite that is unique to Duchamp. Some are no more than a few scrawls on torn scraps of paper; others run on for pages, with precise pseudo-scientific diagrams and calculations in neat script. Most of them date from the years 1912 to 1915, when the ideas for *The Large Glass* were coming to Duchamp one after another, but they are in no particular order; he simply jotted them down and tossed them into a cardboard box that he kept for that purpose. At one time he thought of publishing the notes as a sort of brochure or catalogue, to be consulted alongside the *Glass*, but not until 1934, eleven years after he had stopped working on the *Glass* itself, did he get around to reproducing them. The form he chose then was meticulously and enigmatically Duchampian – a limited edition of ninety-

four notes, drawings, and photographs, printed in facsimile, using the same papers and the same inks or pencil leads, torn or snipped in precisely the same way as the originals, with the same crossings-out and corrections and abbreviations and unfinished thoughts, contained willy-nilly in a rectangular green box covered in green suede with the title, *La Mariée mise à nu par ses célibataires, même* (the same as the *Glass*), picked out in white dots on the front, like a sign on a theatre marquee. A typographic rendering of the notes, translated into English by the artist Richard Hamilton and the art historian George Heard Hamilton, was published under the same title in 1960 and since then there have been other versions published in English, Spanish, Italian, German, Swedish, and Japanese, so that almost anyone who wants to can now approach the *Glass* the way Duchamp thought it should be approached, as an equal mixture of verbal and visual concepts. The *Glass*, he said, 'is not meant to be looked at (through aesthetic eyes); it was to be accompanied by as amorphous a literary text as possible, which never took form; and the two features, glass for the eye and text for the ears and the understanding, were to complement each other and, above all, prevent the other from taking an aesthetic-plastic or literary form.' Eight years of work, in other words, on something that could be thought of as an attempt to answer the question he had asked himself, in a note dated 1913: *Can one make works which are not works of 'art'?*

The *Glass* does have a subject, nevertheless, and a rather popular one at that. Sexual desire, or to be more precise, the machinery of sexual desire, is what we are dealing with here, although we might never suspect it just from looking at the *Glass*. Only by reading the notes can we follow the stages of the erotic encounter, which resembles no other in literature or in art. Before attempting that, however, a word of warning: as the French critic Jean Suquet points out, Duchamp's machinery only works when oiled by humour.

The Bride is basically a motor, Duchamp tells us. She is, in fact, an internal-combustion engine, although her components do not conform to any known model. This bride runs on *love gasoline (a secretion of the bride's sexual glands)*, which is ignited in a two-stroke cycle. The first stroke, or explosion, is generated by the bachelors through an *electrical stripping* whose action Duchamp compares to *the image of a motor car climbing a slope in low gear . . . while slowly accelerating, as if exhausted by hope, the motor of the car turns faster and faster, until it roars triumphantly.* The second stroke is brought about by sparks from her own *desire-magneto.* Although Duchamp suggests in two notes, confusingly, that the electrical stripping 'controls' the bride's

sexual arousal, he makes it clear in others that the bride herself is in full control. She *accepts this stripping by the bachelors, since she supplies the love gasoline to the sparks of the electrical stripping; moreover, she furthers her complete nudity by adding to the first focus of sparks (electrical stripping) the 2nd focus of the desire-magneto.* The notion of a mysterious female power that is both passive (permitting) and active (desiring) runs through many of the notes on *The Large Glass.* The bachelors, by contrast, are wholly passive. It is the bride's *blank desire (with a touch of malice)* that sets in motion the fantastic erotic machinery whose purpose is to bring about *the blossoming of this virgin who has reached the goal of her desire.*

The mechanico-erotic language of the notes on the bride has no visual counterpart in *The Large Glass* itself. In fact, the upper glass panel that is the bride's domain shows nothing that even remotely suggests female anatomy, clothed or unclothed. What we see instead is a group of abstract, vaguely insectile shapes on the left-hand side, connected to a large cloudlike form that stretches all the way across the top. Each element on the left has a name, although even today, after seventy years of study and conjecture, it is hard to pin down exactly which is which. The large form at the top left is the *pendu femelle,* a decidedly unglamourous term meaning '*hanging female object*'; close examination shows that it does indeed hang from a painted hook at the top of the *Glass.* Underneath that is a *motor with quite feeble cylinders* and its reservoir of *love gasoline,* a sort of *timid-power,* or *automobiline,* which, as you will recall, is secreted from the bride's sexual glands. Just to the right of these forms lies the *wasp,* or *sex cylinder,* a flask-shaped object that narrows at the top and is capped by a pair of snail-like antennae. Under that is the diagonal, sticklike shape of the *desire-magneto* – at least, I think it is the desire-magneto; others have located this vital organ elsewhere in the assembly. Just how all these elements combine to produce the two-stroke internal-combustion cycle is not really clear to me nor, I believe, to anyone else, and I do not think that Duchamp meant it to be. The whole process, as he wrote, is *unanalysable by logic,* and it would not hurt us at this point to suspend our disbelief by a few more notches.

(Calvin Tomkins, 1996)

Truth

and

Beauty:

In

Search

of

Reality

and

the

Ideal

Cézanne's whole life was a long battle to depict unpredigested, cliché-free reality, argues D. H. Lawrence, even if it was only the reality of an apple.

To a true artist, and to the living imagination, the cliché is the deadly enemy. Cézanne had a bitter fight with it. He hammered it to pieces a thousand times. And still it reappeared.

Now . . . we can see why Cézanne's drawing was so bad. It was bad because it represented a smashed, mauled cliché, terribly knocked about. If Cézanne had been willing to accept his own baroque cliché, his drawing would have been perfectly conventionally 'all right', and not a critic would have had a word to say about it. But when his drawing was conventionally all right, to Cézanne himself it was mockingly all wrong, it was cliché. So he flew at it and knocked all the shape and stuffing out of it, and when it was so mauled that it was all wrong, and he was exhausted with it, he let it go; bitterly, because it still was not what he wanted. And here comes in the comic element in Cézanne's pictures. His rage with the cliché made him distort the cliché sometimes into parody, as we see in pictures like *The Pasha* and *La Femme*. 'You *will* be a cliché, will you?' he gnashes. 'Then *be* it!' And he shoves it in a frenzy of exasperation over into parody. And the sheer exasperation makes the parody still funny; but the laugh is a little on the wrong side of the face.

This smashing of the cliché lasted a long way into Cézanne's life; indeed, it went with him to the end. The way he worked over and over his forms was his nervous manner of laying the ghost of his cliché, burying it. Then when it disappeared perhaps from his forms themselves, it lingered in his composition, and he had to fight with the *edges* of his forms and contours, to bury the ghost there. Only his colour he knew was not cliché. He left it to his disciples to make it so.

In his very best pictures, the best of the still-life compositions, which seem to me Cézanne's greatest achievement, the fight with the cliché is still going on. But it was in the still-life pictures he learned his final method

of *avoiding* the cliché: just leaving gaps through which it fell into nothingness. So he makes his landscape succeed.

In his art, all his life long, Cézanne was tangled in a twofold activity. He wanted to express something, and before he could do it he had to fight the hydra-headed cliché, whose last head he could never lop off. The fight with the cliché is the most obvious thing in his pictures. The dust of battle rises thick, and the splinters fly wildly. And it is this dust of battle and flying of splinters which his imitators still so fervently imitate. If you give a Chinese dressmaker a dress to copy, and the dress happens to have a darned rent in it, the dressmaker carefully tears a rent in the new dress, and darns it in exact replica. And this seems to be the chief occupation of Cézanne's disciples, in every land. They absorb themselves reproducing imitation mistakes. He let off various explosions in order to blow up the stronghold of the cliché, and his followers make grand firework imitations of the explosions, without the faintest inkling of the true attack. They do, indeed, make an onslaught on representation, true-to-life representation: because the explosion in Cézanne's pictures blew them up. But I am convinced that what Cézanne himself wanted *was* representation. He *wanted* true-to-life representation. Only he wanted it *more* true to life. And once you have got photography, it is a very, very difficult thing to get representation *more* true-to-life: which it has to be.

Cézanne was a realist, and he wanted to be true to life. But he would not be content with the optical cliché. With the impressionists, purely optical vision perfected itself and fell *at once* into cliché, with a startling rapidity. Cézanne saw this. Artists like Courbet and Daumier were not purely optical, but the other element in these two painters, the intellectual element, was cliché. To the optical vision they added the concept of force-pressure, almost like an hydraulic brake, and this force-pressure concept is mechanical, a cliché, though still popular. And Daumier added mental satire, and Courbet added a touch of a sort of socialism: both cliché and unimaginative.

Cézanne wanted something that was neither optical nor mechanical nor intellectual. And to introduce into our world of vision something which is neither optical nor mechanical nor intellectual-psychological requires a real revolution. It was a revolution Cézanne began, but which nobody, apparently, has been able to carry on.

He wanted to touch the world of substance once more with the intuitive touch, to be aware of it with the intuitive awareness, and to express it in intuitive terms. That is, he wished to displace our present mode of

mental-visual consciousness, the consciousness of mental concepts, and substitute a mode of consciousness that was predominantly intuitive, the awareness of touch. In the past the primitives painted intuitively, but *in the direction* of our present mental-visual, conceptual form of consciousness. They were working away from their own intuition. Mankind has never been able to trust the intuitive consciousness, and the decision to accept that trust marks a very great revolution in the course of human development.

Without knowing it, Cézanne, the timid little conventional man sheltering behind his wife and sister and the Jesuit father, was a pure revolutionary. When he said to his models: 'Be an apple! Be an apple!' he was uttering the foreword to the fall not only of Jesuits and the Christian idealists altogether, but to the collapse of our whole way of consciousness, and the substitution of another way. If the human being is going to be primarily an apple, as for Cézanne it was, then you are going to have a new world of men: a world which has very little to say, men that can sit still and just be physically there, and be truly non-moral. That was what Cézanne meant with his: 'Be an apple!' He knew perfectly well that the moment the model began to intrude her personality and her 'mind', it would be cliché and moral, and he would have to paint cliché. The only part of her that was not banal, known *ad nauseam*, living cliché, the only part of her that was not living cliché was her appleyness. Her body, even her very sex, was known nauseously: *connu, connu!* the endless chance of known cause-and-effect, the infinite web of the hated cliché which nets us all down in utter boredom. He knew it all, he hated it all, he refused it all, this timid and 'humble' little man. He knew, as an artist, that the only bit of a woman which nowadays escapes being ready-made and ready-known cliché is the appley part of her. Oh, be an apple, and leave out all your thoughts, all your feelings, all your mind and all your personality, which we know all about and find boring beyond endurance. Leave it all out – and be an apple! It is the appleyness of the portrait of Cézanne's wife that makes it so permanently interesting: the appleyness, which carries with it also the feeling of knowing the other side as well, the side you don't see, the hidden side of the moon. For the intuitive apperception of the apple is so *tangibly* aware of the apple that it is aware of it *all round*, not only just of the front. The eye sees only fronts, and the mind, on the whole, is satisfied with fronts. But intuition needs all-aroundness, and instinct needs insideness. The true imagination is for ever curving round to the other side, to the back of the presented appearance.

So to my feeling the portraits of Madame Cézanne, particularly the

portrait in the red dress, are more interesting than the portrait of M. Geffroy, or the portraits of the housekeeper or the gardener. In the same way the *Card Players* with two figures please me more than those with four.

But we have to remember, in his figure paintings, that while he was painting the appleyness he was also deliberately painting *out* the so-called humanness, the personality, the 'likeness', the physical cliché. He had deliberately to paint it out, deliberately to make the hands and face rudimentary, and so on, because if he had painted them in fully they would have been cliché. He *never* got over the cliché denominator, the intrusion and interference of the ready-made concept, when it came to people, to men and women. Especially to women he could only give a cliché response – and that maddened him. Try as he might, women remained a known, ready-made cliché object to him, and he *could not* break through the concept obsession to get at the intuitive awareness of her. Except with his wife – and in his wife he did at least know the appleyness. But with his housekeeper he failed somewhat. She was a bit cliché, especially the face. So really is M. Geffroy.

With men Cézanne often dodged it by insisting on the clothes, those stiff cloth jackets bent into thick folds, those hats, those blouses, those curtains. Some of the *Card Players*, the big ones with four figures, seem just a trifle banal, so much occupied with painted stuff, painted clothing, and the humanness a bit cliché. Nor good colour, nor clever composition, nor 'planes' of colour, nor anything else will save an emotional cliché from being an emotional cliché, though they may, of course, garnish it and make it more interesting.

Where Cézanne did sometimes escape the cliché altogether and really give a complete intuitive interpretation of actual objects is in some of the still-life compositions. To me these good still-life scenes are purely representative and quite true to life. Here Cézanne did what he wanted to do: he made the things quite real, he didn't deliberately leave anything out, and yet he gave us a triumphant and rich intuitive vision of a few apples and kitchen pots. For once his intuitive consciousness triumphed, and broke into utterance. And here he is inimitable. His imitators imitate his accessories of tablecloths folded like tin, etc. – the unreal parts of his pictures – but they don't imitate the pots and apples, because they can't. It's the real appleyness, and you can't imitate it. Every man must create it new and different out of himself: new and different. The moment it looks 'like' Cézanne, it is nothing.

But at the same time Cézanne was triumphing with the apple and appleyness he was still fighting with the cliché. When he makes Madame Cézanne most *still*, most appley, he starts making the universe slip uneasily about her. It was part of his desire: to make the human form, the *life* form, come to rest. Not static – on the contrary. Mobile but come to rest. And at the same time he set the unmoving material world into motion. Walls twitch and slide, chairs bend or rear up a little, clothes curl like burning paper. Cézanne did this partly to satisfy his intuitive feeling that nothing is really *statically* at rest – a feeling he seems to have had strongly – as when he watched the lemons shrivel or go mildewed, in his still-life group, which he left lying there so long so that he *could* see that gradual flux of change: and partly to fight the cliché, which says that the inanimate world *is* static, and that walls *are* still. In his fight with the cliché he denied that walls are still and chairs are static. In his intuitive self he *felt* for their changes.

And these two activities of his consciousness occupy his later landscapes. In the best landscapes we are fascinated by the mysterious *shiftiness* of the scene under our eyes; it shifts about as we watch it. And we realize, with a sort of transport, how intuitively *true* this is of landscape. It is *not* still. It has its own weird anima, and to our wide-eyed perception it changes like a living animal under our gaze. This is a quality that Cézanne sometimes got marvellously.

Then again, in other pictures he seems to be saying: Landscape is not like this and not like this and not like this and not . . . etc. – and every *not* is a little blank space in the canvas, defined by the remains of an assertion. Sometimes Cézanne builds up a landscape essentially out of omissions. He puts fringes on the complicated vacuum of the cliché, so to speak, and offers us that. It is interesting in a *repudiative* fashion, but it is not the new thing. The appleyness, the intuition has gone. We have only a mental repudiation. This occupies many of the later pictures: and ecstasizes the critics.

And Cézanne was bitter. He had never, as far as his *life* went, broken through the horrible glass screen of the mental concepts, to the actual *touch* of life. In his art he had touched the apple, and that was a great deal. He had intuitively known the apple and intuitively brought it forth on the tree of his life, in paint. But when it came to anything beyond the apple, to landscape, to people, and above all to nude woman, the cliché had triumphed over him. The cliché had triumphed over him, and he was bitter, misanthropic. How not to be misanthropic when men and women

are just clichés to you, and you hate the cliché? Most people, of course, love the cliché – because most people *are* the cliché. Still, for all that, there is perhaps more appleyness in man, and even in nude woman, than Cézanne was able to get at. The cliché obtruded, so he just abstracted away from it. Those last water-colour landscapes are just abstractions from the cliché. They are blanks, with a few pearly-coloured sort of edges. The blank is vacuum, which was Cézanne's last word against the cliché. It is a vacuum, and the edges are there to assert the vacuity.

(D. H. Lawrence, 1929)

To a lady who, looking at an engraving of a house, called it an ugly thing, he [Constable] said, 'No, madam, there is nothing ugly; *I never saw an ugly thing in my life*: for let the form of an object be what it may, – light, shade, and perspective will always make it beautiful. It is perspective which improves the form of this.'

(C. R. Leslie, *Memoirs of the Life of John Constable, RA*, 1843)

An attempt to take a cast of a beautiful human form almost results in the death of the model.

What was excellent was the great flexibility and vigour of his movements in spite of his inherent defects. The moment he moved, his intentions were evident. The great principle that the form of a part depends on its action was here confirmed. His joints were exquisitely clean. His body bent at the loins like whalebone. He sat upon his heel, and put his foot behind his neck. The bony flatness of his articulations and fleshy fulness of his muscles produced that undulating variety of line so seldom seen in the living figure. Pushed to enthusiasm by the beauty of this man's form, I cast him, drew him, and painted him till I had mastered every part. I had all his joints moulded in every stage, from their greatest possible flexion to their greatest possible extension. The man himself and the moulders took fire at my eagerness, and after having two whole figures moulded, he said he thought he could bear another to be done if I wished it; of course I wished it, so we set to again. In moulding from nature great care is required, because the various little movements of the skin produce perpetual cracks, and if the man's back is moulded first, by the time you come to his chest he labours to breathe greatly, so that you must then

have the plaster rubbed up and down with great rapidity till it sets. We had been repeatedly baffled in our attempt at this stage, and I therefore thought of a plan to prevent the difficulty, to build a wall round him, so that plaster might be poured in, and set all around him equally, and at once. This was agreed upon. The man was put into a position, extremely happy at the promise of success, as he was very proud of his figure. Seven bushels of plaster were mixed at once and poured in till it floated him up to the neck. The moment it set it pressed so equally upon him that his ribs had no room to expand for his lungs to play, and he gasped out, 'I – I – I die.' Terrified at his appearance, for he had actually dropped his head, I seized with the workmen the front part of the mould, and by one supernatural effort split it in three large pieces and pulled the man out, who, almost gone, lay on the ground senseless and streaming with perspiration. By degrees we recovered him, and then, looking at the hinder part of the mould which had not been injured, I saw the most beautiful sight on earth. It had taken the impression of his figure with all the purity of a shell, and when it was joined to the three front pieces there appeared the most beautiful cast ever taken from nature, one which I will defy anyone in the world to equal, unless he will risk, as I unthinkingly did, the killing of the man he is moulding. I was so alarmed when I reflected on what I had nearly done, that I moulded no more whole figures. The fellow himself was quite as eager as ever, though very weak for a day or two. The surgeons said he would have died in a second or two longer. I rewarded the man well for his sufferings, and before three days he came, after having been up all night drinking, quite tipsy, and begged to know, with his eyes fixed, if I should want to kill him any more, for he was quite ready, as he had found it 'a d——d good concern'. However, I had done with him, and would not venture, as I had mastered his form, to run any more such risks.

(Benjamin Robert Haydon, 1786–1846)

The great eighteenth-century German art historian and critic, Johann Joachim Winckelmann, a founding father of the neo-Classical movement, considers the nature of beauty to be a mystery; none the less, he is fairly sure what it is. It is pure and simple.

Colour assists beauty; generally, it heightens beauty and its forms, but it does not constitute it; just as the taste of wine is more agreeable, from its colour, when drunk from a transparent glass, than from the most costly

golden cup. Colour, however, should have but little share in our consideration of beauty, because the essence of beauty consists, not in colour, but in shape, and on this point enlightened minds will at once agree. As white is the colour which reflects the greatest number of rays of light, and consequently is the most easily perceived, a beautiful body will, accordingly, be the more beautiful the whiter it is, just as we see that all figures in gypsum, when freshly formed, strike us as larger than the statues from which they are made.

The highest beauty is in God; and our idea of human beauty advances towards perfection in proportion as it can be imagined in conformity and harmony with that highest Existence which, in our conception of unity and indivisibility, we distinguish from matter. This idea of beauty is like an essence extracted from matter by fire; it seeks to beget unto itself a creature formed after the likeness of the first rational being designed in the mind of the Divinity. The forms of such a figure are simple and flowing, and various in their unity; and for this reason they are harmonious, just as a sweet and pleasing tone can be extracted from bodies the parts of which are uniform. All beauty is heightened by unity and simplicity, as is everything which we do and say; for whatever is great in itself is elevated, when executed and uttered with simplicity. It is not more strictly circumscribed, nor does it lose any of its greatness, because the mind can survey and measure it with a glance, and comprehend and embrace it in a single idea; but the very readiness with which it may be embraced places it before us in its true greatness, and the mind is enlarged, and likewise elevated, by the comprehension of it. Everything which we must consider in separate pieces, or which we cannot survey at once, from the number of its constituent parts, loses thereby some portion of its greatness, just as a long road is shortened by many objects presenting themselves on it, or by many inns at which a stop can be made. The harmony which ravishes the soul does not consist in arpeggios, and tied and slurred notes, but in simple, long-drawn tones. This is the reason why a large palace appears small, when it is overloaded with ornament, and a house large, when elegant and simple in its style.

From unity proceeds another attribute of lofty beauty, the absence of individuality; that is, the forms of it are described neither by points nor lines other than those which shape beauty merely, and consequently produce a figure which is neither peculiar to any particular individual, nor yet expresses any one state of the mind or affection of the passions, because these blend with it strange lines, and mar the unity. According to

this idea, beauty should be like the best kind of water, drawn from the spring itself; the less taste it has, the more healthful it is considered, because free from all foreign admixture. As the state of happiness – that is, the absence of sorrow, and the enjoyment of content – is the very easiest state in nature, and the road to it is the most direct, and can be followed without trouble and without expense, so the idea of beauty appears to be the simplest and easiest, requiring no philosophical knowledge of man, no investigation and no expression of the passions of his soul.

(Johann Joachim Winckelmann, 1764)

Delacroix's view of beauty is historical – what our grandparents thought beautiful we now think ugly (and vice versa).

Do not confuse with the beautiful what other periods called the beautiful. Go further: be bold enough, in almost every case to say that what was the beautiful thirty or forty years ago is now the ugly. See whether you can bear the painting of men like Vanloo and of Boucher [fashionable eighteenth-century painters] who delighted our grandmothers and who were the admiration of people who may well have been difficult to please, like Voltaire for example, and other great minds of the time. It will be necessary for another Revolution to change people's ideas once more before we can work out from all this material just the men who have true merit.

(Eugène Delacroix, 1798–1863)

In his last years, John Richardson argues, Picasso painted his women with greater reality, and more freedom, than ever before.

Picasso singled out the physicality of Degas's 'pig-faced whores' for admiration. 'You can smell them,' he said. This physicality is what so much of Picasso's art is about. Just as in his twenties he and Braque had devised Cubism as a way of rendering reality more palpably than ever before, so in his eighties, as he told Hélène Parmelin, he aimed to do a painting of a woman on a chair that would be as *real* as the woman herself – so real that it would contain everything pertaining to the woman and yet would resemble nothing in our experience. So real that people seeing her would say 'Bonjour, Madame'. And Picasso described how he had

once shown his great *Woman in a Chemise in an Armchair* of 1913 to Braque: 'Is this woman *real?*' Picasso had asked. 'Could she go out in the street? Is she a woman or a picture?' Picasso went on at Braque. 'Do her armpits smell?' And the two artists proceeded to use the armpit quotient as a test of *real* painting. 'This one smells a bit but not that one . . .' I remember hearing Picasso listing other intimate attributes that a painting of a woman should convey – attributes I will spare the reader.

The physicality with which Picasso endowed his late works is one of the reasons why they met with such scorn. People were shocked, and as shocked people often do, they took refuge in disdain; Picasso's notion of femininity was infantile, senile, vulgar. Ironically, these accusations were much the same that an uncomprehending public had made against another artist who had a place of honour in Picasso's pantheon and with whom he identified, Manet. The only difference was that Second Empire Philistines had the excuse of ignorance in the face of the *Déjeuner sur l'Herbe* or *Olympia*, whereas a hundred years later critics were supposed to be proof against the shock of the new.

This shared feeling of rejection at the hands of an uncomprehending public goes a long way toward explaining Picasso's continuing identification with Manet. Given that Picasso had an instinctive grasp of art history, and a very clear idea of where he, Picasso, stood in relation to the past and the present, he had no problem identifying with Manet as the first modern artist, one who had set out to shock the bourgeoisie and had been pilloried for his pains, one who had been denounced for 'shamelessness' and 'vulgarity', for painting 'a yellow-bellied courtesan', 'a female gorilla made of india-rubber'. Had Manet painted 'Olympia' in the guise of a Circassian slave or coquettish Bathsheba, he would have given no offence. It was her blatant nakedness as opposed to artistic nudity that was a threat. Picasso admired *Olympia* and the girl in the *Déjeuner* for all the things that the Second Empire had found so shocking, not least the outdoors juxtaposition of a naked woman and fully clothed men. And he set out to paint nudes who would be far more threatening, far more shocking than Manet's.

No doubt about it. Picasso's 'super-real' (his word) women *are* threatening. Had they been pretexts for celestial Mozartian painting like Matisse's Odalisques, or – on a much lower level – perverse spectres of sex appeal like Dali's or Bellmer's rubbery anthropoids, they would have been artistically acceptable. But these hefty, smelly creatures who scratch their

parts and pick their terrible toes with banana-sized fingers, and expose themselves in a matter-of-fact, unerotic way, threatened a generation nurtured on art that had been deodorized and sanitized, a generation that had mostly turned away from reality except in the gimmicky or eye-fooling forms of pop art or photo-realism.

A further obstacle to liking these late works is the deceptive clumsiness of their technique. People who should have known better suggested that the artist had become senile and sloppy and that his hand had lost its cunning. Picasso played into their hands by boasting that 'chaque jour je fais pire'. What of course he meant was that 'chaque jour je fais mieux': that he was out to eradicate artistic clichés (including Picassian ones) and all trace of fine painting or virtuosity from his work. Did Picasso, who had been aware of Oscar Wilde and his work from student days, know of his great dictum? 'I have solved the riddle of Truth. A truth in Art is that whose contrary is also true.'

No, far from losing any of his cunning, Picasso still had to make things as difficult as possible for himself and, by extension, for the viewer. True, in the past, dexterity, or rather his ingenious attempts to conceal dexterity, had on occasion got the better of him. Seldom, however, in the last paintings. The technique is very much there, above all the infinite variety of the formal invention and the wonderful plasticity of the paint, but it is never an end in itself.

In fact, the clumsiness of Picasso's very late paintings is disingenuous to the point of deceptiveness. Technique, said Picasso, is important, 'on condition that one has so much . . . that it completely ceases to exist'. There is nothing hit-or-miss about his seemingly hit-or-miss style. The point was to preserve the directness and spontaneity of his first rush of inspiration, to be as free and loose and expressive as possible. In old age Picasso had finally discovered how to take every liberty with space and form, colour and light, fact and fiction, time and place, not to mention identity.

(John Richardson, 'L'Époque Jacqueline', 1988)

A masterpiece by Velázquez – Las Meninas *(*The Maids of Honour*) – receives the highest possible praise from another painter.*

This painting was highly esteemed by His Majesty [Philip IV of Spain], and while it was being executed he went frequently to see it being painted. So did our lady Doña Mariana of Austria and the Infantas and ladies, who

came down often, considering this a delightful treat and entertainment. It was placed in His Majesty's office in the lower Apartments, among other excellent works.

When Luca Giordano came – in our day – and got to see it, he was asked by King Charles II, who saw him looking thunderstruck, 'What do you think of it?' And he said, 'Sire, this is the Theology of Painting.' By which he meant that just as Theology is the highest among the branches of knowledge, so was that picture the best there was in Painting.

(Antonio Palomino, 1724)

Only painting can capture the true, subjective reality, according to this account of Picasso's table talk.

There were five or six of us, including Picasso and Jacqueline, eating together on the Croisette, on the terrace of a Cannes restaurant. It was the end of summer, and the kind of night into which one longs to plunge as though into a sea. But on the pavement in front of us, in the bright light of the café terraces, a lively, mysterious crowd, the crowd of Cannes, swarmed in both directions. We were fascinated.

Girls in shorts a few inches long, showing interminable legs, beautiful as the day, or on the other hand without the figure for that sort of thing, rubbing shoulders with extravagant dowagers decked out in sheath dresses, sequins and foundation cream, with summer-beaten necks sweating under sable or mink stoles; narrow-shouldered melancholy-faced American sailors, their white trousers drawn tightly over their buttocks, mechanically chewing gum; young dreamboats in casual gear, with hard or melting eyes, old men clamped in their white suits on the seats of their Jaguars, and made to be packed away at night into a drawer, piece by piece, like 'the general of whom nothing was left'; mothers with their babies, and families taking the air, dragging each other by the hand; a girl to dream of, a girl to kill, a girl to weep for, and so on . . .

Fascinated, we watched the stream, terrifyingly, marvellously renewed from second to second.

One ought to paint all that, said Picasso. *But how? How could one really manage to paint all that AS IT IS, not forgetting the lady's little dog and the squinting sailor? All at once, exactly as we see them there. And us as well, since we are there too. But how could it be done? It's impossible . . .*

(Hélène Parmelin, 1966)

In his efforts to make his work closer and closer to reality, an elderly painter named Frenhofer in a story by Balzac produces something very much like an abstract painting.

'Come in, come in,' said the old man, beaming with happiness. 'My work is perfect, and now I can exhibit it with pride. Never will painter, brushes, colours, canvas, and light produce a rival to *Catherine Lescault*, the beautiful courtesan!'

Impelled by intense curiosity, Porbus and Poussin ran into the centre of a vast studio covered with dust, where everything was in confusion, with pictures hanging on the walls here and there. They paused at first before a life-size picture of a woman, half-nude, at which they gazed in admiration.

'Oh! do not waste time over that,' said Frenhofer; 'that is a canvas that I daubed to study a pose; that picture is worth nothing at all. Those are my mistakes,' he continued, pointing to a number of fascinating compositions on the walls about them.

Thereupon, Porbus and Poussin, dumbfounded by that contemptuous reference to such works, looked about for the portrait he had described to them, but could not succeed in finding it.

'Well, there it is!' said the old man, whose hair was in disorder, whose face was inflamed by supernatural excitement, whose eyes snapped, and whose breath came in gasps, like that of a young man drunk with love. – 'Ah!' he cried, 'you did not anticipate such perfection! You are in presence of a woman and you are looking for a picture. There is such depth of colour upon that canvas, the air is so true, that you cannot distinguish it from the air about us. Where is art? lost, vanished! Those are the outlines of a real young woman. Have I not grasped the colouring, caught the living turn of the line that seems to mark the limits of the body? Is it not the self-same phenomenon presented by objects that swim in the atmosphere like fish in the water? Mark how the outlines stand out from the background! Does it not seem to you as if you could pass your hand over that back? For seven years I have studied the effects of the joining of light and figures. See that hair, does not the light fall in a flood upon it? Why, she breathed, I verily believe! – Look at that bosom! Ah! who would not kneel and adore it? The flesh quivers. Wait, she is about to rise!'

'Can you see anything?' Poussin asked Porbus.

'No. – And you?'

'Nothing.'

The two painters left the old man to his raving, and looked about to see whether the light, falling too full upon the canvas that he pointed out to them, did not neutralize all its fine effects. They examined the painting from the right side and the left and in front, stooping and standing erect in turn.

'Yes, oh! yes, that is a canvas,' said Frenhofer, misunderstanding the object of that careful scrutiny. 'See, there are the frame and the easel, and here are my paints, my brushes.'

And he seized a brush which he handed them with an artless gesture.

'The old lansquenet is making sport of us,' said Poussin, returning to his position in front of the alleged picture. 'I can see nothing there but colours piled upon one another in confusion, and held in restraint by a multitude of curious lines which form a wall of painting.'

'We are mistaken,' said Porbus, 'look!'

On drawing nearer, they spied in one corner of the canvas the end of a bare foot standing forth from that chaos of colours, of tones, of uncertain shades, that sort of shapeless mist; but a lovely foot, a living foot! They stood fairly petrified with admiration before that fragment, which had escaped that most incredible, gradual, progressive destruction. That foot appeared there as the trunk of a Parian marble Venus would appear among the ruins of a burned city.

'There is a woman underneath!' cried Porbus, calling Poussin's attention to the layers of paints which the old painter had laid on, one after another, believing that he was perfecting his picture.

The two artists turned instinctively toward Frenhofer, beginning to understand, but only vaguely as yet, the trance in which he lived.

'He speaks in perfect good faith,' said Porbus.

'Yes, my friend,' interposed the old man, rousing himself, 'one must have faith, faith in art, and live a long, long while with his work, to produce such a creation. Some of those shadows have cost me many hours of toil. See on that cheek, just below the eye, there is a slight penumbra which, if you observe it in nature, will seem to you almost impossible to reproduce. Well, do you fancy that that effect did not cost me incredible labour? And so, dear Porbus, scrutinize my work with care, and you will understand better what I said to you about the manner of treating the model and the contours. Look at the light on the bosom, and see how I have succeeded, by a succession of heavy strokes and relief work, in catching the genuine light and combining it with the gleaming whiteness of the light tints; and how, by the contrary process, by smoothing down the lumps and roughness

of the paint, I have been able, by dint of touching caressingly the contour of my figure, swimming in the half-light, to take away every suggestion of drawing and of artificial methods, and to give it the aspect, the very roundness of nature. Go nearer and you will see that work better. At a distance, it is invisible. Look! at that point, it is very remarkable, in my opinion.'

With the end of his brush he pointed out to the two painters a thick layer of light paint.

Porbus put his hand on the old man's shoulder and turned toward Poussin.

'Do you know that in this man we have a very great artist?' he said.

'He is even more poet than artist,' said Poussin, with perfect gravity.

'That,' added Porbus, pointing to the canvas, 'marks the end of our art on earth.'

'And, from that, it will pass out of sight in the skies,' said Poussin.

'How much enjoyment over that piece of canvas!' exclaimed Porbus.

The old man, absorbed in reverie, did not listen to them; he was smiling at that imaginary woman.

'But sooner or later he will discover that there is nothing on his canvas!' cried Poussin.

'Nothing on my canvas!' exclaimed Frenhofer, glancing alternately at the two painters and his picture.

'What have you done?' said Porbus in an undertone to Poussin.

The old man seized the young man's arm roughly, and said to him:

'You see nothing there, clown! varlet! miscreant! hound! Why, what brought you here, then? – My good Porbus,' he continued, turning to the older painter, 'can it be that you, you too, are mocking at me? Answer me! I am your friend; tell me, have I spoiled my picture?'

Porbus hesitated, he dared not speak; but the anxiety depicted on the old man's white face was so heart-rending that he pointed to the canvas, saying:

'Look!'

Frenhofer gazed at his picture for a moment and staggered.

'Nothing! nothing! And I have worked ten years!'

He fell upon a chair and wept.

'So I am an idiot, a madman! I have neither talent nor capability! I am naught save a rich man who, in walking, does nothing more than walk! So I shall have produced nothing!'

He gazed at his canvas through his tears, then suddenly rose proudly from his chair, and cast a flashing glance upon the two painters.

'By the blood, by the body, by the head of Christ! you are jealous dogs who seek to make me believe that it is ruined, in order to steal it from me! I see her!' he cried, 'she is marvellously lovely.'

(Honoré de Balzac, 1831)

Some people, like the naturalist, stuff nature, thinking that they are making it immortal.

Writing is not describing, painting is not depicting. Verisimilitude is merely an illusion.

(Georges Braque, *Notebooks 1917–1947*)

In conversation with his friend, the writer Johann Eckermann, Goethe holds forth on the unnaturalness of great art.

We had returned too early for dinner, and Goethe had time to show me a landscape by Rubens, of a summer's evening ... The whole seemed to me to be composed with such truth, and the details painted with such fidelity, that I said Rubens must have copied the picture from nature.

'Not at all,' said Goethe, 'so perfect a picture was never seen in nature; we are indebted to the poetic mind of the painter for its composition. But the great Rubens had such an extraordinary memory that he carried the whole of nature in his head; she was always at his command, down to the minutest details. Hence his truth in the whole and in the details, so that we think it simply a copy from nature. Such landscapes are not painted any more today; that way of feeling and seeing nature is quite gone, and our painters have no poetry ...'

'You have already seen this picture,' said he, 'but no one can look enough at something really excellent, and this time there is something very special about it. Will you tell me what you see?'

'Beginning from the background,' said I, 'I see in the far distance a very clear sky, as if after sunset. Then, a village and a town in the evening light. In the middle is a road, along which a flock of sheep is hurrying to the village. On the right of the picture are several haystacks, and a cart piled high with hay. Unharnessed horses are grazing near by. On one side, among the bushes, are several mares with their foals, which seem as if

they are going to stay out all night. Then, towards the foreground is a group of large trees, and finally, right in the foreground, to the left, are various labourers returning homewards.'

'Good,' said Goethe, 'that seems to be all. But the main point is still lacking. All these things – the flock of sheep, the haycart, the horses, the returning labourers – which side are they lit from?'

'The light falls,' said I, 'on the side facing us, and the shadows are thrown into the picture. The returning labourers in the foreground are especially brightly lit, which gives an excellent effect.'

'But how has Rubens achieved this beautiful effect?'

'By placing these light figures on a dark ground,' I answered.

'But how is this dark ground produced?' said Goethe.

'It is the strong shadow thrown towards the figures by the group of trees,' I said, and then went on with surprise: 'But how? For the figures cast their shadows into the picture, while the trees, on the contrary, cast theirs towards the spectator. Thus we have light from two different sides, which is quite contrary to nature.'

'That is the point,' said Goethe with a little smile. 'It is thus that Rubens proves himself great, and shows the world that he has the freedom of spirit to stand *above* nature, and handle her according to his higher purposes. The double lighting is certainly a violation of nature, and you may well say that it is contrary to it. But if it is against nature, I must say at once that it is *higher* than nature. It is the bold stroke of the master, by which he, as a genius, shows that art is not subject to natural demands, but has its own laws.

'The artist,' Goethe continued, 'must certainly copy nature faithfully and reverently in his details: he must not arbitrarily change the structure of the bones, or the position of the sinews and muscles in an animal so that its peculiar character is destroyed. But in the higher regions of artistic activity, when a picture becomes an independent image, he has freer play, and here he may have recourse to *fictions*, as Rubens has done with the double lighting in his landscape.

'The artist has a twofold relationship to nature; he is at once her master and her slave. He is her slave in that he must work with ordinary means, so as to be understood, but her master in that he subjects these ordinary means to his higher purposes, making them subservient to them.

'The artist wants to speak to the world through a whole, but he does not find this whole in nature; it is the fruit of his own mind, or, if you like, of the influx of a fructifying divine breath.

'If we look at this landscape of Rubens cursorily, everything appears as natural to us as if it had been copied from nature. But this is not so: so beautiful a picture has never been seen in nature – any more than a landscape by Poussin or Claude Lorrain, which appears very natural to us, but which we look for in vain in the natural world.'

(Johann Eckermann, reported conversations with Goethe, 11 and 18 April 1827)

Keats has a lot of questions to ask about a Grecian urn. It famously replies, at least according to the poet, that beauty and truth are one and the same.

Thou still unravished bride of quietness,
 Thou foster-child of Silence and slow Time,
Sylvan historian, who canst thus express
 A flowery tale more sweetly than our rhyme:
What leaf-fringed legend haunts about thy shape
 Of deities or mortals, or of both,
 In Tempe or the dales of Arcady?
 What men or gods are these? What maidens loth?
What mad pursuit? What struggle to escape?
 What pipes and timbrels? What wild ecstasy?

Heard melodies are sweet, but those unheard
 Are sweeter; therefore, ye soft pipes, play on;
Not to the sensual ear, but, more endeared,
 Pipe to the spirit ditties of no tone:
Fair youth, beneath the trees, thou canst not leave
 Thy song, nor ever can those trees be bare;
 Bold Lover, never, never canst thou kiss,
Though winning near the goal – yet, do not grieve;
 She cannot fade, though thou hast not thy bliss,
 For ever wilt thou love, and she be fair!

Ah, happy, happy boughs! that cannot shed
 Your leaves, nor ever bid the Spring adieu;
And, happy melodist, unwearièd,
 For ever piping songs for ever new;
More happy love! more happy, happy love!

For ever warm and still to be enjoyed,
 For ever panting and for ever young;
All breathing human passion far above,
 That leaves a heart high-sorrowful and cloyed,
 A burning forehead, and a parching tongue.

Who are these coming to the sacrifice?
 To what green altar, O mysterious priest,
Lead'st thou that heifer lowing at the skies,
 And all her silken flanks with garlands drest?
What little town by river or sea-shore,
 Or mountain-built with peaceful citadel,
 Is emptied of this folk, this pious morn?
And, little town, thy streets for evermore
 Will silent be; and not a soul, to tell
 Why thou art desolate, can e'er return.

O Attic shape! fair attitude! with brede
 Of marble men and maidens overwrought,
With forest branches and the trodden weed;
 Thou, silent form! dost tease us out of thought
As doth eternity. Cold Pastoral!
 When old age shall this generation waste,
 Thou shalt remain, in midst of other woe
 Than ours, a friend to man, to whom thou sayst,
'Beauty is truth, truth beauty, – that is all
 Ye know on earth, and all ye need to know.'

(John Keats, 1819)

In Proust's view it is the artist who defines the way the rest of us subsequently see.

People of taste tell us nowadays that Renoir is a great eighteenth-century painter. But in so saying they forget the element of Time, and that it took a great deal of time, even at the height of the nineteenth century, for Renoir to be hailed as a great artist. To succeed thus in gaining recognition, the original painter or the original writer proceeds on the lines of the oculist. The course of treatment they give us by their painting or by their prose is not always pleasant. When it is at an end the practitioner says to

us: 'Now look!' And, lo and behold, the world around us (which was not created once and for all, but is created afresh as often as an original artist is born) appears to us entirely different from the old world, but perfectly clear. Women pass in the street, different from those we formerly saw, because they are Renoirs, those Renoirs we persistently refused to see as women. The carriages, too, are Renoirs, and the water, and the sky; we feel tempted to go for a walk in the forest which is identical with the one which when we first saw it looked like anything in the world except a forest, like for instance a tapestry of innumerable hues but lacking precisely the hues peculiar to forests. Such is the new and perishable universe which has just been created. It will last until the next geological catastrophe is precipitated by a new painter or writer of original talent.

(Marcel Proust, 1919)

The Spanish writer and philosopher Ortega y Gasset argues that Velázquez was the supreme master of reality in painting.

In order to obtain its emotive effects – what is wont to be called aesthetic emotion – painting had always been compelled to flee to another world far from this one in which human life actually happens and runs its course. Art was a dream, a delirium, fable or convention, a decoration of formal graces. Velázquez asks himself if it might not be possible to make art of this world, with life as it is; art, for that reason, totally distinct from traditional art, in a way its inversion. With radical and energetic determination, he cuts loose from that conventional and fantastic world. He vows not to depart from the actual surroundings in which he exists. All over Europe, for two centuries without interruption, there had been produced quantities of poetic painting, of formal beauty. Velázquez, in his secret soul, feels in face of all this what nobody had felt before, but which is the anticipation of the future: he feels satiated with beauty and poetry, and has an ardent longing for prose. Prose is the form of maturity which art reaches after long experiences of poetic play. It is not possible, thinks Velázquez, that prodigious skill in handling brushes can have no other end, no deeper or more *serious* purpose, than that of telling conventional tales or creating ornament. The imperative of seriousness is that which induces prose.

No artist among his contemporaries expressed such feelings, or at least not with any clarity. We must therefore envisage Velázquez as a man who,

in dramatic solitude, maintains his art in face of and in opposition to all the values triumphant in his time, both in painting and in poetry. We could not wish for greater proof of this interpretation than that afforded by the inventory of Velázquez's library . . . For in this library, of considerable size for those days, there is no more than one book of verse, and that a book of no particular account. On the other hand, the remaining books are principally works of mathematical science, together with several volumes of natural science, geography and travel, and a few of history.

Now it will be understood why earlier I thought it appropriate to record that Descartes belongs to exactly the same generation as Velázquez. The disciplines in which the two were engaged could not have been further apart – they are almost the two opposite poles of culture. Nevertheless, I find an exemplary parallelism between these two men. Descartes, too, in his profound solitude, turned against the intellectual principles still in force in his time; that is to say, against all tradition – as much against the scholars as against the Greeks. To him also the traditional method of exercising thought was hieratic formalism, based on blind conventions, and incapable of integrating itself in the actual life of each man. It is essential that the individual construct for himself a system of convictions wrought with the evidence produced in his personal nature. For this it is necessary to purge thought of all that is not a pure relation of ideas, ridding it of all the legends with which the senses overlay the truth. In this manner thought is brought to itself and converted into *raison*. Finally, we must not forget that Descartes was the initiator of the grand prose style which was to be employed in Europe from 1650 to the Romantic epoch.

Thus each of the two men exercised, in their opposite disciplines, the same conversion. Just as Descartes reduces thought to rationality, Velázquez reduces painting to visuality. Both focus the activity of culture upon immediate reality. Velázquez, perhaps the greatest connoisseur of the artistic past existing in his day, probably regarded its huge bulk with admiration, but as being on a par with, say, archaeology.

Until then, everyday reality had been distorted, exaggerated, brought to excess, dressed up, or supplanted. What should be done in the future? The very opposite: let it be, merely extract the picture from it. Hence one of the characteristics which immediately claim attention in Velázquez's pictures: what his contemporaries called the 'tranquillity' of his painting. Nothing disquiets us in his canvases, despite the fact that in some there are many figures, and in *The Surrender of Breda* a whole crowd of people,

which at the hand of any other painter would give an impression of tumult. What is the cause of this surprising repose in the work of a painter belonging to the age of the Baroque, which had brought the painting of restlessness up to the point of frenzy? Not only was the actual movement of bodies depicted, but this was employed to give the whole picture a formal movement, as if stirred by a swift fluid current, some abstract gale. Even the figures at rest were given forms which are in perpetual motion. The naked legs of the soldiers in the *Saint Maurice* of El Greco undulate like flames. An example which shows what I mean and which is the prototype of Baroque mobility can be seen in Rubens's *Christ on the Cross*.

In contrast to all this is the tranquillity of Velázquez's work, the most surprising thing about which is that in his scenes the figures are not at rest, they too are in motion. In my opinion there are two principal causes for this feeling of repose. One is his gift for assuring that the things he paints, although in motion, should be at their ease. And this, in its turn, arises from his presenting them in their appropriate movements, in their customary attitudes. He not only respects the form the object possesses in its spontaneous appearance but also in its pose. The horse on the right in *The Surrender of Breda* moves, but in a manner so familiar that it equals repose.

But Velázquez does even more for his figures. Not only does he take from the things themselves – and not from his own fantasy – the position in which he presents them, but from among an object's gestures and movements he selects the one which reveals greatest ease. This quality of grace of Velázquez's figures is their poetic element. But it is evident that this poetry, too, comes from reality and not from the formalism which is added to it by fantasy. It is precisely a class of poetry that before I have called prose. Spanish people of all walks of life have the gift of moving with grace and elegance; this is what gives that 'Spanish air' which northern people always discover in the figures of Velázquez and which is for them one of their greatest charms.

But there is another reason why Velázquez's paintings give us an impression of tranquillity, so unexpected in a painter of the Baroque epoch. El Greco or the Carracci, Rubens or Poussin painted bodies in movement, these movements being informed by a vague and imprecise motivation, so that we could imagine the figures in other attitudes without changing the theme of the picture. The reason for this is that those painters wanted their pictures to show movement in general, and did not intend to portray a particular movement by individualizing it. But let us observe

the great pictures of Velázquez. *The Drinkers* represents the instant where Bacchus crowns a drunken soldier; *The Forge of Vulcan*, the instant where Apollo enters the god's smithy and tells him bad news: *Joseph's Coat*; the instant where his brothers show Jacob his blood-stained garment; *The Surrender of Breda*, the instant where a defeated general surrenders the keys of the city to a conquering general and the latter rejects them; the equestrian portraits, the instant in which the horse leaps; *Las Meninas*, a precise instant in the painter's studio [in fact, in the royal palace]. If, after all, a scene is real it is necessarily composed of successive instants, in each of which the movements are distinct. They are instants which cannot be mingled, mutually exclusive according to the exigency of all real time. Other painters paint movements 'moving', while Velázquez paints movements in one single, arrested moment. In fact, the pictures of Velázquez have a certain photographic aspect: it is their supreme quality. In focusing the painting upon what is real, he arrives at the ultimate consequences. On the one hand, he paints all the figures in the picture as they appear from one viewpoint, without moving the eye, and this affords his canvases an incomparable spatial unity. But on the other hand, he portrays the happening as it is in a certain and determinate instant; this gives them a temporal unity so strict that it has been necessary to await the marvellous mechanical invention of instantaneous photography to arrive at anything similar, and, incidentally, to show us Velázquez's audacious intuition. Now we can well understand how he differed from the other Baroque painters of movement. The latter painted movements appertaining to many instants which, for that very reason, were incapable of co-existing in one instant alone.

Painters, until Velázquez, had wished to flee the temporal and invent an alien world immune to time, peopled by creatures of eternity. He attempts the contrary: he paints time itself, which is the instant, which is existence as it is condemned to be, to pass, to decay. That is the thing he eternalizes and that, according to him, is the mission of painting: to give eternity precisely to the instant – almost a blasphemy!

This for me is what is meant by making the portrait the principle of painting. This man portrays the man and the pitcher, he portrays the form, portrays the attitude, portrays the instant. And there, ultimately, is *Las Meninas*, where a portraitist is portraying the portrayal.

(José Ortega y Gasset, 1972)

De Kooning explains how he prefers not to confront reality, but to dip into it.

Each new glimpse is determined by many,
Many glimpses before.
It's this glimpse which inspires you – like an occurrence
And I notice those are always my moments of having an idea
That maybe I could start a painting.

Everything is already in art – like a big bowl of soup
Everything is in there already:
And you just stick your hand in, and find something for you.
But it was already there – like a stew.

There's no way of looking at a work of art by itself
It's not self-evident
It needs a history; it needs a lot of talking about:
It's part of a whole man's life.

Y'know the real world, this so-called real world,
Is just something you put up with, like everybody else.
I'm in my element when I am a little bit out of this world:
then I'm in the real world – I'm on the beam.
Because when I'm falling, I'm doing all right;
when I'm slipping, I say, hey, this is interesting!
It's when I'm standing upright that bothers me:
I'm not doing so good; I'm stiff.
As a matter of fact, I'm really slipping, most of the time,
into that glimpse. I'm like a slipping glimpser.

I get excited just to see
That sky is blue; that earth is earth.
And that's the hardest thing: to see a rock somewhere,
And there it is: earth-coloured rock,
I'm getting closer to that.

Then there is a time in life when you just take a walk:
And you walk in your own landscape.
(Willem de Kooning, *Sketchbook 1: Three Americans*, 1960)

Gallery-going: The Experience of Looking at Art

One of Iris Murdoch's heroines makes an impromptu but improving visit to the National Gallery in London.

Dora hadn't especially intended to visit the National Gallery, but once she was there she went in. It was as good a place as any other to decide what to do. She no longer wanted any lunch. She wondered if she should try telephoning Sally again; but she no longer wanted to see Sally. She climbed the stairs and wandered away into the eternal springtime of the air-conditioned rooms.

Dora had been in the National Gallery a thousand times and the pictures were almost as familiar to her as her own face. Passing between them now, as through a well-loved grove, she felt a calm descending on her. She wandered a little, watching with compassion the poor visitors armed with guidebooks who were peering anxiously at the masterpieces. Dora did not need to peer. She could look, as one can at last when one knows a great thing very well, confronting it with a dignity which it has itself conferred. She felt that the pictures belonged to her, and reflected ruefully that they were about the only thing that did. Vaguely, consoled by the presence of something welcoming and responding in the place, her footsteps took her to various shrines at which she had worshipped so often before: the great light spaces of Italian pictures, more vast and southern than any real South, the angels of Botticelli, radiant as birds, delighted as gods, and curling like the tendrils of a vine, the glorious carnal presence of Susanna Fourment, the tragic presence of Margarethe Trip, the solemn world of Piero della Francesca with its early-morning colours, the enclosed and gilded world of Crivelli. Dora stopped at last in front of Gainsborough's picture of his two daughters. These children step through a wood hand in hand, their garments shimmering, their eyes serious and dark, their two pale heads, round full buds, like yet unlike.

Dora was always moved by the pictures. Today she was moved, but in a new way. She marvelled, with a kind of gratitude, that they were all still here, and her heart was filled with love for the pictures, their authority,

their marvellous generosity, their splendour. It occurred to her that here at last was something real and something perfect. Who had said that, about perfection and reality being in the same place? Here was something which her consciousness could not wretchedly devour, and by making it part of her fantasy make it worthless. Even Paul, she thought, only existed now as someone she dreamt about; or else as a vague external menace never really encountered and understood. But the pictures were something real outside herself, which spoke to her kindly and yet in sovereign tones, something superior and good whose presence destroyed the dreary trance-like solipsism of her earlier mood. When the world had seemed to be subjective it had seemed to be without interest or value. But now there was something else in it after all.

These thoughts, not clearly articulated, flitted through Dora's mind. She had never thought about the pictures in this way before; nor did she draw now any very explicit moral. Yet she felt that she had had a revelation. She looked at the radiant, sombre, tender, powerful canvas of Gainsborough and felt a sudden desire to go down on her knees before it, embracing it, shedding tears.

Dora looked anxiously about her, wondering if anyone had noticed her transports. Although she had not actually prostrated herself, her face must have looked unusually ecstatic, and the tears were in fact starting into her eyes. She found that she was alone in the room, and smiled, restored to a more calm enjoyment of her wisdom. She gave a last look at the painting, still smiling, as one might smile in a temple, favoured, encouraged and loved. Then she turned and began to leave the building.

Dora was hurrying now and wanting her lunch. She looked at her watch and found it was teatime. She remembered that she had been wondering what to do; but now, without her thinking about it, it had become obvious. She must go back to Imber at once. Her real life, her real problems, were at Imber; and since, somewhere, something good existed, it might be that her problems would be solved after all. There was a connection; obscurely she felt, without yet understanding it, she must hang on to that idea: there was a connection. She bought a sandwich and took a taxi back to Paddington.

(Iris Murdoch, *The Bell*, 1958)

At fifty-six, Edward Burne-Jones takes a rather early valedictory stroll around the National Gallery.

I went into the National Gallery and refreshed myself with a look at the pictures. One impression I had was of how much more importance the tone of them is than the actual tint of any part of them. I looked close into the separate colours, and they were all very lovely in their quality – but the whole colour-effect of a picture then is not very great. It is the entire result of the picture that is so wonderful. I pried into the whites, to see how they were made, and it is astonishing how little white there would be in a white dress – none at all in fact – and yet it looks white. I went again and looked at the Van Eyck [the Arnolfini double portrait], and saw how clearly the like of it is not to be done by me. But he had many advantages. For one thing, he had all his objects in front of him to paint from. A nice, clean, neat floor of fair boards well scoured, pretty little dogs, and everything. Nothing to bother about but making good portraits – dresses and all else of exactly the right colour and shade of colour. But the tone of it is simply marvellous, and the beautiful colour each little object has, and the skill of it all. He permits himself extreme darkness though. It's all very well to say it's a purple dress – very dark brown is more the colour of it. And the black, no words can describe the blackness of it. But the like of it is not for me to do – can't be – not to be thought of.

As I walked about there I thought, if I had my life all over again, what would I best like to do in the way of making a new start once more? It would be to try and paint more like the Italian painters. And that's rather happy for a man to feel in his last days – to find that he is still true to his first impulse, and doesn't think he has wasted his life in wrong directions.

(Edward Burne-Jones, 1889, in Georgina Burne-Jones, 1904)

A Greek traveller and writer of the second century AD visits Praxiteles's celebrated sculpture of Venus, at Knidos in modern-day Turkey, with two friends, one homosexual, one heterosexual.

Now, as we had decided to anchor at Cnidus to see the temple of Aphrodite, which is famed as possessing the most truly lovely example of Praxiteles's skill, we gently approached the land with the goddess herself, I believe, escorting our ship with smooth calm waters. The others

occupied themselves with the usual preparations, but I took the two authorities on love, one on either side of me, and went round Cnidus, finding no little amusement in the wanton products of the potters, for I remembered I was in Aphrodite's city. First we went round the porticos of Sostratus and everywhere else that could give us pleasure and then we walked to the temple of Aphrodite. Charicles and I did so very eagerly, but Callicratidas was reluctant because he was going to see something female, and would have preferred, I imagine, to have had Eros of Thespiae instead of Aphrodite of Cnidus.

And immediately, it seemed, there breathed upon us from the sacred precinct itself breezes fraught with love. For the uncovered court was not for the most part paved with smooth slabs of stone to form an unproductive area but, as was to be expected in Aphrodite's temple, was all of it prolific with garden fruits. These trees, luxuriant far and wide with fresh green leaves, roofed in the air around them. But more than all others flourished the berry-laden myrtle growing luxuriantly beside its mistress and all the other trees that are endowed with beauty. Though they were old in years they were not withered or faded but, still in their youthful prime, swelled with fresh sprays. Intermingled with these were trees that were unproductive except for having beauty for their fruit – cypresses and planes that towered to the heavens and with them Daphne, who deserted from Aphrodite and fled from that goddess long ago. But around every tree crept and twined the ivy [ivy was sacred to Bacchus, the god of wine and promoter of love], devotee of love. Rich vines were hung with their thick clusters of grapes. For Aphrodite is more delightful when accompanied by Dionysus and the gifts of each are sweeter if blended together, but, should they be parted from each other, they afford less pleasure. Under the particularly shady trees were joyous couches for those who wished to feast themselves there. These were occasionally visited by a few folk of breeding, but all the city rabble flocked there on holidays and paid true homage to Aphrodite.

When the plants had given us pleasure enough, we entered the temple. In the midst thereof sits the goddess – she's a most beautiful statue of Parian marble – arrogantly smiling a little as a grin parts her lips. Draped by no garment, all her beauty is uncovered and revealed, except in so far as she unobtrusively uses one hand to hide her private parts. So great was the power of the craftsman's art that the hard unyielding marble did justice to every limb. Charicles at any rate raised a mad distracted cry and exclaimed, 'Happiest indeed of the gods was Ares who suffered chains

because of her!' And, as he spoke, he ran up and, stretching out his neck as far as he could, started to kiss the goddess with importunate lips. Callicratidas stood by in silence with amazement in his heart.

The temple had a door on both sides for the benefit of those also who wish to have a good view of the goddess from behind, so that no part of her be left unadmired. It's easy therefore for people to enter by the other door and survey the beauty of her back. And so we decided to see all of the goddess and went round to the back of the precinct. Then, when the door had been opened by the woman responsible for keeping the keys, we were filled with an immediate wonder for the beauty we beheld. The Athenian who had been so impassive an observer a minute before, upon inspecting those parts of the goddess which recommend a boy, suddenly raised a shout far more frenzied than that of Charicles. 'Heracles!' he exclaimed, 'what a well-proportioned back! What generous flanks she has! How satisfying an armful to embrace! How delicately moulded the flesh on the buttocks, neither too thin and close to the bone, nor yet revealing too great an expanse of fat! And as for those precious parts sealed in on either side by the hips, how inexpressibly sweetly they smile! How perfect the proportions of the thighs and the shins as they stretch down in a straight line to the feet! So that's what Ganymede looks like as he pours out the nectar in heaven for Zeus and makes it taste sweeter. For I'd never have taken the cup from Hebe if she served me.' While Callicratidas was shouting this under the spell of the goddess, Charicles in the excess of his admiration stood almost petrified, though his emotions showed in the melting tears trickling from his eyes.

When we could admire no more, we noticed a mark on one thigh like a stain on a dress; the unsightliness of this was shown up by the brightness of the marble everywhere else. I therefore, hazarding a plausible guess about the truth of the matter, supposed that what we saw was a natural defect in the marble. For even such things as these are subject to accident and many potential masterpieces of beauty are thwarted by bad luck. And so, thinking the black mark to be a natural blemish, I found in this too cause to admire Praxiteles for having hidden what was unsightly in the marble in the parts less able to be examined closely. But the attendant woman who was standing near us told us a strange, incredible story. For she said that a young man of a not undistinguished family – though his deed has caused him to be left nameless – who often visited the precinct, was so ill-starred as to fall in love with the goddess. He would spend all day in the temple and at first gave the impression of pious awe. For in

the morning he would leave his bed long before dawn to go to the temple and only return home reluctantly after sunset. All day long would he sit facing the goddess with his eyes fixed uninterruptedly upon her, whispering indistinctly and carrying on a lover's complaints in secret conversation.

But when he wished to give himself some little comfort from his suffering, after first addressing the goddess, he would count out on the table four knucklebones of a Libyan gazelle and take a gamble on his expectations. If he made a successful throw and particularly if ever he was blessed with the throw named after the goddess herself, and no dice showed the same face, he would prostrate himself before the goddess, thinking he would gain his desire. But, if as usually happens he made an indifferent throw on to his table, and the dice revealed an unpropitious result, he would curse all Cnidus and show utter dejection as if at an irremediable disaster; but a minute later he would snatch up the dice and try to cure by another throw his earlier lack of success. But presently, as his passion grew more inflamed, every wall came to be inscribed with his messages and the bark of every tender tree told of fair Aphrodite. Praxiteles was honoured by him as much as Zeus and every beautiful treasure that his home guarded was offered to the goddess. In the end the violent tension of his desires turned to desperation and he found in audacity a procurer for his lusts. For, when the sun was now sinking to its setting, quietly and unnoticed by those present, he slipped in behind the door and, standing invisible in the inmost part of the chamber, he kept still, hardly even breathing. When the attendants closed the door from the outside in the normal way, this new Anchises [Anchises, the father of Aeneas, though a mortal had enjoyed the love of Aphrodite] was locked in. But why do I chatter on and tell you in every detail the reckless deed of that unmentionable night? These marks of his amorous embraces were seen after day came and the goddess had that blemish to prove what she'd suffered. The youth concerned is said, according to the popular story told, to have hurled himself over a cliff or down into the waves of the sea and to have vanished utterly.

(Attributed to Lucian, AD *c.*115–*c.*180)

Rembrandt gives a word of advice about the hanging of one of his pictures.

In haste
27 January 1639

My Lord, hang this piece in a strong light, so that one may look at it from a distance, and it may appear at its best.
 (Rembrandt van Rijn to Constantin Huygens, 1639)

In the Museum of Modern Art in New York, a Sartrean hero discovers that art is not enough in the face of Franco, Hitler and the Second World War.

Gomez had indulged in a shrug. Here was destiny pouring colour on his head just when he had ceased to believe in his destiny. I know perfectly well what ought to be done about it, but somebody else will have to do it. He had clung to Ritchie's arm, walking quickly, with a fixed stare in his eyes. Colours had thrust at him from every side, bursting like tiny flasks of blood and gall. Ritchie had pushed him into the Museum: and here he now was, with there, on the other side of the glass pane, the spread of *Nature*'s green, crude, unrendered, an organic secretion like honey or curdled milk. There it was, to be *taken*, to be *handled*. *I'll* take it, and work it to a pitch of incandescence . . . But what business is it of mine? I'm no longer a painter. He heaved a sigh. An art critic is not paid to spend his time worrying about the imperfect colour-sense of wild grass. His business is to think about what other men have thought. At his back were other men's colours displayed on squares of canvas; concentrations, essences and thoughts. *They* had had the good fortune to be *achieved*. Somebody had taken them, inflated them, breathed life into them, pushed them to the very limits of their nature, and now, their destiny accomplished, there was nothing more for them to hope, save to be preserved in museums. Other men's colours: that was now his lot.
 'Oh, well,' he said: 'I'd better start earning my hundred dollars.'
 He turned round. Fifty pictures by Mondrian were set against white, clinical walls: sterilized painting in an air-conditioned gallery. No danger here, where everything was proof against microbes and the human passions. He went up to a picture and stared hard at it. Ritchie was watching his face and smiling in anticipation.
 'Doesn't say a thing to me!' muttered Gomez.

Ritchie stopped smiling, but the expression of his face was one of conscientious understanding.

'Sure,' he said tactfully: 'you can't expect it to come back all at once: you got to give your mind to it.'

'Give my mind to *that*?' Gomez echoed the words ill-temperedly: 'not me!'

Ritchie turned and looked at the picture. On a grey ground was a black vertical line crossed by two horizontals. At the left-hand extremity of the upper horizontal was a blue disc.

'I sort of had a hunch you *liked* Mondrian.'

'So did I,' said Gomez.

They stopped in front of another picture. Gomez stared at it and tried to *remember*.

'Have you *got* to write about these?' inquired Ritchie nervously.

'I haven't got to: but Ramon would like my first article to be about Mondrian . . . thinks it would strike the required highbrow note.'

'Oh, I do hope you'll watch yourself,' said Ritchie: 'it wouldn't do to start off by being too destructive.'

'Why not?' asked Gomez, beginning to bristle. Ritchie's smile spread a gentle irony:

'Easy to see you don't know the American public. The one thing it can't take is being startled. Weigh in by making a name for yourself: say simple, sensible things, and say them with charm, and, if you *must* attack someone, then for Pete's sake don't let it be Mondrian: he's our god.'

'Naturally,' said Gomez: 'he doesn't ask any questions.'

Ritchie shook his head and made a clucking sound with his tongue. This he did more than once, to express disapprobation.

'He asks the whale of a lot.'

'Yes, but not embarrassing questions.'

'Oh, I see what you're getting at: you mean questions about sex and the meaning of life, and poverty – things like that? I certainly was forgetting you done your studying in Germany. Gründlichkeit [thoroughness, diligence] – eh?' he said, slapping the other on the back: 'don't you think all that's a bit dated?'

Gomez made no reply.

'As I see it,' said Ritchie, 'it's no part of the painter's business to ask embarrassing questions. If some guy came along and asked me whether I wanted to go to bed with my mother, I'd fling him out on his ear – except he was carrying out a piece of scientific research. I don't see why

painters should have the right to ask me questions in public about my complexes. Like everybody else,' he added in a more conciliatory tone, 'I got my troubles. But when I think they're getting me down I don't slip off to a museum – no, sir, I put through a call to a psychoanalyst. Folk ought to stick to their jobs. A psychoanalyst gives me confidence, because he's started off by being psychoanalysed himself. So long as painters don't do that, why, they're talking at cross purposes, and I sure don't ask them to give me a look at myself.'

'What do you ask them for?' asked Gomez, more for the sake of saying something than because he wanted to know. He was looking at one of the pictures with surly hostility. He was thinking – 'transparent as water, nothing in it.'

'I ask them for innocence,' said Ritchie: 'take this one, now . . .'

'Well, what about it?'

'It's just seraphic!' said Ritchie ecstatically: 'we Americans like painting to be something that appeals to happy folk, or to folk who are trying to be happy.'

'I'm not happy,' said Gomez, 'and I should be a rotter if I tried to be, with all my friends either in prison or shot.'

Ritchie repeated the clucking sound.

'See here,' he said: 'I know all about your personal troubles – fascism, the defeat of the Allies, Spain, your wife and kid – sure I know! But it's a good thing to get *above* all that occasionally.'

'Not for a moment!' said Gomez: 'not for one single, solitary moment!'

(Jean-Paul Sartre, 1947)

David Sylvester deplores the Duveen Galleries at the Tate Gallery and the British Museum.

Its flaws as a setting for sculpture are the consequences of a singleminded pursuit by its main architect, John Russell Pope, of its underlying purpose, which was to provide a famous dealer in need of respectability, Lord Duveen, with a chance to display his munificence on a colossal scale. So the space seems designed to diminish any person or thing that enters it. Completed in 1937, it also has something of the bullying pomposity characteristic of official buildings erected in countries under totalitarian rule. Meanwhile at the British Museum Duveen was employing Pope to execute a takeover of our greatest artistic possession, or ward, the

Parthenon Marbles. Before they could be installed in the house he had built for them the Luftwaffe mercifully destroyed it. Blindly the British Museum Trustees rebuilt it and in 1962 moved the sculptures in. Till then they had, of course, been one of the seven wonders of the world. Since then any pleasure still to be had from looking at them has been mixed with a good deal of pain.

(David Sylvester, 'Serra', 1992, in his *About Modern Art*, 1996)

Henry James unstrings his critical bow a little at the Pitti Palace in Florence.

One grows to feel the collection of pictures at the Pitti Palace splendid rather than interesting. After walking through it once or twice you catch the key in which it is pitched – you know what you are likely not to find on closer examination; none of the works of the uncompromising period, nothing from the half-groping geniuses of the early time, those whose colouring was sometimes harsh and their outlines sometimes angular. Vague to me the principle on which the pictures were originally gathered and of the aesthetic creed of the princes who chiefly selected them. A princely creed I should roughly call it – the creed of people who believed in things presenting a fine face to society; who esteemed showy results rather than curious processes, and would have hardly cared more to admit into their collection a work by one of the laborious precursors of the full efflorescence than to see a bucket and broom left standing in a state saloon. The gallery contains in literal fact some eight or ten paintings of the early Tuscan School – notably two admirable specimens of Filippo Lippi and one of the frequent circular pictures of the great Botticelli – a Madonna, chilled with tragic prescience, laying a pale cheek against that of a blighted Infant. Such a melancholy mother as this of Botticelli would have strangled her baby in its cradle to rescue it from the future. But of Botticelli there is much to say. One of the Filippo Lippis is perhaps his masterpiece – a Madonna in a small rose-garden (such a 'flowery close' as Mr William Morris loves to haunt), leaning over an Infant who kicks his little human heels on the grass while half a dozen curly-pated angels gather about him, looking back over their shoulders with the candour of children in *tableaux vivants*, and one of them drops an armful of gathered roses one by one upon the baby. The delightful earthly innocence of these winged youngsters is quite inexpressible. Their heads are twisted about toward the spectator as if they were playing at leapfrog and were expecting

a companion to come and take a jump. Never did 'young' art, never did subjective freshness, attempt with greater success to represent those phases. But these three fine works are hung over the tops of doors in a dark back room – the bucket and broom are thrust behind a curtain. It seems to me, nevertheless, that a fine Filippo Lippi is good enough company for an Allori or a Cigoli, and that that too deeply sentient Virgin of Botticelli might happily balance the flower-like irresponsibility of Raphael's *Madonna of the Chair*.

Taking the Pitti collection, however, simply for what it pretends to be, it gives us the very flower of the sumptuous, the courtly, the grand-ducal. It is chiefly official art, as one may say, but it presents the fine side of the type – the brilliancy, the facility, the amplitude, the sovereignty of good taste. I agree on the whole with a nameless companion and with what he lately remarked about his own humour on these matters; that, having been on his first acquaintance with pictures nothing if not critical, and held the lesson incomplete and the opportunity slighted if he left a gallery without a headache, he had come, as he grew older, to regard them more as the grandest of all pleasantries and less as the most strenuous of all lessons, and to remind himself that, after all, it is the privilege of art to make us friendly to the human mind and not to make us suspicious of it. We do in fact as we grow older unstring the critical bow a little and strike a truce with invidious comparisons. We work off the juvenile impulse to heated partisanship and discover that one spontaneous producer isn't different enough from another to keep the all-knowing Fates from smiling over our loves and our aversions. We perceive a certain human solidarity in all cultivated effort, and are conscious of a growing accommodation of judgement – an easier disposition, the fruit of experience, to take the joke for what it is worth as it passes. We have in short less of a quarrel with the masters we don't delight in, and less of an impulse to pin all our faith on those in whom, in more zealous days, we fancied that we made out peculiar meanings. The meanings no longer seem quite so peculiar. Since then we have arrived at a few in the depths of our own genius that are not sensibly less striking.

And yet it must be added that all this depends vastly on one's mood – as a traveller's impressions do, generally, to a degree which those who give them to the world would do well more explicitly to declare. We have our hours of expansion and those of contraction, and yet while we follow the traveller's trade we go about gazing and judging with unadjusted confidence. We can't suspend judgement; we must take our notes, and

the notes are florid or crabbed, as the case may be. A short time ago I spent a week in an ancient city on a hilltop, in the humour, for which I was not to blame, which produces crabbed notes. I knew it at the time, but couldn't help it. I went through all the motions of liberal appreciation; I uncapped in all the churches and on the massive ramparts stared all the views fairly out of countenance; but my imagination, which I suppose at bottom had very good reasons of its own and knew perfectly what it was about, refused to project into the dark old town and upon the yellow hills that sympathetic glow which forms half the substance of our genial impressions. So it is that in museums and palaces we are alternate radicals and conservatives. On some days we ask but to be somewhat sensibly affected; on others, Ruskin-haunted, to be spiritually steadied. After a long absence from the Pitti Palace I went back there the other morning and transferred myself from chair to chair in the great golden-roofed saloons – the chairs are all gilded and covered with faded silk – in the humour to be diverted at any price.

(Henry James, 'Florentine Notes', 1874)

Goethe assesses, and reassesses, and re-reassesses Michelangelo's frescoes in the Sistine Chapel.

22 November [1786]
On the Feast of St Cecilia

I must write a few lines to keep alive the memory of this happy day or, at least, make a historical report of what I have been enjoying. The day was cloudless and warm. I went with Tischbein to the square in front of St Peter's. We walked up and down until we felt too hot, when we sat in the shadow of the great obelisk – it was just wide enough for two – and ate some grapes we had bought near by. Then we went into the Sistine Chapel, where the light on the frescoes was at its best. Looking at these marvellous works of Michelangelo's, our admiration was divided between the *Last Judgement* and the various paintings on the ceiling. The self-assurance, the virility, the grandeur of conception of this master defy expression. After we had looked at everything over and over again, we left the chapel and entered St Peter's.

2 December [1786]

On 28 November we visited the Sistine Chapel again and got them to open the gallery for us, because from there the ceiling can be seen at closer range. The gallery is rather narrow and we squeezed into it along the iron railing with some difficulty and some feeling of danger – people who suffer from vertigo would be advised to stay below – but this was more than made up for by the masterpiece which met our eyes. At present I am so enthusiastic about Michelangelo that I have lost all my taste for Nature, since I cannot see her with the eye of genius as he did. If only there were some means of fixing such images firmly in one's memory! At any rate, I shall bring home as many engravings and drawings made after his work as I can get hold of. From the chapel we went to the loggias of Raphael, and, though I hardly dare admit it, I could not look at them any longer. After being dilated and spoiled by Michelangelo's great forms, my eye took no pleasure in the ingenious frivolities of Raphael's arabesques, and his Biblical stories, beautiful as they are, do not stand up against Michelangelo's. What a joy it would give me if I could see the works of both more frequently and compare them at leisure without prejudice, for one's initial reactions are bound to be one-sided . . .

First it was Raphael I preferred, then it was Michelangelo. One can only conclude that man is such a limited creature that, though his soul may be open to greatness, he never acquires the capacity to recognize and appreciate equally, different kinds of greatness . . .

August [1787]

IN RETROSPECT

It was at the beginning of this month that I definitely made up my mind to stay [in Italy] another winter. An instinctive feeling that, at this point, I was not nearly ready to leave and that I could not find anywhere else the proper peaceful atmosphere for finishing my works finally decided me, and once I had told my friends at home of my decision, a new era began.

The great heat, which grew steadily worse and set limits to any excessive activity, made one look for cool places to work in, and one of the most pleasant was the Sistine Chapel. At that time the artists had just rediscovered Michelangelo. In addition to all the other qualities they admired, they said that he surpassed all others in his sense of colour, and it became the

fashion to dispute whether he or Raphael was the greater genius. The latter's *Transfiguration* was often severely criticized and the *Disputa* considered his best work. All this pointed towards the coming predilection for an earlier school of painting, a taste which a dispassionate observer could only regard as a symptom of mediocre and unoriginal talents.

It is so difficult to comprehend one great talent, let alone two at the same time. To make things easier for us, we take sides; that is why the reputation of artists and writers is always fluctuating. Now one rules the day, now another. Personally, I ignored these disputes and spent my time in direct observation of anything which seemed to me to be worth looking at. Soon the fashion for preferring the great Florentine spread from the artists to the art-loving public, which is why, just at this time, Count Fries commissioned Bury and Lipps to make watercolour copies of the frescoes in the Sistine Chapel. The custodian was handsomely tipped and let us enter by the back door next to the altar, and settle down there whenever we liked. We even used to have meals there, and I remember that one day I was overcome by the heat and snatched a noon nap on the papal throne . . .

March [1788]

CORRESPONDENCE

Rome, 1 March

Last Sunday we went to the Sistine Chapel, where the Pope and Cardinals were celebrating Mass. For me it was a novel spectacle, since, during Lent, the cardinals are robed in violet instead of red. A few days before I had seen some paintings by Albrecht Dürer and therefore enjoyed all the more seeing something similar in real life. The whole ceremony was of a unique grandeur and yet quite simple, so that I don't wonder that the foreigners who flock here during Holy Week are overwhelmed. I knew the chapel very well (last summer I ate my midday meal there and took a siesta on the papal throne), and the frescoes almost by heart, but when these form the surroundings to the function for which the chapel was intended, they look quite different, and I hardly recognized the place.

(Johann Wolfgang von Goethe, 1786–8)

A famous formalist art critic answers a philistine inquiry; the witness to this exchange, another celebrated critic, explains the answer.

One day while the show, 'Three American Painters' was hanging at the Fogg Museum at Harvard, Michael Fried and I were standing in one of the galleries. To our right was a copper painting by Frank Stella, its surface burnished by the light which flooded the room. A Harvard student who had entered the gallery approached us. With his left arm raised and his finger pointing to the Stella, he confronted Michael Fried. 'What's so good about that?' he demanded. Fried looked back at him. 'Look,' he said slowly, 'there are days when Stella goes to the Metropolitan Museum. And he sits for hours looking at the Velázquez, utterly knocked out by them and then he goes back to his studio. What he would like more than anything else is to paint like Velázquez. But what he knows is that that is an option that is not open to him. So he paints stripes.' Fried's voice had risen. 'He wants to be Velázquez *so he paints stripes.*'

I don't know what the boy thought, but it was clear enough to me. That statement, which linked Velázquez's needs to Stella's in the immense broad jump of a single sentence, was a giant ellipsis whose leap cleared three centuries of art. But in my mind's eye it was more like one of those strobe photographs in which each increment of the jumper's act registers on the single image. I could see what the student could not, and what Fried's statement did not fill in for him. Under the glittering panes of that skylight, I could visualize the logic of an argument that connected hundreds of separate pictorial acts into the fluid clarity of a single motion, an argument that was as present to me as the paintings hanging in the gallery – their clean, spare surfaces tied back into the faint grime of walls dedicated to the history of art. If Fried had not chosen to give the whole of that argument to the student, he had tried to make the student think about one piece of the obvious: that Stella's need to say something through his art was the same as a seventeenth-century Spaniard's; only the point in time was different. In 1965, the fact that Stella's stripes were involved with what he wanted to say – a product, that is, of *content* – was clear enough to me.

(Rosalind Krauss, 1972)

The poet Rainer Maria Rilke repeatedly visits the Cézannes at the Salon d'Automne of 1907 in Paris. As he writes to his wife, each time he goes he sees more.

Paris VIe, 29, rue Cassette,
October 7, 1907 (Monday)

. . . I went back to the Salon d'Automne this morning, and found Meier-Graefe [1867–1937, influential critic and supporter of the Impressionists and Post-Impressionists] in front of the Cézannes again . . . Count Kessler [Harry, Graf Kessler, 1868–1937, writer and patron of the arts] was there too and told me many beautiful and honest things about the new *Book of Images*, which he and [Hugo von] Hofmannsthal had read aloud to each other. All of this happened in the Cézanne room, which makes an immediate claim on one's attention with its powerful pictures. You know how much more remarkable I always find the people walking about in front of paintings than the paintings themselves. It's no different in this Salon d'Automne, except for the Cézanne room. Here, all of reality is on his side: in this dense quilted blue of his, in his red and his shadowless green and the reddish black of his wine bottles. And the humbleness of all his objects: the apples are all cooking apples and the wine bottles belong in the roundly bulging pockets of an old coat. Farewell . . .

Paris VIe, 29, rue Cassette,
October 8, 1907

. . . It's strange to walk through the Louvre after two days in the Salon d'Automne: you notice two things right away: that every insight has its parvenus, upstarts who make a hue and cry as soon as they catch on, – and then, that perhaps these aren't particularly illuminating insights at all. As if these masters in the Louvre didn't know that painting is made up of colour. I've looked at the Venetians: they're of an indescribably radical colourfulness; you can feel how far it goes in Tintoretto. Almost farther than with Titian. And so on into the eighteenth century, where the only thing separating their colour scale from Manet's is the use of black. Guardi has it, incidentally; it was unavoidable, right there in the middle of all that brightness, ever since the laws against luxurious display decreed the use of black gondolas. But he uses it more as a dark mirror than as a colour; Manet was the first – encouraged by the Japanese, certainly – to give it equal value among the other colours. There was also a Venetian woman painter, a contemporary of Guardi and Tiepolo, who was invited to all

the courts and whose name was among the most celebrated of her time: Rosalba Carriera. Watteau knew about her, and they exchanged a few pastels, her self-portraits perhaps, and held one another in tender regard. She travelled a lot, painted in Vienna, and one and a half hundred of her works are still preserved in Dresden. Three portraits are in the Louvre. A young lady, her face raised up by the straight neck and then turned naively toward the viewer, and in front of her décolleté lace dress she holds a small clear-eyed capuchin monkey who is peering out from the lower edge of the half-length portrait as eagerly as she's looking out on top, just a bit more indifferently. He's reaching out with one small perfidious black hand to draw her tender, distracted hand into the picture by one slender finger. This is so full of one period that it is valid for all times. And it is lovely and lightly painted, but really painted. There's also a blue cloak in the picture and one whole lilac-white gillyflower stem, which, strangely, takes the place of a breast decoration. And I noticed that this blue is that special eighteenth-century blue that you can find everywhere, in La Tour, in Peronnet, up to Chardin [three prominent eighteenth-century French artists], where it still hasn't lost its elegance, even though he uses it rather heedlessly in the ribbon of his peculiar hood (in the self-portrait with the horn-rimmed pince-nez). (I could imagine someone writing a monograph on the colour blue, from the dense waxy blue of the Pompeiian wall paintings to Chardin and further to Cézanne: what a biography!) For Cézanne's very unique blue is descended from these, it comes from the eighteenth-century blue which Chardin stripped of its pretension and which now, in Cézanne, no longer carries any secondary significance. Chardin was the intermediary in other respects, too; his fruits no longer remind you of a gala dinner, they're scattered about on the kitchen table and don't seem to care whether they are beautifully eaten or not. In Cézanne they cease to be edible altogether, that's how thinglike and real they become, how simply indestructible in their stubborn thereness. When you see Chardin's portraits of himself, you think he must have been a queer old lone wolf. Perhaps tomorrow I'll tell you to what an extent and how sadly this was the case with Cézanne. I know a few things from his last years when he was old and shabby and children followed him every day on his way to his studio, throwing stones at him as if at a stray dog. But inside, way inside, he was marvellously beautiful, and every once in a while he would furiously shout something absolutely glorious at one of his rare visitors. You can imagine how that happened. Farewell . . . ; that was today . . .

Paris VIe, 29, rue Cassette,
October 10, 1907

. . . If one didn't know (and know more and more) that without resistance there would be no movement and none of the rhythmic circulation of all the things we encounter, this would be very confusing and upsetting: that because of the money you won't be coming to see the Salon d'Automne (which I'm so preoccupied with) and that for the same reason I'll probably have to forgo my own trip, even though inwardly, in my expectation, it's still awaiting me, strong and undamaged . . .

Meanwhile I'm still going to the Cézanne room, which, I suppose, you can somewhat imagine by now, after yesterday's letter. I again spent two hours in front of a few pictures today; I sense this is somehow useful for me. Would it be instructive for you? I can't really say it in one breath. One can really see all of Cézanne's pictures in two or three well-chosen examples, and no doubt we could have come as far in understanding him somewhere else, at Cassirer's [Paul Cassirer, 1871–1926, Berlin art dealer and publisher] for instance, as I find myself advancing now. But it all takes a long, long time. When I remember the puzzlement and insecurity of one's first confrontation with his work, along with his name, which was just as new. And then for a long time nothing, and suddenly one has the right eyes . . . I would almost prefer, if you should be able to come here some day, to lead you to the *Déjeuner sur l'Herbe*, to this female nude seated among the green mirrorings of a leafy wood, every part of which is Manet, shaped by an indescribable expressive capacity which suddenly, after many unavailing attempts, came about, was there, succeeded. All his means were released and dissolved in succeeding: you'd almost think no means were used at all. I stood in front of it for a long time yesterday. But it's valid, the miracle, only for one person, every time; only for the saint to whom it happens. Cézanne had to start all over again, from the bottom . . . Farewell until the next time . . .
(Rainer Maria Rilke, October 1907)

Among the many shocks the avant-garde art of the twentieth century delivered, one of the most disconcerting was that brought by the early work of Jasper Johns. The critic Leo Steinberg considers its impact.

Let me take an example from nearer home and from my own experience.

Early in 1958, a young painter named Jasper Johns had his first one-man show in New York. The pictures he showed – products of many years' work – were puzzling. Carefully painted in oil or encaustic [hot wax], they were variations on four main themes:

Numbers, running in regular order, row after row all the way down the picture, either in colour or white on white.

Letters, arranged in the same way.

The American Flag – not a picture of it, windblown or heroic, but stiffened, rigid, the pattern itself.

And finally, Targets, some tricoloured, others all white or all green, sometimes with little boxes on top into which the artist had put plaster casts of anatomical parts, recognizably human.

A few other subjects turned up in single shots – a wire coathanger, hung on a knob that projected from a dappled grey field. A canvas, which had a smaller stretched canvas stuck to it face to face – all you saw was its back; and the title was *Canvas*. Another, called *Drawer*, where the front panel of a wooden drawer with its two projecting knobs had been inserted into the lower part of a canvas, painted all grey.

How did people react? Those who had to say something about it tried to fit these new works into some historical scheme. Some shrugged it off and said, 'More of Dada, we've seen this before; after Expressionism comes nonsense and anti-art, just as in the twenties.' One hostile New York critic saw the show as part of a sorrowful devolution, another step in the systematic emptying out of content from modern art. A French critic wrote: 'We mustn't cry "fraud" too soon.' But he was merely applying the cautions of the past; his feeling was that he was being duped.

On the other hand, a great number of intelligent men and women in New York responded with intense enthusiasm, but without being able to explain the source of their fascination. A museum director suggested that perhaps it was just the relief from Abstract Expressionism, of which one had seen so much in recent years, that led him to enjoy Jasper Johns; but such negative explanations are never adequate. Some people thought that the painter chose commonplace subjects because, given our habits of overlooking life's simple things, he wanted, for the first time, to render them visible. Others thought that the charm of these paintings resided in the exquisite handling of the medium itself, and that the artist deliberately chose the most commonplace subjects so as to make them *invisible*, that is, to induce absolute concentration on the sensuous surface alone. But this didn't work for two reasons. First, because there was no agreement

on whether these things were, in fact, well painted. (One New York critic of compulsive originality said that the subjects were fine, but that the painting was poor.) And, secondly, because if Johns had wanted his subject matter to become invisible through sheer banality, then he had surely failed – like a debutante who expects to remain inconspicuous by wearing blue jeans to the ball. Had reticent subject matter been his intention, he would have done better to paint a standard abstraction, where everybody knows not to question the subject. But in these new works, the subjects were overwhelmingly conspicuous, if only because of their context. Hung at general headquarters, a Jasper Johns flag might well have achieved invisibility; set up on a range, a target could well be overlooked; but carefully remade to be seen point-blank in an art gallery, these subjects struck home.

It seems that during this first encounter with Johns's work, few people were sure of how to respond, while some of the dependable avant-garde critics applied tested avant-garde standards – which seemed suddenly to have grown old and ready for dumping.

My own first reaction was normal. I disliked the show, and would gladly have thought it a bore. Yet it depressed me and I wasn't sure why. Then I began to recognize in myself all the classical symptoms of a philistine's reaction to modern art. I was angry at the artist, as if he had invited me to a meal, only to serve something uneatable, like tow and paraffin. I was irritated at some of my friends for pretending to like it – but with an uneasy suspicion that perhaps they did like it, so that I was really mad at myself for being so dull, and at the whole situation for showing me up.

And meanwhile, the pictures remained with me – working on me and depressing me. The thought of them gave me a distinct sense of threatening loss or privation. One in particular there was, called *Target with Four Faces*. It was a fairly large canvas consisting of nothing but one three-coloured target – red, yellow, and blue; and above it, boxed behind a hinged wooden flap, four life casts of one face – or rather, of the lower part of a face, since the upper portion, including the eyes, had been sheared away. The picture seemed strangely rigid for a work of art and recalled Baudelaire's objection to Ingres: 'No more imagination; therefore no more movement.' Could any meaning be wrung from it? I thought how the human face in this picture seemed desecrated, being brutally thingified – and not in any acceptable spirit of social protest, but gratuitously, at random. At one point, I wanted the picture to give me a sickening suggestion of human sacrifice, of heads pickled or mounted as trophies. Then, I hoped, the

whole thing would come to seem hypnotic and repellent, like a primitive sign of power. But when I looked again, all this romance disappeared. These faces – four of the same – were gathered there for no triumph; they were chopped up, cut away just under the eyes, but with no suggestion of cruelty, merely to make them fit into their boxes; and they were stacked on that upper shelf as a standard commodity. But was this reason enough to get so depressed? If I disliked these things, why not ignore them?

It was not that simple. For what really depressed me was what I felt these works were able to do to all other art. The pictures of de Kooning and Kline, it seemed to me, were suddenly tossed into one pot with Rembrandt and Giotto. All alike suddenly became painters of illusion. After all, when Franz Kline lays down a swath of black paint, that paint is transfigured. You may not know what it represents, but it is at least the path of an energy or part of an object moving in or against a white space. Paint and canvas stand for more than themselves. Pigment is still the medium by which something seen, thought, or felt, something other than pigment itself, is made visible. But here, in this picture by Jasper Johns, one felt the end of illusion. No more manipulation of paint as a medium of transformation. This man, if he wants something three-dimensional, resorts to a plaster cast and builds a box to contain it. When he paints on a canvas, he can only paint what is flat – numbers, letters, a target, a flag. Everything else, it seems, would be make-believe, a childish game – 'let's pretend.' So, the flat is flat and the solid is three-dimensional, and these are the facts of the case, art or no art. There is no more metamorphosis, no more magic of medium. It looked to me like the death of painting, a rude stop, the end of the track.

I am not a painter myself, but I was interested in the reaction to Jasper Johns of two well-known New York abstract painters: one of them said, 'If this is painting, I might as well give up.' And the other said, resignedly, 'Well, I am still involved with the dream.' He, too, felt that an age-old dream of what painting had been, or could be, had been wantonly sacrificed – perhaps by a young man too brash or irreverent to have dreamed yet. And all this seemed much like Baudelaire's feeling about Courbet, that he had done away with imagination.

The pictures, then, kept me pondering, and I kept going back to them. And gradually something came through to me, a solitude more intense than anything I had seen in pictures of mere desolation. In *Target with Faces*, I became aware of an uncanny inversion of values. With mindless

inhumanity or indifference, the organic and the inorganic had been levelled. A dismembered face, multiplied, blinded, repeats four times above the impersonal stare of a bull's-eye. Bull's-eye and blind faces – but juxtaposed as if by habit or accident, without any expressive intent. As if the values that would make a face seem more precious or eloquent had ceased to exist; as if those who could hold and impose such values just weren't around.

Then another inversion. I began to wonder what a target really was, and concluded that a target can only exist as a point in space – 'over there', at a distance. But the target of Jasper Johns is always 'right here'; it is all the field there is. It has lost its definitive 'Thereness'. I went on to wonder about the human face, and came to the opposite conclusion. A face makes no sense unless it is 'here'. At a distance, you may see a man's body, a head, even a profile. But as soon as you recognize a thing as a face, it is an object no longer, but one pole in a situation of reciprocal consciousness; it has, like one's own face, absolute 'Hereness'. So then surely Jasper Johns's *Target with Faces* performs a strange inversion, because a target, which needs to exist at a distance, has been allotted all the available 'Hereness', while the faces are shelved.

And once again, I felt that the levelling of those categories, which are the subjective markers of space, implied a totally non-human point of view. It was as if the subjective consciousness, which alone can give meaning to 'here' and 'there', had ceased to exist.

And then it dawned on me that all of Jasper Johns's pictures conveyed a sense of desolate waiting. The face-to-the-wall canvas waits to be turned; the drawer waits to be opened. That rigid flag – does it wait to be hoisted or recognized? Certainly the targets wait to be shot at. Johns made one painting using a lowered window shade which, like any window shade in the world, waits to be raised. The empty hanger waits to receive somebody's clothes. These letters, neatly set forth, wait to spell something out; and the numbers, arranged as on a tot board, wait to be scored. Even those plaster casts have the look of things temporarily shelved for some purpose. And yet, as you look at these objects, you know with absolute certainty that their time has passed, that nothing will happen, that that shade will never be lifted, those numbers will never add up again, and the coat hanger will never be clothed.

There is, in all this work, not simply an ignoring of human subject matter, as in much abstract art, but an implication of absence, and – this is what makes it most poignant – of human absence from a man-made

environment. In the end, these pictures by Jasper Johns came to impress me as a dead city might – but a dead city of terrible familiarity. Only objects are left – man-made signs which, in the absence of men, have become objects. And Johns has anticipated their dereliction.

These, then, were some of my broodings as I looked at Johns's pictures. And now I'm faced with a number of questions, and a certain anxiety.

What I have said – was it *found* in the pictures or read into them? Does it accord with the painter's intention? Does it tally with other people's experience, to reassure me that my feelings are sound? I don't know. I can see that these pictures don't necessarily look like art, which has been known to solve far more difficult problems. I don't know whether they are art at all, whether they are great, or good, or likely to go up in price. And whatever experience of painting I've had in the past seems as likely to hinder me as to help. I am challenged to estimate the aesthetic value of, say, a drawer stuck into a canvas. But nothing I've ever seen can teach me how this is to be done. I am alone with this thing, and it is up to me to evaluate it in the absence of available standards. The value which I shall put on this painting tests my personal courage. Here I can discover whether I am prepared to sustain the collision with a novel experience. Am I escaping it by being overly analytical? Have I been eavesdropping on conversations? Trying to formulate certain meanings seen in this art – are they designed to demonstrate something about myself or are they authentic experience?

They are without end, these questions, and their answers are nowhere in storage. It is a kind of self-analysis that a new image can throw you into and for which I am grateful. I am left in a state of anxious uncertainty by the painting, about painting, about myself. And I suspect that this is all right. In fact, I have little confidence in people who habitually, when exposed to new works of art, know what is great and what will last.

(Leo Steinberg, 1972)

Matisse bequeaths a Cézanne to the French nation.

Nice, 10 November 1936

Yesterday I consigned to your shipper Cézanne's [*Trois*] *Baigneuses*. I saw the picture carefully packed and it was supposed to leave that very evening for the Petit Palais.

Allow me to tell you that this picture is of the first importance in the work of Cézanne because it is a very solid, very complete realization of a composition that he carefully studied in several canvases, which, now in important collections, are only the studies that culminated in the present work.

In the thirty-seven years I have owned this canvas, I have come to know it quite well, I hope, though not entirely; it has sustained me morally in the critical moments of my venture as an artist; I have drawn from it my faith and my perseverance; for this reason, allow me to request that it be placed so that it may be seen to its best advantage. For this it needs both light and perspective. It is rich in colour and surface, and seen at a distance it is possible to appreciate the sweep of its lines and the exceptional sobriety of its relationships.

I know that I do not have to tell you this, but nevertheless I think it is my duty to do so; please accept these remarks as the excusable testimony of my admiration for this work which has grown increasingly greater ever since I have owned it.

Allow me to thank you for the care that you will give it, for I hand it over to you with complete confidence . . .

Henri Matisse

(Henri Matisse, letter to Raymond Escholier, 10 November 1936)

A Philistine abroad:

I wonder why some things are? For instance, Art is allowed as much indecent licence today as in earlier times; but the privileges of Literature in this respect have been sharply curtailed within the past eighty or ninety years. Fielding and Smollett could portray the beastliness of their day in the beastliest language; we have plenty of foul subjects to deal with in our day, but we are not allowed to approach them very near, even with nice and guarded forms of speech. But not so with Art. The brush may still deal freely with any subject, however revolting or indelicate. It makes a body ooze sarcasm at every pore, to go about Rome and Florence and see what this last generation has been doing with the statues. These works, which had stood in innocent nakedness for ages, are all fig-leaved now. Yes, every one of them. Nobody noticed their nakedness before, perhaps; nobody can help noticing it now, the fig-leaf makes it so conspicuous.

But the comical thing about it all is, that the fig-leaf is confined to cold and pallid marble, which would be still cold and unsuggestive without this sham and ostentatious symbol of modesty, whereas warm-blooded paintings which do really need it have in no case been furnished with it.

At the door of the Uffizi, in Florence, one is confronted by statues of a man and a woman, noseless, battered, black with accumulated grime – they hardly suggest human beings – yet these ridiculous creatures have been thoughtfully and conscientiously fig-leaved by this fastidious generation. You enter, and proceed to that most-visited little gallery that exists in the world – the Tribune – and there, against the wall, without obstructing rag or leaf, you may look your fill upon the foulest, the vilest, the obscenest picture the world possesses – Titian's *Venus*. It isn't that she is naked and stretched out on a bed; no, it is the attitude of one of her arms and hand. If I ventured to describe that attitude, there would be a fine howl; but there the Venus lies, for anybody to gloat over that wants to; and there she has a right to lie, for she is a work of art, and Art has its privileges. I saw young girls stealing furtive glances at her; I saw young men gaze long and absorbedly at her; I saw aged, infirm men hang upon her charms with a pathetic interest. How I should like to describe her – just to see what a holy indignation I could stir up in the world – just to hear the unreflecting average man deliver himself about my grossness and coarseness, and all that. The world says that no worded description of a moving spectacle is a hundredth part as moving as the same spectacle seen with one's own eyes; yet the world is willing to let its son and its daughter and itself look at Titian's beast, but won't stand a description of it in words. Which shows that the world is not as consistent as it might be.

There are pictures of nude women which suggest no impure thought; I am well aware of that. I am not railing at such. What I am trying to emphasize is the fact that Titian's *Venus* is very far from being one of that sort. Without any question it was painted for a *bagnio* [i.e. a brothel], and it was probably refused because it was a trifle too strong. In truth it is too strong for any place but a public art gallery. Titian has two *Venuses* in the Tribune; persons who have seen them will easily remember which one I am referring to.

In every gallery in Europe there are hideous pictures of blood, carnage, oozing brains, putrefaction – pictures portraying intolerable suffering – pictures alive with every conceivable horror, wrought out in dreadful detail – and similar pictures are being put on the canvas every day and publicly exhibited – without a growl from anybody, for they are innocent, they are

inoffensive, being works of art. But suppose a literary artist ventured to go into a painstaking and elaborate description of one of these grisly things, the critics would skin him alive. Well, let it go, it cannot be helped; Art retains her privileges, Literature has lost hers. Somebody else may cipher out the whys and the wherefores and the consistencies of it – I haven't got time.

(Mark Twain, 1898)

Matisse recalls looking at paintings in his youth.

I can still hear old Pissarro exclaiming at the 'Indépendants' [the exhibition at the Salon des Indépendants, where Cézanne exhibited in 1899, 1901 and 1902; this painting was probably his *Nature morte: bouteille de menthe*], in front of a very fine still-life by Cézanne representing a cut-crystal water carafe in the style of Napoleon III, in a harmony of blue: 'It's like an Ingres.'

When my surprise passed, I found, and I still find, that he was right. Yet Cézanne spoke exclusively of Delacroix and of Poussin.

Certain painters of my generation frequented the masters of the Louvre, to whom they were led by Gustave Moreau [painter and teacher – Matisse was one of his pupils], before they became aware of the Impressionists. It was only later that they began to go to the rue Laffitte or even more important, to Durand-Ruel's [like Vollard, see below, a well-known Parisian art dealer] to see the celebrated *View of Toledo* and the *Road to Calvary* by El Greco, as well as some Goya portraits and *David and Saul* by Rembrandt.

It is remarkable that Cézanne, like Gustave Moreau, spoke of the masters of the Louvre. At the time he was painting the portrait of Vollard, Cézanne spent his afternoons drawing at the Louvre. In the evenings, on his way home, he would pass through the rue Laffitte, and say to Vollard: 'I think that tomorrow's sitting will be a good one, for I'm pleased with what I did this afternoon in the Louvre.' These visits to the Louvre helped him to detach himself from his morning's work, for the artist always needs such a break in order to judge and to be in control of his work of the previous day.

At Durand-Ruel's I saw two very beautiful still-lifes by Cézanne, biscuits and milk bottles and fruit in deep blue. My attention was drawn to them

by old Durand to whom I was showing some still-lifes I had painted. 'Look at these Cézannes that I cannot sell' he said, 'you should rather paint interiors with figures like this one or that.'

(Henri Matisse, 'Notes of a Painter on His Drawing', 1939)

Robert Hughes foresees the public moving past Van Gogh at 'full contemplation speed'
– and in a later article considers the history of the 'blockbuster'.

If you once thought Vincent the Dutchman had been a trifle oversold, from Kirk Douglas gritting his mandibles in the loony bin at St-Rémy to Greek zillionaires screwing his cypresses to the stateroom bulkheads of their yachts, you would be wrong. The process never ends. Its latest form is 'Van Gogh in Arles', at New York City's Metropolitan Museum of Art. Viewed as a social phenomenon rather than as a group of paintings and drawings, this show epitomizes the Met's leanings to cultural Reaganism: private opulence, public squalor. Weeks of private viewings have led up to its actual public opening, this week. Rarely has the idea of artistic heroism been so conspicuously tied to the ascent of the social mountain. But now all this will change. The general public, one may predict, will see very little. Its members will struggle for a peek through a milling scrum of backs; will be swept at full contemplation speed (about thirty seconds per image) through the galleries; will find their hope to experience Van Gogh's art in its true quality thwarted. Distanced from the work by crowds and railings, they may listen on their Acoustiguides to the Met's director, Philippe de Montebello, on the merits of the deceased. Then they will be decanted into the bazaar of postcards, date books, scarves – everything but limited-edition bronze ashtrays in the shape of the Holy Ear – that the Met provides as a coda. Finally, laden with souvenirs like visitors departing from Lourdes, they will go home. Vincent, we hardly knew ye . . .

The blockbuster, that curse of American museology, began with two events: André Malraux's loan of the *Mona Lisa* to the United States in 1963 (so that the world's two famous ladies, Mona and Jackie, could be in the same room at the same time) and the appearance of Michelangelo's Vatican *Pietà* at the World's Fair in Flushing Meadow in 1964, looking like a replica of itself done in margarine, the viewers carried past it on a moving walkway. It produced at its height, frenetic events like Tut and

clunkers like the Metropolitan Museum's 1983 Vatican show. It ended with that saturnalia of 'heritage' nostalgia, 'Treasure Houses of Great Britain', at the National Gallery of Art in Washington, DC, in 1988. But the time of the blockbuster is gone; and it is no loss.

(Robert Hughes, 1984 and 1990, in his *Nothing If Not Critical*, 1990)

John Updike wonders whether the blockbuster is worth the trouble.

Boston's publicity drums have been throbbing for months in anticipation of 1985's 'Renoir' show at the Museum of Fine Arts. An article in the August 20th Boston *Globe* portrayed William Murphy, 'Director of Operations', standing 'hunched over a blueprint with red and green lines marking viewing paths and guard stations snaking through galleries'. 'Publicity officer' Christopher Bowden was quoted as crowing, 'There'll be pictures, Renoir posters, Renoir books. Renoir T-shirts and sweatshirts. Renoir buttons.' Thirty-six thousand five-dollar tickets had already been sold as of the first week of August; half a million people were expected; staff members were close to buckling under the immense pressure from friends and relatives for Renoir-oriented favours; shuttle buses from Copley Square and crowd-counting photoelectric cells were in the works. The invasion of Grenada hadn't warranted more logistics than this 'mega-show'. Museum 'officials', with a nostalgic backward glance to the 'New World' exhibit of two years ago, when the weight of the crowds more than once broke the escalators, reassured the obviously alarmed reporter that 'High-interest shows such as "Renoir" are necessary ... to boost attendance and broaden the museum's base.'

My wife and I, as museum members, received frequent bulletins as to the show's grandeur and the prodigious difficulties bound to assail those who attempted to see it. Important-looking polychrome tickets by Ticketron arrived in the mail, assigning us a precise admission time on one of the members' days, before the universal onrush. We were warned that the parking around the museum and in its newish, I. M. Pei-designed parking lot would be impossible, and so it proved. Traffic on Huntington Avenue slowed to a honking, snarling crawl as we neared the citadel of art. Panicked lest we miss our appointed hour and be relegated to a dark afternoon in remotest December, we found an illegal spot in some mazy casbah off the Fenway and scurried pell-mell through the thickening mobs. Inside the formerly stately museum, hullabaloo had attained a carnival

pitch; the crush at the cloakroom merged indistinguishably with the crush at the admission counter. Upstairs, at the head of the not-as-yet-broken escalator, two infinite parallel lines had formed: one for the twelve-thirty people, and one for the one o'clocks, which included us. Things were running, rumour had it, forty-five minutes late. My mind fled back to the *Globe* article, and Director of Operations Murphy's guarded estimate: 'We'll set an arbitrary level of 700 people at a time. As long as the average stay isn't over an hour, we're OK.' Evidently, the individual viewing time for the ninety-seven assembled paintings was exceeding the projected thirty-seven seconds each.

Our line, though long and unmoving, was good-tempered. We were, after all, museum members – tiny art patrons. Half of the males looked like George Bush at assorted points in his evolution, wearing end-of-summer suits and that blinking, stooping air of wry martyrdom with which Boston-area men escort their wives to cultural events; and the other half looked like post-*Howl* Allen Ginsberg, outfitted by L. L. Bean. There seemed to be, perhaps in response to Renoir's love of young flesh, a remarkable number of babies, harnessed to their parents by a well-stitched wealth of slings, knapsacks, and neo-papooses. Rain beat gently on the skylights as we shuffled our way, with nary a sideways glance, through the dim chambers of Tibetan art, where three-eyed godlings danced in eternal fire. Less than an hour behind schedule, we were admitted to the fulgent galleries where the show hung. It is no small compliment to Renoir's vitality to say that he wasn't trampled underfoot.

The paintings made their splashes, in their ornate old plaster frames, on the blue-grey wall, and some were indeed splendid. But such a concentration, after such hoopla, made it clearer than it should have been that Renoir does not quite rank with the heroic masters of early modern painting – specifically, with his friends Monet and Cézanne. Compared with either, he didn't look hard enough. He saw what he wanted to see, and turned it as he aged into an inward vision, a mythology. The shimmering, breezy outdoors of Impressionism gradually grows furry and comes indoors and in the end becomes a kind of tapestry, a green-and-blue background scrubbed in behind nudes painted in quite another style, a style of enamelled pallor. The brushstrokes turn greasier, the colours rawer, the drawing vaguer. In the end the people all look Mexican, and a lumpy muralism reminds us that Renoir began to paint as a decorator of porcelain, fans, blinds, and walls. Old artists are entitled to caricature themselves, but – though his huge pottery women are said to have inspired

Picasso in one of his phases – Renoir's final turn is less usefully, less searchingly extreme than Monet's virtually abstract water lilies or Cézanne's sketchy, segmented watercolours, which showed the way to Cubism.

Such is the sour mood of unappreciation induced by a megashow. Poor Renoir, he didn't ask for this. Placed in the Impressionist/Post-Impressionist galleries of a major museum, a half-dozen canvases by him speak with their own charming accent and glow by their own tender light. But the numerous paintings in Boston, dutifully consumed by the eyeball as one shuffles past in a slow pedestrian choo-choo, begin to deposit on the retina an accumulated taste of artificial sweetener . . .

The line at the souvenir shop was the worst yet, and the woman behind me began to whimper that she was going to faint. Yet, with the grim fortitude that made New England rocky, we hung in there with our postcards and Renoir notepaper and $19.95 catalogues, and purchased. I didn't see anybody buying any of the 50-cent buttons, though. As my wife and I approached the spot where we had left our car, I saw on its windshield a lyrical dab of a colour Renoir never used – Day-Glo orange, the colour of a Boston parking ticket.

(John Updike, 1985)

Mysterious Beauties: Art and Revelation

One of Proust's characters, the writer Bergotte, expires in front of a Vermeer.

The circumstances of his death were as follows. A fairly mild attack of uraemia had led to his being ordered to rest. But an art critic having written somewhere that in Vermeer's *View of Delft* (lent by the Gallery at The Hague for an exhibition of Dutch painting), a picture which he adored and imagined that he knew by heart, a little patch of yellow wall (which he could not remember) was so well painted that it was, if one looked at it by itself, like some priceless specimen of Chinese art, of a beauty that was sufficient in itself, Bergotte ate a few potatoes, left the house, and went to the exhibition. At the first few steps he had to climb, he was overcome by an attack of dizziness. He walked past several pictures and was struck by the aridity and pointlessness of such an artificial kind of art, which was greatly inferior to the sunshine of a windswept Venetian palazzo, or of an ordinary house by the sea. At last he came to the Vermeer which he remembered as more striking, more different from anything else he knew, but in which, thanks to the critic's article, he noticed for the first time some small figures in blue, that the sand was pink, and, finally, the precious substance of the tiny patch of yellow wall. His dizziness increased; he fixed his gaze, like a child upon a yellow butterfly that it wants to catch, on the precious little patch of wall. 'That's how I ought to have written,' he said. 'My last books are too dry, I ought to have gone over them with a few layers of colour, made my language precious in itself, like this little patch of yellow wall.' Meanwhile he was not unconscious of the gravity of his condition. In a celestial pair of scales there appeared to him, weighing down one of the pans, his own life, while the other contained the little patch of wall so beautifully painted in yellow. He felt that he had rashly sacrificed the former for the latter. 'All the same,' he said to himself, 'I shouldn't like to be the headline news of this exhibition for the evening papers.'

He repeated to himself: 'Little patch of yellow wall, with a sloping roof, little patch of yellow wall.' Meanwhile he sank down on to a circular settee;

whereupon he suddenly ceased to think that his life was in jeopardy and, reverting to his natural optimism, told himself: 'It's nothing, merely a touch of indigestion from those potatoes, which were under-cooked.' A fresh attack struck him down; he rolled from the settee to the floor, as visitors and attendants came hurrying to his assistance. He was dead.

(Marcel Proust, 1920–1)

Cubism verges on the mystical in the mind of Georges Braque – who, with Picasso, invented it.

You see, I have made a great discovery: I no longer believe in anything. Objects don't exist for me except in so far as a rapport exists between them or between them and myself. When one attains this harmony, one reaches a sort of intellectual non-existence – what I can only describe as a state of peace – which makes everything possible and right. Life then becomes a perpetual revelation. That is true poetry.

Do these ideas of mine derive from Zen-Buddhism? I don't think so. True, in recent years I have read a great deal about Zen-Buddhism but this philosophy has had no influence on me . . . I am only interested to find out how closely certain tenets of Zen-Buddhism correspond to views that I have held for a long time.

However, don't ask me to explain too much! 'The only valid thing in art is that which cannot be explained,' I once wrote. I still feel this very strongly. To explain away the mystery of a great painting – if such a feat were possible – would do irreparable harm, for whenever you explain or define something you substitute the explanation or the definition for the real thing . . . Believe me, there are certain mysteries, certain secrets in my own work which even I don't understand nor do I try to do so . . . Mysteries have to be respected if they are to retain their power. Art disturbs: science reassures.

No object can be tied down to any one sort of reality; a stone may be part of a wall, a piece of sculpture, a lethal weapon, a pebble on a beach, or anything else you like, just as this file in my hand can be metamorphosed into a shoehorn or a spoon, according to the way in which I use it. The first time this phenomenon struck me was in the trenches during the First World War when my batman turned a bucket into a brazier by poking a few holes in it with his bayonet and filling it with coke. For me this

commonplace incident had a poetic significance: I began to see things in a new way. Everything, I realized, is subject to metamorphosis; everything changes according to circumstances. So when you ask me whether a particular form in one of my paintings depicts a woman's head, a fish, a vase, a bird, or all four at once, I can't give you a categorical answer, for this 'metamorphic' confusion is fundamental to what I am out to express. It's all the same to me whether a form represents a different thing to different people or many things at the same time. And then I occasionally introduce forms which have no literal meaning whatsoever. Sometimes these are accidents which happen to suit my purpose, sometimes 'rhymes' which echo other forms, and sometimes rhythmical motifs which help to integrate a composition and give it movement.

(Georges Braque, in John Richardson, 1959)

A Tiepolo on a Venetian ceiling offers a vision of heaven.

At the Scuola dei Carmini he decorated for the Carmelite confraternity a ceiling, the centre of which was to be 'a Madonna descending from Heaven, holding in her hand a sacred scapular which she proffers to St Simon Stock'. The terms of the commission were accepted by Tiepolo in January 1740, but it was two or three years before the central picture and its surrounding ones of *Virtues* were finished. The *Madonna of Mount Carmel* is a vision which eclipses the splendours even of St Clement's vision; indeed, it is probably Tiepolo's greatest masterpiece in religious painting. He understood well enough what was required by the subject that was to some extent *his* subject: an assuaging vision of the supernatural to mortals.

The scene which he specifically illustrates here was a vital moment in the history of the Carmelite order. The Virgin is said to have appeared on this occasion to St Simon at Cambridge, though that detail has clearly not bothered Tiepolo. The scapular, two pieces of cloth joined by strings, is the means of obtaining an important indulgence according to a Papal Bull that is perhaps a forgery but which Tiepolo accepts: those who have worn the scapular will be liberated from Purgatory through the Madonna's intercession on the first Saturday after their death 'or as soon as possible'.

The comforting doctrine of this statement is carefully expressed in the painting. Purgatory lies all about St Simon, and the litter of tombstones, skulls, and cloudy horrors of yawning graves contrasts with the tall white

figure of the Madonna triumphantly wielding aloft the Child and swept through the sky by attendant angels. The vision is almost a hallucination, and the figures of it are heightened beyond normality. We feel, and share, the saint's privilege as he crouches low before the air-borne apparitions; like him we seem annihilated before this infraction of Nature's order ...

Tiepolo's mind is instinctively on the side of divinity, excited by triumphs, apotheoses and glories; he magnifies the whole conception of the Carmelite vision to his own more splendid dimensions whereby Cambridge sinks into being a Palladian-style cornice but heaven becomes a great space swept by agitated, graceful, feminine forms. In this world of celestial servants it is not the Madonna who holds the sacred scapular; the office is delegated to an angel who carries it in one hand while supporting the Madonna's draperies with another.

(Michael Levey, 1959)

Samuel Palmer finds paradisaical visions in Blake's illustrations to Virgil's First Eclogue.

They are visions of little dells, and nooks, and corners of Paradise; models of the exquisitest pitch of intense poetry. I thought of their light and shade, and looking upon them I found no word to describe it. Intense depth, solemnity, and vivid brilliancy only coldly and partially describe them. There is in all such a mystic and dreamy glimmer as penetrates and kindles the inmost soul, and gives complete and unreserved delight, unlike the gaudy daylight of this world. They are like all that wonderful artist's works the drawing aside of the fleshly curtain, and the glimpse, which all the most holy, studious saints and sages have enjoyed, of that rest which remaineth to the people of God. The figures of Mr Blake have that intense, soul-evidencing attitude and action; and that elastic, nervous spring which belongs to uncaged immortal spirits.

(Samuel Palmer, Notebook, 1824)

Proust argues that we need artists to reveal the beauty of our surroundings to us.

Take a young man of modest means and artistic tastes, sitting in the dining-room at that sad and mundane moment when one has just finished lunch but when the table has not yet been completely cleared. His

imagination filled with the splendour of museums, of cathedrals, of mountains, of the sea, it is ill at ease and bored, with a sensation close to nausea, a feeling verging on world-weariness, that he sees a last knife left lying on the half-turned-back tablecloth which hangs right down to the ground, next to the remains of an underdone and tasteless cutlet. On the sideboard a little sunlight glancing cheerfully off the glass of water which slaked lips have left almost untouched, brings cruelly out, like an ironic laugh, the traditional mundanity of this unaesthetic spectacle. At the far end of the room the young man can see his mother, already sitting working, slowly unwinding, with her habitual calm, a skein of red wool. And behind her, perched on a cupboard, next to some brandy that is being held in reserve for a 'big occasion', a short, fat cat, seeming to be the evil if inglorious genius of this domestic mediocrity.

The young man turns away his gaze and now it falls on the gleaming, spotless silver, and below on the glowing firedogs. More put out by the orderliness of the room than by the disorder on the table, he envies those financiers of taste who have only beautiful things about them, in rooms where everything, down to the coal-tongs in the fireplace or the knob on the door, everything is a work of art. He curses this ambient ugliness and, ashamed of having remained for a quarter of an hour experiencing not the shame of it, but disgust and as if its fascination, he gets to his feet and, if he cannot catch a train for Holland or for Italy, goes to the Louvre to have sight of Veronese palaces, of Van Dyck princes, of Claude harbours, which this evening will again make the return to these workaday scenes in their familiar frame drab and exasperating.

If I knew this young man, I would not deter him from going to the Louvre but rather accompany him there; but, taking him into the Lacaze gallery and into the French eighteenth-century gallery, or into some other French gallery, I would make him stop in front of the Chardins. And once he had been dazzled by this opulent depiction of what he had called mediocrity, this appetizing depiction of a life he had found insipid, this great art of a nature he had thought paltry, I should say to him: Are you happy? Yet what have you seen here but a well-to-do bourgeoise pointing out to her daughter the mistakes she has made in her needlework (*The Industrious Mother*), a woman carrying loaves of bread (*The Return from Market*), a kitchen interior where a live cat is walking over some oysters, while a dead ray-fish hangs on the wall, a sideboard already half cleared with knives left lying on the tablecloth (*The Buffet*), or less still, dining or kitchen utensils, not only the pretty ones, like Saxe chocolate-jars, but

those you find most ugly, a shiny lid, pots of every shape and material (the salt-cellar, the strainer), the sights that repel you, dead fish lying on the table (in the picture of *The Ray-fish*), and the sights that nauseate you, half-emptied glasses and too many full glasses (*The Buffet*).

If you now find all this beautiful to look at, it is because Chardin found it beautiful to paint. And he found it beautiful to paint because he found it beautiful to look at. The pleasure his depiction of a room with someone sewing gives you, of a pantry, a kitchen, a sideboard, is the pleasure, seized hold of as it passed, released from the moment, made timeless and profound, that seeing a sideboard, a kitchen, a pantry, a room with someone sewing gave to him. So inseparable are they one from the other that if he was unable to confine himself to the first but sought to give himself and to give others the second, you cannot confine yourself to the second but will necessarily return to the first. You had already experienced, unconsciously, the pleasure that the spectacle of modest lives or of still-life affords, else it would not have arisen in your heart when Chardin came to summon it with his brilliant and imperative language. Your consciousness was too inert to descend so far. It had to wait until Chardin came to take it up inside you and raise it into consciousness. Then you recognized it and savoured it for the first time. If when you look at a Chardin you can say to yourself, this is intimate, is comfortable, is alive like a kitchen, when you walk about a kitchen you will say to yourself, this is interesting, this is grand, this is beautiful like a Chardin. Chardin will have been a man who merely took delight in his dining room, amidst the fruit and the glasses, but a man of a keener awareness, his delight too intense so that it overflowed into unctuous brushstrokes and immortal pigments. You will be a Chardin, less great no doubt, but great to the extent that you love him, that you become him again, for whom, as for him, metals and earthenware will take on life and fruit will speak.

(Marcel Proust, *c.* 1895, in *Against Sainte-Beuve*, 1954)

The American abstract painter Barnett Newman affirms the continuing validity of the sublime, although not of the beautiful.

The invention of beauty by the Greeks, that is, their postulate of beauty as an ideal, has been the bugbear of European art and European aesthetic philosophies. Man's natural desire in the arts to express his relation to the Absolute became identified and confused with the absolutisms of perfect

creations – with the fetish of quality – so that the European artist has been continually involved in the moral struggle between notions of beauty and the desire for sublimity . . .

The failure of European art to achieve the sublime is due to this blind desire to exist inside the reality of sensation (the objective world, whether distorted or pure) and to build an art within a framework of pure plasticity (the Greek ideal of beauty, whether that plasticity be a romantic active surface or a classic stable one). In other words, modern art, caught without a sublime content, was incapable of creating a new sublime image and, unable to move away from the Renaissance imagery of figures and objects except by distortion or by denying it completely for an empty world of geometric formalisms – a *pure* rhetoric of abstract mathematical relationships – became enmeshed in a struggle over the nature of beauty: whether beauty was in nature or could be found without nature.

I believe that here in America, some of us, free from the weight of European culture, are finding the answer, by completely denying that art has any concern with the problem of beauty and where to find it. The question that now arises is how, if we are living in a time without a legend or mythos that can be called sublime, if we refuse to admit any exaltation in pure relations, if we refuse to live in the abstract, how can we be creating a sublime art?

We are reasserting man's natural desire for the exalted, for a concern with our relationship to the absolute emotions. We do not need the obsolete props of an outmoded and antiquated legend. We are creating images whose reality is self-evident and which are devoid of the props and crutches that evoke associations with outmoded images, both sublime and beautiful. We are freeing ourselves of the impediments of memory, association, nostalgia, legend, myth, or what have you, that have been the devices of Western European painting. Instead of making *cathedrals* out of Christ, man, or 'life', we are making [them] out of ourselves, out of our own feelings. The image we produce is the self-evident one of revelation, real and concrete, that can be understood by anyone who will look at it without the nostalgic glasses of history.

(Barnett Newman, 'The Sublime is Now', 1948)

An Iris Murdoch character is hampered from becoming an artist by too much vision.

Tim had lived now for a long time with himself as a painter. He had been ambitious and ceased to be, he had been disappointed and ceased to be. He knew he was absolutely, and would always be, a painter. What else was he? He was Daisy's lover, keeper, friend. That was enough for a life. He went on trying, though he never tried very hard. Any artist who is not a beginner faces the problem of enlarging into a working space the line that runs between 'just begun' and 'too late'. The hard work lies in the middle, when preliminaries are done, and the end is not yet enclosing the form. This is the space which longs to collapse, which the artist's strength must faithfully keep open. Tim was vaguely aware of this, but he was idle and lacked confidence. He was almost but not quite aware that he chose daily to remain mediocre. His efforts tended to be either 'sketches' or 'spoilt'. Yet he kept on drawing and in this activity something purely good, often mislaid, tended to come back. He knew nothing, he read nothing, but he kept on looking. Tim possessed by nature a gift yearned for by sages, he was able simply to *perceive*! (He did not realize that this was exceptional, he thought everybody could do it.) This gift does not of course ensure that its owner can paint well or indeed at all. In Tim's case it was almost a hindrance. He got so much pleasure from the external world, he thought sometimes why trouble to paint, it's all there, *there* in front of me, unless one's great, why bother, why not just live happily with Nature so long as one has eyes? Even Cézanne said he could not possibly create the wonderful colours that he saw.

(Iris Murdoch, *Nuns and Soldiers*, 1980)

How

to

Do

It:

The

Practical

Aspects

of

Art

The painter Eva Gonzales receives a lesson in still-life painting from Manet, as recorded by the critic Philippe Burty.

Get it down quickly. Don't worry about the background. Just go for the tonal values. You see? When you look at it, and above all when you think how to render it as you see it, that is, in such a way that it makes the same impression on the viewer as it does on you, you don't look for, you don't see the lines on the paper over there do you? And then, when you look at the whole thing, you don't try to count the scales of the salmon. Of course not. You see them as little silver pearls against grey and pink – isn't that right? – look at the pink of this salmon, with the bone appearing white in the centre and then greys like shades of mother of pearl! And the grapes, now do you count each grape? Of course not. What strikes you is their clear amber colour, and the bloom which models the form by softening it. What you have to decide with the cloth is where the highlights come and then the planes which are not in direct light. Half-tones are for the *Magasin pittoresque* engravers. The folds will come by themselves if you put them in their proper place. Ah! M. Ingres, there's the man! We're all just children. There's the one who knew how to paint materials! Ask Bracquemond [Félix Bracquemond, 1833–1914, artist and print-maker] . . . Above all keep your colours fresh!

(Édouard Manet, as recorded by Philippe Burty, *c.*1868–70)

And Paul Sérusier receives a lesson in colour from Gauguin, as Maurice Denis recalls.

It was at the beginning of 1888 that the name of Gauguin was revealed to us by Sérusier, back from Pont-Aven, who showed us, not without a certain mystery, a cigar-box cover on which could be seen a landscape [later called *The Talisman*]. It seemed crude because of its synthetic formulation in

purple, vermilion, Veronese green and other pure colours – just as they came out of the tube – with almost no white mixed in. 'How do you see this tree,' Gauguin had said, standing in one of the corners of the Bois d'Amour [a forest near Pont-Aven in Brittany]. 'Is it really green? Use green then, the most beautiful green on your palette. And that shadow, rather blue? Don't be afraid to paint it as blue as possible.'

(Maurice Denis, 'The Influence of Paul Gauguin', 1903)

William Hazlitt, a failed painter but a brilliant essayist, argues that it is more pleasurable to paint than to write (though himself spent far more time doing the latter than the former).

After I have once written on a subject, it goes out of my mind: my feelings about it have been melted down into words, and *then* I forget. I have, as it were, discharged my memory of its old habitual reckoning, and rubbed out the score of real sentiment. For the future it exists only for the sake of others. – But I cannot say, from my own experience, that the same process takes place in transferring our ideas to canvas; they gain more than they lose in the mechanical transformation. One is never tired of painting, because you have to set down not what you knew already, but what you have just discovered. In the former case you translate feelings into words; in the latter, names into things. There is a continual creation out of nothing going on. With every stroke of the brush a new field of inquiry is laid open; new difficulties arise, and new triumphs are prepared over them. By comparing the imitation with the original, you see what you have done, and how much you have still to do. The test of the senses is severer than that of fancy, and an over-match even for the delusions of our self-love. One part of a picture shames another, and you determine to paint up to yourself, if you cannot come up to Nature. Every object becomes lustrous from the light thrown back upon it by the mirror of art: and by the aid of the pencil we may be said to touch and handle the objects of sight. The air-drawn visions that hover on the verge of existence have a bodily presence given them on the canvas: the form of beauty is changed into a substance: the dream and the glory of the universe is made 'palpable to feeling as to sight'. – And see! a rainbow starts from the canvas, with all its humid train of glory, as if it were drawn from its cloudy arch in heaven. The spangled landscape glitters with drops of dew after the shower. The 'fleecy fools' show their coats in the gleams of the setting

sun. The shepherds pipe their farewell notes in the fresh evening air. And is this bright vision made from a dead, dull blank, like a bubble reflecting the mighty fabric of the universe? Who would think this miracle of Rubens's pencil possible to be performed? Who, having seen it, would not spend his life to do the like? See how the rich fallows, the bare stubble-field, the scanty harvest-home, drag in Rembrandt's landscapes! How often have I looked at them and nature, and tried to do the same, till the very 'light thickened' and there was an earthiness in the feeling of the air! There is no end of the refinements of art and nature in this respect. One may look at the misty glimmering horizon till the eye dazzles and the imagination is lost, in hopes to transfer the whole interminable expanse at one blow upon the canvas. Wilson [Richard Wilson, eighteenth-century landscape painter] said, he used to try to paint the effect of the motes dancing in the setting sun. At another time, a friend, coming into his painting room when he was sitting on the ground in a melancholy posture, observed that his picture looked like a landscape after a shower: he started up with the greatest delight, and said, 'That is the effect I intended to produce, but thought I had failed.' Wilson was neglected; and, by degrees, neglected his art to apply himself to brandy. His hand became unsteady, so that it was only by repeated attempts that he could reach the place or produce the effect he aimed at; and when he had done a little to a picture, he would say to any acquaintance who chanced to drop in: 'I have painted enough for one day: come, let us go somewhere.' It was not so Claude [Claude Lorrain, seventeenth-century French landscape painter] left his pictures, or his studies on the banks of the Tiber, to go in search of other enjoyments, or ceased to gaze upon the glittering sunny vales and distant hills; and while his eye drank in the clear sparkling hues and lovely forms of nature, his hand stamped them on the lucid canvas to last there for ever! One of the most delightful parts of my life was one fine summer, when I used to walk out of an evening to catch the last light of the sun, gemming the green slopes or russet lawns, and gilding tower or tree, while the blue sky, gradually turning to purple and gold or skirted with dusky grey, hung its broad marble pavement over all, as we see it in the great master of Italian landscape. But to come to a more particular explanation of the subject: –

The first head I ever tried to paint was an old woman with the upper part of the face shaded by her bonnet, and I certainly laboured at it with great perseverance. It took me numberless sittings to do it. I have it by me still, and sometimes look at it with surprise, to think how much pains

were thrown away to little purpose – yet not altogether in vain if it taught me to see good in everything, and to know that there is nothing vulgar in Nature seen with the eye of science or of true art. Refinement creates beauty everywhere: it is the grossness of the spectator that discovers nothing but grossness in the object. Be this as it may, I spared no pains to do my best. If art was long, I thought that life was so too at that moment. I got in the general effect the first day; and pleased and surprised enough I was at my success. The rest was a work of time – of weeks and months (if need were), of patient toil and careful finishing. I had seen an old head by Rembrandt at Burleigh House, and if I could produce a head at all like Rembrandt in a year, in my lifetime, it would be glory and felicity and wealth and fame enough for me! The head I had seen at Burleigh was an exact and wonderful facsimile of nature; and I resolved to make mine (as nearly as I could) an exact facsimile of nature. I did not then, nor do I now believe, with Sir Joshua, that the perfection of art consists in giving general appearances without individual details, but in giving general appearances with individual details. Otherwise, I had done my work the first day. But I saw something more in nature than general effect, and I thought it worth my while to give it in the picture. There was a gorgeous effect of light and shade; but there was a delicacy as well as depth in the chiaroscuro which I was bound to follow into all its dim and scarce perceptible variety of tone and shadow. Then I had to make the transition from a strong light to as dark a shade, preserving the masses, but gradually softening off the intermediate parts. It was so in nature; the difficulty was to make it so in the copy. I tried, and failed again and again; I strove harder, and succeeded as I thought. The wrinkles in Rembrandt were not hard lines, but broken and irregular. I saw the same appearance in nature, and strained every nerve to give it. If I could hit off this edgy appearance, and insert the reflected light in the furrows of old age in half a morning, I did not think I had lost a day. Beneath the shrivelled yellow parchment look of the skin, there was here and there a streak of the blood colour tingeing the face; this I made a point of conveying, and did not cease to compare what I saw with what I did (with jealous, lynx-eyed watchfulness) till I succeeded to the best of my ability and judgement. How many revisions were there! How many attempts to catch an expression which I had seen the day before! How often did we try to get the old position, and wait for the return of the same light! There was a puckering-up of the lips, a cautious introversion of the eye under the shadow of the bonnet, indicative of the feebleness and suspicion of old age, which at last we

managed, after many trials and some quarrels, to a tolerable nicety. The picture was never finished, and I might have gone on with it to the present hour.

(William Hazlitt, 'On the Pleasure of Painting', *Table Talk*, 1821–2)

How to make the still-life last? Cézanne found his apples rotted, and the American painter Audrey Flack had similar problems.

Audrey Flack often paints still-lifes of food, and is undaunted by the fact that some foods stand still better than others. To prepare the photograph from which she painted a banana split sundae, she used four gallons of ice cream, which kept melting and sliding under the hot lights. The whipped cream ran, and the cherry had to be precisely dropped so that it wouldn't sink out of sight before the photo was snapped. It was a long and frustrating afternoon enjoyed only by Audrey's teenage daughter Hannah, who consumed the rejects – and skipped dinner.

(Audrey Flack, in *The Artists' Cookbook*, 1977)

The fourteenth-century Italian painter and handbook-writer, Cennino Cennini, makes a modest suggestion about landscape painting.

If you wish to acquire a good style for mountains, and to have them look natural, take some large stones, sharp-edged and not smooth, and copy them from nature, applying the lights and darks as the rule prescribes.

(Cennino Cennini, *c.*1390)

Gauguin details the difficult circumstances under which his great painting Whence Do We Come? What Are We? Where Are We Going? *was created.*

I did not write to you last month; I had nothing more to say to you except to repeat that I no longer had any courage. Having received nothing from Chaudet [Georges-Alfred Chaudet, a painter and part-time dealer whom Gauguin had left as his representative in Paris] by the last post, and suddenly almost recovering my health, so that there was no longer any chance of dying naturally, I wanted to kill myself. I left to conceal myself in the mountains where my dead body would have been devoured by the

ants. I did not have a revolver, but I had some arsenic which I had saved during my eczema. I do not know whether the dose was too strong or whether the vomitings nullified the action of the poison by rejecting it. Finally, after a night of terrible suffering, I went back home. During this whole month, I have been afflicted with pressures at the temples and spells of dizziness and nausea when I was having my meagre meals. This month I receive 700 francs from Chaudet and 150 francs from Maufra [Maxime Maufra, collector]: with that I pay the most furious creditors. Then I begin again to live as before, in misery and shame. In May the bank will seize and sell at a miserable price all I possess; among other things my paintings. Then we shall see how to start again in another way. I must tell you that in December my mind was indeed made up. So, before dying, I wanted to paint a big canvas which I had in mind, and during that whole month I worked day and night in an incredible fever. By God, it is not made like a Puvis de Chavannes [Pierre, nineteenth-century French painter, known for his murals and large paintings], studies from nature, preparatory cartoon, etc. It is all done in a bold style, directly with the brush, on sackcloth full of knots and wrinkles, so it looks terribly rough.

They will say that it is careless ... not finished. It is true that one is not a good judge of one's own work; however, I believe that this canvas not only surpasses all the preceding ones, but also that I will never do anything better or even similar to it. Before dying I put into it all my energy, such a painful passion under terrible circumstances, and a vision so clear without corrections, that the haste disappears and the life surges up. It does not smell of the model, of professional techniques and of so-called rules – from all of which I always did free myself, although sometimes with trepidation.

It is a canvas about five feet [high] by twelve [wide]. The two upper corners are chrome yellow, with an inscription on the left, and my name on the right, like a fresco on a golden wall with its corners damaged.

To the right, below, a sleeping baby and three seated women. Two figures dressed in purple confide their thoughts to each other. An enormous crouching figure which intentionally violates the perspective, raises its arm in the air and looks in astonishment at these two people who dare to think of their destiny. A figure in the centre is picking fruit. Two cats near a child. A white goat. An idol, both arms mysteriously and rhythmically raised, seems to indicate the Beyond. A crouching girl seems to listen to the idol. Lastly, an old woman approaching death appears reconciled and resigned to her thoughts. She completes the story. At her feet a strange

white bird, holding a lizard in its claw, represents a futility of words.

The setting is the bank of a stream in the woods. In the background the ocean, and beyond the mountains of a neighbouring island. In spite of changes of tone, the landscape is blue and Veronese green from one end to another. The naked figures stand out against it in bold orange.

If anyone said to the students competing for the Rome Prize [Prix de Rome] at the École des Beaux-Arts, the picture you must paint is to represent *Whence Do We Come? What Are We? Where Are We Going?* what would they do? I have finished a philosophical work on this theme, comparable to the Gospels. I think it is good; [if I have the strength to copy it I will send it to you].

(Paul Gauguin, letter from Tahiti to Daniel de Monfried, February 1898)

Marcel Duchamp instructs his sister Suzanne in how to create a 'readymade' work of art by remote control.

Now, if you went up to my place you saw in my studio a bicycle wheel and a *bottle rack*. I had purchased this as a sculpture already made. And I have an idea concerning this bottle rack: Listen.

Here, in NY, I bought some objects in the same vein and I treat them as '*readymade*'. You know English well enough to understand the sense of '*ready made*' that I give these objects. I sign them and give them an English inscription. I'll give you some examples:

I have for example a large snow shovel upon which I wrote at the bottom: *In advance of the broken arm*, translation in French, *En avance du bras cassé*. Don't try too hard to understand it in the Romantic or Impressionist or Cubist sense – that has nothing to do with it.

Another 'readymade' is called: *Emergency in favour of twice*, possible translation in French: *Danger (Crise) en faveur de 2 fois*. This whole preamble in order to actually say:

You take for yourself this bottle rack. I will make it a '*Readymade*' from a distance. You will have to write at the base and on the inside of the bottom ring in small letters painted with an oil-painting brush, in silver and white colour, the inscription that I will give you after this, and you will sign it in the same hand as follows:

(from) Marcel Duchamp.

Unfortunately, Suzanne had already thrown out both the bottle rack and the bicycle wheel – almost all his original readymades were accidentally discarded in similar ways (those now to be seen in museums are carefully fabricated replicas). Furthermore, the second page of the letter has vanished, and with it Duchamp's inscription. Many years later he told Robert Rauschenberg that he could not remember the phrase he had intended.

(Marcel Duchamp, *c.* January 1915)

How Benvenuto Cellini cast his great sculpture of Perseus.

Left to myself in this way, I regained my self-confidence and rid myself of all those troublesome thoughts that used to torment me from time to time, often driving me to bitterly tearful regret that I had ever quit France, even though it had been to go on a charitable mission to Florence, my beloved birthplace, to help out my six nieces. I now fully realized that it was this that had been at the root of all my misfortunes, but all the same I told myself that when my *Perseus* that I had already begun was finished, all my hardships would give way to tremendous happiness and prosperity.

So with renewed strength and all the resources I had both in my limbs and my pocket (though I had very little money left) I made a start by ordering several loads of wood from the pine forest at Serristori, near Monte Lupo. While waiting for them to arrive I clothed my *Perseus* with the clays I had prepared some months previously in order to ensure that they would be properly seasoned. When I had made its clay tunic, as it is called, I carefully armed it, enclosed it with iron supports, and began to draw off the wax by means of a slow fire. It came out through the air vents I had made – the more of which there are, the better a mould fills. After I had finished drawing off the wax, I built round my *Perseus* a funnel-shaped furnace. It was built, that is, round the mould itself, and was made of bricks piled one on top of the other, with a great many gaps for the fire to escape more easily. Then I began to lay on wood, in fairly small amounts, keeping the fire going for two days and nights.

When all the wax was gone and the mould well baked, I at once began to dig the pit in which to bury it, observing all the rules that my art demands. That done, I took the mould and carefully raised it up by pulleys and strong ropes, finally suspending it an arm's length above the furnace, so that it hung down just as I wanted it above the middle of the pit. Very, very slowly I lowered it to the bottom of the furnace and set it in exact

position with the utmost care: and then, having finished that delicate operation, I began to bank it up with the earth I had dug out. As I built this up, layer by layer, I left a number of air holes by means of little tubes of terracotta of the kind used for drawing off water and similar purposes. When I saw that it was perfectly set up, that all was well as far as covering it and putting those tubes in position was concerned, and that the workmen had grasped what my method was – very different from those used by all the others in my profession – I felt confident that I could rely on them, and I turned my attention to the furnace.

I had had it filled with a great many blocks of copper and other bronze scraps, which were placed according to the rules of our art, that is, so piled up that the flames would be able to play through them, heat the metal more quickly, and melt it down. Then, very excitedly, I ordered the furnace to be set alight.

The pine logs were heaped on, and what with the greasy resin from the wood and the excellence of my furnace, everything went so merrily that I was soon rushing from one side to another, exerting myself so much that I became worn out. But I forced myself to carry on.

To add to the difficulties, the workshop caught fire and we were terrified that the roof might fall in on us, and at the same time the furnace began to cool off because of the rain and wind that swept in at me from the garden.

I struggled against these infuriating accidents for several hours, but the strain was more than even my strong constitution could bear, and I was suddenly attacked by a bout of fever – the fiercest you can possibly imagine – and was forced to throw myself on to my bed.

Very upset, forcing myself away from the work, I gave instructions to my assistants, of whom there were ten or more, including bronze-founders, craftsmen, ordinary labourers, and the men from my own workshop. Among the last was Bernardino Mannellini of Mugello, whom I had trained for a number of years; and I gave him special orders.

'Now look, my dear Bernardino,' I said, 'do exactly as I've shown you, and be very quick about it as the metal will soon be ready. You can't make any mistakes – these fine fellows will hurry up with the channels and you yourself will easily be able to drive in the two plugs with these iron hooks. Then the mould will certainly fill beautifully. As for myself, I've never felt so ill in my life. I'm sure it will make an end of me in a few hours.'

And then, very miserably, I left them and went to bed.

As soon as I was settled, I told my housemaids to bring into the

workshop enough food and drink for everyone, and I added that I myself would certainly be dead by the next day. They tried to cheer me up, insisting that my grave illness would soon pass and was only the result of excessive tiredness. Then I spent two hours fighting off the fever, which all the time increased in violence, and I kept shouting out: 'I'm dying!'

Although my housekeeper, the best in the world, an extraordinarily worthy and lovable woman called Fiore of Castel del Rio, continually scolded me for being so miserable, she tended to all my wants with tremendous devotion. But when she realized how very ill I was, and how low my spirits had fallen, for all her unflagging courage she could not keep back her tears, though even then she did her best to prevent my noticing them.

In the middle of this dreadful suffering I caught sight of someone making his way into my room. His body was all twisted, just like a capital S, and he began to moan in a voice full of gloom, like a priest consoling a prisoner about to be executed.

'Poor Benvenuto! Your work is all ruined – there's no hope left!'

On hearing the wretch talk like that I let out a howl that could have been heard echoing from the farthest planet, sprang out of bed, seized my clothes, and began to dress. My servants, my boy, and everyone else who rushed up to help me found themselves treated to kicks and blows, and I grumbled furiously at them:

'The jealous traitors! This is deliberate treachery – but I swear by God I'll get to the root of it. Before I die I'll leave such an account of myself that the whole world will be dumbfounded!'

As soon as I was dressed, I set out for the workshop in a very nasty frame of mind, and there I found the men I had left in such high spirits all standing round with an air of astonished dejection.

'Come along now,' I said, 'listen to me. As you either couldn't or wouldn't follow the instructions I left you, obey me now that I'm here with you to direct my work in person. I don't want any objections – we need work now, not advice.'

At this, a certain Alessandro Lastricati cried out:

'Look here, Benvenuto, what you want done is beyond the powers of art. It's simply impossible.'

When I heard him say that I turned on him so furiously and with such a murderous glint in my eye that he and all the others shouted out together:

'All right then, let's have your orders. We'll obey you in everything while there's still life in us.'

And I think they showed this devotion because they expected me to fall down dead at any minute.

I went at once to inspect the furnace, and I found that the metal had all curdled, had caked as they say. I ordered two of the hands to go over to Capretta, who kept a butcher's shop, for a load of young oak that had been dried out a year or more before and had been offered me by his wife, Ginevra. When they carried in the first armfuls I began to stuff them under the grate. The oak that I used, by the way, burns much more fiercely than any other kind of wood, and so alder or pinewood, which are slower burning, is generally preferred for work such as casting artillery. Then, when it was licked by those terrible flames, you should have seen how that curdled metal began to glow and sparkle!

Meanwhile I hurried on with the channels and also sent some men up to the roof to fight the fire that had begun to rage more fiercely because of the greater heat from the furnace down below. Finally I had some boards and carpets and other hangings set up to keep out the rain that was blowing in from the garden.

As soon as all that terrible confusion was straightened out, I began roaring: 'Bring it here! Take it there!' And when they saw the metal beginning to melt my whole band of assistants were so keen to help that each one of them was as good as three men put together.

Then I had someone bring me a lump of pewter, weighing about sixty pounds, which I threw inside the furnace on to the caked metal. By this means, and by piling on the fuel and stirring with pokers and iron bars, the metal soon became molten. And when I saw that despite the despair of all my ignorant assistants I had brought a corpse back to life, I was so reinvigorated that I quite forgot the fever that had put the fear of death into me.

At this point there was a sudden explosion and a tremendous flash of fire, as if a thunderbolt had been hurled in our midst. Everyone, not least myself, was struck with unexpected terror. When the glare and noise had died away, we stared at each other, and then realized that the cover of the furnace had cracked open and that the bronze was pouring out. I hastily opened the mouths of the mould and at the same time drove in the two plugs.

Then, seeing that the metal was not running as easily as it should, I realized that the alloy must have been consumed in that terrific heat. So I sent for all my pewter plates, bowls, and salvers, which numbered about two hundred, and put them one by one in front of the channels, throwing

some straight into the furnace. When they saw how beautifully the bronze was melting and the mould filling up, everyone grew excited. They all ran up smiling to help me, and fell over themselves to answer my calls, while I – now in one place, now another – issued instructions, gave a hand with the work, and cried out loud: 'O God, who by infinite power raised Yourself from the dead and ascended into heaven!' And then in an instant my mould was filled. So I knelt down and thanked God with all my heart.

Then I turned to a plate of salad that was there on some bench or other, and with a good appetite ate and drank with all my band of helpers. Afterwards I went to bed, healthy and happy, since it was two hours off dawn, and so sweetly did I sleep that it was as if I hadn't a thing wrong with me. Without a word from me that good servant of mine had prepared a fat capon, and so when I got up – near dinner time – she came to me smiling and said:

'Now then, is this the man who thought he was going to die? I believe the blows and kicks you gave us last night, with you so enraged and in such a devilish temper, made your nasty fever frightened that it would come in for a beating as well, and so it ran away.'

Then all my poor servants, no longer burdened by anxiety and toil, immediately went out to replace those pewter vessels and plates with the same number of earthenware pots, and we all dined happily. I never remember in my life having dined in better spirits or with a keener appetite.

After dinner all those who had assisted came to visit me; they rejoiced with me, thanking God for what had happened and saying that they had learnt and seen how to do things that other masters held to be impossible. I was a little boastful and inclined to show off about it, and so I preened myself a little. Then I put my hand in my purse and paid them all to their satisfaction.

My mortal enemy, that bad man Pier Francesco Riccio, the Duke's major-domo, was very diligent in trying to find out how everything had gone: those two whom I strongly suspected of being responsible for the metal's curdling told him that I obviously wasn't human but rather some powerful fiend, since I had done the impossible, and some things which even a devil would have found baffling.

They greatly exaggerated what had happened – perhaps to excuse themselves – and without delay the major-domo wrote repeating it all to the Duke who was at Pisa, making the story even more dramatic and marvellous than he had heard it.

I left the cast to cool off for two days and then, very, very slowly, I

began to uncover it. The first thing that I found was the head of Medusa, which had come out beautifully because of the air vents, just as I had said to the Duke that the nature of fire was to ascend. Then I began uncovering the rest, and came to the other head – that is the head of the *Perseus* – which had also succeeded beautifully. This came as much more of a surprise because, as can be seen, it's a good deal lower than the *Medusa*.

The mouths of the mould were placed above the head of the *Perseus*, and by the shoulders, and I found that all the bronze there was in my furnace had been used up in completing the head of the *Perseus*. It was astonishing to find that there was not the slightest trace of metal left in the channels, nor on the other hand was the statue incomplete. This was so amazing that it seemed a certain miracle, with everything controlled and arranged by God.

(Benvenuto Cellini, 1558–62)

A fundamental gastronomic formula from the American Pop artist Roy Lichtenstein.

My favourite recipe? Primordial Soup. It is the atmosphere that may have generated life on earth.

PRIMORDIAL SOUP
 8 cc hydrogen
 5 cc ammonia
 6 cc methane
 10 cc water vapour
 dash of nitrogen
 heaping tablespoon carbon monoxide

Mix well in blender. Faulty connections should supply electrical sparks. Ultraviolet light should help. Wait for complex molecules to develop. Pour mixture into two-quart enamel saucepan and simmer over low heat. Soon, in geological time, amino acids will synthesize, become protein, and begin self-replications. When two quarts have developed, remove from heat.

Note: Garnish with parsley. Serve with lemon slices on the side.

(Roy Lichtenstein, in *The Artists' Cookbook*, 1977)

Jackson Pollock describes his method of creating the classic drip paintings.

My painting does not come from the easel. I hardly ever stretch my canvas before painting. I prefer to tack the unstretched canvas to the hard wall or the floor. I need the resistance of a hard surface. On the floor I am more at ease. I feel nearer, more a part of the painting, since this way I can walk around it, work from the four sides and literally be *in* the painting. This is akin to the method of the Indian sand-painters of the West.

I continue to get further away from the usual painter's tools such as easel, palette, brushes, etc. I prefer sticks, trowels, knives and dripping fluid paint or a heavy impasto with sand, broken glass and other foreign matter added.

When I am *in* my painting, I am not aware of what I'm doing. It is only after a sort of 'get acquainted' period that I see what I have been about. I have no fears about making changes, destroying the image, etc., because the painting has a life of its own. I try to let it come through. It is only when I lose contact with the painting that the result is a mess. Otherwise there is pure harmony, an easy give and take, and the painting comes out well.

(Jackson Pollock, 1948)

A tip for sculptors from Bernini.

Speaking of sculpture and of the difficulty of achieving success, especially in obtaining a resemblance in marble portraits, he [Bernini] told me one remarkable thing, and this he has since repeated on all occasions: that if someone whitened his hair, beard, eyebrows, and, if it were possible, the pupils of his eyes and his lips, and in that state showed himself to those who are wont to see him every day, they would scarcely recognize him. In order to prove this he added: when a person faints, the pallor alone which spreads over his face makes him almost unrecognizable, and it is often said 'He no longer seems himself.' It is equally difficult to achieve a likeness in a marble portrait, which is all of one colour. He said another thing even more extraordinary: sometimes in order to imitate the model well it is necessary to introduce in a marble portrait something that is not found in the model. This seems to be a paradox, but he explained it thus: in order to represent the darkness that some people have around the eye, it is necessary to deepen the marble in the place where it is dark in order to represent the effect of that colour and thus make up by skill, so to

speak, the imperfection of the art of sculpture, which is unable to give colour to objects. However, he said, the model is not the same as the imitation. Afterwards, he added a rule which, according to him, should be followed in sculpture, but of which I am not as convinced as of the preceding ones. He said: a sculptor creates a figure with one hand held high and the other hand placed on the chest. Practice teaches that the hand in the air must be larger and fuller than the one resting on the chest. This is because the air surrounding the first alters and consumes something of the form or, to express it better, something of the quantity of the form.

(Paul de Fréart, Sieur de Chantelou, 6 June 1665)

One eminent Victorian painter, Lord Leighton, gives another, Edward Burne-Jones, a word of friendly advice.

Leighton was friendly and happy about *The Depths of the Sea* when he saw it finished; and a trace of his visit remains in the shoal of little fishes that Edward afterwards painted swimming round a pillar of the mermaid's cave. Leighton's note, written on thinking over their talk in the studio, follows:

'Dear Ned, when you shewed me your delightful picture the other day you said you had intended to put fishes along the upper edge of the water, but that you had altered your mind, and you added "Wasn't I right?" I, not liking, out of shyness, to say "No," said "Yes" – wherein I spake a foolish thing – after my too frequent habit! On the contrary I like the idea of the fish up there *hugely* – they would emphasize the fanciful character which is the charm of the picture, and would bring home to the vulgar eye (a dull orb and a multitudinous) the *underwateriness* which you have indicated by those delightful green swirls in the background. *Liberavi animam meam* – put them in, Ned, they will be lovely.'

(Georgina Burne-Jones, 1904)

Artists offer various views on that most vexed of questions, how to finish a picture, something which, as can be seen from the extract from Pliny the Elder (translated in the seventeenth century), has been a problem since the days of the ancient Greeks.

But what should I speake of these painters, whenas *Apelles* surmounted all that either were before, or came after. This *Apelles* flourished about

the 112 Olympias, by which time hee became so consummate and accomplished in the art, that hee alone did illustrate and inrich it as much, if not more, than all his predecessors besides: who compiled also divers bookes, wherein the rules and principles, yea and the very secrets of the art are comprised. The speciall gift that he had was this, that he was able to give his pictures a certain lovely grace inimitable: and yet there were in his time most famous and worthy painters, whom he admired, whose works when hee beheld hee would praise them all, howbeit not without a but: for his ordinarie phrase was this, Here is an excellent picture, but that it wants one thing, and that is the *Venus* it should have; which *Venus* the Greeks call *Charis*, as one would say, the grace: and in truth he would confesse, that other mens pictures had all things els that they should have, this onely excepted; wherein hee was persuaded that he had not his peere or second.

Moreover, he attributed unto himselfe another propertie, wherein hee gloried not a little, and that was that hee could see to make an end when a thing was well done. For beholding wistly upon a time a piece of worke of *Protogenes* his doing, wherein he saw there was infinite pains taken, admiring also the exceeding curiositie of the man in each point beyond all measure, he confessed and said, That *Protogenes* in everie thing else had done as well as himselfe could have done, yea and better too. But in one thing he surpassed *Protogenes*, for that he could not skill of laying worke out of his hand when it was finished well enough. A memorable admonition, teaching us all, That double diligence and overmuch curiositie doth hurt otherwhiles. This painter was not more renowned for his skill and excellencie in art, than he was commended for his simplicitie and singleness of heart: for as he gave place to *Melanthius* in disposition, so hee yeelded to *Asclepiodorus* in measures and proportion, that is to say, in the just knowledge how far distant one thing ought to be from another.

(Pliny the Elder, first century AD, translated by Philemon Holland, 1601)

The New York Abstract Expressionists consider the same conundrum of how to finish a painting, with Robert Motherwell in the chair, Hans Hofmann, Barnett Newman, Adolph Gottlieb, Willem de Kooning, Ad Reinhardt and William Baziotes on the panel.

HOFMANN: A very great Chinese painter once said the most difficult thing in a work of art is to know the moment when to stop.

MODERATOR MOTHERWELL: The question then is, 'How do you know when a work is finished?'

BAZIOTES: I consider my painting finished when my eye goes to a particular spot on the canvas. But if I put the picture away about thirty feet on the wall and the movements keep returning to me and the eye seems to be responding to something living, then it is finished.

GOTTLIEB: I usually ask my wife ... I think a more interesting question would be, 'Why does anyone start a painting instead of finishing it?'

NEWMAN: I think the idea of a 'finished' picture is a fiction. I think a man spends his whole lifetime painting one picture or working on one piece of sculpture. The question of stopping is really a decision of moral considerations. To what extent are you intoxicated by the actual act, so that you are beguiled by it? To what extent are you charmed by its inner life? And to what extent do you then really approach the intention or desire that is really outside of it? The decision is always made when the piece has something in it that you wanted.

DE KOONING: I refrain from 'finishing' it. I paint myself out of the picture, and when I have done that, I either throw it away or keep it. I am always in the picture somewhere. The amount of space I use I am always in, I seem to move around in it, and there seems to be a time when I lose sight of what I wanted to do, and then I am out of it. If the picture has a countenance, I keep it. If it hasn't, I throw it away. I am not really very much interested in the question.

REINHARDT: It has always been a problem for me – about 'finishing' paintings. I am very conscious of ways of 'finishing' a painting. Among modern artists there is a value placed upon 'unfinished' work. Disturbances arise when you have to treat the work as a finished and complex object, so that the only time I think I 'finish' a painting is when I have a deadline. If you are going to present it as an 'unfinished' object, how do you 'finish' it?

HOFMANN: To me a work is finished when all parts involved communicate themselves, so that they don't need me.

MODERATOR MOTHERWELL: I dislike a picture that is too suave or too skilfully done. But, contrariwise, I also dislike a picture that looks too inept or blundering. I noticed in looking at the Carré exhibition of young French painters who are supposed to be close to this group, that in 'finishing' a picture they assume traditional criteria to a much greater degree than we do. They have a real 'finish' in that the picture is a real

object, a beautifully made object. We are involved in 'process' and what is a 'finished' object is not so certain.

(Quoted in Robert Motherwell and Ad Reinhardt, 1951)

As does Jackson Pollock:

Mr and Mrs Frank Seixas, East Hampton acquaintances, brought another couple to Pollock's studio to see his work. When he described his method to them, the wife asked, 'But, Mr Pollock, how do you know when you're finished?' He replied, 'How do you know when you're finished making love?'

(B. H. Friedman, 1973)

Picasso, and others:

Nine times out of ten, when a painter says to you: 'No, that canvas isn't quite finished . . . there's a little something missing . . . I'll have to finish it off . . .' nine times out of ten you can be sure that in order to finish it off . . . well, he'll finish it off. You know, the way they finish off people executed by a firing squad. With a revolver shot in the head.

(Pablo Picasso, quoted in Hélène Parmelin, 1966)

When I've painted a woman's bottom so that I want to touch it, then [the painting] is finished.

(Pierre Auguste Renoir, 1841–1919, to his son Jean)

When my head, heart and big toe tell me.

(Terry Frost, on being asked how he knew when he had finished a painting, interview on *Desert Island Discs*, 1998)

The painter Keith Vaughan records the view of another British painter, Graham Sutherland, that it is best not to finish a picture quite, but to leave it with an enlivening flaw.

18 APRIL 1944 I want to set down all I can remember of what Graham Sutherland said last Sunday about painting. We were discussing the question of perfection in art. It started by S. telling us of someone who had bought a painting of his asking him some time afterwards whether he could do anything about a small area in the right-hand bottom corner which somehow the client found unsatisfactory. S. was much impressed by this and agreed to take the painting back and do what he could because he knew himself that this was the one point in the picture which was not quite resolved. That led on to the suggestion as a general principle that in all great paintings there was always one such point, a flaw if you like, which had not been completely resolved, and which was in fact essential to the strength and beauty of the whole work. The flaw could not be repaired without the whole painting being damaged. It was as if a painting were trying to approach a complete equilibrium but could never quite reach it; if it did it would disintegrate, the tension would snap. Whether or not a person was sensitive to this particular quality could be tested by asking him which he preferred: Bellini's *Agony in the Garden,* or Mantegna's. The Mantegna is obviously the more perfect. The articulation of the whole picture space is flawless; the transition from body to limb from limb to hand and hand to fingers is effortless and consummate. Bellini's is altogether different. There is a tremendous sense of strain in bringing the objects into relationship. A feeling of anxiety that it may at any moment not quite succeed, and the whole picture fail. This feeling permeates the whole picture, it gives a vibrant tension to every relationship. The Bellini is the greater picture. The Mantegna is the more perfect.

He mentioned Seurat's *Bathers* as another example of a painting which was very nearly perfect, but was made into a great painting by the one or two places where it didn't quite come off. It is the recognition of these places that gives a scale for measuring the greatness of the achievement in the rest of the picture. He said in some of Picasso's paintings one never seems to come to the end. One resolves form after form but still further forms are disclosed which need resolving. He would not like to have one of these pictures on his wall, he said.

I asked him if he thought it was still possible to paint the great myths; Prometheus, for instance, or a Crucifixion or an Agony in the Garden. I

said I didn't see they had become any less valid for certain individuals merely because they had ceased to be generally accepted. He said there was no real reason why they should not be painted if one could feel strongly enough about them. The question of understanding the subject and not simply illustrating it was so important. It is essential that one can believe in the reality of the subject. For example, it is possible to paint a picture of a man being attacked by a dog because such a situation, though not necessarily experienced, is sufficiently near to experience for the imagination to be able to handle it truthfully. Whereas a man being attacked by a lion is incomprehensible to anyone who has not been so attacked, and so is not a legitimate subject for most painters. As for a Crucifixion he did not know whether there was anyone who could handle it. 'It is an embarrassing situation,' he said, 'to say the least of it, to contemplate a man nailed to a piece of wood in the presence of his friends.'

(Keith Vaughan, 18 April 1944)

Damien Hirst gives the low down on how to make a pickled-cow piece in several sections.

A guy from a knackers yard in Guildford cuts the cows. He cuts all the hard bone areas first, like the head, the sternum and the pelvis. Then he ties it back together, freezes it solid over two days and chainsaws the rest of it. Then he delivers it to us at the studio where the dirty work starts: we have to inject it constantly for around a week (before it decays) in a swimming-pool-sized tank of formaldehyde, wearing dry suits and masks. We have to take all the shit out of its stomachs. The liquid has turned brown and we are up to our knees in it.

(Damien Hirst, 1997)

The Japanese master Hokusai implies that what is needed to succeed in art is a long life. On the occasion of this statement, he was seventy-five years old, and had just made the fifth and last name-change of his career, from 'Iitsu, Formerly Hokusai', to 'Manji, Old Man Mad About Painting'. Under his new signature he set down the following declaration:

From the age of six I had a penchant for copying the form of things, and from about fifty, my pictures were frequently published; but until the age

of seventy, nothing that I drew was worthy of notice. At seventy-three years, I was somewhat able to fathom the growth of plants and trees, and the structure of birds, animals, insects, and fish. Thus when I reach eighty years, I hope to have made increasing progress, and at ninety to see further into the underlying principles of things, so that at one hundred years I will have achieved a divine state in my art, and at one hundred and ten, every dot and every stroke will be as though alive. Those of you who live long enough, bear witness that these words of mine prove not false.

As it turned out, he did not quite get his wish, for he died at the age of eighty-nine.

In the end, Hokusai's countdown to one hundred fell just ten years short of the mark. On his deathbed in the Fourth Month of 1849, Iijima Kyoshin reported, 'he gave a great sigh and said, "If only I could have just another ten years." Some time passed, and he spoke again "just another five years – then I could become a real artist."' Whether true or not, the anecdote is perfectly in character.

(Katsushika Hokusai, *c.*1835 and 1849, the latter recounted by Henry Smith, 1988)

Significant

Form:

Shape,

Weight,

Mass

and

Volume

in

Art

In one of Joyce Cary's novels, Abel, a sculptor, is hard at work on a war memorial when the painter Gulley Jimson pays a call.

There was the usual mess. Dust, chips, half a bottle of stout on her ladyship's Bechstein. The model's clothes hanging on the crystal wall light and the model herself, a thick little blonde girl called Lolie, walking up and down and slapping herself with both hands to get back her circulation. Lolie has long hair and it was hanging down to her buttocks. Which was more than three-quarters of the woman, as she has the shortest legs in London.

'Isn't it good, Mr Jimson?' said Lolie. 'You tell him it's good.'

Abel paid no attention to her. He said to me, 'Look at that, Jimson. You see it was really a double block. A small one set into a big one at the corner. That was the character of the mass. Two levels on top – then the verticals of the small cube. Then the big block with the oblique left side . . .'

'Well,' I said. 'You've got that side all right.'

'I haven't touched that side,' he said, passing his hand over it as if stroking a horse. 'And I don't want to – it's a beauty. But come round here.'

He'd cut the little block into a woman's head and breasts and forearms. Forearms and breast on one horizontal plane. Head tilted sideways to get the cheek flat, and the hair flat down her back for the side of the stone. It was not bad for a young chap of thirty-four or so. 'That's not too bad,' I said. 'It's chunky.'

'Yes,' he said, 'but has it got the weight,' cupping his big hands like a pair of soup tureens. 'Can you feel her weight?'

'Heavier than the stone,' I said. 'Why, she looks about sixteen tons by herself – she's nearly as thick as Lolie.'

Lolie scratched herself with both hands at once, and said in a cross voice, 'It's coming on very nicely, and a nice subject, too. Earth mourning for her sons. But he never will listen to anything I say.'

'It's a bloody subject, of course,' said Abel. 'But I haven't bothered

with the name. It was the town council planted that on me. One of them was educated. But we needn't worry about that.'

'It's time for tea,' said Lolie.

'Just turn round a bit, darling,' said Abel, 'yes, that's it.' And he turned her round by her shoulders. 'Look at that back. There's something there.' And he passed the back of his great knuckly ham down her spine. 'If you forget it's meat.'

'Tell him he couldn't do it nicer, Mr Jimson,' said Lolie. 'He's only cross with it because he hasn't had his tea. That's what he wants. You tell him.'

'Look at what I've done with it – slop, just slop. Lost all the monumental. And that corner, oh my God . . .'

'Well,' I said, 'what did you mean – knocking that hole in the left side? What's it doing, that hole? What's it for?'

'Don't ask me,' he said, throwing his hammer on the floor and making a bit of the parquet jump right out of its socket. 'I thought I saw one of the dead there, sitting up with his head on his shoulder. I could feel him this morning, and this edge of the block is the line of his jaw and neck.'

'Well,' I said, 'I don't see why that shouldn't come out all right. You've got him square enough too. You could cut your fingers on his chin.'

'Yes, but what about the corner?' I saw a lying figure at the bottom, with a flat back giving the side plane. 'Excuse me, darling.' He took Lolie by the shoulders, pushed her to her knees and pressed her head down on her shoulder.

'Oh dear,' said Lolie, 'he'll only spoil it. And it was so nice. Oh dear, if only he'd had his tea at the proper time. But what's the good of talking?'

'You see,' said Abel, combing down Lolie's hair with a chisel. 'If you forget the flesh, the planes come right out,' and he moved his great flat paddles in the air as if rubbing them on a surface. 'Solid as rocks. And so I cut into the block above it, cut out the whole corner. But it went soft. And it goes on getting softer. However sharp you make the edges. And now I can't even see the next vertical. Got to be a vertical there. That's the whole character of the block. Must have another cube. For the blockiness. But Christ, look at it now – it's gone soft – it's rotten. You could put your bloody fingers through it like bad butter.' And he gave the stone a prod as if he really expected his finger to go through it.

'What I keep on saying,' said Lolie, 'some ammunition boxes. It's on the battlefield, isn't it? Earth surrounded by her dead. And you can't get

anything squarer than ammunition boxes. But you better tell him, Mr Jimson – he won't listen to me. Not since I married him.'

'Why, darling,' said Abel, 'I have the highest regard for your taste. Just bend over a little further. That's it,' and he said to me, 'I thought I might do something with Lolie's head, by flattening it off a bit.'

(Joyce Cary, 1944)

The young Henry Moore would have understood what Abel was talking about.

The removal of the Greek spectacles from the eyes of the modern sculptor (along with the direction given by the work of such painters as Cézanne and Seurat) has helped him to realize again the intrinsic emotional significance of shapes instead of seeing mainly a representation value, and freed him to recognize again the importance of the material in which he works, to think and create in his material by carving direct, understanding and being in sympathy with his material so that he does not force it beyond its natural constructive build, producing weakness; to know that sculpture in stone should look honestly like stone, that to make it look like flesh and blood, hair and dimples is coming down to the level of the stage conjuror . . .

The sculpture which moves me most is full blooded and self-supporting, fully in the round, that is, its component forms are completely realized and work as masses in opposition, not being merely indicated by surface cutting in relief; it is not perfectly symmetrical, it is static and it is strong and vital, giving out something of the energy and power of great mountains. It has a life of its own, independent of the object it represents.

(Henry Moore, May 1930)

Henri Gaudier-Brzeska, a fierce young Modernist of the Vorticist persuasion, saw in sculptural form the essence of each epoch in the history of man.

Gaudier-Brzeska Vortex

Sculptural energy is the mountain.

Sculptural feeling is the appreciation of masses in relation.

Sculptural ability is the defining of these masses by planes.

The PALEOLITHIC VORTEX resulted in the decoration of the Dordogne caverns.

Early Stone-Age man disputed the earth with animals.

His livelihood depended on the hazards of the hunt – his greatest victory the domestication of a few species.

Out of the minds primordially preoccupied with animals Fonts-de-Gaume gained its procession of horses carved in the rock. The driving power was life in the absolute – the plastic expression the fruitful sphere.

The sphere is thrown through space, it is the soul and object of the vortex –

The intensity of existence had revealed to man a truth of form – his manhood was strained to the highest potential – his energy brutal – HIS OPULENT MATURITY WAS CONVEX.

The acute fight subsided at the birth of the three primary civilizations. It always retained more intensity East.

The HAMITE VORTEX of Egypt, the land of plenty –

Man succeeded in his far-reaching speculations – Honour to the divinity!

Religion pushed him to the use of the VERTICAL which inspires awe. His gods were self-made, he built them in his image, and RETAINED AS MUCH OF THE SPHERE AS COULD ROUND THE SHARPNESS OF THE PARALLELOGRAM.

He preferred the pyramid to the mastaba [ancient Egyptian tomb].

The fair Greek felt this influence across the middle sea.

The fair Greek saw himself only. HE petrified his own semblance.

HIS SCULPTURE WAS DERIVATIVE his feeling for form secondary. The absence of direct energy lasted for a thousand years . . .

Besides these highly developed peoples there lived on the world other races inhabiting Africa and the Ocean islands.

When we first knew them they were very near the paleolithic stage. Though they were not so much dependent upon animals their expenditure of energy was wide, for they began to till the land and practice crafts rationally, and they fell into contemplation before their sex: the site of their great energy: THEIR CONVEX MATURITY.

They pulled the sphere lengthways and made the cylinder, this is the VORTEX OF FECUNDITY, and it has left us the masterpieces that are known as love charms.

The soil was hard, material difficult to win from nature, storms frequent, as also fevers and other epidemics. They got frightened: This is the

VORTEX OF FEAR, its mass is the POINTED CONE, its master-pieces the fetishes.

And WE the moderns: Epstein, Brancusi, Archipenko, Dunikowski, Modigliani, and myself, through the incessant struggle in the complex city, have likewise to spend much energy.

The knowledge of our civilization embraces the world, we have mastered the elements.

We have been influenced by what we liked most, each according to his own individuality, we have crystallized the sphere into the cube, we have made a combination of all the possible shaped masses – concentrating them to express our abstract thoughts of conscious superiority.

Will and consciousness are our

<div align="center">

VORTEX

</div>

(Henri Gaudier-Brzeska, 20 June 1914)

A great abstract painter, Wassily Kandinsky, speaks eloquently of the power of simple, geometric forms.

An empty canvas, apparently really empty, that says nothing and is without significance. Almost dull, in fact. In reality, however, crammed with thousands of undertone tensions and full of expectancy. Slightly apprehen-sive lest it should be outraged. Yet docile enough. Ready to do what is required of it, and only asking for consideration. It can contain anything but cannot sustain everything. Though it emphasizes what is true, it does the same to what is false. It riddles the visage of falsity pitilessly, and raises her voice to a scream too shrill to be endured.

An empty canvas is a living wonder – far lovelier than certain pictures.

What are its basic elements? Straight lines, a straight, narrow surface, hard, inflexible, maintained without regard to anything but itself and apparently going on its own gait like a destiny that has already been fulfilled. Thus and not otherwise. Stretched, free, tense, evading and yielding, elastic, and indeterminate in semblance like the fate which awaits us. It could become something different, but abstains from doing so. Hardness and softness at once, and combinations of both that are infinite in their possibilities.

Every line says 'Here I am!' Each holds its own, reveals its own eloquent features, and whispers 'Listen, listen to my secret!'

A line is a living wonder.

A dot. Lots of little dots which are just a little smaller here and just a

little larger there. All of them have their place within its compass, and yet retain their mobility – a host of little tensions ceaselessly repeating their chorus of 'Listen! Listen!' They are little messages which by echoing each other in unison help to build up the one great central affirmation, 'Yes'.

A black circle – distant thunder, a world apart which seems to care for nothing and retires within itself, a conclusion on the spot. A 'Here I am!' pronounced slowly, rather coldly.

A red circle – it stands fast, holds its ground, is immersed in itself. Yet it also moves because it covets each other place as well as its own. Its radiance overcomes every obstacle and penetrates into the remotest corners. Thunder and lightning together. A passionate 'Here I am!'

A circle is a living wonder.

But the most wonderful thing of all is this: to combine all these voices with still others, lots and lots of them (for besides the simple basic forms and colours already mentioned, there are plenty more really), in one picture – a picture which thus becomes a simple and integral 'HERE I AM!'

(Wassily Kandinsky, 1937)

Art is when things appear rounded.

(Maurice Denis, 'Definition of Neotradition', 1890)

Roger Fry lauds the sculpture of Africa.

What a comfortable mental furniture the generalizations of a century ago must have afforded! What a right little, tight little, round little world it was when Greece was the only source of culture, when Greek art, even in Roman copies, was the only indisputable art, except for some Renaissance repetitions! Philosophy, the love of truth, liberty, architecture, poetry, drama, and for all we know music – all these were the fruits of a special kind of life, each assisted the development of the other, each was really dependent on all the rest. Consequently if we could only learn the Greek lessons of political freedom and intellectual self-consciousness all the rest would be added unto us.

And now, in the last sixty years, knowledge and perception have poured upon us so fast that the whole well-ordered system has been blown away, and we stand bare to the blast, scarcely able to snatch a hasty generalization or two to cover our nakedness for a moment.

Our desperate plight comes home to one at the Chelsea Book Club, where are some thirty chosen specimens of negro sculpture. If to our ancestors the poor Indian had 'an untutored mind', the Congolese's ignorance and savagery must have seemed too abject for discussion. One would like to know what Dr Johnson would have said to any one who had offered him a negro idol for several hundred pounds. It would have seemed then sheer lunacy to listen to what a negro savage had to tell us of his emotions about the human form. And now one has to go all the way to Chelsea in a chastened spirit and prostrate oneself before his 'stocks and stones'.

We have the habit of thinking that the power to create expressive plastic form is one of the greatest of human achievements, and the names of great sculptors are handed down from generation to generation, so that it seems unfair to be forced to admit that certain nameless savages have possessed this power not only in a higher degree than we at this moment, but than we as a nation have ever possessed it. And yet that is where I find myself. I have to admit that some of these things are great sculpture – greater, I think, than anything we produced even in the Middle Ages. Certainly they have the special qualities of sculpture in a higher degree. They have indeed complete plastic freedom; that is to say, these African artists really conceive form in three dimensions. Now this is rare in sculpture. All archaic European sculpture – Greek and Romanesque, for instance – approaches plasticity from the point of view of bas-relief. The statue bears traces of having been conceived as the combination of front, back, and side bas-reliefs. And this continues to make itself felt almost until the final development of the tradition. Complete plastic freedom with us seems only to come at the end of a long period, when the art has attained a high degree of representational skill and when it is generally already decadent from the point of view of imaginative significance.

Now, the strange thing about these African sculptures is that they bear, as far as I can see, no trace of this process. Without ever attaining anything like representational accuracy they have complete freedom. The sculptors seem to have no difficulty in getting away from the two-dimensional plane. The neck and the torso are conceived as cylinders, not as masses with a square section. The head is conceived as a pear-shaped mass. It is conceived as a single whole, not arrived at by approach from the mask, as with almost all primitive European art. The mask itself is conceived as a concave plane cut out of this otherwise perfectly unified mass.

And here we come upon another curious difference between negro

sculpture and our own, namely, that the emphasis is utterly different. Our emphasis has always been affected by our preferences for certain forms which appeared to us to mark the nobility of man. Thus we shrink from giving the head its full development; we like to lengthen the legs and generally to force the form into a particular type. These preferences seem to be dictated not by a plastic bias, but by our reading of the physical symbols of certain inner qualities which we admire in our kind, such, for instance, as agility, a commanding presence, or a pensive brow. The negro, it seems, either has no such preferences, or his preferences happen to coincide more nearly with what his feeling for pure plastic design would dictate. For instance, the length, thinness, and isolation of our limbs render them extremely refractory to fine plastic treatment, and the negro scores heavily by his willingness to reduce the limbs to a succession of ovoid masses sometimes scarcely longer than they are broad. Generally speaking, one may say that his plastic sense leads him to give its utmost amplitude and relief to all the protuberant parts of the body, and to get thereby an extraordinarily emphatic and impressive sequence of planes. So far from clinging to two dimensions, as we tend to do, he actually underlines, as it were, the three-dimensionalness of his forms. It is in some such way, I suspect, that he manages to give to his forms their disconcerting vitality, the suggestion that they make of being not mere echoes of actual figures, but of possessing an inner life of their own. If the negro artist wanted to make people believe in the potency of his idols he certainly set about it in the right way.

Besides the logical comprehension of plastic form which the negro shows, he has also an exquisite taste in his handling of material. No doubt in this matter his endless leisure has something to do with the marvellous finish of these works. An instance of this is seen in the treatment of the tattoo cicatrices. These are always rendered in relief, which means that the artist has cut away the whole surface around them. I fancy most sculptors would have found some less laborious method of interpreting these markings. But this patient elaboration of the surface is characteristic of most of these works. It is seen to perfection in a wooden cup covered all over with a design of faces and objects that look like clubs in very low relief. The *galbe* of this cup shows a subtlety and refinement of taste comparable to that of the finest Oriental craftsmen.

It is curious that a people who produced such great artists did not produce also a culture in our sense of the word. This shows that two factors are necessary to produce the cultures which distinguish civilized

peoples. There must be, of course, the creative artist, but there must also be the power of conscious critical appreciation and comparison. If we imagined such an apparatus of critical appreciation as the Chinese have possessed from the earliest times applied to this negro art, we should have no difficulty in recognizing its singular beauty. We should never have been tempted to regard it as savage or unrefined. It is for want of a conscious critical sense and the intellectual powers of comparison and classification that the negro has failed to create one of the great cultures of the world, and not from any lack of the creative aesthetic impulse, nor from lack of the most exquisite sensibility and the finest taste. No doubt, also, the lack of such a critical standard to support him leaves the artist much more at the mercy of any outside influence. It is likely enough that the negro artist, although capable of such profound imaginative understanding of form, would accept our cheapest illusionist art with humble enthusiasm.

(Roger Fry, 1920)

Quentin Bell, son of Vanessa Bell, and second-generation Bloomsbury, remembers Fry's preoccupation with mass and form.

It is said that when Roger Fry was giving a lecture on handwriting he came, after showing examples of Renaissance and medieval scripts, to a slide on which he had reproduced a page from a letter written to him by Virginia Woolf. While discussing the problems raised by that lively, elegant, idiosyncratic hand Fry, for once in a way, lost touch with his audience, for the example of handwriting that he had chosen provided a spirited, highly scandalous and perhaps mendacious story involving several people who were present in the lecture room. With characteristic innocence he had completely forgotten that handwriting might be considered rather for the message that it conveys than for the forms it assumes; he had chosen the letter at random and prepared the slide without ever actually reading the words formed by those interesting characters.

'Se non è vero è ben trovato'; the story certainly gives a notion of Fry's careless indifference to anything save the matter in hand, his inability to conceive that other people could treat an aesthetic question with anything less than his own fine seriousness. It is less true if it be taken as an example of his attitude to art as a whole. Certainly in the period between 1910 and say, 1925, Fry was deeply and almost exclusively concerned with plastic

values; I have heard him describe the agonized body of Christ upon the cross as 'this important mass'.

(Quentin Bell, 1989)

David Sylvester explains why two large lumps of steel placed in the Tate Gallery by the sculptor Richard Serra give him an exhilarating sense of mass and space.

The solid steel blocks have not come from the forge as regular, perfectly geometric cuboids. As the surfaces differ from those of minimal sculpture in being, through the workings of industrial processes, variegated and random, the forms are palpably imperfect: the top plane of the nearer cuboid has a definite slope; everywhere edges that look as if they might have been sharp and hard – as they are when Serra is working, as he mostly has, with steel plates – are here blunt and soft. Though these irregularities have again come about in the course of the manufacturing process, not through gestures of the artist's hand, the effect is analogous to that of Mondrian's brushmarks, palpable brushmarks which break up surfaces that would otherwise have been immaculate and predictable, giving them relief and animation. As those brushstrokes are an echo of the free painterly handling in Mondrian's early romantic landscapes, the roughness of Serra's blocks relates to his early sculptures made by splashing molten lead on to a wall and floor. Obviously, Serra's untidiness is still more akin to the cultivated imperfections in Newman's straight lines.

Perhaps the first impression on coming into the south gallery is one of surprise at the daring of the work's absolute austerity. Perhaps the next, on approaching the first block, is that there's a deep solemnity about it which counters any feeling of surprise by conferring a sense of inevitability on the work. At the same time, the initial illusion that the blocks are the same height, followed by doubts on getting nearer as to whether this is so, engage the mind in the question of height, so that, when you get to the first block, you find – if you're between, say, five foot five and six foot tall – that its height is a tease. You can more or less see over it – certainly you can see the top plane, especially as the slope rises away from you – but you are still slightly bemused as to how its height relates to your own: it's a bit like dancing with an unfamiliar partner who isn't ridiculously taller or shorter than yourself. (I imagine that the short and the tall cannot respond to this work as others do: this applies to a lot of minimal art, the impact of which is so often bound up with its height in

relation to ours.) As you leave that block behind and approach the other, there is a point at which you realize that this one is going to be higher. When you reach it you find – unless you are inordinately tall – that its top is above the level of your line of sight. Nothing teasing here; it is so decidedly something high that it might as well be as high as a house. This makes it more menacing than the first block. So does the fact that its edges look relatively sharp where those of the other are softened for the eye (as my colleague Marla Prather pointed out) by the way light falls on that visible top plane.

Everything about *Weight and Measure* – how the blocks relate to each other, how they relate to the space, how they relate to yourself – is a function of that difference between a barrier that is like a garden fence across which you can chat with a neighbour and a barrier that might as well be Gordale Scar. The blocks are utterly different entities though they are identical in their dimensions but for a difference of 13 per cent in their height. I am reminded of something said to me by Giacometti about the way in which the crucial differences in how art operates are physically very small: 'It's always extremely limited. Like the fact that you can only survive with a temperature of – what – between 36 and 39 degrees – and that's already very very bad. So you can only really live with a temperature between 36.8 and 37.8. And everything's like that.'

Contemplation of the blocks triggers a variety of visceral responses. Their massive sense of solidity weighs me down, making me feel that my own body is very firmly planted on the ground. The energy emanating from them transfers itself to my body, so that it feels lifted by that energy. The taller block gives off an energy which has more intensity and speed than the other's: as I stand looking at it from its far side, my body is assailed not only by the force emanating directly from it but by waves of force which seem to have bounced back from the surrounding walls so that they bombard me, like hailstones, from all sides and above. Turning away from the block and looking towards the end of the gallery, I'm amazed to find that that academic, bombastic architecture suddenly looks beautiful: the sculpture has diminished its theatricality, and in looking more sober it also looks finely proportioned. Turning around and walking back to the smaller block, I invariably find on getting there that it's a soothing, calming presence. It is (as Serota said to me) like coming home. It seems to be hospitable, like a tomb in which I can imagine myself at rest. The measurements which in reality would be relevant in a practical sense to its becoming that are no different from what they are in the other

block, which – here again the relative height is everything – seemed forbiddingly impenetrable.

(David Sylvester, 'Serra', 1992, in his *About Modern Art*, 1996)

The art historian Bernard Berenson sees the essence of art as being its ability to evoke feelings of weight and mass. That, he suggests, is what made Masaccio and Giotto great.

In sculpture Donatello had already given body to the new ideals when Masaccio began his brief career, and in the education, the awakening, of the younger artist the example of the elder must have been of incalculable force. But a type gains vastly in significance by being presented in some action along with other individuals of the same type; and here Donatello was apt, rather than to draw his meed of profit, to incur loss by descending to the obvious – witness his bas-reliefs at Siena, Florence, and Padua. Masaccio was untouched by this taint. Types, in themselves of the manliest, he presents with a sense of the materially significant which makes us realize to the utmost their power and dignity; and the spiritual significance thus gained he uses to give the highest import to the event he is portraying; this import, in turn, gives a higher value to the types, and thus, whether we devote our attention to his types or to his action, Masaccio keeps us on a high plane of reality and significance. In later painting we shall easily find greater science, greater craft, and greater perfection of detail, but greater reality, greater significance, I venture to say, never. Dust-bitten and ruined though his Brancacci Chapel frescoes now are, I never see them without the strongest stimulation of my tactile consciousness. I feel that I could touch every figure, that it would yield a definite resistance to my touch, that I should have to expend thus much effort to displace it, that I could walk around it. In short, I scarcely could realize it more, and in real life I should scarcely realize it so well, the attention of each of us being too apt to concentrate itself upon some dynamic quality, before we have at all begun to realize the full material significance of the person before us. Then what strength to his young men, and what gravity and power to his old! How quickly a race like this would possess itself of the earth, and brook no rivals but the forces of nature! Whatever they do – simply because it is they – is impressive and important, and every movement, every gesture, is world-changing. Compared with his figures, those in the same chapel by his precursor, Masolino, are childish, and those by

his follower, Filippino, unconvincing and without significance, because without tactile values. Even Michelangelo, where he comes in rivalry, has, for both reality and significance, to take a second place. Compare his *Expulsion from Paradise* (in the Sistine Chapel) with the one here by Masaccio. Michelangelo's figures are more correct, but far less tangible and less powerful; and while he represents nothing but a man warding off a blow dealt by a sword, and a woman cringing with ignoble fear, Masaccio's Adam and Eve stride away from Eden heartbroken with shame and grief, hearing, perhaps, but not seeing, the angel hovering high overhead who directs their exiled footsteps.

Masaccio, then, like Giotto a century earlier – himself the Giotto of an artistically more propitious world – was, as an artist, a greater master of the significant, and, as a painter, endowed to the highest degree with a sense of tactile values, and with a skill in rendering them. In a career of but few years he gave to Florentine painting the direction it pursued to the end. In many ways he reminds us of the young Bellini. Who knows? Had he but lived as long, he might have laid the foundation for a painting not less delightful and far more profound than that of Venice. As it was, his frescoes at once became, and for as long as there were real artists among them remained, the training school of Florentine painters.

(Bernard Berenson, 1896–7)

It isn't enough to make people see the object you paint. You must also make them touch it.

(Georges Braque, in *Notebooks 1917–1947*)

Ruskin displays a surprising sensitivity to the abstract aspects of art.

We are to remember, in the first place, that the arrangement of colours and lines is an art analogous to the composition of music, and entirely independent of the representation of facts. Good colouring does not necessarily convey the image of anything but itself. It consists in certain proportions and arrangements of rays of light, but not in likenesses to anything. A few touches of certain greys and purples laid by a master's hand on white paper will be good colouring; as more touches are added beside them, we may find out that they were intended to represent a dove's neck, and we may praise, as the drawing advances, the perfect

imitation of the dove's neck. But the good colouring does not consist in that imitation, but in the abstract qualities and relations of the grey and purple.

In like manner, as soon as a great sculptor begins to shape his work out of the block, we shall see that its lines are nobly arranged, and of noble character. We may not have the slightest idea for what the forms are intended, whether they are of man or beast, of vegetation or drapery. Their likeness to anything does not affect their nobleness. They are magnificent forms, and that is all we need care to know of them, in order to say whether the workman is a good or bad sculptor.

(John Ruskin, 1853)

The critic David Sylvester finds all of art in a print on his own wall.

Usually the works that are going to matter most to one, like the people who are going to matter most, start doing so as one first sets eyes on them. The work I've chosen to write about is a piece I managed to live with for many years without seeing anything very special in it, and this despite the fact that it's by a painter whose art I normally respond to so immediately that when I'm in museums, I use it like a drug. I would not, though, have bothered to go on living with this particular example had it not been for the circumstances in which I acquired it.

It is a lithograph from an edition of thirty printed in 1961, one of three untitled lithographs of that year which were Barnett Newman's first attempt at printmaking. Two years after he died, in 1970, his widow, Annalee Newman, whom I had not seen since his death, came to London at the time of his retrospective at the Tate and brought the print with her as a present for me. (It is a print she has given to several friends, as the artist had done.) I was very touched by her gesture and was glad to have a copy of one of Newman's three first prints to go with the copy I already had of one of his two last prints, *Untitled Etching No. 1* of 1969, also in monochrome, which I had bought from Newman's dealer shortly after it was pulled. But I wasn't so moved by the lithograph itself, and though I kept it on the wall, twenty years passed before I began to see it.

This happened when I finally started responding to the richness of the black, its simultaneous flatness and depth, hardness and softness. Black was a sacred colour for the Abstract Expressionists, it was their lapis lazuli; they made a mystique of it, partly perhaps because of its austerity,

partly perhaps because there was something splendidly macho in being able to produce a good strong black. If it took me so long to respond to the obvious beauty and depth, soft depth, of the black in the Newman print, it must have been because I was somehow thrown by the adjacent grey, with its rubbed texture – thrown, I think, by a scratchiness that made it seem awkward. But then that awkwardness suddenly became interesting, the rubbed grey suddenly took on a strange, elusive colour, and everything was singing.

And now it was stopping me in my tracks every day, several times a day. It was not only gripping but incredibly sufficient. The more I looked at it, the more it made me wonder why painters since time immemorial had bothered to put in all those arms and legs and heads. (And I'm no Modernist by persuasion: Michelangelo and Poussin are my cup of tea.) The print's elementary scope seemed to encompass everything a picture needed, yet I couldn't explain to myself why it was so absorbing and compelling. This mystery only added to its stature.

Nevertheless, I kept on asking myself what it was in the work that could give it such a hold. One possible answer was that the print is a wonderfully condensed embodiment of two opposing and basic forms of existence in modern painting – that the adjacent rectangles juxtapose the essence of Bonnard with the essence of Matisse. Another was the thought that in making this piece Newman was beginning even more than was his custom with a *tabula rasa*. It was one of his great strengths that his work asked fundamental questions about whatever medium he worked in, asked what were its first principles and requirements. So it was as if, making prints for the first time, working for the first time on a surface that was not going to be the surface of the actual work, he started thinking about the first principles of filling a surface, and proceeded to do exercises exemplifying them upon this unfamiliar surface, the lithographic stone.

Perhaps he started with the thought that it would be a good idea to separate the dimensions of the image from the dimensions of the surface. Why not do the obvious and draw a rectangle within that of the sheet? Next, why not articulate this inner rectangle by simply dividing it into two with a line, which might as well be a vertical line? Ought the line to bisect the rectangle? It would be more interesting if it didn't, but the asymmetry should be close enough to symmetry to suggest that that had been a possibility. Next, how to distinguish between the two halves? Since the sheet was going to be white, why not begin with its opposite, black? And then why not use the other half to mediate between white and black –

not just to mediate but to show the transition between them by having them intermingle, in such a way as to leave no doubt that the white had been the ground, the black the additive? And so as to convey the sense of a process?

Perhaps the attribution to the work of such a programme helps to explain its air of improvised inevitability. Perhaps, too, the thought of that programme gives a meaning to its minimalism, implying that it is not only an exemplar but a sort of allegory of the principle of less is more. That is speculation. What I know is that when I stand and look at it the whole of art is there.

(David Sylvester, 'Newman II', 1994, in his *About Modern Art*, 1996)

Pliny records a curious classical parallel with minimal abstraction in the vein of Barnett Newman.

An amusing exchange took place between Protogenes and Apelles. The former lived in Rhodes and Apelles sailed there, eager to acquaint himself with Protogenes's works – for he was only known to him by reputation. He made at once for his fellow artist's studio, but the latter was not at home. An old woman was looking after a large board resting on an easel. She announced that Protogenes was not in and asked who was looking for him. Apelles said, 'This person,' as he took up a brush and painted an extremely fine line in colour across the board.

On Protogenes's return the old woman showed him what Apelles had done. The story goes that, after a close inspection of the line, Protogenes said that the visitor had been Apelles, since such a line could not be the work of anyone else. Protogenes, using another colour, superimposed an even finer line on the first one. As he left his studio he told the old woman to show this to Apelles if he returned, and to add that he was the person for whom Apelles was searching. So it happened. For Apelles came back and, red-faced at being beaten, divided the lines with a third colour, leaving no room for any finer line.

So Protogenes admitted defeat and rushed down to the harbour in search of his visitor. He decided that the board should be preserved for posterity to be wondered at by all, but particularly by artists. I am told that it was destroyed by the first fire in Augustus's palace on the Palatine. This work had previously been the object of wide admiration, containing, as it did, nothing other than barely visible lines. Hanging among the

outstanding masterpieces by many artists it looked blank. For this reason it attracted notice and was more celebrated than any other work on display.

(Pliny the Elder, first century AD)

Despairing of ever finding the right form, Joyce Cary's character, Abel the sculptor, goes missing. Gulley Jimson has not seen him for days.

But neither had anyone else seen Abel. Though he was easy to see with his eyes, his hair, his hands, his scarlet socks and green sandals. I began to think that he'd had an accident or even gone into the country.

But Lolie never lost hope. 'No,' she said, 'he wouldn't go into the country except just passing through on business, because he can't stand scenery. It reminds him of pictures. And I feel sure he hasn't drowned himself again. He left his tools behind.'

'Did he drown himself before?'

'Twice. First time he jumped off Westminster Steps, but it turned out very well. Because the chap who fished him out had no lobes to his ears, and gave him an idea for an abstract bit of stuff he was doing, an urn or something; and the second time he put all his hammers in his pocket and jumped off Waterloo Bridge, but as soon as he hit the water, he got such a strong feeling of the horizontal that he shouted for the police. And he went straight home and did a thing called Plane Surface, which everybody thought was a joke. And between you and me, so it was. But it kept him happy for six weeks. And made a nice pastry board afterwards. Thank God he's chucked the abstract stuff,' said Lolie. 'He's still rotten, but he's not abstract any more.'

I was not surprised to hear that Lolie didn't admire the abstract; no more than if a coster's moke had told me it didn't take much interest in St Paul's dome.

'I suppose he doesn't need a model when he's doing the abstract?' I said.

'No, he only needs a woman. And the things it drives him to! A little more of the abstract and we'd both have gone potty. What is there to bite on in the abstract? You might as well eat triangles and go to bed with a sewing machine.'

Lolie was right about Abel. He met us in the street one day, on his way back to the flat. And he hadn't been in the country. He had spent the week in a drinking club down in Belgravia, drinking all night and sleeping

it off all day. He hadn't had anything to eat but bread and cheese; his hair was full of flue off the floor and his beard was two inches long. His face was green, his eyes were crimson; and he had the shakes. But he was full of energy and enthusiasm. He had got a plastic notion. 'It's a feeling of declivity,' he said. 'I just had been sick,' he said, 'and I was looking at the bowl when it came to me, "That's what I've been feeling after – declivity."' And I thought it was acclivity. You see, Jimson,' he said, waving his great hands as if he were wiping up a fishmonger's slab. 'I was trying to feel this thing upwards, against the grain, when all the time it was really downwards – like this. Here, Lolie, take off and I'll show him.'

And Lolie was so pleased to have her husband back that she began to take off in the street. I was glad to get her into the flat while she was still partly decent. And in two minutes Abel got Sir William's dining table propped up on one edge against a pile of books, and Lolie hanging on the top edge by her arms and chin. 'I want the descending shapes,' he said, 'in a big way.'

(Joyce Cary, 1944)

Cézanne offers his advice to a fellow painter, advice which, if famous, is also slightly puzzling. Why the cone? What about the cube?

May I repeat what I told you here: treat nature by the cylinder, the sphere, the cone, everything in proper perspective so that each side of an object or a plane is directed towards a central point. Lines parallel to the horizon give breadth, that is a section of nature or, if you prefer, of the spectacle that the *Pater Omnipotens Aeterne Deus* spreads out before our eyes. Lines perpendicular to this horizon give depth. But nature for us men is more depth than surface, whence the need of introducing into our light vibrations, represented by reds and yellows, a sufficient amount of blue to give the impression of air.

(Paul Cézanne to Émile Bernard, 15 April 1904)

A

Sense

of

Place:

Art

and

Travel

At the Venice Biennale, Howard Jacobson learns about art, and also about words. He reports to his mother, and also to Peter Fuller, art critic and editor extraordinary and irreplaceable.

Monday June 20

My dear Mamma,

I am arrived safely and in one piece, though so sensible of my good fortune at being here that I feel there are ten of me, and it is all any of us can do to keep our pens from flying from our fingers.

Venice, mama, just think of it! Venice, where Byron philandered and taught himself Armenian; where Henry James degusted ices and impressions; where the divine Tadzio (not one of my favourites, I know) fished and frolicked to the serious detriment of German literature; and where, in two days time, I will experience my first ever Biennale.

A water bus brought me from the airport some four hours ago, and although that method of transport turned out to be less poetical than I had imagined it, I need hardly describe to you, who know better than any of what susceptible materials I am composed, the palpitating expectancy with which I stepped aboard. Indeed, mama, you will not be surprised to learn that even as I sped across the torpid, rotting lagoon, a somewhat distempered fancy took possession of me. Was not Venice sinking by the hour? Then what if the weight of this 43rd Esposizione Internazionale d'Arte, the combined tonnage of all that art and art criticism, all those canvases and catalogues and connoisseurs, were to prove too much for her at last? I shaped a prayer that was not, I am ashamed to say, entirely devoid of selfishness. 'Float, sublime city,' I entreated. 'Stay up just long enough at least for me to behold with my own eyes this international gathering of cognoscenti, and to hear with my own ears the judgements of those who, through love of genius and beauty, intone an exalted language. Stay up, stay up, so that I might, if only once, feel a Biennale, and so that the Biennale might, if only once, feel me.'

And lo! mama – the city floated.

Tuesday June 21

Dearest Mama,

A stroke of the most wonderful good fortune. I have secured myself –
before the Biennale proper has even started – an invitation to a party!
Here is how it came about.

I rose early, impatient with curiosity and, to tell the truth, much vexed
by mosquitoes. (It is not pretty, waking to find your own blood on the
bed clothes.) After several hours wandering about the city, acquainting
myself with *fondamentas* and listening to my footfall echo through deserted
sottoportegos, not in search of picturesque *piscinas* or distressed *palazzo* walls
like any common tourist, but in expectation of catching sight of some
famous aesthetician in a gondola, some critic or curator of renown
descending to a *vaporetto*, I paused for a *macchiato* and *panino* in a shaded
corner of the Campo Morosini. As yet, I had no entries in my William
Morris autograph book (the one you bought me from the Royal Academy)
save for that of an Italian shop girl I had accosted by the Rialto on the
mistaken assumption that she was Marina Vaizey. It was then that I espied
a group whose air of melancholy bohemianism – we have remarked upon
that look of bruised expectancy before – proclaimed them at once to be
painters of the Australian school.

An uncharacteristic forwardness on my part quickly led to the desired
outcome, and I was soon escorted round their exhibition at a deconsecrated
basilica nearby – what a passionate affair these Australians enjoy with the
tactility of paint! – presented with an invitation to their party that very
evening, and made the recipient of such intimacies as you would have
thought available only to those who had never been parted from one
another for more than one hour in the whole of their lives.

I pray you, do not vex yourself, mama. Merely because your son whiles
away a morning in the Campo Morosini kissing Australians, that is no
cause for you to be reaching for your salts or struggling with such figments
as I know are wont to haunt you on the Tadzio question. I am here for
art, mama, not sensuality.

PS: Are not coincidences strange occurrences? Returning to my room to
bathe my temples, I do believe I caught a glimpse of Robert Hughes
ruminating by a *ponte* in a straw hat of the kind I think they call a panama.
But as I cannot be entirely certain it was he, and being always mindful of
the treatment meted out to poor Schnabel for asserting he had spotted

the fearsome critic in a leather bomber jacket, I commend my observations to your discretion.

Wednesday June 22

Dear Peter Fuller,
This to apprise you of my progress.

I began this morning, where I knew you would prefer me to, at the British Pavilion. I introduced myself to Tony Cragg as soon as the British Council's wine and cherries ran out, which was not long, and conveyed to him your good wishes for his success. On hearing your name he staggered backwards, very nearly losing his balance altogether, causing me to fear for his safety, he being a slight man, much less physically substantial than his sculptures. Once he had recovered, I repeated your name to him, imagining that he had misheard it the first time, whereupon he seemed bent on going through the whole performance again, but was able to steady himself long enough to say, 'You're not one of *his* henchmen are you?' and to make it evident to me that, for his part, he would not object if our acquaintance were to terminate as abruptly as it had begun.

I hardly need tell you how greatly embarrassed I was by this unexpected turn of events. Supposing your name, or at least that of your journal, to be a key that would open every door, I find the first one I try slammed closed against my face. Am I to descry a universality in this hostility, or has the sculptor foolishly taken it into his head to feel personally the criticism levelled at him in the summer edition of your magazine – viz. that he is without skill, imagination, technical competence, transforming power and, if I remember the list correctly, all sense of sculptural tradition? A pity if it is so, for by the standards of your journal he might be said to have come off rather lightly. And besides, is not an artist meant to be, wherever possible, a tittle above what is no more than tattle?

In fact – as I would gladly have informed him to his face had he not so painfully rebuffed me – I thought his work to be lacking in neither fancy nor variety; seldom attaining to monumentality, it is true, and even less frequently raising whimsy unto wit; but bold in its selection of materials, and banal only when political. (But then what man is not banal when he is political?)

You will understand I do not say Cragg is Michelangelo. How many miracles must one artist perform? Is it not sufficient – and my source for this is the Biennale catalogue – that two long-dead trees waiting to be

worked on in Cragg's studio responded with such sympathy to his spirit of creativity that they returned to life again, remembering what was good about it, and sprouted 'bright green shoots and leaves'.

Bright green shoots, Peter, out of a sapless bark. I put it to you as a matter of paramountcy – whether *Modern Painters* addresses itself sufficiently to the thaumaturgical aspect of art.

I am posting this immediately, to have it off my chest.

Sunday June 26

Dear, dear Mama,
My plane is delayed some seven or eight hours, and I am writing to you, to make the time pass the quicker, in a pizza restaurant – I can bear no longer saying *ristorante* – across the road from Treviso airport.

Guess who I have met here? Sarah Kent, the *Time Out* critic we have exchanged words about from time to time. She is so serene, mama. Almost conventual. And she took me for a Dutchman! Yet when I mentioned the journal I was writing for her face assumed an agitated expression, and the arms that had been so still and graceful before began to turn, one around the other, like the rollers of a mangle.

Fortunately there was an agreeable art dealer at our table, of sufficient vivacity to bend our minds to other matters. 'Venice is not important to me,' he informed us. 'Basle is where I do the schmoozing. Basle's the place. I know one New York dealer who turned over 23 million at Basle.'

It is most odd, mama, but at this, Sarah Kent's hands began their mangling again.

'To us it's just fruit and veg,' the art dealer continued, unaware of the strain he was placing on some sensibilities. 'It's just a commodity. We're all waiting for a maestro to come along and wake things up. People have reached their serious-money levels. What's needed now is something new and compelling.' He laughed, not without a becoming amusement, I thought, at his own descent into dealer's argot. 'Compelling,' he explained, 'is the current buzz word in New York.'

I believed it not entirely out of the question that Sarah Kent might catch herself in her own mangle and come out ironed. She sighed and let her head droop like a madonna's. 'That's the trouble with words,' she said, 'you run out of them so quickly.'

Oh, mama, would that were only so.

(Howard Jacobson, 1988)

Manet in Venice.

One day at the Louvre I saw a visitor standing before Manet's *Olympia*, in whom I recognized the painter Charles Toché. I went up to him and reminded him that I had often heard him speak of his relations with Manet.

'How did you come to know him?' I asked.

'I was in Venice, eating an ice at the Café Florian, when the great painter, whose elegant figure was familiar to me, came and sat down near by. His wife was with him, and I was struck by her majestic bearing. Her sunshade fell down and I stooped to pick it up. Manet thanked me: "I see you're a Frenchman. Mon Dieu, how this place bores me." Madame Manet smiled at me. Her rosy, childish face beamed from under an enormous hat. "Édouard likes joking," she said. "He's playing the Parisian."'

'M. Toché, tell me about that famous picture of Manet's, *Les Pieux du Grand Canal.*'

'I shall not forget Manet's enthusiasm for that motif: the white marble staircase against the faded pink of the bricks of the façade, and the cadmium and greens of the basements. Oscillations of light and shade made by the passing barges in the rough water, that drew from him the exclamation, "Champagne bottle-ends floating!" Through the row of gigantic twisted posts, blue and white, one saw the domes of the incomparable Salute, dear to Guardi. "I shall put in a gondola," cried Manet, "steered by a boatman in a pink shirt, with an orange scarf – one of those fine dark chaps like a Moor of Granada." Some of the guests of the villa Medicis were listening to Manet from a neighbouring boat. At these last words they sniggered. I heard the word "pompier" . . .

'When the picture was finished, I was really astounded. One could not imagine anything more true, better situated in the atmosphere. Replying to a remark of mine, "It was not at school," Manet said, "that I learnt to construct a picture. On my first day at Couture's they gave me an antique to draw from. I turned it about in every direction. It seemed to me most interesting head downwards. Anyway, after two or three attempts I gave up trying to get anything out of the antique. But I learnt a great deal during my voyage to Brazil. I spent night after night watching the play of light and shade in the wake of the ship. During the day I watched the line of the horizon. That taught me how to plan out a sky."'

'How did Manet paint? I remember Cézanne saying, "Manet spatters his tones on to the canvas."'

'That expresses it. It was not at all a linear process, but with rapid individual touches he scattered shadows, lights, reflections over the canvas with astonishing sureness, and his layout was made.

'I remember dining with him in a little restaurant opposite the Giudecca. The table was laid in an arbour covered with vines. A little opening in this arbour framed the lovely church of San Salvatore, whose pink tones contrasted with the glaucous green of the water and the black spindle-shapes of the gondolas. Manet observed and analysed the different colours taken on by each object as the light faded. He defined their values and told us how he would try to reproduce them, steeped in this ashy twilight greyness. Suddenly he got up, and taking his paintbox and a little canvas, he ran down to the quay. There, with a few strokes of the brush, he set up the distant church.'

'Any picture by Manet certainly suggests brushstrokes put down definitely, once for all.'

'Wait a bit! That was what I thought before I had seen him at work. Then I discovered how he laboured, on the contrary, to obtain what he wanted. The *Pieux du Grand Canal* itself was begun I know not how many times. The gondola and gondolier held him up an incredible time. "It's the devil," he said, "to suggest that a hat is stuck firmly on a head, or that a boat is built of planks cut and fitted according to geometrical laws!"'

I could have listened all day to M. Toché.

'One day,' he went on, 'I was expatiating on the possibility of combining poetry and reality in a picture, when Manet exclaimed, "If that ass of a Courbet were to hear you! His idea of reality was ... Well, look at his *Burial at Ornans*, for instance, in which he has succeeded in burying everybody, priests, gravediggers, mourners and all. The horizon itself is six feet underground."'

'Really, was Manet so hard on Courbet? What did he think of his fellow Impressionists?'

'Monet alone found favour with him. He called Cézanne "a bricklayer who paints with his trowel." And Renoir he looked upon as a decent sort of chap who had taken up painting by mistake.'

A few days later M. Toché and I met again.

'You tell me you often had the chance of seeing Manet at work?' I said, eager to hear more.

'In Venice I used to go and join him almost every day. The lagoons,

the palaces, the old houses, scaled and mellowed by time, offered him an inexhaustible variety of subjects. But his preference was for out-of-the-way corners. I asked him if I might follow him in my gondola. "As much as you like," he told me. "When I am working, I pay no attention to anything but my subject." Now and then he would make a gesture of annoyance that set his boat rocking, and I would see his palette knife scraping away with ferocity. But all at once I would hear the refrain of a song, or a few notes whistled gaily. Then Manet would call out to me, "I'm getting on, I'm getting on! When things are going well, I have to express my pleasure aloud."'

'M. Toché, how do you account for Manet, the bantering Parisian, the true *boulevardier*, having such a passion for Spain and Italy?'

'He liked Spain much the better of the two. "Spain," he said to me one day, "is so simple, so grandiose, so dramatic with its stones and its green-black trees. Venice, when all is said, is merely scenery."'

'But the great Venetian painters . . . ?'

'One morning I was looking with him at the *Glory of Venice*, by Veronese, in the Ducal Palace. "There's something about that that leaves one cold," he said. "So much useless effort, so much wasted space in it. Not a shadow of an emotion. I like the Carpaccios, they have the naive grace of illuminations in missals. And I rank highest of all the Titians and Tintorettos of the Scuola di San Rocco. But I always come back, you know, to Velázquez and Goya."'

'What did he think of Tiepolo?'

'Tiepolo irritated him. "These Italians bore one after a time," he would say, "with their allegories and their *Gerusalemme Liberata* and *Orlando Furioso*, and all that noisy rubbish. A painter can say all he wants to with fruits or flowers, or even clouds."

'I remember wandering with him round the stalls of the Pescheria Vecchia, under the bridge of the Rialto. Manet was intoxicated by light. He bubbled over with delight at the sight of the enormous fish with their silver bellies. "That," he cried, "is what I should have liked to paint if the Conseil Municipal of Paris had not refused my decorative scheme for the Hôtel de Ville. You know, I should like to be the St Francis of still-life." Another time we went to the vegetable market. Manet, a slender figure in blue, his straw hat tilted to the back of his head, went striding over the heaps of provisions and vegetables. He stopped suddenly before a row of pumpkins, the kind that grows only on the shores of the Brenta. "Turks' heads in turbans!" he cried. "Trophies from the victories of Lepanto and Corfu!"

'When Manet had been working hard, he would set out, by way of relaxation, to "discover" Venice. Madame Manet would accompany him, and they would wander through the most tortuous of the little streets, or, taking the first gondola that came, explore the narrow *canaletti*. Manet was mad on old tumbledown houses, with rags hanging from the windows, catching the light. He would stop to look at the handsome shock-headed girls, bare-necked, in their flowered gowns, who sat at their doors stringing beads from Murano or knitting stockings of vivid colours. In the fishing quarter, at San Pietro di Castello, he would stop before the great piles topped with enormous eel-pots made of withies, that the light turned to amethyst. He marvelled at the children, burnt golden by the sun, shaking off their fleas on the crumbling steps of the old staircases and quarrelling among themselves, their faces smeared with polenta and watermelon. The afternoon would end up with visits to the second-hand dealers, in whose miserable booths there was no hint of the sumptuous antique shops that were to arise on the same sites fifty years later. Nothing delighted him so much as to ferret out an old piece of lace, a finely worked jewel, a valuable engraving.

'He would often arrange to meet me during the evening. Venice is particularly pleasant in the evening, and Manet liked going out after dinner. He became talkative on these occasions, and did not scruple to tease Mme Manet in my presence, usually on the subject of her family, and particularly of her father, a typical Dutch *bourgeois*, sullen, fault-finding, thrifty, and incapable of understanding an artist. But a fisherman had only to start singing a barcarolle, or a guitar to throb, and instantly Manet would fall silent, caught by the charm of nocturnal Venice. His wife, who was an excellent pianist, expressed the delight it would be to her to play Schubert, Chopin or Schumann in such surroundings. So with her consent I laid a little plot. One evening after dinner I invited her and her husband to come for a trip on the water. I had our boat rowed towards a canal beside the Bridge of Sighs. There a wide barge was moored, of the kind used for household removals. I had had a piano put aboard her, concealed by rugs, and Mme Manet, as arranged, had been complaining of the rocking of our gondola, and I suggested we should get into this other boat, which was much steadier. We started off in the direction of San Giorgio Maggiore. Suddenly, under Mme Manet's fingers, a melody arose. It was a romance of Schumann's. That moment, Manet told us later, left him with the most delicious impression of his whole stay in Venice.'

'What a relaxation Venice must have been for Manet, after the busy life of Paris!'

'In Venice he thought of nothing but painting. What a number of plans he made that were never to be realized! There was that Sunday in September, for instance, when I accompanied him to Mestre, where regattas were being held in the lagoon. Each racing gondola, with its rowers clad in blue and white, seemed a fold of an immense serpent. Lying on the cushions of our boat, a rug over his knees, one hand dragging in the water, Manet, from under his wife's parasol, described to us the plan of a picture he would like to paint of this regatta. Manet, who was considered an extravagant innovator at the École des Beaux-Arts, had thought out this composition according to such classical rules that the statement he made of it to us would, I fancy, have delighted Poussin. I noted down with the greatest care the incomparable lesson that I had just heard.

'This must have been one of the last things Manet enjoyed in Venice. Not long afterwards he came to my room early one morning, and I was struck by his dejected air.

'"I have been recalled to Paris," he told me. "My life here was too pleasant, I suppose. Who knows what fresh worries await me over there?" I accompanied my delightful new friends to the station. On the way, Manet gazed once more, intently, at the Grand Canal, the rose-coloured palaces, the old weathered houses, the gigantic piles looking like bagwigs as they emerged from the slight fog. Up to the moment when he got into the train, Manet said not a word.'

(Ambroise Vollard, 1936)

In Venice, Goethe theorizes about the Venetian-ness of Venetian art.

I visited the Palazzo Pisani Moretta to look at a painting by Paolo Veronese. The female members of the family of Darius are kneeling at the feet of Alexander and Hephaestus. The mother mistakes Hephaestus for the King, but he declines the honour and points to the right person. There is a legend connected with this picture according to which Veronese was for a long time an honoured guest in this palace and, to show his gratitude, painted it in secret, rolled it up and left it under his bed as a gift. It is certainly worthy of such an unusual history. His ability to create a harmony through a skilful distribution of light and shade and local colours without any single dominant tone is conspicuous in this painting, which is in a remarkable state of preservation and looks as fresh as if it had been painted

yesterday. When a canvas of this kind has suffered any damage, our pleasure in it is spoiled without our knowing the reason.

Once it is understood that Veronese wanted to paint an episode of the sixteenth century, no one is going to criticize him for the costumes. The graded placing of the group, the mother in front, behind her the wife, and then the daughters in order, is natural and happy. The youngest princess, who kneels behind all the rest, is a pretty little mouse with a defiant expression. She looks as if she were not at all pleased at coming last.

My tendency to look at the world through the eyes of the painter whose pictures I have seen last has given me an odd idea. Since our eyes are educated from childhood on by the objects we see around us, a Venetian painter is bound to see the world as a brighter and gayer place than most people see it. We northerners who spend our lives in a drab and, because of the dirt and the dust, an uglier country where even reflected light is subdued, and who have, most of us, to live in cramped rooms – we cannot instinctively develop an eye which looks with such delight at the world.

As I glided over the lagoons in the brilliant sunshine and saw the gondoliers in their colourful costume, gracefully posed against the blue sky as they rowed with easy strokes across the light-green surface of the water, I felt I was looking at the latest and best painting of the Venetian school. The sunshine raised the local colours to a dazzling glare and even the parts in shadow were so light that they could have served pretty well as sources of light. The same could be said of the reflections in the water. Everything was painted clearly on a clear background. It only needed the sparkle of a white-crested wave to put the dot on the i.

Both Titian and Veronese possessed this clarity to the highest degree, and when we do not find it in their works, this means that the picture has suffered damage or been retouched.

(Johann Wolfgang von Goethe, 8 October 1786)

On the other hand, the novelist Mary McCarthy theorizes about the virility of the arts of Florence.

Florence is a manly town, and the cities of art that appeal to the current sensibility are feminine, like Venice and Siena. What irritates the modern tourist about Florence is that it makes no concession to the pleasure principle. It stands four-square and direct, with no air of mystery, no

blandishments, no furbelows – almost no Gothic lace or baroque swirls. Against the green Arno, the ochre-and-dun file of hotels and palazzi has the spruce, spare look of a regiment drawn up in drill order. The deep shades of melon and of tangerine that you see in Rome, the pinks of Venice, the rose of Siena, the red of Bologna have been ruled out of Florence as if by municipal decree. The eye turns from mustard, buff, ecru, pale yellow, cream to the severe black-and-white marbles of the Baptistery and of Santa Maria Novella's façade or the dark-green and white and flashing gold of San Miniato. On the Duomo and Giotto's bell tower and the Victorian façade of Santa Croce, there are touches of pink, which give these buildings a curious festive air, as though they alone were dressed up for a party. The general severity is even echoed by the Florentine bird, which is black and white – the swallow, a bachelor, as the Florentines say, wearing a tail coat.

The great sculptors and architects who stamped the outward city with its permanent image or style – Brunelleschi, Donatello, Michelangelo – were all bachelors. Monks, soldier-saints, prophets, hermits were the city's heroes. Saint John the Baptist, in his shaggy skins, feeding on locusts and honey, is the patron, and, except for the Madonna with her boy baby, women saints count for little in the Florentine iconography. Santa Reparata, a little Syrian saint, who once was patron of the Cathedral, was replaced by the Madonna (Santa Maria del Fiore) early in the fifteenth century. The Magdalen as a penitent and desert-wanderer was one of the few female images, outside of the Madonna, to strike the Florentine imagination; Donatello's gaunt sculpture of her stands in the Baptistery: a fearsome brown figure, in wood, clad in a shirt of flowing hair that surrounds her like a beard, so that at first glance she appears to be a man and at second glance almost a beast. Another of these hairy wooden Magdalens, by Desiderio, is in the church of Santa Trinità. Like these wild creatures of the desert, many of the Florentine artists were known for their strange ascetic habits: Paolo Uccello, Donatello, Piero di Cosimo, Michelangelo, Pontormo. When he was doing a statue of Pope Julius II in Bologna, Michelangelo, though an unsociable person, slept four to a bed with his workmen, and in Rome, so he wrote his relations, his quarters were too squalid to receive company . . .

White, black, grey, dun, and bronze are the colours of Florence – the colours of stone and metal, the primitive elements of Nature out of which the first civilizations were hammered – the Stone Age, the Bronze Age, the Iron Age. The hammer and the chisel strike the sombre music of

Florentine art and architecture, of the Florentine character. Those huge iron gratings on the windows of Florentine palaces, the iron rings and the clamps for torches that are driven into the rough bosses of stone came from the gloomy iron mines of Elba, a Tuscan possession. You can still hear the sound of the forge in the workshops of the Oltrarno, and the biggest industry of modern Florence is a metallurgical works.

The Florentines of the Middle Ages and the Renaissance, when they went into battle, carried statuary with them. Savonarola, though he was supposedly an enemy of art, had a Donatello Infant Jesus borne in procession on the day of the Bonfire of Vanities, when so many secular paintings were burnt, including the studies from life of Fra Bartolomeo. Among the people, it was believed, as late as the present century, that spirits were imprisoned in statues. The statue of Neptune by Ammannati in the fountain of the Piazza della Signoria is called 'Il Biancone' or 'The Great White Man' by the poor people, who used to say that he was the mighty river god of the Arno turned into a statue because, like Michelangelo, he spurned the love of women. When the full moon shines on him, so the story goes, at midnight, he comes to life and walks about the Piazza conversing with the other statues. Michelangelo's *David*, before it became a statue, used to be known as *The Giant*. It was a great block of marble eighteen feet high that had been spoiled by Agostino di Duccio; personified by popular fancy, it lay for forty years in the workshops of the Cathedral, until Michelangelo made the Giant into the Giant-Killer, that is, into a patriotic image of the small country defeating its larger foes. Giants, it was related, had built the great Etruscan stone wall of Fiesole, and many stories were told in Florence of beautiful maidens being turned into pure white marble statues.

More than any other piazza in Italy, the Piazza della Signoria evokes the antique world, not only in the colossal deified statues, the *David*, the *Neptune* (of which Michelangelo said, 'Ammannato, Ammannato, che bel marmo hai rovinato,' thinking, that is, of the damage to the *marble* wrought by the inept sculptor), the hideous *Hercules and Cacus*, but in the sober Loggia dei Lanzi, with its three lovely full arches and its serried statuary groups in bronze and marble. Some are antique Greek and Roman; some are Renaissance; some belong to the Mannerist epoch; one to the nineteenth century. Yet there is no disharmony among them; they seem all of a piece, one continuous experience, a coin periodically reminted. It is a sanguinary world they evoke. Nearly all these groups are fighting. The helmeted bronze Perseus, by Cellini, is holding up the dripping head of

Medusa, while her revolting trunk lies at his feet; Hercules, by Giambol- ogna, is battling with Nessus the Centaur; Ajax (after a Greek original of the fourth century B C) is supporting the corpse of Patroclus. There are also the *Rape of the Sabine Women*, by Giambologna, the *Rape of Polixena*, by Pio Fedi (1866), and *Germany Conquered*, a Roman female statue, one of a long line of Roman matronly figures that stand against the rear wall, like a chorus of mourners. Two lions – one Greek, one a sixteenth-century copy – flank these statuary groups, which are writhing, twisting, stabbing, falling, dying, on their stately pedestals. Nearby, at the entrance to Palazzo Vecchio, Judith, by Donatello, displays the head of Holofernes, and in the courtyard, Samson struggles with a Philistine. Down the square, Cosimo I rides a bronze horse.

This square, dominated by Palazzo Vecchio, which was the seat of govern- ment, has an austere virile beauty, from which the grossness of some of the large marble groups does not at all detract. The cruel tower of Palazzo Vecchio pierces the sky like a stone hypodermic needle; in the statuary below, the passions are represented in their extremity, as if strife and discord could be brought to no further pitch. In any other piazza, in any other city, the line-up of murderous scenes in the Loggia dei Lanzi (named for Cosimo I's Swiss lancers, who stood on guard there, to frighten the citizenry) would create an effect of *terribilità* or of voluptuous horror, but the Florentine classical spirit has ranged them under a porch of pure and refined arches (1376–81), which appear to set a ceiling or limit on woe.

This was the civic centre, distinct from the religious centre in the Piazza of the Duomo and the Baptistery and from the two market places. Donatello's *Judith and Holofernes* was brought here from Palazzo Medici, where it had been part of a fountain, and set up on the *aringhiera* or balustraded low terrace of Palazzo Vecchio as an emblem of public safety; an inscription on the base declares that this was done by the people in 1495 – when the Medici had just been chased out and their treasures dispersed. The *aringhiera* was the platform from which political orations were delivered and decrees read by the signory to the people (this is the derivation of the word 'harangue'), and the statue of Judith cutting off the tyrant's head was intended to symbolize, more succinctly than words, popular liberty triumphing over despotism. The Medici were repeatedly chased out of Florence and always returned. When Cosimo I installed himself as dictator, he ordered from Cellini the *Perseus and Medusa*, to commemorate the triumph of a restored despotism over democracy. Meanwhile, Michelangelo's *Brutus* (now in the Bargello) had been com- missioned, it is thought, by a private citizen to honour the deed of

Lorenzino de' Medici, who had earned the name Brutus by assassinating his distant cousin, the repugnant tyrant Alessandro. This same Lorenzino was infatuated with the antique and had been blamed by his relation Pope Clement VII for knocking the heads off the statues in the Arch of Constantine in Rome – the meaning of this action remains mysterious. Another republican, Filippo Strozzi, of the great banking family, when imprisoned by Cosimo I, summoned up the resolution to kill himself by calling to mind the example of Cato at Utica.

The statues in the square were admonitory lessons or 'examples' in civics, and the durability of the material, marble or bronze, implied the conviction or the hope that the lesson would be permanent. The indestructibility of marble, stone, and bronze associate the arts of sculpture with governments, whose ideal is always stability and permanence. The statue, in Greek religion, is thought to have been originally a simple column, in which the trunk of a man or, rather, a god was eventually descried. Florentine sculpture, whether secular or religious, retained this classic and elemental notion of a pillar or support of the social edifice. Other Italians of the Renaissance, particularly the Lombards, were sometimes gifted in sculpture, but the Florentines were almost always called upon by other cities when it was a question of a public, that is, of a civic, work. The great equestrian statue of the *condottiere* Gattamelata that stands in the square at Padua was commissioned from Donatello; when the Venetians wanted to put up a statue along the same lines (the Colleone monument), they sent for Verrocchio. The state sculptor of the Venetian Republic was the Florentine, Sansovino.

(Mary McCarthy, 1959)

Van Gogh begins to feel at home in Provence.

Now that I have made a start in the south, I can hardly conceive of going anywhere else. Better not to do any more moving – just to keep going out into the countryside.

I'm sure I should have a greater chance of success if I tackled subjects – and even business matters – on a somewhat bigger scale, instead of confining myself to one that is too small.

And for that very reason I'm thinking of working on larger canvases and going over boldly to the 30 square. These cost me 4 francs apiece here, and taking carriage into account that isn't expensive.

The latest canvas completely slays all the rest – it's only a still-life with coffee pots and cups and plates in blue & yellow, but it's in a different class. It must be due to the drawing.

I can't help recalling what I've seen of Cézanne's work, because – as in the harvest which we saw at Portier's – he has brought out the harsh side of Provence so much.

It has changed entirely from what it was in the spring, but certainly [my love for] the countryside, which is already beginning to appear scorched, has grown no less. You could say that everything has old gold, bronze and copper in it, and this, together with the green-azure of the white-hot sky, imparts a delicious, exceptionally harmonious colour, with broken tones à la Delacroix

If Gauguin were willing to join us it would be, I think, a step forward for us. It would establish us firmly as openers-up of the south, and no one could argue with that.

I must try to achieve the solidity of colour I got in that picture which slays all the rest. I remember Portier used to say that his Cézannes, seen on their own, looked like nothing on earth, but that when placed next to other canvases they wiped the colour out of all the rest. And also that the Cézannes looked good in gold, which implies a brilliant palette.

Perhaps, perhaps, I am therefore on the right track and am getting an eye for the countryside here.

We'll have to wait and see.

This latest picture stands up well to the red surroundings of the bricks with which the studio is paved. When I put it on the floor, on this brick-red, *deep red*, ground, the colour of the picture does not looked washed-out or blanched.

The countryside near Aix – where Cézanne works – is just the same as here, it is still the Crau. When I get back home with my canvas and say to myself, hallo, I've got old Cézanne's very tones, all I mean is that since Cézanne, just like Zola, is *so at home in these parts* and hence knows them so intimately, one must be making the same mental calculation to arrive at the same tones. It goes without saying that seen side by side they would go together, but not look alike. With a handshake, I hope you'll be able to write one of these days,

Ever yours,
Vincent

(Vincent Van Gogh to Théo Van Gogh, 12–13 June 1888)

For my part, I'm getting on better here than I did in the north. I even work right in the middle of the day, in the full sun, with no shade at all, out in the wheatfields, and lo and behold, I am as happy as a cicada. My God, if only I had known this country at 25 instead of coming here at 35! At that time I was fascinated by grey, or rather lack of colour. I kept dreaming of Millet, and then I also had such acquaintances among the Dutch painters as Mauve, Israëls, etc.

Here is a sketch of a sower: a large piece of land with clods of ploughed earth, for the most part a definite purple. A field of ripe wheat, in yellow ochre with a little carmine.

The sky chrome yellow, almost as bright as the sun itself, which is chrome yellow 1 with a little white, while the rest of the sky is chrome yellow 1 and 2 mixed. Thus very yellow.

The Sower's smock is blue and his trousers white.

Size 25 canvas, square.

There are many touches of yellow in the soil, neutral tones produced by mixing purple with the yellow, but I couldn't care less what the colours are in *reality* . . .

(Vincent Van Gogh to Émile Bernard, *c.*18 June 1888)

The English painter Patrick Heron, visiting the haunts of Cézanne and Matisse in the South of France, sees the landscape not through their eyes, exactly, but through their images.

The most profound experiences of which we are capable invariably burn into our consciousness a precise date, time and place. I never visited Aix-en-Provence until the summer of 1962 – and then only for an hour, heading the family car in what I hoped was the direction of the sacred mountain. We were already outside the town when we swung round a corner to the left ... and there it was, even more to the left, at the top of a slight valley and already framed by the boughs of three pines, exactly as Cézanne saw it in the sublime version at the Courtauld. Not pine needles, or bark-encrusted bending boughs, but separated, single, dry, square-tipped brush-strokes it was that hung in the air before one's eyes. In rhythmic ranks, vibrating gently in all directions, they formed strata of separated colour which miraculously solidified there in front of one, in the so-recognizable opalescent atmosphere surrounding the mountain over there! Rose, ochre, violet and cobalt ... one already saw the paint embedded in the air!

Another moment, long ago in 1933. A most inspired art master at my boarding school – Ludvig van der Straeten – having sworn to my father that he would not attempt to teach me to paint (a stern request my immensely supportive father had made to him in writing), one afternoon drove me at speed, in his Ford V8, all the way from Harpenden to Trafalgar Square, parked the car, slammed the door, unlocked, at the bottom of the National Gallery steps, on the Pall Mall side, and said 'Follow'. In silence he led me quickly to a room where this very Cézanne of the mountain (*Mont Sainte-Victoire with Large Pine*, *c.*1887) was hanging, together with other Courtauld paintings on loan to the National. Having raced to the spot, all I can remember Vandy saying was 'Look', as he raised an arm, pointing directly at this *Mont Sainte-Victoire*. Back in Harpenden I immediately painted my first Cézannes – landscapes, not still-lifes.

Back to Aix. I had slammed on the car brakes as we rounded that bend into the sudden full view of the breathtaking Cézanne subject I had known for so long. We'd even skidded, slightly, into the pine needles. A moment later, wandering a few feet above the road, I was confronted by a newish limestone marker which said, very simply, that Cézanne had painted the mountain from this spot – unnecessary as information, but excellently reverential as a salute. How good it would be if Aix would now remove

the gigantic cross mistakenly added in recent years to the very crest of this most famous of all mountains in the history of painting.

Years before, staying on the tip of the Cap d'Antibes, in 1948, and walking along the road on the eastern side of the Cap, I had suddenly seen that we had arrived at the subject of the Matisse painting, *Route sur le Cap d'Antibes*, of 1926, complete with every angle of the road and, again, the pine branches. Edging into a corner of the wall on the landward side of the road, until I felt I could photograph Matisse's subject exactly as he'd seen and composed it, my elbow was pressed hard into the mossy stones of the wall. It occurred to me to peel the moss away from those stones. And sure enough, there I found old palette scrapings of scarlet, ultramarine, violet, lemon and emerald, all oxidizing deep in a small crevice. Thrilled, but not surprised, it was a discovery I still recall with intense emotion. To have the experience of standing precisely where the great painter once saw what he saw – and to know that what he saw was what I now also saw, but saw *through* his paint, *through* his brushstrokes, *through* his selected distortions of the visual data yielded at that exact point in the landscape . . . this was an experience which it was essential to have. It conferred the ability to identify with the near past, and to share an exact experience with a great painter.

(Patrick Heron, 'Solid Space in Cézanne', 1996)

In a letter, Poussin provides an insight into the origins of Southern classicism.

The beautiful girls whom you will have seen in Nîmes will not, I am sure, have delighted your spirit any less than the beautiful columns of Maison Carrée [a Roman temple]; for the one is no more than an old copy of the other.

(Nicolas Poussin to his friend Chantelou, 1642)

Does the landscape of childhood form an artist's sensibility? John Berger considers the case of Courbet.

The region in which a painter passes his childhood and adolescence often plays an important part in the constitution of his vision. The Thames developed Turner. The cliffs around Le Havre were formative in the case of Monet. Courbet grew up in – and throughout his life painted and often

returned to – the valley of the Loue on the western side of the Jura mountains. To consider the character of the countryside surrounding Ornans, his birthplace, is, I believe, one way of constructing a frame which may bring his work into focus.

The region has an exceptionally high rainfall: approximately 51 inches a year, whereas the average on the French plains varies from 31 inches in the west to 16 inches in the centre. Most of this rain sinks through the limestone to form subterranean channels. The Loue, at its source, gushes out of the rocks as an already substantial river. It is a typical karst region, characterized by outcrops of limestone, deep valleys, caves and folds. On the horizontal strata of limestone there are often marl deposits which allow grass or trees to grow on top of the rock. One sees this formation – a very green landscape, divided near the sky by a horizontal bar of grey rock – in many of Courbet's paintings, including *The Burial at Ornans*. Yet I believe that the influence of this landscape and geology on Courbet was more than scenic.

Let us first try to visualize the mode of appearances in such a landscape in order to discover the perceptual habits it might encourage. Due to its folds, the landscape is *tall*: the sky is a long way off. The predominant colour is green: against this green the principal events are the rocks. The background to appearances in the valley is dark – as if something of the darkness of the caves and subterranean water has seeped into what is visible.

From this darkness whatever catches the light (the side of a rock, running water, the bough of a tree) emerges with a vivid, gratuitous but only partial (because much remains in shadow) clarity. It is a place where the visible is discontinuous. Or, to put it another way, where the visible cannot always be assumed and has to be grasped when it does make its appearance. Not only the abundant game, but the place's mode of appearances, created by its dense forests, steep slopes, waterfalls, twisting river – encourages one to develop the eyes of a hunter.

Many of these features are transposed into Courbet's art, even when the subjects are no longer his home landscape. An unusual number of his outdoor figure paintings have little or no sky in them (*The Stonebreakers*, *Proudhon and His Family*, *Girls on the Banks of the Seine*, *The Hammock*, most of the paintings of *Bathers*). The light is the lateral light of a forest, not unlike light underwater which plays tricks with perspective. What is disconcerting about the huge painting of the *Studio* is that the light of the painted wooded landscape on the easel is the light that suffuses the

crowded Paris room. An exception to this general rule is the painting of *Bonjour Monsieur Courbet*, in which he depicts himself and his patron against the sky. This, however, was a painting consciously situated on the faraway plain of Montpellier.

I would guess that water occurs, in some form or another, in about two-thirds of Courbet's paintings – often in the foreground. (The rural bourgeois house in which he was born juts out over the river. Running water must have been one of the first sights and sounds which he experienced.) When water is absent from his paintings, the foreground forms are frequently reminiscent of the currents and swirls of running water (for example, *The Woman with a Parrot, The Sleeping Spinning-Girl*). The lacquered vividness of objects, which catch the light in his paintings, often recalls the brilliance of pebbles or fishes seen through water. The tonality of his painting of a trout underwater is the same as the tonality of his other paintings. There are whole landscapes by Courbet which might be landscapes reflected in a pond, their colour glistening on the surface, defying atmospheric perspective (for example, *The Rocks at Mouthier*).

He usually painted on a dark ground, on which he painted darker still. The depth of his paintings is always due to darkness – even if, far above, there is an intensely blue sky; in this his paintings are like wells. Wherever forms emerge from the darkness into the light, he defines them by applying a lighter colour, usually with a palette knife. Leaving aside for the moment the question of his painterly skill, this action of the knife reproduced, as nothing else could, the action of a stream of light passing over the broken surface of leaves, rock, grass, a stream of light which confers life and conviction but does not necessarily reveal structure.

Correspondences like these suggest an intimate relationship between Courbet's practice as a painter and the countryside in which he grew up. But they do not in themselves answer the question of what *meaning* he gave to appearances. We need to interrogate the landscape further. Rocks are the primary configuration of this landscape. They bestow identity, allow focus. It is the outcrops of rock which create the presence of the landscape. Allowing the term its full resonance, one can talk about *rock faces*. The rocks are the character, the spirit of the region. Proudhon, who came from the same area, wrote: 'I am pure Jurassic limestone.' Courbet, boastful as always, said that in his paintings, 'I even make stones think.'

A rock-face is always there. (Think of the Louvre landscape which is called *The Ten O'Clock Road*.) It dominates and demands to be seen, yet its appearance, in both form and colour, changes according to light and

weather. It continually offers different facets of itself to visibility. Compared to a tree, an animal, a person, its appearances are only very weakly normative. A rock can look like almost anything. It is undeniably itself, and yet its substance does not posit any particular form. It emphatically exists and yet its appearance (within a few very broad geological limitations) is arbitrary. It is only like it is, this time. Its appearance is, in fact, the limit of its meaning.

To grow up surrounded by such rocks is to grow up in a region in which the visible is both lawless and irreducibly real. There is visual fact but a minimum of visual order. Courbet, according to his friend Francis Wey, was able to paint an object convincingly – say a distant pile of cut wood – *without knowing what it was*. That is unusual amongst painters, and it is, I think, very significant.

In the early romantic *Self-portrait with a Dog*, he painted himself, surrounded by the darkness of his cape and hat, against a large boulder. And there his own face and hand are painted in exactly the same spirit as the stone behind. They were comparable visual phenomena, possessing the same visual reality. If visibility is lawless, there is no hierarchy of appearances. Courbet painted everything – snow, flesh, hair, fur, clothes, bark – as he would have painted it had it been a rock-face. Nothing he painted has interiority – not even, amazingly, his copy of a Rembrandt self-portrait – but everything is depicted with amazement: amazement because to see, where there are no laws, is to be constantly surprised.

It may now seem that I am treating Courbet as if he were 'timeless', as unhistorical as the Jura mountains which so influenced him. This is not my intention. The landscape of the Jura influenced his painting in the way that it did, given the historical situation in which he was working as a painter, and given his specific temperament. Even by the standards of Jurassic time, the Jura will have 'produced' only one Courbet. The 'geographical interpretation' does no more than ground, give material, visual substance to, the social-historical one.

(John Berger, *About Looking*, 1980)

Albrecht Dürer visits the sights of Bruges and Ghent in 1521.

On the Saturday after Easter, with Hans Lüber and Master Jan Prevost, a good painter born at Bruges, I set out from Antwerp towards Bruges by way of the Scheldt and came to Beveren, a large village. From there

to Vracene, also a big village; thence we passed through some villages and came to a fine large village, where the rich farmers live, and there we breakfasted. Thence we journeyed towards St Paul's, the rich abbey, and went through Caudenborn, a fine village; thence through the large village of Kalve, and thence to Ertvelde; there we lay the night and started early on Sunday morning and came from Ertvelde to a small town. From that we went to Ecloo, which is a mighty large village; it is plastered, and has a square; there we breakfasted. Thence we went to Maldegem, and then through other villages, and came to Bruges, which is a fine noble town. I paid 21 stivers for fare and other expenses. And arriving at Bruges, Jan Prevost took me into his house to lodge, and the same night prepared a costly meal, and asked much company to meet me. The next day Marx, the goldsmith, invited me, and gave me a costly meal and asked many to meet me; afterwards they took me to see the Emperor's house, which is large and splendid. There I saw the chapel which Roger [van der Weyden] painted, and some pictures by a great old artist. I gave the man who showed them to us 1 stiver; afterwards I bought two ivory combs for 30 stivers. Thence they took me to St James's and let me see the splendid paintings of Roger and Hugo [van der Goes], who are both great masters. Afterwards I saw the alabaster Madonna in Our Lady's Church that Michelangelo of Rome made; afterwards they took me to many churches and let me see all the fine paintings, of which there is abundance there, and when I had seen the Jan [Van Eyck] and all the other things, we came at last to the Painters' Chapel, in which there are good things. Then they prepared a banquet for me, and I went thence with them to their guildhall; there were many honourable men gathered together, goldsmiths, painters, and merchants, and they made me sup with them, and they gave me presents and sought my acquaintance and did me great honour; and the two brothers Jacob and Peter Mostaert, the town councillors, gave me twelve cans of wine, and the whole assembly, more than sixty persons, accompanied me home with many torches. I also saw in their shooting gallery the great fish tub from which they eat, which is 19 feet long, 7 high, and 7 broad.

Early on Tuesday we departed, but before that, I did Jan Prevost's portrait in silverpoint, and gave his wife 10 stivers at parting. And so we travelled to Ursel; there we breakfasted. On the way there are three villages. Then we travelled towards Ghent, again through three villages, and I paid 4 stivers for the journey, and 4 stivers for expenses; and on my arrival at Ghent, there came to me the dean of the painters and brought with him

the first masters in painting; they showed me great honour, received me most courteously, and commended to me their goodwill and service, and supped with me. On Wednesday early they took me to the tower of St John's, whence I looked all over the great and wonderful town, where I had just been treated as a great person. Afterwards I saw the Jan [Van Eyck] picture [the Ghent Altarpiece], which is a very splendid, deeply studied painting, and especially the *Eve*, the *Mary*, and *God the Father* were extremely good. Then I saw the lions and drew one of them in silverpoint; also I saw on the bridge, where men are beheaded, two pictures which were made as a sign that there a son had beheaded his father. Ghent is beautiful and a wonderful town; four great waters flow through it. I gave 3 stivers as a tip to the sacristan and the lions' keeper. I saw many other remarkable things in Ghent, and the painters with their dean did not forget me, but ate with me morning and evening, and paid for everything, and were very friendly. I gave away 5 stivers at the inn on leaving. Then early on Thursday I set out from Ghent and came through various villages to the inn called The Swan, where we breakfasted; thence we passed through a beautiful village and came to Antwerp, and I paid 8 stivers for the fare.

(Albrecht Dürer, 6–11 April 1521)

In Morocco, the critic and curator John Elderfield contends, Henri Matisse found a personal paradise.

When Matisse started to paint for the very first time, during a long convalescence when he was twenty years of age, he was startled and delighted by how it affected him. 'I felt transported into a kind of paradise,' he said. 'In everyday life I was usually bored and vexed by the things that people were always telling me I must do. Starting to paint I felt gloriously free, quiet and alone.'

The Moroccan garden was a place of freedom, quiet, and solitude, a kind of paradise; and Matisse did not object when his friend Marcel Sembat wrote that he had transformed the Moroccan landscape into a terrestrial paradise. It was, in fact, the first of three specific venues that Matisse chose to represent the ideal conditions of his art, and the seminal one: the second, Nice, was a reimagination of Morocco; the third, Oceania, a replacement modelled on it. After *Le Bonheur de Vivre*, in which Matisse first imagined what his paradisal garden might look like, *Nu Bleu* had attempted to locate it geographically in an African oasis. But the location

did not take and the depicted landscapes of his art became increasingly bare, primal, even forbidding. Returning to Africa in 1912, after having seen oriental gardens in representations and Moorish ones in reality, he discovered a more cultivated than primitive pastoral; as such, one more easily transported back home. In France, in the late spring and summer of 1912, he began methodically to picture his own surroundings as a kind of paradise . . .

When Matisse painted his Moroccans as a mysterious backward race, as much primal as exotic but tending to inertia, he was using established conventions as a way of painting his own personal pastoral, his *rêve du bonheur.* This is why he was compelled to generalize: because Arcadia could be anywhere. (Thus *Zorah Debout* not only recalls any number of Persian miniatures; as Alfred Barr observed, it also brings to mind Holbein's *Christina of Denmark.*) This is why he had to avoid detail: because Arcadia is an imaginary location and cannot be specified. This is why he purged figures of expression: because he was painting not contemporary individuals but atemporal, representative types. (Even Manet's comparable images look positively animated in contrast.) And this is why he so rigorously flattened everything to the surface. The light of Morocco did tend to flatten. So did the very familiar images of Morocco that Matisse must have seen, namely travel photographs: at times, there are striking resemblances between such photographs and Matisse's paintings. But mainly, it was representation of Arcadia that required flatness. It was not something to be seen in deep space, not something real to be observed as if through a window. It was something imaginary to be projected on the surface of memory, something that spread out over the surface as a map did, and like a map it signified rather than described. The *Café Marocain* is such a map of Morocco as an Arcadia.

There is a considerable range of pictorial feeling across the group of Moroccan figure paintings. While not characterizations of people, they are characterizations of types: Matisse did vary his technique from subject to subject in the interpretation of character. Thus, he interpreted the character played by Fatma (a friendlier version of the traditional proud negress) by using denser, more compacted paint than he did for the character played by Zorah (an innocent version of the mysteriously sensual odalisque), who got a lighter, more ethereal treatment, and he reserved the most fluid treatment of all for the part of the colourful warrior, assumed with great equanimity by the Riffians, whose images have been freely improvised from very liquid paint. And in each of these cases, the

characterization extended to the entire pictorial surface, not merely to the boundaries of the represented character.

In line with this, *Café Marocain* may be thought of as Matisse's interpretation of the character of the meditating Moroccan. But this subject is very different from the others and must be painted very differently: because it asks for characterization of that part in the Moroccan cast where character, as such, is sublimated and disappears. In reverie and contemplation, all is reduced to an almost featureless state, to a pale, tonal similarity that mutes the individual self, blurring the division between it and its surroundings. And yet, to the observer, the individual self seems enclosed within itself, abstracted, deprived of communication with its surroundings. Matisse's picture allows of such interpretation as an illustration of Moroccan reverie. It was certainly based on a café that he visited and shows a view of Moroccan life he found fascinatingly exotic and personally sympathetic. That is to say, it is simultaneously a condensation of reality and a model of the imagination.

Matisse would later muse about 'some paradise where I shall paint frescoes'. This is, effectively, what he had done in making the *Café Marocain*: using not oil but a water-based, distemper medium for the delicate continuity of its matt surface and working in an environment he had come to think of as paradise, he progressively reduced the image until it reached the state of clarity that for him was grace. 'To perfect is to simplify' is the motto of his last decorative composition for twenty years.

His period of decorative art was thus ended, not to be reopened until after he took another exotic journey, to Tahiti, in 1930. And then, commissioned to paint a mural for Dr Barnes, did his sight of the lunettes over the windows in the house at Merion perhaps recall the arcade of a Moroccan café? We do not know. But the pastel tonality was reprised and the dance that Matisse painted was of extremely relaxed measure . . .

At various moments in Matisse's early Nice period . . . Moroccan reference seems very explicit. Then he made numerous paintings of odalisques in exotic costumes before staged decorative settings. At the beginning and at the end of this period, for example in *Déjeuner Oriental* of 1917 and in *Odalisque et Tabouret* of 1928, Matisse depicted actual black or oriental models as if in some Middle Eastern harem. More often he dressed up his regular model. In the early and mid-1920s when most of these representations were made, it was Henriette Darricarrère who assumed the role of an odalisque, posed in what amounted to a makeshift theatre constructed from hanging patterned textiles and Moorish screens.

'I do odalisques,' Matisse explained, 'in order to do nudes. But how does one do the nude without it being artificial? And then, because I know that they exist. I was in Morocco. I have seen them.' The nude is an artificial convention, not to be found in life as nakedness is. To make the nude seem real in art meant finding nakedness in life in its most artificial form. 'As for odalisques,' he added later, 'I had seen them in Morocco, and so was able to put them in my pictures back in France without playing make-believe.' This is to say: what Matisse was creating was made up, of course, but it was not mere make-believe because Matisse did believe in its reality. Morocco had shown him such a reality. Now he was painting it.

Of course, he was painting a fantasy – a private oasis of earthly delights – but fantasy not in the sense of the incredible, not as something entirely separated from reality, but rather what reality can be confused with and mistaken for. And in so far as the Nice odalisques are remembrances of Morocco, they are fantasies, in the same sense, of Morocco too. Matisse may have seen in Moroccan brothels women dressed and posed like those he painted in Nice. But he did not paint them in Morocco. The Moroccan paintings may be sensual but they are never sexual. What Matisse made in Nice was, therefore, not a re-creation of the Moroccan experience; rather, a re-creation of what it might have been. This is why it is presented as drama: to make it persuasive. This is why it had to be so thoroughly detailed: to make the drama seem authentic. And this is why it required a realist style: to persuade us that it is true. While flat modern simplification produced a 'grand style', Matisse said, the use of half-tones was 'much closer to the truth'.

More than the objects of pleasure, the continuity of shimmering light produced by films and thin layers of colour associates the Nice-period paintings with those done in Morocco. Whites breathing through colour, perhaps the most important of the lessons Matisse learned from Cézanne, spread unifying light to express the homogeneous spectacle of the world. But there was another and even more radical way that light and its continuity could be expressed; an entirely opposite way, by using 'black as a colour of light and not as a colour of darkness.' In 1916, three years after his return from Morocco and one year before he first moved to Nice, Matisse used this method to paint *Les Marocains*.

This, his definitive 'souvenir du Maroc', as he described it, is luminous without being light. And its black unifies by first dividing. The multiplicity of reality, explored in the Moroccan paintings separately, is suggested in one work. The three zones, denoting architecture, melons, and Moroccan

men, seem independent memories. They appear to have been observed from different angles. Matisse used the spatial cell convention he learned from Islamic art in this stylistically most non-exotic context. But these separate souvenirs of Morocco are linked by the continuity of the black field as if by a continuous undercurrent of feeling. Black is suggestive of light. It evokes the intensity of tropical sun and shadow, their erosion of form, and conveys a remarkable sense of physical heat. As important, however, black is 'a force . . . to simplify the construction,' the simplifying force of memory, which remembers Morocco not merely for its climate or its light or its individual marvels but for its continuous mystery. And yet, its mysteriousness is quite unlike that of the Moroccan Triptych, say; it is not quite celebratory of Morocco. It is a form of elegy.

When Matisse first thought to paint a large remembrance picture of his Moroccan experience, shortly after the April 1913 Bernheim-Jeune exhibition [Parisian art dealer] of his works made in Morocco, he considered a beach scene. He soon abandoned that idea and, instead, eventually reworked his large *Demoiselles à la Rivière*, giving it what could well be a Moroccan setting. In any event, 1913 was a year of change and readjustment. Matisse re-established contacts with the Parisian avant-garde, took long walks and horse-rides with Picasso, confronted Cubism; his art was too much in flux for an important synthetic work. He considered returning to Morocco for the winter but at the very last moment decided against it, saying that he did not want the temptations of the picturesque to disperse his energies. It was not until late in 1915 that he was able to settle to what he obviously considered a definitive painting. He began it as a reprise of *Café Marocain*. As completed in 1916, it could hardly be more different. Both are products of pictorial reduction and elimination. In the earlier work, the result is simplification that produces calm by having removed anything disturbing. In the later work, the result is simplification that accepts – within an environment of calm – contradiction, dissonance, and extraordinary tension.

Matisse had returned from the opportunism of clarity to the conscientiousness of anxiety, and would spend the rest of his life trying to get back. *Les Marocains* remembers Morocco in 1916, at the height of a terrible war, the destroyer of nature to an extent no previous war had been, the tangible agent of the anti-pastoral. Therefore that picture remembers not only what is past but also what is lost. The Golden Age had always been in the past. Pastoral had always been instinct with elegy. But it had always, before, seemed recoverable.

This is not to say that Matisse is for ever a changed artist because of the war. Rather, that his so-called experimental period of the war years effectively ended the youth of his art and its idealized peace. His re-involvement in Morocco with the discovery of form purely in the process of painting prepared for what happened in the experimental period; so did his return to nature and the discovery of its visual uncertainty as being so extreme as to require multiple and stylistically various representations. There was not a sudden break in Matisse's artistic development after Morocco as is often claimed. And yet there was a most critical change. He would again paint pictures with the freshness of those he made in Morocco, but never of the same innocence. When Matisse returned from Morocco, it was to begin a longer and more arduous journey.

(John Elderfield, 1990)

David Hockney discovers California in 1963.

When I got to Los Angeles I didn't know a soul. People in New York said You're mad for going there if you don't know anybody and you can't drive. They said At least go to San Francisco if you want to go West. And I said No, no, it's Los Angeles I want to go to. So it was arranged; I was going to have an exhibition in New York, at Charles Alan's Gallery, and I said I'd paint the pictures in California. Charles said It's crazy, you know you won't even be able to leave the airport if you can't drive; it's madness. So he phoned up this guy who was a sculptor there, who showed in his gallery, called Oliver Andrews. He very kindly came to meet me at the airport and he drove me to a motel in Santa Monica and just dropped me. He gave me his phone number. I got into the motel, very thrilled; really, *really* thrilled, more than in New York the first time. I was so excited. I think it was partly a sexual fascination and attraction. I arrived in the evening. Of course I'd no transport but the motel was right by the bottom of Santa Monica Canyon, just where Christopher Isherwood lives. I didn't know him then and although I had his address I didn't know it was near there. I checked into this motel and walked on the beach and I was looking for the town; couldn't see it. And I saw some lights and I thought, that must be it. I walked two miles, and when I got there all it was was a big gas station, so brightly lit I'd thought it was the city. So I walked back and thought, what am I going to do? Next morning I phoned up Oliver and said I want to go into the town; I must buy a bicycle. And he said

All right, I'll take you. It appeared the town was just at the back; I'd been looking the wrong way. He took me to buy a bicycle and he told me about an English writer there. I said You mean Christopher Isherwood? And he said Yes. He knew him. So I said I'd love to meet him.

I had read John Rechy's *City of Night*, which I thought was a marvellous picture of a certain kind of life in America. It was one of the first novels covering that kind of sleazy sexy hot night-life in Pershing Square. I looked on the map and saw that Wilshire Boulevard which begins by the sea in Santa Monica goes all the way to Pershing Square; all you have to do is stay on that boulevard. But of course, it's about eighteen miles, which I didn't realize. I started cycling. I got to Pershing Square and it was deserted; about nine in the evening, just got dark, not a soul there. I thought, where is everybody? I had a glass of beer and thought, it's going to take me an hour or more to get back; so I just cycled back and I thought, this just won't do, this bicycle is useless. I shall have to get a car somehow.

Then Oliver came to visit me next day and said How's the cycling going? And I said Well, I went to Pershing Square. Why did you go to Pershing Square? Nobody in Los Angeles ever goes to downtown Los Angeles, he said. I said I'll have to get a car. And he said I'll take you to the licence place and you can get a provisional licence and then you can drive round, practise a bit; it's easy, driving. I'd never driven before in my life. He showed me a bit of driving. He said All you do is put your foot here to go and your foot there to stop; automatic car, no gears; so I tried it out. We went up to the licence place and they said You fill out this form. And the form had questions on it like What is the top speed limit in California: 45 miles an hour, 65 miles an hour, 100 miles an hour. Well, you can guess, you don't have to be too smart or even to have read the Highway Code. And all the questions were like this. I just picked the answers using common sense. And they said You made four mistakes; that's allowed. Where's your vehicle? I said How do you mean, where's the vehicle? They said You take the driving test now, the practical bit; you passed the first part. I said Could I come back tomorrow? They said Come back this afternoon; you get three goes for your three dollars. If you fail you can come back. Oliver was amused that I'd inadvertently passed the first part of the test, and he showed me a bit, and then said You might as well have a go. And they gave me the licence.

I was thrilled but frightened. I thought, that's all you do and everybody's zipping about you? I went and bought a Ford Falcon in the afternoon, which cost about a thousand dollars; first car I'd ever had; and I was very

scared driving it. I thought, I'll have to practise; and I just drove anywhere. I got on a freeway the second day and I daren't move off any of the lanes and I went all the way to San Bernardino on the freeway, sixty miles inland. I thought, I'll turn round here, if I can find where you get off. Then there's a sign: Las Vegas 200 miles. And I thought, wonderful, I'll practise in the desert, and I drove all the way to Las Vegas, and drove back at night.

The day after, I found a studio. Just drove down to Venice, this place for rent, little sign up. I said I'll take it; room overlooking the sea, not very big. Then I just rented a small apartment, very easy to find in Los Angeles. You just drive down the streets and there are notices saying 1½ rooms to let; a very American way, I thought, half a room. I imagined the half-room being from the ceiling halfway down the walls. Within a week of arriving there in this strange big city, not knowing a soul, I'd passed the driving test, bought a car, driven to Las Vegas and won some money, got myself a studio, started painting, all in a week. And I thought, it's just how I imagined it would be . . .

I went into an art store and it was full of American equipment. I'd tried acrylic paint in England before and I hadn't liked it at all; texture, colours weren't so very good. But the American ones I liked. It was superior paint. And so I started to use it. It has one or two effects. For one thing you can work on one picture all the time because you never have to wait for it to dry, whereas you might work on two or three oil paintings at a time because it takes so long for the paint to dry.

I began to meet artists. In those days, all the galleries in Los Angeles were on one street in Hollywood. They were run by young people; they showed young artists. I didn't know the artists there at all; I was quite surprised. On a Monday evening the galleries were all open, and people parked their cars and walked up this street and looked in. It was very pleasant, and it was also a way for artists to meet each other socially each week. In a city like Los Angeles it's difficult to meet people accidentally. In Paris it's easy, but not in Los Angeles. At the top of the street there is that place called Barney's Beanerie; Ed Kienholz made a replica of it later. I went there to look around, and I talked, met, was introduced to people. There were a lot of young artists there about my age and there was a kind of small California Pop Art school, but I'd never heard of it. The only Californian artists I'd ever heard of before I went there were Richard Diebenkorn and David Park; they were from Northern California and painted in a slightly Bomberg way. Diebenkorn is a marvellous painter

and a wonderful draughtsman; marvellous drawings always. He's always underplayed in America.

The very first picture I painted there was *Plastic Tree Plus City Hall* and the second was *California Art Collector*, and then *Ordinary Picture* which still has curtains.

After I'd been there a couple of months, Kasmin [John Kasmin, David Hockney's London dealer] came out on his first visit to California, to see me and some collectors. I went with him to visit the collectors. I'd never seen houses like that. And the way they liked to show them off! They were mostly women – the husbands were out earning the money. They would show you the pictures, the garden, the house. So then I painted a picture, *California Art Collector*, in February 1964: it's a lady sitting in a garden with some art; there was a Turnbull sculpture. There was a lot of sculpture by Bill Turnbull; somebody'd been and sold them there a few years before. The picture is a complete invention. The only specific thing is the swimming pool, painted from an advertisement for swimming pools in the Sunday edition of the *Los Angeles Times*. The houses I had seen all had large comfortable chairs, fluffy carpets, striped paintings and pre-Columbian or primitive sculptures and recent (1964) three-dimensional work. As the climate and the openness of houses (large glass windows, patios, etc.) reminded me of Italy, I borrowed a few notions from Fra Angelico and Piero della Francesca.

I got into work straight away. By this time I had met Christopher Isherwood and we instantly got on. He was the first author I'd met that I really admired. I got to know him and Don Bachardy, whom he lives with, very well; they would invite me out, take me around to dinner; we had marvellous evenings together. Christopher is always interesting to talk to about anything and I loved it, really loved it. I don't know how it was that we hit it off, but we did. It wasn't only that we were English, but we were both from northern England. I remember Christopher later said Oh David, we've so much in common; we love California, we love American boys, and we're from the north of England. Of course Christopher's from the opposite side of the north of England: his family was quite rich, mine is working class.

I went to visit the place where *Physique Pictorial* was published in a very seedy area of downtown Los Angeles. It's run by a wonderful complete madman and he has this tacky swimming pool surrounded by Hollywood Greek plaster statues. It was marvellous! To me it had the air of Cavafy in the tackiness of things. Even Los Angeles reminded me of Cavafy; the

hot climate's near enough to Alexandria, sensual; and this downtown area was sleazy, a bit dusty, very masculine – men always; women are just not part of that kind of life. I love downtown Los Angeles – marvellous gay bars full of mad Mexican queens, all tacky and everything. The *Physique Pictorial* people get men, boys, when they've just come out of the city gaol: Do you want to earn ten dollars? Take your clothes off, jump in the pool, that sort of thing. They're all a bit rough-looking, but the bodies are quite good. The faces are terrible, not pretty boys, really. I must admit I have a weakness for pretty boys; I prefer them to the big, butch, scabby ones. I was quite thrilled by the place, and I told the guy. I bought a lot of still photographs from him, which I still have.

(David Hockney, 1976)

The correct setting for a painting by the seventeenth-century Spanish master Francisco de Zurburán.

Many of Zurburán's paintings remain in Andalusia, but only a fraction of these are in the settings for which they were originally intended. He painted his major works mainly for monasteries and convents, and most of these institutions either fell on hard times in later years or else were dissolved: in either case nineteenth-century collectors, responding to the growing fashion for his art, made every possible effort to acquire the paintings. Two of Zurburán's most important Andalusian commissions were for the Charterhouses at Jerez de la Frontera and Seville. A visit to the former institution greatly helps an understanding of Zurburán's art, even though all his paintings that were once there have long been dispersed. The Charterhouse lies in fertile, undulating countryside several kilometres to the east of Jerez. In the early Baroque period its church was given a sumptuously ornate façade and embellished inside; but the greater part of the complex was finished in the late fifteenth to early sixteenth centuries, and is in a Gothic style. It is the only Charterhouse still functioning in Andalusia, and you have to be male and get special permission to pass through its gates.

The Carthusian monks are few in number and occupy only a small area of the original vast complex. Unable now to work the large orchard which they own, they dedicate much of their spare time to maintaining the surviving parts of the Charterhouse in a state of spotless cleanliness. The odd monk in his coarse white garment and with shaved head walks silently

by, disappearing into the darker recesses of a sharply lit cloister. The atmosphere is of perfect order and complete silence. Zurburán was the ideal artist to produce work for such an environment, and his pictorial style was also excellently suited to portray the austere robes of the Carthusians. The placing of these robes against the artist's characteristic dark backgrounds creates a most powerful effect, as can be seen in Zurburán's panels of saints now in the Museum of Fine Arts at Cádiz. These and a group of other small panels in Cádiz are all that remains in Andalusia of his Jerez altarpiece. In the Museum of Fine Arts in Seville, however, you can see the three large works that Zurburán executed for the Sacristy of Seville's own Charterhouse. The most impressive of these works depicts the moment when the Carthusian bishop St Hugo observes a bowl of meat turning into ashes, thus offering him divine justification of the Carthusian practice of vegetarianism and abstinence. A group of Carthusians are shown in icon-like formation behind a long refectory table. For those lucky few who have been to the Charterhouse at Jerez, memories of the refectory there will come back as you look at this scene, which reveals to the full Zurburán's genius as a painter of simple still-lifes in which the humblest object is invested with tranquil dignity. The table is covered in a plain white cloth, and sparingly laid with the same blue and white ceramic bowls and mugs that are still in use in Jerez's Charterhouse today.

(Michael Jacobs, 1990)

Robert Hughes on the quintessential Catalan art of Joan Miró.

There cannot be many images of cardinal social virtue in modern art, but one of them was certainly painted by the Catalan artist Joan Miró. It is *The Farm, Montroig*, a portrait of the place where he spent much of his childhood and to which, for the rest of his life, his imagination would always return. He began to paint it in 1921, in the place itself: the family house, or *casa pairal*, in a small village near Tarragona, south of Barcelona. He then took the unfinished picture, along with a bunch of dried grass from the farm – a fetish of contact with the Catalunya he was about to lose – to Paris. Shifting between lodgings, he lost the grass but replaced it with some from the Bois de Boulogne; the picture was too advanced by then to lose any truth by the substitution. Miró finished it in Paris in 1922 and eventually sold it to Ernest Hemingway, who for the rest of his

life revered it as *his* fetish of Iberian memory: 'It has in it,' he wrote, 'all that you feel about Spain when you are there and all that you feel when you are away and cannot go there. No one else has been able to paint these two very opposing things.'

He was right; *The Farm* is, above all, an expatriate's painting, combining in one image the intense pressure of immediate experience of one's homeland and an equally extreme longing for it. Everything on the farm, the leaves on the trees no less than each crack in the old wall and pebble in the red Tarragonese earth, is rendered with utter fidelity: the landscape is a palace of recollection, a mnemonic device in itself. Miró's sense of separation and longing is conveyed by a kind of visual accountancy, an exact totting up and tallying of everything that is (or was) the case on the family farm. It could be a pictorial form of the meticulous inventory that went with peasant marriage contracts. Each tool, pitcher, keg, press, cart, watering can, donkey, dog, chicken, goat, pigeon, and donkey's rump (just visible through the door of the *bestiar* on the ground floor of the farmhouse) is turned to the light, delineated, listed, fixed. The sharp focus, the hallucinated clarity of light, make the painting exquisitely frank. But they also produce the effect of looking down the wrong end of a telescope, so that the scene is remote as well. Hence *The Farm*'s power as an image of nostalgia for what is distant but vivid and dear, for the sights, smells, and sounds of childhood. Such longings are known in Catalan as *enyoranca*.

Enyoranca was the basic trope that suffused the nationalistic literature of Catalunya from Carles Aribau's 'Oda a la Pàtria' (1833) right through the nineteenth century and into the early twentieth, when Miró was an art student on the top floor of the Llotja, or Lodge, the Barcelona stock exchange. Indeed, a suitable gloss on *The Farm* might have been the lines of Barcelona's poet-priest Jacint Verdaguer in his most popular short poem, 'L'Émigrant', which every Barcelonese schoolboy was taught to recite as a matter of course:

> Dolça Catalunya,
> patria del meu cor,
> quan de tu s'allunya,
> d'enyoranca es mor.

> Sweet Catalunya
> homeland of my heart
> to be far from you
> is to die of longing.

There are other elements behind *The Farm*: continuity, conservatism, precise craftsmanship, and something the Catalans untranslatably call *seny*.

By tradition, when Catalans reflect on themselves they get absorbed by the differences that set them off, individually and as a 'nation', from the rest of Spain. Speculating about this *fet differential*, as Barcelona's great fin-de-siècle poet Joan Maragall called it, was a favourite intellectual sport in Miró's youth, filling countless essays. Usually the argument devolved, as such arguments will, into a play of stereotypes. Thus when Catalans looked at Castile, they saw sloth, privilege, and a morbid tendency to inwardness, bred of long years of aristocratic effeteness; a taste for oppressing others, particularly Catalans; a lack of practical sense. The image of the Castilian as occupying leech, taxing the lifeblood out of Catalunya, was standard in Barcelona from the seventeenth century to the death of Franco in the late twentieth.

When Castilians looked at Catalans, they had their say too. Catalans were dull. They were pedantic and resentful by turns, usually both; too addicted to material things to understand the classic austerities of Castile, let alone its spirituality; and inordinately self-satisfied with their patch of Mediterranean earth – a polity of grocers, barking at one another in a bastard language. No Catalan, in their view, could see beyond the pig in his yard, the fat angel sent to earth by God to supply Catalans with their daily viaticum of *butifarra* [pork sausage] and ham.

When the Catalans observed themselves, it was a different story. Loyal, patriotic (as long as you understood that the *pàtria* was Catalunya, not the Iberian abstraction dear to Madrid centralists), practical, ingenious, innovative though respectful for their roots, the whole mass of virtues leavened with just a *xic* of humour – what a people! For once, the Lord got it right, and though Catalans might not take their piety to the edge of superstition (like the Sevillians, say, who were practically Arabs anyhow), they had every right to praise Him for placing them on earth, armed with the virtues for which they were justly famous: *continuitat, mesura, ironia*, and *seny*.

That *The Farm* is conceived in praise of *continuitat* is evident enough. The farm is old and goes back for generations; its tools are traditional; it represents an unchanging order of work, dictated by seasons and weather, by the fertility of the soil and the benignity of that strange, electric-blue sky. The same with *mesura*, for nothing in the painting lacks order, proportion, a sense of graded repetition. A clan that works steadfastly at the same task, down the generations, trusting in the work of the hand to

make things tangible and spaces habitable, eschewing abstract speculation and fanciful enthusiasm – that family has *mesura*, and its members are the right kind of folk to belong on such a farm as this. *Ironia* is present in the copy of a French newspaper, *L'Intransigeant*, neatly folded and weighted down on the foreground by a watering can. It is the only foreign thing in the painting – a sign of Miró's destination, Paris, and of course a reference to Cubism with its newsprint and cut-off headlines, but also a confession that he, in quitting the idealized Catalunya of his ancestors, is being 'intransigent' (the word is the same in Catalan), a stubborn prodigal son, the *hereu*, or 'heir', leaving his birthright. Put *continuitat, mesura,* and *ironia* together, and you are on the way to *seny*.

Seny signifies, approximately, 'common sense'; it means what Samuel Johnson meant by 'bottom', an instinctive and reliable sense of order, a refusal to go whoring after novelties. In traditional Catalan terms it comes to 'natural wisdom' and is treated almost as a theological virtue. When the fifteenth-century Catalan metaphysical poet Ausiàs March wanted words to sum up his devotion to the unnamed woman his verses address, he called her either *llir entre cards* (lily among thistles) or *plena de seny* (woman full of wisdom). Catalans suppose that *seny* is their main national trait. It is to them what *duende* (literally 'goblin', and by extension a sense of fatality or tragic unpredictability) is to more southern Spaniards. It is a country virtue, arising from the settled routines and inflexible obligations of rural life. In *The Forms of Catalan Life* (1944) Josep Ferrater Mora gave a lengthy disquisition on *seny*. 'The man with *seny* is, primordially, the well-tempered man; that is to say, the man who contemplates things and human actions with a serene vision.' It was the mirror reverse of Castilian quixotism. It was opposed to intellectual over-refinement. Its inherent danger was being lowbrow. The pragmatic nature of *seny*, he thought, gave Catalans a markedly anti-spiritual stamp and set their collective temperament some-where between the puritan and the Faustian: 'Faustian man or Romantic man are those to whom salvation and morality matter little; Puritan man is only concerned with salvation and morals. The man of *seny* renounces neither salvation nor experience, and is always trying to set up a fruitful integration between both opposed, warring extremes.'

Perhaps Catalan *seny* is, as Mora thought, anti-spiritual; this would seem to be borne out by the recent experience of a Catalan friend who went home for Christmas to his native village and attended midnight mass with his relatives. The church was packed. The priest and deacon brought forth the image of the Infant Jesus so that everyone in the congregation could

kiss its wooden feet. A long line began to shuffle toward the communion rail; so long, the priest realized, that it would be three in the morning before he got to dinner. There was a whispered confabulation. The deacon scurried into the sacristy and emerged with another wooden Jesus; two lines formed, and the kissing was over in half the time. Perhaps only in Catalunya, the first industrial region of Spain, could time-and-motion study be so quickly and instinctively applied to piety.

The relief from *seny* is *rauxa*. *Rauxa* means 'uncontrollable emotion, outburst'. It applies to any kind of irrational or Dionysiac or (sometimes) just plain dumb activity – getting drunk, screwing around, burning churches, and disrupting the social consensus. The purpose of feast days is to give *rauxa* a sanctioned outlet: on Saint John's Night, in June, for instance, the whole of Catalunya is lighted by bonfires as its towns erupt in the continuous thunder of *petardes*, fireworks, which go on until five or six in the morning. Not even in New York on the Fourth of July is the bombardment so intense. *Rauxa* and *seny* coexist like heads and tails on a coin; you cannot separate them, and the basic reason that Joan Miró is seen as so quintessentially a Catalan artist is that he displayed both at once in such abundance.

Probably the most pervasive cultural form of *rauxa* is an abiding taste for obscene humour: not so much sexual – or not more so, anyway, than in the United States and possibly rather less so than in the rest of Spain – as scatological. The Catalan preoccupation with shit would make Sigmund Freud proud; no society offers more frequent and shining confirmations of his theories of anal retention. In this respect, the Catalans resemble other highly mercantile people such as the Japanese and the Germans.

The pleasures of a good crap are considered in Catalunya on a level with those of a good meal; 'Menjar be i cagar fort / I no tingues por de la mort,' goes the folk saying: 'Eat well, shit strongly, and you will have no fear of death.'

The image of shit has a festive quality unknown in the rest of Europe. On the Feast of the Kings, January 6, children who have been good the previous year are given pretty sweetmeats; the bad ones get *caca i carbo*, 'shit and coal', emblems of the hell that awaits them if they do not mend their childish ways. These days the coal is left out and the gift consists of brown-marzipan turds made by confectioners, some elaborately embellished with spun-sugar flies. Then there is the *tio*, or 'uncle', a cross between the French *bûche de Noël* and the Mexican *piñata*. This artificial log, filled with candy and trinkets, is produced amid great excitement at

Christmas; the children whack it with sticks, exclaiming, 'Caga, tiet, caga!' ('Shit, Uncle, shit!') until it breaks and disgorges its treasures.

If you find yourself in Barcelona just before Christmas, go to the Cathedral and browse the stalls that have been set up in front of its façade, where figures for the crèche are sold. They are what you expect: the shepherds, the Magi, Mary, Baby Jesus, the sheep, the oxen. But there is one who is a complete anomaly, met with nowhere else in the iconography of Christendom. A red Catalan cap, or *barretina*, flopping over his head, the fellow squats, breeches down, with a small brown cone of excrement connecting his bare buttocks to the earth. He is the immemorial fecundator, whom nature calls even as the Messiah arrives. Nothing can distract him from the archetypal task of giving back to the soil the nourishment that it supplied to him. He is known as the *caganer*, the 'shitter', and he exists in scores of versions: some pop-eyed with effort, others rapt in calm meditation, but most with no expression at all; big papier-mâché ones three feet tall, minuscule terracotta ones with caca pyramids no bigger than mouse turds, and all sizes in between. During Christmas 1989, the Museum of Figueras held an exhibition of some five hundred *caganers*, borrowed from private collections all over Catalunya. (There are, of course, collectors who specialize in them.) It was solemnly and equably reviewed in the Barcelona papers, with close-up photos of one or two of the figures, just as one might wish to reproduce a David Smith totem or a nude by Josep Llimona. The origins of the *caganer* are veiled in antiquity and await the attentions of scholarship. Sixteenth-century sculptures of him exist, but he seems to be curiously absent from medieval painting. He is, essentially, a folk-art personage rather than a high-art one. His place is outside the manger, not inside the altarpiece. Yet he makes an unmistakable entrance into twentieth-century art in the work of that great and shit-obsessed son of Catalunya, Joan Miró. If you look closely at *The Farm, Montroig*, you will see a pale infant squatting in front of the cistern where his mother is doing the washing. This boy is none other than the *caganer* of Miró's childhood Christmases; it may also be Miró himself, the future painter of *Man and Woman in Front of a Pile of Excrement* (1935).

(Robert Hughes, *Barcelona*, 1992)

Suffering from a fatal disease, the painter Michael Andrews sets out with his wife June on an artistic journey of discovery of the River Thames, its source and its mouth.

On June 1, 1994, Andrews was operated on for what proved to be cancer. He came home a fortnight later to convalesce and began working again as soon as he could. His idea for the next painting was to go to the source of the Thames. Three months later, he and June went on by car to Kemble in Gloucestershire. The day was hot and he was frail. At Thames' Head the meadow was dry; the subject evaporated. He took photographs though and as they returned through Cotswold villages he was intrigued by the diminutive scale, particularly the bridges in front of each house, one stride long, spanning the baby Thames.

'Many parts of Oxfordshire were just too bijou for him. He wanted it wild with weeds growing. He was going to go back when the water was there.'

He filled a board with his photographs of the stream and began on the painting, working on a stretch of potential water and the bulk of foliage. Then he set it aside and concentrated on the other picture.

On October 12 they were driven to Cliffe, on the Isle of Grain, hoping to get a good view of the Thames estuary. It was no use: too flat, too muddled. Two days later they tried the Essex side, taking the train to South Benfleet and a taxi to the sea wall on Canvey Island.

'We sat up there on a seat, watched the tide go out and men with shovels and margarine tubs dig up worms,' June says. 'People passed and said "Not such a good day today." It was where men had dug for centuries and you could see they had their favourite places for digging and were all keeping an eye on each other. Mike didn't draw; he photographed.'

There was little pretence at normal working. He no longer cycled to the studio. June and Mel went with him by taxi. The cancer spread. 'I'm just thinking of finishing the next two pictures,' he told his doctor.

'Every time he went into hospital for a check-up or scan we had to take him to the studio first. As if he thought he might not see it again.'

In the Thames paintings deep washes of emotion are suspended and preoccupations merge. There are precedents: Constable's elegiac *Hadleigh Castle* (just inland from Canvey Island), the dark landscapes of Degas. But their flux and redefinition are also his lifelong concerns and the incidentals are traceable back to his schoolboy drawings of riverbank picnics and a cartoon Noah's barge.

In what proved to be his last paintings, Andrews struck out on to

quicksands, going at it from all sides, working from inchoate accident to planted graphic detail. The three pictures share a sense of ascending vision. Seen in the perspective of his previous themes, they are his most elemental achievement . . .

On the studio wall, above a confusion of arrows and obliterations, was written 'Estuary & Upper Thames late Sept 94'. The painting set-up, as he left it, was busier than usual with supporting material. The photographs of estuary and source were there for reference, not guidance. They gave no sense of what the locations had felt like. Thinking back to their day on the sea wall at Canvey Island, June remembers the scene looking 'terribly old-fashioned'. The immemorial lugwormers were eliminated from the estuary painting, but fishermen were retained, and Andrews added a group of figures from a photograph published in the *Independent* to commemorate the centenary of Tower Bridge. Stocky late-Victorians, standing on a boat and on the end of the jetty, they could be men from Degas or Sickert, or they could be Mr Polly or Mr Kipps. Whoever they are, they are positioned as intermediaries, looking out to sea.

Quilp drowned [Daniel Quilp, a monstrous and vengeful character in Dickens's *The Old Curiosity Shop*]. The river 'toyed and sported with its ghastly freight, now bruising it against the slimy piles, now hiding it in mud or long rank grass, now dragging it heavily over rough stones and gravel, now feigning to yield it to its own element, and in the same action luring it away, until, tiring of the ugly plaything, it flung it on a swamp.'

Thames Painting: The Estuary is a finale. The ground is stained and raddled, muddied and tidemarked. We pass over it, seeing the wetness drain away, seeing the figures – which give you the scale – and finding, towards the top, that the light is too strong: the water whitens to brilliance. Look any further and we'll be dazzled.

(William Feaver, 1998)

In a letter to his friend, the Reverend Fisher, Constable defines 'Constable country' – that is, the country of his heart, which is anywhere that reminds him of his riverside childhood in Suffolk.

How much I wish I had been with you on your fishing excursion in the New Forest! What river can it be? But the sound of water escaping from mill-dams, &c. willows, old rotten planks, slimy posts, and brickwork, I love such things. Shakespeare could make everything poetical; he tells us

of poor Tom's haunts among 'sheep cotes and mills'. As long as I do paint, I shall never cease to paint such places. They have always been my delight, and I should indeed have been delighted in seeing what you describe, and in your company, 'in the company of a man to whom nature does not spread her volume in vain'. Still I should paint my own places best; painting is with me but another word for feeling, and I associate 'my careless boyhood' with all that lies on the banks of the Stour; those scenes made me a painter, and I am grateful; that is, I had often thought of pictures of them before I ever touched a pencil.

(John Constable to the Reverend John Fisher, 23 October 1821, quoted in C. R. Leslie, *Memoirs of the Life of John Constable, RA*, 1843)

The
Probity
of
Art:
Drawing

An eleventh-century Chinese poet advises on how to draw bamboo, and other such things, by fostering an internal sense of their inner life.

When a young bamboo sprouts, it is only an inch long, but the joints and leaves are already latent in it. All nature grows this way, whether it be cicadas and snakes, or bamboos that shoot up a hundred feet high. Nowadays the artists construct a bamboo, joint by joint and leaf by leaf. Where is the bamboo? Therefore in painting bamboos, one must have bamboo formed in one's breast; at the time of painting, one concentrates and sees what one wants to paint. Immediately one follows the idea, handles one's brush to pursue the image just seen, like a hawk swooping down on a rabbit. With a moment's hesitation, it would be lost. This is what Yü-k'o taught me. I understood what he meant, but could not carry it out. That is because my hand refused to obey me, through lack of practice. There are things with which you are vaguely familiar; you seem to know it, but when you want to paint it, you are at a loss. This is true not only of painting bamboo . . . [My brother] Tse-yu cannot paint; he merely understands the idea. I understand not only the idea, but also have learned the technique . . .

I have been of the opinion that men, animals, houses and furniture have a constant form. On the other hand, mountains and rocks, bamboos and trees, ripples, mists and clouds have no constant form [*hsing*], but have a constant inner nature [*li* – an inner law of their being]. Anybody can detect inaccuracies in form, but even art specialists are often unaware of errors in the inner nature of things. Therefore some artists find it easier to deceive the public and make a name for themselves by painting objects without constant forms. However, when a mistake is made with regard to form, the mistake is confined to that particular object; but when a mistake is made in the inner nature of things, the whole is spoiled. There are plenty of craftsmen who can copy all the details of form, but the inner nature can be understood only by the highest spirits. Yü-k'o's paintings of bamboos, rocks and dried-up trees may be said to have truly seized

their inner nature. He understands how these things live and die, how they twist and turn, are blocked and compressed, and how they prosper and thrive in freedom. The roots, stalks, joints and leaves go through infinite variations, never alike, and yet always appropriate; they are true to nature and satisfying to the human spirit. These are records of the inspirations of a great soul . . .

(Su Tung-p'o, 1036–1101)

Mistakes in draughtsmanship aren't necessarily fatal, according to another Chinese sage, unless they spoil the harmony of the whole.

Sometimes this happens, as a line may be out of place, or the positions and sizes of things may be wrong, or perhaps the human figures are extremely well drawn yet the scenery is imperfect, or the bridges and houses are properly located but wrong in dimensions. All this does not detract from the picture as a whole. But if a mistake is made with regard to the brushstrokes, if at some point a stroke is made which does not belong, the picture is spoiled in spite of the fact that in regard to material presentation of forms it may be quite correct. I have often seen works of ancient artists containing many mistakes. Yet these do not spoil the picture as a whole because it is bound together by one unitary force of conception. The accidental errors therefore do not matter. I cannot think much of a painting which excels in extremely fine details but has a totally undistinguished conception. Such work may have its admirers among the stupid people, but will be laughed at by those who know.

(Shen Tsung-ch'ien, *fl.* 1781)

Ingres makes a celebrated point:

Drawing is the probity of art.

To draw does not mean simply to reproduce contours; drawing does not consist merely of line: drawing is also expression, the inner form, the plane, modelling. See what remains after that. Drawing includes three-and-a-half-quarters of the content of painting. If I were asked to put up a sign over my door I should inscribe it: 'School for Drawing', and I am sure that I should bring forth painters.

(Jean Auguste Dominique Ingres, 1780–1867)

Defending Delacroix, Baudelaire distinguishes between three types of drawing.

An overriding taste demands sacrifices, and masterpieces are nothing if not so many extracts from nature. That is why we have to suffer the consequences of a great passion whatever it may be, accept a talent with all its potential, and not bargain with genius. That is what has never occurred to people who wax sarcastic about Delacroix's drawing; especially the sculptors, prejudiced and one-eyed folk beyond bearing, whose judgement is worth at most half that of an architect. Sculpture, for which colour is meaningless, and any expression of movement difficult, can have no claim to the attention of an artist particularly dedicated to movement, colour and atmosphere. These three elements necessarily require shapes that are not too clearly defined, lines that are light and hesitant, and bold touches of colour. Delacroix is the only artist today whose originality has not been impaired by the cult of straight lines; his figures are always in movement, and his draperies fluttering. From Delacroix's standpoint, the line does not exist; for however fine it be, a teasing geometrician can always suppose it thick enough to contain a thousand others; and for colourists, who seek to render the eternal restlessness of nature, lines are as in the rainbow, nothing but the intimate fusion of two colours.

Besides, there are several styles in drawing, just as there are several ranges of colour – the exact or stupid style, the physiognomical and the imaginative. The first is negative and inaccurate, by its slavish copying, natural but absurd; the second is a naturalist style, but idealized, the style of a genius who knows how to select, organize his subject, how to correct, divine, scold nature; and lastly the third style, which is the noblest and the strangest, can afford to neglect nature; it depicts another nature, which reflects the mind and the temperament of the artist.

Physiognomic drawing is usually characteristic of sensualists like M. Ingres; creative drawing is the privilege of genius.

The hallmark of drawings by the supreme artists is truth of movement, and Delacroix never transgresses that natural law.

(Charles Baudelaire, 'The Salon of 1846')

Matisse describes his attitude to drawing, and makes the point – a crucial one – that lines can and should generate light.

My line drawing is the purest and most direct translation of my emotion. The simplification of the medium allows that. At the same time, these drawings are more complete than they may appear to some people who confuse them with a sketch. They generate light; seen on a dull day or in indirect light they contain, in addition to the quality and sensitivity of line, light and value differences which quite clearly correspond to colour. These qualities are also evident to many in full light. They derive from the fact that the drawings are always preceded by studies made in a less rigorous medium than pure line, such as charcoal or stump drawing, which enables me to consider simultaneously the character of the model, the human expression, the quality of surrounding light, atmosphere and all that can only be expressed by drawing. And only when I feel drained by the effort, which may go on for several sessions, can I with a clear mind and without hesitation, give free rein to my pen. Then I feel clearly that my emotion is expressed in plastic writing. Once my emotive line has modelled the light of my white paper without destroying its precious whiteness, I can neither add nor take anything away. The page is written; no correction is possible. If it is not adequate, there is no alternative than to begin again, as if it were an acrobatic feat. It contains, amalgamated according to my possibilities of synthesis, the different points of view that I could more or less assimilate by my preliminary study.

The jewels or the arabesques never overwhelm my drawings from the model, because these jewels and arabesques form part of my orchestration. Well placed, they suggest the form or the value accents necessary to the composition of the drawing. Here I recall a doctor who said to me: 'When one looks at your drawings, one is astonished to see how well you know anatomy.' For him, my drawings, in which movement was expressed by a logical rhythm of lines, suggested the play of muscles in action.

(Henri Matisse, 'Notes of a Painter on His Drawing', 1939)

Introducing an exhibition of graphic art from prehistory to Damien Hirst, an influential teacher and painter defends a broad definition of drawing.

An artist's sense of purpose, and the quality and appropriateness of his or her response through drawing, matters far more than skill or talent

alone. Skill is the ability to do exceptionally well exactly what needs to be done. It manifests itself in any number of ways. But skill without vision is empty: skill alone does not produce great drawing.

The differences between a drawing by Ingres and one by Agnes Martin are obvious. Despite these differences, they clearly share certain crucial characteristics: the pervasive sense of calm and order, the restrained passion, the exceptional subtlety and sensitivity of their use of line. Both require skills, related but different skills. They look different because the intent, the order of emphasis, of each artist is different. The great quality of each drawing as a work of art is its capacity to embody fully the singular vision of the artist.

There are two principal misconceptions about drawing. The first is that there is a single form of 'good drawing', a way of making drawings that is somehow basic and 'common-sensical' (naturalistic representation), against which those drawings taking other forms are considered deviant. The second is that all drawing in the past conformed to the rules of 'good drawing', deviant drawing being exclusive to our own century. This exhibition clearly shows the falsity of both these ideas.

My purpose has been to take a fresh look at the art of other times and other cultures through the context of our own. For this reason, although the selection covers the whole sweep of history, about half the works come from the twentieth century, particularly from the past forty years. This is the culture of our own time, the lens through which we view the world. The present influences the past more than the past influences the present.

I was asked to select the works for this exhibition *as an artist*. My whole understanding of art has come from my experience as an artist. There is a difference between the way artists look at and consider works of art from the way historians, critics, collectors, curators, and dealers usually do. It is unfortunate that people trying to understand art often treat artists with scepticism, while giving credence to the views of art's 'secondary' interpreters, who often have unacknowledged agendas, prejudices, frustrations, and limitations. They are never neutral observers. Artists can be fiercely partisan, but their position is always explicit – through their work.

A work of art, like everything else, has many uses, but for artists it is not primarily an object of connoisseurship, a historical or cultural record, or a commodity. For artists, a work of art is alive, a living reality, or it is of only marginal interest. To be truly experienced, a work of art needs to be felt, more than understood. Artists bring to the art of others, and to

the art of the past, the same criteria of living critical engagement essential to their own work. To experience an ancient work of art *as a work of art* is not to be put in touch with the past, but to bring that work into contact with one's own present. My intention in this exhibition is to allow this immense and diverse body of work – ancient, old, modern and new – to be seen as part of the living present.

An exhibition of this kind is only possible because of the special character of drawing itself. What drawings have in common is greater than their differences.

It would be neither possible nor fruitful to try to make a similar exhibition of painting or sculpture. I do not mean simply for practical reasons, but because the differences between paintings or sculptures of so many ages and artists would overwhelm their potential points of contact. There is a cultural as well as a physical density that characterizes painting and sculpture that is in contrast to the fluidity of drawing. The great paintings of Rembrandt manifest most strongly the values of his own time, while his drawings manifest equally those of our own. The drawings of Rembrandt can speak directly to the work of Beckmann or Guston, those of Leonardo to Newman or Andre, of Michelangelo to Duchamp, of Cambiaso to de Kooning.

The most striking thing about many of the drawings of the past and of other cultures is how 'modern' they look. I believe that this is because the qualities we have come to value most highly in art in the twentieth century have always been present in art, but usually in the past have characterized only modest and 'secondary work'; that is, drawings. These characteristics include spontaneity, creative speculation, experimentation, directness, simplicity, abbreviation, expressiveness, immediacy, personal vision, technical diversity, modesty of means, rawness, fragmentation, discontinuity, unfinishedness, and open-endedness. These have always been the characteristics of drawing.

Seen in this light, the lines of continuity between the art of the past and that of our own time are both strong and clear. It is my view that the new in art is never truly new, but the result of ascribing high value and importance to an aspect of art that was previously not thought worthy of serious consideration. In our own century, we have come to place the highest value on those characteristics which have previously been seen only as aspects of the early stages in the making of a work of art, stages exemplified by drawing. The expressive freedom shown by artists in previous centuries in the preliminary stages of their work, in their drawings,

is seen in much of the major finished work of the twentieth century.

The spontaneous, personal, and undogmatic qualities of drawing have been highly appropriate models for art in a century characterized by the fragmentation of both the systems of belief and the languages of expression. In a way unique to our times, artists today must discover, select, and develop for themselves the forms of expression appropriate to their needs and abilities. Our emphasis on individuality, innovation, and originality is the inevitable consequence of our cultural circumstances. What our pluralist society has sacrificed by the loss of cultural coherence has been more than compensated for by the unprecedented growth of the range of expression.

How a drawing is made determines its character. Line drawings often reveal an immediacy and directness bordering on rawness. They show precisely what is needed, no more and no less. No other form is so flexible, responsive, or revealing. Line drawings manifest a particular rigour and economy, as though the eye and the mind of the artist were truly concentrated at that tiny point of contact between the marker and the surface – the pen or pencil or brush and the paper. They range from the sensual to the severe. At their most sensual, they are not indulgent. At their most severe, they do not lack feeling.

In my search, I occasionally came across two similar drawings by the same artist, one of which had remained only as line, while the other had been coloured in or overpainted with coloured washes. The latter always seemed to me to have dated more than the simple line drawing, as though the colour was more particular to the period of its making, fixing the work more implacably in its own time. Line on its own seems capable of acquiring a quality of timelessness.

(Michael Craig-Martin, 1995)

Giotto, if we are to believe this story, produced a startlingly minimalist response to a papal request for a drawing.

Pope Benedict IX, who was intending to have some paintings commissioned for St Peter's, sent one of his courtiers from Trevisi to Tuscany to find out what sort of man Giotto was and what his work was like. On his way to see Giotto and to find out whether there were other masters in Florence who could do skilful work in painting and mosaic, this courtier spoke to many artists in Siena. He took some of their drawings and then

went on to Florence itself, where one day he arrived at Giotto's workshop to find the artist at work. The courtier told Giotto what the Pope had in mind and the way in which he wanted to make use of his services, and, finally, he asked Giotto for a drawing which he could send to His Holiness. At this Giotto, who was a very courteous man, took a sheet of paper and a brush dipped in red, closed his arm to his side, so as to make a sort of compass of it, and then with a twist of his hand drew such a perfect circle that it was a marvel to see. Then, with a smile, he said to the courtier: 'There's your drawing.'

As if he were being ridiculed, the courtier replied:

'Is this the only drawing I'm to have?'

'It's more than enough,' answered Giotto. 'Send it along with the others and you'll see whether it's understood or not.'

The Pope's messenger, seeing that that was all he was going to get, went away very dissatisfied, convinced he had been made a fool of. All the same when he sent the Pope the other drawings and the names of those who had done them, he also sent the one by Giotto, explaining the way Giotto had drawn the circle without moving his arm and without the help of a compass. This showed the Pope and a number of knowledgeable courtiers how much Giotto surpassed all the other painters of that time. And when the story became generally known, it gave rise to the saying which is still used to describe stupid people: 'You are more simple than Giotto's O.' This is a splendid witticism, not only because of the circumstances which gave rise to it but also because of the pun it contains, the Tuscan word *tondo* meaning both a perfect circle and also a slow-witted simpleton.

(Giorgio Vasari, 1568)

Robert Hughes laments the decline in the teaching of drawing.

When Fischl started out to paint, the odds were against the very idea of narrative painting based on the human figure. Born in New York City in 1948, he went to art school in 1970 at the California Institute for the Arts in Los Angeles – just at the height of the belief, then endemic in the American art world, that Painting was Dead. Cal Arts epitomized the frivolity of late-modernist art teaching – no drawing, just do your own thing and let Teacher get on with his. 'Everybody was naked,' Fischl recalled of one of these 'life classes'. 'Half the people were covered with paint . . . The two models were sitting in the corner absolutely still, bored

to tears. Everyone else was throwing stuff around and had climbed up into the roof and jumped into buckets of paint. It was an absolute zoo . . . They didn't teach technique at Cal Arts.'

Art education that has repealed its own standards can destroy a tradition by not teaching its skills, and that was what happened to figure painting in the United States between 1960 and 1980. Fischl has been badly hampered by it, and the exaggerated demand for his work is also a function of it: very few collectors knew how to judge a figure painting, so that any attempt at figuration can slide by on its declared intensity of sentiment. Fischl can't draw as well as the average Beaux-Arts student in 1930, never mind 1880. He aspires to a mode of figuration that is tense, dramatic and full of body. He has managed to reconstruct at least some of his birthright; his figures, although they inhabit a different sexual and psychic world from that of late-nineteenth-century America, have a direct matter-of-factness that distantly recalls Winslow Homer. But the signs of loss do show.

(Robert Hughes, 'Eric Fischl', 1988)

Although there are paintings by Holbein in US collections, the body of his graphic work is in England and on the Continent. The most important part of it belongs to the British royal family and is housed at Windsor; it comprises the many sketches Holbein made of the nobility and gentry at the court of Henry VIII during his two sojourns in London, a short spell from 1526 to 1528 and a long one of eleven years that finished with his death, of the plague, in 1543. Much of this oeuvre is on view at the Pierpont Morgan Library in New York City, where it is amplified by material from the library's own collection – rare editions and manuscripts by and about Holbein's circle of patrons and friends, prints derived from his images, and so forth.

Nobody, one may morosely predict, will ever draw the human face as well as this again. The tradition is cut, the bow unstrung. But the drawings remain – abraded, retouched, sometimes (as in a study of the bony, intense face of Bishop John Fisher) vandalized by later hands, yet through it all, radiating their freshness of scrutiny. What strikes one first about them is their self-evident truth. Nobody else got the knobbly, mild face of English patrician power so aptly, or saw so clearly the reserves of cunning and toughness veiled by the pink mask. The idea that Holbein was criticizing his subjects is, of course, absurd; and yet his rapport with them was so acute that he could render their unease at the unfamiliar sensation of

being limned. Young Sir John Godsalve, one of whose offices was resonantly called the Common Meter of Precious Tissue, is watching Holbein as Holbein watches him: calm and yet withdrawn to the fine edge of nervousness. It is the look people used to direct at cameras a hundred years ago, before everyone got used to the lens.

One knows these faces; better shaved, they populate the West End in London today. Even the women, as in Holbein's elegant full-face study of Mary Zouch, square-jawed and pale, are reborn among the Sloane Rangers outside Harrods. 'Here is Derich himself; add voice and you might doubt if the painter or his father created him,' runs an inscription on one of Holbein's portraits of a Hanseatic merchant in London, and for once the clichés about 'speaking likeness' do indeed seem fresh. In drawing after drawing, the nervous mobility of the pencil or black chalk, linking blank spaces of paper together in casual but strict tensions between mark and void, creates a pictorial equivalent of the sitter's thought as well as the artist's. Hence the authority of Holbein's drawings of his friend Sir Thomas More, which maintain the etiquette of distance and yet hint at the complexities of emotion such a face could display.

Holbein's formal resources were inexhaustible. His touch went all the way from emphatic black strokes to the subtlest frizzing and tonings of grey in a beard, and his sense of how to 'tune' hard linear passages against evanescent transitions of tone seems never to have failed him. Sometimes he used technical aids: it is thought that some of the drawings were traced from the sitter's image on a transparent glass pane; this practice represents an early use of the principle of the camera obscura advocated by Dürer, and a forerunner of photo-derived painting. But the liveliness of touch is something no camera can give. Every hair in the scalp lives and has its place. The curve of a mouth or the arch of an eyelid is precisely weighted against the amount of blank space it must enliven. The intensity of detail shifts with marvellous fluency.

It is not certain how far Holbein wanted these drawings to be taken as finished works of art, but the fact that he did not discard them even when they had been developed into paintings suggests that he placed more than instrumental value on them. But whatever the cause of their preservation, one can be only grateful for it. No other group of Renaissance drawings offers so vivid a picture of a class. They are as fraught with human interest as any court memoir by Hervey or Saint-Simon.

(Robert Hughes, 'Hans Holbein', 1983)

An exchange on the subject of drawing between the critic John Berger and the artist
Leon Kossoff.

Dear Leon,

I still remember clearly the first time I visited you in your studio, or the
room you were then using as a studio. It was some 40 years ago. I
remember the debris and the omnipresent hope. The hope was strange
because its nature was that of a bone, buried in the earth by a dog.

Now the bone is unburied and the hope has become an impressive
achievement. Except that the last word is wrong, don't you think? To hell
with achievement and it's recognition which always comes too late. But
a hope of redemption has been realized. You have saved much of what
you love.

All this is best not said in words. It's like trying to describe the flavour of
garlic or the smell of mussels. What I want to ask you about is the studio.

The first thing painters ask about a studio-space usually concerns the
light. And so one might think of a studio as a kind of conservatory or
observatory or even lighthouse. And of course light is important. But it
seems to me that a studio, when being used, is much more like a stomach.
A place of digestion, transformation and excretion. Where images change
form. Where everything is both regular and unpredictable. Where there's
no apparent order and from where a well-being comes. A full stomach is,
unhappily, one of the oldest dreams in the world. No?

Perhaps I say this to provoke you, because I'd like to know what images
a studio (where images are made) suggests to you – you who have spent
years alone in a studio. When we enter one, we go blind in order to see.
Tell me . . .

Dear John,

Thank you for your letter. Almost 40 years ago you wrote a very generous
piece on my work, *The Weight*. It was the first and, for many years, the
only constructive and positive response to the work, and I never thanked
you. But I have never forgotten it, and in the strange time I am living
through, now, of having to gather my work (and my life I suppose)
together for a first retrospective, I am frequently reminded of it.

All the things you say about the studio are true and the place I work in is
much the same as it has always been. A room in a house – a much larger
house. There is mess and paint everywhere on the walls – on the floor.

Brushes are drying by the radiator, unfinished paintings are on the walls

with drawings of current subjects. There is a place for the model to sit in a corner and a few reproductions on the wall that I've had most of my painting life. I don't worry much about the light, sometimes it can be awkward as the room faces due south, then I turn the painting round or start a new version. I seem engaged in an endless cycle of activities. For the best part of 40 years I have been left alone but recently, owing to extra exposure and studio visits the place has become like a deserted ship.

Do you remember when we first saw the revealing and moving photographs of Brancusi's and Giacometti's studios in the 1950s? It was a special time. Now every book on every artist includes a photograph of the studio. It has become a familiar stage-set for the artist's work. Has the activity become more important than the resulting image, or does the image need the confirmation of the studio and the myth of the artist because it's not strong enough to be on its own?

I don't know what the work will look like when it finally appears on the walls of the Tate. The main thing that has kept me going all these years is my obsession that I need to teach myself to draw. I have never felt that I can draw and as time has passed this feeling has not changed. So my work has been an experiment in self-education.

Now, after all this drawing, if I stand before a vast Veronese I experience the painting as an exciting exploratory drawing in paint. Or, looking at Velázquez's *Pope Innocent X*, at present in the National Gallery, I wonder, after moving to the nearby early *Christ after Flagellation*, at the transformation of his capacity to draw with paint. Recently I saw a book of Fayum portraits [the Egyptian mummy paintings] and, thinking about their closeness to Cézanne and the best Picasso, I am reminded of the importance of drawing to all art since the beginning of time. I know this is all familiar to you – even simplistic – but it's where I begin and end.

The exhibition will commence with the thick painting you wrote about. Will the later, relatively lighter and thinner work be seen to have emerged out of my need to relate to the outside world by teaching myself to draw?

Dear Leon,
I don't, of course, find your thought about drawing 'simplistic'. I too have been looking at that extraordinary book of Fayum portraits. And what first strikes me, as it must strike everybody, is their thereness. They are there in front of us, here and now. And that's why they were painted – to remain here, after their departure.

This quality depends on the drawing and the complicity, the inter-

penetrations, between the head and the space immediately around it. (Perhaps this is partly why we think of Cézanne.) But isn't it also to do with something else – which perhaps approaches the secret of this so mysterious process which we call drawing – isn't it also to do with the collaboration of the sitter? Sometimes the sitter was alive, sometimes dead, but one always senses a participation, a will to be seen, or, maybe, a waiting-to-be-seen.

It seems to me that even in the work of a great master, the difference between his astounding works and the rest, always comes down to this question of a collaboration with the painted, or its absence.

The romantic notion of the artist as creator eclipsed – and today the notion of the artist as a star still eclipses – the role of receptivity, of openness in the artist. This is the pre-condition for any such collaboration.

So-called 'good' draughtsmanship always supplies an answer. It may be a brilliant answer (Picasso sometimes), or it may be a dull one (any number of academics). Real drawing is a constant question, is a clumsiness, which is a form of hospitality towards what is being drawn. And, such hospitality once offered, the collaborations can sometimes begin.

When you say: 'I need to teach myself to draw,' I think I can recognize the obstinacy and the doubt from which that comes. But the only reply I can give is: I hope you never learn to draw! (There would be no more collaboration. There would only be an answer.)

Your brother Chaim (in the larger 1993 portrait) is there like one of the ancient Egyptians. His spirit is different, he has lived a different life, he is awaiting something different. (No! that's wrong, he's awaiting the same thing but in a different way.) But he is equally there. When somebody or something is there, the painting method seems to be a detail. It is like the self-effacement of a good host.

Pilar (1994) is there to a degree that makes us forget every detail. Through her body, her life was waiting to be seen, and it collaborated with you, and your drawing in paint allowed that life to enter.

You don't draw in paint in the same way as Velázquez – not only because times have changed, but also because time has changed, your openness is not the same either (he with his open scepticism, you with your fervent need for closeness), but the riddle of collaboration is still similar.

Maybe when I say *your* 'openness', I'm simplifying and being too personal. Yes, it comes from you, but it passes into other things. In your painting of Pilar, the surface of pigment, those gestures one upon another

like the household gestures of a mother during a life-time, the space of the room – all these are *open* to Pilar and her body waiting-to-be-seen. Or is it, rather, waiting-to-be-recognized?

In your landscapes the receptivity of the air to what it surrounds is even more evident. The sky opens to what is under it and in *Christchurch Spitalfields, Morning 1990*, it bends down to surround it. In *Christchurch Stormy Day, Summer 1994*, the church is equally open to the sky. The fact that you go on painting the same motif allows these collaborations to become closer and closer. Perhaps in painting this is what intimacy means? And you push it very far, in your own unmistakable way. For the sky to 'receive' a steeple or a column is not simple, but it's something clear. (It's what, during centuries, steeples and columns were made for.) But you succeed in making an early summer suburban landscape 'receive', be open to, a diesel engine!

And there I don't know how you do it! I can only see that you've done it. The afternoon heat has something to do with it. But how does that heat become drawing? How does such heat draw in paint? It does, but I don't know how. What I'm saying sounds complex. In fact all I'm saying is already there in your marvellous and very simple title: *Here Comes the Diesel*.

You say that on the walls of your painting rooms there are some reproductions which have been pinned there for years. I wonder what? Last night I dreamt I saw at least one. But this morning I've forgotten it.

I suppose that soon you'll be hanging the paintings at the Tate. I've never done it but I guess it's a very hard moment. It's difficult to hang paintings well because their *therenesses* compete. But apart from this difficulty, what I guess is hard is being forced to see them as exhibits. For Beuys it was OK because his collaboration was with the spectator. But for iconic works like yours it may seem, I imagine, like a dislocation, and therefore a violence. Yet don't worry – they will hold their own. They are coming from their own place, like the train between Kilburn and Willesden Green.

Dear John,
No one has written about the work of drawing and painting with such directness and selfless insight as you have in your last letter to me. That it's 'my' work you are writing about is less important than the fact that, through your words, you acknowledge the separateness and independence of the images.

'Thereness' follows nothingness. It is impossible to premeditate. It is to do with the collaboration of the sitter, as you say, but also to do with the disappearance of the sitter the moment the image emerges. Is this what you mean by 'the self-effacement of the good host'? The Fayum portraits of course emerge out of an attitude to life and death quite different from our own. In the pyramids there was life after death and the life was in the 'thereness' of the portraits. If there is something of this quality in the painting of Pilar it has more to do with the processes I am involved with than trying to paint a certain picture.

Pilar came to sit for me some years ago. She comes two mornings a week. For the first two or three years I drew from her. Then I started to paint her. Painting consists of working over the whole board quickly, trying to relate what was happening on the board to what I thought I was seeing. The paint is mixed before starting – there is always more than one board around to start another version. The process goes on a long time, sometimes a year or two. Though other things are happening in my life which affect me, the image that I might leave appears moments after scraping, as a response to a slight change of movement or light. Similarly with the landscape paintings. The subject is visited many times and lots of drawings are made, mostly very quickly. The work is begun in the studio where each new drawing means a new start until one day a drawing appears which opens up the subject in a new way, so I work from the drawing as I do from the sitter. It's the process I am engaged in that is important.

I'm not too worried about the hanging of the paintings. The Tate are very good at this. The experience will be very strange. I haven't seen many of the pictures for a very long time and as the event draws closer I become more aware that the work will represent an experiment in living which has been exciting, interesting and extending so I'm not so concerned about success or failure as I am about holding myself together to keep the experiment going. This is rather difficult.

(Leon Kossoff and John Berger, 1 June 1996)

A further thought from Leon Kossoff.

Drawing is not a mysterious activity. Drawing is making an image which expresses commitment and involvement. This only comes about after seemingly endless activity before the model or subject, rejecting time and

again ideas which are possible to preconceive. And, whether by scraping off or rubbing down, it is always beginning again, making new images, destroying images that lie, discarding images that are dead.

(Leon Kossoff, *The Paintings of Frank Auerbach*, 1978)

A
Difficult
Relationship:
Artists
and
Patrons

Benjamin Robert Haydon, an awkward man and an unsuccessful artist, offers some words of advice on how to deal with patrons.

Because genius is dependent on title for development – at least for employment. Because rank, at any rate, is entitled to civility, on the principle of rank being a reward to the possessor or his ancestor for some personal qualification or heroic deed. Of course, centuries of possession say something for conduct; and because whatever tends to obstruct genius and deprive it of employment is pernicious to its display. Painters should, therefore, not be talkers except with their brushes, or writers except on their art; because the display of too much power when others know something, is apt to excite envy and injure a painter's development of his art. Men are content that you should know more of painting than they do, but they don't like that you should know as much of any other thing; because they feel if this man can paint and yet be informed as well as we are in other matters, we are nobody, and we won't patronize him. But if this man knows nothing out of his art, why we are somebody in something. We can spell and he can't; we know French, and he does not; we read Homer, and he knows nothing of him. In a word, we can talk at dinner, and he must be silent, except when we want to know a matter where it is no disgrace that he should know more than ourselves, on the same principle as we tolerate a tailor, a shoemaker, a carpenter, a butcher, or a surgeon.

Therefore, Oh ye artists who can spell, speak French, and read Homer, never show your patrons they speak bad French, or read bad Greek, and spell carelessly, but listen to their French as if it was Racine's, to their Greek as if old Homer himself were spouting, and read their epistles as if they had orthography, grammar, and common sense. Do this and you will drink their claret, adorn their rooms, ride their horses, visit their châteaux, and eat their venison. But if, on the contrary, you answer the French not meant for you to understand, rectify their quotations which you are not supposed ever to have heard of, and discuss opinions only

put forth for you to bow to, you will not eat their venison, you will not adorn their apartments, you will not ride their horses, you will not drink their claret, or visit their châteaux, at any rate more than once. And, so, artists, be humble and discreet.

(Benjamin Robert Haydon, 30 June 1825)

Joyce Cary's fictional painter, Gulley Jimson, moves into his patron's flat while the latter is away, and begins to provide him with art.

The porter and I had a little chat and a couple of gallons next morning at the Red Lion and he was so good as to call up the police for me, and to explain that I had been left in charge of the flat for the present, and took full responsibility for the property.

The porter had been very polite to me ever since he had discovered that I was a distinguished person. Now, when my boots flopped, he looked the other way; like a young lady when a baron shows a fly-button. He was most delicate in his feelings for the great. And beer. One of the old guard. A True Blue.

On the next morning after my bread and dripping on the mahogany, I took down the family portraits in the dining room to see what the wall was like. For I hadn't forgotten my promise to Sir William of a mural above the sideboard. Tigers and orchids for a hundred guineas. The wall was not what I expected, and when I knocked in the tigers, lightly touched, with a piece of charcoal from her ladyship's box, they wouldn't stay on the shape. It was too square, like a backyard. It asked for hens and daisies.

But afterwards, when I took down the watercolours in the studio to have a look at the other walls, I made a discovery. A good wall is often ruined by pictures, and I have found most excellent material in unexpected places, for instance behind a collection of Old Masters. And this was a gem. It was on the right side of the studio, near the entrance hall; framed between two doors and perfectly lighted by reflection from the ceiling. One of the sweetest walls I had ever seen. It made the remaining pictures look like fly-blows. I took them down and stacked them in the bathroom.

A good wall, as they say, will paint itself. And as I looked at this beautiful shape, I saw what it was for. A raising of Lazarus.

I jumped up at once and sketched the idea with a few touches of a pencil, where it wouldn't show behind the pictures. This gave me a parallelogram on a slant from top left to bottom right, the grave. And I

saw it in burnt sienna with a glass-green Lazarus up the middle stiff as an ice man; cactus and spike grass all round, laurel green; a lot of yellow ochre feet in the top corner and bald heads in the bottom triangle – one small boy looking at a red beetle on a blue-green leaf. But it was the feet that jumped at me. The finest feet I'd ever seen, about four times life-size. I only had to put a line round 'em. Then I got out her ladyship's nice little colour box and rubbed on some body colour. It would all wash off. And I couldn't go wrong with those feet. They came up like music. Down on the left, in foreground, about a yard long and two feet high to the ankle bone – a yellow pair, long and stringy, with crooked nails; then a black pair, huge and strong with muscles like lianas; a child's pair, pink and round, with nails like polished coral; an odd pair, one thick and calloused, with knotty toes curled into the dust, one shrunk and twisted, its heel six inches from the ground, standing on its toes, a cripple's feet, full of resolution and pain; then a coffee-coloured pair with a bandage, an old woman's feet, flat, long, obstinate, hopeless, clinging to the ground with their bellies like a couple of discouraged reptiles, and gazing at the sky with blind broken nails; then a pair of Lord's feet, pink in gold sandals with trimmed nails and green veins, and one big toe raised impatiently.

When I fell down into a chair about tea-time and looked at those feet, a voice inside me said, They're good, good, good. Nobody has done better. The Works of Gulley Jimson. Jee-sus, Jimson, perhaps you are a genius. Perhaps the crickets are right.

And a masterpiece like that on the Beeder's wall. To be covered up by a lot of drawing-room pictures. *The Hon. Mrs Teapot* by Reynolds. Here's mud in your eye, your ladyship, and all down your left cheek. *Lady Touch-me-not* by Gainsborough, in one flitting, what soul in the eyes; the soul of a great baby. In milk and dill water. Poor sole, it's a flat life. One flatness on another. Flattery to flats.

But I'll get my feet on canvas, I thought. And I went into the kitchen for the teapot and the bread and jam. Lady Beeder had left only the tin teapot out. But I'd found a nice piece of Sèvres in a glass case in the studio. Tea out of tin. Not in the land of Beulah. And the Sèvres made good tea, though a bit on the simpering side. But there were only two slices of bread left, and when I'd eaten them, I was still hungry. I tried a few cupboard locks with a bent sardine key and opened two of 'em, but nothing inside except the best dinner plates and a lot of odd silver.

Then all at once I had an idea. To sell Lazarus to Sir William instead of the tigers. It was a better bargain for him. He'd get a masterpiece worth

thousands for a hundred guineas, or, say, a hundred and fifty. And I could still make a copy on canvas.

And as for getting payment, I'd take an advance. In the only way open to me. Under the circumstances. Damme, I thought, looking at those feet, I'm giving him immortality. The glory he's tried to buy all his life. *The Raising of Lazarus* by Gulley Jimson, OM, in the possession of Sir William Beeder. People will point at him in the street. One or two dealers, anyhow. Waiting for him to pop the hooks.

So off I went to the pop shop with the Sèvres teapot and a few apostle spoons. Two quid. And stood myself the best dinner I'd had in five years. No more scrimping and scramping, I said, for Gulley Jimson, OM. His navel shall no longer shrink from the light. Not when he carries it in front of him like the headlights of an express train. Puff, puff. That's the secret. Meet the Professor. My publicity agent. And fetch another Aristotle, waiter. The philosopher is full of drink. As well as meat.

But I played fair by Sir William. Always treat a patron well so long as he keeps his bargain. And doesn't try to cheat you. By getting a masterpiece that's going to be worth ten thousand pounds for a couple of hundred dirty money and two of soft soap. I put the pawn tickets in an envelope and wrote my account on the outside. *Raising of Lazarus* by Gulley Jimson £157 10s, advance £2.

(Joyce Cary, 1944)

Gainsborough reveals to a friend what he really thought of all those gentlemen whose portraits he painted.

Now damn gentlemen, there is not such a set of enemies to a real artist in the world as they are, if not kept at a proper distance. *They* think . . . that they reward our merit by their company and notice; but I, who blow away all the chaff and by G— in their eyes too if they don't stand clear, know that they have but one part worth looking at, and that is their purse.

(Thomas Gainsborough to W. Jackson, 1767)

Michelangelo deals with a small criticism of his great David *from an important patron, Piero Soderini, the Gonfalonier or head of the Florentine government.*

When he saw the *David* in place Piero Soderini was delighted; but while

Michelangelo was retouching it he remarked that he thought the nose was too thick. Michelangelo, noticing that the Gonfalonier was standing beneath the Giant [i.e. the *David*] and that from where he was he could not see the figure properly, to satisfy him climbed on the scaffolding by the shoulders, seized hold of a chisel in his left hand, together with some of the marble dust lying on the planks, and as he tapped lightly with the chisel let the dust fall little by little, without altering anything. Then he looked down at the Gonfalonier, who had stopped to watch, and said:

'Now look at it.'

'Ah, that's much better,' replied Soderini. 'Now you've really brought it to life.'

(Giorgio Vasari, 1568)

Michelangelo studies antique statues in the garden of the great collector Lorenzo de' Medici — the Magnificent — and makes a snowman, possibly the most splendid in the history of art, for Lorenzo's son.

At that time the custodian or keeper of all the fine antiques that Lorenzo the Magnificent had collected at great expense and kept in his garden on the Piazza di San Marco was the sculptor Bertoldo. He had been a pupil of Donatello's, and the chief reason why Lorenzo kept him in his service was because he had set his heart on establishing a school of first-rate painters and sculptors and wanted Bertoldo to teach and look after them. Bertoldo was now too old to work; nevertheless, he was very experienced and very famous, not only for having polished the bronze pulpits cast by Donatello but also for the many bronze casts of battle scenes and the other small things he had executed himself with a competence that no one else in Florence could rival. So Lorenzo, who was an enthusiastic lover of painting and sculpture, regretting that he could find no great and noble sculptors to compare with the many contemporary painters of ability and repute, determined, as I said, to found a school himself. For this reason he told Domenico Ghirlandaio [the painter, 1449–94, Michelangelo's master] that if he had in his workshop any young men who were drawn to sculpture he should send them along to his garden, where they would be trained and formed in a manner that would do honour to himself, to Domenico, and to the whole city. So Domenico gave him some of the best among his young men, including Michelangelo and Francesco Granacci. And when they arrived at the garden they found

Torrigiano (a young man of the Torrigiani family) [Pietro Torrigiano, 1472–1528, a Florentine sculptor who worked in England, notably on the tomb of Henry VII] working there on some clay figures in the round that Bertoldo had given him to do. After he had seen these figures, Michelangelo was prompted to make some himself; and when he saw the boy's ambitious nature Lorenzo started to have very high hopes of what he would do. Michelangelo was so encouraged that some days later he set himself to copy in marble an antique faun's head which he found in the garden; it was very old and wrinkled, with the nose damaged and a laughing mouth. Although this was the first time he had ever touched a chisel or worked in marble, Michelangelo succeeded in copying it so well that Lorenzo was flabbergasted. Then, when he saw that Michelangelo had departed a little from the model and followed his own fancy in hollowing out a mouth for the faun and giving it a tongue and all its teeth, Lorenzo laughed in his usual charming way and said:

'But you should have known that old folk never have all their teeth and there are always some missing.'

In his simplicity Michelangelo, who loved and feared that lord, reflected that this was true, and as soon as Lorenzo had gone he broke one of the faun's teeth and dug into the gum so that it looked as if the tooth had fallen out; then he waited anxiously for Lorenzo to come back. And after he had seen the result of Michelangelo's simplicity and skill, Lorenzo laughed at the incident more than once and used to tell it for a marvel to his friends. He resolved that he would help and favour the young Michelangelo; and first he sent for his father, Lodovico, and asked whether he could have the boy, adding that he wanted to keep him as one of his own sons. Lodovico willingly agreed, and then Lorenzo arranged to have Michelangelo given a room of his own and looked after as one of the Medici household. Michelangelo always ate at Lorenzo's table with the sons of the family and other distinguished and noble persons who lived with that lord, and Lorenzo always treated him with great respect. All this happened the year after Michelangelo had been placed with Domenico, when he was fifteen or sixteen years old; and he lived in the Medici house for four years, until the death of Lorenzo the Magnificent in 1492. During that period, as salary and so that he could help his father, Michelangelo was paid five ducats a month; and to make him happy Lorenzo gave him a violet cloak and appointed his father to a post in the Customs. As a matter of fact all the young men in the garden were paid salaries varying in amount through the generosity of that noble and magnificent citizen

who supported them as long as he lived. It was at this time that, with advice from Politian, a distinguished man of letters, Michelangelo carved from a piece of marble given him by Lorenzo the *Battle of Hercules with the Centaurs*. This was so beautiful that today, to those who study it, it sometimes seems to be the work not of a young man but of a great master with a wealth of study and experience behind him. It is now kept in memory of Michelangelo by his nephew Lionardo, who cherishes it as a rare work of art. Not many years ago Lionardo also kept in his house in memory of his uncle a marble Madonna in bas-relief, little more than two feet in height. This was executed by Michelangelo when he was still a young man after the style of Donatello, and he acquitted himself so well that it seems to be by Donatello himself, save that it possesses more grace and design. Lionardo subsequently gave this work to Duke Cosimo de' Medici, who regards it as unique, since it is the only sculpture in bas-relief left by Michelangelo.

To return to the garden of Lorenzo the Magnificent: this place was full of antiques and richly furnished with excellent pictures collected for their beauty, and for study and pleasure. Michelangelo always held the keys to the garden as he was far more earnest than the others and always alert, bold, and resolute in everything he did. For example, he spent many months in the church of the Carmine making drawings from the pictures by Masaccio; he copied these with such judgement that the craftsmen and all the others who saw his work were astonished, and he then started to experience envy as well as fame.

It is said that Torrigiano, who had struck up a friendship with Michelangelo, then became jealous on seeing him more honoured than himself and more able in his work. At length Torrigiano started to mock him, and then he hit him on the nose so hard that he broke and crushed it and marked Michelangelo for life. Because of this, Torrigiano, as I describe elsewhere, was banished from Florence.

When Lorenzo the Magnificent died, Michelangelo went back to live with his father, filled with sorrow at the death of a great man who had befriended every kind of talent. While he was with his father he obtained a large block of marble from which he carved a Hercules eight feet high, which stood for many years in the Palazzo Strozzi. This work, which was very highly regarded, was later (when Florence was under siege) sent to King Francis in France by Giovanbattista della Palla. It is said that Piero de' Medici, who had been left heir to his father, Lorenzo, often used to send for Michelangelo, with whom he had been intimate for many years,

when he wanted to buy antiques such as cameos and other engraved stones. And one winter, when a great deal of snow fell in Florence, he had him make in his courtyard a statue of snow, which was very beautiful. Piero did Michelangelo many favours on account of his talents, and Michelangelo's father, seeing his son so highly regarded among the great, began to provide him with far finer clothes than he used to.

(Giorgio Vasari, 1568)

Rembrandt explains why it has taken him so long to complete two paintings for Frederick Henry, Prince of Orange, and in doing so uses a phrase which might give the clue to his art, if we could be sure we understood it. With the letter, to the Prince's secretary, who probably arranged the commission, he includes a little gift in the form of a large painting.

My Lord: Because of the great joy and devotion which filled me in doing well the two works which His Excellency ordered me to make, the one where the dead body of Christ is put into the grave, and the other where Christ rises from the dead to the great alarm of the guards, these same two pieces are now finished through studious diligence, so that I am now inclined to deliver them to His Excellency in an effort to please him. In both these [paintings] I have concentrated on expressing *die meeste ende die naetuereelste beweechgelickheyt* [a controversial phrase that might mean 'the greatest movement' or 'the greatest inward emotion'], and that is then the chief reason why these pictures have remained so long under my hands.

Therefore I ask Your Lordship if you will be so kind as to tell His Excellency about it, and if you will agree that I should send these two pictures first to your house, as I did before. But before I do this, I await an answer by letter.

And since My Lord has troubled himself a second time in these matters, in appreciation I shall add one piece 10 feet long and 8 feet high for My Lord's own home.

And wishing you good luck and happiness, Amen.

My Lord, your obedient and devoted servant,

Rembrandt

(Rembrandt van Rijn to Constantin Huygens, 12 January 1639)

Sickert characterizes the average patron of his day.

Now I will describe to you, briefly, the modus operandi of many a patron in this country.

Long, long after a painter's battle is lost or won, long after his stock has been safely housed in the dealer's cellars, our patron, being slightly deaf, and very slow-moving, and extremely suspicious, meets at dinner someone who tells him, what everyone has known for twenty years, that works signed with such-and-such names have gone up strangely in value.

'Dear me!' he says. 'You surprise me! Tut, tut, tut! I must see if I can't get some. What did you say was the name? Degas, Monet. Really?'

Scenting a profit, off he goes to the biggest dealers. 'I want to see some pictures by So-and-so, and So-and-so. What! Thousands of pounds? Impossible! Dear me! Well, let me have half a dozen at my house to look at for a while, so that I may choose at leisure.'

'Certainly, sir, if you will pay carriage and insurance.'

That is arranged to the satisfaction of both sides. Our patron then marches every expert he has ever met past this little 'appro' [i.e. on approval] collection. Some of the experts are painters, some writers, some dealers, some ladies who have sat to a fashionable portrait painter, and so rank as 'artistic'. One and all, having a sprat or two of their own to fry, crab the 'appro' collection, nicely, but unmistakeably. Our patron, slightly discouraged, ends by picking out a very minor work by a name of the second rank, and pays a few hundreds for it. These hundreds include the original artist's price, interest on it for a matter of fifteen or twenty years, part rent of premises in Bond Street, or the Rue Laffitte for the same time, plus what the French call 'false expenses', postage, cabs, telegrams, and odds and ends of that kind. And note that patrons of this type consider themselves as real friends of the arts, that they generally frequent and prefer the society of artists, and are always slightly puzzled and aggrieved that they are not regarded with positive enthusiasm by the whole artistic profession.

Add to this that the purchase I have sketched above is a poor speculation. The patron has paid the full price of the name for a minor example. And we all know that, in any master's work, the tendency is for the masterpieces to go up, and the minor example down, with the sifting of time.

(Walter Sickert, 1910)

There is only one hugely influential patron in contemporary British art. Matthew Collings, sometime editor of Artscribe *magazine, considers his impact.*

Last night I dreamed I was writing an article about Charles Saatchi and I was ticking off all the points about him that I had to remember on a list and one point said, Drank the finger bowl. The time I drank the finger bowl was when I was meeting the Saatchis, Charles and Doris, in a Japanese restaurant in the mid-80s, to beg them to buy *Artscribe* and get us out of debt. They showed me how to use chopsticks and then when the finger bowl arrived I drank it. As soon as I'd done it, I knew it was probably wrong, but they were kind enough not to say anything, and maybe even drank their finger bowls too.

In those days Charles Saatchi looked like the one press photo of him that was always used in the papers, even though it had probably been taken in 1975. Curly dark hair, bland smile, straight-looking suit and tie. Then suddenly later on he started looking good, wearing designer clothes, and that's been his look ever since. A hedonist millionaire suntanned designer groovy guy.

They didn't buy *Artscribe* after all, partly because someone at the Tate Gallery told them not to. Thanks Tate Gallery! But also partly because they wisely decided it might be bad for the credibility of an art magazine to be owned by the collectors of the art that the magazine was mainly featuring.

Later on when I was unemployed, I would bump into Saatchi occasionally and he was always very supportive and would say encouraging things like, What are you going to do now? Why don't you open a gallery? But then I was working at the BBC, and a job I had there quite early on was to write the commentary for a short film about Saatchi's art collecting, and after that he never spoke to me again. And of course I felt guilty, although at the same time I couldn't understand what the film had said that was so bad. He just doesn't like anything to be said about him that isn't incredibly bland praise. When people are like that we kind of roll our eyes a bit. But if it was us, of course, we'd feel the same.

And really you have to admit he's been an amazing force in the London artworld. At this moment the whole thing more or less depends on him. He just goes round all the shows buying them up. In other countries there are lots of medium-energy collectors and one or two really huge, high-energy ones. But in this country there are very few collectors and

almost all of them are low-energy except for him. He is nuclear-energy. The other countries' art scenes depend on the middle ground of medium collectors, whereas over here we depend only on him. All the young artists go around scratching their heads and wondering what would happen if he just stopped doing it. Would the curators at the Tate Gallery go around buying all that stuff, or the BBC, or the Arts Council, or the Queen, or Sting? No. Hey, the young artists would be broke!

(Matthew Collings, 1997)

An austere medieval saint takes a dim view of medieval art: in the church it is only there to encourage the faithful to greater benefactions, while in the cloister it serves no purpose at all. The patronage of art is vanity, and expensive vanity, at that.

For I know not how it is that, wheresoever more abundant wealth is seen, there do men offer more freely. Their eyes are feasted with relics cased in gold, and their purse strings are loosened. They are shown a most comely image of some saint, whom they think all the more saintly that he is the more gaudily painted. Men run to kiss him, and are invited to give; there is more admiration for his comeliness than veneration for his sanctity. Hence the church is adorned with gemmed crowns of light – nay, with lustres like cartwheels, girt all round with lamps, but no less brilliant than the precious stones that stud them. Moreover we see candelabras standing like trees of massive bronze, fashioned with marvellous subtlety of art, and glistening no less brightly with gems than the lights they carry. What think you is the purpose of all this? The compunction of penitents, or the admiration of the beholders? O vanity of vanities . . .

In the cloister, under the eyes of the Brethren who read there, what profit is there in those ridiculous monsters, in that marvellous and deformed comeliness, that comely deformity? To what purpose are those unclean apes, those fierce lions, those monstrous centaurs, those half-men, those striped tigers, those fighting knights, those hunters winding their horns? Many bodies are there seen under one head, or again, many heads to a single body. Here is a four-footed beast with a serpent's tail; there, a fish with a beast's head. Here again the forepart of a horse trails half a goat behind it, or a horned beast bears the hinder quarters of a horse. In short, so many and so marvellous are the varieties of divers shapes on every hand, that we are more tempted to read in the marble than in our books,

and to spend the whole day in wondering at these things rather than in meditating the law of God. For God's sake, if men are not ashamed of these follies, why at least do they not shrink from the expense?

(St Bernard of Clairvaux, *c*.1125, in Elizabeth G. Holt, 1956)

Imagination

The American artist Robert Rauschenberg is at heart a dancer, claims the writer, critic, and gallery director Bryan Robertson.

But it was the range and wholly individual nature of work shown in the downtown Guggenheim that seemed to take on a special energy and eloquence of its own. It is a pleasure to add that a good deal of this enlivening work was also the latest in date, a revelation for everyone in terms of vitality, colour, light and scale. Many big transfer paintings had been made on gleamingly reflective surfaces, like copper or stainless steel, and these – apart from the reflective spatial ambiguity – had a buoyancy and the specific brilliance of high-keyed very fresh colour. Seen in the context of the theatre pieces, shown nearby on film and photograph – Rauschenberg as a performer, choreographer and designer of sets, costumes and lighting – the recent work took on another dimension which seemed to illuminate his oeuvre as a whole. What emerged very clearly from the downtown installation [the Rauschenberg exhibition took place both at the uptown Guggenheim on 5th Avenue, and the downtown Guggenheim in SoHo] – and referred us back in memory to some uptown works – is that Rauschenberg is, pre-eminently, from first to last, a *performer*, and that the whole of his art springs from the essential character of performance, its directness, apparent spontaneity, swiftness – *speed* – animation and lightness of touch.

The idea of the artist as a performer is probably, in some ways, as old as the concept of patronage and commissioned murals, ceiling decorations or altarpieces – some aspects of Michelangelo's labour for Pope Julius in the Sistine Chapel meet some of the conditions and requirements of performance. But with the decline of that inspired level of patronage, we arrived at a situation in the first half of the twentieth century when, on the whole, we preferred our artists to be confined to studios, with their creations separated from their untidy begetters and neatly corralled into the neutral terrain of an art gallery. An artist working in public, performing in public, was a highly suspect, flashy notion. On the other hand we still

enjoyed the stirring spectacle of the *composer* as performer, from Paganini and Liszt, through to Rachmaninov in the 1930s, interpreting his own piano music with unmatched virtuosity. Ravel played his Piano Concerto in G all over Europe around the same time, and Stravinsky conducted *Le Sacré du Printemps* and *Les Noces* everywhere – but these examples really do no more than extend into our own time the examples set by Mozart and Haydn as self-interpreters.

More recently, David Tudor and John Cage brought another dimension to the notion of the artist or composer as performer, with only half a piano, or the piano wires taped, or in a recital consisting of absolute silence, so that the concept of a 'performance' by the composer was extended into a neo-Dada territory of anarchic or absurdist theatre. At the same time, 'Happenings and Events' materialized in New York and elsewhere, and finally the rather less engaging sequences began of conceptual performance works and installation pieces, rehearsing or presenting conceptual arguments, formal, social or political, but still a kind of performance.

I believe that it was Picasso's startling appearance on camera in Clouzot's terrific film *Le Mystère Picasso* in 1951, when he made drawings with coloured light in a darkened room and then painted a big picture behind glass, also on camera, which most dramatically brought to everyone's attention the idea, freshly delivered, of the artist as performer – which, until that breathtaking moment, had been extremely suspect. Around the same time, Jackson Pollock was improvising with paint, mesh, cord and assorted bits and pieces, a collage behind glass – also functioning steadily within the camera's gaze as the work developed – for Hans Namuth's film that used also a collage-like, very spatial score by Morton Feldman. This was the essence of inspired improvisation at work by an artist in a performance which disclosed a radically new technical and spiritual approach to art that also invoked ancient usages. A little later, and rather differently, as an imaginative extension of the ancient idea of follies – but brought out of the private estate and private patronage into the participatory world of public performance and state sponsorship – came Christo and his team of workers with the floating islands, fences straddling a continent and wrapped bridges and buildings.

Rauschenberg came out of all this, not in any sense of obligation or adherence to direct lineage, but simply through being a highly sophisticated, exceptionally gifted young artist working in Manhattan in the 1950s and then the 60s, with an imagination sympathetic to the notion of spontaneity.

Abstract Expressionism had helped clear the air. If his art was unprecedented from the beginning in its range, attack, energy and character, then the water had at least been partially tested. In the late 1940s, he had studied at Black Mountain College in North Carolina under Josef Albers. (Rauschenberg once gave me a jokey explanation for his early *White* paintings: 'After months of Albers's colour theory, I couldn't even think about colour any more and I made the *White* paintings'. But then he went on to make the *Black* and the *Red* paintings . . . In this sense, Rauschenberg's paintings, even when less directly conceptual than these early works, may also be seen as performance pieces.) At that time he began a potent friendship with the choreographer Merce Cunningham, the composer John Cage, and with David Tudor, who was busily putting music, and notably piano music, through the wringer. This group of friends, inspired by Cage, precipitated and staged at Black Mountain the first 'Happening'. Rauschenberg has of course been an integral part for long periods of the Cage–Cunningham–Tudor–Johns axis, which has played such a vital role in dance, stage design and performance in the US, as well as serving as a fund-raising agency over the years for all kinds of artists fallen on bad times.

The central impulse and identity of all Rauschenberg's work is improvisation and performance. No other artist in the twentieth century has also been a dancer and an experienced performer on stage and a choreographer. It's an odd concept as well as unique: can you imagine considering, in addition to their paintings, the performances of Léger or Matisse as *dancers*? Such a new kind of hybrid being could only have surfaced in the 60s, and in the USA. Of course Rauschenberg was not a great dancer or even a particularly good one, but he had enough physical grace, control and stage presence to hold his own, and he knew how to move or stand in relation to other dancers on stage. Like other Americans, Rauschenberg had absorbed some of the instinctive feeling for casual, inconsequential gesture and movement in dance which Martha Graham had been the first to set against her more formalized and hieratic use of stylized movement. And most of his stage appearances come under the heading of performance rather than dance, often involving nothing more complicated than standing up and sitting down in a kind of musical-chairs sequence – which is one memory I retain of a semi-danced 'Happening' at the New York Armoury, with Rauschenberg and the marvellous dancers Yvonne Rainer and Steve Paxton walking from one group of dancers to another, or climbing up and down ropes. Physically demanding perhaps, but not really dance. But he certainly danced well enough on occasion, notably in his poetic

extravaganza of 1963, *Pelican*, in which with other dancers he appeared on rollerskates and wearing a parachute. More weightily and resoundingly, Rauschenberg has also designed sets and costumes and all the lighting for dozens of stage works, some of them pure dance choreographed by himself, but mostly for the choreography of Paul Taylor, Merce Cunningham, Viola Farber or Tricia Brown; with other works presented as performance pieces for himself in association with various dancers, or on stage with fellow artists – such as Tinguely, Niki de Saint-Phalle or Frank Stella.

If Rauschenberg always brought an inspired element of play into his stage work as a performer, alone or with others, or as a designer of sets and lighting, this element was more tightly focused and extended in his concern for assemblage: in the big *Oracle* of 1962–5, for example, the grand 'five-part assemblage with five concealed radios, ventilation duct, automobile door on typewriter table with crushed metal; ventilation duct in wash-tub and water with wire baskets; constructed staircase control unit housing batteries and electronic components; and wood window frame with ventilation duct'. A few of these assemblages seem now rather marooned in their time and place, but others transcend their moment with undimmed verve, notably those constructions involving neon and other light forms. Those which don't quite pass the test of time perhaps fall under Wallace Stevens's verdict on free, unbridled aestheticism: 'The essential fault of Surrealism is that it invents without discovering.'

Always animated by Rauschenberg's instinct for spontaneity is his lifelong use of photography and the printed image. He experimented at Black Mountain in 1949 with photographic blueprints, and some of his own early photography was like Walker Evans without the people; but since those early excursions nobody in this century has used printed images – our daily, visual world currency – as Rauschenberg has presented and redeployed them over such a wide range of references, from harbours and markets and shantytowns to moon landings, from images of JFK to anonymous athletes and dancers. Nobody has worked harder to pioneer innovative techniques in printmaking itself. Nobody has used collage so grandly or sumptuously, setting printed imagery and painting in tense relationship, and nobody else can touch Rauschenberg's sharply instinctive placement.

Events occur at different speeds in Rauschenberg's work, but are composed, counterpointed, reconciled, within variable spaces: the blank, anonymous space of white paper, inhabited and therefore atmospherically or psychologically nuanced space, neutral space, space as colour. His

unerring flair for placement and structure combine to give a highly personal dimension to each composition. The writer Grace Paley has spoken of her refusal to use a single plot line in her stories because 'the absolute line between two points . . . takes all hope away. Everyone, real or invented, deserves the open destiny of life.' *The open destiny of life* – that's Rauschenberg, despite his early disclaimer about wanting to work in the space somewhere between art and life.

(Bryan Robertson, 1998)

Vasari describes the habits of an eccentric Florentine painter of the Renaissance.

While Giorgione and Correggio were to their great credit and glory honouring the regions of Lombardy, Tuscany herself also did not lack men of splendid talents, among whom not the least was Piero, the son of a certain Lorenzo, a goldsmith, and the pupil of Cosimo Rosselli [1439–1507, painter], after whom he was known as and never called other than Piero di Cosimo. And truly when someone teaches us excellence and gives us a good way of life, he puts us no less in his debt and must be no less regarded as a true father than the one who begets us and simply gives us life.

Seeing his son's lively talents and his inclination to the art of design, Piero's father handed him over to the care of Cosimo, who was more than willing to accept him; and as he saw him grow both in years and in talent, among the many disciples he had, he loved him as a son and always held him as such. This young man had from Nature a very lofty spirit, and he was very set apart and very different in his thoughts and fancies from the other young men who were staying with Cosimo to learn the same art. He was sometimes so intent on what he was doing that when some topic was being discussed, as often happens, at the end of the discussion it was necessary to go back to the beginning and recount everything again, since his mind had wandered off on some other track. And he was likewise so fond of solitude that he was never happy except when, wrapped up in his own thoughts, he could pursue his own ideas and fancies, and build his castles in the air; and so his master Cosimo had good reason to think well of him, since he made use of him in his own works so much that time and time again he had him carry through projects of considerable importance, knowing that Piero had a more beautiful style and better judgement than he did himself . . .

Piero did many pictures for a great number of citizens in Florence, dispersed among their houses, and I myself have seen many good examples, as well as various things with many other people. In the noviciate of San Marco is a picture by his hand of Our Lady standing with the Child in her arms, coloured in oils; and for the chapel of Gino Capponi in the church of Santo Spirito at Florence he painted a panel showing the Visitation of Our Lady, with St Nicholas and St Anthony, who is reading with a pair of spectacles on his nose, a very lively figure. Here he counterfeited a book bound in vellum, looking quite old, and as if it were real, and also some spheres for St Nicholas gleaming with highlights, and casting reflections of light one to another, from which men of even his own time realized the strangeness of Piero's mind, and how he pursued difficult problems.

Piero showed this still more after the death of Cosimo, when he stayed all the time shut up indoors and never let himself be seen at work, and followed a way of life more like that of a brute beast than a human being. He would not allow his rooms to be swept; he would eat only when he felt hungry; and he would never let his garden be dug or the fruit trees pruned, but rather he let the vines grow and the shoots trail along the ground; nor were his fig trees or any others ever trimmed, but he was content to see everything run wild, like his own nature, asserting that nature's own things should be left to her to look after, and that was enough. He frequently took himself off to see animals or plants or other things that nature often creates accidentally or from caprice, and he derived from these a pleasure and satisfaction that completely robbed him of his senses; and he mentioned them in his conversation so many times that sometimes, although he himself derived pleasure from this, others found it tedious. He would sometimes stop to contemplate a wall at which sick people had for ages been aiming their spittle, and there he descried battles between horsemen, and the most fantastic cities, and the most extensive landscapes ever seen: and he experienced the same with the clouds in the sky.

(Giorgio Vasari, 1568)

Leonardo da Vinci, like Piero di Cosimo, used old, stained walls as an imaginative aid – if this celebrated tip is anything to go by.

I will not refrain from setting among these precepts a new device for consideration which, although it may appear trivial and almost ludicrous, is nevertheless of great utility in arousing the mind to various inventions. And this is, that if you look at any walls spotted with various stains, or with a mixture of different kinds of stones, if you are about to invent some scene you will be able to see in it a resemblance to various different landscapes adorned with mountains, rivers, rocks, trees, plains, wide valleys, and various groups of hills. You will also be able to see divers combats and figures in quick movement, and strange expressions of faces, and outlandish costumes, and an infinite number of things which you can then reduce into separate and well conceived forms. With such walls and blends of different stones it comes about as it does with the sound of bells, in whose clanging you may discover every name and word that you can imagine.

(Leonardo da Vinci, 1452–1519)

The Surrealist Max Ernst describes how he invented frottage, *making use of shapes suggested not by a wall, but by floorboards. Apparently, Surrealist collage works on similar principles.*

It all started on August 10, 1925, by my recalling an incident of my childhood when the sight of an imitation mahogany panel opposite my bed had induced one of those dreams between sleeping and waking. And happening to be at a seaside inn in wet weather I was struck by the way the floor, its grain accentuated by many scrubbings, obsessed my nervously excited gaze. So I decided to explore the symbolism of the obsession, and to encourage my powers of meditation and hallucination I took a series of drawings from the floorboards by dropping pieces of paper on them at random and then rubbing the paper with blacklead. As I looked carefully at the drawings that I got in this way – some dark, others smudgily dim – I was surprised by the sudden heightening of my visionary powers, and by the dreamlike succession of contradictory images that came one on top of another with the persistence and rapidity peculiar to memories of love.

Now my curiosity was roused and excited, and I began an impartial

exploration, making use of every kind of material that happened to come into my field of vision: leaves and their veins, frayed edges of sacking, brushstrokes in a 'modern' painting, cotton unwound from a cotton-reel, etc., etc. Then I saw human heads, many different beasts, a battle ending in a kiss (*the wind's sweetheart*), rocks, *sea and rain*, *earth tremors*, the *sphinx in its stable*, the *small tables round about the earth*, *Caesar's shoulder blade*, *false positions*, a *shawl covered with flowers of hoarfrost*, *pampas*.

The *cuts of a whip*, *trickles of lava*, *fields of honour*, *inundations and seismic plants*, *scarecrows*, the *edge of the chestnut wood*.

Flashes of lightning before one's fourteenth year, *vaccinated bread*, *conjugal diamonds*, the *cuckoo* (*origin of the pendulum*), the *meal of death*, the *wheel of light*.

A *solar coinage system*.

The *habits of leaves*, the *fascinating cyprus tree*.

Eve, the only one remaining to us.

I put the first fruits of the *frottage* process together, from *sea and rain* to *Eve, the only one remaining to us*, and called it *Natural History*.

I stress the fact that, through a series of suggestions and transmutations arrived at spontaneously like hypnotic visions, drawings obtained in this way lose more and more of the character of the material being explored (wood, for instance). They begin to appear as the kind of unexpectedly clear images most likely to throw light on the first cause of the obsession, or at least to provide a substitute for it.

And so the *frottage* process simply depends on intensifying the mind's capacity for nervous excitement, using the appropriate technical means, excluding all conscious directing of the mind (towards reason, taste, or morals) and reducing to a minimum the part played by him formerly known as the 'author' of the work. The process, in consequence, shows up as a true equivalent of what we now call *automatic writing*. The author is present as a spectator, indifferent or impassioned, at the birth of his own work, and observes the phases of his own development. Just as the poet's place, since the celebrated *Letter of a Clairvoyant*, consists in writing at the dictation of something that makes itself articulate within him, so the artist's role is to gather together and then give out that which makes itself *visible* within him. In devoting myself to this activity (or passivity) – later we called it *paranoiac criticism* – and adapting *frottage*, which seemed at first only applicable to drawing, to the technical mediums of painting (for instance, scratching colours on a prepared coloured ground, over an uneven surface), and in trying all the time to reduce still more my own active participation in the making of a picture, so as to widen the active

field of the mind's capacity for hallucination, I succeeded in being present *as a spectator* at the birth of all my works after August 10, 1925, the memorable day of the discovery of *frottage*. Being a man of 'ordinary constitution' (to use Rimbaud's terms) I have done my best to *make my soul monstrous*. A blind swimmer, I have made myself clairvoyant. I have *seen*. I have become the amazed lover of what I have seen, wanting to identify myself with it.

In 1930, when I had, with a passion that was yet systematic, composed my book, *The Hundred-Headed Woman*, I had an almost daily visit from the *Head of the Birds*, called Loplop, a very special phantom of exceptional faithfulness, who is attached to my person. He presented me with a *heart in a cage, the sea in a cage, two petals, three leaves, a flower and a girl*; and also *the man with the black eggs*, and *the man with the red cloak*. One fine autumn afternoon he told me that one day *a Lacedaemonian had been asked to go and hear a man who could imitate the nightingale perfectly*. The Lacedaemonian answered: *I have often heard the nightingale itself*. One evening he told me some jokes that were not funny. Joke – it is better not to reward a fine action at all than to reward it badly. A soldier had both arms blown off in a battle. His colonel offered him half a crown. The soldier said to him: 'I suppose, sir, you think I've only lost a pair of gloves.'

What is the mechanism of collage?

I think I would say that it amounts to *the exploitation of the chance meeting on a non-suitable plane of two mutually distant realities* (a paraphrase and generalization of the well-known quotation from Lautréamont *'Beautiful as the chance meeting upon a dissecting table of a sewing machine and an umbrella'*) or, more simply, *the cultivation of systematic moving out of place* on the lines of André Breton's theory: *Super-reality must in any case be the function of our will to put everything completely out of place* (*naturally one could go so far as to put a hand out of place by isolating it from an arm, then the hand thereby gains, as a hand; and, what is more, when we speak of putting things out of place we are not thinking only of space*). (Warning to the reader in *The Hundred-Headed Woman*.)

A complete, real thing, with a simple function apparently fixed once and for all (an umbrella), coming suddenly into the presence of another real thing, very different and no less incongruous (a sewing machine) in surroundings where both must feel out of place (on a dissecting table), escapes by this very fact from its simple function and its own identity; through a new relationship its false absolute will be transformed into a different absolute, at once true and poetic: the umbrella and the sewing machine will make love. The mechanism of the process seems to me to

be laid bare by this very simple example. Complete transmutation followed by a pure act such as the act of love must necessarily occur every time the given facts make conditions favourable: *the pairing of two realities which apparently cannot be paired on a plane apparently not suited to them.* Speaking of the collage process in 1920 Breton wrote:

> It is the marvellous capacity to grasp two mutually distant realities without going beyond the field of our experience and to draw a spark from their juxtaposition; to bring within reach of our senses abstract forms capable of the same intensity and enhancement as any others; and, depriving us of any system of reference, to set us at odds with our own memories. (Preface to Max Ernst exhibition, May, 1920.)

The two processes, *frottage* and *collage*, are so alike that without changing much I can use the same words to describe the discovery of the one that I used earlier for the other. One day, in 1919, being in wet weather at a seaside inn, I was struck by the way the pages of an illustrated catalogue obsessed my nervously excited gaze. It was a catalogue of objects for anthropological, microscopic, psychological, mineralogical and paleontological demonstration. I found here united elements such poles apart that the very incongruousness of the assembly started off a sudden intensification of my visionary faculties and a dreamlike succession of contradictory images – double, triple and multiple images coming one on top of the other with the persistence and rapidity peculiar to memories of love, and to the dreams that come between sleeping and waking. These images themselves suggested new ways for them to meet in a new unknown (the plane of unsuitability). All I had to do was to add, either by painting, or drawing, to the pages of the catalogue. And I had only to reproduce obediently what made itself visible within me, a colour, a scrawl, a landscape strange to the objects gathered in it, a desert, a sky, a geological event, a floor, a single line drawn straight to represent the horizon, to get a fixed and faithful image of my hallucination; to transform what had been commonplaces of advertising into dramas revealing my most secret desires.

(Max Ernst, 1937)

The Surrealist René Magritte describes how he freed his imagination.

I felt that the world, that life could be transformed and made more in keeping with thought and feeling.

Between 1925 and 1926, I painted some sixty pictures which were put on show at the Galerie Le Centaure in Brussels. The liberation they asserted naturally infuriated the critics, from whom in any case I expected no worthwhile reaction. It was a wholesale attack. They objected to the presence of things I showed and to the absence of the things I hadn't shown. I had, as it happened, replaced plastic qualities that the critics approved of by an objective representation of objects, which can be clearly apprehended and understood by those people whose taste has not been corrupted by the accumulation around painting of so much empty rhetoric.

In my view, this detached way of representing things is characteristic of a universal style in which the manias and minor preferences of the individual no longer play any part.

For instance, I used light blue when it was necessary to represent the sky and I never represented the sky, as certain bourgeois artists do, to give myself the opportunity to show such-and-such a blue next to such-and-such a grey for which I might have a preference.

The traditionally picturesque, the only form authorized by the critics, could not be found in my pictures and for a very good reason: the picturesque is inoperative and refutes itself each time it reappears in an identical form. What gave it its charm, before it became traditional, was the unexpectedness, the novelty of a strange arrangement of objects. As a result of repeating certain effects of this kind, the picturesque has become repugnantly monotonous and useless.

How, at each 'Spring Exhibition', can the public bear to look at the same old still-lifes or the same old sunlit or moonlit church wall?

All those onions and eggs, sometimes to the right, sometimes to the left, of the inevitable brass pot with its obligatory highlights? Or that swan which, since antiquity, prepares to penetrate thousands of Ledas?

I think the picturesque can be effective, provided it is set in a new context or in certain circumstances. For instance, a legless cripple will cause a sensation at a Court ball. The traditional picturesque of the avenue in the ruined cemetery appeared magical to me as a child because I was discovering it on emerging from the darkness of the underground vaults.

I am also criticized because of the ambiguity of my pictures. What an admission, is it not, on the part of those who make the complaint: they are ingenuously confessing how hesitant they are when left to themselves without the reassurance provided by a so-called expert's guarantee, the test of time or whatever!

I am criticized because of the rare, unusual nature of my interests. A

strange complaint coming from people for whom rarity is a sign of great value.

In my pictures I show objects in situations in which we never encounter them. This fulfils a real, but perhaps unconscious desire felt by most men. Even a banal painter tries, within the limits imposed upon him, to disrupt the order in which he habitually sees objects.

He will allow himself timid audacities and vague hints. Given my intention to make the most everyday objects shriek aloud, they had to be arranged in a new order and take on a disturbing significance. The cracks that we see in our houses and our faces seemed more telling to me when placed in the sky. Turned wooden table legs lost the blameless being usually attributed to them, if they suddenly appeared to be dominating a forest. A female body floating above a town was a distinct improvement on the angels who never appeared to me. I found it very useful to see the Virgin Mary in a state of undress, and I showed her in this new light. I took the iron bells which adorn the necks of our admirable horses and made them sprout like dangerous plants on the edge of abysses.

As for the mystery or enigma constituted by my pictures, I say that it was the best possible proof that I had broken with that whole pattern of absurd mental habits which so often replaces an authentic feeling of existence. The pictures painted during the following years, from 1926 to 1936, were also the outcome of a systematic search for a disturbing poetic effect which, having been achieved by the presentation of objects borrowed from reality, would enclose the real world from which the objects had been borrowed with a disturbing poetic sense – through a perfectly natural exchange. The means used were analysed by Paul Nougé [Belgian biochemist, Communist and Surrealist guru] in a book entitled *Forbidden Images*.

The basic device was the placing of objects out of context: for example, a Louis-Philippe table on an ice floe.

Obviously, the objects chosen had to be of the most everyday kind so as to give the maximum effect of displacement. The sight of a child in flames is more affecting than the conflagration of a distant planet.

Paul Nougé rightly pointed out that certain objects which are invested with an exceptional emotional charge in their own right retain that exact charge even when out of context. Female underwear, for instance, proved very difficult to show in any unexpected light.

(René Magritte, 1938)

Miró, whom Ernst once threatened to throttle unless he said he did not believe in God, provides his own imaginative recipes.

At the time I was painting *The Farm*, my first year in Paris, I had Gargallo's studio. Masson was in the studio next door. Masson was always a great reader and full of ideas. Among his friends were practically all the young poets of the day. Through Masson I met them. Through them I heard poetry discussed. The poets Masson introduced me to interested me more than the painters I had met in Paris. I was carried away by the new ideas they brought and especially the poetry they discussed. I gorged myself on it all night long – poetry principally in the tradition of Jarry's *Surmâle* . . .

As a result of this reading I began gradually to work away from the realism I had practised up to *The Farm*, until, in 1925, I was drawing almost entirely from hallucinations. At the time I was living on a few dried figs a day. I was too proud to ask my colleagues for help. Hunger was a great source of these hallucinations. I would sit for long periods looking at the bare walls of my studio trying to capture these shapes on paper or burlap.

Little by little I turned from dependence on hallucinations to forms suggested by physical elements, but still quite apart from realism. In 1933, for example, I used to tear newspapers into rough shapes and paste them on cardboards. Day after day I would accumulate such shapes. After the collages were finished they served me as points of departure for paintings. I did not copy the collages. I merely let them suggest shapes to me.

(Joan Miró, in Francis Lee, 1947–8)

Just as the whole of a body is similar to its parts – an arm, a hand, a foot – everything in a painting must be homogeneous.

In my paintings, there is a kind of circulatory system. If even one form is out of place, the circulation stops; the balance is broken.

When a painting does not satisfy me, I feel physically uncomfortable, as though I were sick, as though my heart were not working properly, as though I couldn't breathe any more, as though I were suffocating.

I work in a state of passion and excitement. When I begin a painting, I am obeying a physical impulse, a necessity to begin. It's like receiving a physical shock.

Of course, a canvas cannot satisfy me right away. And in the beginning I feel the discomfort I have just described. But since I'm a fighter, I continue the struggle.

It's a struggle between myself and what I am doing, between myself and the canvas, between myself and my discomfort. This struggle excites and inspires me. I work until the discomfort goes away.

I begin my paintings because something jolts me away from reality. This shock can be caused by a little thread that comes loose from the canvas, a drop of water that falls, the fingerprint my thumb leaves on the shiny surface of this table.

In any case, I need a point of departure, whether it's a fleck of dust or a burst of light. This form gives birth to a series of things, one thing leading to another.

A piece of thread, therefore, can unleash a world. I invent a world from a supposedly dead thing. And when I give it a title, it becomes even more alive.

I find my titles in the process of working, as one thing leads to another on my canvas. When I have found the title, I live in its atmosphere. The title then becomes completely real for me, in the same way that a model, a reclining woman, for example, can become real for another painter. For me, the title is a very precise reality.

(Joan Miró, 15 February 1959)

A classical writer of the first century A D *describes an example of chance in art, concerning a painter who was high on lupins (the Surrealists would have approved).*

About the same time, there flourished (as I have said before) *Protogenes*, born he was at Caunos a city in Cilicia, and subject to the Rhodians: he was so exceeding poore at the beginning, and withall, so studious, intentive, and curious in his worke without all end, that fewer pictures by that means came out of his hands, and himselfe never rise to any great wealth . . . But of all the painted tables that ever he wrought, that of *Ialysus* ['a worthy knight, sonne of *Ochimus*'] is accounted the principall, which is now dedicated at Rome within the temple of *Peace*: whiles he was in painting this *Ialysus*, it is said, that he lived only upon steeped Lupines, which might serve him in stead of meat and drinke both, to satisfie his hunger and quench his thirst: and this hee did, for feare least too much sweetnesse of other viands should cause him to feed over liberally, and so dul his spirit and senses. And to the end that this picture should be lesse subject to other injuries, and last the longer, he charged it with foure grounds of colours, which he laid one upon another: that ever as the upper coat went,

that underneath might succeed in the place and shew fresh againe.

In this table, the pourtraiture of a dog is admirable and miraculous; for not only art, but fortune also met together in the painting thereof; for when he had done the dog in all parts to the contentment of his owne minde (and that ywis was a very hard and rare matter with him) and could not satisfie and please himselfe in expressing the froth which fell from his mouth as he panted and blowed almost windlesse with running; displeased he was with the very art it selfe: and albeit he thought that he had bin long enough already about the said froth, and spent therein but too much art and curiositie, yet somewhat (he wist not what) was to be diminished or altered therein: the more workmanship and skill that went thereto, the farther off it was from the truth indeed and the nature of froth (the onely marke that he shot at): for when he had done all that he could, it seemed still but painted froth, and not that which came out of the dogs mouth; whereas it should have been the very same and no other, which had been there before. Hereat he was troubled and vexed in his mind, as one who would not have any thing seene in a picture of his, that might be said like, but the very same indeed. Many a time he had changed his pensill and colours; as often, he had wiped out that which was done, and al to see if he could hit upon it, but it would not be, for yet it was not to his fansie.

At the last, falling clean out with his own workmanship, because the art might be perceived in it, in a pelting chase he flings me the spunge-ful of colours that he had wiped out, full against that unhappy place of the table which had put him to all this trouble: but see what came of it! the spunge left the colours behind, in better order than hee could have laied them, and in truth, as well as his heart could wish. Thus was the froth made to his full mind, and naturally indeed by meere chance, which all the wit and cunning in his head could not reach unto. (After whose example, *Nealces* another painter did the like, and sped as wel, in making the froth falling naturally from a horses mouth; namely, by throwing his spunge against the table before him, at what time as he painted a horse-rider cheering and cherking up his horse, yet reining him hard as he champed upon his bit.) Thus (I say) Fortune taught *Protogenes* to finish his dog.

(Pliny the Elder, first century A D, translated by Philemon Holland, 1601)

Francis Bacon reveals to David Sylvester that he was also in the habit of leaving things to chance.

FB: You know in my case all painting – and the older I get, the more it becomes so – is accident. So I foresee it in my mind, I foresee it, and yet I hardly ever carry it out as I foresee it. It transforms itself by the actual paint. I use very large brushes, and in the way I work I don't in fact know very often what the paint will do, and it does many things which are very much better than I could make it do. Is that an accident? Perhaps one could say it's not an accident, because it becomes a selective process which part of this accident one chooses to preserve. One is attempting, of course, to keep the vitality of the accident and yet preserve a continuity.

DS: What is it above all that happens with the paint? Is it the kind of ambiguities that it produces?

FB: And the suggestions. When I was trying in despair the other day to paint that head of a specific person, I used a very big brush and a great deal of paint and I put it on very, very freely, and I simply didn't know in the end what I was doing, and suddenly this thing clicked, and became exactly like this image I was trying to record. But not out of any conscious will, nor was it anything to do with illustrational painting. What has never yet been analysed is why this particular way of painting is more poignant than illustration. I suppose because it has a life completely of its own. It lives on its own, like the image one's trying to trap; it lives on its own, and therefore transfers the essence of the image more poignantly. So that the artist may be able to open up or rather, should I say, unlock the valves of feeling and therefore return the onlooker to life more violently.

DS: And when you feel that the thing, as you say, has clicked, does this mean that it's given you what you initially wanted or that it's given you what you'd like to have wanted?

FB: One never, of course, I'm afraid, gets that. But there is a possibility that you get through this accidental thing something much more profound than what you really wanted.

(David Sylvester, *Interviews with Francis Bacon*, 1987)

Goya, it seems, also made use of chance, according to this contemporary description of him at work on miniature paintings of heads late in life.

He blackened the ivory plaque and let fall on it a drop of water which, as

it spreads out, lifted away a part of the black ground leaving random light spots. Goya made use of these bared spaces, always turning them into something unexpected and original. These little works also belonged to the family of *Caprichos*; today they would be very much sought after, were it not that the modest man wiped off a good many of them in order to economize on the ivory.

(Laurent Matheron, 1857)

Bernini offers a different prescription for channelling the imagination, but warns against the dangers of an artist being too taken with novelty.

Afterwards he [Bernini] went from his room, where we were, on to his gallery. There he told me that he has a gallery almost exactly like this one in his house at Rome and that it is there that he creates most of his compositions as he walks around; that he notes on the wall with charcoal the ideas as they come to him; that it is usual for agile and imaginative minds to pile up thought upon thought on a subject. When a thought comes to them, they draw it; a second comes, and they note it also; then a third and a fourth; without discarding or perfecting any, they are always attached to the last idea by the special love one has for novelty. What must be done to correct this fault is to let these different ideas rest without looking at them for one or two months. After that time one is in a condition to choose the best one. If by chance the work is urgent and the person for whom one works does not allow so much time, it is necessary to have recourse to those glasses that change the colour of objects or those that make objects seem larger or smaller, and to look at them [the sketches] upside-down, and finally to seek through these changes in colour, size, and position to correct the illusion caused by the love for novelty, which almost always prevents one from being able to choose the best idea.

(Paul de Fréart, Sieur de Chantelou, 6 June 1665)

Delacroix, as interpreted by Baudelaire, deplores the unimaginative realist.

In spite of his admiration for the ardent phenomena of life, never can Eugène Delacroix be confused with that mob of vulgar artists and writers whose myopic intelligence shelters behind that vague and obscure word

realism. The first time I saw M. Delacroix, in 1845, I believe it was (how the swift and voracious years flow away!), we talked about many commonplace subjects, in other words, questions vast in scope and yet of the simplest: nature, for example. At this point, sir, I shall, with your permission, quote a passage of my own, for a paraphrase would not be as good as the words I once wrote, almost under the master's dictation: ' "Nature is but a dictionary," he was fond of saying. To understand clearly the full meaning implied in this remark, we must bear in mind the numerous and ordinary uses a dictionary is put to. We look up the meaning of words, the derivation of words, the etymology of words; and, finally, we get from a dictionary all the component parts of sentences and ordered narrative; but no one has ever thought of a dictionary as a composition in the poetic sense of the word. Painters who obey imagination consult their dictionaries in search of elements that fit in with their conceptions; and even then, in arranging them with artistry, they give them a wholly new appearance. Those who have no imagination copy the dictionary, from which arises a very great vice, the vice of banality, to which are particularly exposed those painters whose speciality lies nearest to so-called inanimate nature: the landscape artists, for example, who regard it generally as a triumph if they can conceal their personalities. They contemplate so much that in the end they forget to feel and to think.'

(Charles Baudelaire, 'The Life and Works of Eugène Delacroix', 1863)

However, the leading realist of nineteenth-century Paris gives a much more down-to-earth account of the place of the imagination.

Painting is in essence a *concrete* art, and can only be the representation of both *real* and *existing* things. It is a totally physical language, and its vocabulary consists of all visible objects . . . Imagination in art is the ability to find the most complete expression for an existing thing, but never the ability to conceive or create an object.

(Gustave Courbet, letter to prospective students, 25 December 1861)

Emotion

A character in a French novel of the decadent 1890s is carried away by the utter lack of emotional restraint in the mystical, horrific Crucifixion *by the German Renaissance painter Matthias Grünewald. The author, J.-K. Huysmans, was an inspiration to Wilde and Beardsley.*

These early craftsmen, in Italy, in Germany, in Flanders above all, had evoked the white splendours of sanctified souls. In their original wall paintings, patiently and surely wrought, appeared figures in pictures drawn from life, masterful and convincing in this reality; and from these forms, often with common faces, from these features, sometimes ugly, yet powerfully conceived in their general aspect, shone forth celestial joys, bitter pangs of suffering, halcyon calms of mind, wild hurricanes of soul. In some sort there was a transformation of matter under stress or strain, a vision from out the prison of the senses over infinite, far-distant horizons.

The revelation of this realistic art had come to Durtal the year before, at a time, however, when he was less wearied than nowadays of the pitiful spectacle of these last years of the century. This was in Germany before a 'crucifixion' by Mattaeus Grünewald.

And he shuddered when he sat before the fire and half closed his eyes in pain. With extraordinary clearness he could now see the picture there before him when he called up the vision, and the same cry of admiration he had given on entering the little gallery of the museum at Cassel he uttered again mentally, as here in his own chamber the Christ rose before him, ghastly on his cross, the upright of which was crossed in lieu of arms by a branch of a tree, half stripped of the bark, that bent like a bow under the weight of the Saviour's body.

Every moment this branch seemed on the point of springing back and in an access of commiseration, throwing far from this scene of crime and outrage the poor corpse now held down earthwards by the huge nails that transfixed the feet.

Long and lean, almost dragged from their sockets, the two arms of the Christ seemed pinioned from shoulder to wrist by the cords of the

contracted muscles. The armpit was collapsed and cracking under the strain. The hands hung opened wide, the thin fingers contorted in a wild gesture half of reproach. The chest quivered convulsively, plastered with congealed sweat. The torso was barred in circles of ridge and furrow by the cage of the sunken ribs. The flesh was tumefied, stained and blackened, spotted with insect bites, pitted as if with pinpricks by the tips of the rods that, breaking off under the skin, still showed the surface pierced here and there by splinters.

Decomposition had set in; from the open wound in the side poured a thicker stream, flooding the hip with blood that matched in colour the deep red juice of the mulberry. Outflows of pinkish serum, rivulets of milky lymph, watery discharges like white Moselle wine, trickled from the bosom and soaked the belly, below which was loosely bound a dripping loincloth. Lower down, the knees, locked tight together, brought the kneecaps into violent contact, while the relaxed legs sank helplessly to the feet, which, pressed one upon the other, stretched long and horrible in full putrefaction, green and ghastly amid torrents of blood. These feet, spongy and curdled, were a grisly spectacle; the swollen flesh rising above the head of the nail, while the shrivelled toes contradicted the imploring gesture of the hands, seeming to be cursing as they clawed with their livid horny nails at the ochreous soil, impregnated with iron like the red earths of Thuringia.

Above this putrefying body the head showed a monstrously exaggerated bulk, chapleted with a disordered crown of thorns, it hung drooping, one haggard eye half opened with a shuddering gaze of pain and terror. The face was rugged, the forehead fleshless, the cheeks parched, while the mouth, unhinged, grinned with jaws contorted by the spasms of atrocious suffering.

So appalling had been the death agony that the very sight of it had abashed the merriment of the executioners and sent them flying from the spot.

Now, under the night sky, the cross seemed to cower very low, almost level with the ground, guarded by two figures that were on watch, either side of the Christ. One is the Virgin, wearing a hood of a pale blood-red that fell in close folds over a dark blue loosely flowing robe, the Virgin, who stands there, her form rigid, her face pallid and swollen with tears, sobbing and burying her nails in the palms of her hands, – the other St John, something of the gypsy to look at or a suntanned rustic of the Suabian highlands, clad in wide-skirted garments as though rudely carved

from the bark of trees, a scarlet gown, a yellow cloak of the hue of chamois-leather, the lining of which, where it was turned back at the elbow, showed the hectic green of unripe citrons. Worn out with weeping, but of sterner stuff than Mary, broken and scarce keeping her foothold, he wrings his hands in a transport of grief, straining towards the dead Christ, whom he gazes at with his red, filmy eyes, while a soundless, suffocating sigh escapes from his strangled throat.

From this blood-bespattered, tear-stained Calvary how far a cry to those dainty Golgothas that, since the Renaissance, the Church adopts as its symbol! This Christ of the spasm-racked visage was not the Christ of the Rich, the Adonis of Galilee, the well-looking dandy, the pretty youth with ruddy locks and forked beard and insipid fine gentleman features, that for four hundred years past the faithful adore. *He* was the Christ of St Justin and St Basil, of St Cyril, of Tertullian, the Christ of the early ages of the Church, the Christ of the common folk, ugly and ill-favoured because he took on himself the sum of all the world's sins and in his humility assumed the most abject shapes.

This was the Christ of the Poor, He who was made like to the most degraded of those he had come to redeem, outcasts and beggars, all those on whose squalor and destitution mankind's cowardly cruelty is wreaked; He was likewise the most human of Christs, the Christ with the weak, suffering flesh, forsaken by the Father, who had interposed only when no new pang was possible, the Christ succoured only by his Mother, whom he had been constrained, as all souls are, to call upon with an infant's cry, his Mother then powerless to be of any avail.

By a supreme act of humility no doubt he had suffered that the Passion should not overpass the stage allotted to the senses to endure, and in obedience to inscrutable laws he had consented that his Divinity should, as it were, be suspended from the day of the buffets and spittings, from all the outrages of his tormentors, to that of the fearful pangs of an interminable death struggle. Thus he had been the better able to suffer, to agonize, to die like a common thief, like a dog, foully, basely, enduring these indignities to the bitter end, even to the ignominy of putrefaction, the supreme contumely of suppuration.

Surely never before had realism dared such subjects; never had painter delineated in such sort the charnel house of the divine, so crudely dipped his brush in the stains of foul secretions and the running sores of wounds. It exceeded all bounds of brutality and horror. Grünewald was the most outrageous of realists; but by dint of gazing on this Redeemer of the

Lazarette, this God of the dead-house, there was wrought a change. From that ulcerous head there filtered gleams of light; a superhuman radiance illumined the gangrenous flesh and shone from the ravaged features. That carrion stretched there on the cross was the indwelling-place of a God and, without aureole or nimbus, its sole adornment the tangled crown of thorns beaded with drops of blood, Jesus appeared in his celestial Supra-essence, between the Virgin, grief-stricken and blind with weeping, and St John whose burning eyes could find no more tears to shed.

Those faces, at first glance so commonplace, glowed with the ecstasy of transfigured souls. No thief was there now, no poor carpenter's wife, no rustic peasant, but supra-terrestrial beings in the presence of a God.

Grünewald was the most outrageous of the realists. Never had painter so magnificently revealed the loftiest heights, so intrepidly lifted the soul to the far-off sphere of the heavens. He had gone to either extreme and from a base of filth had triumphantly distilled the finest cordials of loving charity, the most caustic essences of tears. In this picture was revealed the masterpiece of an art having one fixed aim and object, to represent the invisible and the tangible, to make manifest the lamentable uncleanness of the body, to sublimate the infinite distress of the soul.

No, there was no equivalent in any tongue. In Literature, certain pages of Anne Emmerich on the Passion approached, but in attenuated form, this ideal of supernatural realism and of life at once actual and spiritual. Perhaps too certain effusions of Ruysbroek, that shoot up in twin jets of white and black flames, recalled in certain details the divine lowliness of Grünewald, – but again no! his work remained unique, for it was at one and the same time out of reach of the hand on the level of the ground.

But in that case, – Durtal kept telling himself, – in that case, if I am logical, I end up in the catholicism of the Middle Ages, in the realism of the mystics; no, no! I say, – though it may be after all . . .

(J.-K. Huysmans, 1891)

The moving thing about the paintings of Piero della Francesca, Bernard Berenson found, was that he did not attempt to express emotion.

Piero della Francesca seems to have been opposed to the manifestation of feeling, and ready to go to any length to avoid it. He hesitated to represent the reaction which even an inanimate object would have when subjected to force, the rebound of a log, for instance, when struck by an

axe. Look at the fresco of the Battle between Heraclius and Chosroes and the Decapitation of this Sassanian Monarch. No adequate action, scarcely any facial correspondence. A stiffly vertical trooper, with an immobile face, plunges a dagger into the throat of a youth. The only approach to expression, a soldier in the foreground who screams automatically when an enemy awkwardly seizes him by the hair and threatens him with a drawn sword while he, like a lay figure, jerks out an unarticulated arm.

In the Borgo San Sepolcro fresco the Resurrected Christ, a sturdy stevedore like the Baptist in the early polyptych of the same little town, or the Christ in the London *Baptism*, looks straight ahead of him, dazed and as if waking from a refreshing sleep. It would take great imaginative power to discover in the two other figures just mentioned the faintest correspondence between looks and function. No Holy Spirit would penetrate the head of the grim athlete standing in mid-stream of Jordan. Three Angels, the comeliest figures Piero ever painted, stand by, but it is not certain that any of them is participating.

The Uffizi portraits of the Duke and Duchess of Urbino are conceived as if they were objects in nature, rocks, hills, as topographically as the landscape against which they are seen.

This leads me to observe that Piero was anti-romantic enough to prefer the dreariest or, at best, the least attractive countryside he could find. A loamy, low hillside with tufts of grass or scraggy bushes showing up humbly over clay or sand; a shallow stream may drag its sluggish way along; at the best a plane tree or two raise their tufted leafage over the dull surroundings. Yet how marvellously the silvery tree trunks and the frondage are realized!

Of all Piero's paintings the one I love best, the one that satisfies me more and more every time I see it, is the Urbino *Flagellation*. No feeling appropriate to action is expressed in face or figure, whether of the participants or of the mysterious trio in the foreground. Yet their callousness, their dumbness awe us into asking what they are made of. Not flesh and blood. Perhaps something more akin to the exquisite architecture, the columns, entablatures, ceilings, pavements, all like cut precious stones.

One is almost compelled to conclude that Piero was not interested in human beings as living animals, sentient and acting. For him they were existences in three dimensions whom perchance he would have gladly exchanged for pillars and arches, capitals, entablatures and facets of walls.

Indeed, it is in his architecture that Piero betrays something like lyrical feeling. He paints what he cannot hope to realize, his dream of surroundings worthy of his mind and heart, where his soul would feel at home. As in this *Flagellation*, so in the Arezzo frescoes, in the apse of the Brera altarpiece, in the cloister of the Perugia *Annunciation* (where he did not trouble to paint the figures), and not improbably, the view of a noble city square in an oblong panel at Urbino.

At this point one may venture to ask whether it is not precisely Piero's ineloquence, his unemotional, unfeeling figures, behaving as if nothing could touch them, in short his avoidance of inflation, which, in a moment of exasperated passions like our today, rests and calms and soothes the spectator and compels gratitude and worship.

Art, the painter's art especially, has been so *overexpressive* in recent decades, and now the representational arts most alive, the Cinema and the illustrated press, are so sensational, that whether we know or do not know what is the matter with us, we crave for the inexpressive, the ungrimacing, the ungesticulating; for freedom from posing and attitudinizing, to the extent even of taking to inanimate King Log in preference to the overanimated King Stork. In this case, King Log abandons representation and makes scrawls with brush, chalks, pen, or pencil. That is the only reason for calling them painting, although guaranteed to depict nothing but abstract figures, Euclidean, or even more remote from objects in the world as ordinary mortals see it.

Another characteristic that links Piero della Francesca to Cézanne and both to the most fashionable taste of our day, is that the former is almost as indifferent as the other to what we are accustomed to regard as physical beauty. Both are more aware of bulk and weight than of looks, although neither goes so far as do most of our contemporaries, who deliberately prefer the disagreeable, the ugly, even the bestial.

After sixty years of living on terms of intimacy with every kind of work of art, from every clime and every period, I am tempted to conclude that in the long run the most satisfactory creations are those which, like Piero's and Cézanne's, remain ineloquent, mute, with no urgent communication to make, and no thought of rousing us with look and gesture. If they express anything it is character, essence, rather than momentary feeling or purpose. They manifest potentiality rather than activity. It is enough that they exist in themselves.

But for fear of being whirled into the sandstorms of the reigning metaphysics, I should apply the epithet 'existential' to the works of art I

have in mind. I refer to those that we usually designate as 'classical', the ones to which, after no matter what desertions and rebellions, we return as to our native home.

(Bernard Berenson, 1954)

How Corot created a feeling of unnatural calm in his paintings.

Corot's struggle was not with the classical tradition or the legacy of his immediate predecessors but with the bewildering multiplicity of things seen. A typical, that is to say an early, Corot will always present the spectator with less than the eye actually encompasses, unlike a Constable, which will harry the mind with more than is normally perceived. For Corot the mind is at the service of the eye, to modulate, to control, to unify and to present. The result will be a moderately sized canvas showing an ideally distanced but not remote view of a town or site. This will be extremely calm, and populated by only one or two figures. The viewpoint will be high, as if the artist were looking out of a window across an intervening space. A strange dreamy, creamy placidity will be achieved, as if the site were viewed under an immobile and cloudless sky on an uneventful afternoon. This impression – but the word gives a misleadingly hasty resonance to what was in fact a fixed idea – will be achieved by mixing all the colours with white. Architecture, whether the Hospice at Villeneuve, or the Cabassud houses at Ville d'Avray, will be unaccented, flatly frontal, blind, eschewing surface accidents and details. The result will be an image of extraordinary clarity and peace, strong enough to becalm the spectator into thinking that he too might find so tranquil a scene. He will not, for it does not exist in nature.

(Anita Brookner, 1980, in her *Soundings*, 1997)

Stendhal finds that Michelangelo puts him in mind of the terror and glory of the Napoleonic Wars, during which he had served in the French Army.

After a month's stay in Rome, during which you will have seen nothing but statues, country houses, architecture and frescoes, eventually, on a fine sunny day, you may set foot in the Sistine Chapel. Even now it is still doubtful whether you will enjoy it.

The Italian soul for which Michelangelo painted was moulded by those

fortunate accidents which gave the fifteenth century almost all the qualities necessary for the arts. But, still more important, even among the inhabitants of present-day Rome (degraded by clericalism as they are), the eye is trained from infancy to seeing all the different types of art. However superior a Northerner may fancy himself, first of all he probably has a frigid soul, and secondly he cannot use his eyes and has already reached an age when the education of the body has become a difficult matter.

But let us now presuppose eyes which can see and a soul which can feel. Raising your eyes to the Sistine ceiling you will see compartments of different shapes and the human body reproduced in all guises . . .

Greek sculpture never attempted to produce terrifying effects: there were too many misfortunes in real life. Nothing in the entire realm of art can therefore be compared to the figure of the eternal Being creating the first man out of a void. The attitude, draughtsmanship, drapery, everything is striking, and the soul is shaken by impressions to which the eye is unaccustomed. When, on our unhappy retreat from Russia, we were suddenly wakened in the middle of the dark night by persistent cannon fire, which seemed to draw closer every moment, all our faculties were concentrated on the heart, for we were face to face with destiny; paying no heed to petty concerns, we prepared to do battle with fatality for our own lives. The sight of Michelangelo's pictures recalled for me this half-forgotten sensation. Noble souls are self-sufficient while others are afraid and go mad.

The arrogant expression of the Sistine figures, the audacity and power which mark all their features, the slow stateliness of their movements, the strange unprecedented way the drapery covers them, their striking contempt for everything merely human – everything about them proclaims them to be beings addressed by Jehovah, who pronounces judgement through their mouths.

This character of awesome majesty is most striking in the figure of the Prophet Isaiah. Lost in deep meditation while reading the book of the law, he has placed his hand in the book to mark the passage and, leaning his head on the other arm, he is entirely occupied with lofty thoughts when suddenly he is summoned by an angel. Without the slightest unpremeditated gesture or change of position at the sound of the angel, the prophet slowly turns his head round and seems reluctant to listen to him . . .

Painters who cannot paint give us copies of statues. Michelangelo would

merit this criticism if, like them, he had stopped at the merely *unpleasing*; but he advanced to the point of *terror*, and what is more, the figures he portrays in his *Last Judgement* are quite unprecedented.

(Stendhal, 1817)

Another nineteenth-century French novelist – who was also a painter – is impressed by the colouristic glory with which Rubens presents a revolting subject – The Martyrdom of St Liévin.

Forget that the subject is an ignominious and barbarous murder of a holy bishop, whose tongue has just been torn out, from whose mouth the blood is gushing, and who is writhing in dreadful convulsions; forget the three executioners torturing him, one with a bloody knife between his teeth, the other with clumsy pincers holding out that horrible shred of flesh to the dogs. Only look at the white horse which rears itself in the white sky; the bishop's golden cloak, his white stole; the dogs, speckled with white and black, four or five of them black; two red bonnets; the flushed, red-bearded faces; and all around in this vast field of canvas the delightful harmony of the greys, blues, the whites either dark or pale – and you will only have an impression of a beautiful blending of colour, the most wonderful perhaps and most unexpected that Rubens ever used to express, or, if you wish, to help out and lighten, a scene of horror.

Did Rubens try to produce this contrast? Was it necessary, for the altar it was to fill in the Jesuit's Chapel at Ghent, that this picture should be at once diabolical and heavenly, that it should have both horror and joy, agony and consolation? I think that the poetic nature of Rubens instinctively adopted these antitheses. And if he did so unwittingly, his nature must have inspired him with them. It is well from the first day to accustom one's self to those contradictions, which balance each other and form a genius apart; a great deal of blood and physical strength, but a soaring imagination, a man not afraid of what is horrible, but with a tender and truly calm soul; ugliness and brutality, a total absence of taste in forms, with an enthusiasm which turns ugliness into strength, bloody brutality into terror. That penchant for the apotheoses, of which I spoke . . . can be seen in everything he does. If one understands them properly there is a glory in them; one can hear the sound of the trumpet in the coarsest of his works. He clings tenaciously to this earth, more than any of the masters

whose equal he is; it is the painter who comes to the help of the draughtsman and the philosopher, and makes them free. Many people therefore cannot follow him in his enthusiasms. Indeed, we often surmise an imagination that cannot control itself. We only see that which binds him to common earth, the exaggerated realism, the thick muscles, the figures overdrawn or neglected, the gross types, the flesh, and the blood almost bursting through the skin while we do not notice that he has nevertheless certain formulae, a style and ideal, and that these excellent formulae, this style, and this ideal are in his palette.

Add to this his particular talent of eloquence. To be explicit, his style is what would be called in literature an orator's style. When he extemporizes, this style of his is not very beautiful, but when he chastens it, it is magnificent. It is prompt, sudden, fluent, and fiery; in all cases it is surpassingly convincing and persuasive. It strikes, it astonishes, it repulses you, it galls you, almost always it convinces you, and if there is occasion for it, it touches and softens you more than ever. There are some of Rubens's pictures which disgust us; there are others which make us weep, and this is rare enough in all the schools. He has the weaknesses, the digressions, and also the appealing fervour of great orators. He has to make his perorations, he has to harangue, to wave his arms in the air a little, but there are some things he says which no one else could say. Indeed, his ideas are usually such as cannot be expressed but by eloquence, pathetic gesticulations, and moving appeals.

(Eugène Fromentin, 1876)

An English poet lauds the emotional wisdom of the Old Masters.

About suffering they were never wrong,
The Old Masters: how well they understood
Its human position; how it takes place
While someone else is eating or opening a window or just walking
 dully along;
How, when the aged are reverently, passionately waiting
For the miraculous birth, there always must be
Children who did not specially want it to happen, skating
On a pond at the edge of the wood:
They never forgot
That even the dreadful martyrdom must run its course

Anyhow in a corner, some untidy spot
Where the dogs go on with their doggy life and the torturer's horse
Scratches its innocent behind on a tree.

In Brueghel's *Icarus*, for instance: how everything turns away
Quite leisurely from the disaster; the ploughman may
Have heard the splash, the forsaken cry,
But for him it was not an important failure; the sun shone
As it had to on the white legs disappearing into the green
Water; and the expensive delicate ship that must have seen
Something amazing, a boy falling out of the sky,
Had somewhere to get to and sailed calmly on.
(W. H. Auden, December 1938)

Denis Diderot scoffs at Watteau, and asks that artists should thrill him.

The rituals of courtesy, so attractive, pleasant, and admirable in the world, are disagreeable in the arts of imitation. It's only on firescreens that women can bend their knees and men gesture gracefully with their arms, tip their hats, and step delicately backwards. I know very well that Watteau's paintings will be cited as counter-examples, but I scoff at them and will persist in doing so. Strip Watteau of his sites, his colour, the grace of his figures, that of their clothing; then look at the scene depicted, and judge for yourself. The arts of imitation require something that's savage, crude, striking, enormous. I'm willing to allow a Persian to place his hand against his forehead and bow; but note the character of this bowing man; note his deference, his adoration; note the grandeur of his drapery and his movement. Who is it that deserves such profound homage? His God? His father?

To the platitude of our curtsies and bows add that of our clothing; our ruffled sleeves, our tightly fitting breeches, our squared, pleated coat-tails, our garters, our monogrammed buckles, our pointed shoes. I defy painters and sculptors of even the greatest genius to turn this paltry system to advantage. What a thing would be a marble or bronze version of a Frenchman in his buttoned jerkin, his sword, and his hat!

Let's return to organization, to the arrangement of the figures. A little can, and should, be sacrificed to such technical considerations. How much? I have no idea. But I know I don't want it to compromise expression

or the impact of the subject. First touch me, astonish me, tear me to pieces, make me shudder, weep, and tremble, make me angry; then soothe my eyes, if you can.

(Denis Diderot, *The Salon of 1765*)

Brueghel's emotional restraint is also praised by an English novelist.

But of all Brueghel's pictures the one most richly suggestive of reflection is not specifically allegorical or systematic. *Christ Carrying the Cross* is one of his largest canvases, thronged with small figures rhythmically grouped against a wide and romantic background. The composition is simple, pleasing in itself, and seems to spring out of the subject instead of being imposed on it. So much for pure aesthetics.

Of the Crucifixion and the Carrying of the Cross there are hundreds of representations by the most admirable and diverse masters. But of all that I have ever seen this Calvary of Brueghel's is the most suggestive and, dramatically, the most appalling. For all other masters have painted these dreadful scenes from within, so to speak, outwards. For them Christ is the centre, the divine hero of the tragedy; this is the fact from which they start; it affects and transforms all the other facts, justifying, in a sense, the horror of the drama and ranging all that surrounds the central figure in an ordered hierarchy of good and evil. Brueghel, on the other hand, starts from the outside and works inwards. He represents the scene as it would have appeared to any casual spectator on the road to Golgotha on a certain spring morning in the year 33 A D. Other artists have pretended to be angels, painting the scene with a knowledge of its significance. But Brueghel resolutely remains a human onlooker. What he shows is a crowd of people walking briskly in holiday joyfulness up the slopes of a hill. On the top of the hill, which is seen in the middle distance on the right, are two crosses with thieves fastened to them, and between them a little hole in the ground in which another cross is soon to be planted. Round the crosses, on the bare hilltop stands a ring of people, who have come out with their picnic baskets to look on at the free entertainment offered by the ministers of justice. Those who have already taken their stand round the crosses are the prudent ones; in these days we should see them with camp stools and thermos flasks, six hours ahead of time, in the vanguard of the queue for a Melba night at Covent Garden. The less provident or more adventurous people are in the crowd coming up the hill with the

third and greatest of the criminals whose cross is to take the place of honour between the other two. In their anxiety not to miss any of the fun on the way up, they forget that they will have to take back seats at the actual place of execution. But it may be, of course, that they have reserved their places, up there. At Tyburn one could get an excellent seat in a private box for half a crown; with the ticket in one's pocket, one could follow the cart all the way from the prison, arrive with the criminal and yet have a perfect view of the performance. In these later days, when cranky humanitarianism has so far triumphed that hangings take place in private and Mrs Thompson's screams are not even allowed to be recorded on the radio, we have to be content with reading about executions, not with seeing them. The impresarios who sold seats at Tyburn have been replaced by titled newspaper proprietors who sell juicy descriptions of Tyburn to a prodigiously much larger public. If people were still hanged at Marble Arch, Lord Riddell would be much less rich.

That eager, tremulous, lascivious interest in blood and beastliness which in these more civilized days we can only satisfy at one remove from reality in the pages of our newspapers, was franklier indulged in Brueghel's day; the naive ingenuous brute in man was less sophisticated, was given longer rope, and joyously barks and wags its tail round the appointed victim. Seen thus, impassively, from the outside, the tragedy does not purge or uplift; it appalls and makes desperate; or it may even inspire a kind of gruesome mirth. The same situation may often be either tragic or comic, according as it is seen through the eyes of those who suffer or those who look on. (Shift the point of vision a little and *Macbeth* could be paraphrased as a roaring farce.) Brueghel makes a concession to the high tragic convention by placing in the foreground of his picture a little group made up of the holy women weeping and wringing their hands. They stand quite apart from the other figures in the picture and are fundamentally out of harmony with them, being painted in the style of Roger van der Weyden. A little oasis of passionate spirituality, an island of consciousness and comprehension in the midst of the pervading stupidity and brutishness. Why Brueghel put them into his picture is difficult to guess; perhaps for the benefit of the conventionally religious, perhaps out of respect for tradition; or perhaps he found his own creation too depressing and added this noble irrelevance to reassure himself.

(Aldous Huxley, 1925)

Damien Hirst says that the point about his dot paintings is that they can't express any emotion; so what they express, presumably, is the predicament of an artist too self-aware to express anything.

Dan Bonsall, a friend at art school who made sculptures and collages, once remarked that he felt like a painter, only he didn't use oil paints and canvas. I always wanted to be a painter much more than a sculptor or an artist, but I was overwhelmed by the infinite possibilities of painting. I think it's got something to do with the void, the void of the blank canvas where anything and everything is possible beyond gravity, beyond life, in the realms of the imagination. Max Beckmann used to paint his canvases black to represent the void and everything he painted he saw as an object that he placed between himself and that void.

I believe that after Pollock created a distance between the brush and the canvas by flinging the paint, there was nowhere to go with painting . . . but people still go to St Ives, still make action paintings. The urge to be a painter is still there even if the process of painting is meaningless, old-fashioned. Today there are better ways for artists to communicate to an audience raised on television, advertising and information on a global level.

I often get asked about the spot paintings – 'I love your work but why do you do those stupid spots? They're not good paintings,' or 'The paintings are great/better than your other works, but Richter already did it.' They have nothing to do with Richter or Poons or Bridget Riley or Albers or even Op. They're about the urge or the need to be a painter above and beyond the object of a painting. I've often said that they are like sculptures of paintings.

I started them as an endless series like a sculptural idea of a painter (myself). A scientific approach to painting in a similar way to the drug companies' scientific approach to life. Art doesn't purport to have all the answers; the drug companies do. Hence the title of the series, 'The Pharmaceutical Paintings', and the individual titles of the paintings themselves: *Acetaldehyde* (1991), *Albumin Human Glycated* (1992), *Androstanolone* (1993), *Arabinitol* (1994), etc.

Art is like medicine – it can heal. Yet I've always been amazed at how many people believe in medicine but don't believe in art, without questioning either.

I first studied art in Leeds from an emotional, painterly perspective – 'paint how you feel' – painting as truth. But lies are a part of life, and

painting like life has to take this on board if it's worth doing. If you're happy, you paint a happy yellow-and-red painting; if you're depressed you paint a sombre brown-and-purple painting; or if you're smart you give up painting and share your good feelings with your friends, or when you're down, cheer up and don't drag people down to your level, take anti-depressants – the difference between art and life.

In the spot paintings the grid-like structure creates the beginning of a system. On each painting no two colours are the same. This ends the system; it's a simple system. No matter how I feel as an artist or a painter, the paintings end up looking happy. I can still make all the emotional decisions about colour that I need to as an artist, but in the end they are lost. The end of painting. And I'm still painting; am I a painter? Or a sculptor who paints? Or just an artist? I don't know. It's not important. But it is very important that there is an endless series or enough to imply an endless series (after all, I'm not On Kawara [Japanese artist whose work consists of dates painted on canvases]).

I believe painting and all art should be ultimately uplifting for a viewer. I love colour. I feel it inside me. It gives me a buzz. I hate taste – it's acquired. I like the way the paintings look like they could have been made by a big machine – the machine being the artist in the future. The reason I play snooker and pool is because it enables me to try to behave like a machine. A machine could play snooker flawlessly. People trying to be machines, machines trying to be people. Snooker has a similar but three-dimensional feel to the paintings. Maybe that's it; I doubt it.

I once said that the spot paintings could be what art looks like viewed through an imaginary microscope. I love the fact that in the paintings the angst is removed. I have also said that I once took pills when I was a child thinking they were sweets, and several reviewers picked up on this as a reason for the pharmaceutical paintings. If you look closely at any one of these paintings a strange thing happens: because of the lack of repeated colours there is no harmony. We are used to picking out chords of the same colour and balancing them with different chords of other colours to create meaning. This can't happen. So in every painting there is a subliminal sense of unease; yet the colours project so much joy it's hard to feel it, but it's there. The horror underlying everything. The horror that can overwhelm everything at any moment.

I once said that if you titled all the paintings *Isolated Elements for the Purpose of Understanding*, then it would be easier to relate them to the rest of my works. Not that there's a problem in making very different works.

After all, whatever I make will be a 'Damien Hirst'. I can't avoid that. And I'm a Gemini, if you believe in that bullshit, which I kind of do and kind of don't. So, am I a sculptor who wants to be a painter, or a cynical artist who thinks painting is now reduced to nothing more than a logo? And how do the installations fit into all this? It's not my problem. Art is about life – there isn't anything else. As an artist you make art for people who haven't even been born yet. I said before that I wish I'd never said anything about 'The Pharmaceutical Paintings', and I still wish I hadn't. They are what they are, perfectly dumb paintings which feel absolutely right.

(Damien Hirst, 1997)

The fifteenth-century Italian architect and writer Leon Battista Alberti advises the artists of the Renaissance on how to grab an audience by the heartstrings.

A narrative picture will move the feelings of the beholders when the men painted therein manifest clearly their own emotions. It is a law of our nature – than which there is nothing more eager or more greedy for what is like itself – that we weep with the weeping, laugh with the laughing, and grieve with those who grieve. But these emotions are revealed by the movements of the body.

A narrative picture should include some figure announcing and explaining to us what is taking place there; either beckoning to us with its hand to come and see; or warning us with angry visage and menacing eyes to keep away; or pointing to some danger or some marvel; or inviting us to weep or laugh together with them.

(Leon Battista Alberti, 1436)

A contemporary British critic considers how a contemporary British painter, Sir Howard Hodgkin, makes the unrepresentability of emotions part of his emotional art.

Feelings complicate matters. Hodgkin wants to paint pictures of 'emotional situations', but his art acknowledges (even insists on) the unrepresentability of the kinds of emotional situations that make up any life. His pictures attempt to address those aspects of human experience, shadowy, half apprehended, which it is beyond the capacities of certain kinds of traditionally representational art to express. They are an attempt to be true, however allusively and metaphorically, to what it is to be a living human being.

Hodgkin's art is about the density and interwovenness of existence. It is about the fact that experience is not straightforward, that a life is not like a projected film, unrolling frame by frame. References to the visible world may or may not be present in a specific picture, but that does not make such a picture any more or less faithful to its subject. There are moments in life when feelings exceed perceptions, when the world inside takes precedence over the world outside: every moment in every life is a confrontation, a meeting of inner and outer, an encounter between self and non-self. What makes the pictures brave and touching and (despite their usually modest scale) so enormously ambitious is the way in which they strive to remain as resistant to simplification and as ultimately ungraspable as experience itself.

The obscurity of the paintings is never flippant or unthinking. Their blurrings and dim glimmers and ambiguous half-resemblances might not represent the world literally, but they nevertheless respond to the urgings of reality. What things look like is not their concern, or only a small part of it. They are views on to a different order of truth. *Love Letter* (1984–88) is a blue oculus in whose centre you see what could be a landscape prospect interrupted by a translucent, vertical shimmer of grey that could be a sunbeam breaking through cloud cover or a sudden squall. A flesh-coloured fragment in its foreground could be a detail of a human body, it could be the page of the title's 'letter', or it could be a glimpsed expanse of some sandy beach. But the picture invites such figurative interpretations while simultaneously declaring that they are beside the point. It tempts resolution, into an image of *this* person, in *this* place, but refuses to be easily resolved. It has the quality of a dream that cannot quite be remembered, whose precise forms remain, tantalizingly, just below the surface of conscious recollection.

Hodgkin's pictures often carry this oneiric charge, often seem loaded with a significance that cannot be exactly articulated – as if what survives, after the transmutation of memory into art, is the intensity of a feeling without the incidental paraphernalia of its narration. *Love Letter*, like many of Hodgkin's paintings, has depth and something like perspectival recession. It can fairly easily be divided into foreground, middle ground and distance. It is full of suggestions of the play of light and shade and of almost meteorological effects. But what is missing is, precisely, the traditional object of such illusionism: the illusion itself. It is as if the language of figurative art has been directed away from its old object, the external world, and turned inwards.

Hodgkin does not set out to paint what the world looks like, but what it feels like. Perhaps it is more accurate to say that his pictures deliberately confuse those two things, and that on their territory vision and feeling, perception and emotion, meet. Hodgkin's apparent imprecision is, in reality, extremely precise. It enables him to picture the waywardness of all recollection, its multiple uncertainties. The real subject of *Love Letter* is the errant nature of consciousness, the way feelings (love or any other emotion) cannot be easily defined or even recalled. It is a picture about the imperfection of memory and the incommunicability of experience.

One of the most common devices of Hodgkin's art is the image framed within the frame, as if seen through an open window or door (or keyhole). This has a very precise physical effect on the viewer, who responds as if choreographed, stepping close and peering into the picture as if looking into a miniature theatre. It also has a powerful determining effect on the psychology of the encounter between viewer and work of art: looking at a Hodgkin like *Love Letter* feels like looking at something private. It feels like looking surreptitiously, even a little furtively. It feels like looking *in on* something. There is a sense in which the paintings make children of those who look at them. They can awaken childhood memories of things seen or felt intensely but obliquely, experienced vividly but not entirely comprehended. Hodgkin's art constantly reincarnates the child's sense of the weirdness of the world.

Many of the paintings have the character of fragments of overheard conversation, suddenly chanced-upon moments of life, loaded with a significance and an urgency that eludes precise definition. Their storyless-ness is also a form of openness. They require a suspension of one kind of curiosity, the desire for narrative clarity. They require inventiveness on the part of the viewer, a degree of imaginative involvement without which the feelings they seek to invoke cannot come into being. They require that their vulnerability be met and answered by an equivalent vulnerability on the part of whoever engages with them. Their intimacy is demanding.

Jealousy (1977) is a poisonous little painting of a poisonous little emotion. Here is a life gone terribly wrong condensed into a single, tiny image that defies analysis, or at least makes it inappropriate. Analyse the painting into its constituent parts, and you are left with nothing much in particular: a red blob silhouetted against a screen of green dots on a yellow ground, triply framed within bands of orange, dark brown and orange again. Analyse the painting into its constituent parts, and you are left with an abstraction. But enter *into* the painting, and it becomes something different.

That blob becomes a human figure, huddled and closed in on itself, locked away in some private room of some private house. The picture is an image of the retentive, uncharitable nature of the emotion that is its subject. It is an image of jealousy as a negative form of self-possession, self-possession transmuted into self-pity; an image, too, of jealousy as an appalling form of loneliness.

This is painting that knows the power of omission. The feelings that are registered are only half-stated, are represented through hints and allusions, which means that the viewer has to meet them half-way and supply the rest from experience. They cannot be conclusively interpreted, but they would fail if it were otherwise. Susan Sontag once described interpretation as the revenge of the intellect upon art. These pictures are art's revenge upon the intellect. They do not make their appeal to the distant, barricaded mentality of the professional exegete. They ask for other forms of response . . .

This is where, for all its near-abstractness, his painting achieves its own form of moral integrity. The artist's refusal to encapsulate the feelings he tries to paint within easily read narratives stems from modesty and forbearance, from the knowledge that a real emotion is always too complex to be packaged into a scenario. Hodgkin's multiple omissions are also ways of modestly admitting defeat, of acknowledging how much is beyond the capacity of any work of art to include.

(Andrew Graham-Dixon, 1994)

Henry James finds a lady in an altarpiece admirably calm until one looks into the depths of her eyes.

The same church contains another great picture for which the haunter of these places must find a shrine apart in his memory; one of the most interesting things he will have seen, if not the most brilliant. Nothing appeals more to him than three figures of Venetian ladies which occupy the foreground of a smallish canvas of Sebastian del Piombo, placed above the high altar of San Giovanni Crisostomo. Sebastian was a Venetian by birth, but few of his productions are to be seen in his native place; few indeed are to be seen anywhere. The picture represents the patron saint of the church, accompanied by other saints and by the worldly votaries I have mentioned. These ladies stand together on the left, holding in their hands little white caskets; two of them are in profile, but the foremost

turns her face to the spectator. This face and figure are almost unique among the beautiful things of Venice, and they leave the susceptible observer with the impression of having made, or rather having missed, a strange, a dangerous, but a most valuable, acquaintance. The lady, who is superbly handsome, is the typical Venetian of the sixteenth century, and she remains for the mind the perfect flower of that society. Never was there a greater air of breeding, a deeper expression of tranquil superiority. She walks a goddess – as if she trod without sinking the waves of the Adriatic. It is impossible to conceive a more perfect expression of the aristocratic spirit either in its pride or in its benignity. This magnificent creature is so strong and secure that she is gentle, and so quiet that in comparison all minor assumptions of calmness suggest only a vulgar alarm. But for all this there are depths of possible disorder in her light-coloured eye.

(Henry James, 1882, in his *Italian Hours*, 1909)

Ruskin extols the emotional role of the Venetian dog.

The dog is ... constantly introduced by the Venetians in order to give the fullest contrast to the highest tones of human thought and feeling. I shall examine this point presently farther, in speaking of pastoral landscape and animal painting; but at present we will merely compare the use of the same mode of expression in Veronese's *Presentation of the Queen of Sheba.*

This picture is at Turin, and is of quite inestimable value. It is hung high; and the really principal figure, the Solomon, being in the shade, can hardly be seen, but is painted with Veronese's utmost tenderness, in the bloom of perfect youth, his hair golden, short, crisply curled. He is seated high on his lion throne: two elders on each side beneath him, the whole group forming a tower of solemn shade. I have alluded, elsewhere, to the principle on which all the best composers act, of supporting these lofty groups by some vigorous mass of foundation. This column of noble shade is curiously sustained. A falconer leans forward from the left-hand side, bearing on his wrist a snow-white falcon, its wings spread, and brilliantly relieved against the purple robe of one of the elders. It touches with its wings one of the golden lions of the throne, on which the light also flashes strongly; thus forming, together with it, the lion and eagle symbol, which is the type of Christ throughout medieval work. In order to show the meaning of this symbol, and that Solomon is typically invested with the

Christian royalty, one of the elders, by a bold anachronism, holds a jewel in his hand of the shape of a cross, with which he (by accident of gesture) points to Solomon; his other hand is laid on an open book.

The group opposite, of which the Queen forms the centre, is also painted with Veronese's highest skill; but contains no point of interest bearing on our present subject, except its connection by a chain of descending emotion. The Queen is wholly oppressed and subdued; kneeling, and nearly fainting, she looks up to Solomon with tears in her eyes; he, startled by fear for her, stoops forward from the throne, opening his right hand, as if to support her, so as almost to drop the sceptre. At her side her first maid of honour is kneeling also, but does not care about Solomon; and is gathering up her dress that it may not be crushed; and looking back to encourage a negro girl, who, carrying two toy birds, made of enamel and jewels, for presentation to the King, is frightened at seeing her Queen fainting, and does not know what she ought to do; while, lastly, the Queen's dog, another of the little fringy-paws, is wholly unabashed by Solomon's presence, or anybody else's; and stands with his forelegs well apart, right in front of his mistress, thinking everybody has lost their wits; and barking violently at one of the attendants, who has set down a golden vase disrespectfully near him.

(John Ruskin, *Modern Painters*, 1860)

Paint

and

Stone,

etc.:

The

Materials

of

Art

Flesh was the reason why oil painting was invented.
 (Willem de Kooning, 'The Renaissance and Order', 1950)

Flesh is indeed the reason Kremnitz White was invented, at least it seems for Lucian Freud.

The centre of gravity in Freud's recent painting is not the illustration or the fantasy. It is the simple quality of representation, which anyone can see, the fact that the human subject is better made, more 'living and precise' and more seriously realized than any other painter is capable of.

Anyone can see it; the truism is unquestioned. What is open to debate is the critical proposition, that virtue and value in painting are connected with its status as admirable figurative craftsmanship, like an object of virtù. Luckily painting as good as this does not need critical debate. Having climbed the critical ladder, we throw it away; the philosopher is surely in mind. Kick it away, I would guess. All we need is to recognize that the elusive emotional coloration, the dark as well as the light of a man, could not have emerged except in the metaphor of paint moulded visually and manually on outward experience, with the exceptional compulsion, an emotional drive that is, perhaps unusually, powerful, and a realism to match it.

The loaded paint that first surprised me on my visit to the Paddington studio grew heavier and more encrusted. It coagulated in little lumps which accumulated more of the drying paint, until the surface was coarsely granular where he had always needed it to be most refined. He explained that this was caused by Kremnitz White, a pigment with twice as much lead even as Flake White; he handed me a tube to feel its weight. Often he painted on regardless; sometimes he scraped it flat as the rest of us would have done. He always finishes by getting a unique and luminous consistency of his own. In *Pregnant Nude*, for example, the light itself seems to granulate as it falls on the thighs, with an incandescence that is very responsive to the richness of flesh. 'I quite like flesh having Kremnitz

White as a Leitmotif, but then I am afraid of losing unity and adopt it for hair and clothes as well.' Watching the new picture, which is the biggest picture that he has attempted, I found myself brooding on the lumps and spots and fearful of the risk to the equation of flesh with paint which I enjoy. Half the usefulness of Kremnitz White was perhaps that it prevented the kind of painting that people wanted him to go on doing. 'When you talk about the equation,' he said, 'it makes me uneasy. I want paint to *work as flesh*, which is something different. I have always had a scorn for "la belle peinture" and "la delicatesse des touches". I know my idea of portraiture came from dissatisfaction with portraits that resembled people. I would wish my portraits to be *of* the people, not *like* them. Not having a look of the sitter, *being* them. I didn't want to get just a likeness like a mimic, but to *portray* them, like an actor.' ('*Portray*' was said with a peculiar intensity.) 'As far as I am concerned the paint *is* the person. I want it to work for me just as flesh does.'

(Lawrence Gowing, *Lucian Freud*, 1982)

Sickert, an English painter of Anglo-Irish-Danish extraction, brought up in Munich, extols the French way with paint.

'*La peinture*', the phrase conveys a whole host of definite principles and associations in French. To translate it, 'the art of painting', conveys nothing of the kind. Shall I venture on the impossible task of hinting at a definition? An evocation, shall I say, produced in accordance with certain laws known to everyone, great and small, in Paris? As much, and the kind of truth, shall I say?, as can be expressed by the clean and frank juxtaposition of pastes (*pâtes*), considered as opaque, rather than as transparent, and related to each other in colour and values by the deliberate and conscious act of the painter. And in order to make clearer my conception of the positive, shall I hint at the nature of the negative? The staining of a white canvas in the manner of a watercolour is not '*la peinture*': nor is the muffling-up of the painting in the indecision of universal glaze. '*La peinture*' is as fresh and clean in colour as a fresh herring, while the pictures that are glazed can at most be said to be kippered. We may perhaps say that glazing has been the vice of English painting. An example, once for all, of *la bonne peinture* is perhaps better than words. At a gallery in Bond Street may now be seen *Le Passage du Ravin* by Géricault. Here is a concentrated instance of *la bonne peinture* of the men of 1830, which, please remark, not only geniuses and

phoenixes practised at that time, but all French painters. Here is the fine flower of the French technique of the period. Here is painting as good as painting, as the lithography of Daumier is good as lithography, or the etching of Karel Dujardin as etching. Here is the same painting as that of Delacroix, shall we say saner, or shall we say less inspired? These judgements are not for me. I am a student, and not a pontiff.

(Walter Sickert, December 1908)

In retrospect, Patrick Heron finds that the colours and spaces of Braque's paintings changed according to when one looked at them. In the 1940s the colours seemed daring, in the 1950s, muted.

When I saw twenty-odd paintings by Braque (they dated from 1942 to 1945, roughly) at the Tate Gallery in June, 1946, I was amazed at the strength and hard-hitting resonance of his colour. Even the subtle olives and greys and blacks of that large and superb masterpiece, *Interior* (1942) (it reappeared this time as *Interior: The Grey Table*), seemed to me *daring*, in their space-evoking function, and purely as *colour*. Today, though, one is amazed not by the strength of Braque's colour, but by its *muted* subtlety. By comparison with the best contemporary painting (by painters whose reputations have been made since 1946), Braque now seems an Old Master, especially in his colour. The very planes of green or grey (in *Interior: The Grey Table*, for instance) which, in 1946, seemed to me revolutionary in their function as formal devices for evoking space (essentially a limited, enclosed, 'interior' space; the claustrophobic space of parlour or kitchen) now seem, themselves, spatially constricted; and, in colour, gentle, muted – almost as though a fine grey or ochre gauze veil were drawn across the entire picture, introducing a common mixture into each colour – so that there is almost never the full punch of pure hues, or primaries. The supremely *tonal* nature of Braque's thought is thus now more apparent than ever before . . .

The non-figurative art of today seeks a spatial freedom and certainty in the interaction of colours at once harsher and brighter than Braque's – and through formal gestures and statements that are not controlled, as his are, by either rectilinearity or curvilinearity – but by a *new* feeling of formal coherence and consistency which depends on neither. The apparent accident of handling, the natural energy of a dripping pigment almost imperceptibly guided by the artist's hand – this new art is apparently very

far removed from that of the Master of Cubist collage. Yet there is always continuity, at one level or another, between the best of one generation and the next. And in point of fact, we do not have to look far in the recent canvases of Georges Braque to find formal statements that are overtly contemporaneous with Tachism – especially with the thickly knifed planes and facets and ragged oblongs of Nicolas de Staël. In the small landscapes of wheat fields, and in certain of the beach scenes, which Braque painted between 1951 and 1955, what we have is a sort of figurative Tachism. The mounds of extremely gritty, inch-high paint have a double reading: at one moment you are responding to their purely abstract configuration as coloured, kneaded matter; at the next, a ridge of string-like splatters of indigo suddenly settles back into space and becomes the stormy August skyline which lowers over the wheatfields. Nor is this extreme freedom with the pigment (paint plus sand, and even small pebbles, it sometimes seems) a new departure for Braque. There have always been passages in his works (since 1930 particularly) where the instinctive writhing of the painter's wrist has been given free rein.

So I am saying: With a painter as great as Braque it is meaningless for younger painters to say either 'We accept him' or 'We reject him'. Modern art has not flowed round a figure of this size: it has flowed through him. We may have the *feeling* that we reject: but the fact is, we are only who we are and where we are because, in large measure, Braque is who he is where he is. Our present hopes and researches would not exist if his own had not preceded them.

(Patrick Heron, review of 'Georges Braque', February 1957)

The impact of Frank Auerbach's early, immensely thickly painted, work is described by his dealer, herself a painter.

It is seldom that one remembers the full strangeness of the first impact of works of art with which, over the years, one has grown familiar. But I remember the extraordinary effect of Auerbach's early paintings of Primrose Hill, all in yellow ochre, grooved, engraved, as if in wet gravelly sand: as if one had fallen asleep after long contemplation of some Rembrandt with a glimpse of mysterious parkland in the golden-brown distance, and then in a dream found oneself actually walking in the landscape. And that first large head of E.O.W., mud-coloured, silvery, and greenish umber, as haunting as if one had dredged up from the Nile the half-effaced relief of

some great head from ancient Egypt: the powerful brow, the bony ridges of the eye sockets heavily shadowing the down-bent eyes, the strongly marked cheekbones, and then the narrow nose which still does not quite prepare one for the small, fine mouth – a severe, spiritual face, and, above, the great mass of the cranium, the hair sweeping round and round and finally lost in widening circles: uncannily alive.

There were also portraits of Leon Kossoff, among them two heads very much larger than life, which seemed as if the planes were carved out of a stubbornly resistant rock face of grey stone, and further defined with white and black paint, which looked as if it had got there by itself, by accident, and yet was delicately exact. The effect of a combination of art with natural forces and materials is very strong, and contributes to their beauty, mystery, and reality.

This would perhaps be the best place for a few words on the unavoidable subject of thick paint.

The emphasis on material in modern art probably arises largely from the artist's difficult position today. He is not wanted. He has lost his status as the skilled practitioner of a recognized craft. It is hard for him to earn a living. More than most, he must be tormented by doubt as to the worth of his work, his own worth, sanity, even reality. Natural, organic things – feathers, fibres, wood, bone – such as many modern artists have incorporated in their work, have a reality which becomes ever more precious as the world fills up with plastics – and to handle real stuff, even thick paint, gives to some extent the feeling of being a craftsman, of being real oneself. This has probably contributed to the comparatively recent excessive attention to what was always known but taken as a matter of course by good artists, namely, that any art develops out of the possibilities inherent in its medium. To make an image that is real, that convinces, even surprises, himself – this is what the artist has always wanted, but today, in his desperate situation, he wants it probably more than ever before, except perhaps in very early times when it was still associated with magic.

(Helen Lessore, 1986)

This preoccupation with thick paint, however, seems, at the least, to go back to Rembrandt himself.

For the rest, his works were at the time so highly valued and so much sought after that, as the saying goes, you had to beg of him as well as pay

him. For years he was so overwhelmed with orders that people had to wait long for their pictures, although, especially in the last years of his life, he worked so fast that his pictures, when examined from close by, looked like having been daubed with a bricklayer's trowel. For that reason visitors to his studio who wanted to look at his works closely were frightened away by his saying, 'The smell of the colours will bother you.' It is said that he once painted a picture in which the colours were so heavily loaded that you could lift it from the floor by the nose. You see also stones and pearls, in necklaces and turbans, painted with an impasto so thick as if they were chiselled; and through this manner of painting his pictures have a powerful effect even when seen from a long distance.

(Arnold Houbraken, 1721)

Karel van Mander – the northern-European equivalent to Vasari – describes the celebrated invention of oil paint by Jan Van Eyck in fifteenth-century Bruges. Unfortunately – as is true of many famous tales of invention – the story is a little exaggerated (oil paint had been known for centuries before). But if Van Eyck didn't invent it, he certainly made it look great.

These brothers, that is Jan and Hubert Van Eyck, made many works in glue and egg paint – for no other technique was known, except in Italy where one also worked on fresco. And because the town of Bruges in Flanders overflowed with much wealth in former times, on account of the great commerce which was carried on there by various nations – more so than in any other town in the whole of these Netherlands – and because art likes to be near wealth so as to be maintained with rich rewards, Joannes went to live in the aforementioned town of Bruges where all manner of merchants abounded. Here he made many works on wood with glue and egg – and was very famous because of his great art in the various countries to which his works were taken. He was (according to some) also a wise, learned man, very inventive and ingenious in various aspects of art; he investigated numerous kinds of paint and to that end practised alchemy and distillation. He got so far as to succeed in varnishing his egg or glue paint with a varnish made of various oils which pleased the public very much as it gave the work a clear, brilliant shine. In Italy many had searched for this secret in vain, for they could not find the correct technique. On one occasion Joannes made a painting on which he had spent much time, diligence and labour (for he always did things

with great fastidiousness and accuracy). When it was finished he varnished the painting according to his new invention in the now usual way and set it to dry in the sun – but whether the planks were not properly joined and glued, or whether the heat of the sun was too great, the picture split along the joints and came apart. Joannes was very upset that his work was thus lost and ruined by the sun and determined to ensure that the sun should never again cause him such a loss. Thus, put off using egg paint and varnish, he eventually set about investigating and considering how to make a varnish which could dry indoors and away from the sun. When he had finally thoroughly explored many oils and other natural materials, he found that linseed and nut oil dried best of all; by boiling these along with other substances which he added, he made the best varnish in the world. And since such industrious, quick-thinking spirits strive toward perfection through continually researching, he discovered by much experimentation that paint mixed with such oils blended very well, dried very hard and when dry resisted water well; and also that the oil made the colours much brighter and shinier in themselves without having to be varnished. And what astonished and delighted him even more was that he noticed that paint made thus with oil spread thinly and handled better than was possible with the wetness of the egg or glue medium and did not demand such a linear technique. Joannes was highly delighted with this discovery and with good reason: for an entirely new technique and way of working was created, to the great admiration of many, even in distant Countries where Fame, trumpeting it forth, had already flown so that people came from the land of the Cyclops and ever-smouldering Mount Etna to see such a remarkable invention – as shall be described anon. Our art needed only this noble invention to approximate to, or be more like, nature in her forms.

(Karel van Mander, 1604)

An other-worldly Pre-Raphaelite, Edward Burne-Jones, is understandably horrified to discover from another celebrated Victorian painter the origin of one of his pigments.

This year began an increase of intimacy with Mr (now Sir Lawrence) Alma-Tadema and his family, and though distance prevented frequent meeting, personal friendship steadily strengthened. At rare intervals they would join us at lunch on Sunday, bringing bright life and warm kindness with them. One of these times was remembered by us all as the day of the

funeral of a tube of mummy-paint. We were sitting together after lunch in the orchard part of the Grange garden, the men talking about different colours that they used, when Mr Tadema startled us by saying he had lately been invited to go and see a mummy that was in his colourman's workshop before it was ground down into paint. Edward scouted the idea of the pigment having anything to do with a mummy – said the name must be only borrowed to describe a particular shade of brown – but when assured that it was actually compounded of real mummy, he left us at once, hastened to the studio, and returning with the only tube he had, insisted on our giving it decent burial there and then. So a hole was bored in the green grass at our feet, and we all watched it put safely in, and the spot was marked by one of the girls planting a daisy root above it.

(Georgina Burne-Jones, 1904)

Siri Hustvedt and her daughter discover a whole world of space and light in the still-lifes of the Italian painter Giorgio Morandi. The latter's materials were paint and canvas, of course, but also the humble bottles, cups, vases and boxes that he endlessly arranged and rearranged to produce his art.

I had just arrived at the Peggy Guggenheim Gallery in Venice. My eleven-year-old daughter, Sophie, who accompanied me, settled herself on the floor of the first room with sketchbook and pencil. We had come to look at the exhibition of Giorgio Morandi's late work, from 1950 to 1964 – the year of the artist's death – and Sophie knew that we were going to be there a very long time. The gallery wasn't crowded, but it wasn't empty either, and as I stood in that first room, trying to digest what I was seeing, I heard an exchange between an American couple. The husband, who apparently had entered the gallery through the other door and come to the first paintings last, looked around him with a somewhat bewildered expression on his face and called to his wife, 'More bottles!' From the other room, I heard her answer him in an accusatory voice, 'I told you. They're all the same!'

I don't quote this couple to make fun of them, but rather to begin with what they so succinctly pointed out. In his last years, Morandi mostly painted the same things, and he did paint a lot of bottles. He did not, however, paint only bottles, and yet the man's comment resonates with the experience of seeing the work, because the most recognizable objects in these canvases are often bottles. Almost every work includes at least

one bottle, although there are paintings which feature a pitcher or some other quickly identifiable object . . .

The overall visual effect of the paintings as you walk from room to room in the gallery is one of a refinement that nearly aches with subtlety. The colours, the light, the little things on a vanishing table or shelf create an impression of an exquisite, cerebral distance, but the fact is that when you get close to the paint, when you stick your nose right up to a canvas, there is something rough and suggestive about the way the objects are painted. The canvas shows through. The lines that delineate the objects wobble and wave . . .

Looking at these late canvases of Morandi, I kept thinking of the words *behind, under, beyond.* These are not bottles and vases and cups, and although they may suggest a city, they are not cities either. After looking for a while, they did not even seem like still-lifes any more. It is as if I were seeing forms that evoked *idea* rather than *thing.* The object – bottle, cup, cloth, vase – recedes into some larger mystery.

When I looked at the series of six paintings from 1952, which all include a yellow cloth and were hung together in one room in the gallery, I felt as if the canvases were having a mute conversation with one another. The white fluted bottle, its ridges less evident in this series than in some of the other paintings, remains as an anchor on the right in all of them. The striking yellow cloth remains front centre. The cup and cylindrical vase are constant anchors on the left. What changes is the object between the flanking white bottle and the vase. A brown form, described as a basket, is substituted by a green bowl in others, the hue of which changes dramatically between two canvases, from dark green in one to a much yellower tone in the other. In these two canvases, there is an additional object, an extended cylindrical white form that appears behind the white bottle. In the series, the shifting happens in the space between white objects, from one brown to another, from one green to another. It made me think that Morandi was exploring between-ness itself, asking what constitutes a border. In the canvas with the paler green bowl, the bowl seems to tip upward. Its edge behind the white cylinder is outlined in deep grey, which continues downward to divide the yellow cloth and white cup, a fine dark line of distinction that is nearly erotic in its closeness. After looking for a while, I found this darkness between cup and cloth obsessively interesting, more interesting than the objects themselves . . .

(Siri Hustvedt, 1998)

The American critic Jed Perl argues that Paul Klee is a master at using paint to make us think.

In recent years a great deal of scholarly attention has focused on Klee, probably because he's one of the few twentieth-century artists to whom the art historian's iconographic methodology can be readily applied. There have been some formidable art-historical essays written about Klee – the research has really panned out. But the study of iconography (which was developed in order to reclaim for the modern viewer a web of references and associations that would have been relatively obvious to the Renaissance or Baroque artist's cultivated contemporaries) isn't all that necessary for the museum-goer's understanding of Klee. Happily, we still share Klee's general cultural framework – the worlds of art, music, and science still look much the way they did to him.

But even if we have little trouble getting the general drift of Klee's thought, we may leave the retrospective awestruck at his ability to find a form to express his every thought. We're in the hands of an artist who's actually communicating with us through paint – and that's miraculous, coming at a time when most painters don't seem to know how to communicate and when the self-styled communicators in the art world don't know or care about painting. Klee puts it all together; he plants an idea within a painting, and we actually enter into that idea, and feel through it. You don't have to know that the paintings he called 'Magic Squares' are based on music theory to enter into the discourses between different voices that go on in *Rhythmical* (1930) and *New Harmony* (1936). When there's a little figure walking through one of Klee's landscapes, it's a floating intelligence. Klee makes us think about how the weather, geography, terrain touch that little figure; he builds toward a fairly complicated sense of the world. Whether a Klee is totally abstract or rather figurative, the artist never lets us think *at* the painting. We're not theorizing; we're connecting to something that's built into the image; we're thinking *out of* the painting. He generates an unprecedented variety of thoughts from paint. It's in this sense that Klee is a far greater artist than Miró, whose work, both collectively and individually, has a more coherent look, for the simple reason that it's less richly generative of thought.

Of all the modern painters, none speaks more urgently to the present moment than Paul Klee. As time goes by Matisse and Picasso and even Mondrian look more and more like an integral part of the European easel-painting tradition, and that tradition looks more and more like

something to which we'll never again have an uncomplicated connection. Klee is different. He conceived the studio as a laboratory and developed an elaborate methodology that recalls the approach of the scientific researcher. His lectures and notebooks – posthumously collected in two enormous volumes, *The Thinking Eye* and *The Nature of Nature* – come out of the same need to address epochal transitions that had earlier given birth to da Vinci's writings. In Klee's thought there's an in-depth acceptance of how far we've travelled from the world that supported traditional art-gallery art. Unlike Mondrian and Kandinsky, though, he finds little consolation in spirituality or idealism. Klee studied the changes taking place in civilization – in art, music, science, mathematics, the state. He lived through the destabilization of culture that sent Duchamp and so many others into the no man's land of anti-art, but he wouldn't turn his back on art. He had a courage – and a gift – that puts Duchamp and his progeny to shame. Klee is the outsider as modern hero; he's also the romantic comedian who sent up everything and yet won through to the heart of Western art in the end.

In his earliest images, especially those grotesque 'Inventions' of 1905, Klee eulogized the dying graphic traditions of Middle Europe and the nasty, angular style of the Viennese Art Nouveau. The work of the twenty-six-year-old artist was like a dry riverbed, full of peculiar fossils and queer remnants of lost civilizations. It looked like a dead end, until, at the beginning of World War I, he found it within himself to flood that old riverbed with the pure waters of modern French art, and suddenly everything sprang to life – a new life, full of unforeseen evolutionary leaps. For Klee – and for us – painting is a river or an ocean on which we venture forth. Nothing is fixed or solid, and we can look up, down, to left and right, forward and back. Painting is the Mediterranean, with its classical traditions; the Rhine, with its fairy tales and Wagnerian myths; but also the Nile and the River Styx. In some of his last pictures, Klee is climbing into Charon's boat, for a visit to Hell.

(Jed Perl, June 1987)

The influential American critic Clement Greenberg considers the reasons why Picasso and Braque first began to stick bits and pieces of paper on to their paintings.

Collage was a major turning point in the evolution of Cubism, and therefore a major turning point in the whole evolution of modernist art in this

century. Who invented collage – Braque or Picasso – and when is still not settled. Both artists left most of the work they did between 1907 and 1914 undated as well as unsigned; and each claims, or implies the claim, that his was the first collage of all. That Picasso dates his, in retrospect, almost a year earlier than Braque's compounds the difficulty. Nor does the internal or stylistic evidence help enough, given that the interpretation of Cubism is still on a rudimentary level.

The question of priority is much less important, however, than that of the motives which first induced either artist to paint or glue a piece of extraneous material to the surface of a picture. About this, neither Braque nor Picasso has made himself at all clear. The writers who have tried to explain their intentions for them speak, with an unanimity that is suspect in itself, of the need for renewed contact with 'reality' in face of the growing abstractness of Analytical Cubism. But the term 'reality', always ambiguous when used in connection with art, has never been used more ambiguously than here. A piece of imitation-woodgrain wallpaper is not more 'real' under any definition, or closer to nature, than a painted simulation of it; nor is wallpaper, oilcloth, newspaper or wood more 'real', or closer to nature, than paint on canvas. And even if these materials were more 'real', the question would still be begged, for 'reality' would still explain next to nothing about the actual *appearance* of the Cubist collage.

There is no question but that Braque and Picasso were concerned, in their Cubism, with holding on to painting as an art of representation and illusion. But at first they were more crucially concerned, in and through their Cubism, with obtaining *sculptural* results by strictly non-sculptural means; that is, with finding for every aspect of three-dimensional vision an explicitly two-dimensional equivalent, regardless of how much verisimilitude might suffer in the process. Painting had to spell out, rather than pretend to deny, the physical fact that it was flat, even though at the same time it had to overcome this proclaimed flatness as an aesthetic fact and continue to report nature.

Neither Braque nor Picasso set himself this programme in advance. It emerged, rather, as something implicit and inevitable in the course of their joint effort to fill out that vision of a 'purer' pictorial art which they had glimpsed in Cézanne, from whom they also took their means. These means, as well as the vision, imposed their logic; and the direction of that logic became completely clear in 1911, the fourth year of Picasso's and Braque's Cubism, along with certain contradictions latent in the Cézannian vision itself.

By that time, flatness had not only invaded but was threatening to swamp the Cubist picture. The little facet-planes into which Braque and Picasso were dissecting everything visible now all lay parallel to the picture plane. They were no longer controlled, either in drawing or in placing, by linear or even scalar perspective. Each facet tended to be shaded, moreover, as an independent unit, with no legato passages, no unbroken tracts of value gradation on its open side, to join it to adjacent facet-planes. At the same time, shading had itself been atomized into flecks of light and dark that could no longer be concentrated upon the edges of shapes with enough modelling force to turn these convincingly into depth. Light and dark in general had begun to act more immediately as cadences of design than as plastic description or definition. The main problem at this juncture became to keep the 'inside' of the picture – its content – from fusing with the 'outside' – its literal surface. *Depicted* flatness – that is, the facet-planes – had to be kept separate enough from *literal* flatness to permit a minimal illusion of three-dimensional space to survive between the two.

Braque had already been made uncomfortable by the contraction of illusioned space in his pictures of 1910. The expedient he had then hit upon was to insert a conventional, trompe-l'oeil suggestion of deep space *on top* of Cubist flatness, between the depicted planes and the spectator's eye. The very un-Cubist graphic tack-with-a-cast-shadow, shown trans-fixing the top of a 1910 painting, *Still Life with Violin and Pitcher*, suggests deep space in a token way, and destroys the surface in a token way. The Cubist forms are converted into the illusion of a picture within a picture. In the *Man with a Guitar* of early 1911 (in the Museum of Modern Art), the line-drawn tassel-and-stud in the upper left margin is a similar token. The effect, as distinct from the signification, is in both cases very discreet and inconspicuous. Plastically, spatially, neither the tack nor the tassel-and-stud *acts* upon the picture; each suggests illusion without making it really present.

Early in 1911, Braque was already casting around for ways of reinforcing, or rather supplementing, this suggestion, but still without introducing anything that would become more than a token. It was then, apparently, that he discovered that trompe-l'oeil could be used to undeceive as well as to deceive the eye. It could be used, that is, to declare as well as to deny the actual surface. If the actuality of the surface – its real, physical flatness – could be indicated explicitly enough in certain places, it would be distinguished and separated from everything else the surface contained.

Once the literal nature of the *support* was advertised, whatever upon it was not intended literally would be set off and enhanced in its nonliteralness. Or to put it in still another way: depicted flatness would inhabit at least the semblance of a semblance of three-dimensional space as long as the brute, undepicted flatness of the literal surface was pointed to as being still flatter.

The first and, until the advent of pasted paper, the most important device that Braque discovered for indicating and separating the surface was imitation printing, which automatically evokes a literal flatness. Block letters are seen in one of his 1910 paintings, *The Match Holder*, but being done rather sketchily, and slanting into depth along with the depicted surface that bears them, they merely allude to, rather than state, the literal surface. Only in the next year are block capitals, along with lower-case letters and numerals, introduced in exact simulation of printing and stencilling, in absolute frontality and outside the representational context of the picture. Wherever this printing appears, it stops the eye at the literal plane, just as the artist's signature would. By force of contrast alone – for wherever the literal surface is not explicitly stated, it seems implicitly denied – everything else is thrust back into at least a memory of deep or plastic space. It is the old device of the *repoussoir*, but taken a step further: instead of being used to push an illusioned middleground farther away from an illusioned foreground, the imitation printing spells out the real paint surface and thereby pries it away from the illusion of depth.

The eye-undeceiving trompe l'oeil of simulated typography supplements, rather than replaces, the conventional eye-deceiving kind. Another literally and graphically rendered tassel-and-stud embeds flattened forms in token depth in Braque's *Portuguese* (1911), but this time the brute reality of the surface, as asserted by stencilled letters and numerals, closes over both the token illusion of depth and the Cubist configurations like the lid on a box. Sealed between two parallel flatnesses – the depicted Cubist flatness and the literal flatness of the paint surface – the illusion is made a little more present but, at the same time, even more ambiguous. As one looks, the stencilled letters and numerals change places in depth with the tassel-and-stud, and the physical surface itself becomes part of the illusion for an instant: it seems pulled back into depth along with the stencilling, so that once again the picture plane seems to be annihilated – but only for the fraction of another instant. The abiding effect is of a constant shuttling between surface and depth, in which the depicted

flatness is 'infected' by the undepicted. Rather than being deceived, the eye is puzzled; instead of seeing objects in space, it sees nothing more than – a picture.

Through 1911 and 1912, as the Cubist facet-plane's tendency to adhere to the literal surface became harder and harder to deny, the task of keeping the surface at arm's length fell all the more to eye-undeceiving contrivances. To reinforce, and sometimes to replace, the simulated typography, Braque and Picasso began to mix sand and other foreign substances with their paint; the granular texture thus created likewise called attention to the reality of the surface and was effective over much larger areas. In certain other pictures, however, Braque began to paint areas in exact simulation of wood graining or marbleizing. These areas by virtue of their abrupt density of pattern, stated the literal surface with such new and superior force that the resulting contrast drove the simulated printing into a depth from which it could be rescued – and set to shuttling again – only by conventional perspective; that is, by being placed in such relation to the forms depicted within the illusion that these forms left no room for the typography except near the surface.

The accumulation of such devices, however, soon had the effect of telescoping, even while separating, surface and depth. The process of flattening seemed inexorable, and it became necessary to emphasize the surface still further in order to prevent it from fusing with the illusion. It was for this reason, and no other that I can see, that in September 1912, Braque took the radical and revolutionary step of pasting actual pieces of imitation-woodgrain wallpaper to a drawing on paper, instead of trying to simulate its texture in paint. Picasso says that he himself had already made his first collage toward the end of 1911, when he glued a piece of imitation-caning oilcloth to a painting on canvas. It is true that his first collage looks more Analytical than Braque's, which would confirm the date he assigns it. But it is also true that Braque was the consistent pioneer in the use of simulated textures as well as of typography; and moreover, he had already begun to broaden and simplify the facet-planes of Analytical Cubism as far back as the end of 1910 . . .

Synthetic Cubism began with Picasso alone, late in 1913 or early in 1914; this was the point at which he finally took the lead in Cubist innovation away from Braque, never again to relinquish it. But even before that, Picasso had glimpsed and entered, for a moment, a certain revolutionary path in which no one had preceded him. It was as though, in that instant, he had felt the flatness of collage as too constricting and

had suddenly tried to escape all the way back – or forward – to literal three-dimensionality. This he did by using utterly literal means to carry the forward push of the collage (and of Cubism in general) *literally* into the literal space in front of the picture plane.

Some time in 1912, Picasso cut out and folded a piece of paper in the shape of a guitar; to this he glued and fitted other pieces of paper and four taut strings, thus creating a sequence of flat surfaces in real and sculptural space to which there clung only the vestige of a picture plane. The affixed elements of collage were extruded, as it were, and cut off from the literal pictorial surface to form a bas-relief. By this act he founded a new tradition and genre of sculpture, the one that came to be called 'construction'. Though construction sculpture was freed long ago from strict bas-relief frontality, it has continued to be marked by its pictorial origins, so that the sculptor-constructor González, Picasso's friend, could refer to it as the new art of 'drawing in space' – that is, of manipulating two-dimensional forms in three-dimensional space.

(Clement Greenberg, 'Collage', 1959, in his *Art and Culture*, 1961)

Constable imagines a picture by Watteau to have been painted in a medium rather different from oil paint. His friend, the painter Charles Leslie, writes:

I had asked Constable to look at a copy of a Watteau, *The Ball*, from the Dulwich Gallery, on which I was then engaged at the Academy; and to this his next note alludes.

'Dear Leslie, I missed you on the day we should have met at the school of painting by about half an hour. Your Watteau looked colder than the original, which seems as if painted in honey; so mellow, so tender, so soft, and so delicious; so I trust yours will be; but be satisfied if you touch but the hem of his garment, for this inscrutable and exquisite thing would vulgarize even Rubens and Paul Veronese ... My dear little girls are beautifully bronzed; they have had a happy visit.'

(C. R. Leslie, *Memoirs of the Life of John Constable, RA*, 1843)

John Ruskin pays a visit to the Pre-Raphaelite Edward Burne-Jones in his Fulham house, the Grange. As his wife remembers, Burne-Jones was out and in his absence Ruskin came a slight cropper.

The Mirror of Venus was all but finished early in 1875, and with this fact is connected in my mind one of Ruskin's visits to the Grange. As we lived so far apart he generally wrote beforehand to say when he was coming, but on the day I remember he arrived without any warning, and brought with him Cardinal Manning. Unfortunately Edward was out, and so, according to a rule that in his absence no one should be shewn into his working studio, I took the visitors upstairs into another room where he kept pictures that were either finished or waiting their turn. Here stood *The Mirror of Venus* on an easel, and they both looked at it for some time – the Cardinal not committing himself to any remark but a question: 'Is it in oil or watercolour?' It was an oil picture, but that was a point in Edward's work not to be decided at a glance – his method in both mediums being very similar – and Ruskin was silent until he had examined it carefully. Kneeling down so as to look more closely into the workmanship of the foreground, in a few seconds he came to a conclusion, and raising his eyes said, so quietly and authoritatively, 'Pure watercolour, my lord,' that I felt no inclination to contradict him.

(Georgina Burne-Jones, 1904)

A Modernist to the core, the critic Clement Greenberg suggests that modern painting puts a new emphasis on paint (and flatness).

Realistic, naturalistic art has dissembled the medium, using art to conceal art. Modernism used art to call attention to art. The limitations that constitute the medium of painting – the flat surface, the shape of the support, the properties of the pigment – were treated by the old masters as negative factors that could be acknowledged only implicitly or indirectly. Under Modernism these same limitations came to be regarded as positive factors, and were acknowledged openly. Manet's became the first Modernist pictures by virtue of the frankness with which they declared the flat surfaces on which they were painted. The Impressionists, in Manet's wake, abjured underpainting and glazes, to leave the eye under no doubt as to the fact that the colours they used were made of paint that came from tubes or pots. Cézanne sacrificed verisimilitude or correctness, in order

to fit his drawing and design more explicitly to the rectangular shape of the canvas.

(Clement Greenberg, 'Modernist Painting', 1960)

It is well to remember that a picture – before being a battle horse, a nude woman, or some anecdote – is essentially a plane surface covered with colours assembled in a certain order.

(Maurice Denis, 'Definition of Neotradition', 1890)

Gilbert & George argue that painting is outmoded – and take issue with one of the editors of this anthology.

GAYFORD: Do you believe photography has superseded painting?

GILBERT: I think for visual imagery, totally. You can still make interesting aesthetically pleasing pictures or cartoons. There will always be a big school of that. We don't believe painting will stop, but as a powerful form it's finished. The new visuals are coming from cameras.

GEORGE: Things that will actually affect people's lives. Like the television took over from artists drawing the news in newspapers, the same will happen with art – the main thrust of art. There'll always be someone doing oil paintings. Always be someone doing wildlife paintings. We think that one test is that if you show a normal person a canvas by a contemporary painter, they won't know when it was done. 1930? 1940? They won't say, 'Wow! That's obviously done today, that's today's living breathing language.' It's not the only test, but it's one test. Art should live and breathe its time. We even think that the Western world around us is already looking a little bit like our work.

GILBERT: Even the old, Renaissance art is only famous from being photographed and reproduced again and again. It's all the camera. Paint is such an old-fashioned idea.

GAYFORD: I love it.

GEORGE: It's still not going to have a big role in the formation of the art of the future. A lot of twentieth-century art has been to do with panic with the camera. The artists said, 'My God, we're out of a job. We can't do classic pictures because the camera does it better, so we'll have to do something weird.' They couldn't embrace that form like the news media just embraced it. They sacked the sketcher and sent the

cameraman in. People said that art was dead, but they've never said news was dead.

(Gilbert & George, 1997)

The English critic Tim Hilton considers the relationship between two masters of welded-steel sculpture – the American David Smith, and the Englishman Sir Anthony Caro – a relationship that was partly a matter of style, partly a matter of materials.

The meeting between Caro and the American sculptor David Smith has often been taken as the clue to the Englishman's art. It has appeared to many commentators that in 1959 there was some spark of realization that set off the progress of Caro's independent sculpture. It is of course true that Smith's work introduced Caro to the idea of welding, and therefore of making his work by a collage technique. Later on, Caro's first historians established the notion of a tradition of welded sculpture to which the English artist was heir. It was argued that there was a line that passed from Picasso through González to David Smith and thence to Caro. Today, one must adjust both these interpretations. The 'tradition' of welded sculpture must be considered beside the massive influence of painting on Caro; and it is now apparent that his relationship with Smith has become both more explicit and more vital as his own career has developed. This is an especial and perhaps unique case of artistic influence, for Smith's example has become more important as Caro has become more independent. Caro's work immediately after 1960 is not really similar to Smith's. But in the years when he was creating with complete originality, his vocabulary became close to Smith's because he was using the older artist's own steel. We may feel that Caro's use of Smith's metal was an acknowledgement that the 'tradition' of welded sculpture was in truth a thin and tenuous connection. Caro indeed 'went beyond' Smith, as he had always wished to do. But at one point in his career he, literally, put himself in Smith's position. It is as though he knew that it would take more than one man to reinvent the sculptural medium. A moving aspect of Smith's influence on Caro is the impression that they have been contemporaries.

The facts of the two artists' personal acquaintance may be briefly put. Caro met Smith in New York in 1959 at a party given by Robert Motherwell and Helen Frankenthaler: he also saw one 'Sentinel' sculpture at French & Co. Caro did not return to America for three years after this first trip.

In this period he made his own original sculpture. The two men met again in 1963, when Smith prepared the welding shop for Caro at Bennington College. Caro's visits to the studio at Bolton Landing, ninety miles from Bennington, increased his admiration for Smith's direct approach to art. There is one Smith sculpture, *Cubi XXIII*, that appears to have been affected by Caro's *Flats*, which was made in Bennington in 1964. At this time Caro learnt much of the older artist's personality, industry, and of his assertion of the highest status for sculpture. But we should remember that Caro was not as close to Smith as he was to Greenberg, Noland, and the painter Jules Olitski, who was also a member of the Bennington Art Faculty. Welcomed into this group, stimulated by their example, Caro was able to feel rivalry with Smith. His achievement was evident, but Caro did not wish to live in his shadow. 'I wanted to beat him,' he frankly records. Then, in May of 1965, while Caro was still at Bennington, Smith was killed in a car crash.

The real meaning of these relationships lies in the art . . . Unfortunately, we must also record the effect (not on Caro personally) of reputation and publicity. Caro's is a private art, but it has been made at a time when leading artists, and critics, have been famous. Caro's differing friendships with Greenberg and Smith were dramatized after Smith's death: so also was Caro's position in English art. It happened that three months earlier Greenberg had responded to a show of Caro's at the Washington Gallery of Modern Art. The text he wrote was his first published writing on the sculptor. It was printed in *Arts Yearbook* in 1966 and in the following year in the then influential London-based journal *Studio International*. Greenberg wrote of Caro that 'He is the only new sculptor whose sustained quality can bear comparison with Smith's. With him it has become possible at long last to talk of a generation in sculpture that really comes after Smith's.' Probably this announcement was unexpected: Caro's first one-man show at Emmerich in 1964 was not much noticed, and he exhibited in only one group show during his time at Bennington. The year of Smith's death also saw, in England, the 'New Generation' exhibition at the Whitechapel. In this show of nine sculptors six had come straight from St Martin's. Caro did not contribute, but the exhibition (noticeable for the quantity of coloured work) was held to reflect his teaching. This gave rise to misapprehensions, all simplistic, about his influence. The nature of his and of others' work was intermingled. The New Generation's modish success interfered with a clear sight of anyone's art. Thus, Caro in 1965 was held to be both David Smith's successor and the father of a fashion.

Caro's reaction to this mélange of personal and public views of art was exemplary. In the three or four years after Smith's death he formed an artistic attitude to him, maintained to this day, in which tact, delicacy, respect and ambition are all combined. He now did something that was true to his association and filiation. Caro arranged to purchase the stock of metal that Smith had collected for his own use and had stored at Bolton Landing. Thirty-seven tons of tank ends, angles, channels, bronze, stainless steel, rods, plate, were then shipped to Caro's own studio in Hampstead. Smith's material became Caro's, and has been used when occasion required from that day to this. One need not say that this was more than a gesture, more significant than a painter inheriting another's paint. For the stock dictated that there would often be an identity of vocabulary between the two artists. It would be in motif rather than in conception, because of the nature of Caro's abstractness, but it would none the less be there. Thus the assumption of the stock demonstrated, as nothing else could, both Caro's respect and his independence. It was as though the freedom of Smith's art now became Caro's constraint – while Caro could not but show his own freedom from that inspiration. Above all, it placed the relationship between the two men utterly in terms of their art and their medium.

(Tim Hilton, 1984)

To the critic Adrian Stokes, stone and water are the basis of Mediterranean art, as exemplified in the fifteenth-century sculptures of Agostino di Duccio at Rimini.

Refracted light through clear water throws marble into waves, tempers it with many dimensional depths. Hence the poignancy of submerged temples, or of an Aphrodite's marble arm dragged over the clear and elongating pebbles by the nets of Cnidian fishermen.

We approach one aspect of Quattro Cento sculpture. For the Agostino reliefs in the Tempio have the appearance of marble limbs seen in water. From the jointure of so many surfaces as are carved in these reliefs, from the exaggerated perspective by which they are contrived, from the fact that though bas-reliefs they suggest forms in the round, we are reminded of those strange elongations of roundness, those pregnant mountings up and fallings away of flatness, those transient foreshortenings that we may see in stones sunk in clear waters, in the marble floors themselves of baths; we experience again the potential and actual shapes of the stone in

water, changing its form, glimmering like an apparition with each ripple or variation of light. But whereas we pick the stone out of the tide or tread the bath floor to discover its real shape, Agostino's forms never cease to be potential as well as actual. Yet this suggested potentiality causes no hiatus in the impression they afford. These shapes are definite enough, unequivocal: only they have as well the quality of apparition which, so far from mitigating the singleness of their impact on the eye, makes them the more insistent and even unforgettable. They glow, luminous in the rather dim light of the Tempio. Their vitality abounds. The life, the glow of marble has not elsewhere been dramatized thus. For, by this peculiar mode of bas-relief in which forms in the round are boldly flattened out, the pregnant functions imputed to stone in its relation with water are celebrated with all the accumulated force of Mediterranean art. These reliefs are the apotheosis, not only of Sigismondo who built the Tempio, and of Isotta his mistress, but of marble and limestone and all the civilizations dependent upon their cult.

Pregnant shapes of such a kind are possible only in relief carving. We begin to understand how, at its first elaboration, perspective science was the inspiration, the true and deep inspiration, and not merely the means, of Renaissance art; why it was the early Renaissance carvers, rather than the painters, who discovered and elaborated this science. We begin to understand how it is that what I have called Quattro Cento sculpture, with its stone-blossom and incrustation, with its love of stone, of movement, liquid and torrential movement within the stone (needing perspective to measure distance), with its equal love to carve shells and growth and steady flower, should be considered the core and centre of the Renaissance. The Renaissance is a gigantic yet concentrated reassertion of Mediterranean values. The diverse cultures of all the centuries since classical times were commandeered for this expression, and thus reinforced the imitation of classical modes, themselves of several periods. Thousands of years of art were employed in this furore. But again, the core, the central fury, was the love of concrete objects. Each diverse Mediterranean feeling for stone found a new vehemence. And of those feelings of which I write throughout these volumes, I consider the most fundamental one to be connected with the interaction of stone and water. In a sense, the fecund stone-blossom is already connected with some association of moisture in the stone.

(Adrian Stokes, 1934)

A sculptor speaks of stone.

Carving to me is more interesting than modelling, because there is an unlimited variety of materials from which to draw inspiration. Each material demands a particular treatment and there are an infinite number of subjects in life each to be re-created in a particular material. In fact, it would be possible to carve the same subject in a different stone each time, throughout life, without a repetition of form.

(Barbara Hepworth, April 1930)

Bad Reviews and Stinging Replies: Artists and Critics

A contemporary critic is attacked in a premature autobiography, and takes his revenge.

Six months ago I took myself out of Julian Schnabel's memoirs. When Random House was circulating its manuscript in the hope of selling serial rights, an extract came my way from a friendly editor:

> At the beginning of the 80s things are hazy in my mind . . . I remember some guy coming up to me, I think his name was Richie or Robbie Huge. I noticed he was wearing . . . a bow tie with a black leather jacket, although the tie was almost obscured by his triple chin. He whispered in my ear, 'Could we go somewhere alone? Maybe to the wine bar and talk about you – I mean your work? I've always intended to write about it.' I said, 'Sure, let's talk.' After some introductory flattery, his voice dropped down a tone. He whispered, 'Will you chain me up?' I said, 'I'm sorry Robbie, I'm not into that sort of stuff.' His reaction was one of shame inflected with hate. In his sort of cockney accent, he said you'll pay for this one day. Reading his antisemetic [*sic*] babbling and personal attacks on me in Space magazine I found out he is a man of his word.

For Space, read *Time*.

Never having met Julian Schnabel, I began to wonder from what elements he had concocted this 'memory'. I once had a black leather jacket, but in 1973 my motorcycle was stolen from a sidewalk in SoHo and I gave the now useless garment to an art historian in Worcester, Massachusetts. (Fourteen years later an old photo of me wearing it on my lost hog appeared in *New York* magazine, where Schnabel presumably saw it.) To be called anti-Semitic by a man who couldn't spell the word was weird enough, but what about those chains? I puzzled over them for days until a friend, a scarred veteran of the psychoanalytic couch, pointed out that this mystifying passage could only record Schnabel's own desire to 'chain up' – that is, silence – any sceptic who doubts his genius. I called the publisher. There was a sound of foreheads being clutched. The

paragraph was cut. Thus [the book] lost its one and only spicy bit, although perhaps not its only fictional one.

The unexamined life, said Socrates, is not worth living. The memoirs of Julian Schnabel, such as they are, remind one that the converse is also true. The unlived life is not worth examining. Writing them at thirty-five, he has set some kind of a record for premature retrospection, at least among artists. No wonder he needs to invent.

'It's sort of a cross between Charles Dickens and Gertrude Stein,' he told one reporter. For Julian Schnabel is nothing if not a celebrity – a minor one by the standards of the mass media, but quite a big fish in the art pond. If he is not a household name like Pablo Picasso, Jackson Pollock or Andy Warhol, that is not for lack of trying; indeed, through the last years of his life Andy had Schnabel at his feet, looking up, missing nothing. 'The hall of Fame,' wrote a nineteenth-century wag,

> . . . is high and wide,
> The waiting-room is full,
> And some go in through the door marked *Push*,
> And some through the door marked *Pull*.

As a true self-constructed American, Schnabel chose the former. His entry was propelled by a megalomaniac, painfully sincere belief in his own present genius and future historical importance. Between writers and readers this kind of lapel-grabbing has dubious value as a promotional tactic, and in any case it never works for long. (After their second books, what will persuade the discriminating reader that something worthwhile will come out of Bret Easton Ellis or Tama Janowitz, the Bright Young Things of lower Manhattan whose media-struck careers in the mid-eighties seem so close to Schnabel's?) But the American art system is more plagued by inflation and vitiated by fashion than the literary world because while a book confers no status on its owner, a painting may. There is a crack of doubt in the soul of every collector. In it lurks the basilisk whose gaze paralyses taste: the fear that today's klutz may turn out to be tomorrow's Picasso, so that nothing except the manifestly out-of-date may be rejected with impunity. This hardy little reptile was particularly active at the moment Schnabel came on the scene, because in the first half of the eighties the demand for hot, young, new, exciting contemporary art shot through the ceiling. All of a sudden scores and then hundreds of the very new rich (arbs, developers, soap-opera producers, agents, admen and all manner

of important folk whose uncertainty in cultural matters matched their professional vanity) decided that, being amply entitled to Total Everything Now, they would also become 'major' art collectors . . .

[They] had been raised on folk myths of the totally expressive artist as scapegoat or hero – van Gogh and his ear, Pollock and his booze, Rothko slitting his wrists, Joseph Beuys wrapped in felt and fat beside his crashed Stuka. After the *cuisine minceur* of the seventies, a time of small pebbles on floors and sheets of typing paper on gallery walls, they were aching for something hot and heavy. They got it in abundance from Schnabel's Gaudí-derived plates and Beuys-derived antlers, his heavy surfaces of horsehide and velvet choked with slimy pigment, and his incoherent layering of 'mythic' imagery. The art looked radical without being so; it was merely novel, and that quality soon outwears itself. However, in 1980 the uncertainty of new-market taste was such that if someone stood up to assert loudly and repeatedly that he was a genius, there was a chance he would be believed. This was the strategy of Schnabel and his first dealers, Mary Boone and Leo Castelli, and it worked brilliantly. Everyone wanted a genius, and in Schnabel our time of insecure self-congratulation and bulimic vulgarity got the genius it deserved. There was a more than accidental correspondence between Schnabel's success in meeting the nostalgia for big macho art in the early eighties, and Sylvester Stallone's restoration of American *virtù* through the character of Rambo.

Indeed, Schnabel's work is to painting what Stallone's is to acting – a lurching display of oily pectorals – except that Schnabel makes bigger public claims for himself. Grace Glueck interviewed him for *The New York Times* and recorded his solemn opinion that his 'peers' were 'Duccio, Giotto and van Gogh.' One might suppose that such displays of invulnerable conceit would have turned Schnabel into a figure of fun overnight. In England, where his work has never acquired a following among critics, artists or the public, they did – and Schnabel, in a recent interview with the editors of *Flash Art*, sagaciously attributed this reaction to 'a history of philistinism in England from Shakespeare to George Bernard Shaw and Evelyn Waugh.' But the American art world, despite its recent fixations on the idea of irony, does not have much sense of humour: too much is at stake to entertain the thought that a hero might be a buffoon. Like the political analysts who, only a year ago, supposed Reagan's image would never succumb to the real results of his dimwittedness, some critics persist in treating Schnabel as though his fame were a given cultural fact, which no perception of the ineptitude of his work can alter. 'No one expected

him,' pants Thomas McEvilley in his catalogue essay to the Schnabel retrospective that opened at the Whitney Museum of American Art in New York this month. 'No one knew they wanted him. Yet somehow the age demanded him . . . There is nothing anyone can do about it.' The notion that the man is an emanation of the zeitgeist no doubt matches the artist's fantasies about himself. It even has a small truth, since only a culture as sodden with hype as America's in the early eighties could possibly have underwritten his success.

(Robert Hughes, 'Julian Schnabel', 1987)

Brian Sewell, the art critic of the London Evening Standard *is assailed by his detractors in the letters column of the paper he writes for, and defends himself bravely.*

Criticism, to which I came as the sad end to a once promising career, has brought me the enmity of many artists, art historians, art critics, art dealers, Arts Council officials and advisers, museum curators, directors and trustees, photographers, a rag-tag-and-bobtail of generalists from radio and television, entertainers, auctioneers' dogbodies, and even an expert on spaghetti westerns masquerading as a cultural historian. Thirty-five of these worthies wrote in January this year to the *Evening Standard* demanding that something should be done – but what, quite? – a muzzle? – castration? – the old Byzantine recourses of the tongue ripped out with pincers or the eyes scooped from their sockets with a sharpened spoon?

As members of the art world – writers, critics, artists, art historians, curators, dealers – we take the greatest exception to Brian Sewell's writing in your paper. His virulent homophobia and misogyny are deeply offensive, particularly the remarks made in the recent review of the exhibition 'Writing on the Wall'.

Although, very occasionally, he says something perceptive on subjects where he has some expertise, he is deeply hostile to and ignorant about contemporary art.

In place of an informed critique, week in and week out he serves up the same tedious menu of formulaic insults and predictable scurrility – the easiest and cheapest form of demagogy. The *Evening Standard* is London's only evening paper; London, with its wide and diverse range of museums, galleries, auction houses and artists, is one of the world's leading art centres. We believe that the capital deserves better than Sewell's dire mix of sexual and class hypocrisy, intellectual posturing and artistic prejudice.

Kathy Adler, Don Anderson, Paul Bailey, Michael Craig-Martin, Graham Crowley, Joanna Drew, Angela Flowers, Matthew Flowers, Professor Christopher Frayling, René Gimpel, John Golding, Francis Graham-Dixon, Susan Hillier, John Hoole, John Hoyland, Sarah Kent, Nicholas Logsdail, Susan Loppert, Professor Norbert Lynton, George Melly, Sandy Nairne, Janet Nathan, Prue O'Day, Maureen Paley, Sir Eduardo Paolozzi, Deanna Petherbridge, Bridget Riley, Michele Roberts, Bryan Robertson, Karsten Schubert, Richard Shone, Nikos Stangos, Marina Warner, Natalie Wheen and Rachel Whiteread, etc.

Reviews written this year prove that I am unrepentant.

I tell an uncomfortable truth from time to time, tease a little when I sense pomposity and jargon, am roused to rage when confronted by mindless political correctitudes and the cultural and historical distortions that they introduce, and occasionally utter asides that reflect long years of practice in a lofty Christian faith now lost or discarded (I am not sure which). I am not hostile to contemporary art, whatever is meant by that portmanteau term, but find much of it tediously imitative, empty of any intellectual force, sans meaning (from conceptual artists I have far too often heard the response 'It means whatever you want it to mean,' when a concept should surely mean only what the *artist* wants it to mean), certainly sans beauty, and often made in a fugitive form from fugitive materials. Why should a critic offer readers 'an informed critique' – which in this context means no more than favourable propaganda – of so-called artists who have no skills and scant education, and whose work is far the inferior in wit, whimsy and achievement [to that] of most professional window dressers, and as short-lived? I have no prejudice against homosexuals and women, but see no reason why such matters as gender, sexuality, race and colour should ever require the critic to adjust his judgement to allow for a disability (for disabled is surely how they see themselves) that he does not recognize – Frink was neither more nor less a sculptor because she was a woman, Sonia Boyce neither a better nor worse painter because she is black, and Francis Bacon (who occasionally wrote me gleeful notes of support) needed no pigeonhole of homosexuality to define the parameters within which he must be judged; does any artist really wish to be received into posterity's bosom on the grounds of race, gender and sexual proclivity, rather than for the response of spectators to the grace, grandeur, passion, nobility and skill that lend painting and sculpture something of the character that we recognize as quality?

If membership of the art world (whatever that too may mean) implies

that the critic must voice the views of the generality of that world and be its instrument, then criticism in this country is moribund, the contrary voice as stifled as it was in Stalin's Russia and Hitler's Germany. We are deluged with official support for contemporary art in all its extreme incarnations, but not for any form of it that smacks of continuing and developing the traditions of the past; as long as this mysterious and self-appointed 'art world' perceives an artist's work as new, vast sums of public money will bolster it through the agencies of the Arts Council, the Institute of Contemporary Art, the Tate, Hayward, Whitechapel, Serpentine and other galleries; more public money still is spent on art schools in which the uneducated and incapable pretend to teach ineducable students by the thousand, all supported by an extravagant structure of Government grants; and further pressure is imposed on the dissident when he is confronted by the vanity of commercial patrons, ill informed, the art world's dupes, who are persuaded into sponsorship. That all these in their power should seek to suppress the dissent of one critic writing, not for an influential and intellectually respected national daily or Sunday broadsheet, but for a catch-all evening paper restricted to the London area – a paper for the parish pump, as it were – suggests a measure of insecurity that I find quite heartening.

(Brian Sewell, 1994)

Whistler adopts the unkindest of all methods of attack, reprinting excerpts from his critics' writings (in this case about his etchings and drypoints, mainly of Venice).

MR WHISTLER AND HIS CRITICS

A CATALOGUE

Out of their own mouths shall ye judge them

'Who breaks a butterfly upon a wheel?'

Etchings and Dry-points

'His pictures form a dangerous precedent.'

VENICE

'Another crop of Mr Whistler's little jokes.' *Truth*

MURANO — GLASS FURNACE
'Criticism is powerless here.' *Knowledge*

DOORWAY AND VINE
'He must not attempt to palm off his deficiencies upon us as manifestations of power.' *Daily Telegraph* . . .

SAN BIAGIO
'So far removed from any accepted canons of art as to be beyond the understanding of an ordinary mortal.' *Observer* . . .

TURKEYS
'They say very little to the mind.' *F. Wedmore*
'It is the artist's pleasure to have them there, and we can't help it.' *Edinburgh Courant*

NOCTURNE RIVA
'The Nocturne is intended to convey an impression of night.'
P. G. Hamerton
'The subject did not admit of any drawing.' *P. G. Hamerton*
'We have seen a great many representations of Venetian skies, but never saw one before consisting of brown smoke with clots of ink in diagonal lines.' . . .

NOCTURNE PALACES
'Pictures in darkness are contradictions in terms.'
Literary World . . .

TEMPLE
'The work does not feel much.' *Times*

LITTLE SALUTE
'As for the lucubrations of Mr Whistler, they come like shadows and will so depart, *and it is unnecessary to disquiet one's self about them.*' . . .

WOOL CARDERS
'They have a merit of their own, and I do not wish to understand it.'* *F. Wedmore*

*'Mr Wedmore is the lucky discoverer of the following:- 'Vigour and exquisiteness are denied – are they not? – even to a Velasquez'!

UPRIGHT VENICE
'Little to recommend them save the eccentricity of their titles.' . . .

LITTLE COURT
'Merely technical triumphs.' *Standard*

REGENT'S QUADRANT
'There may be a few who find genius in insanity.'

LOBSTER POTS
'So little in them.'* *P. G. Hamerton* . . .

*The same Critic holds: 'The Thames is beautiful from Maidenhead to Kew, but not from Battersea to Sheerness.'

NOCTURNE SHIPPING
'This Archimago of the iconographic aoraton, or graphiology of the Hidden.' *Daily Telegraph*

'Amazing!'

'Popularity is the only insult that has not yet been offered to Mr Whistler.' *Oscar Wilde* . . .

RIVA
'He took from London to Venice his happy fashion of suggesting lapping water.' *F. Wedmore*

REFLECTION: Like Eno's Fruit Salt or the 'Anti-mal-de-Mer.'

'Even such a well-worn subject as the Riva degli Schiavoni is made original (?) by being taken from a high point of view, and looked at lengthwise, instead of from the canal.' . . .

DRURY LANE
'In Mr Whistler's productions one might safely say that there is no culture.' *Athenæum*

THE BALCONY
'His colour is subversive.' *Russian Press* . . .

TRAGHETTO

'The artist's present principles seem to deny him any effective chiaroscuro.' *P. G. Hamerton*

'Mr Whistler's figure drawings, generally defective and always incomplete.' . . .

> REFLECTION: Sometimes generally always.

THE RIALTO

'Mr Whistler has etched too much for his reputation.'

F. Wedmore

'Scampering caprice.' *S. Colvin*

> REFLECTION: This Critic, it is true, is a Slade Professor.

'Mr Whistler's drawing, which is sometimes that of a very slovenly master.'

LONG VENICE

'After all, there are certain accepted canons about what constitutes good drawing, good colour, and good painting; and when an artist deliberately sets himself to ignore or violate all of these, it is desirable that his work should not be classed with that of ordinary artists.' *'Arry*

NOCTURNE SALUTE

'The utter absence, as far as my eye* may be trusted, of gradation.' *F. Wedmore*

*?

'There are many things in a painter's art which even a photographer cannot understand.'

Laudatory notice in Provincial Press

FURNACE NOCTURNE

'There is no moral element in his chiaroscuro.'

Richmond Eagle . . .

PALACES

'The absence, seemingly, of any power of drawing the forms of water.'* *F. Wedmore*

*See No. 30, *The Riva*.

'He has never, so far as we know, attempted to transfer to copper any of the more ambitious works of the architect.'

Pall Mall Gazette

'He has been content to show us what his eyes can see, and not what his hand can do.' *St James's Gazette*

SALUTE DAWN

'Too sensational.' *Athenæum*

'Pushing a single artistic principle to the verge of affectation.'

Sidney Colvin . . .

Taking the Bait

By the simple process of applying snippets of published sentences to works of art to which the original comments were never meant to have reference, and sometimes, too, by lively misquotation – as when a writer who 'did not wish to understate' Mr Whistler's merit is made to say he 'did not wish to understand' it, Mr Whistler has counted on good-humouredly confounding criticism. He has entertained but not persuaded; and if his literary efforts with the scissors and the paste-pot might be taken with any seriousness we should have to rebuke him for his feat. But we are far from doing so. He desired, it seems, to say that he and Velasquez were both above criticism. An artist in literature would have said it in fewer words; but indulgence may fairly be granted to the less assured methods of an amateur in authorship.

F. Wedmore

The Academy, Feb. 24, 1883.

An Apology

. . . For naturally I have all along known, and the typographer should have been duly warned, that with Mr Wedmore, as with his brethren, it is always a matter of understating, and not at all one of understanding.

(James McNeill Whistler, 'Mr Whistler and His Critics', 1883)

Picasso, however, laments the lack of really vicious critical attacks these days.

The terrible thing nowadays . . . is that nobody speaks ill of anybody. If we believe all we read, all's well. In every exhibition there's something. And in any case, everything goes, or nearly everything. They can be indifferent or even a little spiteful. But nobody slaughters anybody, one thing's as good as another, you don't wipe the floor with anything, or crack anything up to the skies. Everything's on one level. Why? Surely not because it's true. Well, then? Because they aren't thinking any more? Or because they daren't say what they think?

(Pablo Picasso, as reported by Hélène Parmelin, 1966)

Paradise, in the view of Burne-Jones, is the absence of critics.

He sent nothing to the Spring Exhibition of the Grosvenor Gallery, and, when a friend wrote to ask the reason of this, answered: 'I have just come from the sea, where I went to rid me of a grievous cold, and I have been out of the world and have forgotten that such things as exhibitions were – but now I am reminded. And the why of my having no pictures to shew this year is that I have begun so many and finished none – and just for once I thought how delightful it would be to have a foretaste of Paradise and be at peace. And it is peace – no dear friend now can come and say, "Did you see what the *Observer* says of you?" It is so delightful that I have a mind to repeat the experiment for good.'

(Georgina Burne-Jones, 1904)

Rodin defends his statue of Balzac – on the boulevard Raspail in Paris – against the slings and arrows of outrageous critics.

I no longer have to fight for my sculpture; it has been able to defend itself for a long time. To say that my *Balzac* was executed in order to hoax the public is an insult that would once have infuriated me. Today I pay no attention to such things and keep on working. My life is one long course of study. To scoff at others would be to scoff at myself. If truth must die, my *Balzac* will be broken in pieces by future generations; but if truth is eternal, *I predict that my statue will make its way alone.*

While we are talking of this spiteful affair which will probably last a

long time, I want to say something that needs to be said clearly. My statue, which people are making fun of because they cannot destroy it, is the result of a whole lifetime of effort; it is the mainspring of my aesthetic theory. From the day of its conception I was a changed man. My development was along fundamental lines. I had forged a link between the great tradition of the past and my own time which each day became stronger.

Aesthetic lawmakers are against my *Balzac*, also the majority of the public and the press. What does it matter? The statue will make its own way into people's minds, either by force or persuasion. There are young sculptors who go and see it and who think about it while searching for their ideals.

(Auguste Rodin, 1898, in Denys Sutton, 1966)

Ruskin has a thorough go at Canaletto.

The mannerism of Canaletto is the most degraded that I know in the whole range of art. Professing the most servile and mindless imitation, it imitates nothing but the blackness of the shadows; it gives no single architectural ornament, however near, so much form as might enable us even to guess at its actual one; and this I say not rashly, for I shall prove it by placing portions of detail accurately copied from Canaletto side by side with engravings from the daguerreotype: it gives the buildings neither their architectural beauty nor their ancestral dignity, for there is no texture of stone nor character of age in Canaletto's touch; which is invariably a violent, black, sharp, ruled penmanlike line, as far removed from the grace of nature as from her faintness and transparency: and for his truth of colour, let the single fact of his having omitted *all record whatsoever of the frescoes* whose wrecks are still to be found at least on one half of the unrestored palaces [of Venice], and, with still less excusableness, all record of the magnificent coloured marbles, many of whose greens and purples are still undimmed upon the Casa Dario, Casa Trevisan, and multitudes besides, speak for him in this respect.

Let it be observed that I find no fault with Canaletto for his want of poetry, of feeling, of artistical thoughtfulness in treatment, or of the various other virtues which he does not so much as profess. He professes nothing but coloured daguerreotypeism. Let us have it; most precious and to be revered it would be: let us have fresco where fresco was, and

that copied faithfully; let us have carving where carving is, and that architecturally true. I have seen daguerreotypes in which every figure and rosette, and crack and stain, and fissure is given on a scale of an inch to Canaletto's three feet. What excuse is there to be offered for his omitting, on that scale, as I shall hereafter show, all statement of such ornament whatever? Among the Flemish schools, exquisite imitations of architecture are found constantly, and that not with Canaletto's vulgar black exaggeration of shadow, but in the most pure and silvery and luminous greys. I have little pleasure in such pictures; but I blame not those who have more; they are what they profess to be, and they are wonderful and instructive, and often graceful, and even affecting; but Canaletto possesses no virtue except that of dexterous imitation of commonplace light and shade; and perhaps, with the exception of Salvator [Rosa], no artist has ever fettered his unfortunate admirers more securely from all healthy or vigorous perception of truth, or been of more general detriment to all subsequent schools.

(John Ruskin, *Modern Painters*, 1843)

While Whistler, returning to the grievance he nursed after his libel case against Ruskin, demolishes utterly the latter's right to pronounce on art, as he does that of English critics in general.

The position of Mr Ruskin as an art authority we left quite unassailed during the trial. To have said that Mr Ruskin's prose among intelligent men, as other than a *littérateur*, is false and ridiculous, would have been an invitation to the stake; and to be burnt alive, or stoned before the verdict, was not what I came into court for.

Over and over again did the Attorney-General cry out aloud, in the agony of his cause, 'What is to become of painting if the critics withhold their lash?'

As well might he ask what is to become of mathematics under similar circumstances, were they possible. I maintain that two and two the mathematician would continue to make four, in spite of the whine of the amateur for three, or the cry of the critic for five. We are told that Mr Ruskin has devoted his long life to art, and as a result – is 'Slade Professor' at Oxford. In the same sentence, we have thus his position and its worth. It suffices not, Messieurs! a life passed among pictures makes not a painter – else the policeman in the National Gallery might assert himself. As well

allege that he who lives in a library must needs die a poet. Let not Mr Ruskin flatter himself that more education makes the difference between himself and the policeman when both stand gazing in the Gallery.

There they might remain till the end of time; the one decently silent, the other saying, in good English, many high-sounding empty things, like the cracking of thorns under a pot – undismayed by the presence of the Masters with whose names he is sacrilegiously familiar; whose intentions he interprets, whose vices he discovers with the facility of the incapable, and whose virtues he descants upon with a verbosity and flow of language that would, could he hear it, give Titian the same shock of surprise that was Balaam's, when the first great critic proffered his opinion.

This one instance apart, where collapse was immediate, the creature Critic is of comparatively modern growth – and certainly, in perfect condition, of recent date. To his completeness go qualities evolved from the latest lightnesses of today – indeed, the *fine fleur* of his type is brought forth in Paris, and beside him the Englishman is but rough-hewn and blundering after all; though not unkindly should one say it, as reproaching him with inferiority resulting from chances neglected.

The truth is, as compared with his brother of the Boulevards, the Briton was badly begun by nature.

(James McNeill Whistler, 'Whistler *v.* Ruskin', 1878)

The painter and poet William Blake comments caustically in the margins of his copy of the Discourses on Art *by his grander (albeit older, and by then dead) contemporary, the painter and critic Sir Joshua Reynolds. (Lines in the extract in italic type are from Reynolds's text.)*

This Man was Hired to Depress Art.

This is the Opinion of Will Blake: my Proofs of this Opinion are given in the following Notes . . .

Having spent the Vigour of my Youth & Genius under the Opression of Sr Joshua & his Gang of Cunning Hired Knaves Without Employment & as much as could possibly be Without Bread, The Reader must Expect to Read in all my Remarks on these Books Nothing but Indignation & Resentment. While Sr Joshua was rolling in Riches, Barry was Poor & Unemploy'd except by his own Energy; Mortimer was call'd a Madman, & only Portrait Painting applauded & rewarded by the Rich & Great. Reynolds & Gainsborough Blotted & Blurred one against the other &

Divided all the English World between them. Fuseli, Indignant, almost hid himself. I am hid.

One of the strongest-marked characters of this kind . . . is that of Salvator Rosa.

Why should these words be applied to such a Wretch as Salvator Rosa? Salvator Roșa was precisely what he Pretended not to be. His Pictures are high Labour'd pretensions to Expeditious Workmanship. He was the Quack Doctor of Painting. His Roughnesses & Smoothnesses are the Production of Labour & Trick. As to Imagination, he was totally without Any.

I will mention two other painters, who, though entirely dissimilar . . . have both gained reputation . . . The painters I mean, are Rubens and Poussin. Rubens . . . I think . . . a remarkable instance of the same mind being seen in all the various parts of the art. The whole is so much of a piece . . .

All Rubens's Pictures are Painted by Journeymen & so far from being all of a Piece, are The most wretched Bungles.

His Colouring, in which he is eminently skilled, is notwithstanding too much of what we call tinted.

To My Eye Rubens's Colouring is most Contemptible. His Shadows are of a Filthy Brown somewhat of the Colour of Excrement; these are fill'd with tints & messes of yellow & red. His lights are all the Colours of the Rainbow, laid on Indiscriminately & broken one into another. Altogether his Colouring is Contrary to The Colouring of Real Art & Science.

Opposed to Rubens's Colouring Sr Joshua has placed Poussin, but he ought to put All Men of Genius who ever Painted. Rubens & the Venetians are Opposite in every thing to True Art & they Meant to be so; they were hired for this Purpose.

The mind is but a barren soil; a soil which is soon exhausted, and will produce no crop . . .

The mind that could have produced this Sentence must have been a Pitiful, a Pitiable Imbecillity. I always thought that the Human Mind was

the most Prolific of All Things & Inexhaustible. I certainly do Thank God that I am not like Reynolds.

(William Blake, annotations to Reynolds's *Discourses on Art, c.* 1808)

Manet had a most direct way with critics, as Ambroise Vollard discovers in this exchange with the painter Charles Toché.

'Evidently,' said I, 'Manet bore the jeers of his contemporaries with more philosophy than Cézanne, who was known to say, "Don't they know I'm Cézanne?"'

'That depends. Mme Manet told me that a great, or rather a famous, art critic, a friend of the family, had once been so bold as to refer ironically to one of her husband's pictures in the Press. Two days later, Manet went out early, saying he was going to do a sketch in the Bois de Boulogne. On his return he announced that he had just run his sword through the wag's shoulder.'

(Ambroise Vollard, 1936)

He who exhibits his works in public should wait many days before going to see them, until all the shafts of criticism have been shot and people have grown accustomed to the sight.

(Jacopo Tintoretto, 1518–94)

Henry James quietly disposes of the reputation of Frederic, Lord Leighton, eminent Victorian and President of the Royal Academy.

I am fully conscious that Lord Leighton incurs a kind of aesthetic grudge, by the mere occupation, for so many weeks, of those admirable rooms of the Royal Academy which are usually, in winter, given up to older names and sturdier presences. When the light is mild, the days short, the sounds muffled and the spectators few, the Old Masters at Burlington House, gathered wondrously from English homes, diffuse, in the quiet halls, from year to year, an effect that is half of melancholy, half of cheer, and that, if the programme varies, one rather resentfully misses. I am not less reminiscent of the splendid obsequies, last spring, that at the time

made us ask some of the questions of which the answer seems now to be coming in as ruefully as a shy child comes into a drawing room. The day was suave and splendid, congruous, somehow, with the whole 'note' of Leighton's personality. The funeral, in the streets cleared of traffic and lined, for the long passage to St Paul's, with the multitude, had the air of a national demonstration, and under the dome of the great church, where all the England of 'culture' seemed gathered, the rites had the impressiveness of a universal mourning. They formed a suggestive hour, none the less, for a spectator not exempt from the morbid trick of reflection. They were for all the world so like some immense *committal* of the public spirit, that it was impossible not to wonder to what it was this spirit committed itself. Now that upwards of a year has come round, the reply would appear to be – simply to nothing at all.

The case bids fair – as far as we have got, at least – to offer promising material for at least one page of that history of the inconsequence of the mind of the multitude which has yet to be written, but for which, here and there, a possibly maniacal student will be found collecting illustrations. It always comes back, with the fluctuating fortune of artist, of author, of *any* victim of 'public attention', to the same, the eternal bewilderment: is the key to the enigma that there was too much noise yesterday, or that there is not enough of it today? Lord Leighton's beautiful house, almost immediately after his funeral, was offered as a memorial to the nation if the nation would subscribe to buy it. The nation, scarce up from its genuflections at St Paul's, buttoned its pocket without so much as scratching its head. Since then his two sisters – one of them the accomplished Mrs Sutherland Orr, friend and biographer of Browning – have generously made known that they will present the house as a museum for relics of their brother if the public, in its commemorative enthusiasm, will collect the relics and keep up the establishment. Nothing is more presumable than that the public will do nothing of the sort. Small blame, however, to the persons who were misguided by the great show of homage and who must be now asking themselves what in the world it meant. They will scarce find an obvious answer, I think, in the fine vacant chambers of the Academy. It may probably, however, be figured out there – in the presence of so much beauty and so little passion, so much seeking, and, on the whole, so little finding – that the late President of the institution was one of the happy celebrities who take it out, as the phrase is, in life. Life was generous to him, as nature had been, and he drank deep of what it can

give. The great demonstration last year was, like his peerage, simply a part of his success. It was not, as it were, of the residuum – it was still on the wrong side of the line.

(Henry James, 'Lord Leighton and Ford Madox Brown', 23 January 1897)

Chardin remonstrates with the jury of the Paris Salon; they forget, he claims, just how difficult it is to be an artist.

Messieurs, Messieurs, go easy. Find the worst painting that's here, and bear in mind that two thousand wretches have broken their brushes between their teeth in despair of ever producing anything as good. Parrocel, whom you call a dauber, and who is one in comparison with Vernet, this Parrocel is an exceptional man relative to the crowd that abandoned the career they began to pursue at the same time as he. Lemoyne said it took thirty years to learn how to retain the qualities of one's original sketch, and Lemoyne was no fool. If you listen to me, you might learn to be a bit more indulgent.

(Jean Baptiste Siméon Chardin, in Denis Diderot, *The Salon of 1765*)

Baudelaire defends a certain variety of criticism, the impassioned sort. Paul Gavarni (1804–66) was a talented French engraver, lithographer, and painter in watercolour and oils, whose engravings Baudelaire had greatly admired.

What is the good of it? The large and frightening question mark seizes the critic by the scruff of the neck at the very first step he wants to take in his first chapter. The artist's first grudge against criticism is that it can teach nothing to the bourgeois, who wants neither to paint nor to versify, nor has it anything to teach art, whose offspring it is.

And yet how many artists of today owe to it alone their poor little reputations! That perhaps is the chief reproach to be made to it.

You must have seen Gavarni's drawing of a painter, bending over his canvas, and behind him a personage full of gravity and dryness, stiff as a poker and with a white cravat, in his hand the latest of his newspaper articles. 'If art is noble, criticism is holy. Who says that? – The critics!' If the artist so easily assumes the chief part, that is no doubt because the critic is as humdrum as so many of his fellow critics.

As for techniques and processes, as seen in the works themselves,

neither public nor artists will find anything about them here. Those things are learned in the studio and the public is interested only in the results.

I sincerely believe that the best criticism is the criticism that is entertaining and poetic; not a cold analytical type of criticism, which, claiming to explain everything, is devoid of hatred and love, and deliberately rids itself of any trace of feeling, but, since a fine painting is nature reflected by an artist, the best critical study, I repeat, will be the one that is that painting reflected by an intelligent and sensitive mind. Thus the best accounts of a picture may well be a sonnet or an elegy.

(Charles Baudelaire, 'The Salon of 1846')

In a lecture, John Constable lambasts some Italianate Dutch landscapists of the seventeenth century; indeed, as the sequel reveals, he goes a bit further than most critics would.

Peter de Laar, who travelled from Holland into Italy, and was there surnamed 'Bamboccio', probably from the class of subjects he painted, which were the various sports of the populace and the transactions of vulgar life, gave rise to a school called by the Italians, 'The Bambocciate'. Of this school were Both and Berghem, who, by an incongruous mixture of Dutch and Italian taste, produced a bastard style of landscape, destitute of the real excellence of either. In their works, all the commonplace rules of art are observed; their manipulation is dextrous, and their finish plausible; yet their pictures carry us in imagination only into their painting rooms, not as the pictures of Claude and Poussin do, into the open air. They rarely approach truth of atmosphere. Instead of freshness they give us a clean and stony coldness, and where they aim at warmth they are what painters call *foxy*. Their art is destitute of sentiment or poetic feeling, because it is factitious, though their works being specious, their reputation is still kept up by the dealers who continue to sell their pictures for high price.[1] . . .

[1] After this lecture, one of Constable's auditors, a gentleman possessing a fine collection of pictures, said to him, 'I suppose I had better sell my Berghems,' to which he replied, 'No, sir, that will only continue the mischief, *burn them.*'

(John Constable, 2 June 1833, quoted in C. R. Leslie, *Memoirs of the Life of John Constable, RA*, 1843)

Baudelaire sets to work on a star of the nineteenth-century French Salon, Ary Scheffer.

Now to choose a striking example of the imbecility of M. Ary Scheffer, let us examine the subject of the painting entitled *Saint Augustin et Sainte Monique*. A worthy Spanish painter, with the twin pieties of art and religion, would, in his simplicity, have done his best to portray the general idea in his mind of St Augustine and St Monica. Here no such thing; the aim is to express the following passage, with brushes and paints: 'We sought between us what might be the nature of that life eternal, which *the eye has not seen, the ear has not heard and which the heart of man cannot rise to.*' This is the height of absurdity. It suggests to me a dancer executing a step in mathematics!

Time was when the public was kindly disposed towards M. Ary Scheffer; his poetical paintings recalled the most cherished memories of the great poets and that was enough. The fleeting vogue M. Ary Scheffer enjoyed was a homage to the memory of Goethe. But painters, even those possessed of only meagre originality, have for a long time now been showing the public genuine painting, executed with a sure hand and according to the simplest rules of art; as a result, the public has slowly lost its taste for invisible painting, and today, like all publics, shows itself heartless and cruel towards M. Ary Scheffer. Upon my word, they are right.

Furthermore, these works are so cheerless, so mournful, so neutral, and so muddy that many people have mistaken pictures by M. Ary Scheffer for those by M. Henry Scheffer [brother of Ary], another Girondin of painting. To me, they look like the pictures by M. Delaroche [academic painter of historical subjects] washed out by heavy rain.

(Charles Baudelaire, 'The Salon of 1846')

Two Abstract Expressionists write in response to a critic.

Mr Edward Alden Jewell
Art Editor, New York Times
229 West 43 Street
New York, NY

Dear Mr Jewell:
To the artist, the workings of the critical mind is [*sic*] one of life's mysteries. That is why, we suppose, the artist's complaint that he is

misunderstood, especially by the critic, has become a noisy commonplace. It is, therefore, an event when the worm turns and the critic of the TIMES quietly yet publicly confesses his 'befuddlement', that he is 'non-plussed' before our pictures at the Federation Show. We salute this honest, we might say cordial reaction towards our 'obscure' paintings, for in other critical quarters we seem to have created a bedlam of hysteria. And we appreciate the gracious opportunity that is being offered us to present our views.

We do not intend to defend our pictures. They make their own defence. We consider them clear statements. Your failure to dismiss or disparage them is prima facie evidence that they carry some communicative power.

We refuse to defend them not because we cannot. It is an easy matter to explain to the befuddled that *The Rape of Persephone* is a poetic expression of the essence of the myth: the presentation of the concept of seed and its earth with all its brutal implications: the impact of elemental truth. Would you have us present this abstract concept with all its complicated feelings by means of a boy and girl lightly tripping?

It is just as easy to explain *The Syrian Bull*, as a new interpretation of an archaic image, involving unprecedented distortions. Since art is timeless, the significant rendition of a symbol, no matter how archaic, has as full validity today as the archaic symbol had then. Or is the one 3,000 years old truer?

But these easy programme notes can help only the simple-minded. No possible set of notes can explain our paintings. Their explanation must come out of a consummated experience between picture and onlooker. The appreciation of art is a true marriage of minds. And in art, as in marriage, lack of consummation is ground for annulment.

The point at issue, it seems to us, is not an 'explanation' of the paintings but whether the intrinsic ideas carried within the frames of these pictures have significance.

We feel that our pictures demonstrate our aesthetic beliefs, some of which we, therefore, list:

1 To us art is an adventure into an unknown world, which can be explored only by those willing to take the risks.
2 This world of the imagination is fancy-free and violently opposed to common sense.
3 It is our function as artists to make the spectator see the world our way – not his way.

4 We favour the simple expression of the complex thought. We are for the large shape because it has the impact of the unequivocal. We wish to reassert the picture plane. We are for flat forms because they destroy illusion and reveal truth.

5 It is a widely accepted notion among painters that it does not matter what one paints as long as it is well painted. This is the essence of academicism. There is no such thing as good painting about nothing. We assert that the subject is crucial and only that subject matter is valid which is tragic and timeless. That is why we profess spiritual kinship with primitive and archaic art.

Consequently if our work embodies these beliefs, it must insult anyone who is spiritually attuned to interior decoration; pictures for the home; pictures for over the mantle; pictures of the American scene; social pictures; purity in art; prize-winning potboilers; the National Academy; the Whitney Academy; the Corn Belt Academy; buckeyes; trite tripe; etc.

Sincerely yours,
Adolph Gottlieb
Marcus Rothko

(Adolph Gottlieb and Mark Rothko [partially drafted by Barnett Newman], 7 June 1943)

Paul Klee receives a polite letter from a gallery revealing that his exhibition is going down extremely badly; he sends a politely reassuring reply.

Winterthur, November 21, 1910, addressed to Herr Klee, painter in Bern:

'Your works have been on show at our gallery since November 15th. We are obliged to note, however, that the great majority of the visitors expressed very unfavourable opinions about your works, and several well known, respected personalities asked us to stop displaying them. As a result, we beg you to tell us right away what we should do; perhaps you might send us explanations about your work which we could hand out to the visitors of the exhibition. Hoping to hear from you, we remain respectfully yours, The Art Gallery at High House.'

My reply: 'Dear Sir, Your embarrassment is certainly regrettable. But as a connoisseur of art you have no doubt heard that, here and there, good artists have come into conflict with the public. Without trying to compare myself to anyone, I need only mention the familiar name of

Hodler [a leading Swiss painter of the day], whose bearer now does handsomely, in spite of earlier friction. An artist who, in addition to his works, provides explanations of them must have little confidence in his art. That is the critics' role, and I refer you to the review by Trog, *Neue Züri Zytig*, October 30, 1910. At the end of the time of exhibition agreed between us, be so kind as to send the works to the Kunsthalle in Basel. Respectfully, Klee.'

(Paul Klee, 1910)

Margaret Thatcher denies ever having made a famous derogatory remark, and offers a useful piece of advice about understanding art, and life.

When I researched my biography, I thought it fair to check on Francis's claim that when she visited the Tate Gallery Mrs Thatcher asked who was our greatest painter. When told Francis Bacon, she recoiled – 'Not that horrible man who paints those dreadful pictures!' which pleased him. At the annual summer party in the back garden of the *Spectator*'s offices in Doughty Street in 1993, the crush was so formidable that I heard cries of 'The Baroness – the Baroness is coming,' and turned round to find myself pressed against her, eye to eye. Unable to move away, I thanked her for replying to my letter.

'Who are you?' she demanded imperiously, though not discourteously. When I explained, she reiterated: 'I have *absolutely* no recollection whatsoever of ever saying such a remark. I am a *great* admirer of his work, but as with any artist there will always be some works which are preferable to others.'

I caught sight of the *Spectator* editors – Alexander Chancellor, Charles Moore and Dominic Lawson, plus Enoch Powell, higher up, looking furious, and shrugged to indicate that far from monopolizing her, I was unable to break free.

'I asked them to show me modern art,' she continued, 'and I couldn't see anything in it at all. The next time I began to understand.' Suddenly she jabbed a finger in my chest: '*See, see, see,*' she told me, '*learn, learn, learn.*' At that moment the crush shifted and the editors advanced like a human chain in the surf to rescue her.

(Daniel Farson, *Never a Normal Man*, 1997)

Light,

Colour,

Space

According to David Sylvester, the abstract paintings of Barnett Newman give us an enhanced feeling of being where we are.

'One thing that I am involved in about painting,' Newman told me, 'is that the painting should give man a sense of place: that he knows he's there, so he's aware of himself. In that sense he relates to me when I made the painting because in that sense I was there. And one of the nicest things that anybody ever said about my work is when you yourself said that standing in front of my paintings you had a sense of your own scale. This is what I think you meant, and this is what I have tried to do. That the onlooker in front of my painting knows that he's there. To me, the sense of place has not only a mystery but has that sense of metaphysical fact. I have come to distrust the episodic, and I hope that my painting has the impact of giving someone, as it did me, the feeling of his own totality, of his own separateness, of his own individuality, and at the same time of his connection to others, who are also separate.' The intention sounds abstract, moralistic. In reality it sums up exactly what the impact is of a painting such as *Vir Heroicus* or – to name a masterpiece of the following decade – *Shining Forth (to George)* (1961).

The painting's vibration alternates between its holding itself in, a totally resistant and opaque yet luminous surface, and advancing into the space between it and us as if it were reaching out to us. But only advancing towards us, not engulfing us. It is immaculately flat; at the same time it becomes three-dimensional through its animation of the space in front of it.

As against the compressed violence pervading the whole surface of a Mondrian, a Newman presents static areas interrupted by areas of explosive tension whose isolation makes them all the more aggressive: a zip can go through us from our own scalp down as if a sword were cleaving us in two. The term 'zip' is nicely chosen in that a zip is something which essentially has to do with touching: it brings out the way in which Newman is never purely visual, always tactile. Berenson wrote how Cézanne 'gives

the sky its tactile values as perfectly as Michelangelo has given them to the human figure'. Newman too makes every mark on his canvas – and the parts left bare – resonant with tactile values.

However large the canvas, the scale is not dominating. It is rigorously related to human scale. Thus we mentally measure the distances between its verticals in terms of the span of our own reach – by stretching out our arms in imagination, in judging how far they have to be stretched out in order to span that interval. Again, with, say, *Day One* (1951–52), the narrow tallness calls our height in question, measures our height against its greater height, makes us perceive through this shortfall our height as it is. Yet again, with the triangular canvas, *Jericho* (1968–69), the relationship of the sloping sides to a single vertical band – placed as if to mirror our asymmetry – arouses consciousness of the relationship of our arms to our flanks as we stand upright and suggests a rhythmic movement that seems to embody our breathing. In ways like this the canvas we are faced with makes us experience a sustained heightened awareness of what and where we are.

The similar emphatic frontality of a Rothko creates a related kind of confrontation. Here we are faced with a highly ambiguous presence which seems, on the one hand, ethereal, empty, on the other solid and imposing, like a megalith. It is a presence that alternates between seeming to be receptive, intimate, enveloping, and seeming to be menacing, repelling. It plays with us as the weather does, for it is a landscape, looming up over us, evoking the elements, recalling the imagery of the first verses of the Book of Genesis – the darkness upon the face of the deep, the dividing of the light from the darkness, the creation of the firmament, the dividing of the waters from the waters. 'Often, towards nightfall,' Rothko once said to me, 'there's a feeling in the air of mystery, threat, frustration – all of these at once. I would like my painting to have the quality of such moments.' And of course it does have that quality; it belongs to the great Romantic tradition of sublime landscape. Newman's art does not have to do with man's feelings when threatened by something in the air; it has to do with man's sense of himself. The painting gives us a sense of being where we are which somehow makes us rejoice in being there. It heightens, through the intensity of the presence of its verticals, our sense of standing there. With its blank surface somehow mysteriously returning our glance, it confronts us in a way that recalls confrontation with a Giacometti standing figure, that separate presence which mirrors us while it insists upon its separateness from us – and thereby sanctifies our separateness . . .

Moreover, that feeling has a mystical dimension.

'For Newman,' [the American art critic Harold] Rosenberg [asserts], 'painting was a way of *practising* the sublime, not of finding symbols for it.' Practising the sublime meant making paintings capable 'of giving someone, as it did me, the feeling of his own totality . . .' And the paintings do indeed make one feel whole. They restore, they induce a sense of integration. They have the therapeutic action that Matisse said he wanted his work to have, and believed it did have, as in the famous story of how, when he and Francis Carco were staying at the same hotel and Carco went down with flu, Matisse brought in several of his paintings and hung them on the wall before going off for the day.

Matisse's most elaborate attempt to make an art that would heal and exalt was the Chapelle du Rosaire at Vence. Standing or seated there in the light of its coloured windows, we can feel cleansed of disquiet and depression, restored to ourselves. But we are not transported into a stratum that has 'a kind of metaphysical hum': the imagery is too specific, too close to nature. In both of the windows along the north wall the overall shape suggests that of a chasuble stretched out in performance of the liturgy; at the same time, the repeated rows of repeated shapes within clearly present a series of pairs of parted thighs: it is a nice counterpoint of images of sacred and profane love. But it does not go beyond being an exhilarating play of idealized natural forms; it involves no communion with 'the unknowable'. Newman, on the contrary, does evoke something of the mystery of being. His imagery, as I've said, does not give us the *landscape* of the first chapter of the Book of Genesis; his art does give us the primal *command* of the Book of Genesis. 'In the beginning . . . the earth was without form, and void . . . And God said, Let there be light: and there was light.' Earth could be given form, according to that book, only when there was light. Now, to say that Newman's fields of colour are always emanations of light is to speak of something he has in common with Matisse and all Matisse's valid heirs; but Newman's light has something more, something that provokes thoughts of primordial light. That something is a violence. Newman's zip, as I said before, can seem to go clean through us. In French a zip is *une fermeture éclair*, 'a lightning fastener'. The zip in Newman's paintings is a bolt of lightning, with the speed and violence of a *revelation* of light. That is one aspect of his evocation of the mystery of being. The other is that intense awareness of our bodies and where they are which he induces through confronting us with perpendicular

forms as unspecific and as resonant as the columns of a Doric temple.

In front of *Vir Heroicus Sublimis* Le Corbusier's words keep coming back to mind: 'Remember the clear, clean, intense, economical, violent Parthenon – that cry hurled into a landscape made of grace and terror. That monument to strength and purity.' And the searing quality of the white zip frequently brings back another image of a temple: 'And, behold, the veil of the temple was rent in twain from the top to the bottom . . .' In checking whether I had remembered the wording correctly, I redis-covered the wording of the context: 'Now from the sixth hour there was darkness over all the land unto the ninth hour. And about the ninth hour Jesus cried with a loud voice, saying, Eli, Eli, lama sabachthani? That is to say, My God, my God, why hast thou forsaken me? . . . Jesus, when he had cried again with a loud voice, yielded up the ghost. And, behold, the veil of the temple was rent in twain from the top to the bottom . . .' The sublimity of Newman's art follows from how its order and wholeness include disruption and destruction, and contain them.

(David Sylvester, 'Newman I', 1986, in his *About Modern Art*)

Matisse explains how he created a mood of spiritual peace and contemplation in his Chapel of the Holy Rosary, Vence.

This chapel is for me the culmination of a lifetime of labour.
The ceramics of the Chapel of the Rosary at Vence have produced reactions of such astonishment that I would like to try to dispel them.

These ceramic panels are composed of large squares of glazed white tile bearing drawings in black outline which decorate them while still leaving them very light. The result is an ensemble of black on white in which the white dominates, and whose density forms a balance with the surface of the opposite wall, which is composed of stained glass windows which run from the floor to the ceiling, and which express, through their adjacent forms, an idea of foliage which is always of the same origin, coming from a characteristic tree of the region: the cactus with large oval spine-covered stalks, which bear yellow and red flowers.

These stained-glass windows are composed of three carefully chosen colours of glass, which are: an ultramarine blue, a bottle green, and a lemon yellow, used together in each part of the stained-glass window. These colours are of quite ordinary quality; they exist as an artistic reality only with regard to their quantity, which magnifies and spiritualizes them.

To the simplicity of these three constructive colours is added a differentiation of the surface of some of the pieces of glass. The yellow is roughened and so becomes translucent only while the blue and the green remain transparent, and thus completely clear. This lack of transparency in the yellow arrests the spirit of the spectator and keeps it in the interior of the chapel, thus forming the foreground of a space which begins in the chapel and then passes through the blue and green to lose itself in the surrounding gardens. Thus when someone inside can see through the glass a person coming and going in the garden, only a metre away from the window, he seems to belong to a completely separate world from that of the chapel.

I write of these windows – the spiritual expression of their colour to me is indisputable – simply to establish the difference between the two long sides of the chapel, which, decorated differently, sustain themselves by their mutual opposition. From a space of bright shadowless sunlight which envelops our spirit on the left, we find, passing to the right, the tile walls. They are the visual equivalent of a large open book where the white pages carry the signs explaining the musical part composed by the stained-glass windows.

In sum, the ceramic tiles are the spiritual essential and explain the meaning of the monument. Thus they become, despite their apparent simplicity, the focal point which should underline the peaceful contemplation that we should experience; and I believe this is a point that should be stressed.

In their execution the artist is revealed with complete freedom. Thus, having from the first foreseen these panels as illustrations of these large surfaces, during the execution he gave a different feeling to one of these three: that of the Stations of the Cross.

The panel of Saint Dominic and that of the Virgin and the Christ Child are on the same level of the decorative spirit, and their serenity has a character of tranquil contemplation which is proper to them, while that of the Stations of the Cross is animated by a different spirit. It is tempestuous. This marks the encounter of the artist with the great tragedy of Christ, which makes the impassioned spirit of the artist flow out over the chapel. Initially, having conceived it in the same spirit as that of the first two panels, he made it a procession of succeeding scenes. But, finding himself gripped by the pathos of so profound a tragedy, he upset the order of his composition. The artist quite naturally became its principal actor; instead of reflecting the tragedy, he has experienced it and this is how he has

expressed it. He is quite conscious of the agitation of the spirit which this passage from the serene to the dramatic arouses in the spectator. But isn't the Passion of Christ the most moving of these three subjects?

I would like to add to this text that I have included the black and white habits of the Sisters as one of the elements of the composition of the chapel; and, for the music, I preferred to the strident tones – however enjoyable, too explosive – of the organ, the sweetness of the voices of women which with their Gregorian chant can become a part of the quivering coloured light of the stained-glass windows.

(Henri Matisse, 'The Chapel of the Rosary, 1951')

A postcard to her mother from the poet Sylvia Plath, after a visit to the Matisse chapel at Vence, in Provence.

To Vence – small, on a sun-warmed hill, uncommercial, slow, peaceful. Walked to Matisse cathedral [*sic*] – small, pure, clean-cut. White, with blue-tile roof sparkling in the sun. But shut! Only open to public two days a week. A kindly talkative peasant told me stories of how rich people came daily in large cars from Italy, Germany, Sweden, etc., and were not admitted, even for large sums of money. I was desolate and wandered to the back of the walled nunnery, where I could see a corner of the chapel and sketched it, feeling like Alice outside the garden, watching the white doves and orange trees. Then I went back to the front and stared with my face through the barred gate. I began to cry. I knew it was so lovely inside, pure white with the sun through blue, yellow and green stained windows.

Then I heard a voice. 'Ne pleurez plus, entrez,' and the Mother Superior let me in, after denying all the wealthy people in cars.

I just knelt in the heart of the sun and the colours of sky, sea and sun, in the pure white heart of the chapel. 'Vous êtes si gentille,' I stammered. The nun smiled. 'C'est la miséricorde de Dieu.' It was.

(Sylvia Plath, 7 January 1956)

The magical tricks the American artist James Turrell plays with light and space – are they pure mysticism or pure hokum? A critic and his wife wonder.

At this hour the gallery is normally closed, but Turrell's outdoor work is best experienced at dawn or dusk, when the quality of light is at its most

dramatic. After leading us up the echoing staircase and out on to the roof, the guard left us in a specially designed viewing room or observatory. He said he'd come back for us at 8.30. Two hours is a long time to spend in an empty room, but fortunately I had coaxed my wife along to keep me company. Here are my notes on what happened next.

THURSDAY, *6.40pm*: This is possibly the most nondescript space I've ever been in. Cheaply built plywood benches line the walls on all four sides of a room in which perhaps twenty-five people could sit at one time. The ceiling is about 20 feet high, with a large square hole cut in the roof, exposing a patch of milky blue sky. Hidden behind the seats I notice electric lights, almost invisible at first, playing upward along the walls.

7pm: Cold and bored, we get up, move around, talk and read in a desultory way. The lonely sound of traffic in the distance reaches us from below. A siren, a passing plane, a jetstream bisecting the open patch of sky above our heads: all count as exciting events. So far, I would hardly describe this as a transfiguring experience. My wife, a reluctant companion on this particular outing, gives me a meaningful look. It says: 'I wasn't going to say anything.'

7.15: After a day of bright sunshine, the sky is a washed-out grey-blue, with wisps of cloud. Looking up, one realizes that the square through which one views the sky has no rim or frame. Turrell has removed any perceptual clue that would enable us to gauge distance. Unless we see a bird or cloud passing across our field of vision, the sky looks like a flat piece of cloth.

7.30: Imperceptibly, the lights in the room have become brighter, warmer – not because they have been turned up, but because the light outside has grown dimmer. The sense of looking into deep space has now disappeared. It is as though the blue patch were a smooth, canopy floating above us. I'm cold.

7.45: All talking has now stopped. Something extraordinary is beginning to happen. Outside, birds circle overhead, roosting for the night. As soon as they depart the atmosphere changes. The sky is now empty. Sounds of traffic seem to die away. Night is closing in. Inside, we are surrounded by a bright orange glow. The luminous patch above our heads has been drained of all traces of grey, leaving what I can only describe as the distilled essence of bright cobalt blue.

8.00: This is *l'heure bleue* with a vengeance, and it is changing from minute to minute. Just when you think the colour couldn't become any deeper,

the blue intensifies. Groping for an analogy, I would compare what has been happening to looking at an artist's colour chart. The tints of blue range from royal to cerulean, descending through several shades of ultramarine to a powerful Prussian. At the moment I would describe the colour I'm seeing as a deep indigo.

8.15: What a spectacle! By some magician's trick, the now bright lights around us create the illusion that the isolated patch of sky is solid, as though it were a *thing*, an object one could touch. One could imagine coming here at midnight to make a mad grab at the stars.

8.30: The guard is here but neither of us really wants to leave. Though not a contemplative sort, I feel myself connected to the sky in a way that has never happened before. That preliminary hour or so of boredom, before nature and Turrell put on their *son et lumière*, was an important part of the experience. It allowed the mind slowly to wind down, to empty itself of the day's preoccupations. Lovely though this achingly pure inky blue is, it is the gradual intensification of colour that was so thrilling.

8.45: As we walk outside to the car, the surrounding night is cold and black. It sobers us up. I can view Turrell with a bit more detachment now, and from street level he looks less like a mystic and more like a Barnum. I can't decide whether he's a genius or that genuine American article: a confidence man, a humbug. I suppose a bit of both. And anyway, does it matter? What he does may be hokum, but it's highly enjoyable hokum. It certainly fooled this local.

(Richard Dorment, 21 April 1993)

Adolf Hitler took an extremely dim view of Modernist art, as he explained in this speech delivered in Munich in 1937. As he spoke, according to eyewitnesses, the Führer's critical indignation caused him to foam at the mouth, so that even his close supporters became alarmed by his agitation.

Among the pictures submitted I have observed a number of works which actually lead one to assume that certain people's eyes show them things differently from the way they really are. In other words, there really are men who see today's Germans simply as degenerate cretins and who perceive – or as they would doubtless say 'experience' – the meadows as blue, the sky as green, the clouds as sulphurous yellow, and so on. I do not want to enter into an argument as to whether or not these people actually do see and perceive things in this way, but in the name of the

German people I wish to prohibit such unfortunates, who clearly suffer from defective vision, from trying to foist the products of their faulty observation on to their fellow men as though they were realities, or indeed from dishing them up as 'art'. No, there are only two possibilities. Either these so-called 'artists' really do see things in this way and so believe in what they are representing – if so one would have to investigate whether their eye defects have arisen by mechanical means or through heredity: in the former case these unfortunate people are profoundly to be pitied; in the latter it would be a matter of great concern for the Reich Ministry of the Interior, which would then have to consider ways of putting a stop to the further transmission of such appalling defects of vision – or perhaps, on the other hand, they themselves do not believe in the reality of such impressions, but have other reasons for inflicting this humbug on the nation, in which case it would constitute an offence falling within the area of the criminal law . . .

(Adolf Hitler, 1937)

The audacious and outrageous French artist Yves Klein outlines his plan to activate light and space by illuminating the obelisk in the place de la Concorde in Kleinian blue.

To make it absolutely clear that I am abandoning material and physical Blue, waste and coagulated blood issued forth from the raw material sensibility of space, I want to obtain authorization from the Prefecture of the Seine and the Electricité de France to illuminate in Blue the obelisk on the place de la Concorde. Placing Blue filters over the existing spotlights so that the obelisk is illuminated while the base is left in shadow will restore all the mystical splendour of high antiquity to this monument and, at the same time, will bring the solution to the problem that is always set up in sculpture: the 'pedestal'. Indeed, the obelisk thus lighted will float, immutable and static, in a monumental movement of affective imagination, in space, above the entire place de la Concorde, over its prehistoric gas streetlamps, in the night, as an immense, non-punctuated, vertical exclamation point!

Thus, the tangible and visible Blue will be outside, in the exterior, in the street, and in the interior, it will be the immaterialization of Blue.

Permission was given for this manifestion, but, to Klein's consternation, withdrawn at the last moment.

(Yves Klein, 1958)

Mrs Jackson Pollock – the painter Lee Krasner – gives a definition of her husband's work in terms of freedom and space to a New Yorker *interviewer.*

We asked Pollock for a peep at his work. He shrugged, rose and led us into a twenty-five-by-[fifteen]-foot living room furnished with massive Italianate tables and chairs and hung with spacious pictures, all of which bore an offhand resemblance to tangles of multicoloured ribbon. 'Help yourself,' he said, halting at a safe distance from an abstraction that occupied most of an end wall. It was a handsome, arresting job – a rust-red background laced with skeins of white, black, and yellow – and we said so. 'What's it called?' we asked. 'I've forgotten,' he said, and glanced inquiringly at his wife, who had followed us in. '*Number Two, 1949*, I think,' she said. 'Jackson used to give his pictures conventional titles – *Eyes in the Heat* and *The Blue Unconscious* and so on – but now he simply numbers them. Numbers are neutral. They make people look at a picture for what it is – pure painting.' 'I decided to stop adding to the confusion,' Pollock said. 'Abstract painting is abstract. It confronts you. There was a reviewer a while back who wrote that my pictures didn't have any beginning or any end. He didn't mean it as a compliment, but it was. It was a fine compliment. Only he didn't know it.' 'That's exactly what Jackson's work is,' Mrs Pollock said. 'Sort of unframed space.'

(Berton Roueché, 5 August 1950)

In three letters to his brother Théo of 1888 Van Gogh expounds his conception of expressive colour, by which he means colour that is not necessarily naturalistic.

I shouldn't be very surprised if before very long the Impressionists were to find fault with my way of working, which has been enriched by the ideas of Delacroix rather than theirs.

For instead of trying to reproduce exactly what I see before me, I make more arbitrary use of colour to express myself more forcefully. Well, so much for theory, but let me give you an example of what I mean.

I should like to paint the portrait of an artist friend who dreams great

dreams, who works as the nightingale sings, because it is his nature. This man will be fair-haired. I should like to put my appreciation, the love I have for him, into the picture. So I will paint him as he is, as faithfully as I can – to begin with.

But that is not the end of the picture. To finish it, I shall be an obstinate colourist. I shall exaggerate the fairness of the hair, arrive at tones of orange, chrome, pale yellow. Behind the head – instead of painting the ordinary wall of the shabby apartment, I shall paint infinity, I shall do a simple background of the richest, most intense blue that I can contrive, and by this simple combination, the shining fair head against this rich blue background, I shall obtain a mysterious effect, like a star in the deep blue sky.

I used the same approach in the portrait of the peasant. Without wanting in this case, however, to conjure up the mysterious brilliance of a pale star in the blue of infinity. But by imagining the marvellous man that I was about to paint right in the middle of the sweltering midday heat of harvest, I arrived at the flashing orange colours like red-hot iron and the luminous tones of old gold in the shadows . . .

I'm sending you a little sketch at long last to give you at least some idea of the direction my work is taking. Because I feel quite well again today. My eyes are still tired, but I had a new idea all the same and here is the sketch of it.

As always a size 30 canvas.

This time it's simply my bedroom. Only here everything depends on the colour, and by simplifying it I am lending it more style, creating an overall impression *of rest or sleep*. In fact, a look at the picture ought to rest the mind, or rather the imagination.

The walls are pale violet. The floor – is red tiles.

The wood of the bed and the chairs is the yellow of fresh butter, the sheet and the pillows very light lime green.

The blanket scarlet.

The window green.

The washstand orange, the basin blue.

The doors lilac.

And that's all – nothing of any consequence in this shuttered room.

The sturdy lines of the furniture should also express undisturbed rest.

Portraits on the wall, and a mirror, and a hand towel, and some clothes.

The frame – because there is no white in the picture – will be white.

This by way of revenge for the enforced rest I have had to take.

I shall work on it again all day tomorrow, but you can see how simple the conception is. The shadows and the cast shadows are left out and it is painted in bright flat tints like the Japanese prints . . .

I am always caught between two currents of thought, firstly, material difficulties, turning this way and that to make a living, and then, the study of colour. I keep hoping that I'll come up with something. To express the love of two lovers by the marriage of two complementary colours, their blending and their contrast, the mysterious vibrations of related tones. To express the thought of a brow by the radiance of a light tone against a dark background. To express hope by some star. Someone's passion by the radiance of the setting sun. That's certainly no realistic trompe-l'oeil, but something that really exists, isn't it?

(Vincent Van Gogh to Théo Van Gogh, 11 August, 3 September, and 16 October 1888)

The monochrome painter Yves Klein reveals a mystical, medieval love for pure colour.

I did not like colours ground with oil. They seemed to be dead. What pleased me above all was pure pigments in powder like the ones I often

saw at the wholesale colour dealers. They had a burst of natural and extraordinarily autonomous life. It was truly colour in itself. Living and tangible colour material.

What upset me was to see this incandescent powder lose all its value and become dulled and lowered in tone once it was mixed with a glue or whatever medium was intended to fix it to the support. One could obtain the effects of impasto, but in drying it was no longer the same thing: the actual magic colour had disappeared.

Each grain of powder appeared to have been individually killed by the glue or whatever ingredient was intended to bind it to others and to the support.

Irresistibly drawn to this new monochrome material, I decided to undertake the technical research necessary to find a medium capable of fixing the pure pigment to the support without altering it. The colour value would then be represented in a pictorial manner. Obviously, I was quite charmed by the possibility of leaving the grains of pigment in total freedom, as they exist in powder, perhaps mixed but independent with all particles being similar. 'Art is total freedom, it is life. As soon as there is imprisonment in whatever way, freedom is attacked and life diminishes in function of the degree of imprisonment.'

In order to leave the powdered pigment that I discovered at the wholesale colour dealers free, while presenting it in paintings, I simply would have had to spread it out on the ground. The invisible force of attraction would have kept it on the surface of the ground without altering it. At the time, I did not consider this as a possible or acceptable solution for the visual-arts public, no matter how informal it might be. Thus, I set about to work in a pictorial form, that is to say, I set about to paint monochrome pictures!

(Yves Klein, *c.*1958)

A structuralist, novelist, and art historian analyses the medieval love of colour.

The most obvious symptom of qualitative aesthetic experience was the medieval love of light and colour. Quite a number of interesting writings provide evidence of this feeling, and they reveal something quite contrary to the aesthetic tradition which we have examined in previous chapters ... Medieval theorists looked upon beauty as something intelligible, a kind of mathematical quality, even when they were discussing purely

empirical matters such as the experience of metre or the design of the human body. But when it came to their experience of colour – of gems, materials, flowers, light, and so on – the Medievals revealed instead a most lively feeling for the purely sensuous properties of things. Their love of proportion was expressed initially as a theoretical doctrine, and was only gradually transferred to the sphere of practice and precept. Their love of colour and light, by contrast, was a spontaneous reaction, typically medieval, which only afterwards came to be expressed scientifically within their metaphysical systems. The beauty of colour was everywhere felt to be beauty pure and simple, something immediately perceptible and indivisible, and with no element of the relational as was the case with proportion.

Immediacy and simplicity characterized the medieval love of light and colour. The figurative art of the period shows quite a different colour consciousness from that of succeeding centuries. It confined itself to simple and primary colours. It had a kind of chromatic decisiveness quite opposed to sfumatura. It depended on a reciprocal coupling of hues that generated its own brilliance, and not on the devices of chiaroscuro, where the hue is determined by light and can even spread beyond the edges of the design. In poetry, too, colours were always decisive, unequivocal: grass was green, blood red, milk snowy white. There were superlatives for every colour – for example, *praerubicunda* for roses – and while a colour might have many shades, it was never allowed to fade and blur into shadows. Medieval miniatures testify to this love of the integral colour, to the vivacity of chromatic combinations. We find it not only in the mature works of the Flemish and Burgundians – one thinks of the *Très riches heures du duc de Berry* – but also in earlier works such as the eleventh-century miniatures of Reichenau: 'Set off by this all-pervading golden sheen, such eminently cool, bright hues as lilac, sea-green, sand-yellow, pink and bluish-white (characteristic of Reichenau miniatures) seem to shine with their own light.' And there is literary evidence of the connection between the lively visual imagination of the poet and that of the painter, in Chrétien de Troyes's *Érec et Énide*:

The one who went at her behest came bringing to her the mantle and the tunic, which was lined with white ermine even to the sleeves. At the wrists and on the neckband there was in truth more than half a mark's weight of beaten gold, and everywhere set in the gold there were precious stones of divers colours, indigo and green, blue and dark brown ... The mantle was

very rich and fine: laid about the neck were two sable skins, and in the tassels there was more than an ounce of gold; on one a hyacinth, and on the other a ruby flashed more bright than burning candle. The fur lining was of white ermine; never was finer seen or found. The cloth was skilfully embroidered with little crosses, all different, indigo, vermilion, dark blue, white, green, blue, and yellow.

(Umberto Eco, 1986)

Picasso makes a despondent observation about colour.

We were driving through a dazzling landscape. Sun. Meadows. Olive trees. Lakes and cypresses. Mountains.

Picasso said, 'The terrible thing is that there's not one of these colours that you can buy in tubes. They'll sell you thousands of greens. Veronese green and emerald green and cadmium green and any sort of green you like; but that particular green, never.'

(Pablo Picasso, as reported by Hélène Parmelin, 1966)

Baudelaire defines the musical quality of colour.

This great symphony of today, which is the eternally renewed variation of the symphony of yesterday, this succession of melodies, where the variety comes always from the infinite, this complex hymn is called colour.

In colour we find harmony, melody and counterpoint.

(Charles Baudelaire, 'The Salon of 1846')

Matisse insists that black is a colour . . .

Before, when I didn't know what colour to put down, I put down black. Black is a force: I depend on black to simplify the construction. Now I've given up blacks.

The use of black as a colour in the same way as the other colours – yellow, blue or red – is not a new thing.

The Orientals made use of black as a colour, notably the Japanese in their prints. Closer to us, I recall a painting by Manet in which the velvet jacket

of a young man with a straw hat is painted in a blunt and lucid black.

In the portrait of Zacharie Astruc by Manet, a new velvet jacket is also expressed by a blunt luminous black. Doesn't my painting of the *Marocains* use a grand black which is as luminous as the other colours in the painting?

Like all evolution, that of black in painting has been made in jumps. But since the Impressionists it seems to have made continuous progress, taking a more and more important part in colour orchestration, comparable to that of the double-bass as a solo instrument.

(Henri Matisse, 'Black Is a Colour', 1946)

. . . And also that colour is essential to our sense of space and freedom.

Colour helps to express light, not the physical phenomenon, but the only light that really exists, that in the artist's brain.

Each age brings with it its own light, its particular feeling for space, as a definite need. Our civilization, even for those who have never been up in an aeroplane, has led to a new understanding of the sky, of the expanse of space. Today there is a demand for the total possession of this space.

Awakened and supported by the divine, all elements will find themselves in nature. Isn't the Creator himself nature? . . .

Colour, above all, and perhaps even more than drawing, is a means of liberation.

Liberation is the freeing of conventions, old methods being pushed aside by the contributions of the new generation. As drawing and colour are means of expression, they are modified.

Hence the strangeness of new means of expression, because they refer to other matters than those which interested preceding generations.

(Henri Matisse, 'Observations on Painting', 1945)

The magic of the paintings of Raphael's master, Pietro Perugino (c.1445–1523), argues Bernard Berenson, lies in their expansive sense of space.

One of his earliest works is the fresco, in the Sistine Chapel, of *Christ Giving the Keys to Peter*, a work in which he has given more attention to structure than you shall find him doing again. As if by miracle, several persons are standing on their feet. Note, however, that these are neither Christ nor the Apostles, whom doubtless Pietro was already painting by

rote, but portraits of his own friends. And as if to explain the miracle, he has, on the extreme left, introduced himself standing by Luca Signorelli, with whom he then was closely associated. Yet you will not find even these persons life-enhancing by means of their tactile values or their movement. And throughout this fresco, Perugino's figures are no more attractive than Pintoricchio's, no better constructed than in the frescoes of those Florentine mediocrities, Cosimo Rosselli and Ghirlandaio, in movement contemptible beside Botticelli. And still among the paintings of the Sistine Chapel Perugino's is certainly not the least agreeable. Nay, is there one more delightful? It is the golden, joyous colour, the fine rhythm of the groups, and above all the buoyant spaciousness of this fresco that win and hold us. Our attention first falls on the figures in the foreground, which, measured against the pavement cunningly tessellated for the purpose, at once suggest a scale more commensurate with the vastness of nature than with the puniness of man. Nor do these grand figures crowd the square. Far from it. Spacious, roomy, pleasantly empty, it stretches beyond them, inward and upward, over groups of men, surely of the same breed, but made small by the distance, until, just this side of the horizon's edge, your eye rests on a temple with soaring cupola and airy porticoes, the whole so proportioned to the figures in the foreground, so harmonized with the perspective of the pavement, that you get the feeling of being under a celestial dome, not shut in but open and free in the vastness of the space. The effect of the whole is perfectly determined both by the temple, through which runs the axis of this ideal hemisphere, and by the foreground, which suggests its circumference. And taking it as a sphere, you are compelled to feel as much space above and beyond the dome as there is between it and yourself.

(Bernard Berenson, 1896–7)

An untrained painter and retired fisherman from St Ives takes a trenchant view on the subject.

i do not put Collers what do not Belong, i Think it spoils The pictures. Their have Been a lot of paintins spoiled By putin Collers where They do not Blong.

(Alfred Wallis to Jim Ede, 30 November 1935)

But can colour be separated from light and space? The painter Patrick Heron argues that they are the same thing.

Colour is the utterly indispensable means for realizing the various species of pictorial space. Mere perspectival drawing, mere chiaroscuro of mono-chromatic tone – these may render illusionist verisimilitude of reality: but it is a dead version; they cannot produce that fully created thing, found nowhere else, not even in photographs, which I call pictorial space. The imaginative, intuitive re-creation of form which, for years, I have been trying to pin down in a definition is only conceivable in terms of a vibrant picture surface. And this vibration is colour. Pictorial space ... is an illusion of depth *behind* the actual canvas. It may also be a projection – of plane or mass – apparently in front of the canvas. But the existence of pictorial space implies the partial obliteration of the canvas's surface from our consciousness. This is the role of colour: to push back or bring forward the required section of the design. The advance or recession of different colours in juxtaposition is a physical property of colour: it is a physical impossibility to paint shapes on a surface, using different colours in a variety of tones, and avoid the illusion of the recession of parts of that surface. Colour is therefore as powerful an agent of spatial expression as drawing. Indeed, one 'draws' with flat washes of colour, as often as not, and not with line at all. Tonal colour is thus the sole means of bestowing that physical vibrancy and resonance without which no picture is alive. And this vibration can be conveyed in 'hueless colours' – that is, in blacks, whites and greys – no less than by the full, chromatic range.

 (Patrick Heron, *Space in Colour*, 1953)

Having to hide a smuggled Titian reveals the luminosity of space to Oskar Kokoschka.

An experience of quite another order belongs to this same period. One day a few months before the outbreak of the First World War, Carl Moll returned from Italy with a painting by Titian, which he left in my studio to be hidden from the public eye. The painting, *Venus with Organ-player*, had belonged to a Prince of Orleans, of the Italian branch of the family, and had been brought secretly over the frontier. After the war it was purchased by the Kaiser-Friedrich-Museum in Berlin where it remains, as one of the glories of the museum's collection.

The picture dates from the middle of Titian's career when, to replace the classical drawing and local colouring of the Renaissance style, he began his search for new means to convey the luminosity of space. This endeavour culminates in the *Pietà* in the Accademia in Venice, perhaps his last work, where the light transforms and recreates space, and the static Renaissance perspective is broken by a new visual concept: the scene begins to move instead of being read like a page in a book. For the first time, in the *Pietà*, Titian does not present the Passion of the Son of God, but rather an image of the transience of Creation – and thus an image of the modern world as created by man.

The movement of the beholder's eye is no longer directed by the signposts of contour and local colour, but is governed by luminous intensity. This creative achievement introduced into painting the miraculous quality of Archaic Ionian sculpture, where the surface is resolved into tiny facets, and light not only touches it but stirs it into life. Here, the spell of Egypt was finally broken. Henceforth light – and not only cubical mass or volume – distinguishes spatial composition.

Titian remained forgotten for a long time after his death. Poussin, not a great painter but the possessor of an excellent eye, was the first to discover, from an intensive study of Titian, that his work contained a quality foreign to all other painters and far different from the drawing and local colour of the Renaissance: luminosity, the dynamic action of colour. Methodically, by geometrical analysis, Poussin set out to extract this secret from the composition. He broke the surface up into facets of varying sizes, producing a 'space crystal'. He thus struck out on a path which distinguishes him entirely from the classical painters of his time – and from Ingres; for classicists acknowledge only classical drawing and local colour as the expressive resources of their art. But to learn from Titian the triumph of light, the triumph of *lumen* over *volumen*, would have required a mental struggle for which Poussin was not equipped.

Cézanne, in his own way indirectly a pupil of Poussin's, went further by methodically transposing the analysis of the pictorial structure into terms of colour. But Cézanne was the child of a scientific age; he moved away from the dynamism of colour, and towards abstraction. Cubism, which lacks light as a source of movement, carried the process of abstraction still further. In the end, art returned to the static vision, the still-life.

Unfortunately the Titian *Venus with Organ-player* stayed with me only for a few months; the war put an end to my surreptitious pleasure. But, as a result of this game of hide-and-seek with the origin of illumination

in space, my eyes were opened as they had been in childhood when the secret of light first dawned on me.

(Oskar Kokoschka, 1974)

The critic John Elderfield discovers in the work of Matisse – as did Baudelaire in that of Delacroix – that all colours make grey, even if they are not mixed.

In winter in Tangier, the rain often ends late in the afternoon: when it does, the dark blue clouds split open to spill out a pinkish beige on to the previously white walls of the Casbah, the shadows turning cool green in contrast. Loti was correct in describing Tangier as the white city. But its whiteness is that of a canvas waiting to receive colour – blue, pink, and green – that nature provides.

In the gardens and in the surrounding countryside the same pinkness, suffusing the sky, turns lavender on the trunks and branches of trees while the same greenness is similarly adjusted, toward blue, by the dense foliage. And whether in town or in country, simultaneously with this sudden tinting of the world comes another transformation of it, one that would be called more remarkable if it could be separated for comparison. Surfaces both of light and of shade appear to vibrate, not only at their meeting, which is to be expected with any such complementary contrast, but also internally, as if the suddenly sprung radiance of colour had loosened the very structure of the existing substance, immingling with it in a still-tremoring suspension. More even than the hue itself, this effect of colour as if suspended in some almost lacteal medium is the marvel produced by Moroccan light. When Matisse most successfully re-created it, he did so by means of scumbled layers of thin, transparent, and translucent pigment. He still continued, as previously, to spread colour as a single flat film. But in Morocco he also began to spread it as a layered substance. The complex reality of the subject was analogized by improvising a new richness from the reality of the paint.

The effect of pearlescent light that I am describing is dramatized when the sun's beams are low, as at dawn or in the late afternoon. *Les Acanthes* must have been brought to its conclusion toward the end of the day. Such an effect, however, is a function not mainly of the angle of light but of its intensity and softness together. Thus it also exists at bright high noon and in summer too. *Sur la Terrasse* is the vehicle of its most compelling realization since Delacroix painted his *Sultan du Maroc* in 1845. What

Baudelaire said of Delacroix's work is also true of Matisse's: 'In spite of the splendour of its hues, this picture is so harmonious that it is grey – as grey as nature, as grey as the summer atmosphere when the sun spreads over each object a sort of twilight film of trembling dust.'

(John Elderfield, 1990)

El Greco shocks a more academically minded colleague, who was also Velázquez's father-in-law, with an unorthodox opinion.

I was greatly surprised – forgive me this anecdote, which I am not relating out of envy – when, having asked Domenico Greco in the year 1611: 'Which is the more difficult, drawing or colouring?' he answered: 'Colouring.'

Yet this was not so amazing as it was to hear him speak with so little esteem of Michelangelo, who is the father of painting, and say that he was a good man but did not know how to paint. However, those who are acquainted with this man will not think it strange that he should have departed from the common sentiment of the rest of the artists, for he was as odd in everything as he was in painting.

(Francisco Pacheco, 1649)

Leonardo da Vinci advocates a method of producing soft and gentle lighting.

If you have a courtyard which, when you so please, you can cover over with a linen awning, the light will then be excellent. Or when you wish to paint a portrait paint it in bad weather, at the fall of the evening, placing the sitter with his back to one of the walls of the courtyard. Notice in the streets at the fall of the evening the faces of the men and women when it is bad weather, what grace and softness they display. Therefore, O painter, you should have a courtyard fitted up with the walls tinted in black, and with the roof projecting forward a little beyond the wall; and the width of it should be ten braccia [yards, from the Italian for arm], and the length twenty braccia, and the height ten braccia; and you should cover it over with the awning when the sun is on it, or else you should make your portrait at the hour of the fall of the evening when it is cloudy or misty, for the light then is perfect.

(Leonardo da Vinci, 1452–1519)

What

is

Art?

The artist's first creation is himself.
 (Harold Rosenberg, 1973)

Andy Warhol answers the big question.

'Art?' Warhol once asked in response to the inevitable question. 'Isn't that a man's name?'
 (Andy Warhol, in Arthur C. Danto, *Encounters and Reflections*, 1990)

Art, Barnett Newman insists, is one of the fundamental human activities.

What was the first man, was he a hunter, a toolmaker, a farmer, a worker, a priest, or a politician? Undoubtedly the first man was an artist.

A science of palaeontology that sets forth this proposition can be written if it builds on the postulate that the aesthetic act always precedes the social one. The totemic act of wonder in front of the tiger-ancestor came before the act of murder. It is important to keep in mind that the necessity for dream is stronger than any utilitarian need. In the language of science, the necessity for understanding the unknowable comes before any desire to discover the unknown.

Man's first expression, like his first dream, was an aesthetic one. Speech was a poetic outcry rather than a demand for communication. Original man, shouting his consonants, did so in yells of awe and anger at his tragic state, at his own self-awareness and at his own helplessness before the void. Philologists and semioticians are beginning to accept the concept that if language is to be defined as the ability to communicate by means of signs, be they sounds or gestures, then language is an animal power. Anyone who has watched the common pigeon circle his female knows that she knows what he wants.

The human in language is literature, not communication. Man's first

cry was a song. Man's first address to a neighbour was a cry of power and solemn weakness, not a request for a drink of water. Even the animal makes a futile attempt at poetry. Ornithologists explain the cock's crow as an ecstatic outburst of his power. The loon gliding lonesome over the lake, with whom is he communicating? The dog, alone, howls at the moon. Are we to say that the first man called the sun and the stars *God* as an act of communication and only after he had finished his day's labour? The myth came before the hunt. The purpose of man's first speech was an address to the unknowable. His behaviour had its origin in his artistic nature.

Just as man's first speech was poetic before it became utilitarian, so man first built an idol of mud before he fashioned an axe. Man's hand traced the stick through the mud to make a line before he learned to throw the stick as a javelin. Archaeologists tell us that the axehead suggested the axehead idol. Both are found in the same strata, so they must have been contemporaneous. True, perhaps, that the axehead idol of stone could not have been carved without axe instruments, but this is a division in métier, not in time, since the mud figure anticipated both the stone figure and the axe. (A figure can be made out of mud, but an axe cannot.) The God image, not pottery, was the first manual act. It is the materialistic corruption of present-day anthropology that has tried to make men believe that original man fashioned pottery before he made sculpture. Pottery is the product of civilization. The artistic act is man's personal birthright.

The earliest written history of human desires proves that the meaning of the world cannot be found in the social act. An examination of the first chapter of Genesis offers a better key to the human dream. It was inconceivable to the archaic writer that original man, that Adam, was put on earth to be a toiler, to be a social animal. The writer's creative impulses told him that man's origin was that of an artist, and he set him up in a Garden of Eden close to the Tree of Knowledge, of right and wrong, in the highest sense of divine revelation. The fall of man was understood by the writer and his audience not as a fall from Utopia to struggle, as the sociologicians would have it, nor, as the religionists would have us believe, as a fall from Grace to Sin, but rather that Adam, by eating from the Tree of Knowledge, sought the creative life to be, like God, 'a creator of worlds', to use Rashi's phrase, and was reduced to the life of toil only as a result of a jealous punishment.

In our inability to live the life of a creator can be found the meaning of the fall of man. It was a fall from the good, rather than from the

abundant, life. And it is precisely here that the artist today is striving for a closer approach to the truth concerning original man than can be claimed by the palaeontologist, for it is the poet and the artist who are concerned with the function of original man and who are trying to arrive at his creative state. What is the reason d'être, what is the explanation of the seemingly insane drive of man to be painter and poet if it is not an act of defiance against man's fall and an assertion that he return to the Adam of the Garden of Eden? For the artists are the first men.

(Barnett Newman, 'The First Man Was an Artist', October 1947).

Contemporary art, so some claim, can be made of anything and about anything. The critic Arthur C. Danto lauds Andy Warhol for the part he played in this development.

Bitter as the truth may be to those who dismissed him as a shallow opportunist and glamour fiend, the greatest contribution to this history was made by Andy Warhol, to my mind the nearest thing to a philosophical genius the history of art has produced. It was Warhol himself who revealed as merely accidental most of the things his predecessors supposed essential to art, and who carried the discussion as far as it could go without passing over into pure philosophy. He brought the history to an end by demonstrating that no visual criterion could serve the purpose of defining art, and hence that Art, confined to visual criteria, could not solve his personal problem through art-making alone. Warhol achieved this, I think, with the celebrated Brillo boxes he exhibited a quarter-century ago at Eleanor Ward's Stable Gallery in New York.

A great deal more was achieved through the Brillo boxes than this, to be sure, but what was most striking about them was that they looked sufficiently like their counterparts in supermarket stockrooms that the differences between them could hardly be of a kind to explain why they were art and their counterparts merely cheap containers for scouring pads. It was not necessary to fool anyone. It was altogether easy to tell those boxes turned out by Warhol's Factory from those manufactured by whatever factory it was that turned out corrugated cardboard cartons. Warhol did not himself make the boxes, nor did he paint them. But when they were displayed, stacked up in the back room of the gallery, two questions were inevitable: What was it in the history of art that made this gesture not only possible at this time but inevitable? And, closely connected with this: Why were *these* boxes art when their originals were just boxes?

With these two questions posed, a century of deflected philosophical investigation came to an end, and artists were liberated to enter the post-philosophical phase of Modernism free from the obligation of self-scrutiny.

(Arthur C. Danto, *Encounters and Reflections,* 1990)

Art has become a game, argues Francis Bacon in conversation with David Sylvester.

FB: . . . Of course so many things have happened since Velázquez that the situation has become much more involved and much more difficult, for very many reasons. And one of them, of course, which has never actually been worked out, is why photography has altered completely this whole thing of figurative painting, and totally altered it.

DS: In a positive as well as a negative way?

FB: I think in a very positive way. I think that Velázquez believed that he was recording the court at that time and recording certain people at that time; but a really good artist today would be forced to make a game of the same situation. He knows that the recording can be done by film, so that that side of his activity has been taken over by something else and all that he is involved with is making the sensibility open up through the image. Also, I think that man now realizes that he is an accident, that he is a completely futile being, that he has to play out the game without reason. I think that, even when Velázquez was painting, even when Rembrandt was painting, in a peculiar way they were still, whatever their attitude to life, slightly conditioned by certain types of religious possibilities, which man now, you could say, has had completely cancelled out for him. Now, of course, man can only attempt to make something very, very positive by trying to beguile himself for a time by the way he behaves, by prolonging possibly his life by buying a kind of immortality through the doctors. You see, all art has now become completely a game by which man distracts himself; and you may say it has always been like that, but now it's entirely a game. And I think that that is the way things have changed, and what is fascinating now is that it's going to become much more difficult for the artist, because he must really deepen the game to be any good at all.

(David Sylvester, *Interviews with Francis Bacon,* 1987).

Selecting work for an exhibition leads the British novelist William Boyd to reflect that there are shared values in art – at least, up to a point.

In 1928, introducing a book of Veronese's frescoes, Paul Valéry wrote that 'contemporary artists have their merits, but one has to admit that they rarely attempt great work; they seem uneasy . . . they no longer like to invent. If they do invent, it is often to do with detail . . . bits and pieces absorb them. Today our art seems created only in a spirit of exhaustion.' This in 1928! What would he have said today? Probably exactly the same, and doubtless the identical sentiments could have been reiterated in 1828 or 1728 and so on. It's important to remember, it seems to me, that in any society at any given time over the last 2,000 years most of the art produced was, at best, mediocre or banal; at worst, below consideration. Genuine talent has always been a scarce commodity, genius unbelievably rare. What has come down to us from preceding centuries is the *crème de la crème*, posterity's judgement sifting nuggets of excellence from tons of indifferent ore.

Some of those working on posterity's behalf are art critics, much maligned, but whom we might see as the shock troops, the first wave over the top, if you like, in the complex business that is the forming of a consensus – however vague, however shifting – about which work has merit, which has value, which artist is worth celebrating and, perhaps, which art is worth preserving. This endless effort of evaluation is not confined to them alone, however: many others participate, worldwide, and it is constantly going on . . . and its effects – like erosion, like a tree growing – are hard to discern in the short or even medium term. But it is happening all the same, constantly – one might say that this is what culture is about – and we all, in one way or another, when we bid for a picture, go to an exhibition, read a catalogue, buy a poster or a postcard reproduction – play some part, however infinitesimal, in the process.

I had the opportunity in June of this year, along with five other *confrères*, of participating in a vastly accelerated and concentrated version of this, for want of another expression, universal exercise of taste. 'The Discerning Eye' is an annual exhibition of a particular and beguiling nature (this is its fifth year). It is for work of small scale – no painting may be larger than 20 x 20 inches. Six selectors are invited to choose approximately sixty paintings that they are happy to declare are a fair representation of their taste, pictures that enshrine the selector's artistic credo, that represent, put most simply, 'the sort of painting they like'. The sixty pictures are

chosen from three categories. From an open selection; from invited, 'lesser-known' artists; and from invited 'well-known' artists ('well-known' meaning having had a solo exhibition in an established London gallery). The last two categories are the easiest filled. Each selector has already made up his mind (there were no 'hers' this year) about whom he admires and respects. The invited artists submit a small selection and a choice is made.

However, the most fascinating aspect of the exercise is the open selection. This year the response was huge: over 2,500 pictures were submitted, and several hundred pieces of sculpture. We had two days to boil this mass down to approximately one hundred and twenty pictures – let's say twenty or so from each selector. The exhibition's title suddenly became all too apposite . . .

Such a concentrated, accelerated and relentless method of evaluation was both oddly exhilarating and highly intriguing. There was no time for musing, no humming and hawing, no 'yes maybes' or 'what ifs?' Your critical standards – the benchmarks and touchstones of your taste – had to operate almost instantly and completely independently. I cannot speak for my fellow selectors, but this is what was going on in my head. As the paintings whizzed by, I scrutinized them first for any sign of expertise or virtuosity, second, for any evidence of integrity and honesty, and third, for any manifestation of thought (wit, audacity, originality). One hopes, of course, to encounter all these facets in the individual work of art, but this is, inevitably, very rare. I would say that technical skill – whether graphic, tonal, compositional or in the handling of paint or other media – was what gained a picture its initial high estimation and ensured its selection. Sad though it is to admit, so much of the work was so ineptly done that simple evidence of an ability to draw blazed like a beacon. As the two days wore on, it seemed to me that amongst the selectors – six individuals with strong opinions and entrenched and sometimes differing tastes – our demands, our criteria for selection, steadily converged. Occasionally we disagreed; occasionally our differing agendas were plain to see, and occasionally all of us wanted to select one artist's work. In these instances, what produced this unanimity was clear and unmistakable evidence of skill, of finesse, of graphic or painterly flair. Not all the pictures we finally chose were 'wonderful' or 'exceptional', but most of them, I feel, have something of merit about them.

More controversially, I would say further – but this is only my opinion – that our basic standards of judgement over the many hours of selection

were on the whole pretty objective. This may seem a strange observation to make in this day and age where subjectivity rules, but I have to say that contemplating an endless stream of the undistinguished, the unachieved and the unequivocally appalling made the old verities glow like jewels.

(William Boyd, 1996)

Jackson Pollock gives a practical demonstration of what art is.

Guston remembers a weekend at this time when he and Tomlin visited Pollock in Springs while Lee was away. It was a good weekend. Jackson's mood was gentle, even the second night when Guston and Tomlin did most of the talking. However, at some point in the course of their discussion of Renaissance art, Jackson picked up a very large nail and drove it into the living-room floor, saying, 'Damn it, that's art.'

(B. H. Friedman, 1973)

I have little to tell you; indeed one says more and perhaps better things about painting when facing the motif than when discussing purely speculative theories – in which, as often as not, one loses oneself.

(Paul Cézanne to Charles Camoin, 28 January 1902)

The influential critic Hilton Kramer believes that an audience immersed in popular culture is forgetting how to appreciate the art of painting.

Something strange and unacknowledged has been happening to the place occupied by the art of painting in our aesthetic experience. By a great many people who now take a professional interest in the visual arts – not only critics and historians and museum curators and cultural bureaucrats, but a large number of artists, too – painting is no longer felt to be the primary locus of their artistic concerns. It is no longer what it once was: their first love among the arts, and their most enduring passion. It isn't that they actively dislike it, however. There are those who do, of course, for a variety of political or other non-aesthetic reasons, but the people I have in mind do not feel any special animus against painting. It is simply that they are not now sufficiently intimate with the art of painting to have strong feelings about it one way or the other. Painting is, in some

fundamental sense, just no longer *there* for them as an aesthetic imperative. They have either lost or, more likely, have never acquired the ability to 'see' it as something central to their artistic experience. It has been effectively supplanted by other media – photography, video, assemblage, arrangements of objects claiming to be sculpture, and that whole range of display or tableau that goes by the name of conceptual art – that are said to have greater immediacy and legibility, and hence greater relevance to contemporary life.

For a large part of the public, too, a painting is once again what it was for the benighted philistine public of yesteryear – merely a picture, a representation, an image, an icon of instruction, amusement, or edification that is expected to yield up its essential 'message' without mystery or complication. Whereas in the past the message was likely to be about God or history, love or death or glory, or some other sentiment that received opinion had rendered instantly recognizable, today it is likely to be about sexuality, ecology, class, race, or other issues currently deemed to be politically correct. Alas, we now have a generation of critics and museum curators who seem to have a taste for nothing but image-art and propaganda art of this persuasion.

For the public that comes to contemporary exhibitions in search of such images and messages, media like those employed by Robert Rauschenberg or Gilbert & George, for example, are bound to be more appealing than the art of painting – unless, of course, painting deliberately attempts to ape the effects of such non-painterly media in order to satisfy this taste for a relevant, up-to-date imagery. Nowadays we see quite a lot of these pictures that strive to do precisely that, but they have little or nothing to do with the art of painting. This Pop-oriented graphic art adopts the methods of advertising art to serve some current cause or sentiment, but it has about as much to do with a sensibility for painting as the front page of the daily newspaper, which, since the introduction of colour printing into daily journalism, is likely to be designed in a similar style. It is the counterpart in our time of the old academic Salon art that itself had lost touch with the great tradition of Western painting, and it is no accident that the emergence of Pop Art, which did so much to corrupt both painting and our understanding of it, was accompanied by a remorseless revival of the *pompier* painting of the last century. In their relation to the aesthetics of painting, the works of Robert Rauschenberg, Gilbert & George, Andy Warhol, Roy Lichtenstein, Jeff Koons, Jenny Holzer, and sundry others of their line, are directly parallel to the works of Frederic

Leighton, Adolphe William Bouguereau, Franz Xavier Winterhalter, and other academic horrors of the nineteenth-century Salon . . .

The truth is that a total immersion in popular culture, which itself is now far more degraded in its values than it was even a couple of generations ago, unfits the mind for the comprehension of high art. I was reminded of this a few years ago when the National Gallery of Art in Washington mounted a remarkable exhibition devoted to a single painting – Titian's *The Flaying of Marsyas*. The painting had lately been included in an exhibition of the Venetians in London, and when it was brought to Washington after the close of the London show, it offered some of us on this side of the Atlantic a rare opportunity to see one of the greatest paintings of the entire Western tradition. Yet on the several visits I made to see this painting, *no one was there*. I had the gallery entirely to myself. Which was lovely for me, but very sad for what it indicated about the loss in understanding that our cultural life had suffered.

Elsewhere in the National Gallery, of course, there were the usual crowds bustling about the contemporary galleries where, as I recall, the work of Robert Rauschenberger – the National Gallery's favourite living artist – was very much in evidence. In the old West Wing, there was also a third-rate exhibition of Impressionist paintings for which a great many people were standing in line, four abreast, right out into the street and up the block. No one in that line seemed to know that in galleries immediately adjacent to the corridor in which the crowd was standing there were Impressionist and other nineteenth-century French paintings vastly superior in aesthetic quality to most of what awaited them in the show they had come to see. But the crowd hadn't come to look at painting. They had come to experience a media event, and even the resources of the National Gallery could not turn *The Flaying of Marsyas* into a media event. So Titian lost out to Rauschenberg and Caillebotte [Gustave Caillebotte, French Impressionist painter] – artists whose works live on much easier terms with a taste for kitsch. To the allegory that Titian had so magnificently painted in *The Flaying of Marsyas* was thus added another – an allegory on the fate of painting itself at the end of the twentieth century.

(Hilton Kramer, 'In Defence of Painting', 1993)

Art is harmony.

(Georges Seurat to Maurice Beaubourg, 1890)

According to Van Gogh, however, it is not so much the art as the artist that counts, as he writes to his brother Théo.

Zola, who otherwise, in my opinion, makes some colossal blunders when he judges pictures, says something beautiful about art in general in Mes haines: 'Dans le tableau (l'oeuvre d'art), je cherche, j'aime l'homme – l'artiste.'

There you have it; I think that's absolutely true. I ask you, what kind of *man*, what kind of visionary, or *thinker*, observer, what kind of human character is there behind certain canvases extolled for their technique – often *no kind at all*, as you know. But a Raffaëlli is somebody, a Lhermitte is *somebody*, and with many pictures by almost unknown people one has the feeling that they were made with a *will*, with *feeling*, with *passion*, with *love*.

(Vincent Van Gogh to Théo Van Gogh, 15 July 1885)

Warhol elaborates on the role of the artist.

To be really rich, I believe, is to have one space. One big empty space.
 I really believe in empty spaces, although, as an artist, I make a lot of junk.
 Empty space is never-wasted space.
 Wasted space is any space that has art in it.

An artist is somebody who produces things that people don't need to have but that he – for *some reason* – thinks it would be a good idea to give them.

(Andy Warhol, 1975)

Arthur C. Danto, a philosopher as well as a critic, believes that art has turned into philosophy, and that it was Andy Warhol, as much as anyone, who was responsible for the transformation.

It is possible to place alongside Clement Greenberg's lamentation that

nothing had happened in art in the last thirty years – that never in its history had art moved so slowly – a deeply alternative interpretation. This would be that art was not moving slowly but that the very concept of history in which it moved slowly or rapidly had itself vanished from the art world, and that we were now living in what I have been calling 'post-historical' times. Greenberg tacitly subscribed to a developmental progressive view of history, which had indeed been the way that art had been conceived since Vasari at least – as a narrative of progress in which gains and breakthroughs were made in the advancement of art's goals. The goals had changed under Modernism, but the great narrative Greenberg proposed remained developmental and progressive, and in 1964 he saw colour-field abstraction as the next step toward purifying painting. But – pop! – the train of art history was blown off the tracks and has been awaiting repair for thirty years. When on that muggy August afternoon in 1992 someone asked him whether he saw any hope at all, he answered that, well, he had thought for a long time that Jules Olitski was our best painter. The implication was that it was painting that would finally save art, get the train back on its tracks, and move to the next station – we would know we had arrived when we had arrived – in the great progressive advance of Modernism.

The alternative view would be that rather than a transit interrupted, art, construed historically, had reached the end of the line because it had moved on to a different plane of consciousness. That would be the plane of philosophy, which, because of its cognitive nature, admits of a progressive developmental narrative which ideally converges on a philosophically adequate definition of art. At the level of artistic practice, however, it was no longer an historical imperative to extend the tracks into the aesthetic unknown. In the post-historical phase, there are countless directions for art-making to take, none more privileged, historically at least, than the rest. And part of what that meant was that painting, since no longer the chief vehicle of historical development, was now but one medium in the open disjunction of media and practices that defined the art world, which included installation, performance, video, computer, and various modalities of mixed media, not to mention earthworks, body art, what I call 'object art', and a great deal of art that had earlier been invidiously stigmatized as craft. That painting was no longer the 'key' did not mean that something else was to take over from it, for in truth by the early 1990s the visual arts, in the vastly widened sense that term now took, no longer had the sort of structure that made a developmental history

interestingly thinkable or even critically important. Once we move to some sector of the visual arts other than painting and possibly sculpture, we encounter practices that can doubtless be refined upon, but where the potentialities are lacking for a progressive development of the kind painting had so readily lent itself to over the centuries, in its first phase as the project of achieving increasingly adequate representations of the world, and, in its Modernist phase, increasingly adequate attainments of its pure state. The final phase – the philosophical phase – was now to find an increasingly adequate definition of itself, but this, I am claiming, is a philosophical rather than an artistic task. It was as if a great river had now resolved itself into a network of tributaries. And it was the lack of a single current that Greenberg read as the absence of anything happening at all. Or rather, he read all the tributaries as variations of the same theme – what he called 'novelty art'.

(Arthur C. Danto, *After the End of Art*, 1997)

I never wanted to be a painter, I wanted to be a tap dancer.

(Andy Warhol, 1975)

Joyce Cary's Bohemian artist, Gulley Jimson, advocates a severe penalty for committing art.

'Mr Jimson doesn't mean it,' said Plantie, turning red. There was still a bit of the old Flanders sergeant in Plantie. 'For what is an artist for, but to make us see the beauty of the world.'

'Well,' I said severely. 'What is art? Just self-indulgence. You give way to it. It's a vice. Prison is too good for artists – they ought to be rolled down Primrose Hill in a barrel full of broken bottles once a week and twice on public holidays, to teach them where they get off.'

(Joyce Cary, 1944)

Art, the Dadaist poet Tristan Tzara claims, is not that important anyway.

Art is not the most precious manifestation of life. Art has not the celestial and universal value that people like to attribute to it. Life is far more

interesting. Dada knows the correct measure that should be given to art: with subtle, perfidious methods, Dada introduces it into daily life. And vice versa.

(Tristan Tzara, 1924)

Aesthetics is for the artist as ornithology is for the birds.

(Barnett Newman, 1972)

In Art there is only one thing that counts; the thing you can't explain.

(Georges Braque, in *Notebooks 1917–1947*)

It's a rummy business.

(J. M. W. Turner, 1775–1851, on being asked to make a statement about art)

There is no solution because there is no problem.

(Marcel Duchamp, 1887–1968, a favourite saying)

Bibliography

Alberti, Leon Battista, *On Painting* (1436), in *Artists On Art*, edited by Robert John Goldwater and Marco Treves, New York, Pantheon Books, 1945; London, Kegan Paul, 1947

Alpers, Svetlana, *Rembrandt's Enterprise: The Studio and the Market*, London, Thames & Hudson, 1988

Aretino, Pietro, letter to Titian, May 1544, in Pietro Aretino, *Selected Letters*, translated by George Bull, London, Penguin, 1967

Artaud, Antonin, 'Van Gogh: The Man Suicided by Society' (1947), in *An Antonin Artaud Anthology*, edited by Jack Hirschman, San Francisco, City Lights Books, 1965

Artists' Cookbook, The; *see* Museum of Modern Art, New York

'Artists' Session, 35 East 8th Street, New York'; *see* Robert Motherwell

Auden, W. H., 'Musée Des Beaux-Arts' (1938), in *W. H. Auden: A Selection by the Author*, London, Penguin, 1958

Ayrton, Michael, *The Rudiments of Paradise*, London, Secker & Warburg, 1971

Baglioni, Giovanni, 'Life of Caravaggio', from *Le Vite de' pittori, scultori, et architetti* (Rome, 1642), translation from Howard Hibbard, *Caravaggio*, London, Thames & Hudson, 1983

Baldinucci, Filippo, 'Life of Rembrandt' (1681), from his *Notizie de' professori del desegno da Cimabue in qua* (1681–1728), in T. Borenius, *Rembrandt*, Oxford, Phaidon, 1944

Balzac, Honoré de, 'The Unknown Masterpiece' (1831), English translation in Caxton Edition, London, 1899

Barnes, Julian, *A History of the World in 10½ Chapters*, London, Jonathan Cape, 1989

Barnes, Julian, 'The Artist as Voyeur', *Modern Painters*, Vol. IX, No. 3, Autumn 1996

Baudelaire, Charles, 'The Salon of 1846', in *Charles Baudelaire: Selected Writings on Art and Literature*, translated by P. E. Charvet, London, Penguin, 1972

Baudelaire, Charles, 'The Life and Works of Eugène Delacroix' (1863), in *Charles Baudelaire: Selected Writings on Art and Literature*, translated by P. E. Charvet, London, Penguin, 1972

Bell, Quentin, *Bad Art*, London, Chatto & Windus, 1989

Berenson, Bernard, *Piero della Francesca, or The Ineloquent in Art*, London, Chapman & Hall, 1954

Berenson, Bernard, *Italian Painters of the Renaissance* (1894–1907), Vol. II, *Florentine and Central Italian Schools* (1896–7); reprinted, Oxford, Phaidon, 1968

Berger, John, *Ways of Seeing*, London, BBC and Penguin, 1972

Berger, John, *About Looking*, London, Writers & Readers, 1980

Berger, John and Leon Kossoff; *see* Kossoff, Leon

Bernard of Clairvaux, Saint, 'Apologia to William, Abbot of St-Thierry' (*c.*1125), translation in *A Documentary History of Art*, Vol. I, *The Middle Ages and the Renaissance*, edited by Elizabeth G. Holt, New York, Doubleday, 1956

Blake, William, annotations to Reynolds's *Discourses* (*c.*1808), in *The Complete Writings of William Blake*, edited by Geoffrey Keynes, Oxford, Oxford University Press, 1966; reprinted in Sir Joshua Reynolds, *Discourses On Art*, edited by Robert R. Wark, London, Yale University Press, 1974

Blake, William, MS notebook (*c.*1808–11), in *The Complete Writings of William Blake*, edited by Geoffrey Keynes, Oxford, Oxford University Press, 1966

Blind Man, editorial, sole issue, New York, 1917; reprinted in Calvin Tomkins, *Duchamp, A Biography*, London, Chatto & Windus, 1997

Borenius, T., *Rembrandt*, Oxford, Phaidon, 1944

Boschini, M., *La Carta del navegar pittoresco* (Venice, 1660), translation in Charles Hope, *Titian*, London, Jupiter Books, 1980

Bowery, Leigh, 'The Duke, the Photographer, His Wife and the Male Stripper', *Modern Painters*, Vol. VI, No. 3, Autumn 1993

Bowie, David, 'David Bowie Meets Balthus', *Modern Painters*, Vol. VII, No. 3, Autumn 1994

Boyd, William, 'A Test of Endurance', *Modern Painters*, Vol. IX, No. 3, Autumn 1996

Braque, Georges, *Notebooks 1917–1947*, in *Illustrated Notebooks 1917–1955*, translated by Stanley Appelbaum, New York, Dover Publications, 1971

Brassaï, *The Artists of My Life*, translated by Richard Miller, London, Thames & Hudson, 1982

Brontë, Charlotte, *Villette*, 1853

Brookner, Anita, *The Genius of the Future: Studies in French Art Criticism*, London and New York, Phaidon, 1971

Brookner, Anita, *Soundings*, London, Harvill, 1997

Burne-Jones, Georgina, Lady, *Memorials of Edward Burne-Jones*, London, Macmillan, 1904

Cary, Joyce, *The Horse's Mouth*, London, Michael Joseph, 1944; London, Penguin Twentieth-Century Classics, 1992

Casa, Giovanni della, letter to Cardinal Alessandro Farnese, 1544, in Charles Hope, *Titian*, Jupiter Books, London, 1980

Cellini, Benvenuto, *The Autobiography of Benvenuto Cellini* (1558–62), translated by George Bull, London, Penguin, 1956

Cennini, Cennino, *The Book of the Art* (*c.*1390), in *Artists On Art*, edited by Robert John Goldwater and Marco Treves, New York, Pantheon Books, 1945; London, Kegan Paul, 1947

Cézanne, Paul, letter to Charles Camoin, 28 January 1902, in Herschel B. Chipp, *Theories of Modern Art*, Berkeley, Calif., University of California Press, 1971

Cézanne, Paul, letter to Émile Bernard, 15 April 1904, in Herschel B. Chipp, *Theories of Modern Art*, Berkeley, Calif., University of California Press, 1971

Cézanne, Paul, *Cézanne: A Biography*, translated by John Rewald, London, Thames & Hudson, 1986

Chantelou, Paul de Fréart, Sieur de, *Diary of Cavalier Bernini's Journey in France* (Paris, 1930), in *A Documentary History of Art*, Vol. II, edited by Elizabeth G. Holt, New York, Doubleday, 1958

Chardin, Jean Baptiste Siméon, quoted in *Diderot On Art*, Vol. I, *The Salon of 1765*, edited and translated by John Goodman, London, Yale University Press, 1995

Chatwin, Bruce, 'Howard Hodgkin, 1982', in his *What Am I Doing Here?*, London, Jonathan Cape, 1989

Clark, Kenneth, *The Nude*, London, John Murray, 1955

Clark, Kenneth, *Looking At Pictures*, London, John Murray, 1960

Collings, Matthew, 'Saatchi', *Blimey!*, 21, 1997

Constable, John, to Maria Bicknell, 30 June 1813, in *John Constable's Correspondence II*, edited by R. B. Beckett, Vol. VI, Ipswich, Suffolk Records Society, 1964

Copley, William, quoted in Calvin Tomkins, *Duchamp, A Biography*, London, Chatto & Windus, 1997

Courbet, Gustave, letter to prospective students, 25 December 1861, in *The Letters of Gustave Courbet*, edited and translated by Petra ten-Doesschate Chu, Chicago and London, University of Chicago Press, 1992

Craig-Martin, Michael, *Drawing the Line*, London, South Bank Centre, 1995

Danto, Arthur C., *Encounters and Reflections*, Berkeley, Calif., University of California Press, 1990

Danto, Arthur C., *After the End of Art*, Princeton, NJ, Princeton University Press, 1997

Dawson, Fielding, *An Emotional Memoir of Franz Kline* (1967), quoted in B. H. Friedman, *Jackson Pollock: Energy Made Visible*, London, Weidenfeld & Nicolson, 1973

Deghy, Guy, and Waterhouse, Keith, *Café Royal: Ninety Years of Bohemia*, London, Hutchinson, 1955

Delacroix, Eugène, *The Journal of Eugène Delacroix*, translated by Walter Pach, 1937; reprinted, New York, Hacker Art Books, 1980

Denis, Maurice, 'Definition of Neotradition' (1890), translation in Herschel B. Chipp, *Theories of Modern Art*, Berkeley, Calif., University of California Press, 1971

Denis, Maurice, 'The Influence of Paul Gauguin' (1903), translation in Herschel B. Chipp, *Theories of Modern Art*, Berkeley, Calif., University of California Press, 1971

Diderot, Denis, *Diderot On Art*, Vol. I, *The Salon of 1765*, edited and translated by John Goodman, London, Yale University Press, 1995

Diderot, Denis, *Diderot On Art*, Vol. II, *The Salon of 1767*, edited and translated by John Goodman, London, Yale University Press, 1995

Dorment, Richard, *Daily Telegraph*, 21 April 1993

Dorment, Richard, 'Go With the Flux', *Daily Telegraph*, April 1994

Duchamp, Marcel, letter to Suzanne Duchamp, c.15 January 1915, in Calvin Tomkins, *Duchamp, A Biography*, London, Chatto & Windus, 1997

Duncan, Isadora, *My Life*, New York, Liveright, 1927; reprinted, London, Victor Gollancz, 1968

Dürer, Albrecht, *Dürer's Record of Journeys to Venice and the Low Countries*, edited by Roger Fry, Boston, 1913; reprinted, New York, Dover Publications, 1955

Eckermann, Johann, reported conversations with Goethe, 11 and 18 April 1827, in Johann Wolfgang von Goethe, *Goethe On Art*, selected, edited and translated by John Gage, London, Scolar Press, 1980

Eco, Umberto, *Art and Beauty in the Middle Ages*, translated by Hugh Bredin, London, Yale University Press, 1986

Elderfield, John, 'Matisse in Morocco: An Interpretive Guide', in *Matisse in Morocco*, Washington, DC, National Gallery of Art, 1990

Eno, Brian, *A Year With Swollen Appendices*, London, Faber & Faber, 1997

Ernst, Max, 'Inspiration to Order', translation in *The Painter's Object*, edited by Myfanwy Evans, London, Gerald Howe, 1937

Evans, Myfanwy (ed.), *The Painter's Object*, London, Gerald Howe, 1937

Farson, Daniel, *The Gilded Gutter Life of Francis Bacon*, London, Century, 1993

Farson, Daniel, *Never a Normal Man*, London, HarperCollins, 1997

Feaver, William, *Michael Andrews, The Thames Paintings*, London, Timothy Taylor Gallery, 1998

Fielding, Henry, Preface to *Joseph Andrews*, 1742

Fréart, Paul de, Sieur de Chantelou; *see* Chantelou, Paul de Fréart, Sieur de

Freud, Lucian, 'Some Thoughts on Painting', *Encounter*, Vol. III, No. 1, July 1954

Freud, Sigmund, *Leonardo da Vinci: A Psychosexual Study of an Infantile Reminiscence* (1910), London, Kegan Paul, Trubner & Co., 1932

Friedman, B. H., *Jackson Pollock: Energy Made Visible*, London, Weidenfeld & Nicolson, 1973

Frith, W. P., *Reminiscences*, Vol. I, 1887

Fromentin, Eugène, *The Masters of Past Time* (1876), translated by Andrew Boyle, London, Dent, 1913; reprinted, Oxford, Phaidon, 1948

Frost, Terry, interview on Desert Island Discs, BBC Radio 4, 1998

Frueh, Joanna, 'Towards a Feminist Art Criticism', in *Feminist Art Criticism: An Anthology*, edited by Arlene Raven, Cassandra L. Langer and Joanna Frueh, Ann Arbor, Mich., UMI Research Press, 1988

Fry, Roger (ed.), *Dürer's Record of Journeys to Venice and the Low Countries*, Boston, 1913; reprinted, New York, Dover Publications, 1995

Fry, Roger, 'Negro Sculpture', *Athenaeum*, 1920, in his *Vision and Design*, London, Chatto & Windus, 1928; reprinted, London, Penguin, 1937

Gainsborough, Thomas, letter to W. Jackson, 1767, in Jack Lindsay, *Thomas Gainsborough*, London, Granada, 1981

Gaudier-Brzeska, Henri, 'Vortex', in *Blast*, No. 1, 20 June 1914

Gauguin, Paul, in John Rewald, *Gauguin*, London, Heinemann, 1949

Gauguin, Paul, letter from Tahiti to Daniel de Monfried, February 1898, translation partly by John Rewald, partly by Robert John Goldwater,

in Herschel B. Chipp, *Theories of Modern Art*, Berkeley, Calif., University of California Press, 1971

Gide, André, *Journals 1889–1949*, selected, edited and translated by Justin O'Brien, London, Penguin, 1967

Gilbert & George (1997), in Martin Gayford, 'Interview with Gilbert & George', in *Gilbert & George*, Paris, Musée de l'Art Moderne de la Ville de Paris, 1997

Gimpel, René, *Diary of an Art Dealer*, translated by John Rosenberg, London, Hodder & Stoughton, 1966

Goethe, Johann Wolfgang von, diary entries for 1786–8, in *Italian Journey* (1816–29), translated by W. H. Auden and Elizabeth Mayer, London, Penguin, 1962

Goethe, Johann Wolfgang von, *Goethe On Art*, selected, edited and translated by John Gage, London, Scolar Press, 1980

Goldwater, Robert John, and Marco Treves (eds), *Artists On Art*, New York, Pantheon Books, 1945; London, Kegan Paul, 1947

Gottlieb, Adolph, and Mark Rothko, letter (partially drafted by Barnett Newman) of 7 June 1943, *New York Times*, 13 June 1943

Gowing, Lawrence, *Lucian Freud*, London, Thames & Hudson, 1982

Gowing, Lawrence, *Painter and Apple*, London, Arts Council of Great Britain, 1983

Graham-Dixon, Andrew, *Howard Hodgkin*, London, Thames & Hudson, 1994

Greenberg, Clement, *Art and Culture*, New York, Beacon Press, 1961

Greenberg, Clement, 'Collage' (1959), in his *Art and Culture*, New York, Beacon Press, 1961

Greenberg, Clement, 'Modernist Painting' (1960), in his *Collected Essays and Criticism*, edited by J. O'Brian, Vol. IV, Chicago, Ill., and London, University of Chicago Press, 1993

Greer, Germaine, *The Obstacle Race*, London, Secker & Warburg, 1979

Grosz, George, *The Autobiography of George Grosz: A Small Yes and a Big No*, translated by Arnold J. Pomerans, London, Allison & Busby, 1982

Guerrilla Girls posters, *c.*1987, reproduced in Whitney Chadwick, *Women, Art and Society*, London, Thames & Hudson, 1990

Haydon, Benjamin Robert, *The Autobiography of Benjamin Robert Haydon* (1853), edited by Alexander Penrose, London, G. Bell & Sons, 1927

Hazlitt, William, 'On the Pleasure of Painting', in his *Table Talk*, 1821–2

Hazlitt, William, 'On a Landscape of Nicolas Poussin', in his *Table Talk*, 1821–2

Hepworth, Barbara, from her statement in 'Contemporary English Sculptors', *Architectural Association Journal*, April 1930

Heron, Patrick, *Space in Colour*, London, Hanover Gallery, 1953

Heron, Patrick, review of 'Georges Braque: Exhibition of Paintings at the Tate Gallery', *Arts*, New York, February 1957

Heron, Patrick, 'Solid Space in Cézanne', *Modern Painters*, Vol. IX, No. 1, Spring 1996

Hilton, Roger, 'A Letter from Roger Hilton' (1973), *Studio International*, No. 187, March 1974

Hilton, Tim, *Late Caro*, London, Serpentine Gallery, 1984

Hirst, Damien, *I Want to Spend the Rest of My Life Everywhere, With Everyone, One to One, Always, Forever, Now*, London, Booth-Clibborn, 1997

Hitler, Adolf, speech on the opening of the Haus der Deutschen Kunst, 1937, quoted in Georg Basmann, *Degenerate Art: German Art in the Twentieth Century*, London, Royal Academy, 1985

Hockney, David, *David Hockney by David Hockney*, London, Thames & Hudson, 1976

Hokusai, Katsushika, *One Hundred Views of Mount Fuji*, translated and with an introduction and commentary by Henry Smith, London, Thames & Hudson, 1988

Holt, Elizabeth G. (ed.), *A Documentary History of Art*, Vol. I, 1956, Vol. II, 1958, New York, Doubleday

Holt, Nancy (ed.), *The Writings of Robert Smithson*, New York, New York University Press, 1979; reprinted in *Robert Smithson: The Collected Writings*, edited by Jack D. Flam, Berkeley, Calif., University of California Press, 1996

Hope, Charles, *Titian*, London, Jupiter Books, 1980

Houbraken, Arnold, *Life of Rembrandt* (1721), translation in T. Borenius, *Rembrandt*, Oxford, Phaidon, 1944

Hughes, Robert, 'Hans Holbein' (1983), in his *Nothing If Not Critical*, London, Collins Harvill, 1990

Hughes, Robert, 'Julian Schnabel' (1987), in his *Nothing If Not Critical*, London, Collins Harvill, 1990

Hughes, Robert, 'Eric Fischl' (1988), in his *Nothing If Not Critical*, London, Collins Harvill, 1990

Hughes, Robert, *Frank Auerbach*, London, Thames & Hudson, 1990

Hughes, Robert, *Barcelona*, London, Harvill, 1992

Hustvedt, Siri, 'Not Just Bottles', *Modern Painters*, Vol. II, No. 4, Autumn 1998

Huxley, Aldous, 'Breughel's *Christ Carrying His Cross*' (1925), from *Along the Road*, reprinted in *Collected Essays*, London, Chatto & Windus, 1960

Huysmans, J.-K., *Là-bas* (1891), translated by A. Allinson, London, Fortune Press, 1937

Ingres, Jean Auguste Dominique, in Henri Delaborde, *Ingres's Notes and Thoughts on Art* (1870), translation in *Artists On Art*, edited by Robert John Goldwater and Marco Treves, New York, Pantheon Books, 1945; London, Kegan Paul, 1947

Jacobs, Michael, *A Guide to Andalusia*, London, Viking, 1990

Jacobson, Howard, 'Cast Among the Avid Art Merchants of Venice, A Biennale Virgin Writes Home', *Modern Painters*, Vol. I, No. 3, Autumn 1988

Jahangir, Emperor (1569–1627), *Memoirs*, Vol. II, quoted in Stuart Cary Welch, *Imperial Mughal Painting*, London, Chatto & Windus, 1978

James, Henry, 'Florentine Notes', 1874, in *Italian Hours*, 1909; reprinted, London, Century Hutchinson, 1986

James, Henry, 'John S. Sargent', *Harper's Weekly*, 1893

James, Henry, 'Lord Leighton and Ford Madox Brown', *Harper's Weekly*, 23 January 1897

James, Henry, *The Wings of the Dove*, 1902

James, Henry, *Italian Hours*, 1909; reprinted, London, Century Hutchinson, 1986

Kandinsky, Wassily, 'Empty Canvas, etc.', translated by P. Morton Shand, in *The Painter's Object*, edited by Myfanwy Evans, London, Gerald Howe, 1937

Keats, John, 'Ode on a Grecian Urn', 1819

Klee, Paul, *The Diaries of Paul Klee 1898–1918*, edited by Felix Holt, Berkeley, Calif., University of California Press, 1964

Klein, Yves (1958), quoted in Sidra Stich, *Yves Klein*, London, Hayward Gallery, 1995

Kokoschka, Oskar, *My Life*, translated by David Britt, London, Thames & Hudson, 1974

Kooning, Willem de, 'The Renaissance and Order', *trans/formation*, No. 2, New York, 1991

Kooning, Willem de, in *Sketchbook 1: Three Americans*, New York, Time Inc., 1960

Kossoff, Leon, *The Paintings of Frank Auerbach*, London, Hayward Gallery, 1978

Kossoff, Leon, and John Berger, correspondence, printed in the *Guardian*, 1 June 1996

Kramer, Hilton, 'Encountering Nevelson' (1983), in his *The Revenge of the Philistines: Art and Culture 1972–1984*, London, Secker & Warburg, 1984

Kramer, Hilton, 'In Defence of Painting', *Modern Painters*, Vol. VI, No. 3, Spring 1993

Krauss, Rosalind, 'A View of Modernism', *Art Forum*, September 1972

Lamb, Charles, 'On the Genius and Character of Hogarth', the *Reflector*, No. III, 1811; collected in his *Miscellaneous Essays*

Lawrence, D. H., 'Introduction to These Paintings', in *The Paintings of D. H. Lawrence*, London, Mandrake Press, 1929; reprinted in *Phoenix: The Posthumous Papers of D. H. Lawrence*, London, Heinemann, 1936

Leonardo da Vinci, *The Thoughts of Leonardo da Vinci*, translated by Edward McCurdy, London, Duckworth, 1907

Leonardo da Vinci, *Selections from the Notebooks of Leonardo da Vinci*, edited by Irma A. Richter, Oxford, Oxford University Press, 1977

Leslie, C. R., *Memoirs of the Life of John Constable, RA* (1843); reprinted, London, John Lehmann, 1949

Leslie, C. R., *Autobiographical Recollections by the Late Charles Robert Leslie, RA*, edited by Tom Taylor, 1860

Lessore, Helen, *A Partial Testament*, London, Tate Gallery, 1986

Levey, Michael, *Painting in Eighteenth-Century Venice*, Oxford, Phaidon, 1959; 1980; reprinted London, Yale University Press, 1994

Lewis, David, 'St Ives: A Personal Memoir', in *St Ives 1939–64*, London, Tate Gallery, 1985

Lewis, (Percy) Wyndham, 'Vortex', *Blast*, No. 1, 20 June 1914

Lilley, Marjorie, *Sickert – The Painter and His Circle*, London, Elek, 1971

Lin Yutang, *The Chinese Theory of Art*, translated by the author, London, Heinemann, 1967

Lord, James, *Giacometti: A Biography*, London, Faber & Faber, 1986

Lucian, *Erotes*, translated by M. D. Macleod, London, Heinemann, 1967

McCarthy, Mary, *The Stones of Florence*, London, Heinemann, 1959; London, Penguin, 1972

Maclaren-Ross, Julian, *Memoirs of the Forties*, London, Penguin, 1965

Magritte, René, 'La Ligne de la vie' (1938), translation in *Magritte*, Brussels, 1998; adapted from *René Magritte: Catalogue Raisonné* (1993–7), Vols II and V, edited by David Sylvester, Houston, Tex., 1995, 1997

Malevich, Kasimir, 'From Cubism and Futurism to Suprematism: The

New Realism in Painting' (1916), in *K. S. Malevich: Essays on Art 1915–1933*, Vol. I, Copenhagen, 1969

Mander, Karel van, *The Lives of the Illustrious Netherlandish and German Painters* (1604), edited by Hessel Miedema, translated by Derry Cook-Radnore, Doornspijk, Davaco, 1994

Manet, Édouard, lesson in still-life painting for Eva Gonzales, recorded by Philippe Burty (*c.*1868–70), in *Manet By Himself*, edited by Juliet Wilson-Bareau, London, Macdonald Illustrated, 1991

Manet, Édouard, in *Manet By Himself*, edited by Juliet Wilson-Bareau, London, Macdonald Illustrated, 1991

Manuel II Palaeologus, Emperor of Byzantium (*c.*1400), in T. G. Frisch, *Gothic Art and Architecture: Sources and Documents*, New York, Prentice Hall, 1971

Marinetti, Filippo Tommaso, 'The Foundation and Manifesto of Futurism', *Le Figaro*, 20 February 1909; translation by R. W. Flint, in *Selected Writings of Marinetti*, edited by R. W. Flint, London, 1971

Matheron, Laurent (1857), quoted in Janis Tomlinson, *Goya*, London, Phaidon, 1994

Matisse, Henri, letter to Raymond Escholier, Director of the Museum of the City of Paris, 10 November 1936, translation from Jack D. Flam, *Matisse On Art*, London, Phaidon, 1973

Matisse, Henri, 'Notes of a Painter on His Drawing' (1939), in Jack D. Flam, *Matisse On Art*, London, Phaidon, 1973

Matisse, Henri, 'Observations on Painting' (1945), in Jack D. Flam, *Matisse On Art*, London, Phaidon, 1973

Matisse, Henri, 'Black Is a Colour' (1946), in Jack D. Flam, *Matisse On Art*, London, Phaidon, 1973

Matisse, Henri, 'The Chapel of the Rosary, 1951', in Jack D. Flam, *Matisse On Art*, London, Phaidon, 1973

Melly, George, *Don't Tell Sybil*, London, Heinemann, 1997

Melville, Herman, *Moby-Dick, or the Whale*, 1851

Michel, Alice, 'Degas et sa modèle' (1919), translation in Richard Kendall, *Degas: Beyond Impressionism*, London, National Gallery, 1996

Miró, Joan, from Francis Lee, 'Interview with Miró', *Possibilities*, No. 1, Winter 1947–8, in *Joan Miró, Selected Writings and Interviews*, edited by Margit Rowell, Boston, G. K. Hall & Co., 1986

Miró, Joan, from Yvon Taillandier, 'I Work Like a Gardener', *XXe Siècle*, 15 February 1959, in *Joan Miró, Selected Writings and Interviews*, edited by Margit Rowell, Boston, G. K. Hall & Co., 1986

Moore, Henry, from his statement in 'Contemporary English Sculptors', *Architectural Association Journal*, May 1930

Moore, Henry, Introduction to Michael Ayrton, *Giovanni Pisano*, London, Thames & Hudson, 1969

Moraes, Henrietta, *Henrietta*, London, Hamish Hamilton, 1994

Motherwell, Robert, *et al.*, 'Artists' Session, 35 East 8th Street, New York', in *Modern Artists in America*, edited by Robert Motherwell and Ad Reinhardt, Wittenborn, Schultz, 1951

Murdoch, Iris, *The Bell*, London, Chatto & Windus, 1958

Murdoch, Iris, *Nuns and Soldiers*, London, Chatto & Windus, 1980

Museum of Modern Art, New York, *The Artists' Cookbook*, New York, MoMA, 1977

Nash, Paul, *Outline: An Autobiography and Other Writings*, London, Faber & Faber, 1949

Newman, Barnett, 'The First Man Was an Artist', *Tiger's Eye*, No. 1, New York, October 1947, in Barnett Newman, *Selected Writings and Interviews*, edited by John P. O'Neill, New York, Alfred A. Knopf, 1990

Newman, Barnett, 'The Sublime Is Now', *Tiger's Eye*, No. 6, New York, December 1948, in Barnett Newman, *Selected Writings and Interviews*, edited by J. P. O'Neill, New York, Alfred A. Knopf, 1990

Newman, Barnett, *Selected Writings and Interviews*, edited by John P. O'Neill, New York, Alfred A. Knopf, 1990

Newman, Barnett; *see also* Gottlieb, Adolph

Nicholson, Winifred, and Herbert Read, in 'Reminiscences of Mondrian', *Studio International*, No. 172, December 1966; reprinted in *Unknown Colour – Paintings, Letters, Writings by Winifred Nicholson*, London, Faber & Faber, 1987

O'Connor, F. V., *Jackson Pollock*, New York, Museum of Modern Art, 1967

Olivier, Fernande, *Picasso and His Friends* (1933), translated by Jane Miller, New York, Appleton-Century, 1965

Ortega y Gasset, José, 'Introduction to Velázquez' (1943), in his *Velázquez, Goya and the Dehumanization of Art*, translated by Alexis Brown, London, Studio Vista, 1972

Ovid (Publius Ovidius Naso), *Metamorphoses* (*c.*AD 2–8), translated by Mary M. Innes, London, Penguin, 1955

Pacheco, Francisco, *The Art of Painting* (1649), in *Artists On Art*, edited by Robert John Goldwater and Marco Treves, New York, Pantheon Books, 1945; London, Kegan Paul, 1947

Palmer, Samuel, in A. H. Palmer, *The Life and Letters of Samuel Palmer, Painter and Etcher*, London, 1892

Palomino, Antonio, *Lives of the Eminent Spanish Painters and Sculptors* (1724), translated by Nina Ayala Mallory, Cambridge, Cambridge University Press, 1988

Parmelin, Hélène, *Picasso Says . . .* (1966), translated by Christine Trollope, London, George Allen & Unwin, 1969

Perl, Jed, 'Paul Klee Now' (June 1987), in his *Gallery Going*, San Diego, New York and London, Harcourt Brace Jovanovich, 1991

Plath, Sylvia, postcard to her mother, 7 January 1956, in *Sylvia Plath: Letters Home: Correspondence 1950–63*, selected and edited with a commentary by Aurelia Schober Plath, London, Faber & Faber, 1976

Pliny the Elder, *Natural History*, translated by Philemon Holland, 1601

Pliny the Elder, *Natural History*, translated by John F. Healy, London, Penguin, 1991

Pollock, Jackson, 'Statement', in *Possibilities*, No. 1, Winter 1948–9

Pollock, Jackson, interview with William Wright, 1950, in F. V. O'Connor, *Jackson Pollock*, New York, Museum of Modern Art, 1967

Poussin, Nicolas, letter to his friend Paul de Fréart, Sieur de Chantelou, 1642, quoted in Kenneth Clark, *The Nude*, John Murray, 1955

Proust, Marcel, *Remembrance of Things Past* (1913–27), Vol. II (1919), translated by Terence Kilmartin, London, Chatto & Windus, 1982

Proust, Marcel, *Remembrance of Things Past* (1913–27), Vol. III (1920–1), translated by Terence Kilmartin, London, Chatto & Windus, 1982

Proust, Marcel, 'Chardin and Rembrandt' (*c.*1895), in his *Against Sainte-Beuve* (1954), translated by John Sturrock, London, Penguin, 1971

Read, Herbert; *see* Winifred Nicholson

Reinhardt, Ad; *see* Robert Motherwell

Rembrandt van Rijn, third letter to Constantin Huygens (12 January 1639), in *A Documentary History of Art*, Vol. II, edited by Elizabeth G. Holt, New York, Doubleday, 1958

Rembrandt van Rijn, postscript to his fifth letter to Constantin Huygens (27 January 1639), in *A Documentary History of Art*, Vol. II, edited by Elizabeth G. Holt, Doubleday, 1958

Renoir, Pierre Auguste, to his son, Jean Renoir (n.d.), in *Renoir: A Retrospective*, edited by Nicholas Wadley, London, Hugh Lauter Levin Associates, 1987

Richardson, John, *Braque*, London, Penguin Modern Painters, 1959

Richardson, John, *Late Picasso*, London, Tate Gallery, 1988

Richardson, John, 'L'Époque Jacqueline', in his *Late Picasso*, London, Tate Gallery, 1988

Rilke, Rainer Maria, *Letters on Cézanne*, edited by Clara Rilke, translated by Joel Agee, London, Jonathan Cape, 1988

Rilke, Rainer Maria, on Rodin (1903), in Denys Sutton, *Triumphant Satyr*, London, Country Life, 1966

Robertson, Bryan, 'The Open Destiny of Life', *Modern Painters*, Vol. XI, No. 1, Spring 1998

Rosenberg, Harold, *Discovering the Present: Three Decades in Art, Culture and Politics*, Chicago, Ill., University of Chicago Press, 1973

Rothenstein, William, *Men and Memories*, London, Faber & Faber, 1931

Rothko, Mark; *see* Adolph Gottlieb

Roueché, Berton, 'Unframed Space', *New Yorker*, XXVI, 5 August 1950

Ruskin, John, *Modern Painters* (1840–60), Vol. I, 1843

Ruskin, John, *Modern Painters* (1840–60), Vol. V, 1860

Ruskin, John, *The Stones of Venice*, 1851–3 (1879 edn)

Ruskin, John, *Elements of Drawing*, 1857, Letter 1

Russell, John, *Vuillard*, London, Thames & Hudson, 1971

Salmon, André, *Modigliani: A Memoir (La Vie passionnée de Modigliani)*, translated by Dorothy and Randolph Weaver, London, Jonathan Cape, 1961

Sartre, Jean-Paul, *Iron in the Soul* (1947), translated by Gerald Hopkins, London, Hamish Hamilton, 1986

Seneca, *Epistle*, 121.5, in Euphrosyne Doriadis, *The Mysterious Fayum Portraits*, London, Thames & Hudson, 1995

Seurat, Georges, letter to Maurice Beaubourg, 1890

Sewell, Brian, *The Reviews That Caused the Rumpus*, London, Bloomsbury, 1994

Shen Tsung-ch'ien (*fl.* 1781), in Lin Yutang, *The Chinese Theory of Art*, London, Heinemann, 1967

Sickert, Walter, *A Free House!*, edited by Osbert Sitwell, London, Macmillan, 1947

Smith, Henry; *see* Katsushika Hokusai

Smithson, Robert (1972), in *The Writings of Robert Smithson*, edited by Nancy Holt, New York, New York University Press, 1979; reprinted in *Robert Smithson: The Collected Writings*, edited by Jack D. Flam, Berkeley, Calif., University of California Press, 1996

Steinberg, Leo, *Other Criteria: Confrontations with Modern Art*, New York, Oxford University Press, 1972

Stendhal (Marie Henri Beyle), *L'Histoire de la peinture en Italie* (1817), in *Stendhal and the Arts*, edited by David Wakefield, London, Phaidon, 1973

Stevenson, Robert Louis, 'Some Portraits by Raeburn', in his *Virginibus Puerisque*, 1881; reprinted 1948

Stich, Sidra, *Yves Klein*, London, Hayward Gallery, 1995

Stokes, Adrian, *The Stones of Rimini*, London, Faber & Faber, 1934

Su Tung-p'o (1036–1101), in Lin Yutang, *The Chinese Theory of Art*, London, Heinemann, 1967

Sutton, Denys, *Triumphant Satyr*, London, Country Life, 1966

Sylvester, David, 'Newman I' (1986), 'Constable's Weather' (1991), 'Serra' (1992), 'Newman II' (1994), in his *About Modern Art*, London, Pimlico, 1996

Sylvester, David, *The Brutality of Fact: Interviews with Francis Bacon*, London, Thames & Hudson, 1987

Sylvester, David, *Looking at Giacometti*, London, Chatto & Windus, 1994

Sylvester, David, *About Modern Art*, London, Pimlico, 1996

Tebaldi, Jacopo, letter to Alfonso d'Este, Duke of Ferrara (1521), in Charles Hope, *Titian*, London, Jupiter Books, 1980

Thornbury, (George) Walter, *The Life of J. M. W. Turner, RA*, 1861

Tintoretto, Jacopo, in *Artists On Art*, edited by Robert John Goldwater and Marco Treves, New York, Pantheon Books, 1945; London, Kegan Paul, 1947

Titian (Tiziano Vecelli) to King Philip II of Spain, September 1554, quoted in Charles Hope, *Titian*, London, Jupiter Books, 1980

Tomkins, Calvin, *Duchamp, A Biography*, London, Chatto & Windus, 1997

Tomlinson, Janis, *Goya*, Oxford, Phaidon, 1994

Twain, Mark, *A Tramp Abroad*, 1898; reprinted, London, Century, 1982

Tzara, Tristan, lecture on Dada, 1924, in Herschel B. Chipp, *Theories of Modern Art*, Berkeley, Calif., University of California Press, 1971

Updike, John, 'Is Art Worth It?' (1985), in *Just Looking – Essays on Art*, London, Penguin and André Deutsch, 1987

Vaillant, Annette, 'Monsieur Vuillard' (1961), in John Russell, *Vuillard*, London, Thames & Hudson, 1971

Van Gogh, Vincent, *The Letters of Vincent Van Gogh*, selected and edited by Ronald de Leeuw, translated by Arnold Pomerans, London, Allen Lane The Penguin Press, 1996

Van Gogh, Vincent, to Émile Bernard, *c*.18 June 1888, in *The Letters of Vincent Van Gogh*, selected and edited by Ronald de Leeuw, translated by Arnold Pomerans, London, Allen Lane The Penguin Press, 1996

Van Gogh, Vincent, to Théo Van Gogh, 15 July 1885 and 12–13 June, 11 August, mid-August, 3 September and 16 October 1888, in *The Letters of Vincent Van Gogh*, selected and edited by Ronald de Leeuw, translated by Arnold Pomerans, London, Allen Lane The Penguin Press, 1996

Vasari, Giorgio, *Lives of the Artists* (1568), Vol. I, translated by George Bull, London, Penguin, 1965

Vasari, Giorgio, *Lives of the Artists* (1568), Vol. II, translated by George Bull, London, Penguin, 1987

Vaughan, Keith, *Keith Vaughan's Journals 1939–1977*, London, John Murray, 1989

Vollard, Ambroise, *Recollections of a Picture Dealer*, translated by Violet M. MacDonald, New York, Little, Brown & Co., 1936

Waller, Edmund, 'To Van Dyck', *Poems*, 1645

Wallis, Alfred, letter to Jim Ede, 30 November 1935, quoted in Edwin Mullins, *Alfred Wallis: Cornish Primitive Painter*, London, Macdonald, 1967

Warhol, Andy, *From A to B and Back Again*, London, Picador, 1975

Warhol, Andy, quoted in Arthur C. Danto, 'Andy Warhol on Art', in the latter's *Encounters and Reflections*, Berkeley, Calif., University of California Press, 1990; first published in *The Nation*, 1989

Waugh, Evelyn, *Work Suspended*, London, Chapman & Hall, 1943; London, Penguin, 1967

Wells, John, letter to Sven Berlin, in the latter's 'An Aspect of Creative Life in Cornwall', *Facet*, Vol. III, No. 1, Winter 1948–9

Whistler, James McNeill, 'Whistler *v.* Ruskin' (1878), in his *The Gentle Art of Making Enemies*, London, Heinemann, 1890

Whistler, James McNeill, 'Mr Whistler and His Critics' (1883), in his *The Gentle Art of Making Enemies*, London, Heinemann, 1890

Whistler, James McNeill, 'Mr Whistler's 10 O'Clock Lecture' (1885), in his *The Gentle Art of Making Enemies*, London, Heinemann, 1890

Winckelmann, Johann Joachim (1764), *Winckelmann On Art*, selected and edited by David Irwin, London, Phaidon, 1972

Wollheim, Richard, *Painting As an Art*, London, Thames & Hudson, 1987

Wood, Beatrice, *I Shock Myself: The Autobiography of Beatrice Wood*, Ojai, Calif., Dillingham Press, 1985; reprinted Chronicle Books, 1988

Woolf, Virginia, 'Walter Sickert' (1934), in her *Collected Essays*, Vol. II, London, Hogarth Press, 1966

Yüan Hung-tao (*fl.* 1607), in Lin Yutang, *The Chinese Theory of Art*, London, Heinemann, 1967

Zola, Émile, from his article on the Salon of 1866, quoted in Anita Brookner, *The Genius of the Future: Studies in French Art Criticism,* London and New York, Phaidon, 1971

Zweig, Stefan, *The World of Yesterday: An Autobiography* (1943), London, Cassell, 1953

Acknowledgements

The editors wish to express their gratitude to the following publishers, agents, literary executors and writers for permission to reprint copyright material.

SVETLANA ALPERS: from *Rembrandt's Enterprise: The Studio and the Market* (Thames & Hudson, 1988), to the publishers; PIETRO ARETINO: from his *Selected Letters*, translated by George Bull (Penguin, 1967), to the publishers; ANTONIN ARTAUD: from *An Antonin Artaud Anthology*, edited by Jack Hirschman (City Lights Books, 1965), to the publishers; W. H. AUDEN: 'Musée des Beaux-Arts', from *Collected Shorter Poems 1927–1957*, copyright 1940 and renewed 1968 by W. H. Auden, to Faber & Faber Ltd and Random House Inc.; MICHAEL AYRTON: from *Michael Ayrton: A Biography* by Justine Hopkins (André Deutsch, 1994), to the publishers; JULIAN BARNES: from *A History of the World in 10½ Chapters* (Jonathan Cape, 1989), to Random House UK Ltd and the Peters Fraser & Dunlop Group Ltd; 'The Artist as Voyeur' from the *Sunday Telegraph*, to the Peters Fraser & Dunlop Group Ltd; CHARLES BAUDELAIRE: from *Selected Writings on Art and Literature*, translated by P. E. Charvet (Penguin Classics, 1972), to the publishers; QUENTIN BELL: from *Bad Art* (Chatto & Windus, 1989), to Random House UK Ltd on behalf of the author; BERNARD BERENSON: from *Italian Painters of the Renaissance* (Phaidon, 1952), to the publishers; JOHN BERGER: from *About Looking* (Writers & Readers, 1980), to the publishers; from *Ways of Seeing* (1972), to Penguin Books Ltd; WILLIAM BLAKE: from *Complete Writings*, edited by Geoffrey Keynes (Oxford University Press, 1966), to the publishers; T. BORENIUS: from *Rembrandt* (Phaidon, 1944), to the publishers; LEIGH BOWERY: from *Modern Painters*, to the Estate of Leigh Bowery; DAVID BOWIE: from *Modern Painters* (Autumn 1994), to the author; WILLIAM BOYD: from *Modern Painters*, to The Agency (London) Ltd on behalf of the author; GEORGES BRAQUE: from *Illustrated Notebooks 1917–1955* (Dover, 1971), to the publishers; BRASSAÏ: from *The Artists of My Life*, translated by Richard Miller (Thames & Hudson, 1982), to the publishers and

Madame Brassaï; ANITA BROOKNER: from *Soundings* (Harvill, 1997), to the publishers; JOYCE CARY: from *The Horse's Mouth* (Penguin, 1992), to the publishers; BENVENUTO CELLINI: from *The Autobiography of Benvenuto Cellini*, translated by George Bull (Penguin, 1956), to the publishers; PAUL CÉZANNE: from *Cézanne: A Biography*, translated by John Rewald (Thames & Hudson, 1986), to the publishers; BRUCE CHATWIN: from *What Am I Doing Here?* (Jonathan Cape, 1989), to Random House UK Ltd and Gillon Aitken Associates; KENNETH CLARK: from *The Nude* (1955) and *Looking at Pictures* (1960), to John Murray (Publishers) Ltd; MATTHEW COLLINGS: 'Saatchi' from *Blimey!* (21 Publishing, 1997), to the author; GUSTAVE COURBET: from *The Letters of Gustave Courbet*, translated by Petra ten-Doesschate Chu (University of Chicago Press, 1992), to the publishers; MICHAEL CRAIG-MARTIN: from the catalogue published on the occasion of the 'Drawing the Line' exhibition at the Hayward Gallery, London (1995), to the author; ARTHUR C. DANTO: from *After the End of Art*, © 1997 by Princeton University Press, to the publishers; 'Andy Warhol on Art', from *The Nation* (1989), to the publishers; GUY DEGHY and KEITH WATERHOUSE: from *Café Royal: Ninety Years of Bohemia* (Hutchinson, 1955), to A. P. Watt Ltd; DENIS DIDEROT: from *Diderot On Art*, edited and translated by John Goodman (Yale University Press, 1995), to the publishers; RICHARD DORMENT: from the *Daily Telegraph*, to the author and Ewan Macnaughton Associates on behalf of the Telegraph Group Ltd; ISADORA DUNCAN: from *My Life* (Gollancz, 1968), copyright 1927 by Horace Liveright Inc., renewed © 1955 by Liveright Publishing Corporation, to Liveright Publishing Corporation; ALBRECHT DÜRER: from *Dürer's Record of Journeys to Venice and the Low Countries* (Dover, 1955), to the publishers; UMBERTO ECO: from *Art and Beauty in the Middle Ages*, translated by Hugh Bredin (Yale University Press, 1986), to the publishers; JOHN ELDERFIELD: from *Matisse in Morocco: An Interpretive Guide* (Washington, DC, National Gallery of Art, 1990), © The Museum of Modern Art, to the author; BRIAN ENO: from *A Year with Swollen Appendices* (Faber & Faber, 1997), to the publishers; MAX ERNST: from *The Painter's Object* (1937), © ADAGP Paris, 1998, to the Estate of Max Ernst; DANIEL FARSON: from *Never a Normal Man*, © Daniel Farson, 1997, to the Estate of the Late Daniel Farson and A. M. Heath & Co. Ltd and the publishers; from *The Gilded Gutter Life of Francis Bacon* (Century, 1993), to Random House UK Ltd; WILLIAM FEAVER: from *Michael Andrews, The Thames Paintings* (1998), © William Feaver, 1998, by permission of author c/o Rogers, Coleridge & White Ltd; LUCIAN

FREUD: from *Encounter* (1954), to Goodman Derrick (Solicitors) on behalf of the author; SIGMUND FREUD: from *Leonardo da Vinci and a Memory of his Childhood*, translated by Alan Tyson, © 1957 by The Institute for Psycho-Analysis, to W. W. Norton & Company Inc., and International Thomson Publishing Services Ltd (originally in *Leonardo da Vinci: A Psychosexual Study of an Infantile Reminiscence*, 1932); B. H. FRIEDMAN: from *Jackson Pollock: Energy Made Visible* (1973), to The Orion Publishing Group Ltd; TERESA G. FRISCH: from *Gothic Art 1140–c. 1450* (1971), to Prentice-Hall Inc., Upper Sadle River, NJ; EUGÈNE FROMENTIN: from *The Masters of Past Time* (1948), translated by Andrew Boyle (Phaidon Press) to the publishers; JOANNA FRUEH: from *Feminist Art Criticism: An Anthology* (UMI Research Press, 1988), to HarperCollins Publishers Inc.; ROGER FRY: from *Vision and Design* (Chatto, 1928), originally in *Athenaeum* (1920), to Mrs Pamela Diamond; PAUL GAUGUIN: from *Gauguin* by John Rewald (Heinemann, 1949), to Random House UK Ltd; ANDRÉ GIDE: from *Journals 1889–1949* (1967), to Penguin Books Ltd; RENÉ GIMPEL: from *Diary of an Art Dealer* (Hodder & Stoughton, 1966), to the Peters Fraser & Dunlop Group Ltd; J. W. GOETHE: from *Italian Journey* (1962), to Faber & Faber Ltd; from *Goethe On Art* (Scolar Press, 1980), to the translator; ADOLPH GOTTLIEB: from the *New York Times* (1943), and from *Modern Artists in America* (1951), © Adolph and Esther Gottlieb Foundation/Licensed by VAGA, New York, NY; LAWRENCE GOWING: from *Lucian Freud* (Thames & Hudson, 1982), to the publishers; from *Painter and Apple* (Arts Council of Great Britain), to the Hayward Gallery, London and the Estate of Lawrence Gowing; ANDREW GRAHAM-DIXON: from *Howard Hodgkin* (Thames & Hudson, 1994), to the publishers; CLEMENT GREENBERG: from *The Collected Essays and Criticism*, Volume IV, edited by J. O'Brian (University of Chicago Press, 1993), to the publishers; from *Art and Culture* (Beacon Press, 1961), to the publishers; GERMAINE GREER: from *The Obstacle Race* (Secker & Warburg, 1979), to Random House UK Ltd and Gillon Aitken Associates Ltd; GEORGE GROSZ: from *The Autobiography of George Grosz*, translated by Arnold J. Pomerans (Allison & Busby, 1982), to the translator; GUERRILLA GIRLS: from *Women, Art and Society* by Whitney Chadwick (Thames & Hudson, 1990), to the authors; BARBARA HEPWORTH: from *The Architectural Association Journal* (1930), © Alan Bowness, Hepworth Estate, to Sir Alan Bowness and the Architectural Association School of Architecture; PATRICK HERON: from *Modern Painters* (1996), to DACS; from *Space in Colour*, Hanover Gallery exhibition catalogue (1953), to DACS; from

the Tate Gallery, Arts (NY) exhibition (1957), to DACS; HOWARD HIBBARD: from *Caravaggio* (Thames & Hudson, 1983), to the publishers; ROGER HILTON: from *Studio International* (1974), to Rose Hilton; TIM HILTON: from *Late Caro* (1984), to the Serpentine Gallery; DAMIEN HIRST: from *I Want to Spend the Rest of My Life Everywhere, With Everyone, One to One, Always, Forever, Now* (Booth-Clibborn, 1997), to the publishers; DAVID HOCKNEY: from *David Hockney by David Hockney* (Thames & Hudson, 1976), to the publishers; KATSUSHIKA HOKUSAI: from *One Hundred Views of Mount Fuji*, translated by Henry Smith (Thames & Hudson, 1988), to the publishers; ELIZABETH G. HOLT: from *A Documentary History of Art* (Doubleday, 1956, 1958), © 1947, renewed 1957, 1981 by Princeton University Press, to The University of Iowa Foundation; NANCY HOLT: from *The Writings of Robert Smithson* (New York University Press, 1979; reprinted under the title of *Robert Smithson: The Collected Writings*, edited by Jack D. Flam, University of California Press, 1996), to Dr Nancy Holt; CHARLES HOPE: from *Titian* (Jupiter Books, 1980), to the publishers; ROBERT HUGHES: from *Barcelona* (Harvill, 1992), to the publishers; from *Nothing if Not Critical* (Collins Harvill, 1990), to the publishers; from *Frank Auerbach* (Thames & Hudson, 1990), to the publishers; SIRI HUSTVEDT: from *Modern Painters* (1998), to the author; ALDOUS HUXLEY: from *Collected Essays* (Chatto, 1960), to Mrs Laura Huxley and Random House UK Ltd; MICHAEL JACOBS: from *A Guide to Andalusia* (1990), to Pallas Athene; HOWARD JACOBSON: from *Modern Painters*, to the author; WASSILY KANDINSKY: from *The Painter's Object* (1937), © ADAGP Paris, 1998, to ADAGP on behalf of the Estate of Wassily Kandinsky; PAUL KLEE: from *The Diaries of Paul Klee 1898–1918*, edited by Felix Klee (University of California Press, 1964), © 1964 The Regents of the University of California; YVES KLEIN: from the catalogue published on the occasion of the 'Yves Klein' exhibition at the Hayward Gallery, London (1995), to Daniel Moquay; OSKAR KOKOSCHKA: from *My Life,* translated by David Britt (Thames & Hudson, 1974), to the publishers; WILLEM DE KOONING: from *Sketchbook 1: Three Americans* (1960), to Willem de Kooning Revocable Trust/Artists' Rights Society, New York; from *Modern Artists in America* (1951), to Willem de Kooning Revocable Trust; LEON KOSSOFF: from the catalogue published on the occasion of the 'Frank Auerbach' exhibition at the Hayward Gallery, London (1978), to Leon Kossoff; LEON KOSSOFF and JOHN BERGER: from the *Guardian* (1996), to Guardian Newspapers Ltd; HILTON KRAMER: from *The Revenge of the Philistines: Art and Culture 1972–1984* (Secker

& Warburg, 1984), to the author; from *Modern Painters* (1993), to the author; LEE KRASNER: from the *New Yorker* (1950), to The Pollock-Krasner Foundation Inc.; ROSALIND KRAUSS: from *Art Forum* (1972), to the publishers; D. H. LAWRENCE: 'Introduction to These Paintings' from *Phoenix: The Posthumous Papers of D. H. Lawrence* by D. H. Lawrence and edited by Edward McDonald, © 1936 by Frieda Lawrence, renewed © 1964 by the Estate of the late Frieda Lawrence Ravagli, to Laurence Pollinger Ltd and the Estate of Frieda Lawrence Ravagli, and Viking Penguin, a division of Penguin Putnam Inc; LEONARDO DA VINCI: from *Selections from the Notebooks of Leonardo da Vinci*, edited by Irma A. Richter (Oxford University Press, 1977), to the publishers; HELEN LESSORE: from *A Partial Testament* (Tate Gallery Publications, 1986), to Henry and John Lessore; MICHAEL LEVEY: from *Painting in Eighteenth-Century Venice* (Phaidon, 1959; reprinted Yale University Press, 1994), to Phaidon Press; DAVID LEWIS: from *St Ives 1939–1964* (1985), to Tate Gallery Publications; WYNDHAM LEWIS: from *Blast* (1914), © Estate of Mrs G. A. Wyndham Lewis, by permission of the Wyndham Lewis Memorial Trust; MARJORIE LILLEY: from *Sickert – The Painter and His Circle* (Elek, 1971), to Noyes Publications; JAMES LORD: from *Giacometti: A Biography* (1986), to Faber & Faber Ltd; LUCIAN: from *Erotes*, translated by M. D. Macleod (Heinemann, 1967), to Random House UK Ltd; MARY MCCARTHY: from *The Stones of Florence* (Heinemann, 1959; reprinted Penguin, 1972), to A. M. Heath & Company Ltd; JULIAN MACLAREN-ROSS: from *Memoirs of the Forties* (Penguin, 1965), to Alex Maclaren-Ross; RENÉ MAGRITTE: from *Catalogue Raisonné* (P. Wilson, 1993–7), translated by David Sylvester, to DACS on behalf of the Magritte Foundation; ROLAND MARCHAND: from *Theories of Modern Art: A Source Book by Artists and Critics* (University of California Press, 1971), to the publishers; FILIPPO TOMMASO MARINETTI: 'The Founding and Manifesto of Futurism' from *Selected Writings* by F. T. Marinetti, translated by R. W. Flint and Arthur A. Coppotelli, translation © 1972 by Farrar, Straus & Giroux Inc., to the publishers; HENRI MATISSE: from *Matisse On Art*, edited by Jack D. Flam (Phaidon, 1973), © 1998 Succession Henri Matisse for all extracts of quotes or letters by Henri Matisse. All Rights Reserved, to Georges Matisse; GEORGE MELLY: from *Don't Tell Sybil* (William Heinemann, 1997), © George Melly, 1997, to Random House UK Ltd and A. M. Heath & Co. Ltd on behalf of the author; ALICE MICHEL: from *Degas: Beyond Impressionism* by Richard Kendall (1996), to National Gallery Publications Ltd; JOAN MIRÓ: from 'I Work Like a Gardener' by Yvon Taillandier,

translated by Paul Auster, from *Joan Miró: Selected Writings and Interviews*, edited by Margit Rowell, © 1986 by Margit Rowell, to Twayne Publishers, an imprint of Simon & Schuster Macmillan and Thames & Hudson Ltd; for 'Joan Miró: Comment and Interview' by James Johnson Sweeney from *Partisan Review*, Vol. XV, No. 2 (February, 1948), © Partisan Review, to the publishers; HENRY MOORE: from the *Architectural Association Journal* (1930), to The Henry Moore Foundation and the Architectural Association School of Architecture; from *Giovanni Pisano* by Michael Ayrton (Thames & Hudson, 1969), to the publishers; HENRIETTA MORAES: from *Henrietta* (1994), to Penguin Books Ltd; IRIS MURDOCH: from *The Bell* (1958), to Random House UK Ltd; for *Nuns and Soldiers* (1980), © 1980 by Iris Murdoch, to Random House UK Ltd and Viking Penguin, a division of Penguin Putnam Inc; MUSEUM OF MODERN ART, NEW YORK, from *Artists' Cookbook* (1977), to the publishers; PAUL NASH: from *Outline: An Autobiography and Other Writings* (Faber & Faber, 1949), to The Paul Nash Trustees; BARNETT NEWMAN: from *Selected Writings and Interviews*, edited by John P. O'Neill (New York: Alfred A. Knopf, 1990), © 1990 by The Barnett Newman Foundation, by permission of The Barnett Newman Foundation Inc.; from *Modern Artists in America* (1951), to The Barnett Newman Foundation, New York; WINIFRED NICHOLSON: from *Unknown Colour – Paintings, Letters, Writings* by Winifred Nicholson (Faber & Faber, 1987), © copyright Trustees of Winifred Nicholson, to Jake Nicholson (originally in *Studio International*, 1966); FERNANDE OLIVIER: from *Picasso and His Friends*, translated by Jane Miller (Appleton-Century, 1965), to Gilbert Krill, Trustee of Fernande Olivier's Estate; OVID: from *Metamorphoses*, translated by Mary M. Innes (Penguin, 1955), to the publishers; ANTONIO PALOMINO: from *Lives of the Eminent Spanish Painters and Sculptors*, translated by Nina Ayala Mallory (Cambridge University Press, 1988), to the translator and publishers; JED PERL: from *Gallery Going* (Harcourt Brace Jovanovich, 1991), to Bergholz Literary Services; SYLVIA PLATH: from *Sylvia Plath: Letters Home: Correspondence 1950–1963* by Aurelia Schober Plath (Faber & Faber, 1976), © 1975 by Aurelia Schober Plath, to Faber & Faber Ltd and HarperCollins Publishers Inc.; PLINY THE ELDER: from *Natural History*, translated by John F. Healy (Penguin, 1991), to the publishers; JACKSON POLLOCK: from *Possibilities* (1948–9), to The Pollock-Krasner Foundation Inc.; from *Jackson Pollock* by F. V. O'Connor (Museum of Modern Art, New York, 1967), to The Pollock-Krasner Foundation Inc.; MARCEL PROUST: from *Against Sainte-Beuve*, translated by John Sturrock (Penguin, 1988), to the publishers;

from *Remembrance of Things Past*, translated by C. K. Scott Monrieff and Terence Kilmartin (Chatto & Windus, 1982), translation © 1981 by Random House Inc. and Chatto & Windus, to the publishers; HERBERT READ: from *Studio International* (1966), to David Higham Associates Ltd; JOHN RICHARDSON: from *Late Picasso* (1988), to Tate Gallery Publications; from *Braque* (1959), to Penguin Books Ltd; RAINER MARIA RILKE: from *Letters on Cézanne* (Jonathan Cape, 1988), to Random House UK Ltd and Fromm International Publishing Corporation; BRYAN ROBERTSON: from *Modern Painters* (1998), to the author; HAROLD ROSENBERG: from *Discovering the Present: Three Decades in Art, Culture and Politics* (1973), to the University of Chicago Press; WILLIAM ROTHENSTEIN: from *Men and Memories* (Faber & Faber, 1931), to Mrs Lucy Dynevor; MARK ROTHKO: from the *New York Times* (1943), writings by Mark Rothko © 1998 by Kate Rothko Prizel and Christopher Rothko, to Christopher Rothko; JOHN RUSSELL: from *Vuillard* (Thames & Hudson, 1971), to the publishers; ANDRÉ SALMON: from *Modigliani: A Memoir*, translated by Dorothy and Randolph Weaver (Cape, 1961), to Editions Seghers and Random House UK Ltd and Editions Robert Laffont; JOHN-PAUL SARTRE: from *Iron in the Soul* (1986), to Penguin Books Ltd; BRIAN SEWELL: from *The Reviews That Caused the Rumpus* (Bloomsbury, 1994), to the publishers; WALTER SICKERT: from *A Free House!* (Macmillan, 1947), by permission of Henry Lessore; LEO STEINBERG: from *Harper's Magazine* (March, 1962) and *Metro*, Numbers 4/5 (1962), reprinted in *Other Criteria: Confrontations with Modern Art* (1972), to Oxford University Press Inc.; STENDHAL: from *Stendhal and the Arts*, edited by David Wakefield (Phaidon, 1973), to the publishers; ADRIAN STOKES: from *The Stones of Rimini* (1934), to Faber & Faber Ltd; DAVID SYLVESTER: from *The Brutality of Fact: Interviews with Francis Bacon* (Thames & Hudson, 1987), to the publishers; from *On Modern Art* (Pimlico, 1996), to Random House UK Ltd; from *Looking at Giacometti* (Chatto & Windus, 1994), to Random House UK Ltd; CALVIN TOMKINS: from *Duchamp, A Biography* (Chatto & Windus, 1997), to Random House UK Ltd and the Wylie Agency UK; JANIS TOMLINSON: from *Goya* (Phaidon, 1994), to the publishers; JOHN UPDIKE: from *Just Looking – Essays on Art* (1987), to Penguin Books Ltd; VINCENT VAN GOGH: from *The Letters of Vincent Van Gogh*, translated by Arnold Pomerans (Allen Lane/The Penguin Press, 1996), to the translator; GIORGIO VASARI: from *Lives of the Artists*, translated by George Bull (Penguin, 1987), to the publishers; KEITH VAUGHAN: from *Keith Vaughan's Journals 1939–1977* (1989), to John Murray (Publishers) Ltd;

AMBROISE VOLLARD: from *Recollections of a Picture Dealer*, translated by Violet M. MacDonald (Little, Brown & Co., 1936), to the publishers; NICHOLAS WADLEY: from *Renoir: A Retrospective* (1987), to Hugh Lauter Levin Associates Inc.; ANDY WARHOL: from *The Nation* (1989), to the publishers; from *From A to B and Back Again* (Picador, 1975), to The Andy Warhol Foundation for the Visual Arts; EVELYN WAUGH: from *Work Suspended* (1943), to the Peters Fraser and Dunlop Group Ltd; STUART CARY WELCH: from *Imperial Mughal Painting* (Chatto & Windus, 1978), to George Braziller Inc.; JOHN WELLS: from *Facet* (Winter 1948–9), to the author c/o the Tate Gallery, St Ives; JULIET WILSON-BAREAU: from *Manet By Himself* (1991), to Little, Brown and Company (UK); J. J. WINCKELMANN: from *Winckelmann On Art*, selected and edited by David Irwin (Phaidon, 1972), to the publishers; RICHARD WOLLHEIM: from *Painting As an Art* (Thames & Hudson, 1987), to the publishers; BEATRICE WOOD: from *I Shock Myself: The Autobiography of Beatrice Wood* (reprinted Chronicle Books, 1988), to the publishers; VIRGINIA WOOLF: from *Collected Essays, Volume I*, copyright © 1966 by Leonard Woolf, to Random House UK Ltd and Harcourt Brace & Company; LIN YUTANG: from *The Chinese Theory of Art* (William Heinemann, 1967), to Curtis Brown Ltd; STEFAN ZWEIG: from *The World of Yesterday: An Autobiography* (Cassell, 1943), to the publishers.

Every effort has been made to acknowledge all copyright holders prior to going to press. Penguin regret any inadvertent omissions or inaccuracies. These will be rectified at the earliest opportunity.

Index